W9-AUD-921

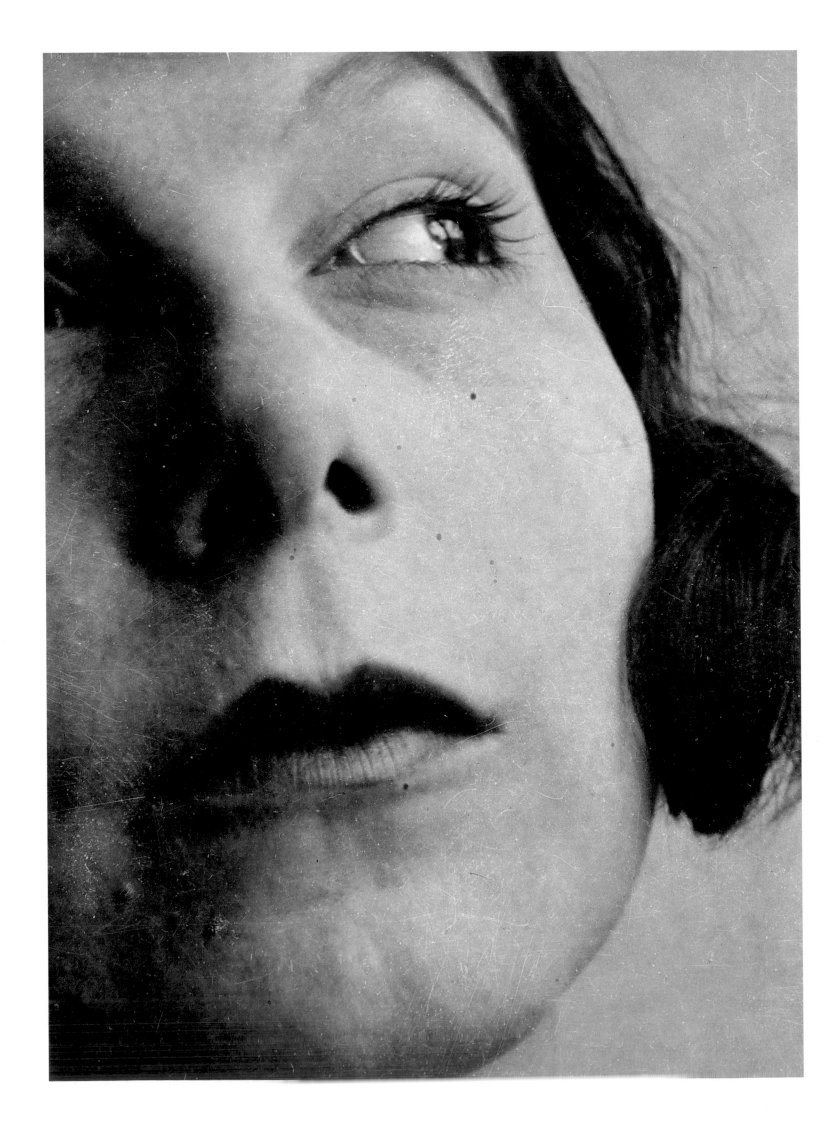

BARRY BERGDOLL | LEAH DICKERMAN

WORKSHOPS FOR MODERNITY

BAUHAUS

1919
1933

The Museum of Modern Art, New York

CONTENTS

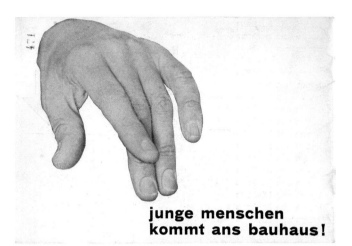

junge menschen
kommt ans bauhaus!

HyundaiCard **GE Partner**

HyundaiCard is delighted to be a part of The Museum of Modern Art's retrospective of the art and design of the Bauhaus. This German school of 1919–33 was an icon of design innovation; its efforts to undo the split between art and industrial production retain currency today and are very much in line with the design philosophy of HyundaiCard, Korea's leading credit card issuer. From scouring the world for the distinguished artists and designers who create its credit cards to helping to bring Korean design products to New York, at the core of everything we do at HyundaiCard is an utmost, constant commitment to bringing more thought-provoking design and its benefits to consumers and society at large.

As one of the first schools of modern design, the Bauhaus brought together some of the most outstanding architects and artists of its time. It was not only an innovative training center but also a place of production and a focus of international debate.

The backdrop for the Museum's historic exhibition is a global economy that is today facing unprecedented turmoil. The exhibition offers a unique platform for rich and authentic dialogues among peoples and cultures, just as the Bauhaus itself did ninety years ago, when the school was born into an industrial society gripped in crisis.

As a key sponsor of this exceptional exhibition, we hope to help to promote design innovation and to broaden public understanding of the school's revolutionary ideas on artistic education and production, as well as of its enduring influence. We welcome you to experience the Bauhaus spirit — to defy and challenge norms so that more innovative designs can be integrated into our lives.

No museum was more profoundly inspired by the Bauhaus than the young Museum of Modern Art. Walter Gropius founded the German school in Weimar in 1919; *Bauhaus 1919–1933: Workshops for Modernity* marks its ninetieth anniversary, and the eightieth of the Museum, which opened in 1929. The Bauhaus was structured to challenge traditional hierarchies of the arts, and to place fine art, architecture, and design on equal footing. Similarly, in both its collections and its organizational structure MoMA embraced media — architecture, design, photography, film — generally ignored by earlier museums. The building that MoMA inaugurated on 53rd Street in 1939 noticeably echoed the buildings that Gropius designed for the school in Dessau in 1925, and the Museum's founding director, Alfred H. Barr, Jr., once wrote, "I regard the three days which I spent at the Bauhaus in 1927 as one of the important incidents in my own education." The establishment of the Bauhaus and MoMA can be seen as parallel efforts to adapt art's existing institutional structures to the art of a new age.

During its first decade, MoMA maintained an intense relationship with the Bauhaus. In the 1930s, masters and students of the school formed part of Germany's artistic and intellectual diaspora, and many made their way to MoMA's galleries, either in person or through their work. The Museum staged its first Bauhaus exhibition in 1938, inviting Gropius and former Bauhaus student and teacher Herbert Bayer to act as organizers; the resulting show was limited to the last five years of Gropius's decade at the Bauhaus, minimizing the school's first years and altogether omitting the period after its founding director's departure. The catalogue became one of the primary ways in which Americans learned about the school. Now, some seventy years later, we are delighted to celebrate the Museum's second major exhibition on the Bauhaus, a tremendous opportunity for new generations to reevaluate the historical significance of this almost mythic school across the full range of its years.

That this project has taken on such consequential dimensions is in no small part the result of a historic collaboration between MoMA and the three major Bauhaus collections in Germany, one in each of the cities in which the Bauhaus was temporarily resident: Weimar, Dessau, and Berlin. A version of this exhibition was presented at the Martin-Gropius-Bau, Berlin, earlier this year. Now this collaboration, possible only since the reunification of Germany in 1990, brings an astounding array of works to the United States for the first time. We are enormously indebted to our German partners, and to Annemarie Jaeggi, Director of the Bauhaus-Archiv Berlin; to Hellmut Seemann, President of the Klassik Stiftung Weimar; and to Philipp Oswalt, Director and Chairman of the Stiftung Bauhaus Dessau, and

Omar Akbar, former Director of that institution, not only for generous loans but for intellectual exchange, encouragement, and cooperative good will.

On the home team we applaud Barry Bergdoll, Philip Johnson Chief Curator of Architecture and Design and the initiator of the New York project, and Leah Dickerman, Curator in the Department of Painting and Sculpture, for taking leadership roles in this multidepartmental endeavor. Andres Lepik, Curator in the Department of Architecture and Design, was an invaluable collaborator in the early phases of planning. We are especially grateful to the generous supporters of the project and of the Museum's programming in general. *Bauhaus 1919–1933: Workshops for Modernity* is made possible by HyundaiCard Company. Major support is provided by Mrs. Stephen M. Kellen, and additional funding is provided by Jerry I. Speyer and Katherine G. Farley and by Robert B. Menschel. The International Council of The Museum of Modern Art has generously contributed to the publication of this catalogue, which brings together an international array of scholars of modern art and German cultural history.

Finally, on behalf of the Trustees and the staff of the Museum, I wish to thank the private individuals and museum colleagues who have allowed us to borrow precious works in their collections for this exhibition. Their generosity has allowed us in many cases to exhibit works that have not yet been seen in the country, and in others to provide a new and revelatory context for familiar ones. A special debt is owed to those institutions and collectors who have made multiple loans, depriving them of large groups of works. Included in this group are our partner institutions, but also The Josef and Anni Albers Foundation, Bethany, Conn.; the Harvard Art Museum/Busch-Reisinger Museum; The Metropolitan Museum of Art, New York; the Centre Pompidou, Paris, Musée national d'art moderne/Centre de création industrielle; Merrill C. Berman; and another, anonymous private collector. Without this extraordinary group of lenders, the exhibition would not have been possible.

Glenn D. Lowry Director, The Museum of Modern Art

Kunstmuseum Basel, Kupferstichkabinett
Bauhaus-Archiv Berlin
Designsammlung Ludewig, Berlin
Staatliche Museen zu Berlin, Nationalgalerie, Museum Berggruen
Staatliche Museen zu Berlin, Neue Nationalgalerie
Zentrum Paul Klee, Bern
Kunsthalle Bielefeld
Gerhard-Marcks-Haus, Bremen
Harvard Art Museum, Busch-Reisinger Museum, Cambridge, Mass.
The Art Institute of Chicago
Museum Ludwig, Cologne
Theaterwissenschaftliche Sammlung, Universität zu Köln, Cologne
Stiftung Bauhaus Dessau
Kupferstich-Kabinett, Staatliche Kunstsammlungen Dresden
Puppentheatersammlung, Staatliche Kunstsammlungen Dresden
Deutsches Architekturmuseum, Frankfurt
Louisiana Museum of Modern Art, Humlebaek
Tate, London
Victoria and Albert Museum, London
Long Beach Museum of Art
The J. Paul Getty Museum, Los Angeles
Die Museen für Kunst und Kulturgeschichte der Hansestadt Lübeck
Die Neue Sammlung — The International Design Museum Munich
Solomon R. Guggenheim Museum, New York
The Jewish Museum, New York
The Metropolitan Museum of Art, New York
Neue Galerie New York
Germanisches Nationalmuseum, Nuremberg
Centre Pompidou, Paris, Musée national d'art moderne/Centre de création industrielle
Musée d'art moderne et contemporain de Strasbourg
Hirshhorn Museum and Sculpture Garden, Smithsonian Institution, Washington, D.C.
Library of Congress, Washington, D.C.
National Gallery of Art, Washington, D.C.
Klassik Stiftung Weimar, Bauhaus-Museum and Graphische Sammlungen
Kunsthaus Zurich

The Josef and Anni Albers Foundation, Bethany, Conn.
Merrill C. Berman
Justus A. Binroth, Berlin
Esther M. English
Joy of Giving Something, Inc.
Collection Herbert Kloiber
Renée Price. Courtesy Neue Galerie New York
Joost and Lore Siedhoff
Michael Szarvasy Collection, New York

Anonymous lenders
Private collection. Courtesy Galerie Ulrich Fiedler, Berlin
Private collection. Courtesy Neue Galerie New York

Erich Comeriner Archiv. Galerie David, Bielefeld
Galerie Berinson, Berlin

ACKNOWLEDGMENTS

A project of this scale owes its existence to many individuals and institutions. We have been most fortunate in the help that we have received and in the goodwill with which it has been given.

The project was made possible by an extraordinary partnership with the three Bauhaus collections in Germany: the Bauhaus-Archiv Berlin, the Klassik Stiftung Weimar, and the Stiftung Bauhaus Dessau. This collaboration has allowed us to show many works that have rarely if ever been seen in the United States. As two of these institutions are located in the former East Germany, our alliance was made possible only with Germany's reunification, in 1990. We are very grateful to Annemarie Jaeggi, Director, Bauhaus-Archiv Berlin; Hellmut Seemann, President, Klassik Stiftung Weimar; and Philipp Oswalt, Director and Chairman, Stiftung Bauhaus Dessau. Klaus Weber at the Bauhaus-Archiv Berlin has been so much a part of our preparations that he seems part of our own team; we are grateful for his humor and wisdom. Among others who facilitated the exhibition, we extend our particular gratitude to Christian Wolsdorff, Elke Eckert, and Monika Tritschler, Bauhaus-Archiv Berlin; Michael Siebenbrodt, Ulrike Bestgen, and Nicole Mende, Klassik Stiftung Weimar; Wolfgang Thöner, Rhoda Riccius, Kirsten Baumann, Regina Bittner, and Katja Szymczak, Stiftung Bauhaus Dessau; and Omar Akbar, former Director, Stiftung Bauhaus Dessau.

Our greatest debt must be to the exhibition's lenders, many of whom have acted as true collaborators, facilitating loans and enlightening us about works in their care. We extend special thanks to Nicholas Fox Weber, Brenda Danilowitz, Oliver Barker, and Jeanette Redensek, The Josef and Anni Albers Foundation, Bethany, Conn.; James Cuno, Mark Pascale, and Joseph Rosa, The Art Institute of Chicago; Hendrik A. Berinson and Ulrike Graul, Galerie Berinson, Berlin; Alfred Pacquement, Laurent Le Bon, Christian Derouet, Quentin Bajac, and Jonas Storsve, Centre Pompidou, Paris, Musée national d'art moderne/Centre de création industrielle; Nathan Koch and Reinhard Sonnak, Galerie David, Bielefeld; Peter Cachola Schmal, Wolfgang Voigt, and Inge Wolf, Deutsches Architekturmuseum, Frankfurt; G. Ulrich Grossmann and Roland Prügel, Germanisches National-museum, Nuremberg; Michael Brand, Judith Keller, Virginia Heckert, and Paul Martineau, The J. Paul Getty Museum, Los Angeles; Richard Armstrong, Susan Davidson, Tracey Bashkoff, Vivien Greene, and Jeffrey Warda, Solomon R. Guggenheim Museum, New York; Thomas Lentz, Peter Nisbet, Laura Muir, and Lizzy Ramhorst, Harvard Art Museum, Busch-Reisinger Museum; Richard Koshalek, Kerry Brougher, and Valerie Fletcher, Hirshhorn Museum and Sculpture Garden, Smithsonian Institution, Washington, D.C.; Joan Rosenbaum and Norman Kleeblatt,

The Jewish Museum, New York; Howard Stein and Sarah Cucinelli, Joy of Giving Something, Inc.; Jutta Hülsewig-Johnen, Kunsthalle Bielefeld; Christoph Becker and Tobia Bezzola, Kunsthaus Zurich; Christian Müller, Kunstmuseum Basel, Kupferstichkabinett; Wolfgang Holler and Agnes Matthias, Kupferstich-Kabinett, Staatliche Kunstsammlungen Dresden; C. Ford Peatross, Library of Congress, Washington, D.C.; Ron Nelson, Long Beach Museum of Art; Poul Erik Tøjner, Louisiana Museum of Modern Art, Humlebæk; Kaspar König, Museum Ludwig, Cologne; Jürgen Fitschen and Arie Hartog, Gerhard-Marcks-Haus, Bremen; Thomas Campbell, Gary Tinterow, Malcolm Daniel, Sabine Rewald, and Mia Fineman, The Metropolitan Museum of Art, New York; Estelle Pietrzyk, Musée d'art moderne et contemporain de Strasbourg; Hans Wisskirchen and Thorsten Rodiek, Die Museen für Kunst und Kulturgeschichte der Hansestadt Lübeck; Earl A. Powell III, Harry Cooper, and Lisa MacDougall, National Gallery of Art, Washington, D.C.; Renée Price, Janis Staggs, Sefa Saglam, and Geoffrey Burns, Neue Galerie New York; Florian Hufnagl, Josef Strasser, and Tim Bechtold, Die Neue Sammlung—The International Design Museum Munich; Lars Rebehn, Puppentheatersammlung, Staatliche Kunstsammlungen Dresden; Udo Kittelmann and Dieter Scholz, Neue Nationalgalerie and Museum Berggruen, Staatliche Museen zu Berlin; Vicente Todoli and Matthew Gale, Tate, London; Elmar Buck and Gerald Köhler, Theaterwissenschaftliche Sammlung, Universität zu Köln, Cologne; Julius Bryant and Christopher Wilk, Victoria and Albert Museum, London; and Juri Steiner and Christine Hopfengart, Zentrum Paul Klee, Bern.

We are also extremely grateful to private lenders: Merrill C. Berman, Justus A. Binroth, Esther M. English, Herbert Kloiber, Manfred Ludewig, Renée Price, Joost and Lore Siedhoff, Michael Szarvasy, and nine anonymous individuals.

We warmly thank others who provided essential assistance with loans: Ina Conzen, Staatsgalerie Stuttgart; Ulrich Fiedler, Galerie Ulrich Fiedler, Berlin; Sabine Fischer, Kunstsammlung Literaturarchiv Marbach; Hendrik Rolf Hanstein, Kunsthaus Lempertz, Cologne; Wulf Herzogenrath, Kunsthalle Bremen; and Elizabeth Kujawski, Diana Kunkel, Vlasta Odell, and Jennifer W. Smith.

The many who assisted our research included Winfried Brenne and Franz Jaschke, Winfried Brenne Architekten, Berlin; Gwen Chanzit, Denver Art Museum; Magdalena Droste; Caroline Bødker Enghoff, Louisiana Museum of Modern Art; Catherine Futter, The Nelson-Atkins Museum of Art, Kansas City, Mo.; Aprile Gallant, Smith College Museum of Art; Kristina Jaspers, Deutsche Kinemathek, Museum für Film und Fernsehen, Berlin;

Karen Koehler, Hampshire College; Sarah Lowengard; Karin von Maur; Christiane Schill; Dean Schwarz; John Tain and Wim DeWit, Getty Research Institute, Los Angeles; Jonas Malmdal, The Swedish Museum of Architecture, Stockholm; Joyce Tsai; Daniel Weiss, GTA Archives, Zurich; and Klaus-Jürgen Winkler, Bauhaus-Universität Weimar. Helping us secure images for this publication were Karine Bomel, Bibliothèque Kandinsky, Centre Pompidou; Jim Frank; Sabine Hartmann, Bauhaus-Archiv Berlin; Christopher William Linnane, Harvard Art Museum; Kira Maye, Art Resource, New York; Margot Rumler, Stiftung Bauhaus Dessau; Jeffrey Sturges; Cornelia Vogt, Klassik Stiftung Weimar; and Christiane Wolf and Petra Goertz, Bauhaus-Universität Weimar, Archiv der Moderne.

At the Museum the project has drawn on virtually every department. Our foremost thanks go to Glenn D. Lowry, Director, who supported us warmly and effectively. The leadership and counsel of Jennifer Russell, Senior Deputy Director for Exhibitions, Collections, and Programs, and Peter Reed, Senior Deputy Director for Curatorial Affairs, have been essential. Among our Trustees, Ronald Lauder and Leon Black have been particularly supportive. Trish Jeffers, Director of Human Resources, and Laura Coppelli, Manager, Employee Relations and Recruitment, have helped us with staffing and management issues.

The multimedia nature of the exhibition has made us more dependent than usual on the expertise of our fellow curators, and on their generosity with interdepartmental loans. In the Department of Painting and Sculpture, we deeply appreciate the trust of Ann Temkin, The Marie-Josée and Henry Kravis Chief Curator, and are thankful for her support. John Elderfield, Chief Curator Emeritus, provided sage and serious counsel in the early phases. Anne Umland, Curator, has offered wise advice. Lilian Tone, Assistant Curator, contributed important research through her own interest in the Bauhaus, and Nora Lawrence, Curatorial Assistant, provided essential early help. The interest of these colleagues has been deeply sustaining. In the Department of Architecture and Design, Andres Lepik, Curator, helped to initiate the project and has generously continued to support it. Juliet Kinchin, Curator, Paul Galloway, Cataloger, and Emma Presler, Department Manager, have answered all manner of questions. In the Department of Photography, Sarah Meister, Curator, and Peter Galassi, Chief Curator, worked with us closely; our conversations with them were collegial in the most expansive sense. Susan Kismaric, Curator, also deserves special thanks. In the Department of Drawings we thank Connie Butler, The Robert Lehman Foundation Chief Curator; Jodi Hauptman, Curator; Kathleen Curry, Assistant Curator; and Alexandra Schwartz, Curatorial Assistant. In the Department of Prints and Illus-

trated Books we are grateful to Deborah Wye, The Abby Aldrich Rockefeller Chief Curator; Sarah Suzuki, Assistant Curator; and Iris Schmeisser, Curatorial Assistant. Finally, in the Department of Film, Anne Morra, Assistant Curator, and Peter Williamson, Film Conservation Manager, facilitated the exhibition of key works. In this context we are also grateful to Charles Kalinowski, Media Services Manager, Information Technology.

In these hard economic times, we are deeply thankful to the show's supporters. The exhibition is made possible by HyundaiCard Company. Major support is provided by Mrs. Stephen M. Kellen, and additional funding is provided by Jerry I. Speyer and Katherine G. Farley and by Robert B. Menschel. We are also tremendously grateful to The International Council of The Museum of Modern Art for its funding of this book, and for hosting a dinner to celebrate our lenders.

Our colleagues in the Department of Development have maintained their optimism and determination in the bleakest of economic environments, and we greatly appreciate their commitment and skill in finding funding for this institution and its programs: Michael Margitich, Senior Deputy Director for External Affairs; Todd Bishop, Director of Exhibition Funding; Mary Hannah, Associate Director of Exhibition Funding; and Lauren Stakias, Associate, Exhibition Funding.

For broadcasting this exhibition to the public we extend warm thanks to the Marketing and Communications departments: Kim Mitchell, Chief Communications Officer; Daniela Stigh, Assistant Director, Communications; Julia Hoffman, Creative Director, Graphic Design and Advertising; and Julie Welch, Associate Director, Marketing.

In the Department of Exhibitions, Maria DeMarco Beardsley, Coordinator; Randolph Black, Associate Coordinator; and Jessica Cash, Assistant to the Coordinator, have brought judgment and diplomacy to the project. Patty Lipshutz, General Counsel, and Nancy Adelson, Deputy General Counsel, have provided invaluable advice. We are indebted to our extraordinarily professional colleagues in the Department of Collection Management and Exhibition Registration: Ramona Bannayan, Director; Sacha Eaton, Assistant Registrar; Corey Wyckoff, Senior Registrar Assistant, Exhibitions; Jeri Moxley, Manager, Collection and Exhibition Technologies; Ian Eckert, Coordinator, Collection and Exhibition Technologies; and Kristen Shirts, Assistant, Collection and Exhibition Technologies. The in-house transportation and installation of artworks was smoothly coordinated by Rob Jung, Manager; Steve West, Assistant Manager; Sarah Wood, Assistant Manager; Karlyn Benson, Registrar Assistant; Kim Loewe, Preparator; and Pamela Popeson, Preparator. James Gara, Chief

Operating Officer; Tunji Adeniji, Director of Facilities and Safety; and Ron Simoncini, Director of Security, have contributed essential support for the program.

In the Department of Exhibition Design and Production, Jerome Neuner, Director; Betty Fisher, Production Manager; Michele Arms, Department Manager; and Peter Perez, Foreman of the Frame Shop, deserve truly special thanks for their creativity and expertise in creating a display that both highlights individual works and draws connections among them. In the Department of Graphic Design, Claire Corey, Production Manager; Brigitta Bungard, Design Manager; and August Heffner, Design Manager, made key contributions to this exhibition's presentation.

Wendy Woon, The Edward John Noble Foundation Deputy Director for Education; Pablo Helguera, Director, Adult and Academic Education; Laura Beiles, Associate Educator, Adult and Academic Programs; Sara Bodinson, Associate Educator, Educational Resources; Francesca Rosenberg, Director, Community and Access Programs; and Allegra Burnette, Creative Director of Digital Media, have designed a rich menu of auxiliary programs and educational materials. Our research drew heavily on the Museum's Library and Archives; we thank Milan Hughston, Chief of Library and Museum Archives; Jennifer Tobias, Librarian; Sheelagh Bevan, Assistant Librarian; David Senior, Acquisitions Coordinator; Jen Bandini, Library Assistant; Michelle Elligott, The Rona Roob Museum Archivist; and Michelle Harvey, Associate Archivist. In Imaging Services, Erik Landsberg, Head of Collections Imaging; Robert Kastler, Production Manager; Roberto Rivera, Production Assistant; Thomas Griesel, Collections Photographer; and John Wronn, Collections Photographer, graciously provided photographs for the exhibition and book.

In the Department of Publications, Christopher Hudson, Publisher; Kara Kirk, Associate Publisher; and Marc Sapir, Production Director, have shepherded this book into print with both tough and tender guidance. As the book's editor, David Frankel, Editorial Director, served as its first reader and improved the text at every turn. The elegant design by Mark Nelson of McCall Associates is wonderfully sensitive to both the book's subject and its ambitions; his faith that every problem has a solution has won him our gratitude and admiration. Hannah Kim, Marketing and Book Development Coordinator; Christina Grillo, Associate Production Manager; and Jennifer Zimmer and Elizabeth Friedland, interns, made important contributions. The quality of the book depends entirely on the authors listed in the Contents, and Jodi Hauptman, Charles W. Haxthausen, Susan Laxton, Alex Potts, and Frederic J. Schwartz offered critical comments on their and our texts. We cannot thank these writers and critics enough.

The variety of the exhibition's objects has taken us to almost every conservator in the Museum. Special thanks to Jim Coddington, Chief Conservator; Lee Ann Daffner, Photography Conservator; Roger Griffith, Associate Sculpture Conservator; Reinhard Bek, Conservation Fellow; Lynda Zycherman, Sculpture Conservator; Margo Delidow, Kress Fellow; Karl Buchberg, Senior Conservator; and Scott Gerson, Assistant Paper Conservator. We are grateful for their insights into the making of the works and for their care for the objects entrusted to us by the exhibition's lenders.

The main burden of this project fell on the Bauhaus curatorial team, an extraordinarily talented and dedicated group. In the Department of Painting and Sculpture, Adrian Sudhalter, Assistant Research Curator and a scholar of Weimar culture, wore many hats, serving as project manager, research director, and author of two contributions to this book. Her judgment and insight are reflected in every aspect of the project. Eleonore Hugendubel, Curatorial Assistant, gracefully handled vast responsibilities, managing the catalogue production on the curatorial side, securing images and rights, and researching and writing. Cara Manes, Administrative Assistant to Leah Dickerman, played an invaluable role; the curators have relied on her organization skills, elegant writing, innate diplomacy, and intelligence throughout the project's complex institutional life. In the Department of Architecture and Design, Dara Kiese, Curatorial Assistant, was an intrepid researcher and brought passion and enthusiasm to a range of administrative tasks. Her own work on Bauhaus media relations and exhibitions was of great value. Colin Hartness, Assistant to the Chief Curator, was a meticulous support in everything from travel arrangements to work flow. A number of dedicated interns deserve our thanks: Grant Alford, Alex Bacon, Iben Falconer, Natalia Lauricella, Tanya Paz, and Lea Richard. The professionalism and impeccable research skills of Maria Marchenkova, the Holly Solomon Twelve-Month Intern, Department of Painting and Sculpture, were essential.

Those closest to the curators may have felt the burdens of this project most. Barry Bergdoll is grateful to many friends and colleagues but above all to Andres Lepik and Cristina Ines Steingraeber for their counsel and hospitality, to the students in his 2008 Columbia University graduate seminar on the Bauhaus, and not least to William Ryall for his loyal support and patience. Leah Dickerman thanks her mother, Mary Dickerman, whose generous help has repeatedly served to balance the demands of work and life. She is also particularly thankful for the love and understanding of her husband, Neil Shneider, and children, Daniel and Livia.

Barry Bergdoll Philip Johnson Chief Curator of Architecture and Design
Leah Dickerman Curator, Department of Painting and Sculpture

The legacy of the Bauhaus has been shaped by the tides of the twentieth century itself. After the school's forced closing, in 1933, many of its faculty and students left Germany for the Americas, Mandate Palestine, South Africa, and elsewhere, and through this diaspora, varied understandings of the Bauhaus proliferated. In the United States, Bauhaus émigrés were influential teachers for several generations of art and architecture students, drawing on pedagogical principles developed at the German school. At the same time, the rationalized idiom of some of the Bauhaus's most famous designs became identified with the spectacular flourishing of American corporate culture. In both parts of divided postwar Germany, the Bauhaus played weighty symbolic roles as an emblem of the aspirations of a new German democratic state. In 1938, The Museum of Modern Art staged an exhibition organized by the school's founding director, Walter Gropius, along with former student and teacher Herbert Bayer, that would crucially shape the American reception of Bauhaus products and principles. That the school has been such a key symbol over many years of intellectual and political debate points to its significance in exploring the tight relationship between modernism and twentieth-century history, but also threatens to overwhelm our knowledge of the Bauhaus's real output: the objects and ideas that it produced.

Bauhaus 1919–1933: Workshops for Modernity, this Museum's first major exhibition on the Bauhaus since that show of 1938, offers an important opportunity to reconsider the school's significance in our own moment. In the years since the reunification of Germany, greater access to archives and collections has nurtured a wealth of fresh scholarship, and the passing of time, and the waning of Cold War political formations, have likewise nurtured new perspectives. In approaching this project our curatorial team has developed a series of principles.

The word "Bauhaus" is often used popularly as a kind of shorthand for an international modern style unmoored from any particular moment. At the outset, we want to counter this chronological vagueness with historical rigor, and tie the Bauhaus to its time — exactly the same years as the Weimar Republic. As early as 1923, Oskar Schlemmer wrote in his diary that "four years of the Bauhaus reflect not only a period of art history, but a history of the times too, because the disintegration of a nation and an era is also reflected in it." The Museum's first Bauhaus exhibition, *Bauhaus 1919–1928*, gave short shrift to the school's first years and completely excised the period after Gropius's departure. In contrast, the present exhibition and catalogue cover the school's full history. The Bauhaus's three directors — Gropius (1919–28), Hannes Meyer (1928–30), and Ludwig Mies

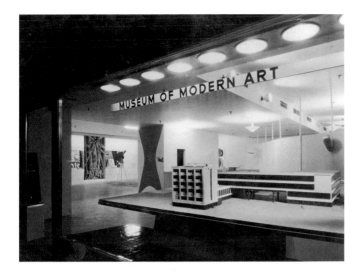

Views of the exhibition *Bauhaus: 1919–1928*, The Museum of Modern Art, New York, December 7, 1938–January 30, 1939. Gelatin silver prints. Each: 7 x 9 1/2" (17.7 x 24.1 cm). The Museum of Modern Art Archives, New York. Photographic Archive

them a commitment to abstraction as the language of the modern and a redefinition of the artist as a designer of systems. Yet perhaps the keenest impulse is a pervasive skepticism about received knowledge. In challenging the way traditional academies taught students through the imitation of historical models, the Bauhaus worked as a laboratory for ongoing experiment.

In his 1919 program for the Bauhaus, Gropius wrote that the arts had become "isolated" in the modern age and the school had to forge a "new unity." Across its fourteen year history, the Bauhaus provided a framework for dialogue among avant-garde artists, architects, and designers. Its faculty and students repeatedly addressed the question of how to redefine art in relation to a modern culture of technological media, mass production, expanding consumerism, and an intensely felt threat of nationalism; the things they made can be understood as a series of propositions on the subject. This exhibition focuses in particular on the productive interrelations among diverse media, mixing works from the school's different workshops to trace formal and conceptual ideas as they manifest in objects made of different materials and for different purposes. The school's structural and teaching practices posed fundamental challenges to the distinction between art and design, and irrevocably changed the terms of both. Such crossing of boundaries gets to the heart of what we feel is central to the Bauhaus's legacy today.

Now we may be able to approach the Bauhaus as a historical phenomenon in some ways for the first time. Our world is no longer the late-modernist one in which artists, designers, and architects intensely sought validation from the Bauhaus, or reacted oedipally against it. In the perspectives freshly possible, what had seemed the paradigmatic modernist institution may offer not only an alternate vision of modernity but a keenly relevant example for our complex present.

Barry Bergdoll and **Leah Dickerman**

van der Rohe (1930–33) — were among the twentieth century's most important architectural minds, but their outlooks diverged. The school also occupied three cities with distinct social climates: it started in Weimar, the home of Johann Wolfgang von Goethe and Friedrich von Schiller, towering figures of the German classical culture of the eighteenth and nineteenth centuries. In 1925, conservative political opposition forced it to leave for the industrial city of Dessau, where it moved into the internationally acclaimed buildings designed for it by Gropius. In 1932, after local Nazi officials closed the Dessau Bauhaus, a small group of students and faculty tried to continue in an abandoned telephone factory in metropolitan Berlin, but the school's doors were shut for the last time on April 11, 1933.

In looking across this historical sweep, we approach the Bauhaus not as an artistic style or a programmatic movement but as a vibrant school. We see a wide range of artists — both men and women, from the school's best-known masters to virtually unknown students — and a broad variety of types of work, from course exercises and unrealized projects to finished artworks and widely distributed goods. This breadth maps and complicates the school's intellectual terrain, and helps us as retrospective observers to see what shapes the school's products into something more than the sum of its individual artists' works: the collective nature of its ideas. Key principles emerge, among

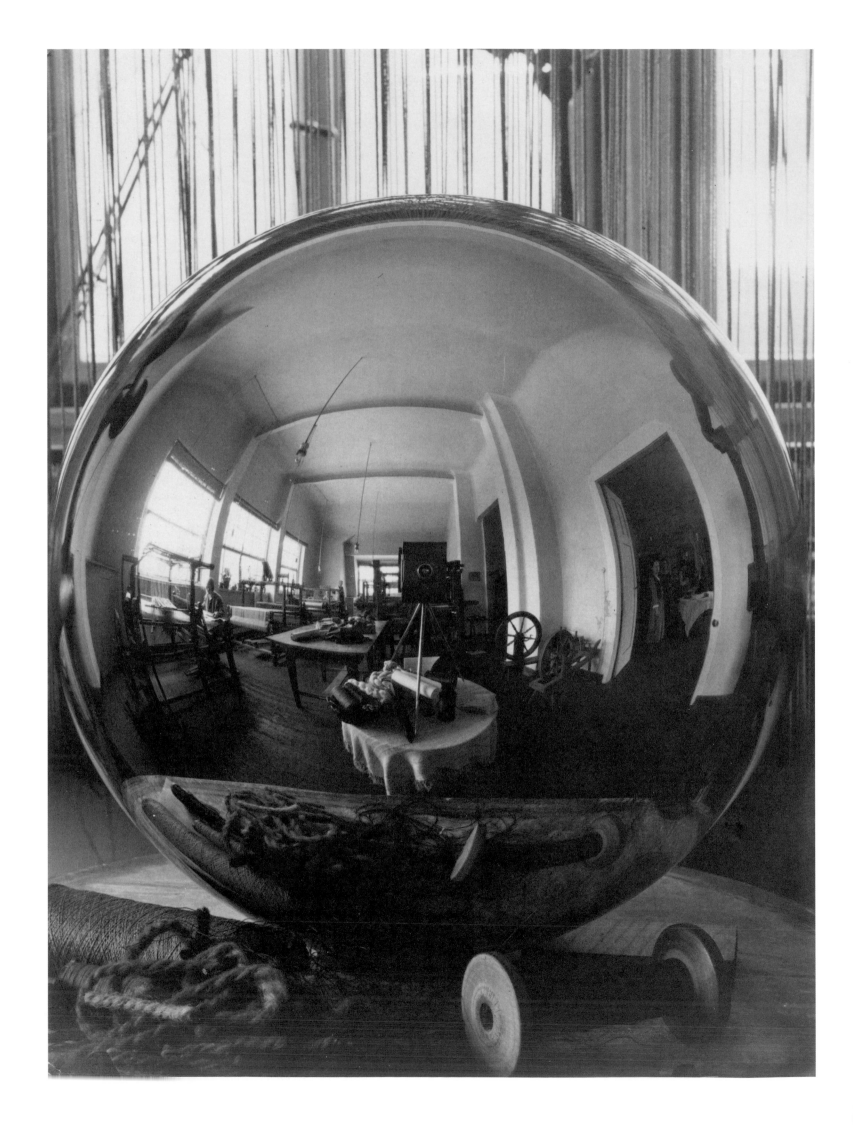

BAUHAUS FUNDAMENTS

LEAH DICKERMAN

Given its diasporic influence in our lives today, the Bauhaus is so familiar that we think of it as a form of ur-modernism, a point of mythic origin. Yet at the same time, there are ways in which it is not well known at all, overshadowed as it has often been by the many meanings given to it in later years.[1] A current strain of writing, conversely, stresses failure, describing its tenuous footing as a business, for example, or the way the goal of creating goods for mass production often eluded it.[2] Despite the iconic quality of so many Bauhaus images and objects, the school's most significant achievement may be its nurturing of a sustained cross-media conversation about the nature of art in the modern age: over the course of fourteen years — precisely those of the tumultuous tenure of the Weimar Republic — the Bauhaus brought together artists, architects, and designers in a kind of cultural think tank for the times. Certainly the duration is unprecedented, but the rich mix of prominent participants in different fields of the visual arts is nearly so. This purposeful diversity, present from the start, provoked a reimagining of the relation between fine art and design that offered a formidable challenge to the distinction between them. The result was hardly monolithic in orientation, but rather a series of positions, varying and sometimes at variance with one another, that attempted to work through the ways in which a new modern culture of technological media, machine production, global communication, and postwar politics might shape the role of the artist. Thinking of the Bauhaus this way highlights its commitment to theory as well as practice, though of course the two are deeply intertwined. Rather than trace the school's complicated history, which has been richly chronicled elsewhere, this essay examines a series of key precepts that gave specific shape to Bauhaus modernism.[3]

Teaching as Experience

Although the Bauhaus was ultimately many things — publisher, advertising agency, industrial-design partner, fabricator — it was first and foremost a school, and its approach to modernism was defined pedagogically. Skeptical about the possibility of teaching the skills necessary for the making of great art, the school's founding director, Walter Gropius, placed "workshops" at the center of its curriculum in his April 1919 manifesto (cats. 38, 39). In doing so he was aligning himself with a current of progressive thinking about design reform established before the war.[4] Already an important element in the program of several modern craft schools, workshop-based education was aimed at bringing students out of the studios of the academies that had flourished in the later nineteenth century, where they were taught by imitating historical examples, and into the process of making things, in order to gain an understanding of materials. And where academic models reinforced the distinction between fine-arts and applied-arts education, the Bauhaus's workshops were to be led by both a master craftsman (*Handwerksmeister*, later *Technischer Meister* or *Werkmeister*) and a fine artist (*Formmeister*), a pairing that spoke of Gropius's desire to assure that technical knowledge was complemented by aesthetic ambition. This too had precedents in modern craft schools,[5] but the radical potential of placing artists in the workshops was heightened by the type of artist Gropius invited to take on the role: his first faculty picks were plucked from the crucible of the avant-garde, theoretically confident and distinctly antiacademic in approach.[6]

The most novel part of the Bauhaus curriculum, however, had no place in Gropius's 1919 program. Dismayed by the talents of the students who enrolled in the first year — a motley crew of war veterans no longer young, leftovers from the Weimar schools that were amalgamated to form the Bauhaus, and those seeking a certain meal in time of rampant food shortages[7] — Johannes Itten (cat. 2), who had become form master for the sculpture, metalwork, woodworking, wall-painting, and weaving workshops, proposed a preliminary course.[8] Itten had founded his own school in Vienna in 1916: his charisma is suggested by the fact that no fewer than sixteen of his students there followed him to the Bauhaus, and perhaps equally by the fact that the famous Alma Mahler, by then married to Gropius, proposed him as a faculty member to her husband. Gropius and Itten agreed that greater theoretical

1

Georg Muche

Untitled (Weaving workshop). 1921
Gelatin silver print
6 ¼ x 4 ¹¹/₁₆" (15.8 x 11.9 cm)
The Museum of Modern Art, New York.
Thomas Walther Collection. Gift of
Thomas Walther

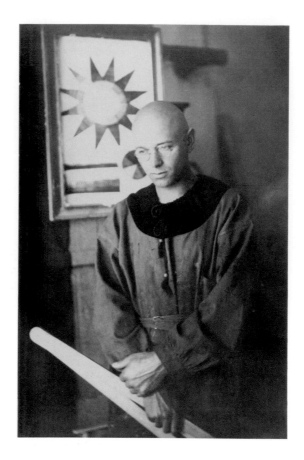

2
Paula Stockmar
Untitled (Johannes Itten with his
Farbenkugel in 7 Lichtstufen und 12 Tönen
[Color sphere in 7 light values and 12 tones]
behind him). c.1921
Gelatin silver print
6 7/16 x 4 5/16" (16.4 x 10.9 cm)
Bauhaus-Archiv Berlin

training was necessary to raise the general level of student work.[9] Intended to offer an introduction to issues of color, form, and materials considered fundamental to all visual expression, the preliminary course erased the boundaries between craft and fine-art education. Taught continuously from the fall of 1920 throughout the school's existence, first by Itten, later by László Moholy-Nagy and Josef Albers, with complementary color and form courses taught by Vasily Kandinsky and Paul Klee, and required from 1921 until 1930 for students of all disciplines, it was in the end the school's most defining pedagogical feature.[10]

Itten began his classes with a focus on the students' bodies, leading a series of exercises that drew on ancient yogic traditions and must have seemed far more exotic in 1920 than today: stretching to produce physical flexibility, isometric relaxation of different body parts in turn, rhythmic chants and breathing — a regime that Klee wryly dubbed "a kind of body massage to train the machine to function with feeling."[11] Yet the Eastern origins and corporeal focus of Itten's practice can be read with a critical edge: Itten often spoke of his interest in Oswald Spengler's book *The Decline of the West* (1918/1922), which denounced Western rationalism and technology.[12] A series of quickfire drawing exercises intended to awaken the psyche, senses, and hand followed: in some, students would be directed to render the experience of a dramatic situation — a storm or battle, for example — rapidly and freely, in a form of automatism predating its adoption by the Surrealists.

Like his own teacher Adolf Hölzel, a pioneer in teaching abstraction, Itten took the old masters as a starting point, projecting black and white lantern slides for the class to analyze. In charcoal drawings made after icons of German culture such as the *Crucifixion* panel from Grünewald's Isenheim Altarpiece of c.1512–16, students used loose, sweeping lines to define the work's essential expressive components (cat. 68). Itten further expounded his theories in his manifesto *Analysen alter Meister* (Analysis of old masters), published in the first and only volume of Bruno Adler's almanac *Utopia* (1921). Here, case studies offered photomechanically printed reproductions of five German masterpieces, along with tools for their analysis: a freehand drawing of each work, rendered lithographically, defining its skeletal structure with notes on its use of color; a page of ornate typography, echoing the work's compositional structure in its visual form and speaking of the work's emotional content; and in one instance a tipped-in sheet of tracing paper printed with a geometric diagram of ruled lines, analyzing the work beneath and summarizing it in mathematical formulas (cat. 67). This luxurious sheet in fact analogizes Itten's lens on the past: a kind of looking through the historically specific — narrative, iconography, period style — to what he saw as timeless abstract laws. In this light a painting like Itten's own *Aufstieg und Ruhepunkt* (Ascent and resting point, 1919; cat. 61) begins to look a good deal like the lattices of lines that he imposed on top of the old masters.

This view supported Itten's basic pedagogical premise, a type of radical formalism at a moment when modernism's embrace of abstraction was still new: all art could be understood as a series of oppositions, of color, texture, material, or graphic mark — large/small, long/short, broad/narrow, thick/thin, much/little, straight/curved, pointed/blunt, smooth/rough, hard/soft, transparent/opaque, continuous/intermittent.[13] The bulk of Itten's preliminary course consisted of exercises in which students explored the effects of these contrasts in abstract compositions using a limited range of basic forms (the circle, the square, the triangle). Collages and assemblages of found scraps scavenged from drawers and workshop floors, charcoal drawings with marks of varying intensities, and wood and plaster reliefs experimenting with texture and three-dimensional form proliferated (cats. 69–72). These compositions also stand as a first effort, repeated in many iterations through the Bauhaus, to define a primary visual language for all artistic practice.

The preliminary course established a series of shaping principles that would extend far beyond Itten's departure, in 1923, after a final break with Gropius. It became one of the school's most distinctive premises that all students should be instructed in the principles of abstraction before moving on to specific areas of study. And Itten's search for fundaments, his sensory-corporeal focus, and his technological/mathematical analytic idiom would serve as the framework for much Bauhaus thinking to come. Foremost among the legacies of the early preliminary course, however, was an overarching sense of epistemological doubt: a skepticism about received knowledge. Itten declared it his aim to rid students of "all the dead wood of convention"[14] — a tabula rasa imperative deeply connected to the experience of World War I. The goal of such "unlearning" was to bring the young artist back to a state of innocence beyond the corruption of culture — to a childlike self — from which learning could begin anew. As scholars have recognized, Itten's course had precedents in progressive thinking about the education of children (he was trained as a primary school teacher), especially that of Friedrich Froebel,[15] the founder of kindergarten, the "children's garden" in which play was central to learning, and Heinrich Pestalozzi, a great influence on Froebel. Pestalozzi in turn imagined his program for the sensory education of children as a practical development of Rousseau's idea, put forth in *Emile* (1762), that education should cultivate innate faculties rather than impose external forms of knowledge.[16] This genealogy of thought provided fertile terrain for Bauhaus thinking about severing arts education from the academic tradition, in which students were schooled in ideas of normative beauty.

Albers described his later version of the preliminary course as a form of experimentation:

First we seek contact with material....Instead of pasting it, we will put paper together by sewing, buttoning, riveting, typing, and pinning it; in other words we fasten it in a multitude of ways. We will test the possibilities of its tensile and compression-resistant strength. In doing so, we do not always create "works of art," but rather experiments; it is not our ambition to fill museums: we are gathering experience.[17]

Experience, not knowledge, was the Bauhaus watchword. But the term is hardly a neutral one, for it is precisely the decline of experience in the modern age that is lamented by so many cultural commentators at the time — Walter Benjamin, Edmund Husserl, Georg Simmel, and Ferdinand Tönnies among them. "Never," wrote Benjamin, "has experience been contradicted more thoroughly: strategic experience has been contravened by positional warfare; economic experience, by the inflation; physical experience, by hunger; moral experience, by the ruling powers."[18] In each of the critic's examples, an overarching understanding of a complex whole has been replaced by a severely impoverished view. The integrated self is succeeded by an anonymous replaceability. In this context, the experiential ambitions of the preliminary course offered a fragile bulwark against the dysphoria of modernity.

Basic Units

Itten's distilling drive initiated a key impulse at the Bauhaus: an effort to define the primary elements of visual form, in a parallel process to the attempt in the preliminary course to return to the basic core of the student's mind, stripped of the interference of cultural convention. Beginning in 1922, both Kandinsky and Klee taught classes on basic form within the preliminary-course curriculum.[19] Kandinsky's book *Punkt und Linie zu Fläche* (Point and line to plane, 1926; cat. 254), based on this teaching program and with a title inventorying the irreducible elements of graphic work, issued an overarching directive: "We must at the outset distinguish basic elements from other elements, viz. — elements without which a work in any particular art cannot even come into existence."[20] As part of this mandate, the theory of color — that most basic component of visual experience — became an important focus within the preliminary-course curriculum. Itten developed a twelve-spoke color wheel, incorporating the three primary colors, three secondary ones, and six intermediate tones, to create a color system that he correlated with the twelve notes of the musical scale (cat. 66). In his earlier writing Kandinsky had concentrated on single colors in isolation in order to define their most basic affective capacities, and had found that "the two great divisions which at once become obvious are: 1) the warmth or coldness of a color; and 2) the lightness or darkness of a color." The number of permutations was thus limited, he concluded: "I. warm and 1) light or 2) dark; or II. cold, and either 1) light or 2) dark."[21] Kandinsky's own preoccupation with the three primary colors and primary forms — triangle, circle, and square — left a direct, ducklinglike imprint on his students, visible in Herbert Bayer's wall-painting design for the staircase in the Van de Velde building the school occupied in Weimar (1923; cat. 192), Peter Keler's cradle (1922; cat. 208), and Heinrich Bormann's graphic analysis of a musical composition (1930; cat. 370). These efforts to describe fundamental elements and the rules of their interaction proved defining in another way as well: science provided a template for art in the modern age, and the Bauhaus was imagined as an experimental laboratory, with art the product not of inspiration but of research.

Kandinsky worked with some sense that the most distilled forms of expression would allow for correspondences among mediums. "Every phenomenon of the external and of the inner world," he wrote in *Punkt und Linie zu Fläche*, "can be given a linear expression — a kind of translation."[22] Linear diagrams he made in 1925 from photographs of the modern dancer Gret Palucca, who often visited the Bauhaus, seem a kind of test case (cats. 381, 382): working from these stilled images — Kandinsky felt that the "precise structuring" of Palucca's movements was best captured by the camera — he made simple linear drawings that defined the "large simple forms" of her poses.[23] Kandinsky was hardly alone at this moment in trying to devise new modes of dance notation that would offer a stable visual code for performance, a kind of language that would capture experience without resorting to text.[24] And he was similarly interested in developing musical notations based on graphic marks and primary forms rather than the conventional script of notes on a staff.[25] These distilled forms, Kandinsky suggested, would offer a framework for crossing boundaries between the visual arts, music, and dance.

The basic units defined within the teaching of the preliminary course became the building blocks for larger systems in the products of the workshops. Around 1922, Bauhaus faculty and students began to create a broad range of works using recombinable modular elements. The artist was reimagined as a designer of systems. To one side of a drawing for a universal lettering, Bayer drew straight and curved elements from which all of the characters in his type system could be shaped (1925; cat. 257). Albers designed molded-glass forms to serve as mobile units for his *Kombinations-Schrift* (Combinatory letters, c. 1928; cats. 259, 260), an alphabet rather less readable than Bayer's but one that announced modularity as its signal purpose. In the ceramics workshop in 1923, Theodor Bogler produced a series of prefabricated molded teapot parts — variant handles, spouts, and lids — that could be attached to a standardized body for a range of alternate vessels (cats. 112–14). Gropius too pursued the idea of

modularity in architecture, designing a series of *Baukasten*, cubic components for single-family housing, which were to be prefabricated, then ordered and combined in different configurations (cat. 28). These primary forms took a place within a new postwar culture of standardization: in 1917, a national organization, the Normenausschus der Deutschen Industrie, had been established to regulate units of measurement, symbols, and basic elements of manufacture (such as screws) within and across industries.[26] The more things were standardized, the more they could be combined.

Grid Logic

By 1922 the Bauhaus had made an important shift away from the marriage of Expressionism and craft reform that had marked its founding years. After an "impassioned romanticism that was a flaming protest against materialism and the mechanization of art and life" came a "reversal of values," wrote Oskar Schlemmer, who arrived at the Bauhaus in the winter of 1921 to head the wall-painting workshop. Schlemmer's text was not without an overheated romanticism of its own:

> Dada, court jester in this kingdom, plays ball with the paradoxes and makes the atmosphere free and easy. Americanisms transferred to Europe, the new wedged into the old world, death to the past, to moonlight, and to the soul, thus the present time strides along with the gestures of a conqueror. Reason and science, "man's greatest powers," are the regents, and the engineer is the sedate executor of unlimited possibilities.[27]

The change was publicly unveiled on the opening day of the 1923 exhibition of student and faculty work, where Gropius gave a speech announcing changes at the school and offered a slogan intended to brush away the remaining cobwebs of mysticism: *Kunst und Technik: Eine neue Einheit* (Art and technology: a new unity).[28]

One explicit change was the introduction of a new business unit, run by a business manager charged with assuring the school's financial viability through partnerships with outside retailers and manufacturers. (The 1923 exhibition itself was mounted in part to solicit buyers for the school's products.) This realignment was complex — the school's relationship to industrial production was in the end ambiguous, characterized by paradoxes and false starts more than sucesses — but at this moment the Bauhaus artist decisively dropped the robe of the shaman to take on the guise of the technician.[29] The visual idiom that emerged is marked by a tenacious embrace of the grid as structuring framework, if stretched into new domains: Anni Albers's textiles (cats. 163, 164, 276), Josef Albers's luminescent glass works (cats. 83, 93, 94, 277–79), the three-dimensional grid of Marcel Breuer's tubular-steel chairs (cats. 296–98, 301, 302), Andor Weininger's kinetic stage designs (cat. 221), and Bayer's Bauhaus letterhead (cat. 245) are only some of many examples. If we can discern the dominant imperatives of other forms of modernism — the way *faktura* belongs to the Russian avant-garde of a certain moment, and fracture to Dada — then it is certainly the thorough working-over of the logic of the grid that gives overarching shape to the products of the Bauhaus.

The change betrays the influence of avant-gardes outside the Bauhaus: the double impact of de Stijl and Constructivism. In 1922, Theo van Doesburg, impresario of the de Stijl group, had forged an alliance between Constructivism, de Stijl, and Dada at the school's doorstep, organizing an international congress in Düsseldorf that May and a second in Weimar itself in September (cat. 3) — a united front of critics of Expressionism. A major show of work from the new Soviet Union, at the Galerie van Diemen, Berlin, in 1922, had offered the West a first view of developments in that country since the Revolution. Van Doesburg had taken up residency in Weimar in April 1921, publishing his *De Stijl* magazine

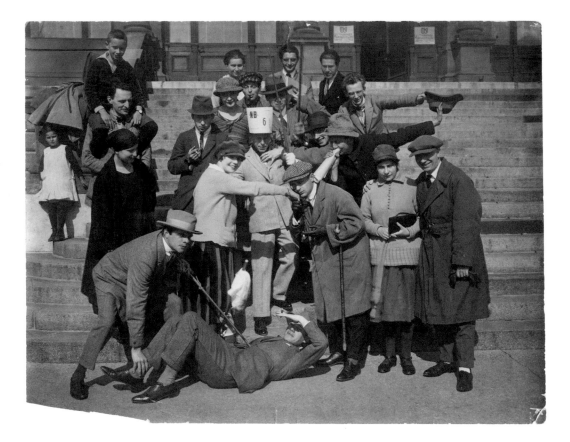

there — the first journal dedicated to a theory of abstraction. And although he was never asked to join the Bauhaus faculty, from 1921 to 1923 he offered private instruction in the city, attended by a number of Bauhaus students, and he served as a familial critic to the school, giving lectures praising its pedagogical ambitions but disparaging the directions taken.[30]

Gropius's hiring of Moholy-Nagy in 1923 gave leadership to the new direction. Three years earlier this Hungarian artist had settled in Berlin, a crossroads for the artists and intellectuals of Central and Eastern Europe, where he had established ties with the Dadaists Raoul Hausmann, Hannah Höch, and Kurt Schwitters; with the Russian El Lissitzky, who had studied with Kazimir Malevich; and with Van Doesburg himself, all key players in Van Doesburg's international congresses. Moholy's work was both manifesto and testing ground for a Constructivist and de Stijl vocabulary. His paintings of this moment — strongly influenced by Lissitzky in particular (cat. 4) — explore the intersection of abstract forms in abstract space, and are inhabited by floating planes without mass and of varying degrees of transparency (cats. 143–45, 147, 152, 153). The model is no longer perspectival, an image of things seen, but rather the idiom of descriptive geometry.

Moholy's latticeworks of forms intersecting on horizontal and vertical axes bring painting close to the language of architecture.[31] (And Moholy, like Lissitzky, often deployed axonometry, a form of spatial projection common in architectural rendering, in which orthogonal lines remain parallel rather than meeting at the vanishing point of traditional perspective.) These works create an equivalence between the floating planes of color in the painted surface and those of the wall, ceiling, and floor of the built structure. This congruence opens the way for the radical integration of painting and architecture in works such as Keler's designs for Moholy's studio (cats. 231, 232) and Bayer's advertising kiosks and other buildings (cats. 224–29). But it also implicitly proposes a new model of architecture, in which planes slide past one another on a three-dimensional grid rather than the closed boxes of traditional architecture (cats. 236–39). Here one sees the ascendancy of what for Yve-Alain Bois are the twin premises of de Stijl:[32] *elementarization*, the distillation of fundamental forms seen in the ruled line and the right angle, and the use of primary colors plus black, gray, and white; and *integration*, the binding

3

Participants in the International Congress of Constructivists and Dadaists, Weimar, 1922
Top row, left to right: Lucia Moholy-Nagy, Alfréd Kemény, László Moholy-Nagy.
Second row from the top: Lotte Burchartz, El Lissitzky, Cornelius van Eesteren, Bernhard Sturtzkopf.
Third row: Max Burchartz (with child), Harry Scheibe, Theo van Doesburg, Hans Vogel, Peter Röhl.
Front row, standing: Alexa Röhl, Nelly van Doesburg, Tristan Tzara, Nini Smit, Hans Arp.
Foreground, left: Werner Graeff. On ground: Hans Richter
Photograph: photographer unknown. September 25 or 26, 1922.
Gelatin silver print. 6 ³⁄₄ x 8 ⁵⁄₈" (17.1 x 21.9 cm). Bauhaus-Archiv Berlin

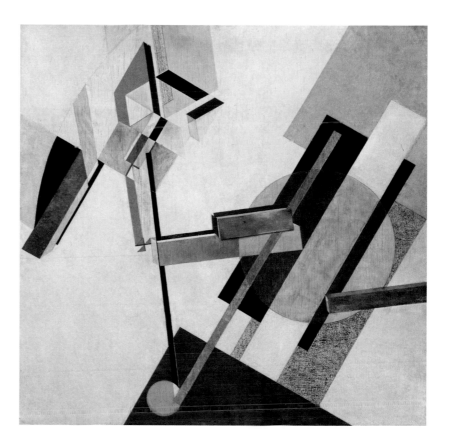

4
El Lissitzky
Proun 19D. c. 1922
Gesso, oil, paper, and cardboard on plywood
38 ³/₈ x 38 ¼" (97.5 x 97.2 cm)
The Museum of Modern Art, New York.
Katherine S. Dreier Bequest

of these forms together in a new, encompassing whole. In the absorption of these principles at the Bauhaus, the grid became a structural tool allowing for the creation of spaces that integrated disparate mediums into overarching designs — painting, furniture, and textiles into architecture (cat. 20). And in the Bauhaus's final phase, Ludwig Hilberseimer and his students — remaking the fan shape of the autocratic city into gridded rectangular blocks — fulfilled this mode of thinking by taking architecture into city planning (cats. 443, 445).

Grid logic of course had special relevance for textile design, since fabric is defined by the horizontal and vertical intersection of warp and weft. The women of the Bauhaus weaving workshop, in rebelling against the leadership of their first form master, the painter Georg Muche,[33] voiced their collective opposition to the use of curvilinear forms that followed a pictorial logic foreign to the making of cloth, committing themselves instead to abstract compositions exploring the infinite possibilities of the grid. Although never a master in their workshop, Klee had an important influence on the weavers, growing out of a mutual interest in pattern and ornament.[34] In his classes Klee used the grid as a matrix for pattern development: students were instructed in a series of almost musical operations — rotation, inversion, mirroring, the transposition of complementary colors (cats. 120, 364, 365). Compositions of colored squares following similar principles flourished in Klee's own watercolors and paintings at this moment (cats. 85–88) — a testament to the proximity of pedagogy and practice. The computerlike punch cards used in the Jacquard looms (p. 208, fig. 1) bought for the workshop in 1925 offered an intensified technological framework for this way of working: the pixillated structures of Gunta Stölzl's Jacquard designs on graph paper (cats. 267, 268) presage digital logic.

Antinationalism

The embrace of a new language of universal form, grounded in the geometric, entailed the purging of a romantic German identity, signaled in emblems of a preindustrial world. This shift is clear in the movement from Carl Jucker's hammered-metal samovar of 1922 (cat. 109), with its spigot in the shape of a bear claw conjuring a German hunting tradition, or from Gyula Pap's candelabra of the same year (cat. 110), its seven arms aligned in a plane making reference to the original Old Temple lamp of biblical description,[35] to the geometrically based metalwork turned out in the metal workshop after Moholy took it over in 1923, much of it by his prodigiously talented student Marianne Brandt (cats. 111, 162, 165–67). (By contrast, in his brief tenure as form master of the metal workshop in 1922, Klee, in the words of Xanti Schawinsky, had guided the production of "spiritual samovars and intellectual doorknobs.")[36] But the story can be told in many ways; Breuer told it himself in his "Bauhaus film" photomontage (1926; cat. 96), which offers a cinematic trajectory from the romantic primitivism of his and Stölzl's "African" chair of 1921 to the support of the human body on a cushion of air at an unspecified date in the future. This swing was surely part of a larger critique of German Expressionism, its nostalgia and

Albert Langen
Verlag für Literatur und Kunst
München

München, im März 1928
27, Hubertusstraße

Sehr geehrte Redaktion,

anbei überreichen wir Ihnen die neueste Erscheinung unseres
Verlages:

Bauhausbücher

Herausgeber Walter Gropius und
L. Moholy-Nagy

Band 8: L. Moholy-Nagy, Malerei, Fotografie, Film.
Mit 100 Abbildungen.
Zweite veränderte Auflage. 3.—5. Tausend

und bitten Sie, falls Sie eine eigne Besprechung nicht vor-
ziehen, um Abdruck nebenstehender Notiz in Ihrem sehr ge-
schätzten Blatte. Für gefällige Übersendung eines Belegs
wären wir Ihnen dankbar.

In Hochachtung

Albert Langen

5

Printed form letter from Albert Langen Verlag,
Munich, to newspapers announcing the
second, revised edition of László Moholy-Nagy,
Malerei, Fotografie, Film (Painting, photography,
film). *Bauhausbücher* no. 8. March 1928
11 x 8 ⅝" (27.9 x 21.9 cm)
Letterpress on paper
Bauhaus-Archiv Berlin

interiority too much the stuff of another moment for many both inside the Bauhaus and well beyond it, in a rare point of avant-garde consensus. But the urgent imperative to define what is essential and universal is characteristically Bauhaus.

Bayer's project to develop a universal lettering (cats. 257, 258), conducted from 1922 until his departure from the school in 1928,[37] took aim at Fraktur, the modern form of the spiky blackletter German script, now emphatically nationalist in claim. Ubiquitous in the 1920s, Fraktur even appears in the business correspondence of Albert Langen, the publisher of the *Bauhausbücher* book series (cat. 5). Bayer sought a letter stripped of such national signifiers, a truly international alphabet that spoke of the dream of unfettered global exchange. He began with Roman letters as the foundation of the Western letterform, but rationalized them, jettisoning their historical traces of handwriting, the up-and-down strokes of the pen seen in the serif flourishes and thicks and thins of traditional letterforms. Instead, Bayer used compass, T-square, and rule to create the small inventory of forms from which all the letters of his alphabet might be made (cat. 257). True, this was the language of the engineer, but put to a specific task: the purging of national identity through geometry, in a repudiation of style and the influence of culture. That it was to be understood politically is clear: a universalist program had strong meaning in this moment after the devastation of World War I, and the consequent shocks of class warfare, failed revolution, and the rising power of the right. Bayer himself wrote that "the typographic revolution," of which he was a pioneer, was "not an isolated event but went hand and hand with a new social and political consciousness."[38] One imagines, then, that a modification introducing Fraktur type into the banknotes that Bayer designed for the state of Thuringia in the midst of the inflationary crisis that took hold in Germany in 1923 was executed without his consent (cat. 6; see also cat. 262).[39]

The connection between the Bauhaus's geometric imperative and the recent experience of war is made explicit in the chess set designed in 1922–24 by Josef Hartwig, the technical master of the woodcarving and stone workshops and an avid chess player himself (cats. 168, 169). In an article in the *Leipziger Tagesblatt* in 1924, Hartwig announced that chess players were in for "an enormous surprise, the demilitarization of chessmen, as it were,"[40] for he had replaced the game's traditional pieces, and their references to medieval warfare, with fully abstract objects. Against the background of the chessboard's grid, the form of each piece was derived from its characteristic movement: both the pawn and the rook, for example, which move parallel to the edges of the board, are cubic, while the L-shaped move of the

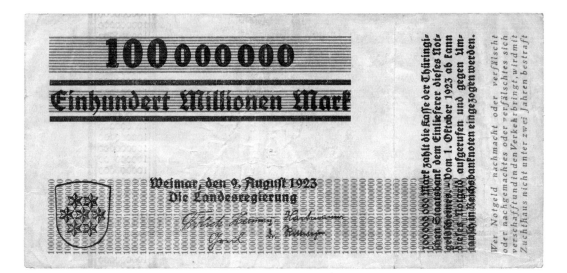

knight is expressed in a cantilevered shape and the bishop's diagonal passage in an "x" form. In later variations of the set, even the chessmen's small base, with its lingering sculptural resonance, disappears, pushing forward this diagrammatic logic. For Hartwig this revamping followed a historical trajectory in which the game, which had functioned "for more than a thousand years as an imitation of a battle between hostile armies," now advanced to its present role "as a pure abstract game of the mind."[41] War versus abstract logic were the terms of discussion.

The twentieth century was rife with proposals for "new men" to serve as the perfect analogues of the age. The list includes the speed-addicted personality of Italian Futurism, the traumatized ego of Dada, the hygienic nationalist of the French *Esprit Nouveau*, the collective, technologically astute subject of the Russian avant-garde, and the armored psyche of proto-fascism. A series of photographs hint at the outlines of a "new figure" for the Bauhaus: in one, by Erich Consemüller, a woman wearing a painted metallic theatrical mask by Schlemmer, and a dress made in the weaving workshop, sits in Breuer's tubular-steel club chair (cat. 7),[47] while in a related image a masked male figure sits at a table with tea-consuming products of the metal workshop spread on top of it (cat. 8). These are half-mechanical automatons, like so many others in the visual culture of the decade, but here the mask is key: its blank visage is both deracinated and classless, just as the Bauhaus accoutrements of modern life are stripped of cultural traces. Devoid of mobile orifices, the rigid form of the mask enforces silence. The Bauhaus subject is a robotic mute: pared down to essential geometric forms, it passes easily across political borders.

Disenchantment with Language

Alfred Arndt recounts a telling anecdote from Itten's course. The students were instructed to "draw the war." Erich Dieckmann, a veteran with a shattered arm, sketched detailed images of trenches and barbed wire, guns and troops. Walter Menzel, who, as the class's youngest student, had escaped the conflict, stabbed the paper with his chalk and quit in frustration. Itten dismissed Dieckmann's work as a "Romantic picture" but praised the emotional authenticity of Menzel's: "It's all sharp points and harsh resistance."[43] Arndt's story speaks to a core Bauhaus fascination with the mute mark, emotionally resonant and disdaining narrative content.

A key text offered theoretical grounding for this disenchantment with the literary: Kandinsky's *Concerning the Spiritual in Art*, of 1911. The essay had been offered as a manifesto, a first theory of abstraction, put forward simultaneously with a practice that served as a model. Together they had had an extraordinary influence on a generation of artists and intellectuals. Kandinsky's towering reputation as a philosopher of abstraction was certainly a prime reason for Gropius's invitation to him to join the Bauhaus faculty, but even before his arrival, in 1922, the text had a shaping influence on Bauhaus thought.

Concerning the Spiritual in Art is permeated by a profound concern with the status of language in art. Describing a salon exhibition, for example, Kandinsky writes that the pictures

6
Herbert Bayer
100,000,000-mark emergency banknote designed for the state bank of Thuringia. Adapted from Bayer's original design to include Fraktur type. 1923
Letterpress on paper
2 3/4 x 5 1/2" (7 x 14 cm)
Bauhaus-Archiv Berlin

represent in colour bits of nature — animals in sunlight or shadow, drinking, standing in water, lying on the grass; near to, a Crucifixion by a painter who does not believe in Christ…; many naked women, seen foreshortened from behind…; portrait of Councillor So and So.…All this is carefully printed in a book — name of artist — name of picture. People with these books in their hands go from wall to wall, turning over the pages, reading the names. Then they go away, neither richer nor poorer than when they came, and are absorbed at once in their business, which has nothing to do with art.[44]

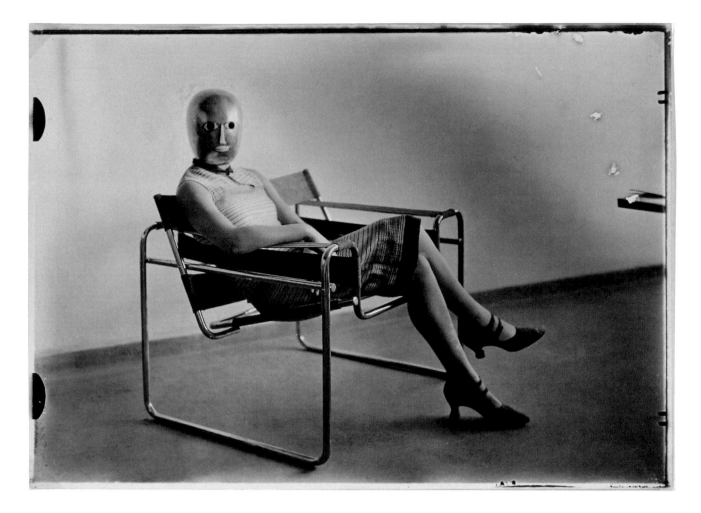

7
Erich Consemüller
Untitled (Woman [Lis Beyer or Ise Gropius]
in B3 club chair by Marcel Breuer wearing
a mask by Oskar Schlemmer and a dress
in fabric designed by Beyer). c. 1926
Gelatin silver print
5 x 6¾" (12.5 x 17.2 cm)
Private collection

Here and elsewhere, Kandinsky builds an association between the verbal and the base materialism of modernity — the "business which has nothing to do with art." For him, the most profound art spurns any content that can be named, instead offering "lofty emotions beyond the reach of words."[45] This wordless terrain is the realm of what Kandinsky calls "inner need."[46] In this paradoxically loquacious argument for the ineffable, abstraction emerges as way to shun the linguistic, to circumvent language — and that form of cognition that is language based. The alternate mode of expression that Kandinsky seeks would isolate the physiological impact of color and form to supplant the communicative with the sensory. Kandinsky stresses the lack of barrier between body and psyche: "The soul being one with the body," he writes, physical impressions may produce "psychic shock."[47]

Kandinsky praises the Belgian Symbolist playwright Maurice Maeterlinck for using words to express an inner harmony by repeating them in a poetic context "twice, three times or even more frequently,"[48] detaching them from their meaning to create an abstract resonance instead. In 1913, in a volume of Kandinsky's own poems called *Sounds*,[49] illustrated with his abstracted woodcuts, the artist guided his reader to repeat words until they became senseless, isolating sound images physiologically. Friedrich Kittler has read a form of logophobia into these verbal techniques, a means of simulating aphasia.[50] Something similar might be seen in the way Klee's painting *Das Vokaltuch der Kammersängerin Rosa Silber* (Vocal fabric of the singer Rosa Silber, 1922; cat. 118) materializes language away from communication: letters become musical or aural units, while the gesso ground and muslin fabric give the surface a thick, textural density, appealing sensually rather than through the frictionless conduits of verbal exchange. Klee was thinking broadly about the alphabet as pictorial in this period, assigning students in his color theory course that same year to make compositions from combinations of letters.[51] And then there is the matter of the title's puns: *vokal* in German means not only "vocal" but "vowel," and in Klee's work, against the gridded backdrop, the R and S of the singer's name appear along with the five vowels, the primary tools of the singer's art.[52] Puns point to the slippage of words, to words' failure to mean unambiguously, and so to the thickening of language itself.

Schlemmer too was self-conscious about the role of words in his *Triadische Ballett* (Triadic ballet, 1922; cats. 216, 217). Schlemmer held up Baroque masked dance, an obsolete theatrical form, as a model for modern performance — "the starting point for renewal."[53] Discussing the abolition of face masks in these dances in 1772, he remarked that "dates which historians consider the milestones of an ascent, actually mark the stages of decline."[54] For Schlemmer, the mask offered a critical counterpoint to the heightened emotional pitch and exaggerated expressive gesture of Expressionist theater

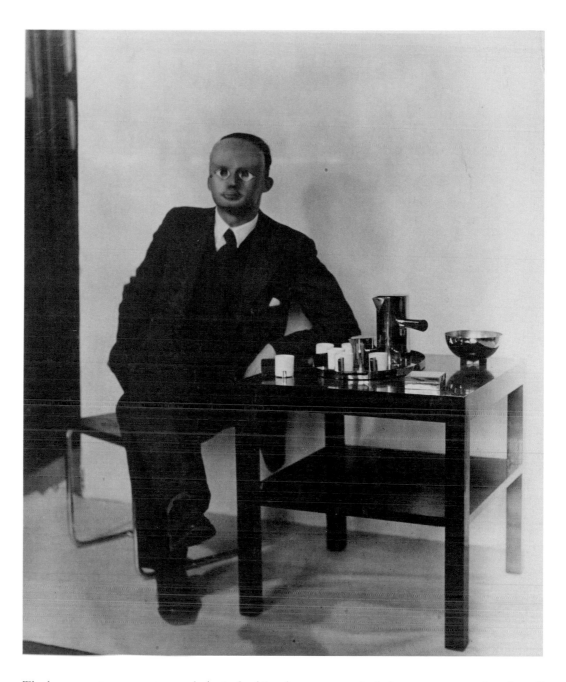

8
Photographer unknown
(probably Erich Consemüller)
Untitled (Man wearing a mask by Oskar
Schlemmer with Bauhaus metal work
on adjacent tabletop). 1926–27
Gelatin silver print
5 ³/₈ x 4 ¹/₂" (13.6 x 11.4 cm)
The J. Paul Getty Museum, Los Angeles

The human actor was not a psychological subject but a geometrical phenomenon — an "art figure" (*Kunstfigur*)[55] created with costumes that rationalized the body through circles, spheres, and triangles. And by far the greatest virtue of Baroque theater for Schlemmer was that of silence.[56]

Disclosing the characteristic Bauhaus belief that there was no principle that could not be rendered diagrammatically, Schlemmer published a drawing contrasting "drama" with "ballet/pantomime," each represented by a right triangle (cat. 9). The long side of the drama triangle is "the oral stage" while the shorter sides are "play or plastic stage" and "visual stage." Ballet/pantomime reverses the values: "play or plastic stage" is now dominant, "visual stage" secondary, and "oral stage" is replaced altogether by "aural stage." In a way that resonates with Kandinsky's writing, Schlemmer reveals a fascination with mute players; he sees the geometrically rationalized figure as a nonlinguistic entity. "When the word is silent," he writes, "when the body alone is articulate and its play is on exhibition...then it is free."[57] Yet at the same time, Schlemmer's extravagant costumes work against the idea of ballet as a kinetic event. Exaggerated headdresses and masks, padded torsos and limbs, inhibit movement at the same time that they lend spectacular visibility to the pose. Moving from one static position to another, each a new, starkly geometric composition, Schlemmer's figures seem designed for photographic representation — and judging from the number of camera images taken of them, this was indeed a major part of their function (cat. 218).

At the Bauhaus, even the act of reading was reconfigured to be less about words. Writing in 1925, Moholy lamented "the monotonous gray of recent books"[58] — the undifferentiated pages fostered by the line-by-line, left-to-right, top-to-bottom mode of reading. In a design of his own from that year, for a section of his book *Malerei Photographie Film* (Painting photography film, the eighth in the *Bauhausbücher* series; cat. 254), Moholy breaks down the traditional page block (cat. 12). Photographs of city views,

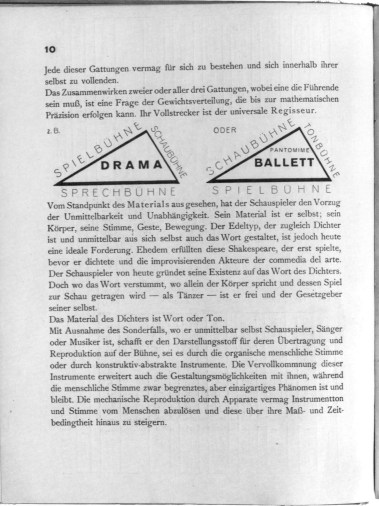

often taken at oblique angles — a wireless mast, electric signs at night, an aerial view of a city square, street lights — are dispersed across asymmetrically composed pages and juxtaposed with bold gridded lines, numbers, pictographs, and staccato bars of text ("electric signs with luminous writing which vanishes and reappears," "tempo tempo-o- tempo-o-o"). Such pages evoke the experience of the modern city, full of flashes of sensory information. In both form and content, *Malerei Photographie Film* was a manifesto for embracing the expanded role of photography in modern life. Precipitous technological changes, Moholy argued — the saturation of the public sphere with photographic images, on cinema screens and in illustrated newspapers and magazines — had fundamentally transformed human perception. People, he suggested, might soon start collecting color slides the way they already collected gramophone records, and "kinetic, projected compositions" and works made from materials produced for the "electro-technical industry" would replace paintings on the walls of modern homes.[59] *Malerei Photographie Film* was a book for this modern world. And it is notable that this new "typographical-visual-synoptical form"[60] dramatically reduced the number of words on the page, forming "a new visual literature"[61] based on the integration of photomechanical printing techniques and avant-garde typographic experimentation.

Moholy was not alone among the designers at the Bauhaus in working to revise the status of the written word. Bayer, for example, designed type that corresponded less to the culture of the book than to speech itself: following the *Kleinschreibung* (literally, "writing small") reform movement, earnestly promoted by Dr. Walter Porstmann, a government efficiency and standards expert, in his 1920 book *Sprache und Schrift*,[62] Bayer famously proposed abandoning capital letters in all Bauhaus correspondence and printed matter. The policy was adopted by Gropius to much criticism.[63] "We do not speak a capital a and a small a," Bayer wrote, pegging typography to the basis of language in sound — that is, language in its sensuous, embodied form.[64] Bayer's type imagines a vocalized word, binding sound and meaning into a unit.

In this pervasive disenchantment with language, it is precisely the body — the psyche and sensorium combined — that seems to offer a conduit for a new form of direct communication. In 1922–23, Kandinsky distributed a psychological test to Bauhaus students and faculty on behalf of the wall-painting workshop (cat. 10). The form instructed recipients to fill in the blank outlines of a triangle, a square, and a circle with the colors that each form seemed to elicit, and if possible (that is, if words might be

9
Oskar Schlemmer
Diagram reproduced in Oskar Schlemmer, *Die Bühne im Bauhaus* (The theater of the Bauhaus). *Bauhausbücher* no. 4. Munich: Albert Langen Verlag, 1925
The Museum of Modern Art Library, New York

10
Vasily Kandinsky
Questionnaire distributed by the
wall-painting workshop, filled in by an
unidentified Bauhaus student (possibly
Gertrud or Alfred Arndt). 1922–23
Lithograph, pencil, and colored crayon
on paper
9 3/16 x 5 15/16" (23.3 x 15.1 cm)
Bauhaus-Archiv Berlin

found) to explain the choice. Perhaps not surprisingly, most agreed with Kandinsky's own well-disseminated linkages: yellow for the triangle, red for the square, and blue for the circle. This type of exercise was not new for Kandinsky; much of his effort in the years he had spent at Inkhuk (the institute of artistic culture), Moscow, immediately before coming to the Bauhaus, lay in charting laws of subjective response to color and form in which the "physiological effect should serve simply as a bridge to the elucidation of the psychological effect."[65] The Bauhaus questionnaire speaks to a defining aspiration: to facilitate a form of immediate prelinguistic communication. Here Kandinsky seems to have been drawing on the work of Wilhelm Wundt, who founded the first laboratory for experimental psychology in Leipzig in 1875, and whose early studies focused on sensory perception, in particular on those sensations that preceded consciously formulated experience.

Yet part of the problem for Kandinsky, in his multiple attempts to chart mechanisms for universal psychic response, seems to have been that of cracking the code. Though overshadowed in recent scholarly thinking by the systems of Sigmund Freud and Ferdinand de Saussure, his approach offers an important modernist model, one that is neither psychoanalytical nor semiotic. Instead, it leans toward the phenomenology of Edmund Husserl, whose methodology was based on bracketing out the existence of the external world in order to attend to the perceiving body and primordial forms of signification.

Gesamtkunstwerk Thinking

In his 1919 program for the new school (cats. 38, 39), Gropius declared his purpose: the arts had become "isolated" in the modern age, and the school had to forge a "new unity." "The Bauhaus," wrote Gropius, "strives to bring together all creative effort into one whole, to reunify all the disciplines of practical art — sculpture, painting, handicrafts, and crafts — as inseparable components of a new architecture."[66] Architecture — and specifically the model of the cathedral — was imagined as the culmination of this new Gesamtkunstwerk, a total work of art binding different forms of creative endeavor together. The house commissioned from Gropius by the Berlin timber merchant Adolf Sommerfeld (cats. 77–82) offered an important first opportunity to realize the architect's aims; built in 1920–21, it involved contributions from the glass painting, woodworking, metalwork, and weaving workshops, all using a new abstract language of cubic ornament to produce an environment at once luxurious, coordinated, and modern.

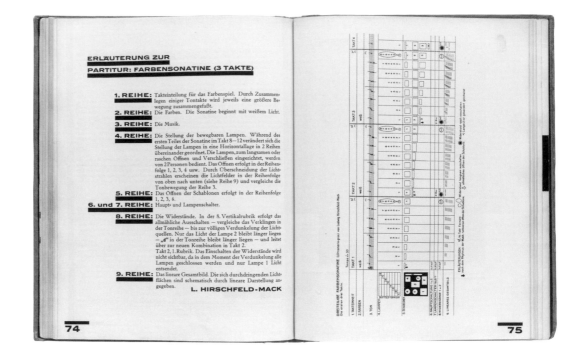

If Gropius saw his "new unity" of mediums as culminating in architecture, the same impetus permeated many of the school's other activities. In this, the director got support from Kandinsky, an influential advocate of the idea of the Gesamtkunstwerk even before World War I. The term itself derived from Richard Wagner, who had used it to describe his vision of opera as a total spectacle expressing the mythic aspirations of a culture. But Kandinsky transformed the concept, imagining a fully abstract intermedia experience addressing an inner world of bodily and psychic effects. In an essay published on the occasion of the Bauhaus exhibition of 1923, Kandinsky began on a familiar note: modernity, he wrote, was characterized by the "isolation of the arts." Theater provided the antidote: it could serve as a "magnet…attracting all these languages together." In its modern form, it would function as an experimental laboratory in which the resources of architecture, painting, sculpture, music, dance, and poetry would be deployed simultaneously to create "a monumental abstract art," both multisensory and immersive.[67]

Abstract theater indeed emerged as something of a modern grail at the Bauhaus, pursued with enormous collective energy. An early program entitled *Mechanisches Kabarett* (Mechanical cabaret; cat. 220), staged by Kurt Schmidt with other students at the 1923 exhibition, spoke more to aspiration than to achievement: in what seems to have been a charmingly goofy presentation, dancers moved rhythmically across the stage to modern music, with brightly painted cutouts of geometric forms attached by belts to their black costumes. Weininger too, over a period of years, developed designs for a mechanized performance featuring abstract moving elements and puppets instead of actors (cat. 221). Baffles around the stage would rotate to reveal different-colored faces, while moving belts, seemingly borrowed from a factory assembly line, would be suspended horizontally and vertically in a grid structure. Weininger, one of the Bauhaus students who attended Van Doesburg's classes in Weimar, later described the project as an outgrowth of his desire to create a "constantly changing de Stijl painting."[68]

Between 1922 and 1925, Ludwig Hirschfeld-Mack, working with Kurt Schwerdtfeger and Hartwig, achieved several stagings of an experimental media form he called "reflected light compositions" (cat. 11). Here, to a musical accompaniment, independently controlled beams of colored light were projected through templates of cutout geometric forms onto the back of a scrim that faced the audience. For Hirschfeld-Mack, the compositions used the very elements of expression neglected in most modern films — "light in motion, arranged in a rhythm based on time sequences" — and these elements, in distilled, abstract form, would stimulate "powerful physical and psychological effects."[69] Abstract light theater was positioned here as an afterimage of the new popularization of film, a way of processing modern sensory experience. Hirschfeld-Mack's primitive media machine has descendants in later Bauhaus efforts such as Kurt Kranz's libretto for an abstract film (1930; cat. 373), whose leporello format moves the viewer's eye from image to image in a sequential way, evoking the duration of time-based media, and Moholy's *Lichtrequisit einer elektrischen Bühne* (Light prop for an electric stage, 1930; cats. 374, 375), a kinetic object with rotating, perforated metal parts that seems to have been designed in part for representation in film and photography. In fact Moholy used it to make works in both mediums.

The culmination of this ambition — the uniting of architecture and performance — may well be the commission Gropius received in 1927 from the radical director Erwin Piscator for a fully mechanized theater (cat. 372). Piscator hoped to replace the "peep box" of the proscenium stage, with

11
Ludwig Hirschfeld-Mack
Script for *Dreiteilige Farbensonatine*
(Color sonatina in three parts)
As reproduced in László Moholy-Nagy,
Malerie Photographie Film (Painting
photography film). *Bauhausbücher*
no. 8 (first edition). Munich:
Albert Langen Verlag, 1925
The Museum of Modern Art Library,
New York

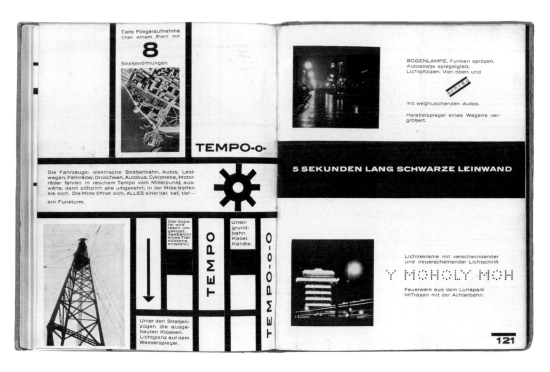

its perspectival assumptions, with a *Raumbühne* ("spatial stage," often translated as "total theater"), a space without stalls, balconies, or boxes that would allow the audience's active participation.[70] This was also to be a space of media saturation: "I imagined," Piscator wrote, "something like a theater machine, technologically designed like a typewriter, an apparatus equipped with the most modern lighting, horizontally and vertically moveable and revolving parts, innumerable film projectors, public address system etc."[71] Gropius's unrealized scheme for this theater, developed with a Bauhaus team that included Weininger, Schawinsky, and Heinz Loew, featured a revolving central disk that could place the stage in the center of the structure for theater in the round. Sets would be replaced by images or film projected from a central media tower onto screens hung between twelve supporting columns, while the parabolic shape of the roof was determined by acoustic considerations.

Not surprisingly, such intermedia impulses transformed the boundaries between mediums, and it is worth meditating on the fate of painting at the Bauhaus. The autonomy of the discrete easel picture was challenged from the school's first years. Over the span of the institution's life, painting became an element of a fully designed environment, in a modernization of an Arts and Crafts model; its ambitions were appropriated by large-scale textile wall hangings; it was reconceived as wall painting, inseparable from the architectural space it defined; and it was dematerialized into mechanically produced light displays. It seems clear that the structure of the Bauhaus, with its Gesamtkunstwerk aspirations, spelled the obsolescence of traditional painting. In contrast to a more familiar narrative of modernism (crucially shaped in an Anglo-American context by the writings of Clement Greenberg) that saw painting on a trajectory toward ever greater medium specificity, the Bauhaus offered an alternate model, one shaped by the productive relationships among artists in different media fostered at the school itself, often across the divide between fine and applied arts.

The Modern Specialist

The ambitious *Bauhausbücher* publication program (cat. 254), a series of books announced by its coeditors, Gropius and Moholy-Nagy, in 1924 (cat. 255), put the school's intellectual agenda on display.[72] Across a series of prospectuses, each offering a list of titles that together total over fifty volumes, we glimpse the invitees to the ultimate Bauhaus fête, a virtual dinner party of the simpatico. Fourteen books were ultimately produced. A 1925 list supplemented works by inhouse authors with proposed texts by Piet Mondrian on design, Van Doesburg on de Stijl aesthetics, Schwitters on Merz, Heinrich Jacoby on musical education, J. J. P. Oud on Dutch architecture, George Antheil on mechanical music, Albert Gleizes on Cubism, Filippo Tommaso Marinetti and Enrico Prampolini on Futurism, Tristan Tzara on Dada, Lajos Kassák and Ernst Kállai on the Hungarian avant-garde, Le Corbusier on architecture, Friedrich Kiesler on the space of the city, Jane Heap on America, and Martin Schäfer on constructive biology.[73] Each planned or realized volume would stand as a primary statement on the nature of the modern. Signaling a thoroughgoing commitment to theoretical analysis, this ambitious series is the Bauhaus program that most fully expresses the school's self-conception as a think tank. "Our goal," wrote Moholy in a letter to the Russian Constructivist Aleksandr Rodchenko, soliciting a contribution, "is to give a summary of all that is contemporary."[74]

12
László Moholy-Nagy
Spread from *Dynamik der Gross-Stadt* (Dynamic of the metropolis) section in Moholy-Nagy, *Malerei Photographie Film* (Painting photography film). *Bauhausbücher* no. 8 (first edition). Munich: Albert Langen Verlag, 1925
The Museum of Modern Art Library, New York

13
Lucia Moholy
Untitled (László Moholy-Nagy). 1926
Gelatin silver print
9 1/16 x 6 1/4" (23 x 15.9 cm)
Bauhaus-Archiv Berlin

But the lists also speak of a political worldview, a commitment to dialogue and internationalism over retreat and isolation. The titles envision a world of keenly interconnected global efforts in different areas of endeavor subsumed under the aegis of "design." Field permeability is the mantra, and a chartlike publication program that Moholy wrote in 1925 offers a manifesto:

> These books deal with the problems of art, science and technology, and for the specialist of today they attempt to furnish information about the complex problems, working methods and research results in various areas of design, thereby providing the individual with a criterion for his own studies and with progress made in other areas. In order to be able to tackle a task of this magnitude the editors have enlisted the cooperation of the most knowledgeable experts from various countries who are trying to integrate their specialized work with the totality of phenomena of the modern world.[75]

Moholy chooses the workmanlike language of the technical expert: with words like "working methods," "information," "specialist," he deploys metaphors of the laboratory, R&D for the arts, pushing aside for good the persona of artist as shaman nurtured by Itten. In a 1925 photo by Lucia Moholy (cat. 13), Moholy played the part: dressed in mechanic's overalls with slicked-back hair, rimless glasses, and tie, he has every bit the look of the factory manager.[76] He poses against a clean white plane uninterrupted by wainscoting or ornament, evoking a de Stijl environment in three dimensions and suggesting what might be the appropriate architectural analogue for this figure of modernity. After the Bauhaus moved to Dessau, in 1925, it abandoned the teaching-model pairing of *Werkmeister* and *Formmeister*, but while technical masters were no longer appointed to the workshops, the role of technician was subsumed by the artists themselves.

The books worked to brand the modern under the name of the Bauhaus. Moholy's distinctive design — the consistent trim size, the placement of logo and series title on front cover and spine, and signature design elements like sans serif lettering and heavy rules — reveals a thought-out plan to give the series an overarching visual identity. This type of thinking was in itself new: the practices of branding and product standardization had emerged only in the years since 1900, as by-products of the vertiginous

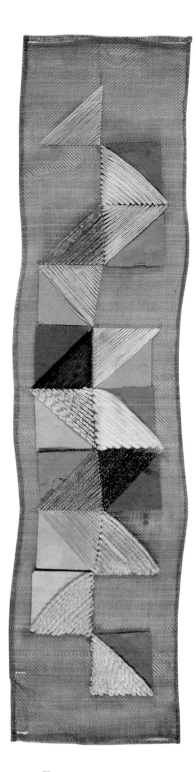

14
Otti Berger
Tasttafel (touch panel) made for preliminary
course taught by László Moholy-Nagy. 1928
Threads and board on wire backing with
loosely attached multicolored square
paper cards
22 7/16 × 5 1/2" (14 × 57 cm)
Bauhaus-Archiv Berlin

growth of a modern commodity culture.[77] But Moholy was also stepping farther into a pioneering role: during the first decades of modern marketing, advertising campaigns had for the most part been developed by business managers and executed by print-shop draftsmen.[78] Offering a combination of avant-garde aesthetics and professional knowledge, Moholy now claimed this role for the visual artist, with the Bauhaus itself as both client and agency.

In 1925, Bayer designed a catalogue for the products of the school's workshops, the famous *Katalog der Muster* (Catalogue of designs), a set of loose-leaf sheets in the new standard A4 size (cat. 202).[79] A few years later, Joost Schmidt created an identity and publicity campaign for the city of Dessau, integrating photography, diagrams, and text into an overall design (cats. 252, 253). By 1926, commercial printers were looking to the Bauhaus for ideas: the print-and-graphics trade journal *Offset. Buch und Werbekunst* published a special issue on Bauhaus typography and advertising, with a cover by Schmidt (cat. 271). In 1929, a publicity card issued by the school described its print and advertising department as a full-service design shop whose capacities included the production of printed matter in modern typography; consulting in new advertising design; layout and production (or overseeing production) of publicity materials, business documents, catalogues, brochures, posters, advertisement etc.; the creation of company logos, trade names, window displays, exhibition designs, and advertising photographs.[80] Artwork was here reimagined as media work; the fine-art printmaking and bookbinding

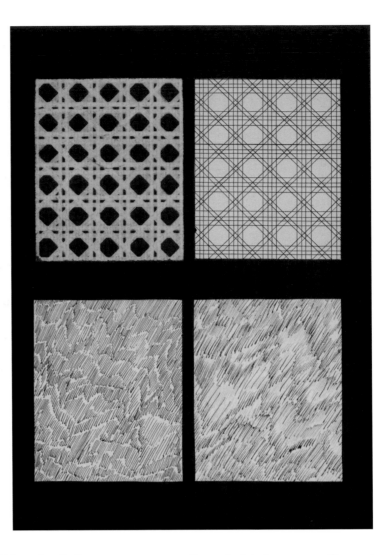

15
Konrad Püschel
Texture study for preliminary course taught
by László Moholy-Nagy. 1926-27
Three ink drawings and one tempera drawing
on cardboard, mounted on cardboard
11 7/16 x 8 1/4" (29 x 21 cm)
Stiftung Bauhaus Dessau

workshops of the school's first years were transformed with the move to Dessau into studios for advertising design and typography.[81] The school's effectiveness in claiming the modern as a brand identity is suggested by Hannes Meyer's ironic quote in a lecture of 1929: "Bauhaus is fashion. All the ladies at the cocktail parties chatter about Bauhaus constructivism. Their calling cards are in lowercase letters."[82]

Tactility

In the Bauhaus worldview as in Walter Benjamin's, experience was closely associated with the handling of things — hence Josef Albers's mandate for "contact with material."[83] Besides debunking traditional academic models of teaching through emulation, Bauhaus pedagogy took aim at another long-held premise of artmaking: the primacy of the visual.

In 1921, a the young Gunta Stölzl, who in 1927 would become the school's first female master, recorded the philosophy of her preliminary-course teacher Itten in her notebook: "Drawing is not the reproduction of what is seen, but making whatever one senses through external stimulus (naturally internal, too) flow through one's entire body."[84] Itten placed sensory training at the core of his teaching, setting exercises in which students closed their eyes and explored a series of textures with their fingertips. "In a short time," he reported, "their sense of touch improved to an astonishing degree."[85] This tactile emphasis was only heightened in later preliminary-course training, with Moholy enthusiastically conducting what he called "tactility exercises" (*Tastübungen*).[86] In his book *Von Material zu Architektur* of 1929, widely known in English as *The New Vision*, Moholy outlined the principles of his Bauhaus teaching, arguing that touch is the foundation of sense perception — the "basic sensory experience, which, nevertheless, has been least developed within a discourse of art."[87] For Moholy, modernity posed a threat to tactile experience: "How neglected our tactile education is was demonstrated to me recently with the director of a training school of nurses who spoke of the difficulties she had encountered in teaching massage."[88] His attempts to rectify this situation in the preliminary course included the assignment of creating chartlike touch panels (*Tasttafeln*), data-gathering tools with which to record the psychological reactions of individuals to different textures.[89] The weaver Otti Berger, for example, made a grid of threads of various fibers holding small colored-paper squares (cat. 14). In other exercises, students were asked to produce optical translations of textural properties (cat. 15).

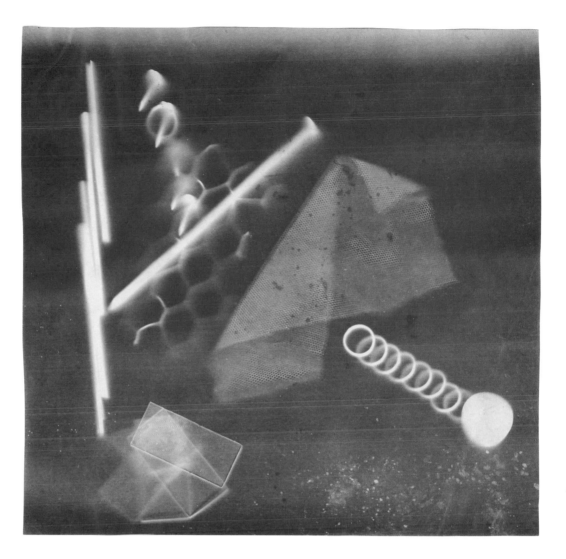

16
Charlotte Voepel-Neujahr
Exercise for preliminary course taught
by Josef Albers. c. 1927–29
Cyanotype (photogram)
11 9/16 x 11 7/16" (29.4 x 29.1 cm)
Bauhaus Archiv Berlin

The sensory, material-based curriculum of the preliminary course nurtured a certain bodily focus in Bauhaus artmaking. It was in this context that Moholy could conceive of the photogram as a major form of avant-garde practice. Made without a camera, by laying materials of varying degrees of transparency on light-sensitive photographic paper, the photogram offered not an image of things seen but a trace of physical contact.

Moholy first experimented with photograms (and with photographic processes generally) in Berlin in 1922, shortly before coming to the Bauhaus the following year. Between 1923 and 1928, photograms became an intense preoccupation for him (cats. 280–85), part of a larger effort to reconceive painting as an art not of pigment but of light — a laboratory form of sorts. Moholy made his abstract photograms alongside his painting practice until 1928, when he abandoned the latter, only to return to it two years later.[90] He continued to make photograms throughout his hiatus from painting, and integrated them, as did Josef Albers, in the teaching of the preliminary course (cat. 16).

These ghostly images mapped an insistently nonperspectival field that fixed "light phenomena."[91] As many commentators have noted, photograms seem to have an intense claim on reality in that they are produced directly by the things they represent. But they also point to the transformative mediation of the artmaking process itself — of media in its primary form.[92] Writing around the time of his first experiments with photograms in 1922, Moholy suggested that, along with abstract films like those of Viking Eggeling and Hans Richter, or experiments using phonographic "groove-manuscript scores," the photogram could serve as a kind of training ground for developing the individual's "functional apparatuses" — for bringing the senses in line with the demands of a new technological age.[93] Herein lay a rationale for abstraction in the context of the Bauhaus: stripped of representational or communicative functions, the dematerialized sensory framework of technological media could reshape human perception.

Tactility reached its apotheosis in the weaving workshop of the late Bauhaus period.[94] After Meyer's appointment as the school's director in 1928, the workshop moved away from large-scale wall hangings exploring grid compositions toward the production of tonally subtle, texturally rich fabrics with a wide variety of functional capacities — the muting of sound, the reflection of light. This subordination of design (with its appeal to the visual) in favor of overall structures and heightened textural qualities reflected the shift of regimes: in the politically charged rhetoric of the Meyer moment, and

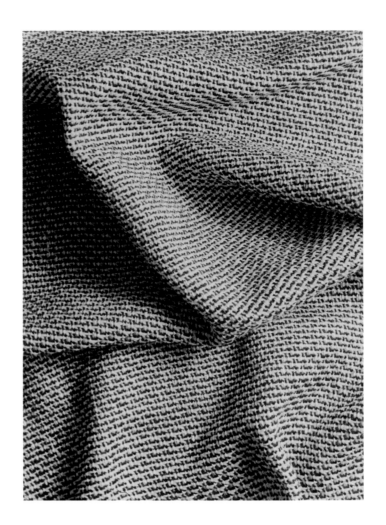

17
Eugen Batz and **Tonja Rapoport**
Photograph taken for photography course
taught by Walter Peterhans. c. 1930
Gelatin silver print
9 1/16 x 6 11/16" (23 x 17 cm)
Bauhaus-Archiv Berlin

in only partially veiled critique of the Gropius years, the "decorative" was attacked on a class basis, as a luxury, and a new mandate was issued for mass production. Indeed one of the key legacies of the school's last years is the signing of licensing agreements for Bauhaus designs, with Körting & Mathiesen, operating under the tradename "Kandem,"[95] and Schwintzer & Gräff in 1928 (to produce lamps),[96] Gebr. Rasch & Co. in 1929 (to produce wallpapers), Polytextil in 1930 (to produce woven fabrics), and van Delden in 1931 (to produce printed fabrics). Tactility was also the basis on which these fabrics were publicized: a campaign promoting Bauhaus textiles was produced within the advertising course (cat. 388), which after the arrival of Walter Peterhans, in 1929, was offered with a concentration in either photography or printing. Peterhans's (and his students') characteristic photographic idiom brings structural detail into focus through extreme closeups and strong raking light, and shows the fabric in folds, highlighting its malleability (cat. 17), rather than as a flat plane with pictorial resonance.[97] "One has to be able to 'comprehend' [a fabric] with one's hands," wrote Berger, champion of this new functional approach, in 1929.[98]

Lilly Reich's arrival at the school in 1932 heralded a new conception of interior space in which textiles were not hung like paintings — as in Gropius's office, where the cubic language of wall hanging and carpet corresponded with the architectural forms (cat. 20) — but diffused into an integrated, highly tactile interior space. In exhibition designs, Reich and Ludwig Mies van der Rohe had created a new model for the domestic interior as a set of flowing, open, sparsely furnished spaces featuring large spans of near-monochrome surfaces (cat. 18). Functional zones were differentiated by materials, such as sheer or nubby fabric drapes, room dividers of rich wooden veneers, plush monochrome carpets, subtly flecked wallpapers, and floor-to-ceiling glass walls that divided interior from exterior. In her time at the Bauhaus, Reich created the structural framework for the coordinated manufacture of the products needed for this new modern interior, presiding over the weaving workshop and the *Ausbau* (interior finishings) department, established in 1929 to integrate what had formerly been the cabinetry, metalwork, and wall-painting workshops. Much of the new mandate was for the creation of textured surfaces. Bormann produced wallpaper designs by rubbing chalk pastel over wove paper in a form of applied frottage (cat. 410), while Hajo Rose used a typewriter to create designs for printed fabrics, an area Reich made particular efforts to revive and modernize (cats. 387, 389, 390).[99] The script spoke of a fascination with the mechanical production of symbols: each letter a discrete unit, in an untethering of the running lines of handwritten script — each the sign of the machine's impact, in language rendered as texture.

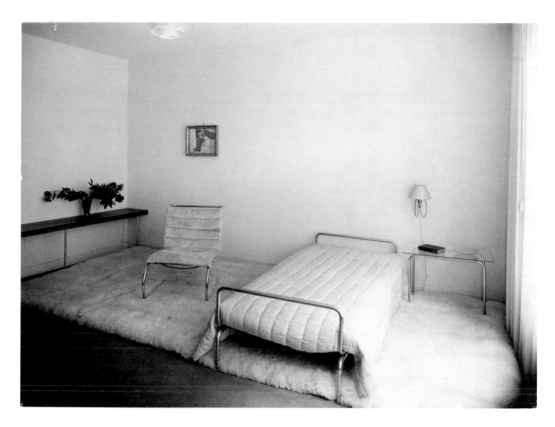

Commemoration

Painting presented a critical paradox for the school. On the one hand, all of Gropius's first appointments were painters, and they played a critical role in the school as teachers and theoreticians, shaping one of its defining legacies: the setting of craft and design in dialogue with contemporary avant-garde artistic practice, in a formative conversation that fundamentally changed the terms of both. On the other, the relevance of the medium itself was suspect; only in 1927 did "free painting and sculpture" classes become part of the school's curriculum.

Despite the contested position of painting in the Gropius years, the medium (and its practitioners on the faculty) had an even less certain role after his departure. Under both Meyer and Mies, the primary focus was architecture. Kandinsky, Klee, Joost Schmidt, and Schlemmer were limited to teaching special subjects within the overarching framework of Josef Albers's preliminary course, and "free painting" classes were isolated from the workshop curriculum, in a kind of slow untwisting of the knotted strands of collaborative, reciprocal pedagogical and theoretical influence between art and design that had existed in the school's earlier years. The importance of the preliminary course itself was also contested, through accusations of "formalism" that echoed similar labels in the Soviet Union of those years. In July 1930, Communist students at the Bauhaus published a broadsheet condemning "the abstract, hence 'non-functional' use of corrugated cardboard, chicken wire etc." in the preliminary course as "a formal 'thing in itself'" and called for the course's abolition.[100] Kandinsky and Josef Albers were particular targets of scorn in this new era of theoretical skepticism, and as of 1930, matriculation in the preliminary course was no longer completely obligatory.[101]

Ultimately the dual pressures of leftist instrumentalism and the increasing efforts of first local, then national Nazi officials to disable the Bauhaus made teaching at the school untenable for many of the painters on the faculty. In 1929, Schlemmer took a position at the Staatliche Akademie für Kunst und Kunstgewerbe in Breslau; Klee left for an appointment at the Düsseldorf Akademie in 1931. At this moment, however, one can see the reemergence of one of painting's most traditional functions, played out against the antimnemonic tenor of the thrust of Bauhaus activities: that of commemoration.

In 1932, the year after Klee's departure and on the eve of the school's flight to Berlin, Kandinsky painted a large gouache that seems so close to the style of Klee it could easily be mistaken for it. Called *Massiver Bau* (Massive building; cat. 326), the work deploys an architectural vocabulary: interlocking rectangles overlay a grid pattern that reads as both floor plan and facade, but in either case most recalls the double Masters' House that Klee and Kandinsky had shared in Dessau — a souvenir of a friendship and of a home, made as Kandinsky prepared to leave for Berlin.

Klee, in the same year but now in Düsseldorf, offered his own meditation on the Bauhaus. Called *Maske Furcht* (Mask of fear; cat. 19), it shows a mask that seems to be none other than the one by Schlemmer worn by the female figure photographed in Breuer's club chair (cat. 7). To this oversized egg-shaped head, Klee adds two pairs of little legs, to create an animated but affectless figure,

18
Lilly Reich
Ground Floor House, in *Die Wohnung unserer Zeit* (The dwelling of our time), *Deutsche Bauausstellung Berlin* (German building exhibition Berlin), organized by Ludwig Mies van der Rohe. 1930–31
View of the lady's bedroom
Photograph: photographer unknown. 1931.
Gelatin silver print. 6 11/16 x 9" (17 x 22.9 cm).
The Museum of Modern Art, New York. Mies van der Rohe Archive, gift of the architect

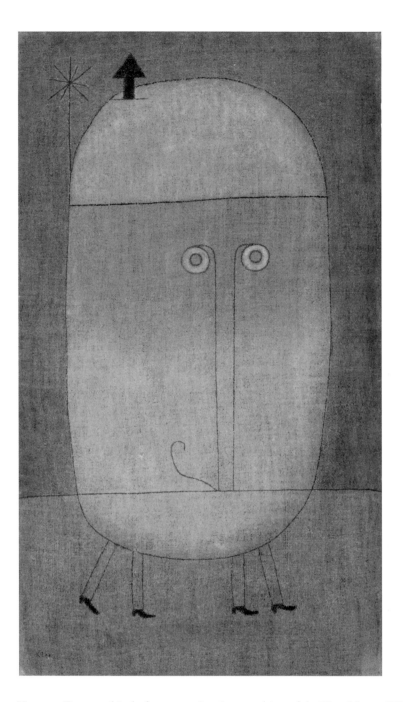

19
Paul Klee
Maske Furcht (Mask of fear). 1932
Oil on burlap
39 5/8 x 22 1/2" (100.4 x 57.1 cm)
The Museum of Modern Art, New York.
Nelson A. Rockefeller Fund

vulnerable in a Humpty Dumpty kind of way — an ironic reworking of the New Man or Woman of the Bauhaus. An arrow that seems plucked from the artist's 1924–25 watercolors (cat. 87) sprouts from the top of the figure's head, evoking — especially with the addition of a mustache curl — the *Pickelhaube*, the spiked helmet of the Prussian imperial army, relinquished with the collapse of the German empire at the end of World War I. Despite Klee's characteristic humor, the picture's title underlines the concealing function of the mask, and the countervailing emotions it may hide.

Perhaps the most famous of all Bauhaus paintings is Schlemmer's *Bauhaustreppe* (Bauhaus stairway; cat. 447). This too was made in 1932, when the artist, now a three-year resident of Breslau, heard about the school's imminent departure from its Dessau building after the National Socialist party's decree evicting it from the city in August of that year. Painted in the weeks following, the work opens a space — the space of memory itself — between Schlemmer's recollection of the stairwell in the Dessau building and the architecture as it actually was. The intertwining of built space and human form relates to the artist's ambition of the time to define a modern form of figurative history painting, but rather than a celebration of a vision of the integration of rationalized bodies in modernist space, the work is a memorial. This trio of paintings, by former colleagues now dispersed, all exhibit a profound nostalgia that speaks to the pressures of history. No longer aiming at "the summary of all that is contemporary," they offer ruminations on the past.

1. For an annotated bibliography on the reception history of the Bauhaus see Andreas Haus, ed., *Bauhaus-Ideen 1919–1994. Bibliographie und Beiträge zur Rezeption des Bauhausgedankens* (Berlin: D. Reimer, 1994). A short essay drawn from Winfried Nerdinger's important book *Bauhaus-Moderne im Nationalsozialismus: zwischen Anbiederung und Verfolgung* (Munich: Prestel, 1993), on the relationship of the school and its students and products to Nazi cultural policy, appears in English in Kathleen James-Chakraborty, ed., *Bauhaus Culture: From Weimar to the Cold War* (Minneapolis: University of Minnesota Press, 2006). On the divided legacy of the Bauhaus in East and West Germany see Greg Castillo, "The Bauhaus in Cold War Germany," in James-Chakraborty, ed., *Bauhaus Culture*, pp. 171–93. Other sources include Rainer K. Wick, "Preliminary Remarks on the Reception of the Bauhaus in Germany," in *Teaching at the Bauhaus* (Ostfildern-Ruit: Hatje Cantz, 2000), pp. 302–37; Paul Betts, *The Authority of Everyday Objects: A Cultural History of West German Industrial Design* (Berkeley, Los Angeles, and London: University of California Press, 2004); Margaret Kentgens-Craig, ed., *The Dessau Bauhaus Building 1926–1989*, trans. Michael Robinson (Basel: Birkhäuser, 1998); and Christian Grohn, *Die Bauhaus-Idee: Entwurf, Weiterführung, Rezeption, Neue Bauhausbücher* (Berlin: Gebr. Mann, 1991). On the reception of the Bauhaus in America see James-Chakraborty, "From Isolationism to Internationalism: American Acceptance of the Bauhaus," in her *Bauhaus Culture*, pp. 153–70. Other sources include Margaret Kentgens-Craig, *The Bauhaus and America: First Contacts, 1919–1936* (Cambridge, Mass.: The MIT Press, 1999); Tom Wolfe, *From Bauhaus to Our House* (New York: Farrar, Straus, and Giroux, 1981); and William H. Jordy, "The Aftermath of the Bauhaus in America," in Donald Fleming and Bernard Bailyn, eds., *The Intellectual Migration: Europe and America, 1930–1960* (Cambridge, Mass.: Belknap Press of Harvard University Press, 1969).

2. See, among others, Frederic J. Schwartz, "Utopia for Sale: The Bauhaus and Weimar Germany's Consumer Culture," in James-Chakraborty, ed., *Bauhaus Culture*, pp. 115–38, and Anna Rowland, "Business Management at the Weimar Bauhaus," *Journal of Design History* 1, nos. 3/4 (1988):153–75.

3. The catalogue of The Museum of Modern Art's 1938 exhibition *Bauhaus 1919–1928*, organized by Walter Gropius, has strongly shaped American reception of the Bauhaus, reproducing many of the works we now consider iconic. Hans Maria Wingler's book *The Bauhaus: Weimar, Dessau, Berlin, Chicago*, trans. Wolfgang Jabs and Basil Gilbert, ed. Joseph Stein (Cambridge, Mass.: The MIT Press, 1969, and later editions) is a defining volume for the historiography of the Bauhaus; first published in German in 1962, as *Das Bauhaus* (3rd rev. ed. 1975), it includes a short narrative history and a vast compilation of documents. Other key histories include Magdalena Droste, *Bauhaus 1919–1933* (Cologne: B. Taschen, 1990); Jeannine Fiedler and Peter Feierabend, *Bauhaus* (Cologne: Könemann, 1999, Eng. trans. 2000); Marcel Franciscono, *Walter Gropius and the Creation of the Bauhaus in Weimar: The Ideals and Artistic Theories of its Founding Years* (Urbana: University of Illinois Press, 1971); Gillian Naylor, *The Bauhaus Reassessed: Sources and Design Theory* (New York: Dutton, 1985); and Frank Whitford, *Bauhaus* (London: Thames & Hudson, 1984).

4. On precedents to the Bauhaus in modern design reform movements see John V. Maciuika, "Wilhelmine Precedents for the Bauhaus," in James-Chakraborty, ed., *Bauhaus Culture*, pp. 1–25; John V. Maciuika, *Before the Bauhaus: Architecture, Politics, and the German State, 1890–1920* (Cambridge: at the University Press, 2005); Schwartz, *The Werkbund: Design Theory and Mass Culture before the First World War* (New Haven: Yale University Press, 1996); Joan Campbell, *The German Werkbund: The Politics of Reform in the Applied Arts* (Princeton: at the University Press, 1978); and Nikolaus Pevsner, *Pioneers of Modern Design from William Morris to Walter Gropius* (Harmondsworth: Penguin, 1960).

5. William Richard Lethaby's Central School of Arts in London, the technical workshops in Birmingham, the Glasgow School of Art, and Hermann Obrist's and Wilhelm Debschitz's private school of art and design in Munich all offered various forms of inspiration for Gropius's dual teaching model. Some of these models are discussed in Maciuika, *Before the Bauhaus*.

6. Gropius drew tightly from an Expressionist pool: all of the artists he invited to join the faculty had connections to *Der Sturm*, the magazine launched by Herwarth Walden in 1910, and to the Berlin gallery of the same name, which together served as the primary institutional structure for Germany's participation in broader avant-garde circles, publishing and exhibiting French modernist work in Germany and defining an Expressionist aesthetic as Germany's own brand of modernism internationally.

7. See Whitford, *Bauhaus*, pp. 29–30.

8. Throughout its history the school used various terms to describe the preliminary course, including *Vorunterricht, Vorlehre, Grundlehre, Grundbegriffe der Gestaltung, Allgemeine, Vorbildung*, and *Vorkurs*. For a description of this shifting terminology see Adrian Sudhalter, "14 Years Bauhaus: A Chronicle," in the present volume.

9. Franciscono, *Gropius and the Creation of the Bauhaus*, p. 162, n. 32. Franciscono refers to the minutes of the *Meisterratssitzung* of September 20, 1920, and of a meeting of faculty and students of October 13, 1920. Sammlung Gropius, Bauhaus-Archiv, Berlin.

10. See Wick, *Teaching at the Bauhaus*, p. 83.

11. Paul Klee, letter to Lily Klee, January 16, 1921, in Felix Klee, ed., *Paul Klee. Briefe and die Familie, vol. II, 1907–1940* (Cologne: DuMont, 1979), p. 970. Eng. trans. in Whitford, *The Bauhaus: Masters and Students by Themselves* (New York: The Overlook Press, 1993), p. 54.

12. Johannes Itten, *Gestaltungs- und Formenlehre. Vorkurs am Bauhaus und später*, 1964, Eng. trans. as *Design and Form: The Basic Course at the Bauhaus and Later*, 1963 (rev. ed. New York: Litton Educational Publishing, 1975), p. 9.

13. For a later articulation of this theory see Itten, *Design and Form*, pp. 10–12.

14. Ibid., p. 7.

15. On the influence of modern thinking about early-childhood education on the Bauhaus see Frederick M. Logan, "Kindergarten and Bauhaus," *College Art Journal* 10, no. 1 (Autumn 1950):36–43; Franciscono, *Gropius and the Creation of the Bauhaus*, pp. 180–81; J. Abbott Miller, "Elementary School," in Ellen Lupton and Abbott Miller, eds., *the abc's of ▲■●: The Bauhaus and Design Theory* (New York: Herb Lubalin Study Center of Design and Typography, the Cooper Union for the Advancement of Science and Art, 1991), pp. 4–21; and Wick, *Teaching at the Bauhaus*.

16. See Abbott Miller, "Elementary School," p. 5.

17. Josef Albers, "Creative Education," 1928, in Wingler, *The Bauhaus*, p. 142.

18. Walter Benjamin, "Experience and Poverty," in *Walter Benjamin: Selected Writings*, vol. 2, *1927–1934*, eds. Marcus Bullock and Michael W. Jennings (Cambridge, Mass.: Belknap Press, 1999), p. 732.

19. Wick, *Teaching at the Bauhaus*, p. 235, and Clark V. Poling, *Kandinsky: Russian and Bauhaus Years, 1915–1933*, exh. cat. (New York: Solomon R. Guggenheim Foundation, 1983), p. 17.

20. Vasily Kandinsky, *Punkt und Linie zu Fläche*, 1926, published in English as *Point and Line to Plane*, 1947, trans. Howard Dearstyne and Hilla Rebay (reprint ed. New York: Dover, 1979), p. 20.

21. Kandinsky, *Über das Geistige in der Kunst*, 1911, published in English as *Concerning the Spiritual in Art*, trans. M. T. H. Sadler (New York: Dover, 1977), p. 36.

22. Kandinsky, *Point and Line to Plane*, p. 68.

23. Kandinsky, "Tanzkurven: Zu den Tänzen der Palucca," in *Das Kunstblatt*, March 1926, p. 117–19, published in English as "Dance Curves: The Dances of Palucca," in *Kandinsky: Complete Writings on Art*, ed. Kenneth C. Lindsay and Peter Vergo (Boston: G. K. Hall, 1982), p. 520.

24. The modern choreographer Rudolph von Laban, for example, developed a notational system, first published in 1926, to transcribe body movements and thus permit the replication of otherwise ephemeral dance ideas. For an in-depth discussion of Laban's system see Matthew S. Witkovsky, "Staging Language: Milča Mayerová and the Czech Book 'Alphabet,'" *The Art Bulletin* 86, no. 1 (March 2004):114–35.

25. See, e.g., cat. 370, by Kandinsky's student Heinrich Bormann, or the musical diagrams in Kandinsky, *Point and Line to Plane*, p. 43.

26. See Robin Kinross, *Modern Typography: An Essay in Critical History* (London: Hyphen Press, 1992), p. 90.

27. Oskar Schlemmer, "The Staatliche Bauhaus in Weimar," from the publicity pamphlet *The First Bauhaus Exhibition in Weimar, July to September 1923*, reprinted in Wingler, *The Bauhaus*, p. 65.

28. Gropius gave his lecture "Kunst und Technik: Eine neue Einheit" on August 15, 1923, in the Bauhaus vestibule.

29. See Schwartz, "Utopia for Sale," and Rowland, "Business Management at the Weimar Bauhaus." On the figure of the technical expert in Weimar Germany see Schwartz, *Blind Spots*, pp. 37–101.

30. See Kai-Uwe Hemken's essays in Bernd Finkeldey et al., *Konstruktivistische Internationale Schöpferische Arbeitsgemeinschaft 1922–1927. Utopien für eine europäische Kultur* (Stuttgart: Gerd Hatje, 1992).

31. See Yve-Alain Bois's important essay "The De Stijl Idea," in Bois, *Painting as Model* (Cambridge, Mass.: The MIT Press, 1990), pp. 116–21. Also see his "Mondrian and the Theory of Architecture," *Assemblage* 4 (1987):102–30. It should be noted, though, that de Stijl was not alone in placing pressure on the boundary between painting and architecture: artists of the Russian avant-garde, especially those schooled in Suprematism, explored the architectural potential of painting from 1920 on.

32. On these two operations see Bois, "The De Stijl Idea."

33. See Anja Baumhoff, *The Gendered World of the Bauhaus: The Politics of Power at the Weimar Republic's Premier Art Institute, 1919–1932* (Frankfurt: Peter Lang, 2001); Droste and Manfred Ludewig, *Das Bauhaus Webt. Die Textilwerkstatt am Bauhaus. Ein Projekt der Bauhaus-Sammlungen in Weimar, Dessau, Berlin* (Berlin: G+H, 1998); Sigrid Wortmann Weltge, *Bauhaus Textiles: Women Artists and the Weaving Workshop* (London: Thames and Hudson, 1993); and T'ai Lin Smith, *Weaving Work at the Bauhaus: The Gender and Engendering of a Medium, 1919–1937*, Ph.D. thesis, University of Rochester, 2006.

34. See Jenny Anger, *Paul Klee and the Decorative in Modern Art* (Cambridge and New York: Cambridge University Press, 2004), pp. 179–80. On the relationship between Klee and the weavers also see Virginia Gardner Troy, *Anni Albers and Ancient American Textiles: From Bauhaus to Black Mountain* (London and Burlington, Vt.: Ashgate Publishing, 2002), pp. 80–89.

35. Exodus 25:31–40, 37:17–24.

36. Xanti Schawinsky, quoted in Sibyl Moholy-Nagy, *Moholy-Nagy: Experiment in Totality* (New York: Harper and Brothers, 1950), p. 38.

37. Bayer began experimenting with typography in 1922–23, inspired by Moholy's forays in the field, which in turn came out of earlier alphabetic explorations by the Russian Constructivists and de Stijl group as well as from Walter Portsmann's findings in the field of speech reform, publicized in his book *Sprache und Schrift* of 1920. Bayer published his "universal" lettering as part of his article "Versuch einer Neuen Schrift," *Offset. Buch und Werbekunst* no. 7 (July 1926):398–404. See Kinross, "Das Bauhaus im Kontext der neuen Typographie," in Ute Brüning, *Das A und O des Bauhauses*, exh. cat. (Berlin: Bauhaus-Archiv, and Leipzig: Edition Leipzig, 1995), pp. 9–14.

38. Herbert Bayer, "On Typography," in *Herbert Bayer: The Complete Works*, ed. Arthur A. Cohen (Cambridge. Mass.: The MIT Press, 1984), p. 350.

39. With thanks to Michael Siebenbrodt, of the Kunstsammlung Weimar, for pointing out this image. See Nele Heise, "Das Baushaus in allen Taschen," in Patrick Rössler, ed., *bauhauskommunikation. Innovative Strategien in Umgang mit Medien, interner und externer Öffentlichkeit* (Berlin: Gebr. Mann Verlag, 2009), pp. 265–80.

40. Josef Hartwig, quoted in Anne Bobzin and Klaus Weber, *Das Bauhaus-Schachspiel von Josef Hartwig/The Bauhaus Chess Set by Joseph Hartwig* (Berlin: Bauhaus-Archiv Museum für Gestaltung, 2006), p. 7.

41. Ibid., p. 8.

42. In her important discussion of the Bauhaus fascination with automata, marionettes, and dolls, Juliet Koss also identifies this image as the embodiment of the new figure of the Bauhaus, though she discusses it in a different way. Koss, "Bauhaus Theater of Human Dolls," in James-Chakraborty, ed., *Bauhaus Culture*, pp. 99–100.

43. Alfred Arndt, "How I got to the Bauhaus in Weimar," 1968, quoted in Whitford, *The Bauhaus: Masters and Students by Themselves*, p. 57.

44. Kandinsky, *Concerning the Spiritual in Art*, p. 3.

45. Ibid., p. 2.

46. Ibid., pp. 29–30 and passim.

47. Ibid., p. 24.

48. Ibid., p. 15.

49. Reprinted in *Kandinsky: Complete Writings on Art*, 1:291–340.

50. Friedrich Kittler, *Discourse Networks 1800/1900* (Stanford: at the University Press, 1992), pp. 216–17. With thanks to Annie Bourneuf for pointing out Kittler's reference to Kandinsky in a discussion on the artist several years ago.

51. Paul Klee, *The Notebooks of Paul Klee*, vol. 1, *The Thinking Eye*, ed. Jürg Spiller, trans. Ralph Manheim (New York: George Wittenborn/Lund Humphries, 1961), p. 215.

52. Alfred H. Barr, Jr., identifies this pun in a letter to Alexander Dorner, October 5, 1955. Artist files, The Department of Painting and Sculpture, The Museum of Modern Art, New York.

53. Schlemmer, "Entry for September 1922," in *The Letters and Diaries of Oskar Schlemmer,*

54. Ibid.

55. Schlemmer, *Die Bühne im Bauhaus*, 1925, published in English as *The Theater of the Bauhaus*, trans. Arthur S. Wensinger (Middletown, Conn.: Wesleyan University Press, 1961), p. 28.

56. "Not burdened with tradition like the opera and the drama, not committed to word, tone and gesture, [theatrical dance] is a free form, destined to impress innovation gently upon our senses: masked, and—especially important—silent." Schlemmer, "Entry for September 1922," p. 127.

57. Schlemmer, *The Theater of the Bauhaus*, p. 20.

58. László Moholy-Nagy, "Zeitgemässe Typographie," in Krisztina Passuth, *Moholy-Nagy* (London: Thames and Hudson, 1985), p. 294.

59. László Moholy-Nagy, *Malerei Photographie Film*, 1925, published in English as *Painting, Photography, Film*, trans. Janet Seligman, 2nd ed. (Cambridge, Mass.: The MIT Press, 1987), pp. 25–26.

60. Schwartz, *Blind Spots*, p. 48.

61. László Moholy-Nagy, *Painting, Photography, Film*, p. 40.

62. See Kinross, *Modern Typography*, pp. 92–93.

63. See Bayer, "typography and design at the bauhaus," in *Herbert Bayer: The Complete Works*, p. 215; Alan Bartram, *Bauhaus, Modernism and the Illustrated Book* (New Haven: Yale University Press, 2004), p. 48; and Brüning, "Herbert Bayer," in Fiedler and Feierabend, *Bauhaus*, p. 338.

64. Bayer, "Towards a Universal Type," *PM* 6, no. 2 (December–January 1939–1940):27–32, reprinted in Michael Bierut, Jessica Helfand, et al., eds., *Looking Closer 3: Classic Writings on Graphic Design* (New York: Allworth Press, 1999), p. 62, where it is incorrectly cited as *PM* 4.

65. See Kandinsky, "Program for the Institute of Artistic Culture," in *Kandinsky: Complete Writings on Art*, 1:455–72.

66. Gropius, "Program of the Staatliche Bauhaus in Weimar," in Wingler, *The Bauhaus*, p. 32.

67. Kandinsky, "The Abstract Synthesis of the Theater," in *Kandinsky: Complete Writings on Art*, 1:506.

68. Andor Weininger, quoted in András Koener, *The Stages of Andor Weininger: From the Bauhaus to New York* (Budapest: 2B Kulturalis es. Müv Alap, 2008), p. 172.

69. Ludwig Hirschfeld-Mack, *Reflected-Light Compositions*, a treatise privately published in 1925, reprinted and trans. in Wingler, *The Bauhaus*, p. 83.

70. Franz Ehrlich, "Bauhaus und Totaltheater," in *Wissenschaftliche Zeitschrift. Hochschule für Architektur und Bauwesen* 29, nos. 5/6 (1983):424.

71. Erwin Piscator, "Project: Total Theater for Erwin Piscator, Berlin," in *The Walter Gropius Archive: An Illustrated Catalogue of the Drawings, Prints and Photographs in the Walter Gropius Archive at the Busch-Reisinger Museum, Harvard University*, ed. Winfried Nerdinger (New York, London, and Cambridge, Mass.: Garland Publishing and Harvard University Art Museums, 1952), 1:152.

72. The text of the 1924 announcement is reproduced in Droste and Fiedler, eds., *Experiment Bauhaus* (Berlin: Bauhaus-Archiv Museum für Gestaltung, 1988), p. 167.

73. "Prospectus '8 Bauhaus Books' by the Albert Langen Press, Munich (1925)," in Wingler, *The Bauhaus*, p. 130, where it is incorrectly dated 1927.

74. László Moholy-Nagy, "Moholy Nagy's letter to Aleksandr Rodchenko, Weimar, 18 December 1923," in Passuth, *Moholy-Nagy*, pp. 392–93.

75. László Moholy-Nagy, "Prospectus," 1925, in Wingler, *The Bauhaus*, p. 130.

76. On this photograph see Schwartz, *Blind Spots*, pp. 37–101.

77. See Morgen Witzel, "Introduction," *Marketing* (Bristol: Thoemmes Press, 2000), pp. vii–xxxvii.

78. See Schwartz, "Utopia for Sale," pp. 119–25, and *Blind Spots*, pp. 91–94. See also Kinross, *Modern Typography*, and Jeremy Aynsley, *Graphic Design in Germany: 1890–1945* (Berkeley, Los Angeles, and London: University of California Press, 2000).

79. Standard paper sizes were another reform implemented by Portsmann at the Normenausschuss der deutschen Industrie. See Kinross, *Modern Typography*, p. 89.

80. See Gerd Fleishmann, *Bauhaus Typografie. Drucksachen, Typographie, Reklame* (Düsseldorf: Edition Marzona, 1984), p. 199.

81. The printmaking workshop was dedicated to advertising design and typography in 1925. In 1927, advertising was offered as one of four main areas of instruction, the others being architecture, theater, and free painting and sculpture. On the history of the adver-

tising workshop see Brüning, *Das A und O des Bauhauses*. On the first years of the print workshop, when it was producing fine-art print portfolios, see Wingler, ed., *Graphic Work from the Bauhaus*, trans. Gerald Onn (Greenwich, Conn.: New York Graphic Society, 1965).

82. Hannes Meyer, notes for a lecture given in Vienna and Basel, 1929, in Meyer, *Bauen und Gesellschaft. Schriften, Briefe, Projekte*, ed. Lena Meyer-Bergner (Dresden: Verlag der Kunst, 1980), p. 54. This trans. from Schwartz, "Utopia for Sale," p. 118.

83. Albers, "Creative Education," from *VI. Internationaler Kongress für Zeichnen, Kunst-unterricht und Angewandte Kunst in Prag, 1928*, published in Prague 1931, quoted in Wingler, *The Bauhaus*, p. 142.

84. Gunta Stölzl, quoted in Whitford, *The Bauhaus: Masters and Students by Themselves*, p. 54. Stölzl's original notebook is in the Bauhaus-Archiv Berlin.

85. Itten, quoted in Whitford, *The Bauhaus: Masters and Students by Themselves*, p. 57.

86. Wick stresses the "haptic" aspect of Moholy's pedagogy in his *Teaching at the Bauhaus*, pp. 149–54.

87. László Moholy-Nagy, *The New Vision*, trans. Daphne M. Hoffman (New York: Wittenborn, Schultz, 1947), p. 23.

88. Ibid., p. 24.

89. Ibid., p. 25.

90. See Passuth, *Moholy-Nagy*, p. 52.

91. László Moholy-Nagy, "Produktion Reproduktion," in *De Stijl* 7 (1922), published in English as "Production Reproduction," in Passuth, *Moholy-Nagy*, p. 289.

92. See László Moholy-Nagy, *Vision in Motion* (Chicago: Paul Theobald, 1947), p. 188.

93. László Moholy-Nagy, "Production Reproduction," p. 289.

94. Smith explores the tactile preoccupation of the Bauhaus weavers after Gropius's departure from the school in "Limits of the Tactile and the Optical: Bauhaus Fabric in the Frame of Photography," *Grey Room* 25 (Fall 2006):6–31. I would however qualify the opposition she sees between this tactile interest and what she describes as the purely optical qualities of Moholy's photography by suggesting a more complex relation between the two, given the tactile focus of Moholy's teaching and the broad sensory basis for perception consistently described in his writing.

95. The brand name "Kandem" derived phonetically from the initials of the last names of the company's founders, Max Körting and Wilhelm Mathiesen — "Ka" [u]nd "eM."

96. See Wingler, *The Bauhaus*, p. 458. This agreement was preceded by earlier collaborations with Kandem by Marianne Brandt and Wilhelm Wagenfeld as early as 1927. See Weber, "'Vom Weinkrug zur Leuchte.' Die Metallwerkstatt am Bauhaus," in *Die Metallwerkstatt am Bauhaus*, exh. cat. Bauhaus-Archiv Berlin (Berlin: Kupfergraben Verlagsgesellschaft, 1992), pp. 28–31.

97. See Smith, "Limits of the Tactile and Optical," p. 7.

98. Berger, "Stoffe im Raum," in *bauhaus—dessau*, special issue of *ReD. Internationale Monatsschrift für moderne Gestaltung* (Prague) 3, no. 5 (1930):143–45, reprinted in Droste and Ludewig, eds., *Das Bauhaus Webt*, p. 224.

99. Hajo Rose's designs won a competition for printed-fabric designs run under the administration of Lilly Reich. On Reich's efforts to revive printed fabrics see Wortmann Weltge, *Bauhaus Textiles*, p. 118; Droste, *Bauhaus 1919–1933*, p. 224; and Fiedler and Feierabend, *Bauhaus*, p. 477

100. "Demand for the Abolition of the Preliminary Course," 1930, in Wingler, *The Bauhaus*, p. 172.

101. See Wick, *Teaching at the Bauhaus*, p. 83.

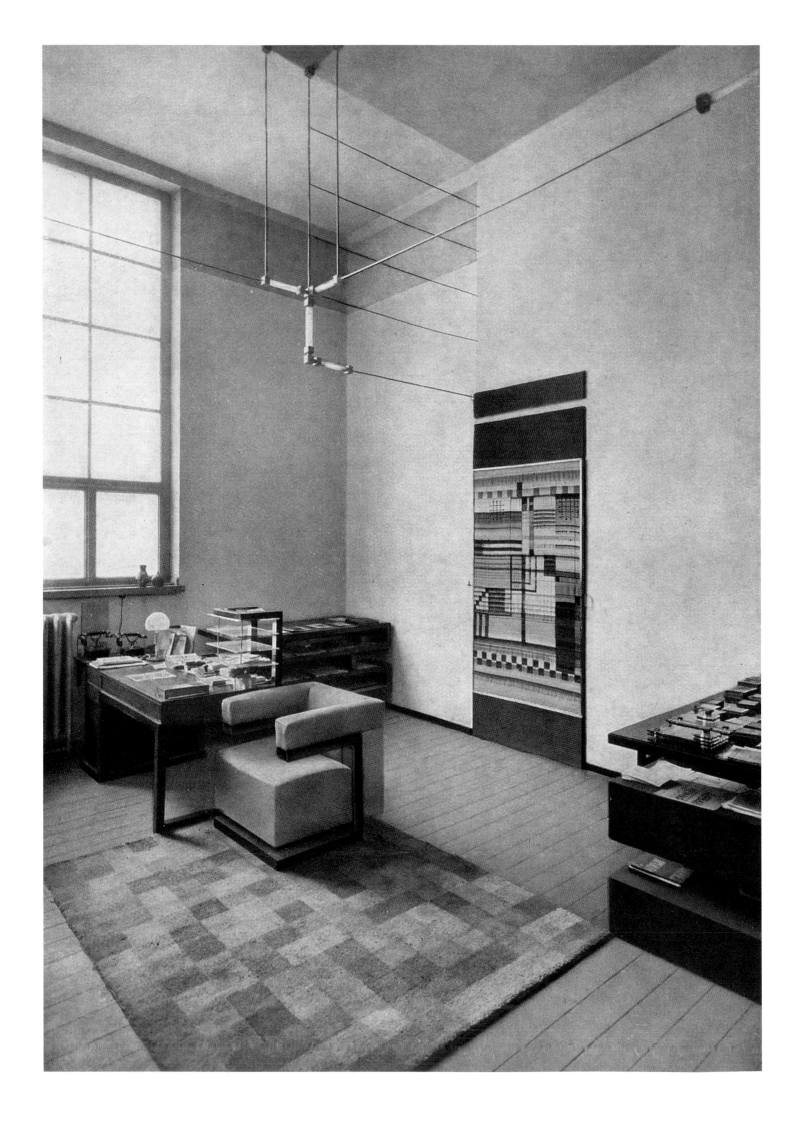

BAUHAUS MULTIPLIED: PARADOXES OF ARCHITECTURE AND DESIGN IN AND AFTER THE BAUHAUS

BARRY BERGDOLL

Houses and even whole housing settlements are being built everywhere; all with smooth white walls, horizontal rows of windows, spacious terraces and flat roofs. The public accepts them, if not always with great enthusiasm, at least without opposition, as the products of an already familiar "Bauhaus style." — Ernst Kállai, "Ten Years of Bauhaus," 1930[1]

Just three years after Walter Gropius finally acted on his long-delayed vision of architecture as central to the Bauhaus — formal architectural instruction began there only in late 1927, with the arrival of Hannes Meyer — the school was already widely credited with the form that modern architecture was taking. Internally the school was characterized by competing visions of an appropriate modern form for everything from tea infusers to housing estates. But even though the Bauhaus had produced barely a single practicing architect, Gropius had harnessed a Europe-wide debate about modern architecture and design that rapidly had a multiplier effect.

Despite the call for "unity" in Gropius's founding manifesto of 1919 (cats. 38, 39) — the "*grosse Bau*" (great building), he wrote, was to provide "the new structure of the future, which will embrace architecture and sculpture and painting in one unity"[2] — the Bauhaus had a tendency to multiply and diversify. Gropius sought a new model of form-making in which the serial product — the multiple — would challenge received notions of artistic practice and authorship. The very name "Bauhaus," one of the only aspects of the institution over which Gropius managed to retain proprietary rights with the school's move from Weimar to Dessau in 1925, was subject to multiple claims and became a ubiquitous adjective. By 1930, when the Hungarian artist and critic Ernst Kállai bemoaned the triumph of "Bauhaus style," the aspirations for art-historical unity had already been buffeted by the vagaries of the brand name and the marketplace.[3]

In 1928, as Meyer took over the directorship and attacked the luxurious ethos of many Bauhaus products — "NO BAUHAUS STYLE AND NO BAUHAUS FASHION"[4] — Kállai warned in the pages of the house organ, *bauhaus*, "Such facile stylistic labeling of the modern must be emphatically rejected."[5] In 1930, in the leftist magazine *Die Weltbühne*, his tone was ironic, his intent to sound alarms about the marketplace's perils: "Houses with lots of glass and shining metal: Bauhaus style. The same is true of home hygiene without home atmosphere: Bauhaus style. Tubular steel armchair frames: Bauhaus style. Lamp with nickel-coated body and a disk of opaque glass as lampshade: Bauhaus style. Wallpaper patterned in cubes: Bauhaus style. No painting on the wall: Bauhaus style. Incomprehensible painting on the wall: Bauhaus style. Printing with sans-serif letters and bold rules: Bauhaus style. everything written in small letters: bauhaus style. EVERYTHING EXPRESSED IN CAPITAL LETTERS: BAUHAUS STYLE."[6] As early as 1929, Oskar Schlemmer noted, "This style can be found everywhere but at the Bauhaus."[7]

This essay explores tensions between the Bauhaus's practices in situ and the school's efforts to broadcast its message through exhibitions, publications, and advertising, with all the attendant new issues of the nature of artistic authorship in relationship to industrial seriality. In 1925 the Dutch architect Theo van Doesburg could declare the results of the school's first five years directionless, which he regretted "since nowhere else in Europe [was] such official opportunity... given for a radical innovation of... education in architecture and the arts."[8] By 1933, when Ludwig Mies van der Rohe, the school's third director, was forced to close the school to avoid further Nazi raids, the Bauhaus had become a victim not only of the period's volatile politics but also, less predictably, of its own successes.

Gropius and the Imperatives of Style in Harmony with Industry

Since his early writings under the auspices of the Werkbund, Gropius had been striving for a marriage between the standardization of industrial production and the then current art-historical concept of style as spiritual unity across media and materials. "Our age, after a sad interregnum, is once

20
Walter Gropius
Director's office, Bauhaus, Weimar, on the occasion of the 1923 exhibition. In the former Hochschule für bildende Kunst, built by Henry van de Velde in 1904–11. 1923
As reproduced in *Neue Arbeiten der Bauhauswerkstätten* (New work of the Bauhaus workshops). *Bauhausbücher* 7.
Munich: Albert Langen Verlag, 1925
The Museum of Modern Art Library, New York

Karaibische Hütte.

again approaching a *'Zeitstil'* [period style] which honors tradition but fights against false romanticism," he wrote in 1910, in a proposal for prefabricated houses in which the demands of industry and of art could be aligned toward a higher stylistic unity. "Even the Dutch brick house, the French block of flats of the eighteenth century, and the Biedermeier town house of around 1800 were repeated in series using the same forms.... The result offered great economy and, even if unintentionally, produced artistic unity."[9]

The argument was borrowed from the turn-of-the-century reform movement, from Hermann Muthesius's *Stilarchitetkur und Baukunst* of 1902 and from Paul Mebes's *Um 1800* of 1908, which celebrated the vernacular as a corrective to revivalist styles. In 1919, Gropius would reframe that reform project as it had been conceived in the Werkbund years to create a novel type of school, one in which practical making was the center of both craft and architectural training. This was the old dream of the nineteenth-century Gothic Revivalists, who had responded to the separation of architecture from the building trades by arguing for a return to the medieval mason's yard as the training ground for architecture and the related crafts, and had rallied around the completion of Cologne Cathedral in 1880 as both a unifying great-building project and a catalyst for defining a new, unified Germany. The Bauhaus lionized that ideal, even borrowing the imagery of the cathedral for the manifesto (cat. 38), while also setting out to form alliances with modern industry. Artists and architects would now create prototypes for machine production.

Gropius had come of age amid the debates over Gottfried Semper's monumental treatise *Der Stil* (1860–63; cat. 21). Crafts, for Semper, were the building blocks of architecture and, like architecture, were the result of complex negotiations between the internal life of form and material and technical constraints. The third volume of Semper's magnum opus, dedicated to architecture, was never completed, much as for eight years Gropius was reluctant to establish a Bauhaus architectural workshop on a par with those devoted to woodworking, ceramics, metalworking, wall painting, printmaking, weaving, and other media. But Semper's influential first volumes laid the groundwork, tracing the origins of architecture to the crafts associated with the making of the earliest shelters. His four modes of making — masonry, ceramics, metalwork, and weaving — corresponded loosely to the initial configuration of the Weimar workshops, and following his basic categories, the division of labor in Gropius's socialist-tinged workshops was not between labor and management but between matter and form, between a skilled craftsman, the "workshop master," who was to teach technique, and an artist, the "form master," a breaker of rules and conventions who would guide the search for form to unanticipated invention.

Semper's followers had reduced his theories to a mechanistic material determinism, a position that Alois Riegl, in his influential theory of *Kunstwollen*, or the will to form, used as a springboard in insisting on the continuity of form across materials and cultures.[10] Gropius cited both Semper and

21
Unknown
Karaibische Hütte (Carib hut), Trinidad.
Engraving based on a model shown in the
Great Exhibition, London, 1851
As reproduced in Gottfried Semper,
*Der Stil in den technischen und tektonischen
Künsten oder Praktische Aesthetik.* Vol. 2.
Frankfurt: Verlag für Kunst und Wissenschaft,
1860–1863. Ex libris Adolf Meyer
The Museum of Modern Art Library, New York

Riegl in lectures to the students in 1919–20 as he slowly built up the curriculum.[11] The famous Bauhaus curricular diagram of 1922 (p. 322) ended not in the *grosse Bau* per se but in something more exploratory, "*Bau*" (building) modified by "*Versuchsplatz*" (experimental worksite), the final result of a sequence: first, the preliminary course (the *Vorlehre*) was to unleash the student's imagination while also introducing him or her to its material constraints; then, in the middle ring, a language of technique and invention was to be taught in a craft workshop; and finally came communal work in architecture. In the absence of formal architectural instruction Gropius sought to provide the form master's teaching through lectures, his own and visiting architects', while students gained technical instruction through courses at Weimar's Staatliche Baugewerkenschule, a professional building school — sixteen of them signed up — and through classes with Gropius's partner, Adolf Meyer.[12] In the early years of the Bauhaus both Johannes Itten, the formulator of the preliminary course, and Gropius produced designs evocative of the cathedral image that Lyonel Feininger had created for the manifesto: Itten with the *Turm des Feuers* (Tower of fire, 1920) and Gropius with his *Märzgefallenen-Denkmal* (Monument to the March dead, 1921; cats. 56, 57), which rose on the skyline like a sculptural version of the *Stadtkrone*, or "city crown," proposed before the war by the architect Bruno Taut. The idea of the *grosse Bau*, however, was quickly transmuted into a new ideal: the house, a modern secular Gesamtkunstwerk.

The Sommerfeld House: First Experimental Worksite of the Bauhaus

The early products of the workshops — Marcel Breuer's extraordinary "African" chair of 1921, for instance (cat. 95), a collaboration with Gunta Stölzl — emerged from a neo-medieval trajectory of promotion from apprentice to journeyman to "young master." Student projects were individualistic, even "directionless," as Van Doesburg would complain. But by 1922, when the "African" chair was photographed for an archive of student work,[13] Breuer had already moved to a different vein. And meanwhile a chance had arisen to work communally: in 1920, the Berlin timber merchant Adolf Sommerfeld commissioned from Gropius a house, which the architect made a testing ground for the workshops (cats. 77–82, 84). Here was a manifesto of Gropius's vision of the architect not as a craftsman of individual solutions and forms but as a designer of constructive systems, the building blocks of a new tectonic culture.

The stylistic sources of Sommerfeld's house mystified critics and historians from the start: for Paul Klopfer, director of the Baugewerkenschule, the house was evocative of "ancient prototypes in old Saxony that still affect us so deeply today,"[14] but it actually drew on a wide range of vernacular and modernist sources. Fred Forbát, a young Hungarian architect who had trained in Budapest and Munich before arriving in Weimar in August 1920, when the design was nearly complete, remembered seeing books including Bruno Taut's *Alpine Architektur* (Alpine architecture, 1919), and the famed Frank Lloyd Wright portfolio published in Berlin by Wasmuth in 1910, on Gropius's studio table. "The strong plasticity, the deep overhanging roof planes, and the clear organization of the floor plans impressed us all," Forbát would recall of Wright's Prairie Houses.[15] Given the stalwart granite base and lighter wooden superstructure of the Sommerfeld House, and its walls and roof system woven together from the same elements, one might easily develop a Semperian reading of Gropius's attitude to the search for the new within the primeval. The series of ceremonies that accompanied the construction process, and the building's final dedication in a great *Richtfest* (topping-out ceremony; cat. 22), point to the nineteenth-century interest in the rituals that tied architecture to society.

The house was built of massive planks and logs, an approach not seen since the log cottages of the nineteenth-century royal parks in Berlin and Potsdam, notably the Alexandrowka Russian colony (1826–27). Besides honoring Sommerfeld's business, the material was significant for Gropius, whose earliest use of the term *Neues Bauen* — the search for an architectural approach embracing modern materials and conditions — appears unexpectedly as the title of an essay on wood:

A new era also needs a new form.... It is no accident that precisely the younger art-
ists like to carve their ideas in wooden logs and tree trunks; they are the ones who
intuitively maintain connection with modern life. Every material has its beauty, its
possibilities, and its time. Wood is *the* building material of the present.... *Wood* has a
wonderful capability for artistic shaping and is by nature so appropriate to the primitive
beginning of our newly developing life. Wood is the original building material of men,
sufficient for all the structural parts of building; walls, floor, ceiling, roof, columns
and beam; it can be sawed, carved, nailed, planed, milled, polished, stained, inlaid,
lacquered, and painted.[16]

The house employed a patented system of precut interlocking timbers, the *Blockbauweise Sommerfeld*
(Sommerfeld block building method), which Gropius would also adopt in a whole catalogue of designs
in wood for the Sommerfeld site: row houses, an administrative building intended to span a street with a
wooden bridge remarkably anticipatory of the Dessau Bauhaus, and service buildings (one still standing).

 The interior of the house both promoted Sommerfeld's company and celebrated a creative
synthesis among the Bauhaus workshops. The herringbone design of the paneling in the great hall echoes
upholstery patterns and veneers in Gropius's prewar furniture, a clear recapitulation of Semper's idea
of *Stoffwechsel*, or the movement of motifs from one material to another. Such transformations would
have an intense history at the Bauhaus in the progression of ways to treat spatial partitions, from wall
painting to wallpaper and even, eventually, to Semper's theory that the original divisions of spaces
inside a house were made of hung textiles, which has its echo in Mies's and Lilly Reich's 1930s interest
in using hanging curtains to create spatial divisions within an open plan. Equally important was the
parallel between the students' and Gropius's own handling of the wood to derive a new abstract lan-
guage of form. Beam ends were notched and carved in crystalline motifs reminiscent of experiments in
the "*Style Sapin*" a few years earlier by Le Corbusier in his native La Chaux-de-Fonds, but probably
more inspired by the underlying geometric abstraction taught by the Dutch architect J. Lauweriks at
the Kunstgewerbeschule Düsseldorf a decade earlier, well-known to Gropius from his work at nearby
Hagen for Peter Behrens.[17] Similar approaches were developed in the elaborately carved teak interior of
the entrance hall (recovered from the officer's mess of a decommissioned warship). The young Bauhaus
journeyman Joost Schmidt worked parquet panels into geometric reliefs (cat. 81), juxtaposing pure
explorations of formal relations in space, using geometric solids such as triangles, hexagrams, and
squares, with representations of the skylines of cities where the Sommerfeld company had business
interests, a type of secular geography reminiscent of medieval carvings of holy cities in cathedral por-
tals. The same use of the crystalline as a path toward abstraction was carried out in stained glass by Josef
Albers, weavings by Dörte Helm, wall paintings by Hinnerk Scheper, and prismatic lighting designed
in the metal workshop. For the entry hall (cat. 80) Breuer designed a table and chairs with members —
radical in that they were rectangular rather than turned on a lathe — that continued the composition
beyond the immediate seating area, a linear extension in space at once evoking the house's construction
and suggesting either an early awareness of the furniture of Gerrit Rietveld or, more likely, a common
inspiration in Wright's early interiors. Made of simply milled elements, Breuer's furniture applied the
exercises in abstract composition taught in the preliminary course to early experiments in the creation
of replicable objects.

 Every Bauhaus workshop but the ceramics shop contributed to the outfitting of the Sommerfeld
House. The program for the *Richtfest*, which Adolf Meyer staged with a bonfire, chorus recitation,
and procession on December 18, 1920, was produced in the printing workshop (cat. 78). Interviewed
in the mid-1960s, Breuer would declare that since his own son wanted to study architecture, he would

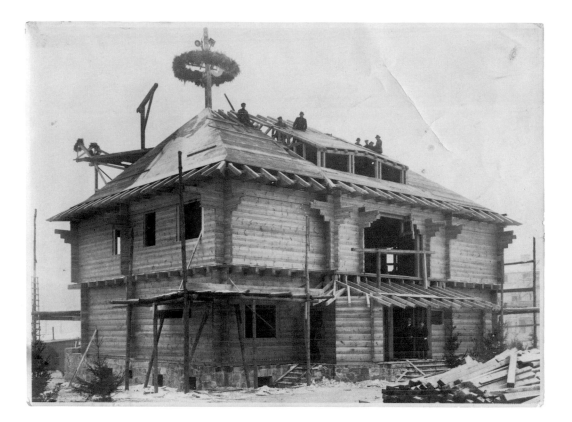

recommend that he first "go work with a carpenter on a building site because a carpenter has a system he can teach."[18]

The development of a replicable house model with the possibility of variants, implicit in the *Blockbauweise Sommerfeld*, appeared in two further experiments in 1921. Forbát recalls in his memoir that when the government minister Walter Rathenau called on Sommerfeld for advice on constructing wooden houses for French war reparations, "There were to be three different types which [Forbát and Gropius] very quickly studied in the Sommerfeld office. With the help of his technical staff they worked on three large-scale types." Forbát was to travel to France with an introduction to the circle around Le Corbusier, whose ideas on houses as machines that might be realized in factories were familiar to Gropius from the pages of *L'Esprit Nouveau*.[19] The housing issue was coalescing as an international common ground, around which Gropius would construct the cultural field for a slowly emerging Bauhaus architecture.

The *Bauhaus-Siedlung*, from Rustic Blockhaus to Cubic Abstraction

Early in 1920, as Gropius was shaping up plans for the Sommerfeld House, he asked both students and masters for designs for a Bauhaus *Siedlung* or communal settlement in the wooded hills outside Weimar. "Today it is impossible for us to think of partial reform without having to take on the totality of life, that is dwelling, children's education, fitness, and still other things," Gropius wrote to Adolf Behne.[20] From the outset the Bauhaus sought to merge its pedagogical program with the reform of daily life, an ideal rooted in Germany's prewar artists' colonies and in particular in Heinrich Tessenow's idea of combining dwellings and workshops as the communal foundations of a new society. Many of the architects associated with the Bauhaus had direct experience of Tessenow's *Handwerkergemeinde* development in Hellerau, outside Dresden, or knew his influential book *Handwerk und Kleinstadt* (Craftwork and small town) of 1919.[21] The ideal took on new resonance in Weimar, though, which had a self-conscious tradition of serving as a *Musterstadt* or model city, a tradition that went back to Goethe and his beloved cubic Garden House a stone's throw from the Bauhaus. In 1923, Georg Muche's Haus am Horn (cat. 23; p. 327, fig. 2), the Bauhaus's first monument to abstraction through architectural design, would be added to the Weimar park landscape within view of Goethe's house, with its famous garden monument juxtaposing cube and sphere.

Despite these Enlightenment precedents, the students planning a *Siedlung* initially reached to other traditions. Walter Determann, having taken the intensive four-week practical training that Gropius had cobbled together at the Baugewerkenschule, drew up a series of naïve but compelling plans, one of which drew clearly on the themes and variations possible in the *Blockbauweise Sommerfeld*. This communal plan was highly ordered, drawing its buildings together in a symbolic crystal, an emblem of transformation, centered on a great communal structure, itself crystalline and an echo of Taut's *Stadtkrone* (cats. 74, 75). Determann's program for a *Haus der Körperbildung* (Physical education building) put the body culture that Itten had introduced in the preliminary course at the core of the community.

22
Walter Gropius and **Adolf Meyer**
Sommerfeld house, Berlin-Steglitz. 1920–21
(destroyed)
Construction site at the time of the *Richtfest*
(the topping-out ceremony, marking the
completion of the structural framework)
Photograph: Plagwitz. December 1920.
Gelatin silver print. 4⅞ x 6⁹/₁₆" (12.4 x 16.7 cm).
Bauhaus-Archiv Berlin

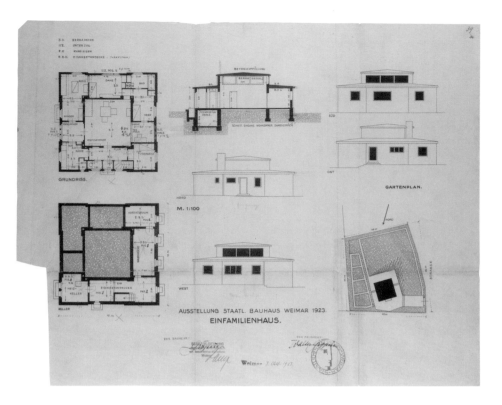

His neo-Baroque style reflected the Expressionist concern with emotive architecture, perhaps even Rudolph Steiner's contemporary Goethenaeum at Dornach in Switzerland. In the years leading up to the Bauhaus exhibition in the summer of 1923, however, this line of research would be limited more and more to the wall-painting workshop, and even here, where the psychological role of color and space was an important theme, it was explored more along lines suggested by painting and weaving than by the sculptural spatial formations of Expressionist architecture. Meanwhile, in the school's architectural explorations, by late 1922 the leitmotif had become the disciplining cube. The influence of geometric abstraction, taught in the preliminary course and by Vasily Kandinsky, gave a new rigor and impetus to the existing practice of square partitioning in the timber *Blockhaus* tradition.

With negotiations underway for a new site for the *Siedlung* — by July the deal had been sealed for land at the edge of the Weimar park *am Horn* — Forbát developed a plan for a community of nineteen single-family houses, thirty-two row houses, and a multiple dwelling for forty bachelors. A key feature of the building system accompanying this plan was a perfectly square living room, lit by a clerestory, to which up to seven cells could be added, progressively internalizing the family's living space as a refuge. Gropius and Forbát would develop this idea into a system dubbed *Wabenbau*, or "beehive construction," featuring a core module and recombinant cubic components. The whole was a central exhibit in models and drawings shown in Gropius's *Ausstellung Internationaler Architekten* (Exhibition of international architects), part of the 1923 Bauhaus exhibition. Several Bauhaus students began to work along parallel lines, and for the first time the Bauhaus had not simply a vague architectural ethos but a line of research.

In April 1922, Bauhaus Siedlung GmbH, a company founded by Gropius, hired Forbát to develop the *Siedlung*, but others worked on it as well, including Farkas Molnár, a young Hungarian who made a perspective drawing revealing a new approach to communal organization. The buildings now centered on a town square demarcated by a great tower, and one building functioned as a bridge across a street to tie different parts of the plan into a whole, as in the unrealized administration building for Sommerfeld and later in Dessau. Using a new cubic language that lent itself both to offsite fabrication through a panelized construction system — a leitmotif of Gropius's approach to prefabrication for the next thirty years[22] — and to flexible floor planning, Molnár's group of buildings edged toward the *Wabenbau* or *Baukasten* (building block; cat. 28) system, presented in model form in the 1923 exhibition. The previous summer Gropius had sought federal funding for the experiment, and Forbát had laid out the philosophy:

The principle for future housing-estate houses was fixed by Gropius: the building parts would be rendered as types, and different compositional elements would be assembled from them. It was actually a matter of creating norms for the formwork for casting concrete. But alongside this technical rationale the architectural advantage of a unified model for the entire housing estate played an equal role.[23]

23
Georg Muche and **Adolf Meyer**
Plans submitted by Gropius for construction permit for the Haus am Horn, Weimar. 1923
Ink and pencil on diazotype
13 ¾ x 26 ¼" (34 x 66.6 cm)
Klassik Stiftung Weimar, Bauhaus-Museum, on long-term loan from the Bauaktenarchiv Weimar

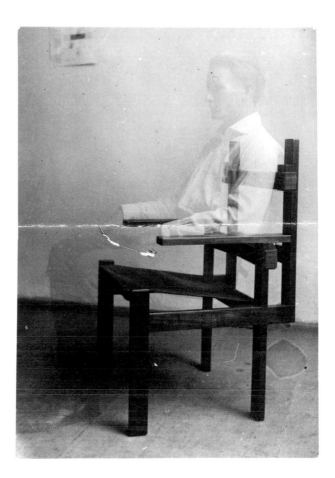

24
Photographer unknown
Untitled (Seated man in Marcel Breuer
armchair later titled TI 1a). n.d.
Gelatin silver print
3⅞ x 2¾" (9.8 x 6.9 cm)
Research Library, The Getty Research
Institute, Los Angeles

Here Gropius's vision of the modern architect as the designer of a system rather than the creator of individual forms reached a crescendo.

That Gropius hoped to revolutionize building from conception to distribution is clear through a pair of images related to Muche's Haus am Horn prototype, built to coincide with the summer exhibition of 1923. One is a photograph of Alma Buscher's toy cabinet for the children's room in the house (cat. 202), the only picture showing people in the Bauhaus albums (an archival record of Bauhaus designs, begun by Gropius in 1922) on furniture. The other depiction of the human figure (cat. 200) is a project for a mural — again, the only figurative image among the many that the wall-painting workshop prepared for the exhibition — that Molnár designed in conjunction with *Der rote Würfel* (The red cube), a radical variant on the Haus am Horn. The conceptual and formal similarities between the *Baukasten* seen in Molnár's mural — prefabricated, standardized parts designed by Gropius to create a variety of houses — and the modifiable box toys that Buscher provided for children to play with while learning (Friedrich Froebel comes to mind) is inescapable. Nearly every element in Gropius's and Buscher's schemes had multiple uses, some planned, others left to the creativity of the architect or child. Among Buscher's toys, a cabinet could become a Punch and Judy stage, and benches could be taken apart to create boxes, a stool and table, or a rolling car. Like the *Vorkurs,* in which the most elemental form could open both compositional and programmatic invention, the *Baukasten,* usable in any number of room types and configurations, and the children's toys opened new horizons of form-making.

In *Der rote Würfel* (cats. 198–200) Molnár worked with the dialogue between geometry and fabrication to create an entire environment, geometric garden included. The "Red Cube" — perhaps, given the sympathy of the Bauhaus Hungarians for the failed Hungarian revolution of 1919, more a political reference than an artistic nod to Kandinsky's *Moscow Red Square* of 1916 — not only defined a new interior space (like the Haus am Horn, with its ring of programmed spaces around a double-height, skylit communal space) but was designed to be prefabricated. Its mural was more radical than Gropius's theories that new settings for domestic life also constituted a fundamental economic and political revolution: depicting a streamlined relationship between *Der Fabrikant* (the fabricator) and *Der Verbraucher* (the consumer), Molnár denounced the "middle-man culture" of modern capitalism. Yet paradoxically he made this argument through a design for the spacious single-family house of a family of considerable means. For all its radical experiments with the complex puzzle of maximizing space in a cube, Molnár's house was quite grand, and its colonnaded pergola in the garden was an abstracted stylization of a villa type frequent in prewar reform architecture like Behrens's Wiegand House (1911–12) in Berlin-Dahlem.

The Haus am Horn itself, or the *Versuchshaus* (Experimental house) as it was also called,[24] concentrated its explorations on new materials and construction procedures rather than on the off-site industrialization of building through prefabrication. Gropius had proposed a demonstration house built of *Baukasten*, and had sought support from the *Reichskunstwart*, the state's artistic advisor, based on an economical new means of building "which would no longer develop the single-family house as a reduced imitation of a villa with correspondingly shrunken rooms."[25] He was disappointed that in an internal competition at the school his project was passed over in favor of Muche's. (Muche, however, a painter who designed his project with Adolf Meyer, was deeply influenced by Gropius's and Forbát's ideas.) Muche created rooms scaled to their functions, and crafted a dialogue between private and communal space eliminating corridors and creating new connections between spaces then usually separated — an axis between the kitchen and the children's room, for example, to allow a servantless mother to supervise children while preparing meals. But the overall vision ran the risk of inviting the accusations of luxury that were to plague the Bauhaus in the coming years, as its greatest chance to realize revenue with its designs depended on a marketplace that over the course of the mid-1920s would increasingly get its steam out of middle-class buying power.

The discourse on prefabricated architecture and the types of furniture that were explored for the Haus am Horn were not always in accord, leading to a whole series of paradoxes setting the stage for debates that would animate the Bauhaus after its move to Dessau. Breuer produced an impressive number of new furniture designs in the months leading up to the 1923 exhibition. Some, such as the so-called "slat chair" (cats. 24, 97), were produced in the workshops in hopes of reaching a market, while others were unique pieces, like an extraordinary woman's vanity with moveable mirror parts. The vanity is one of a number of works that testify to the impact of Constructivist art on the workshops, notably the *Lichtrequisit einer Elektrischen Bühne* (Light prop for an electric stage, 1930; cat. 374), which Moholy began to develop in 1922, and several lamps with moving parts, such as Carl Jucker's extendable electric wall lamp (cat. 26), also exhibited in the 1923 exhibition.[26] Machined parts were increasingly a part of the Bauhaus aesthetic. The issues of unique versus reproducible objects, of utility versus luxury, and of individual artistic signature versus the collective undertaking were here all brought to the fore.

In the furniture for the woman's bed- and dressing room in the Haus am Horn, Breuer exploited different grains of wood and colors to create dynamic tensions between frame and infill, and adapted something of the style of willfully rudimentary connections associated with Rietveld's recent furniture. He too was fascinated by moving parts, and by the changeable compositions produced through sliding panels and articulated joints. The slat furniture not only was visually evocative of the type of geometric abstraction then making its way into Kandinsky's painting, for instance, but also lent itself to the use of precut pieces, opening the way to take the Bauhaus for the first time into serial production. Of the pieces made in 1922–24, the de Stijl–influenced children's furniture (cat. 207) in particular was poised to move in this direction.

25
Marcel Breuer
Design for a woman's bed- and dressing room in the Haus am Horn, Weimar. Axonometric drawing. 1923
As reproduced in *Staatliches Bauhaus in Weimar 1919–1923*. Weimar and Munich: Bauhausverlag, 1923
The Museum of Modern Art, New York
Architecture and Design Study Collection

26
Carl Jacob Jucker
Extendable electric wall lamp, shown in two
positions. 1923
As reproduced in *Staatliches Bauhaus
in Weimar 1919–1923*. Weimar and Munich:
Bauhausverlag, 1923
The Museum of Modern Art Library, New York

Christian Wolsdorff's research has shown that some 250 pieces of Breuer's children's furniture were produced. The Bauhaus workshops had become a place of handcrafted but repetitive serial production — the kind of assembly line that many already saw as the burden of early industrialization, rather than the liberation of the machine called for in Gropius's 1923 programmatic text *"Idee und Aufbau des Staatlichen Bauhauses in Weimar"* (Idea and structure of the state Bauhaus Weimar).[27] In Weimar, production never exceeded the output of the small-scale workshop, a model that had been prevalent in furniture-making for at least two centuries. Even the weaving workshop — the most mechanized of the shops, even if Gropius gendered it by relegating primarily women to the looms — never achieved industrial-scale production. As students often worked to produce the designs of others rather than to develop their own projects, the workshop model that was the core of Bauhaus pedagogy began to reveal rifts between education and production. Products like Josef Hartwig's chess set (1922–24; cats. 168, 169) turned students into tools for filling orders, as though study had been taken over by work-study.

Architecture in the 1923 Exhibition

The 1923 exhibition opened a bifurcation between the Bauhaus as school and the Bauhaus as lynchpin of international publicity. After many delays, the school opened its doors to the public from August 8 to September 30, to account for its first four years. Each workshop organized a display, and the Bauhaus building itself — built in 1904–11 by the Belgian architect Henry Van de Velde — became the showcase for a new ideal of architecture and of architecture-scaled decoration. The wall-painting workshop transformed the staircases, and a director's office was created to provide a first experience of an unprecedented kind of space within a five-meter cube (cat. 20).

Even more than the furnished interiors of the Haus am Horn, the director's office made all of the workshops' products — textiles, graphics, furniture, lighting — integral parts of a radical spatial experiment. Inspired not only by de Stijl extensions of space through linear continuities but also by Wright's technique of weaving one space into another, the office layered both space and spatial perception through line and color, through the suggestion of boundaries and wrapping spaces, and through functional zoning. Here for the first time was a built space with something of the complexity of de Stijl axonometric representations, and also with a complex spatial interpenetration more characteristic of Art Nouveau and even the neo-Baroque that preoccupied German architects around 1900 than of modern architecture since World War I. Ise Gropius noted in a diary entry of February 1926 that Gropius had been looking for a spatial rhythm that could echo Islamic and Gothic architecture, in terms not only of layers of space and screens of transparency but also of the capacity to make space appear light in weight. She noted that only in painting had something of this new spatial imagination emerged.[28] In the catalogue of the 1923 exhibition, Gropius mediated between the nineteenth-century fascination with origins — one thinks again of Semper and Riegl — and modern physics: "The primordial elements of space are: number and movement. Through number alone man distinguishes things, conceptualizes and orders the physical world. It is first through divisibility that

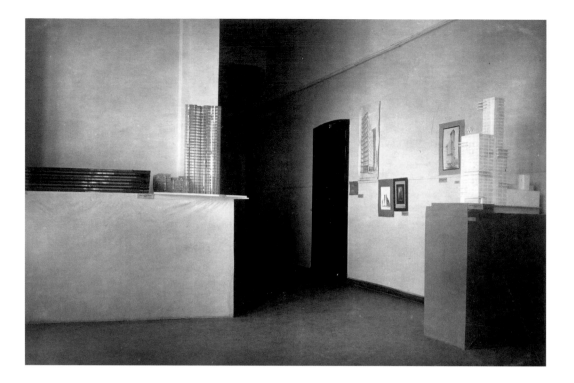

27
Walter Gropius
Ausstellung Internationaler Architekten
(Exhibition of international architects),
Bauhaus, Weimar. Summer 1923
Left: Mies van der Rohe's Glass Skyscraper
(1923) and Concrete Office Building (1923);
right: Gropius's Chicago Tribune Tower (1922)
Photograph: photographer unknown. 1923.
Gelatin silver print. 6¾ x 4¾" (17.2 x 12 cm).
Bauhaus-Universität Weimar, Archiv
der Moderne

the thing separates itself from primordial matter and achieves its own form."[29] But he went on to deal with the relationship between physical and perceptual space.

The exhibition's book, designed by Moholy with a cover by Herbert Bayer (cat. 196), was one of the school's first publishing projects, announcing the intention to create printed media that would circulate a Bauhaus aesthetic. All of the workshops were represented in it, and many of the works illustrated were integral parts of Gropius's and Meyer's architectural commissions — Albers's multi-colored glass window of 1923 for the Otte House, Berlin, for example, its abstraction and color harmonies comparable only to Wright's recent glass work. Theodore Bogler's plaster models of a teapot formed of factory-made elements combinable in at least four different variants (cats. 112–14) was a remarkable parallel to the *Baukasten*, suggesting that more than one workshop was moving toward the idea of the designer as the inventor of a system rather than of individual objects.[30]

The director's office appeared twice in the exhibition, once as a real space on view, and again in a colorful axonometric projection shown in the *Internationale Architekten* section, organized by Gropius to demonstrate the international emergence of a new, abstract sensibility in building. Here, models of *Baukasten*-built structures, presented as products of the "Bauhaus architecture workshop," were exhibited under a bird's-eye view by Molnár of his projected *Bauhaus-Siedlung* and in parallel with *Der rote Würfel*. The rest of the work, though — unlike any other part of the 1923 exhibition, which showcased the school's production down to the design of the display cases — was a carefully selected array of international contemporary architecture.

Axonometric projections figured repeatedly in the architecture section, including parts of the Haus am Horn, notably Breuer's integration of furniture and space in the woman's bedroom (cat. 25). As practiced at the Bauhaus, this then new mode of architectural drawing was partly inspired by the planar representations of space brought to Weimar by Van Doesburg, but was treated with an x-ray transparency closer in spirit to Moholy-Nagy's spatial experiments in painting and photography, which introduced a new quest for transparent spatial layering in both architecture and design. In 1922, defining one of his principle aims in Constructivism as a quest for a new mode of vision, Moholy had written, "Constructivism is neither proletarian nor capitalistic... It expresses the pure form of nature — the direct color, spatial rhythm, the equilibrium of form. It is not confined to the picture-frame and pedestal. It expands into industry and architecture, into objects and relationships. Constructivism is the socialism of vision."[31] In the catalogue, architecture appeared as a coherent body of Bauhaus work in dialogue with the other workshops; but in the exhibition, visitors saw Bauhaus work as an integral part of an emerging European architectural avant-garde. This presentation was the first evidence of Gropius's genius at using his position as director of an unorthodox art school to serve as a leading polemicist for modern architecture.

Some thirty architects, from Czechoslovakia, Denmark, France, Germany, Holland, Hungary, and the United States, provided images for Gropius's show, including Wright, his important influence, and Le Corbusier, his newest rival, from whom the Bauhaus had adopted the idea of the *Wohnmaschine* or "machine for living." The Germans included Taut, Mies, and Erich Mendelsohn, while Hugo Häring and

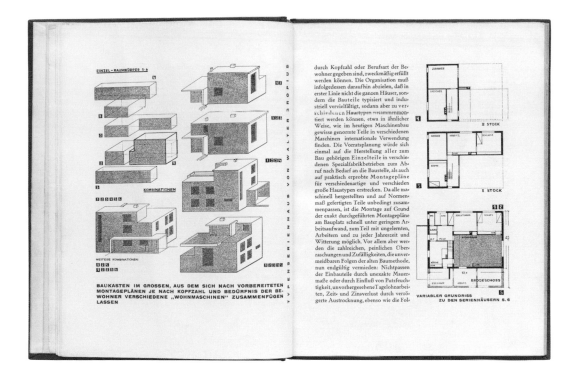

Hans Scharoun were absent — Gropius was culling his own Expressionist past. Recent projects by Gropius and Meyer — the Auerbach House and the municipal theater, both in Jena — were juxtaposed with the work of contemporaries. Mies's proposal for an office building with an integral reinforced-concrete frame was juxtaposed with Gropius's entry to the Chicago Tribune Tower competition of 1922 (cat. 27). Architects making the pilgrimage to Weimar for "Bauhaus Week" in mid-August included J. J. P. Oud, whose lecture on modern Dutch architecture was attended by Mendelsohn, Mies, and Taut.

The display was in many ways a sketch for Gropius's forthcoming book *Internationale Architektur*, the first of the *Bauhausbücher* series. Planned for the summer of 1924, the book was delayed by the impending move to Dessau and appeared only in 1925. After describing the ongoing revolution in architectural and industrial design, Gropius ended the book by explaining the concept of "international" as the shared fundamentals of all architecture: precisely determined form, simplicity in multiplicity, composition according to each building's function, the plan of streets and transportation, and developing the most diverse solutions by limiting the palette to typical basic forms.

Building in Dessau

By the time *Internationale Architektur* went into its second edition, in 1927, the Bauhaus had moved to Dessau and its architecture had gone through a sea change: the edition appeared in time to celebrate the opening of the school's first sustained architecture department, led by the Swiss architect Hannes Meyer. As in the first edition, the plates were arranged to narrate the development of modern architecture, from prewar icons such as Behrens's famous Turbine Hall for the AEG, through a juxtaposition of Van de Velde's theater and Gropius's model-factory buildings at the 1914 Werkbund exhibition in Cologne, to Gropius's Fagus factory at Alfeld, which had also featured in the 1923 exhibition. The line of development from the figures clustered around the Werkbund before the war to the emergence of a Bauhaus architectural spirit, a progression soon to be formulated in early histories of modern architecture by the young American historian Henry-Russell Hitchcock and the German émigré Nikolaus Pevsner, was already being crafted.

The first edition of the book had gone to press late enough to set Gropius's first design for the Bauhaus Masters' Houses in juxtaposition with new housing developments in the Netherlands, revealing a powerful future influence on Gropius's development in the later 1920s. In the second edition the plate sequence was adjusted and substitutions made so that the opening set of images of modern factories led to a spread juxtaposing an aerial view of Gropius's new Bauhaus building in Dessau (aerial photography was a specialty of a local industry, the Junkers aircraft company) with an axonometric projection of Meyer's and Hans Wittwer's entry in the 1927 competition for the League of Nations building in Geneva (cat. 30). Both the buildings and the representations of them are modern: the material palette is concrete, iron, and glass, and the elevated, airborne viewpoints of both photograph and axonometric rendering abstract the structures they show.

Gropius's new Bauhaus building was a veritable demonstration of the call for an architecture born of functional analysis. Unified in the aerial view, its parts are experienced on the ground as

28
Walter Gropius
Baukasten (modular prefabricated building system). 1923
As reproduced in Adolf Meyer, *Ein Versuchshaus des Bauhauses in Weimar. Haus am Horn* (An experimental house by the Bauhaus in Weimar: Haus am Horn). *Bauhausbücher* 3. Munich: Albert Langen Verlag, 1925
Bauhaus-Archiv Berlin

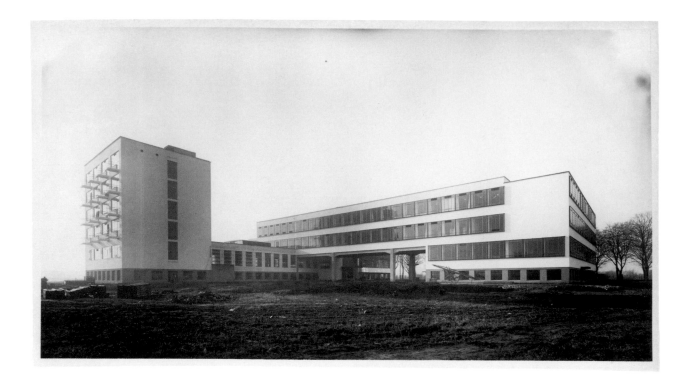

a myriad changing effects of transparency and reflection, of continual realignments quite unlike any of Gropius's previous compositions, with their lingering classical organization. Each part is clearly demarcated in a spiraling composition (cat. 29). Asymmetrical wings house what were originally intended to be two institutions: the Städtische Kunstgewerbe- und Handwerkerschule (a Dessau trades school that ultimately never moved in) in a taciturn earthbound box and the Staatliche Bauhaus itself behind a dramatically cantilevered curtain wall, a realization of the sheer walls of shimmering glass that Mies had projected for the Friedrichstrasse Skyscraper competition in 1921. The curtain wall was a vitrine for Gropius's most original achievement, a training in which the workshop became a laboratory — the metaphor was born at Dessau — for a new type of artistic practice. This was nowhere truer than in the connector from the workshop block to the five-story housing block, which anchored the composition and held the auditorium, where Bauhaus theater would flourish, and the cafeteria, both with their moveable partitions.

In Dessau the teaching was rethought: the print workshop became the typography workshop, and advertising, the modern medium of communication par excellence, became a prime aim of many Bauhaus practices. Wall painting would be developed with a mind to spatial orientation, the building itself serving as a laboratory for the use of color in both pragmatic and psychological orientation (cat. 233). Breuer visited the Junkers factory and took inspiration from its use of tubular steel, which he used to make furniture and which he and others at the Bauhaus hoped to apply to the production of prefabricated housing. Within a year, Marianne Brandt and William Wagenfeld were working with the Kandem lighting company to market Bauhaus lamps, one of many realignments of the school's production as a collaboration with an outside company rather than the process of an internal workshop. The Bauhaus Masters' Houses became laboratories for the new experiments in a total domestic setting (cat. 241).

The Paradoxes of Mechanical Reproduction

The Bauhaus had become an institute of design, a laboratory for *Gestaltung* ("form-giving"), rather than an amalgam of an arts school and a crafts school. "The time of manifestos for *das neue Bauen* is past. It is high time to enter into the study of practical reckoning and exact evaluation of practical experiments," Gropius declared in 1927, in the second issue of *bauhaus*.[32] The key image here is the famous graphic for "*ein bauhaus-film*" (cat. 96) that Breuer produced for the magazine in 1926, just after returning from Paris, where he had seen the work of Le Corbusier and had no doubt encountered that architect's fascination with the Thonet chair, the world's first mass-produced piece of furniture. His "poster" raises key issues with wry humor and an almost willful innocence of the complications of signature, ownership, and rights that were about to jostle the Bauhaus.

The conceit is a poster for a film that would have exceeded even an Andy Warhol movie in duration, since it is meant to last five years. With no transitions, no fade-ins or fade-outs, the "film" — a strip of celluloid showing a chronological sequence of Bauhaus chairs — encapsulates great shifts in the school, not only stylistically but in attitudes toward individual creativity, prototypical consumption,

29
Walter Gropius
Bauhaus building, Dessau. 1925–26
Northeast view
Photograph: Lucia Moholy. 1926. Gelatin silver print. 4 15/16 x 8 7/8" (12.5 x 22.5).
Bauhaus-Archiv Berlin

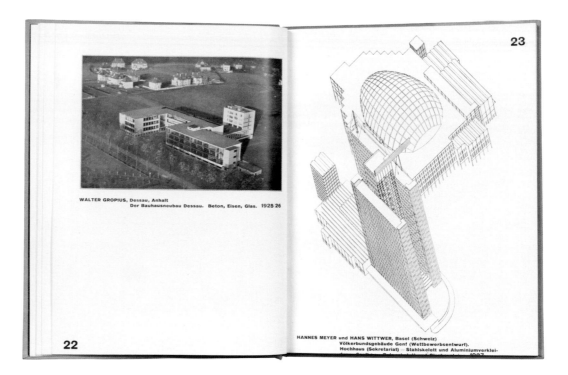

and serial implementation. A neo-Darwinian vision of Bauhaus history as a progressive evolution toward perfection of the species, it glosses over conflict, paradox, and the confused relationship of the workshops to factory production. The first image, captioned "1921," is Breuer's "African" chair (cat. 95), handcrafted down to Stölzl's hand-loomed textile back and seat. By "1921 ½" the form of both chair and upholstery have been rationalized; Breuer is moving toward the distinction between frame and infill that was to be a shared characteristic of Bauhaus tubular-steel, serially produced furniture, of wooden furniture notably by Albers (cats. 274, 275), and of prototypes for a panelized, factory-produced architecture (cat. 28). The film strip has no image for 1922, but this is the year, the Bauhaus albums tell us,[33] when Breuer made the first slat chair, which was being produced in multiples by the end of the year. The first paradox or tension in Gropius's idea of training designers for industry was already becoming apparent, since the students would need to work on the production of serial objects to meet demand.[34]

Did Breuer really not see the crisis in the making? His children's furniture had been among the first Bauhaus products to find a market, but the school's development of uses for tubular steel was to bring with it a whole new range of problems: questions of artists' rights, profits, originality, and authorship would all be activated, along with the nexus of the law, the market, and the Bauhaus's ability to provide for a mass audience, subject to the emergent psychology of the brand, rather than to produce luxury goods. Gropius was continually looking for ways to move production out of the Bauhaus to outside manufacturers, a move entailing a shift toward the idea of the design consultant — a radically new role for the artist in the market economy — and this despite his preference for hands-on training.

"A Bauhaus film lasting five years. Author: Life demanding its rights." With the poster's first two lines of text we are firmly in the world of the material, practical Bauhaus, where the notion that function dictates form is triumphant.[35] But in the next line the idea of rights moves from political discourse to the legal language of artistic property: "Cameraman: Marcel Breuer, who recognizes these rights." Breuer assumed the polemical stance that his were merely the designing mind and hands that channeled the demands of the modern subject, as though he were acting as the medium for the Bauhaus's project. Yet within a year and a half, he had developed a whole line of tubular-steel furniture under his own signature. He further made many of his pieces for the Bauhaus building and the Masters' Houses not in the workshop but in his own studio; if he was following an aesthetic of the assembly line, there is no evidence of it. Thanks to a photograph that Lucia Moholy published in a Dessau newspaper, he received merchandising inquiries even before the first furniture was produced.[36] A crisis arose when he refused to surrender artistic property to the Bauhaus or to turn over anticipated profits. Years later, interviewed by Christopher Wilk, Breuer retorted that even though in intervening decades tubular steel had become the very epitome of the Bauhaus for the broad public, "The [club] chair [cat. 302] was not a Bauhaus product in the sense that a painting by Paul Klee was not a Bauhaus product. [Klee's painting] was done on his own time and with his own money in his own workshop (not work for hire we would say).... To that extent it was not a Bauhaus product."[37]

30
Walter Gropius
Internationale Architektur (International architecture). *Bauhausbücher* 1 (second ed.)
Munich: Albert Langen Verlag, 1927
Spread showing Gropius's Bauhaus building, Dessau, 1925–1926 (left), and Hannes Meyer and Hans Wittwer's competition entry for the League of Nations, Geneva, 1927 (right)
The Museum of Modern Art Library, New York

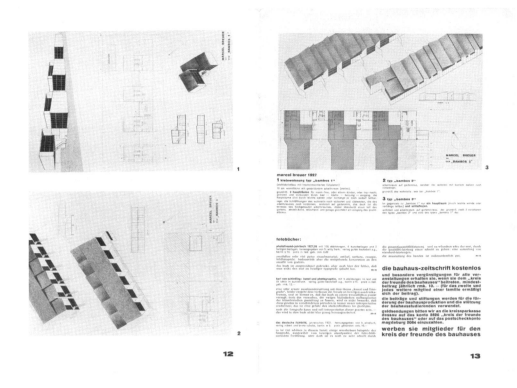

Despite Gropius's hope that Bauhaus products would remain the school's property, on September 12, 1926, Breuer registered seven furniture designs, all of tubular steel.[38] Soon Breuer and another Hungarian architect, Kalman Lengyel, had established a company, Standard Möbel, to market them; Lengyel dealt not with the Bauhaus corporation but directly with Breuer. In February 1926, Ise Gropius had noted in her diary, "Despite his youth, [Breuer] is really the only one who understands what it means to run this Bauhaus,"[39] but later her reaction to his business deal was dismay:

> A very unpleasant event with Breuer. He has made a deal about his metal chairs with a Berlin friend without telling anybody and that will now lead to great difficulties in the negotiations . . . about a Bauhaus GmbH [a limited company, which would be established in 1926 to license the manufacture of Bauhaus products, creating income for the school]. . . . now during the final negotiations one of the most important pieces of the enterprise has been removed.[40]

Standard Möbel's first catalogue was designed by the Bauhaus master Bayer and printed on the Bauhaus printing press (cat. 303). It featured eight designs, all by Breuer, including four new models. In 1928, the company printed a large foldout brochure, *Das neue Möbel* (cat. 300), advertising the "Breuer tubular steel system," a perfect embodiment of Gropius's image of the designer as the maker not of individual objects but of a modern vocabulary. Breuer was struggling to marry functionalism with the search for signature:

> Tubular steel furniture with fabric seatback and armrests is as comfortable as well-upholstered furniture without having its weight, price unwieldiness, and unsanitary quality. One type has been worked out for each of the required kinds of uses and improved to the point where no other variation was possible. . . . due to its durability and sanitary quality Breuer metal furniture is approximately 200 percent more economical in use than ordinary chairs.[41]

In a rare theoretical statement of 1928, "*Metallmöbel und moderne Räumlichkeit*" (Metal furniture and modern spaciousness), Breuer promoted his furniture as "Breuer" work yet also argued for an essentially "styleless" furniture that would, as in Le Corbusier's notion of typological evolution, be utterly the product of purpose and constructive necessity. The new living space was to be a self-portrait of neither architect nor occupants, Breuer wrote; rather, it was to be flexible, "since the outside world today subjects us to the most intense and various impressions, we change our ways of life faster than in former times, and it is now only natural that our environment should be subject to corresponding changes. And so we are brought to furnishings, spaces, and buildings that are alterable, mobile, and variously combinable in as many of their parts as possible."[42] Breuer saw no contradiction in advocating

31
Marcel Breuer
Project for prefabricated houses ("Bambos") for five Bauhaus "young masters," with Walter Gropius as overseer of construction. 1927
As reproduced in *bauhaus: zeitschrift für gestaltung* 2, no. 1 (February 15, 1928)
Bauhaus-Archiv Berlin

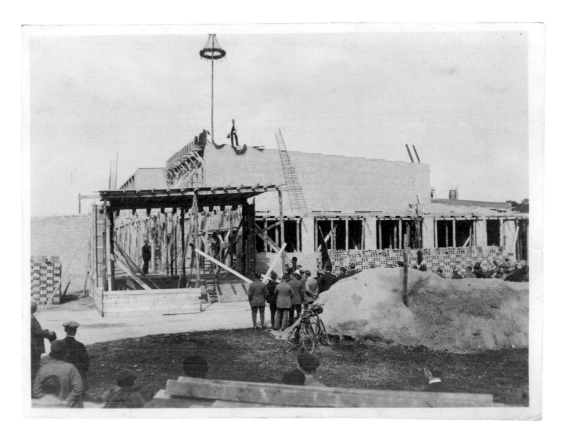

stylistic anonymity while claiming authorship rights. Yet his signature eventually traveled so far from his workshop that he found he ran the risk of being denied rights to his own designs, at the same time that he found himself embroiled in an authorship controversy with Mart Stam, and eventually Mies, over the origins of cantilevered steel furniture.[43]

No less problematic were attempts to take the *Baukasten* and other prefabrication prototypes into production. In proposals of 1927 for small metal houses that he hoped could serve in a *Siedlung* for the "young masters" Bayer, Albers, Hannes Meyer, Marcel Breuer, Otto Meyer-Ottens, and Schmidt (hence the name "Bambos" for these buildings; cat. 31), Breuer had continued the theme of the freestanding cube. He sought to demonstrate that much of the spatial complexity, the combination of single and double-height spaces, and the different solar orientations that had determined Gropius's houses for the established masters might also be achieved in prefabricated metal structures. The proposal went unrealized, but Muche and Richard Paulick did produce a far more rudimentary design, an all-steel experimental house built on the edge of Gropius's Törten housing estate in Dessau. (The director's experiments in concrete at Törten experienced such cost escalations that they contributed to his ultimate resignation.)[44] Tellingly the Steel House was presented in the second issue of *bauhaus* through the conceit of another film-strip montage, Breuer's film strip "poster" on Bauhaus chairs having appeared in the first. Assembly was replacing composition as a fabrication ideal.

Yet offsite factory production remained a dream. The Junkers aircraft company's housing research division created full-scale prototypes of houses, but the Bauhaus either imagined collaborations with industry on paper or through handmade versions of possible metal and concrete factory systems.[45] Even Gropius's sixty units at Törten (cats. 310–14), approved by the Dessau city council in June 1926, had more to do with the Taylorization of the building site than with prefabrication. Concrete blocks, slabs, and beams were produced onsite and the row houses were built assembly-line fashion. Gropius saw this as an effective way of reducing costs and accelerating production; but the system could only work for multiple buildings on a single site, and did not free the construction process from the short building season in northern Europe. Only with Mies's invitation later that year to participate in the Werkbund's housing exhibition at the Weissenhof in Stuttgart could Gropius master the financial and technical means to realize a prototype of a replicable prefabricated house. There, as Richard Pommer and Chris Otto write, he honed his very definition of the modern architect: "Research institutes would be necessary to bring about 'the systematic preparation for the rationalized housing construction.' This research would be undertaken by a team of architect, engineer, and businessman. The house would be understood as the formal organization of life's processes, and the architect as the person who would integrate its scientific, social, technical, and economic factors."[46] This sounds precisely like the program Hannes Meyer was able to realize at the Bauhaus after 1928, even if Gropius would later claim that Meyer's architectural and political orientation had surprised him.

32
Hannes Meyer and **Hans Wittwer**
Bundesschule des Allgemeinen Deutschen Gewerkschaftsbundes (Federal school of the German trade union federation), Bernau. 1928–30
Topping-out ceremony marking the completion of the structural framework, May 16, 1929.
Photograph: photographer unknown.
Gelatin silver print. 3 7/16 x 4 1/2" (8.7 x 11.5 cm).
Bauhaus-Archiv Berlin

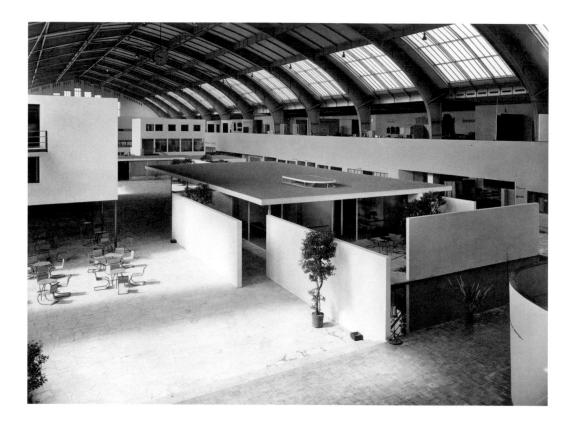

Meyer's Bauhaus, 1928–30

Under Meyer, students turned their attention to designing furniture along the methods that Breuer had explored in 1923–24, in standardized sizes, using standardized, easily milled lengths of affordable wood, to be serially produced in large numbers. These designs were used, for instance, to outfit Meyer's and Wittwer's Bundesschule des Allgemeinen Deutschen Gewerkschaftsbundes (ADGB) in Bernau (1928–30; cats. 32, 345–50). Meyer also based architecture on a search for scientific objectivity far surpassing Gropius's explorations at Stuttgart. By the end of 1928, he had begun to formulate a sharp critique of Gropius's Bauhaus, even if the ensuing, sudden departure of students and masters — notably Breuer, Bayer, and Moholy in Gropius's wake — left the school in turmoil. Meyer did change the tone, but retained more continuity with Gropius's professed ideals than is sometimes imagined. Even if Klee set the tone on the first spread of Meyer's prospectus *junge menschen kommt ans bauhaus!* (young people come to the bauhaus!, 1929), he did so through a construction metaphor: "We construct and keep on constructing; yet intuition is still a good thing."[47] Meyer made it explicit: "The purpose of the Bauhaus is: 1. the thorough spiritual, craft and technical training in full of creatively gifted people for the work of giving form, especially in building."[48]

The faculty had taken a turn toward a more technical basis for architecture, with "technical" understood as involving not merely experiments with new materials and techniques but also a scientific understanding of the human subject, of the psychological as well as physical needs of buildings' occupants. New instructors included the engineer Friedrich Engemann in technical drawing and the architects Anton Brenner in structures, Ludwig Hilberseimer as director of *Baulehre* (which included issues of urbanism), Wilhelm Müller in building materials, and the Dutch modernist Mart Stam, whom Gropius had tried earlier to attract to the Bauhaus, as guest professor for city planning and elementary building construction. Of these only Hilberseimer would make a real imprint on the students' designs, but the shift toward greater architectural emphasis in the school's curriculum was well underway. The *grosse Bau* was no longer a figure but a practical focus.

Included among many photographs of Gropius's Dessau Bauhaus building in *bauhaus* were two views of the project that was to serve as its mirror image, and the focus of Meyer's first eighteen months as director: the ADGB school in Bernau. One of these was a photograph by Walter Peterhans — who would bring photography to the Bauhaus curriculum in 1929 — celebrating the humble, hollow, yellow bricks that made up the new building's *Sachliche* (objective) aesthetic, quite different in ethos from Gropius's Bauhaus buildings in Dessau (although with echoes of his independent Dessau Employment Agency of 1927–29). Meyer and Wittwer were nearly finished with their competition entry for the ADGB when Meyer took the helm at the Bauhaus, on April 1, 1928. Three weeks later their project was chosen over those of Max Berg, Mendelsohn, Max Taut, and other representatives of *Neues Bauen*, and Meyer began to craft the commission as a project for the Bauhaus. To fill the space left behind by the departure of Gropius's office for Berlin, he had set up no private architectural practice of

33
Mies van der Rohe
Die Wohnung unserer Zeit (The dwelling of our time), section of the *Deutsche Bauausstellung Berlin* (German building exhibition Berlin). 1931
Foreground: Mies's Exhibition House.
The one-story building behind it is Lilly Reich's Ground Floor House
Photograph: photographer unknown. 1931.
Gelatin silver print. 6⅝ x 9⅛" (16.8 x 23.2 cm).
The Museum of Modern Art, New York. Mies van der Rohe Archive, gift of the architect

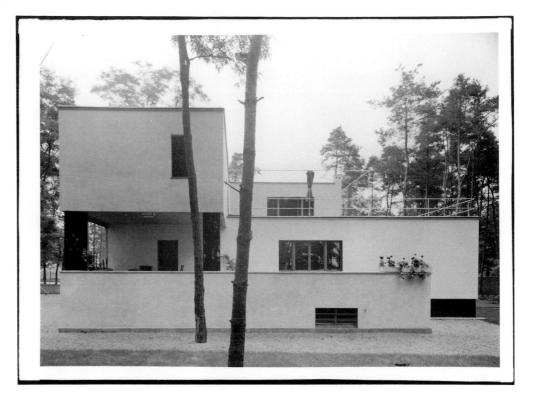

his own in the school, and his hope that through the ADGB project its architecture department would move beyond theoretical discussions to workshop-based practice involved a reappraisal of the architectural office that even Gropius had not fully forged.[49] Meyer was thus able to turn his manifesto *Bauen* (Building), and his publication of a new, scientifically ordered curriculum, into a concrete demonstration.[50]

Meyer's notion of functionalist architecture ranged from the mechanical systems of the ADGB school — the ventilation devised for the bedrooms, for example, and the plumbing of the communal kitchens — to analyses of the biological needs of the occupants. Behne, who had spent years teaching design in working class programs in Berlin, celebrated the fact that the architectural building and the programmatic building here were one. Unlike Gropius in his *Baukasten* scheme, or even in his more recent housing in Törten, Meyer based his plan on human activities, working upward from the students' two-occupant rooms to larger clusters that broke down the school's population into a system of circles or groups, according to a theory worked out by Johann Heinrich Pestalozzi and Victor Aimé in the nineteenth century and given new political impetus by Vladimir Lenin's enthusiasm for it in Russia after 1917. For Meyer, the ADGB building was a construction of both space and social relations, an object lesson in the new, analytical approach to architecture that he was promoting at the Bauhaus. It was also a field of action for his students: the desire for an unpretentious, transformable suite of wooden furniture that could adjust to programmatic and body needs, for example, carried the research into the furniture-making workshop, which set out to equip a *Volkswohnung* or "people's apartment" (cats. 36, 37) a project also related to a commission Meyer had received for an extension to Gropius's Törten housing estate (cats. 352, 353). And among the most innovative aspects of the outfitting of the ADGB was Anni Albers's development of acoustically performative textiles for the auditorium, applying her formal research into pattern and her technical research into different types of synthetic fiber. The themes of Gropius's Bauhaus were systematically being reappraised and reapplied.

The Bauhaus began to forge more profitable commercial links as the Kandem company proved its pragmatic lamp designs (cats. 391–95) commercially viable — lamps that Meyer in turn would use in projects — and Bauhaus wallpapers (cats. 409, 410), manufactured and marketed through Gebrüder Rasch, began to earn income for the school. A poster celebrated the wallpapers as materials used by the best modern architects (cat. 244), allowing even the wall-painting workshop to embrace an ideal of marketing and to disperse a Bauhaus aesthetic through a medium that most modernists had coded as retrograde.

With Hilberseimer's instruction, the matrix of architectural thought shifted from the construction of individual buildings to row houses and the laying out of districts (cat. 445), along with schools and other buildings of urgent social need. Meyer had already returned to the idea of Dessau as a "*Musterstadt*" or model city, making the sociological and topographical study of the city in teams, or cells, of students the foundations of a collective research exercise, preliminary to any architectural

34
Walter Gropius
Bauhaus Master Houses, Dessau. 1925–26
South view of the director's house
Photograph: Lucia Moholy. 1926. Gelatin
silver print. 7 1/8 x 9 3/8" (18.1 x 23.8 cm).
Bauhaus-Archiv Berlin

35
Herbert Bayer
"*Section allemande*," organized by the
Deutscher Werkbund, of the *Exposition de la
société des artistes décorateurs*, Paris. 1930
Photograph: photographer unknown. 1930.
Gelatin silver print. 24 3/8 x 34 1/4" (62 x 87 cm).
Herbert Bayer Collection and Archive,
Denver Art Museum

design. By 1930, however, this reorganization of the school on the analogy of the communist cell, and Meyer's tacit encouragement of the more politically engaged students, had led to friction with Dessau's increasingly right-wing municipal government. A year after Meyer laid out a new sociological basis for all artistic activity — "Building and design are for us one and the same, and they are a social process. As a 'university of design' the Dessau Bauhaus is not an artistic but a social phenomenon"[51] — the political climate had become too tense to tolerate the shades of socialism and communism that had refocused much of the Bauhaus's creativity. In 1930, Dessau Mayor Fritz Hesse, who had helped to facilitate the school's arrival only four years earlier, found himself unable to support Meyer, and the school's second director was effectively purged.

Mies's Bauhaus, 1930–33

Meyer's two years of leadership would later be characterized as marking the great break with Gropius's founding impulse, but it was in fact Mies — whose Bauhaus is the least studied and understood — who effected the most radical changes, partly out of artistic conviction, partly out of pragmatism after the economic crash of 1929. As director, Mies turned the focus away from the preliminary course — optional after 1930 — and the workshops, the building blocks of Gropius's radical curriculum. "I don't want marmalade, not a workshop with a school, but a school alone," he is reputed to have said upon taking over both the Bauhaus and the architecture department.[52] By 1930 a full third of the 170 students declared architecture as their prime interest.

All accounts underscore the conventionally academic nature of Mies's Bauhaus — he insisted on written examinations, for example, which had never before even been considered in the school — but his institution of the ideal of "interior architecture" for the first time made space, rather than structure or program, the focus of training. In 1931, Mies and Lilly Reich, who began teaching at the Bauhaus early in 1932, developed the idea of a domestic zone in which interior and exterior were entirely created from freestanding perimeter walls of masonry, with planes of floor-to-ceiling glass demarcating the passage from interior living space to internalized garden space. This was the aesthetic premiered in Mies and Reich's twinned single-story houses at the *Deutsche Bauausstellung Berlin* in 1931 (cats. 18, 33). Interior spatial divisions were composed of a variety of materials, from movable fabric drapes to wooden screens, often characterized by vibrantly colored and patterned veneers. Semper's theory of transformation (*Stoffwechsel*) implicitly returned, as the work of the wall-painting workshop was transferred to weaving, which by the 1930s had traveled from a stress on its affinities with painting in the school's early years to a new role as a fundamental building block of architectural space. In 1932, Reich took over the weaving workshop from Stölzl and, soon after, the *Ausbau* (interior finishings) department from Alfred Arndt. Mies and Reich experimented in exhibition design, notably for the Berlin *Bauausstellung* of 1931, working more architecturally than Bayer had in his earlier

36
Hannes Meyer
Bauhaus Dessau exhibition, installed at
the Gewerbemuseum Basel. 1929
Photograph: photographer unknown. 1929.
Gelatin silver print. 3 9/16 x 4 3/4" (9 x 12 cm).
Bauhaus-Archiv Berlin

pioneering of the subject. Mies began to teach architectural drawing, long the foundation of academic architectural training, and drawing replaced Gropius's ideal of making and fabrication. It was Mies more than Meyer who dismantled Gropius's ideal. Taking over the director's house (cat. 34), in which Meyer had lived without changes, Mies remodeled Gropius's space, equipping it with milky translucent walls and cladding great picture windows with floor-to-ceiling drapes. In the garden wall that Gropius had built around this prominent corner site, Mies punched a window and added a ledge to create a refreshment stand (*Trinkhalle*) on the path from the Bauhaus toward the students' favorite outing spot on the banks of the Elbe. The wall became a fluid barrier between domestic and commercial, private and public.[53]

The idea of the great architect replaced that of the *grosse Bau*. As the culminating projects of their studies, the architecture students were primarily given the very building types that Mies was working on himself — notably the court house, a perfect framework for training students to deal with the multidimensional spatial and experiential effects that could be derived within the boundaries shared by a garden wall and a large sheet of drafting paper (cats. 435–39).[54] (This model would be the building block for Mies's experiments in domestic design for the next decade.) Mies presided twice over the Bauhaus's closure, once in Dessau and six months later in Berlin. It is not surprising that he retreated the following summer to the North Italian Alps, to work with a small group of students on a set of architectural types that combined for him the tectonic and the philosophical bases of the modern dwelling. The interior qualities of the Bauhaus projects he assigned have long survived the Nazi denigration of the Bauhaus and its artists.

Bauhaus Multiplied

It is often said that the dispersal of the Bauhaus led to its multiplication, as émigrés sought to recover their own visions of their radical institution in new settings. In fact, by the time Mies set out to stabilize the school's explosive political situation in 1930, the meaning of the term "Bauhaus" was already hotly disputed. Gropius never stopped crafting his version of history. Throughout Meyer's short tenure he continued, even intensified, his advertising of the work he had begun, first in 1930 in *Bauhausbauten Dessau* (Bauhaus building Dessau; cat. 254), a *Bauhausbücher*-series volume on the school's transformation of the architectural face of its second hometown. That same year, working with Breuer and Bayer, Gropius staged an essentially "Bauhaus" presentation of modern German design in the Werkbund exhibition in Paris's Grand Palais (cat. 35). Even as the show's tubular-steel furniture, which had reached its apogee in 1928, was capturing the attention of the French press, Meyer was presenting a traveling exhibition — five installations over two years throughout Germany and Switzerland — of the *Volkswohnung*, with its practical no-nonsense furnishings (cats. 36, 37). He would further retaliate in Moscow in 1931, staging an exhibition of his years at the Bauhaus. As it was described in the catalogue, Meyer's

vision of those years had slid firmly leftward: "The Bauhaus exhibition is of exceptional interest for us. On the one hand it is a response to the Bauhaus's final period of development, and on the other it reflects the various movements and contradictions of art in capitalist Germany, leading up to the new awakening of the foundational elements of a proletarian art, which has come into being in irreconcilable opposition to the reigning bourgeois ideology."[55]

By the time the Bauhaus closed its doors in Berlin, in April 1933, its multiple myths were already in gestation and the tendency to subsume much of the European architectural and design avant-garde under a Bauhaus umbrella was already underway, setting in motion a complex reception history in which the signifier "Bauhaus" has only grown in the popular imagination as synonymous with "modernism." The influential artist and critic Walter Dexel, in one of his final essays, "*Der Bauhausstil — ein Mythos*" (Bauhaus style — a myth), written in 1964, uttered a complaint that has been repeated often since, generally to no avail, to judge by such popular diatribes as Tom Wolfe's widely read 1981 book *From Bauhaus to Our House*: "In my opinion it is not the case that the Bauhaus in its time crafted the ideas that we today so easily call Bauhaus style. Today that phrase is used incorrectly to characterize everything that happened in the 1920s."[56] But Dexel was too much of a purist; making and myth-making had gone hand in hand at the Bauhaus in all of its phases, long before Gropius at Harvard, Mies at the Illinois Institute of Technology, Moholy at the New Bauhaus in Chicago, and Albers at Black Mountain College declared themselves and their schools its legitimate successor.

37
Hannes Meyer
Die Volkswohnung (The people's apartment)
exhibition, installed at the Grassi Museum,
Leipzig. September 1929
Photograph: Walter Peterhans. 1929.
Gelatin silver print, 6 x 8 3/8" (15.3 x 21.3 cm)
Bauhaus-Archiv Berlin

1. Ernst Kállai, "Ten Years of Bauhaus," *Die Weltbühne*, no. 21 (January 1930), trans. in Hans Maria Wingler, *The Bauhaus: Weimar, Dessau, Berlin, Chicago* (Cambridge, Mass.: The MIT Press, 1969), p. 161.

2. Walter Gropius, *Programm des Staatlichen Bauhauses in Weimar* (Weimar: Staatliches Bauhaus Weimar, April 1919). Quoted from ibid., p. 31.

3. See Frederic J. Schwartz, "Utopia for Sale: The Bauhaus and Weimar Germany's Consumer Culture," in Kathleen James-Chakraborty, *Bauhaus Culture: From Weimar to the Cold War* (Minneapolis: University of Minnesota Press, 2006), pp. 115–38.

4. Hannes Meyer, 'bauhaus und gesellschaft,' *bauhaus* 3, no. 1 (1929):2. Repr. in Meyer, *Bauen und Gesellschaft: Schriften, Briefe, Projekte* (Dresden: VEB Verlag der Kunst, 1980), p. 50. Author's trans.

5. Kállai, "das bauhaus lebt!," *bauhaus* 2, no. 3 (1928):1. Author's trans.

6. Kállai, "Ten Years of Bauhaus," p. 161.

7. Oskar Schlemmer, diary entry, February 1929, in *The Letters and Diaries of Oskar Schlemmer*, ed. Tut Schlemmer, trans. Krishna Winston (Middletown, Conn.: Wesleyan University Press, 1972), p. 238.

8. Theo van Doesburg, "Teaching at the Bauhaus and Elsewhere," 1925, in Van Doesburg, *On European Architecture: Complete Essays from Het Bouwebedrijf 1925–1931*, trans. Charlotte I. Loeb and Arthur L. Loeb (Basel: Birkhäuser, 1990), p. 74.

9. Gropius, "Program for the Founding of a General Housing-Construction Company Following Artistically Uniform Principles," 1910, unpublished ms., extracted and trans. Wolfgang Jabs and Basil Gilbert in Wingler, *The Bauhaus*, p. 20.

10. See Alois Riegl, *Stilfragen* (Berlin, 1893), and Margaret Iversen, *Alois Riegl: Art History and Theory* (Cambridge, Mass.: The MIT Press, 1993).

11. See Klaus-Jürgen Winkler, *Die Architektur am Bauhaus in Weimar* (Berlin and Munich: Verlag für Bauwesen, 1993), p. 29. On Gropius's reading of Alois Riegl see Wolfgang Pehnt, "Gropius the Romantic," *The Art Bulletin* 53, no. 3 (September 1971):379–92.

12. See Winkler, *Die Architektur am Bauhaus in Weimar*, p. 24, and Wallis Miller, "Architecture, Building and the Bauhaus," in James-Chakraborty, ed., *Bauhaus Culture*, pp. 63–89.

13. See Winkler, ed., *Bauhaus Alben*, 3 vols. (Weimar: Verlag der Bauhaus-Universität, 2006–8).

14. Paul Klopfer, "Die Gropius Ausstellung im Staatl. Bauhaus zu Weimar," *Allgemeine Thüringische Landeszeitung, Deutschland* supplement, July, 5 1922, quoted in Pehnt, "Gropius the Romantic," p. 383.

15. Fred Forbát, unpublished memoir, p. 49. Archives, Arkitekturmuseet, Stockholm. Author's trans. I am grateful to Jonas Malmdal for making this memoir available to me.

16. Gropius, "Neues Bauen," in *Der Holzbau*, a supplement to the *Deutsche Bauzeitung*, 1920/2, quoted in Pehnt, "Gropius the Romantic," p. 384.

17. See *Le Style Sapin. Une Expérience art nouveau à La Chaux-de-Fonds*, ed. Helen Bieri Thomason (Paris: Somogny, 2006). On J. Lauweriks see Annemarie Jaeggi, *Adolf Meyer, Der zweite Mann. Ein Architekt im Schatten von Walter Gropius* (Berlin: Argon, 1994), esp. pp. 29–40.

18. Marcel Breuer, in an unpublished interview with Jane Thompson, January 1966. Courtesy Thompson, Thompson Design Group, Boston.

19. Forbát, unpublished memoir, p. 57.

20. Gropius, letter to Adolf Behne, June 2, 1920. Mappe 8, Arbeitsrat für Kunst, Gropius Archive, Bauhaus-Archiv, Berlin. Quoted in Christian Wolsdorff, entry in Magdalena Droste and Jeannine Fiedler, eds., *Experiment Bauhaus* (Berlin: Bauhaus-Archiv, 1998), p. 318.

21. Ibid.

22. See Herbert Gilbert, *The Dream of the Factory-made House* (Cambridge, Mass.: The MIT Press, 1984).

23. Forbát, unpublished memoir, p. 72.

24. The title of the third of the *Bauhausbücher* (Bauhaus books) series, written by Adolf Meyer and published in 1925, was *Ein Versuchshaus des Bauhauses in Weimar: Haus am Horn* (An experimental house by the Bauhaus in Weimar: Haus am Horn). See cat. 254.

25. Gropius, quoted in Winkler, *Die Architektur am Bauhaus in Weimar*, p. 96.

26. Several museum collections, including MoMA's, contain Moholy's film of the *Lichtrequisit* in motion (cat. 375).

27. Gropius's "Idee und Aufbau des Staatlichen Bauhauses in Weimar" was published in *Staatliches Bauhaus in Weimar 1919–1923* (Weimar and Munich: Bauhausverlag, 1923), pp. 7–18, and later as an independent brochure.

28. Ise Gropius, diary entry, February 29, 1926, unpublished ms., Bauhaus-Archiv, Berlin. Quoted in Winkler and Gerhard Oschmann, *Das Gropius-Zimmer* (Weimar: Verlag der Bauhaus-Universität, 1999), p. 30. Author's trans.

29. Gropius, "Idee und Aufbau," pp. 8–9. Author's trans.

30. The caption to Gropius's *Baukasten* project reads, "Model for serial houses, variation of an identical ground-plan type through interchanging of additions of repeatable spatial cells. Guiding principle: unifications of the greatest possible typification with the greatest possible variation." Gropius, *Staatliches Bauhaus in Weimar 1919–1923*, p. 167. Author's trans.

31. László Moholy-Nagy, quoted in Rainer K. Wick, "Johannes Itten am Bauhaus: Ästhetische Erziehung als Ganzheitserziehung," in Christoph von Tavel and Josef Helfenstein, eds., *Johannes Itten, Künstler und Lehrer* (Bern: Kunstmuseum, 1984), p. 133.

32. Gropius, "systematische vorarbeit für rationellen wohnungsbau," *bauhaus* 2 (1927):1. Author's trans.

33. See Winkler, ed., *Bauhaus Alben*, 1:94–97.

34. *Bauhaus-Möbel. Eine Legende wird besichtigt/Bauhaus Furniture: A Legend Reviewed*, ed. Wolsdorff et al., exh. cat. (Berlin: Bauhaus-Archiv, 2002), p. 25.

35. "ein bauhaus-film. Fünfjahre lang." *bauhaus* 1, no. 1 (December 4, 1926):3.

36. See Christopher Wilk, *Marcel Breuer: Furniture and Interiors* (New York: The Museum of Modern Art, 1981), pp. 38–39.

37. Ibid., p. 40.

38. Ibid., p. 52.

39. Ise Gropius, quoted in ibid., p. 53.

40. Ibid., pp. 53–54.

41. Advertisement printed in *bauhaus* 3, no. 1 (1928). This trans. in Wingler, *The Bauhaus*, p. 452.

42. Breuer, "Metallmöbel und moderne Räumlichkeit," *Das neue Frankfurt* 2 (January 1928):11–12. This trans. in Wingler, *The Bauhaus*, p. 452.

43. See Otakar Máčel, "Avant-garde Design and the Law: Litigation over the Cantilever Chair," *Journal of Design History* 3, nos. 2–3 (1990):125–43.

44. See Wolfgang Thöner and Peter Müller, eds., *Bauhaus Tradition und DDR Moderne. Der Architekt Richard Paulick* (Munich: Deutscher Kunstverlag, 2006), pp. 32–35. See also Georg Muche, "Stahlhausbau," *bauhaus* 1, no. 2 (1927):3–4.

45. See Walter Scheiffele, *bauhaus junkers sozialdemokratie. ein kraftfeld der moderne* (Berlin: form + zweck, 2003).

46. Richard Pommer and Chris Otto, *Weissenhof 1927 and the Modern Movement in Architecture* (Chicago: at the University Press, 1991), p. 92.

47. Klee, in *Junge menschen kommt ans bauhaus!* (Dessau: Bauhausdruck Co-op, 1929), n.p. This trans. in Wingler, *The Bauhaus*, p. 148.

48. Hannes Meyer, in *junge menschen kommt ans bauhaus!*, n.p. Author's trans.

49. Hannes Meyer, letter to Behne, December 24, 1927, repr. in Bauhaus-Archiv and Deutsches Architekturmuseum, *Hannes Meyer 1889–1954. Architekt Urbanist Lehrer* (Berlin: Ernst & Sohn, 1989), p. 216.

50. Hannes Meyer, "bauen," in *bauhaus* 2, no. 4 (1928). Published in English in Claude Schnaidt, *Hannes Meyer. Bauten, Projekte und Schriften/Buildings, Projects and Writings*, trans. D. Q. Stephenson (New York: Architectural Book Publishing Co., 1965), pp. 95–97.

51. Hannes Meyer, "bauhaus und gesellschaft," *bauhaus* 3, no. 1 (1929):2. Reprinted in Meyer, *Bauen und Gesellschaft*, pp. 49–53. Author's trans.

52. Ludwig Mies van der Rohe, quoted in Wolsdorff, "Das Bauhaus unter Mies van der Rohe—ein Mies-Bauhaus?," *Der vorbildliche Architekt. Mies van der Rohes Architekturunterricht 1930–1958 am Bauhaus und in Chicago* (Berlin: Bauhaus-Archiv, 1986), p. 43.

53. See Helmut Erfurth and Elisabeth Tharandt, *Ludwig Mies van der Rohe: Die Trinkhalle, sein einziger Bau in Dessau. Die Zusammenarbeit mit dem Bauhausstudenten Eduard Ludwig* (Dessau: Anhaltische Verlagsgesellschaft mbH Dessau, 1995).

54. See Terence Riley, "From Bauhaus to Court-House," in Riley and Barry Bergdoll, *Mies in Berlin*, exh. cat. (New York: The Museum of Modern Art, 2001), pp. 330–37.

55. A. Mordwinow, *Bauchauz Dessau period rukovodstva Gannesa Majera 1928–1930* (Moscow: State Museum for New Western Art, 1931), p. 8. Author's trans. from an unpublished German translation in the Bauhaus-Archiv Berlin. Courtesy Patrick Rössler.

56. Walter Dexel, "Der Bauhausstil—ein Mythos," reprinted in Dexel, *Der Bauhausstil—ein Mythos. Texte 1921–1965*, ed. Walter Vitt (Starnberg: Josef Keller Verlag, 1976), p. 17.

PLATES

The untitled four-page broadsheet produced by Walter Gropius at the end of April 1919, commonly known as the "Bauhaus manifesto," is a Janus-faced document (cats. 38, 39). It is the founding proclamation of an institution that has become synonymous with visual modernity, exerting a profound influence on design, artistic practice, and art education that extends down to our own day. At the same time, it looks back to a romantically idealized medieval past as a model for the radical transformation of contemporary visual culture. This exhibition is primarily about the first face; this short essay is mostly about the second.

The Bauhaus manifesto begins with a woodcut by Lyonel Feininger, *Kathedrale*, as an untitled cover page. Three pages of text by Gropius follow — a fervently utopian one-page mission statement and a two-page program outlining the principles and pedagogical organization of the school. The text proceeds from the premise that painting, sculpture, and architecture, once integrated in the "great building," have become mutually isolated, to the detriment of all three. The goal of the Bauhaus is to reunite them, and to do so by reviving the lost tradition of *Handwerk*, manual craft. Gropius calls for the creation of a "new guild of craftsmen," ending the "arrogant class division between artisans and artists." He concludes with a heady exhortation: "Let us collectively desire, conceive, and create the new building of the future, which will be everything in one structure: architecture and sculpture and painting, which, from the million hands of craftsmen, will one day rise towards heaven as the crystalline symbol of a new and coming faith."[1]

To illustrate this utopian proclamation, Gropius, significantly, avoided the kind of futuristic architectural fantasy that was so common at the time in the German avant-garde. Instead he asked Feininger, his first faculty hire in Weimar, to provide the illustration — not a fantastic projection of the *Zukunftskathedrale*, the "cathedral of the future," as Gropius called it elsewhere, but a cathedral from the medieval past, a *Gothic* cathedral. While the manifesto makes no explicit mention of such a building, Gropius cites it in virtually every other text from these years, as he also invokes the *Bauhütten*, the medieval mason's lodges "in the golden age of the cathedrals," which inspired the name "Bauhaus."[2] The *Bauhütten* served as a model for the *Arbeitsgemeinschaft*, the small community of architects, artists, and craftsmen who would collaborate on the longed-for *Einheitskunstwerk*, the unified art work.[3] As the art historian Horst Claussen has remarked, Gropius "employed the Middle

Ages as a code to designate something fundamentally new, yet indeterminate," and this, I believe, is how Feininger's *Kathedrale* should be understood.[4]

Gropius's choice of Feininger to illustrate the manifesto seems hardly to have been a matter of mere convenience. Feininger had a long-standing love affair with medieval churches; indeed his first woodcut, made only the previous year, was of the fourteenth-century Gothic church in the Baltic village of Zirchow — a motif of which he had already made seven painted versions, culminating in *Zirchow VII* of 1918 (cat. 42).[5] The woodcut medium, which originated in the late Middle Ages and was revived by the German Expressionists, was particularly well suited to the ethos expressed in the manifesto. As the critic Paul Westheim wrote at the time, the woodcut was "the passion of the young generation of artists," satisfying their urge to "return to a primitive style and to manual craftsmanship."[6]

Moreover, Feininger's Cubist-inspired art was unquestionably one of the strongest German examples of easel painting that, though not integrated into architecture, was filled with what Gropius, in the Bauhaus manifesto, called the "architectonic spirit." The critic Adolf Behne, who was both personally and professionally close to Gropius, considered Feininger second only to Paul Klee as the leading exponent of architectonic painting in Germany, which he designated "Cubist" as opposed to the more lyrical "Expressionist."[7] To be sure, Behne took an idiosyncratically utopian view of Cubism, divining in it "a secret urge to an ultimate unity" and the self-appointed task "to change the European." Most significantly, he believed he saw in it a rebirth of the spirit that had inspired the Gothic and nineteenth-century Romanticism.[8]

Whether Feininger intended it or not, his *Cathedral* was the perfect embodiment of this idea of an affinity between the Gothic and Cubism. The structure of the cathedral can be read most easily in the first proof of the first version, in which it stands isolated against a black ground (cat. 40). It has three discrete gabled portals, three tiers of flying buttresses, and three spires, each crowned by a gleaming star embedded in

38, 39
Lyonel Feininger, cover illustration, and **Walter Gropius,** text
Programm des Staatlichen Bauhauses in Weimar (Program of the state Bauhaus in Weimar; also known as the Bauhaus manifesto). April 1919. Cat. 38: front and back; cat. 39: inner spread Woodcut with letterpress on green paper 11 7/8 x 7 5/16" (30.2 x 18.6 cm)
Harvard Art Museum, Busch-Reisinger Museum. Gift of Julia Feininger

Umfang der Lehre.

Die Lehre im Bauhaus umfaßt alle praktischen und wissenschaftlichen Gebiete des bildnerischen Schaffens.

A. Baukunst,
B. Malerei,
C. Bildhauerei

einschließlich aller handwerklichen Zweiggebiete.

Die Studierenden werden sowohl handwerklich (1) wie zeichnerisch-malerisch (2) und wissenschaftlich-theoretisch (3) ausgebildet.

1. Die handwerkliche Ausbildung — sei es in eigenen allmählich zu ergänzenden, oder fremden durch Lehrvertrag verpflichteten Werkstätten — erstreckt sich auf:

a) Bildhauer, Steinmetzen, Stukkateure, Holzbildhauer, Keramiker, Gipsgießer,
b) Schmiede, Schlosser, Gießer, Dreher,
c) Tischler,
d) Dekorationsmaler, Glasmaler, Mosaiker, Emailleure,
e) Radierer, Holzschneider, Lithographen, Kunstdrucker, Ziseleure,
f) Weber.

Die handwerkliche Ausbildung bildet das Fundament der Lehre im Bauhaus. Jeder Studierende soll ein Handwerk erlernen.

2. Die zeichnerische und malerische Ausbildung erstreckt sich auf:

a) Freies Skizzieren aus dem Gedächtnis und der Phantasie,
b) Zeichnen und Malen nach Köpfen, Akten und Tieren,
c) Zeichnen und Malen von Landschaften, Figuren, Pflanzen und Stilleben,
d) Komponieren,
e) Ausführen von Wandbildern, Tafelbildern und Bilderschreinen,
f) Entwerfen von Ornamenten,
g) Schriftzeichnen,
h) Konstruktions- und Projektionszeichnen,
i) Entwerfen von Außen-, Garten- und Innenarchitekturen,
k) Entwerfen von Möbeln und Gebrauchsgegenständen.

3. Die wissenschaftlich-theoretische Ausbildung erstreckt sich auf:

a) Kunstgeschichte — nicht im Sinne von Stilgeschichte vorgetragen, sondern zur lebendigen Erkenntnis historischer Arbeitsweisen und Techniken,
b) Materialkunde,
c) Anatomie — am lebenden Modell,
d) physikalische und chemische Farbenlehre,
e) rationelles Malverfahren,
f) Grundbegriffe von Buchführung, Vertragsabschlüssen, Verdingungen,
g) allgemein interessante Einzelvorträge aus allen Gebieten der Kunst und Wissenschaft.

Einteilung der Lehre.

Die Ausbildung ist in drei Lehrgänge eingeteilt:

I. Lehrgang für Lehrlinge.
II. " " Gesellen.
III. " " Jungmeister.

Die Einzelausbildung bleibt dem Ermessen der einzelnen Meister im Rahmen des allgemeinen Programms und des in jedem Semester neu aufzustellenden Arbeitsverteilungsplanes überlassen.

Um den Studierenden eine möglichst vielseitige, umfassende technische und künstlerische Ausbildung zuteil werden zu lassen, wird der Arbeitsverteilungsplan zeitlich so eingeteilt, daß jeder angehende Architekt, Maler oder Bildhauer auch an einem Teil der anderen Lehrgänge teilnehmen kann.

Aufnahme.

Aufgenommen wird jede unbescholtene Person ohne Rücksicht auf Alter und Geschlecht, deren Vorbildung vom Meisterrat des Bauhauses als ausreichend erachtet wird, und soweit es der Raum zuläßt. Das Lehrgeld beträgt jährlich 180 Mark (es soll mit steigendem Verdienst des Bauhauses allmählich ganz verschwinden). Außerdem ist eine einmalige Aufnahmegebühr von 20 Mark zu zahlen. Ausländer zahlen den doppelten Betrag. Anfragen sind an das Sekretariat des Staatlichen Bauhauses in Weimar zu richten.

APRIL 1919.

Die Leitung des
Staatlichen Bauhauses in Weimar:
Walter Gropius.

Das Endziel aller bildnerischen Tätigkeit ist der Bau! Ihn zu schmücken war einst die vornehmste Aufgabe der bildenden Künste, sie waren unablösliche Bestandteile der großen Baukunst. Heute stehen sie in selbstgenügsamer Eigenheit, aus der sie erst wieder erlöst werden können durch bewußtes Mit- und Ineinanderwirken aller Werkleute untereinander. Architekten, Maler und Bildhauer müssen die vielgliedrige Gestalt des Baues in seiner Gesamtheit und in seinen Teilen wieder kennen und begreifen lernen, dann werden sich von selbst ihre Werke wieder mit architektonischem Geiste füllen, den sie in der Salonkunst verloren.

Die alten Kunstschulen vermochten diese Einheit nicht zu erzeugen, wie sollten sie auch, da Kunst nicht lehrbar ist. Sie müssen wieder in der Werkstatt aufgehen. Diese nur zeichnende und malende Welt der Musterzeichner und Kunstgewerbler muß endlich wieder eine bauende werden. Wenn der junge Mensch, der Liebe zur bildnerischen Tätigkeit in sich verspürt, wieder wie einst seine Bahn damit beginnt, ein Handwerk zu erlernen, so bleibt der unproduktive „Künstler" künftig nicht mehr zu unvollkommener Kunstübung verdammt, denn seine Fertigkeit bleibt nun dem Handwerk erhalten, wo er Vortreffliches zu leisten vermag.

Architekten, Bildhauer, Maler, wir alle müssen zum Handwerk zurück! Denn es gibt keine „Kunst von Beruf". Es gibt keinen Wesensunterschied zwischen dem Künstler und dem Handwerker. Der Künstler ist eine Steigerung des Handwerkers. Gnade des Himmels läßt in seltenen Lichtmomenten, die jenseits seines Wollens stehen, unbewußt Kunst aus dem Werk seiner Hand erblühen, die Grundlage des Werkmäßigen aber ist unerläßlich für jeden Künstler. Dort ist der Urquell des schöpferischen Gestaltens.

Bilden wir also eine neue Zunft der Handwerker ohne die klassentrennende Anmaßung, die eine hochmütige Mauer zwischen Handwerkern und Künstlern errichten wollte! Wollen, erdenken, erschaffen wir gemeinsam den neuen Bau der Zukunft, der alles in einer Gestalt sein wird: Architektur und Plastik und Malerei, der aus Millionen Händen der Handwerker einst gen Himmel steigen wird als kristallenes Sinnbild eines neuen kommenden Glaubens.

WALTER GROPIUS.

PROGRAMM
DES
STAATLICHEN BAUHAUSES
IN WEIMAR

Das Staatliche Bauhaus in Weimar ist durch Vereinigung der ehemaligen Großherzoglich Sächsischen Hochschule für bildende Kunst mit der ehemaligen Großherzoglich Sächsischen Kunstgewerbeschule unter Neuangliederung einer Abteilung für Baukunst entstanden.

Ziele des Bauhauses.

Das Bauhaus erstrebt die Sammlung alles künstlerischen Schaffens zur Einheit, die Wiedervereinigung aller werkkünstlerischen Disziplinen — Bildhauerei, Malerei, Kunstgewerbe und Handwerk — zu einer neuen Baukunst als deren unablösliche Bestandteile. Das letzte, wenn auch ferne Ziel des Bauhauses ist das Einheitskunstwerk — der große Bau —, in dem es keine Grenze gibt zwischen monumentaler und dekorativer Kunst.

Das Bauhaus will Architekten, Maler und Bildhauer aller Grade je nach ihren Fähigkeiten zu tüchtigen Handwerkern oder selbständig schaffenden Künstlern erziehen und eine Arbeitsgemeinschaft führender und werdender Werkkünstler gründen, die Bauwerke in ihrer Gesamtheit — Rohbau, Ausbau, Ausschmückung und Einrichtung — aus gleich geartetem Geist heraus einheitlich zu gestalten weiß.

Grundsätze des Bauhauses.

Kunst entsteht oberhalb aller Methoden, sie ist an sich nicht lehrbar, wohl aber das Handwerk. Architekten, Maler, Bildhauer sind Handwerker im Ursinn des Wortes, deshalb wird als unerläßliche Grundlage für alles bildnerische Schaffen die gründliche handwerkliche Ausbildung aller Studierenden in Werkstätten und auf Probier- und Werkplätzen gefordert. Die eigenen Werkstätten sollen allmählich ausgebaut, mit fremden Werkstätten Lehrverträge abgeschlossen werden.

Die Schule ist die Dienerin der Werkstatt, sie wird eines Tages in ihr aufgehen. Deshalb nicht Lehrer und Schüler im Bauhaus, sondern Meister, Gesellen und Lehrlinge.

Die Art der Lehre entspringt dem Wesen der Werkstatt:

Organisches Gestalten aus handwerklichem Können entwickelt.

Vermeidung alles Starren; Bevorzugung des Schöpferischen; Freiheit der Individualität, aber strenges Studium.

Zunftgemäße Meister- und Gesellenproben vor dem Meisterrat des Bauhauses oder vor fremden Meistern.

Mitarbeit der Studierenden an den Arbeiten der Meister.

Auftragsvermittlung auch an Studierende.

Gemeinsame Planung umfangreicher utopischer Bauentwürfe — Volks- und Kultbauten — mit weitgestecktem Ziel. Mitarbeit aller Meister und Studierenden — Architekten, Maler, Bildhauer — an diesen Entwürfen mit dem Ziel allmählichen Einklangs aller zum Bau gehörigen Glieder und Teile.

Ständige Fühlung mit Führern der Handwerke und Industrien im Lande.

Fühlung mit dem öffentlichen Leben, mit dem Volke durch Ausstellungen und andere Veranstaltungen.

Neue Versuche im Ausstellungswesen zur Lösung des Problems, Bild und Plastik im architektonischen Rahmen zu zeigen.

Pflege freundschaftlichen Verkehrs zwischen Meistern und Studierenden außerhalb der Arbeit; dabei Theater, Vorträge, Dichtkunst, Musik, Kostümfeste. Aufbau eines heiteren Zeremoniells bei diesen Zusammenkünften.

intersecting diagonal shafts of light.[9] The hierarchical arrangement of these triads, with the central portal and tower larger than those flanking them, corresponds to the idea expressed in the manifesto, of painting and sculpture finding their ultimate fulfillment — and glory — in their subordination to architecture. Feininger used a second state of this print for the cover of the first proof of the manifesto, with the name of the school printed beneath it (cat. 41).

Dissatisfied with this first version, Feininger recut the image, now reversed, on a larger woodblock.[10] The imposing scale of this woodcut, now filling a sheet almost twelve inches in height, makes it much more effective than the first proof, which, with its title, might be falsely construed as identifying the Bauhaus with neo-Gothic architecture. Feininger's final woodcut (cat. 38) is not only larger in scale, it is also dramatically more luminous, and its strongly faceted structure matches Gropius's evocation of the future cathedral as a "crystalline symbol of a coming faith."

The rhetorical effect of the Bauhaus manifesto in its final state seems artfully calculated. One first encounters the image of the cathedral, without label or title. Then, turning the page, one reads the lines "*The ultimate goal of all artistic activity is the building!* To decorate it was once the noblest task of the visual arts, they were indissoluble components of the great art of building." Following on the image of the cathedral, this text appears as a kind of commentary on it — the woodcut evokes the working communities of craftsmen and artists of yore that were now to be revived. Then, following the exhortation to erect the "new building of the future, which will be everything *in one structure*," one moves to page three and the program, the means to achieve this goal, where for the first time the name "Bauhaus" appears — now so much more effectively placed than in the first version. In short, the manifesto has a tripartite sequential structure: model, mission, means.

The ideas in Gropius's manifesto were hardly new. Some of them can be traced back more than a century to the Berlin architect Karl Friedrich Schinkel and to the German Romantics; others were common in the discourse around Expressionism, especially in the heightened expectations brought about by Germany's November 1918 revolution.[11] What distinguishes Gropius from his contemporaries, however, is that unlike them he was appointed director of a state-supported school, where he was able actually to implement these theories and, over the next eight years, to moderate and refine them in the face of the sobering realities of practice, with lasting consequences for the history of modern visual culture.

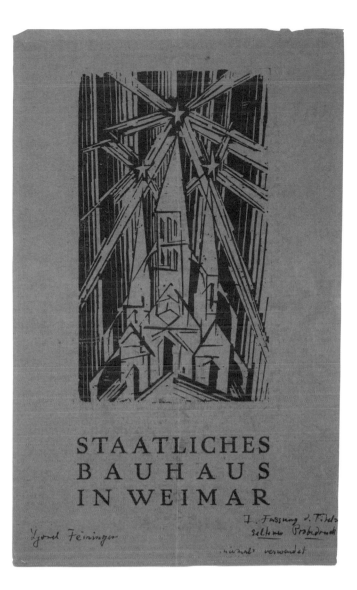

1. The standard English translation appears in Hans Maria Wingler, *The Bauhaus: Weimar, Dessau, Berlin, Chicago,* ed. Joseph Stein (Cambridge, Mass.: The MIT Press, 1969), pp. 31–33; in this essay I have in places offered my own translation.

2. Walter Gropius, "Antworten auf eine Umfrage des Arbeitsrates für Kunst," in Hartmut Probst and Christian Schädlich, eds., *Walter Gropius. Ausgewählte Schriften* (Berlin: Verlag für Architektur und technische Wissenschaften, 1985), 3:70.

3. See various texts by Gropius from 1916 to 1919 in ibid., pp. 60, 61, 62, 65, 67, 70, 74.

4. Horst Claussen, *Walter Gropius: Grundzüge seines Denkens,* Studien zur Kunstgeschichte vol. 39 (Hildesheim: Olms, 1986), p. 32.

5. Leona E. Prasse, *Lyonel Feininger; a Definitive Catalogue of His Graphic Work: Etchings, Lithographs, Woodcuts. Das Graphische Werk: Radierungen, Lithographien, Holzschnitte* (Cleveland: Cleveland Museum of Art, and Berlin: Gebrüder Mann, 1972), p. 112, cat. W1.

6. Paul Westheim, *Das Holzschnittbuch* (Potsdam: Gustav Kiepenheuer Verlag, 1921), p. 5. In 1920 Gropius published an essay on wood, which he called the "ur-building material" of the human race, and thus fitting for the "primitive beginning of our new life that is taking form." Gropius, "Neues Bauen," in Probst and Schädlich, eds., *Walter Gropius. Ausgewählte Schriften,* 3:78.

7. Adolf Behne, *Die Wiederkehr der Kunst* (Leipzig: Kurt Wolff, 1919), pp. 22–24.

8. Ibid., pp. 37–38.

9. The historian of Gothic architecture Stephen Murray kindly informs me that "triple towers in the western frontispiece of a Gothic cathedral never occur in reality—the closest you get is in the Mormon Temple in Salt Lake City.... And while western portals are often gabled (Amiens, Reims, Laon) there is no precedent for the lateral portals having their own roof structure projecting out beyond the body of the building. And no precedent for flyers against towers." Murray, e-mail to the author, January 2, 2009.

10. See Feininger, letter to Gropius, April 26, 1919, quoted in Klaus Weber, "'Clearly I'm for the Printing Workshop': Lyonel Feininger at the Bauhaus," in Ingrid Mössinger and Kerstin Drechsel, eds., *Lyonel Feininger: Loebermann Collection, Drawings, Watercolors, Prints* (Munich and New York: Prestel, 2006), pp. 113–14. The most thorough discussion of Feininger's woodcut and its evolution is Mathias Schirren's "Lichtreflexionen: Lyonel Feiningers Architekturvisionen und die romantische Tradition der modernen Architektur," in Roland März, ed., *Lyonel Feininger: von Gelmeroda nach Manhattan: Retrospektive der Gemälde,* exh. cat. (Berlin: G+H, 1998), pp. 253–61, specifically pp. 256–59.

11. The best account of Gropius's relationship to these ideas remains Marcel Franciscono, *Walter Gropius and the Creation of the Bauhaus in Weimar: The Ideals and Artistic Theories of Its Founding Years* (Urbana: University of Illinois Press, 1971).

40
Lyonel Feininger
Kathedrale (Cathedral). 1919
Woodcut on paper
Composition: 7 1/16 x 4 13/16" (18 x 12.3 cm),
sheet: 11 1/16 x 8 11/16" (28.1 x 22 cm)
The Museum of Modern Art, New York.
Gift of Julia Feininger

41
Lyonel Feininger
Programm des Staatlichen Bauhauses in Weimar (Program of the state Bauhaus in Weimar), preliminary design. 1919
Woodcut with letterpress on green paper
12 9/16 x 7 3/4" (31.9 x 19.7 cm)
Harvard Art Museum, Busch-Reisinger Museum. Gift of Julia Feininger

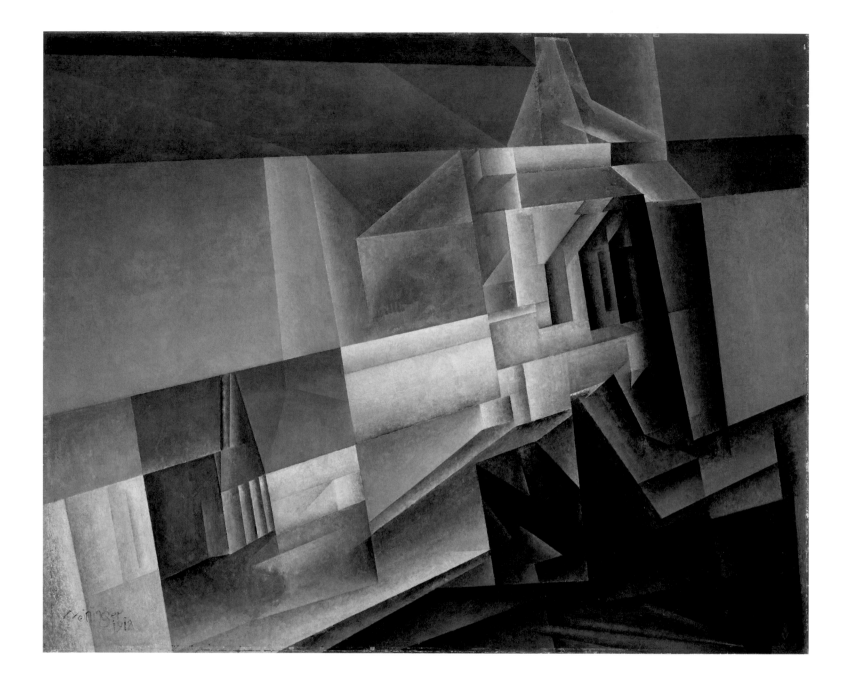

42
Lyonel Feininger
Zirchow VII. 1918
Oil on canvas
31 3/4 x 39 5/8" (80.7 x 100.6 cm)
The National Gallery of Art
Washington, D.C. Gift of Julia Feininger

43
Gerhard Marcks
Die drei Walküren (The three Valkyries).
Plate I of *Das Wielandslied der älteren Edda*
(The Wieland saga of the elder Edda),
portfolio of 10 prints. 1923
Woodcut on paper
Sheet: c. 7 ¹³/₁₆ x 5 ⁵/₈" (19.8 x 14.3 cm)
Klassik Stiftung Weimar, Graphische
Sammlungen

44
Gerhard Marcks
Die drei Brüder (The three brothers).
Plate II of *Das Wielandslied der älteren Edda*
(The Wieland saga of the elder Edda),
portfolio of 10 prints. 1923
Woodcut on paper
Sheet: c. 7 ¹³/₁₆ x 5 ⁵/₈" (19.8 x 14.3 cm)
Klassik Stiftung Weimar, Graphische
Sammlungen

45
Gerhard Marcks
Nidudrs Reiter (Nidudr's knights).
Plate IV of *Das Wielandslied der älteren Edda*
(The Wieland saga of the elder Edda),
portfolio of 10 prints. 1923
Woodcut on paper
Sheet: c. 7 ¹³/₁₆ x 5 ⁵/₈" (19.8 x 14.3 cm)
Klassik Stiftung Weimar, Graphische
Sammlungen

46
Gerhard Marcks, with painting by
Alfred Partikel
Altärchen (Small altar). 1920
Painted wood
16 ¹/₈ x 17 ⁵/₁₆" (41 x 44 cm)
Gerhard-Marcks-Haus, Bremen

47 (far left)
Anny Wottitz
Hand-binding of commercially printed book,
*Chorus Mysticus. Alchemistische Transmutations-
geschichten aus Schmieders Geschichte der
Alchemie 1823* (Tales of alchemic transmutation
from Schmieder's history of alchemy).
Ed. Hans Kayser (Leipzig: Insel, 1923). 1923
Mahogany and ebony, with ink, gouache,
and gold color on parchment
9 1/4 x 6 5/16 x 1 3/8" (23.5 x 16 x 3.5 cm)
Bauhaus-Archiv Berlin

48 (opposite, below right)
Anny Wottitz
Hand-binding of commercially printed book,
Afrikanische Märchen (African fairy tales). Ed.
Carl Meinhof (Jena: Eugen Diederichs, 1921).
1922–23
Plant materials, cords, threads, glass beads,
shells, mirror, and red and violet paper
8 ¼ x 5 ⅛ x 1 ⁵/₁₆" (21 x 13 x 3.3 cm)
Bauhaus-Archiv Berlin

49 (opposite, above right)
Lyonel Feininger (portfolio design) and
Josef Albers (design for relief print on cover)
Cover of *Neue Europäische Graphik V.
Deutsche Künstler* (New European graphics V.
German artists), portfolio of 13 prints. 1921–23
Parchment with printed letters, cardboard
covered with relief print
22 ¹¹/₁₆ x 18 ⁵/₁₆ x ¹³/₁₆" (57.6 x 46.5 x 2 cm) closed
Bauhaus-Archiv Berlin

50
Paul Klee
Aus dem Hohen Lied (II. Fassung)
(From the Song of Songs [II version]). 1921
Watercolor and ink on paper, bordered
with watercolor and ink on cardboard
6 ⅜ x 6 ⅞" (16.2 x 17.4 cm)
Solomon R. Guggenheim Museum, New York

51
Paul Klee
Einst dem Grau der Nacht enttaucht…
(Once emerged from the gray of night…). 1918
Watercolor, ink, and pencil on paper, cut
and recombined with silver paper, bordered
with ink on cardboard
8 ⅞ x 6 ¼" (22.6 x 15.8 cm)
Zentrum Paul Klee, Bern

52
Marguerite Friedlaender (later Wildenhain)
Pitcher. 1922–23
High-fired glazed earthenware, free thrown
and assembled, with slip decoration
Height: 13 3/8" (34 cm)
Bauhaus-Archiv Berlin

53
Max Krehan with slip decoration by
Gerhard Marcks
Pitcher. 1921
High-fired glazed earthenware, free thrown
and assembled, with slip decoration
Height: 15 9/16" (39.5 cm)
Klassik Stiftung Weimar, Bauhaus-Museum

54
Johannes Driesch
Breakfast service. 1921–22
High-fired glazed earthenware, free thrown,
with slip decoration
Circumference of plates: 7 1/2" (19 cm);
height of eggcups: 2 1/8" (6.5 cm)
Private collection, Germany

55
Otto Lindig with slip decoration by
Gerhard Marcks
Jug with lid. 1922
High-fired glazed earthenware, free thrown
and assembled, with slip decoration
Height: 10 5/8" (27 cm)
Klassik Stiftung Weimar, Bauhaus-Museum

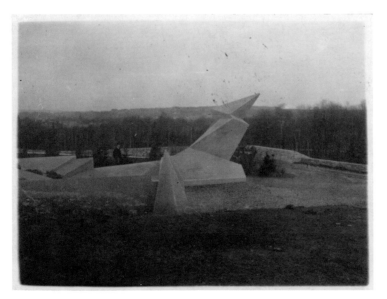

56
Walter Gropius
Partial model for the *Märzgefallenen-Denkmal*
(Monument to the March dead). 1921
Tinted plaster
17 15/16 x 30 11/16 x 20 11/16" (45.5 x 78 x 52.5 cm)
Klassik Stiftung Weimar, Bauhaus-Museum

57
Walter Gropius
Märzgefallenen-Denkmal (Monument to
the March dead), Weimar cemetery. 1922
(destroyed)
Concrete
Photograph: photographer unknown. n.d.
Gelatin silver print. 3 x 4" (7.6 x 10.2 cm).
The Museum of Modern Art, New York.
Architecture and Design Study Collection

58
Theobald Emil Müller-Hummel
Untitled (Pillar with cosmic visions). 1919–20
Carved and painted wood (almost certainly
a propeller blade, probably from a World War I
military airplane)
with brass mountings
36 x 6 7/16 x 3 3/8" (91.4 x 16.4 x 8.6 cm)
Klassik Stiftung Weimar, Bauhaus-Museum.
On loan from Professor J. A. Müller

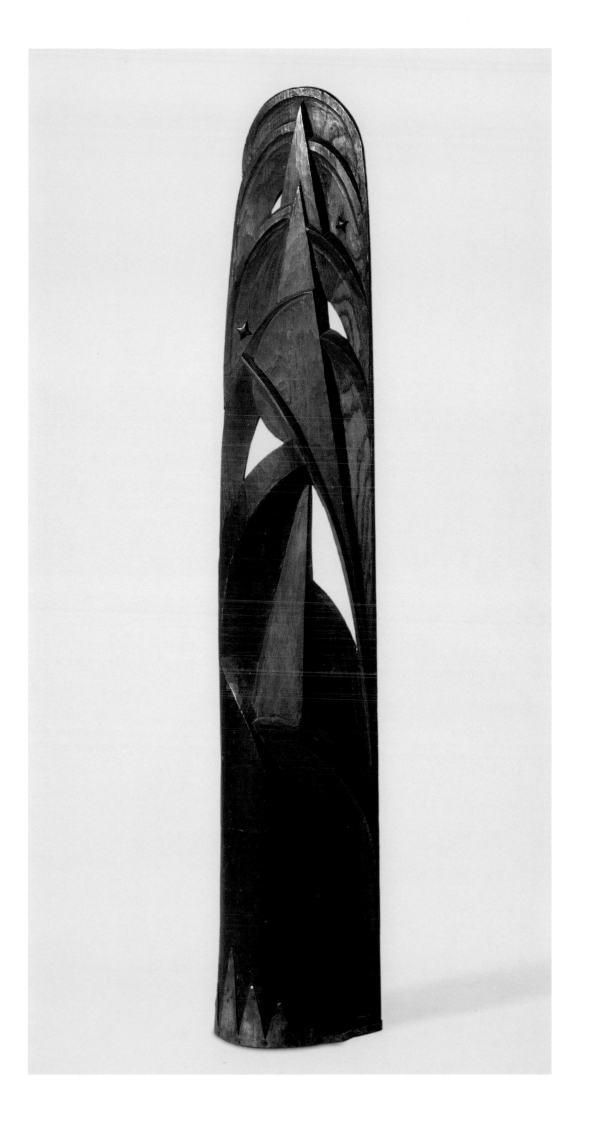

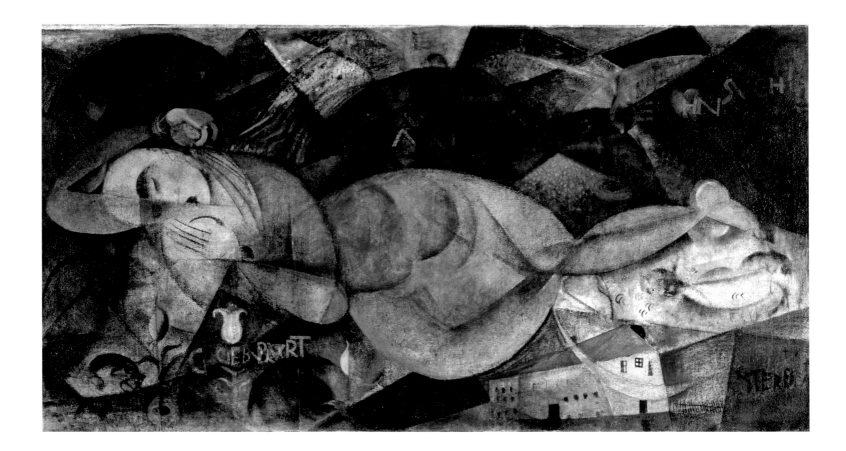

59
Franz Scala
Der Traum (The dream). 1919
Oil on burlap
39 3/8" x 6' 2 13/16" (100 x 190 cm)
Bauhaus-Archiv Berlin

60
Lothar Schreyer (or his students)
Schedule for the winter semester, 1921–22.
1921
Watercolor, tempera, ink, and pencil on paper
6 1/2 x 13" (16.5 x 33 cm)
Bauhaus-Archiv Berlin

61
Johannes Itten
Aufstieg und Ruhepunkt (Ascent and resting point). 1919
Oil on canvas
7' 6 9/16" x 45 1/4" (230 x 115 cm)
Kunsthaus Zurich

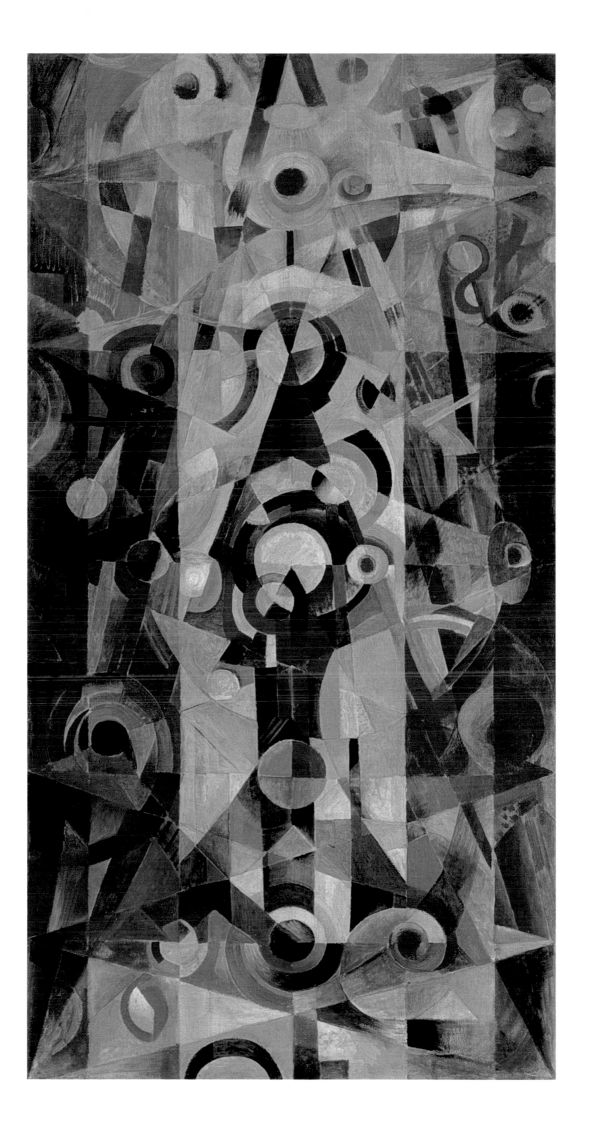

LOTHAR SCHREYER
DEATH HOUSE FOR A WOMAN. C.1920
KLAUS WEBER

"This is the strangest work that I have seen in years. I have never encountered anything like it."[1] It was with this mixture of perplexity and fascination, according to Lothar Schreyer, that his Bauhaus colleague Vasily Kandinsky responded to the brightly painted coffin in his studio. Mounted on the wall above it was the painted lid of another coffin — though Schreyer himself avoided the term "coffin," referring to his macabre studio props as *Totenhaus der Frau* (Death house for a woman) and *Totenhaus des Mannes* (Death house for a man).

A writer, dramatist, and painter who had trained in the law, a friend of Herwarth Walden's (the editor of the journal *Der Sturm*), a radical pioneer of Expressionist theater, director of the Sturm theater and, beginning in 1921, of the Bauhaus theater, Lothar Schreyer was a major avant-garde figure. Yet he is the least well-known of the Bauhaus teachers. His hermetic, virtually impenetrable art and the "sacral Expressionism"[2] of his works for the stage were clearly not very well received at the school, and after the failure of his theater piece *Mondspiel* (Moon play), performed in Weimar in 1923, he moved on. Like Johannes Itten and Georg Muche, Schreyer was a typical figure of the early years of the Weimar Bauhaus, when it was still closely associated with *Der Sturm* and Expressionism, and known for its adherence to the ideals of medieval lodges and its devotion to wide-eyed reformist schemes and esoteric teachings. Even in an atmosphere like this, though, Schreyer's *Totenhäuser* were clearly puzzling — and they remain so to this day.

What led Schreyer to these works? In a chapter on them in a memoir he published in 1956, he complains about the ugliness of traditional coffins, and argues for creating instead "a dignified sarcophagus, not expensive in terms of its materials… but noble in form and marked with the earnestness of life and the joy of eternity. And since one has first to take care of oneself, shortly after marrying I made the first death house for my wife and the second for myself."[3] Schreyer further felt that it was only logical to keep his death house near him at all times as a memento mori.

The *Totenhaus der Frau*, made around 1920, was "a large, narrow shrine, taller at the wider head end than at the narrower foot end…. The basic color of all the paintings was a dark ultramarine blue. An abstract female figure in light blue, dark vermilion, and gold filled the entire surface of the lid. She was archaic and hieratic in form. An even more abstracted female figure was painted in profile on each of the narrow side surfaces, a harplike symbol at either end."[4] Of the *Totenhaus des Mannes*, probably executed at the Bauhaus in early 1922, Schreyer writes, "I first

62
Lothar Schreyer
Design for *Totenhaus der Frau*
(Death house for a woman). 1920
Tempera on paper
6′ 6 1/16″ x 24 13/16″ (198.3 x 63 cm)
Bauhaus-Archiv Berlin. Long-term loan
of the Schreyer family

painted it completely white. But I also had a second lid made, on which I painted a very colorful, abstract male figure, largely Cubist in style, against a yellow background. Around the raised edge was the inscription '*Wir leben um zu sterben/Wir sterben um zu leben*' [We live so as to die/We die so as to live]. This male death image hung in my Bauhaus studio above the *Totenhaus der Frau*."[5]

The originals can no longer be seen, for Schreyer eventually used the coffins to bury his parents. Walden bought the extra lid of the *Totenhaus des Mannes* for his own collection in 1925, but its subsequent fate is unknown.[6] In addition to pencil sketches relating to the *Totenhäuser*, however, Schreyer's estate included a full-size color design for the *Totenhaus der Frau* (cat. 62) — the only surviving documentation of a work now consigned to the grave.[7] The design pictures a largely symmetrically ordered female figure seen in strict frontality on a trapezoidal surface. Her head, her folded arms, and her breasts are simple circles. Her face, with wide-open eyes that seem to stare at the viewer, takes the shape of a rectangle inserted into the circle of the head. An inverted black cross accents the axis of her body, and perpendicular to it lies the small figure of a child. The woman's feet rest on a circle that corresponds to the shape of her head.

The only records of the *Totenhaus des Mannes* are a black and white photograph (cat. 64)[8] and a tempera sketch, presumably made considerably later, that may give an indication of its colors (cat. 63). Dissonant, rigid, and severe — like a piece of stalled machinery — the man's image contrasts sharply with the self-contained, rounded female figure. The composition is asymmetrical, and is dominated by angular shapes. A diagonal black bar across the man's chest is perhaps to be understood as a sword; he appears to wear a pointed helmet, his eyes are closed, and his forehead bears a small cross. In addition to the inscription that Schreyer mentions around the edges, the design incorporates a number of single words, some of them clear enough in the photograph to be read: near the man's head the word *Traum* (Dream) appears a number of times, and on the right are the words *Krieger* (Warrior), *Vater* (Father), *Retter* (Rescuer), and *Toter* (Dead man).

Recumbent figures are standard decorations of sarcophagi, but they are usually posthumous portraits of the deceased, or of their piously arranged corpses. Schreyer, however, produced these images while he and his wife, Margarete, were still alive. A conversation with Kandinsky that he recounts in his memoir provides a clue to the interpretation of the works: according to Schreyer, Kandinsky recognized their meaning immediately in that he compared them to Russian icons, which he in turn believed have been derived from Egyptian mummy portraits. "Such mummy portraits," Kandinsky told Schreyer, "were painted

on the wrappings or the lids of coffins, or what one might call the death houses of the Egyptians. These portraits represent the 'ka,' the mystical 'life body' [Lebensleib] of the deceased. And the figures of saints on our icons…are presented in the form of their life body, that is to say, as figures living in death."[9]

In the early 1920s Schreyer wrote several books on mysticism, and especially on the writings of the seventeenth-century German mystic Jakob Böhme.[10] He dealt here with Böhme's complex theory of the developmental stages of the human soul, its progress from a "vegetable form," still mortal and tied to earthly existence, through an "animal" stage and finally to immortality. Schreyer saw analogies in this theory with Egyptian notions of the afterlife, and it would seem of interest in the present context that he equated Böhme's "vegetable form," or "life body," with the Egyptians' "ka," the "life body" (Lebenskörper), the "vegetative consciousness."[11] According to Schreyer, this was exactly Kandinsky's response when he first saw the Totenhäuser.

Schreyer similarly wrote in his memoir, "I had realized that in death a man lays his body aside, but that the body still belongs to the man."[12] Accordingly, we might see his death-house images as projections of a mysterious "life body," the transition between earthly and eternal life. They are soul portraits — pictures of the soul in a future state. Such things are of course impossible to illustrate, so Schreyer devised pictorial formulas that were abstract yet archetypal: a dead woman and a dead man, their sexual polarities — including oddly archaic gender-role assignments — still in force even in the afterlife. The woman is mother, the man is father and warrior.

Schreyer always understood his extraordinarily various creative activities as parts of a single effort. Painting, writing, and dramaturgy were merely complementary forms of expression. In these early years his poetic and dramatic writing touched repeatedly on birth and death; his texts carried titles like Grabgang (Journey to the grave), Totenschrei (Death wail), Totenklage (Lament for the dead), Totenweinen (Mourning), Kindsterben (Death of a child), and Geburt (Birth). The characters in his theater pieces were always archetypes, called simply Mann (Man), Frau (Woman),

Geliebte (Lover), Mutter (Mother), Kind (Child), or Tod (Death), and the actors were always invisible, hidden behind rigid masks that covered their whole bodies. One of these masks, Maria im Mond (Mary in the moon), created for the Mondspiel at the Bauhaus in 1923 (cat. 65), seems to reflect the female death image on a divine level. Could the soul portraits of the Totenhäuser also be understood as masks? In Schreyer's thinking, actors and masks — like body and soul — were merely different aspects of a higher unity. Mysticism and theater were not so very separate.

1. Vasily Kandinsky, quoted in Lothar Schreyer, Erinnerungen an Sturm und Bauhaus. Was ist des Menschen Bild? (Hamburg and Berlin: Deutsche Hausbücherei, 1956), p. 229. On Schreyer's death houses see particularly the chapters "Das Totenhaus" (pp. 158–63) and "Die Ikone" (pp. 225–36).
2. Oskar Schlemmer, "Bühne," bauhaus 2, no. 3 (1927):1.
3. Schreyer, Erinnerungen, pp. 159–60.
4. Ibid., p. 160.
5. Ibid., p. 161.
6. Ibid., p. 162.
7. Schreyer's estate is preserved on long-term loan to the Bauhaus-Archiv Berlin.
8. Reproduced as Totenbild des Mannes in Walter Gropius, Staatliches Bauhaus Weimar 1919–1923 (Weimar and Munich: Bauhausverlag, 1923), plate 132.
9. Schreyer, Erinnerungen, p. 230.
10. Schreyer, Deutsche Mystik (Berlin: Deutsche Buchgemeinschaft, 1924), and Die Lehre des Jakob Böhme (Hamburg: Hanseatische Verlagsanstalt, 1923).
11. Schreyer, Die Lehre des Jakob Böhme, p. 55.
12. Schreyer, Erinnerungen, p. 158.

63
Lothar Schreyer
Design for Totenhaus des Mannes
(Death house for a man). 1922
(possibly executed around 1960)
Tempera on gray cardboard
18 7/8 x 12 3/8" (48 x 31.5 cm)
Bauhaus-Archiv Berlin

64
Lothar Schreyer
Design for Totenhaus des Mannes
(Death house for a man.
location unknown). c. 1922
Photograph: photographer unknown. n.d.
Gelatin silver print. Bauhaus-Archiv Berlin

65
Lothar Schreyer
Maria im Mond (Mary in the moon).
Costume design for Schreyer's play
Mondspiel (Moon play). 1923
Color lithograph on board
15 11/16 x 11 3/4" (39.8 x 29.8 cm)
Bauhaus-Archiv Berlin

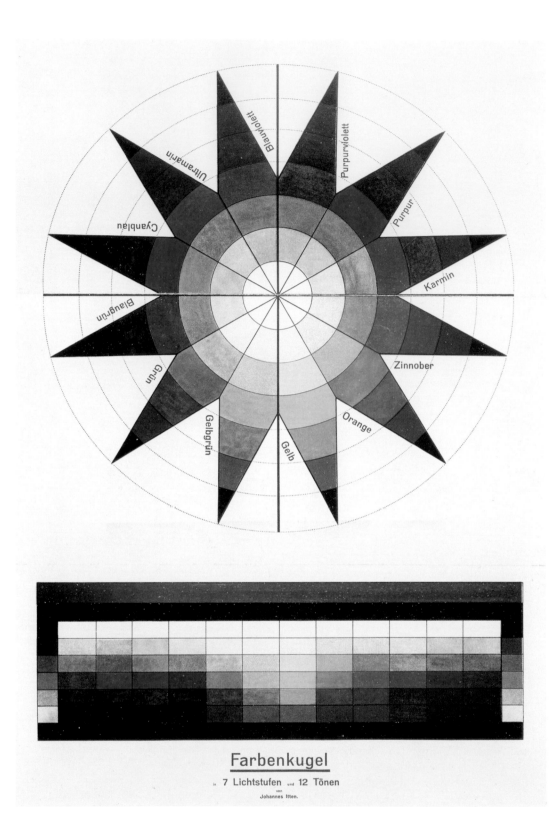

66
Johannes Itten
Farbenkugel in 7 Lichtstufen und 12 Tönen
(Color sphere in 7 light values and 12 tones).
From Bruno Adler, ed. *Utopia: Dokumente
der Wirklichkeit* (Weimar: Utopia, 1921)
Lithograph on paper
18 5/8 x 12 11/16" (47.3 x 32.2 cm)
Bauhaus-Archiv Berlin

67
Johannes Itten
Analysis of Meister Francke's *Adoration of
the Magi* (c. 1424). Foldout from Bruno Adler,
ed. *Utopia: Dokumente der Wirklichkeit*
(Weimar: Utopia, 1921)
Lithograph with printed tracing paper
adhered over central page
12 13/16 x 29 3/4" (32.6 x 75.5 cm)
Bauhaus-Archiv Berlin

68
Rudolf Lutz
Drawing after Matthias Grünewald's
Crucifixion, from the Isenheim Altarpiece
of c. 1512–16, for preliminary course taught
by Johannes Itten. c. 1919
Charcoal on paper
22 5/8 x 17 5/16" (57.5 x 44 cm)
Klassik Stiftung Weimar, Bauhaus-Museum

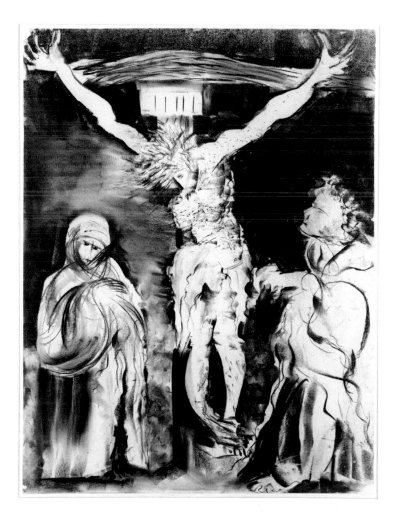

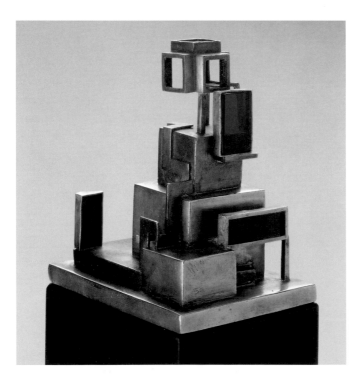

69 (above)
Rudolf Lutz
Relief study for preliminary course taught
by Johannes Itten. 1920–21
Plaster with wood frame
9 1/16 x 7 7/8" (23 x 20 cm)
Bauhaus-Archiv Berlin

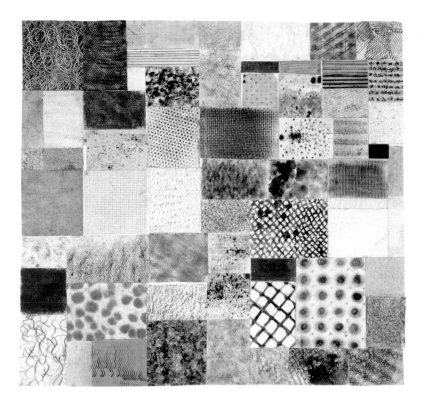

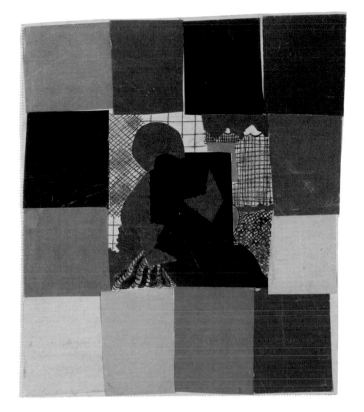

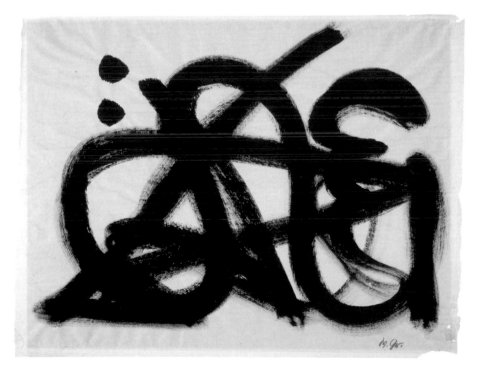

70 (opposite, below)
Naum Slutzky
Study for preliminary course taught
by Johannes Itten. 1920
Brass, copper, and red and blue glass
(with some replacement glass pieces)
2 ¾ x 2 ⅜ x 1 ⅞" (7 x 6.1 x 4.7 cm)
Collection Herbert Kloiber

71
Artist unknown
Texture study for preliminary course taught
by Johannes Itten. 1919
Cut-and-pasted papers with ink, pencil,
and watercolor on paper
12 ¹³/₁₆ x 13 ¹¹/₁₆" (32.6 x 34.7 cm)
Klassik Stiftung Weimar, Graphische
Sammlungen

72
Paul Citroën
Color analyis of a Madonna painting,
after an embroidery from Bavaria or Tyrol
of c.1800, for preliminary course taught
by Johannes Itten. c.1921
Cut-and-pasted colored paper, India ink,
and gouache on paper
9 ¼ x 7 ¹¹/₁₆" (23.5 x 19.5 cm)
Bauhaus-Archiv Berlin

73
Werner Graeff
Rhythmic study for preliminary
course taught by Johannes Itten. 1921–22
Black gouache on paper
22 ¹/₁₆ x 28 ¹⁵/₁₆" (56 x 73.5 cm)
Bauhaus-Archiv Berlin

The question of architecture was discussed at the Bauhaus from the first beginnings of the school. It appeared in the Bauhaus manifesto of April 1919 (cats. 38, 39) which described a "new structure…which will one day rise toward heaven…like the crystal symbol of a new faith" as the collective task of the new artist of the future.[1] And Walter Gropius wrote in a letter that same month, "I imagine a large *Siedlung* taking shape in Weimar, in the vicinity of Berg Belvedere, with a core of public buildings — theaters, a music center, and, as culmination, a house of worship. Every year in the summer there would be a big popular festival here, offering the best expressions of the new times in music, theater, and the figurative arts."[2] From the beginning, then, the Bauhaus was conceived not just as a school but as the germ of something more complex: a community of artists, craftspeople, and apprentices whose final task was the construction of its own *Siedlung* — a settlement, a community, a home. This was the same thing that the architect Bruno Taut was looking for in the concept of the *Stadtkrone*, or city crown, and what Heinrich Tessenow was experimenting with in the *Handwerkergemeinde*, a community of craftspeople that he founded in 1919 in the garden city of Hellerau.[3] From this perspective architecture was not just an academic subject at the Bauhaus but an ultimate goal, which may explain why Gropius put off establishing a department of architecture until 1927, nearly ten years after the school opened.

The new architecture, a collective, popular art and the meeting point for a variety of aesthetic expressions, would emerge, Gropius believed, in opposition to the "old view of the world that is based on classical culture" and would discover in the "darkness of the present time" a "new gothic, whose first symbols are appearing in expressionism."[4] The secret lore of the medieval Masonic guilds, and the numerical rules that had organized the proportions of the cathedrals, assumed for Gropius the sort of initiatory function occupied by theories of color and form in Johannes Itten's teaching of art. Thus the Bauhaus came to merge studies of medieval guilds, Julius Haase's numerological theories, August Thiersch's more academic research into architectural proportions, and the esoteric theosophical theories of J. L. M. Lauweriks (with whom Gropius's architectural partner Adolf Meyer had studied). Early attempts to formulate an architectural doctrine at the Bauhaus were characterized by techniques of triangulation and squaring; ideas about the symbolic meanings of the basic two-dimensional forms (triangle, square, circle) and the corresponding volumetric ones (pyramid, cube, sphere); and the study of harmonic rectangles and the golden section.

The participation of Gerhard Marcks, *Formmeister* of the Bauhaus pottery workshop, in the *Ausstellung für unbekannte Architekten* (the "exhibition of unknown architects," organized by the Arbeitsrat für Kunst in Berlin in April 1919), Itten's experiments with a "tower of fire" and other templelike structures, and the entries of both men in a competition for a monument to the *Märzgefallenen* (the "March dead," trade unionists who had died resisting a right-wing coup) in the autumn of 1920 all demonstrate the importance of architecture to the Bauhaus from the beginning.[5] Meanwhile Gropius clung to the idea of a *Bauhaus-Siedlung* on the Belvedere hill. He had spoken of the plan not only in that letter of 1919 but at the Arbeitsrat für Kunst, Berlin, the same month, proposing that he and Taut develop "a general concept for the *Siedlung*."[6]

No trace of such a project survives, however, and whether the plan of a student, Walter Determann, for a *Siedlung* to the south of Weimar is in any way connected to it is difficult to know. In any case this is the only architectural project developed by a Bauhaus student during the school's early period for which any documentation remains. Determann was one of a group of students who had enrolled in the Bauhaus after studying painting at the old Kunstakademie Weimar. His interest in architecture led him to take preparatory courses at the local *Baugewerkenschule* (professional building school), where the *Bauhäusler* were sent to make up for the absence of architecture courses at the Bauhaus itself.

Determann, whose entry of a project for a house/atelier in the *Ausstellung für unbekannte Architekten* suggests that he received particular attention from Gropius,[7] designed a settlement symmetrically distributed around a central plaza and dominated by a monumental crystal form resting on a heptagonal base (cat. 74). The settlement is completed along the top and bottom of the plan by a large administration and exhibition building (cat. 75) and a physical education building, while houses with gardens and workshops are arranged laterally. Gropius's influence is

74
Walter Determann
Site plan for *Bauhaus-Siedlung* (Bauhaus housing settlement), Weimar. 1920
Opaque paint on tracing paper
26 x 19 11/16" (66 x 50 cm)
Klassik Stiftung Weimar, Graphische Sammlungen. Gift of L. Determann

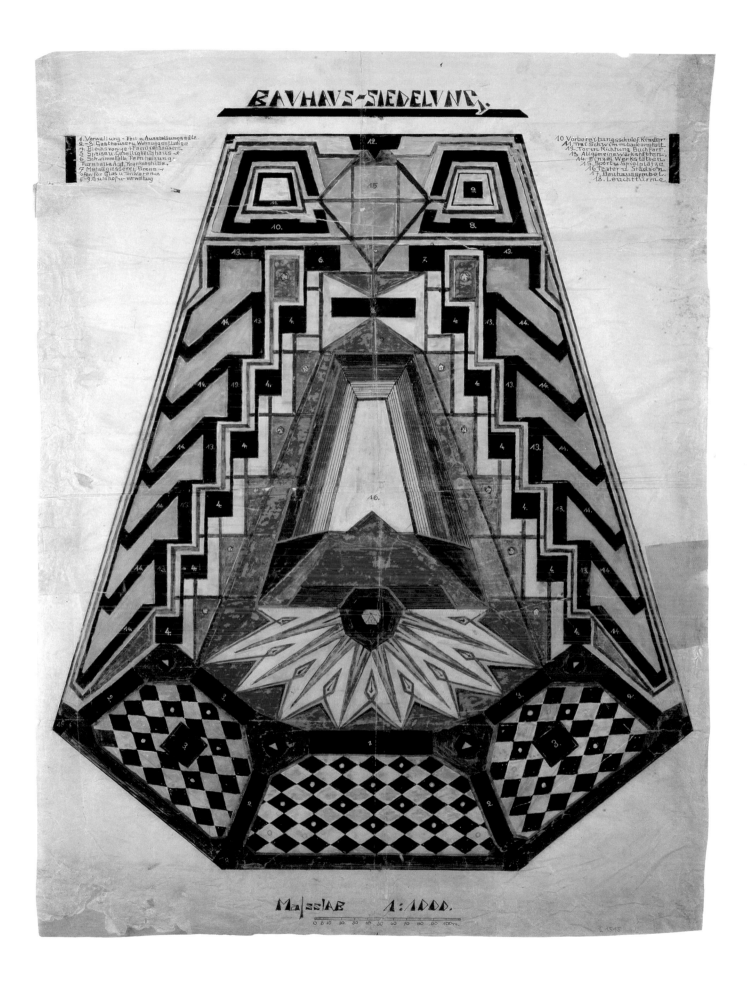

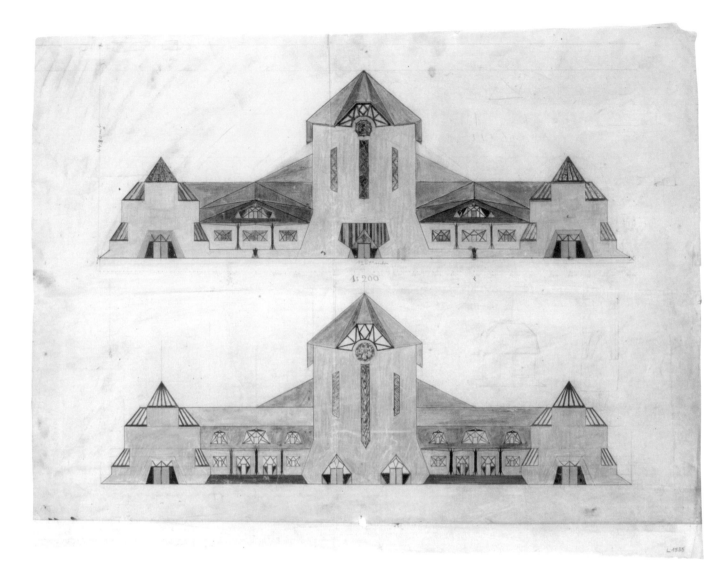

immediately recognizable: the plastic volumes are composed in golden sections and harmonic rectangles, while the motif of the crystal and the vivid polychrome treatment of the site plan give the project an "expressionist" nature. Albeit with the inevitable ingenuous touches of a young architect, Determann's *Siedlung* could almost be a literal illustration of Gropius's letter a few months earlier: a small, compact garden city of dwellings and workshops ringing a monumental group of public buildings that in turn surround a square conceived as a large open-air theater.

In late March of 1920, Gropius revived his plan for a *Bauhaus-Siedlung* when he asked the ministry of the interior for the state of Thuringia for help in addressing the housing shortage among the Bauhaus's nearly 200 students.[8] At the same time, he envisioned a useful educational exercise: the construction of simple wooden sheds, to be hand built by the students. On May 14 of that year it was suggested that the project might be located "*am Horn*," in the hills to the east of Weimar's grand-ducal park,[9] where an experimental house was in fact constructed for the school's exhibition in the summer of 1923.

Some, for example Adolf Behne, raised doubts about the dangers of isolating the Bauhaus community from the urban context. In response, Gropius argued for the need to face "the totality of life, that is *Siedlung*, children's education, fitness, and still other things,"[10] and he invited his teachers and students to put proposals "down on paper in whatever form" by October 15, so that the winter months could be used "for the development of definitive projects and perhaps to begin construction in the spring."[11] The appeal must have been unsuccessful, since a new deadline was established for January 2, 1921.

A second Determann project (cat. 76) is unfortunately the only contribution to this initial phase of the *Bauhaus-Siedlung* that is known to survive. It is completely different in approach from Determann's first project, whose compact geometries now dissolve in the hilly, wooded landscape. This *Siedlung* comprises sixteen units, wooden houses irregularly distributed over the terrain with neither a clearly recognizable street plan nor any large communal structures — a *Siedlung* of small, primitive buildings, romantically scattered in the natural environment.[12] A prototype can easily be detected in Gropius and Meyer's contemporary Sommerfeld House in Berlin (cats. 77–82), although, once again, the ingenuity of the layout fails to hide the inexperience of the young designer in providing livable space.

In the meantime much was happening at the Bauhaus. In 1921 the young Hungarian architect Fred Forbát, a former student of Theodor Fischer's in Munich, arrived in Weimar, and soon became the architect of the proposed *Bauhaus-Siedlung.* That same year Oskar Schlemmer joined the school and revived the discussion about the creation of an architecture department, which he proposed would "give a face to the entire Bauhaus" and at the same time justify the dominance of the visual arts in the school, "since I believe that the new architecture arises from painting. This has been and is the focal point of modern art. It has conquered sculpture and it is on the verge of taking possession of architecture."[13] It may be coincidental that in October 1922, when a designer had to be found for the first house in the *Bauhaus-Siedlung* — the Haus am Horn (cat. 23; p. 327, fig. 2) that would become the center of the Bauhaus exhibition of 1923 — even Gropius found himself approving the choice of a painter, Georg Muche. As he wrote to his friend Lily Hildebrandt, "This is the sense of the Bauhaus . . . that other artists might begin to tackle architecture."[14] The fact that Muche's design was extraordinarily close to one developed earlier by Forbát, an architect, matters little[15] — indeed it attests once again to Gropius's brilliant mix of the pragmatic and the visionary. The original idea of a *Bauhaus-Siedlung* not fundamentally different from the attempts at the "total artwork" seen earlier in the century in artists' colonies such as Darmstadt, and in garden cities such as Hellerau, had been transformed into the experiment of a completely functional prototype — one reproducible on a large scale through prefabrication — for the kind of rational house that is one of the most original features of the new European architecture of the 1920s.

1. Eng. trans. in Hans Maria Wingler, *The Bauhaus: Weimar, Dessau, Berlin, Chicago* (Cambridge, Mass.: The MIT Press, 1969), p. 31.

2. Walter Gropius, letter to Ernst Hardt, April 19, 1919, in Jochen Meyer and Tilla Goetz-Hardt, eds., *Briefe an Ernst Hardt* (Marbach: Deutsches Literaturarchiv, 1975), pp. 109–10.

3. See Bruno Taut, *Die Stadtkrone* (Jena: E. Diederichs, 1919; reprint ed. Berlin: Mann, 2002). On Heinrich Tessenow see, e.g., Marco De Michelis, *Heinrich Tessenow 1876–1950. Das architektonische Gesamtwerk* (Stuttgart: DVA, 1991).

4. Gropius, letters to Lily Hildebrandt, n.d., and to his mother, Manon Gropius, December 1919. Both Bauhaus-Archiv Berlin.

5. See Klaus-Jürgen Winkler, *Die Architektur am Bauhaus in Weimar* (Berlin and Munich: Bauwesen, 1993), and De Michelis, "1923. La questione dell'architettura," in De Michelis and Agnes Kohlmeyer, eds., *Bauhaus 1919–1933. Da Klee a Kandinsky, da Gropius a Mies van der Rohe,* exh. cat. (Milan: Fondazione Mazzotta, 1996), pp. 81–96.

6. See Gropius, letter to Adolf Behne, May 22, 1919. Bauhaus-Archiv Berlin. Mappe 6, Arbeitsrat für Kunst, Gropius Archive.

7. See De Michelis, "1923. La questione dell'architettura," p. 85 and note 30.

8. Gropius, letter to the Ministerium des Innern, Weimar, March 31, 1920. Akte 200, Staatliches Bauhaus, Staatsarchiv Weimar.

9. Protocol of the Bauhaus council of masters, May 14, 1920. Bauhaus-Archiv Berlin.

10. Gropius, letter to Behne, June 2, 1920. Mappe 8, Arbeitsrat für Kunst, Gropius Archive, Bauhaus-Archiv Berlin.

11. Gropius, letter to teachers, October 1, 1920. Akte 201, Staatliches Bauhaus, Staatsarchiv Weimar.

12. See Winkler, *Die Architektur am Bauhaus in Weimar,* pp. 79–81. The sequence of Walter Determann's two *Siedlung* projects is actually undocumented. It seems reasonable to consider the project for the wooded *am Horn* site the second, however, not only for stylistic reasons but because that site was not under discussion at the Bauhaus until May 1920.

13. Oskar Schlemmer, memorandum, December 9, 1921, published in German in Marcel Franciscono, *Walter Gropius and the Creation of the Bauhaus in Weimar: The Ideals and Artistic Theories of Its Founding Years* (Urbana, Chicago, and London: University of Illinois Press, 1971), Appendix F, p. 289.

14. Gropius, letter to Hildebrandt, February 17, 1923. Bauhaus-Archiv Berlin.

15. For Fred Forbát's design, dated 1922, see De Michelis and Kohlmeyer, eds., *Bauhaus 1919–1933,* p. 145. The design is now in the collection of the Arkitekturmuseet, Stockholm.

75
Walter Determann
Main administration and exhibition building (two views), *Bauhaus-Siedlung*, Weimar. 1920
Watercolor and ink over pencil on paper
24 11/16 x 31 5/16" (62.7 x 79.5 cm)
Klassik Stiftung Weimar, Graphische Sammlungen. Gift of L. Determann

76
Walter Determann
Site plan for *Bauhaus-Siedlung*, Weimar. 1920
Pencil and charcoal on tracing paper
23 5/8" x 8' 10 5/16" (60 x 270 cm)
Klassik Stiftung Weimar, Graphische Sammlungen. Gift of L. Determann

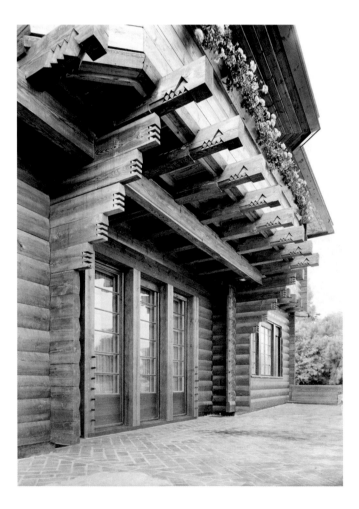

77
Walter Gropius and **Adolf Meyer**
Sommerfeld House, Berlin-Steglitz. 1920–21
(destroyed)
Exterior, garden side
Photograph: Carl Rogge. c. 1922–23.
Gelatin silver print. c. 6¹¹/₁₆ x 9¹/₁₆"
(17 x 23 cm). Bauhaus-Archiv Berlin

78
Martin Jahn
Program (front and back) for the ceremony
marking the completion of the structural
framework of the Sommerfeld House,
December 18, 1920
Lithograph on paper
29¹⁵/₁₆ x 10³/₈" (76 x 26.3 cm)
Bauhaus-Archiv Berlin

79
Walter Gropius and **Adolf Meyer**
Sommerfeld House, Berlin-Steglitz. 1920–21
(destroyed)
Terrace, garden side
Photograph: Carl Rogge. c. 1922–23.
Gelatin silver print. c. 9¹/₁₆ x 6¹¹/₁₆"
(17 x 23 cm). Bauhaus-Archiv Berlin

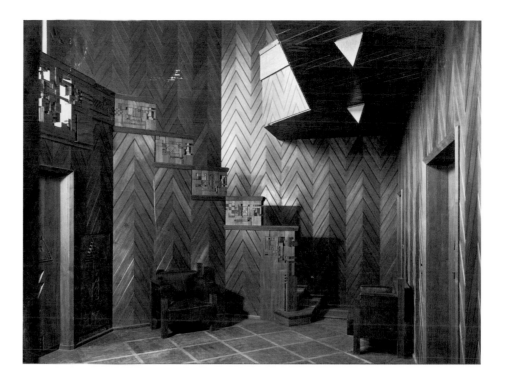

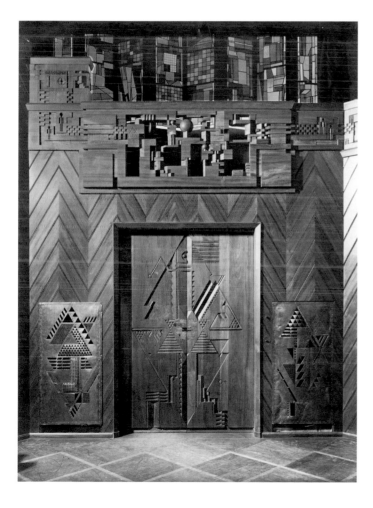

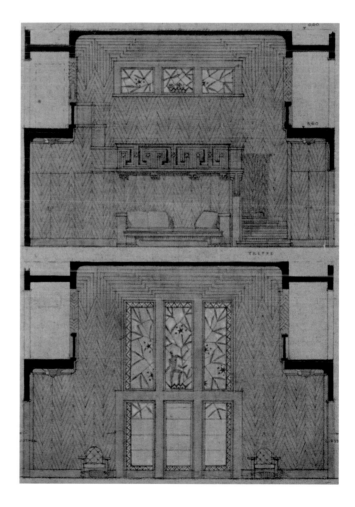

80
Walter Gropius and **Adolf Meyer**
Sommerfeld House, Berlin-Steglitz. 1920–21
(destroyed)
Entrance hall and stair, with wood-carvings
by Joost Schmidt and chairs by Marcel Breuer
Photograph: photographer unknown.
c.1922–23. Gelatin silver print. c. 6 11/16 x 9 1/16"
(17 x 23 cm). Bauhaus-Archiv Berlin

81
Walter Gropius and **Adolf Meyer**
Sommerfeld House, Berlin-Steglitz. 1920–21
(destroyed)
Entrance hall and door, with wood-carvings
by Joost Schmidt and stained-glass window
by Josef Albers
Photograph: photographer unknown.
c.1922–23. Gelatin silver print. c. 9 1/16 x 6 11/16"
(17 x 23 cm). Bauhaus-Archiv Berlin

82
Walter Gropius and **Adolf Meyer**
Sommerfeld House, Berlin-Steglitz. 1920–21
(destroyed)
Preliminary design for the vestibule
(two views). Drawing: Carl Fieger. 1920–21
Pencil, watercolor, and blueprint mounted
on cardboard
10 13/16 x 7 5/8" (27.5 x 19.4 cm)
Stiftung Bauhaus Dessau

JOSEF ALBERS
LATTICE PICTURE. 1921
PETER NISBET

Josef Albers made *Gitterbild* (Lattice picture, also known as Grid mounted) in 1921, when he was thirty-three.[1] Four years earlier, as his first venture in making art with glass, he had created a window for the newly built St. Michael's church in his native Bottrop (fig. 1); four years later he would embark on an extensive series of sandblasted glass panels featuring syncopated arrangements of stacked and staggered rectangles, many of them in black, white, and red. In this trajectory from the expressionistic religiosity of the Bottrop stained glass window, with its devotional inscription ("*Rosa mystica ora pr[o] nobis*," or "Mystical rose, pray for us") and irregular sunburst design, to the geometric abstraction and serial multiplicity of the Skyscrapers series (cats. 440–42), *Gitterbild* is a key transitional work that seems to embody, if not prefigure, the Bauhaus's institutional shift from the mystical subjectivism of Johannes Itten's years at the school to the machine aesthetic propagated by Walter Gropius and László Moholy-Nagy after 1923.

Gitterbild's regular grid of square pieces of colored glass, overlaid with a secondary grid of filigree wire, has not only a rich and intense luminosity but also an insistent materiality and structural logic. The glass pieces are held in place within an iron latticework armature by horizontal and vertical copper wires that evoke the warp and weft of weaving. With ten columns and eleven rows, the work is not exactly square, and there is an equivalent lively, undogmatic variety in the range of glass deployed: most of the tiles are monochrome, but some have mottled surfaces or speckled patterns (from putty residue on the reverse), and fourteen are backed by metal-mesh fragments of widely varying finenesses slotted between the copper wires and the glass. The opacity of the whitish milk-glass tiles obscures the horizontal wires, creating additional variety. Obviously handmade but executed under the neutralizing restraints of both chance (in the apparently random sequence of colors) and order (in the powerful motif of the grid), *Gitterbild* impressively balances — and maybe even synthesizes — these competing impulses. The radicality implicit in this early deployment of an even array of bounded, regular units within a predetermined format can be measured by comparison with similar but less rigorous work in colored grids by two of Albers's contemporaries: Theo van Doesburg's de Stijl windows of the late teens, and Paul Klee's watercolors and paintings of luminous color patches (cats. 85–88). Though only Klee taught at the Bauhaus, both men were living in Weimar in 1921.

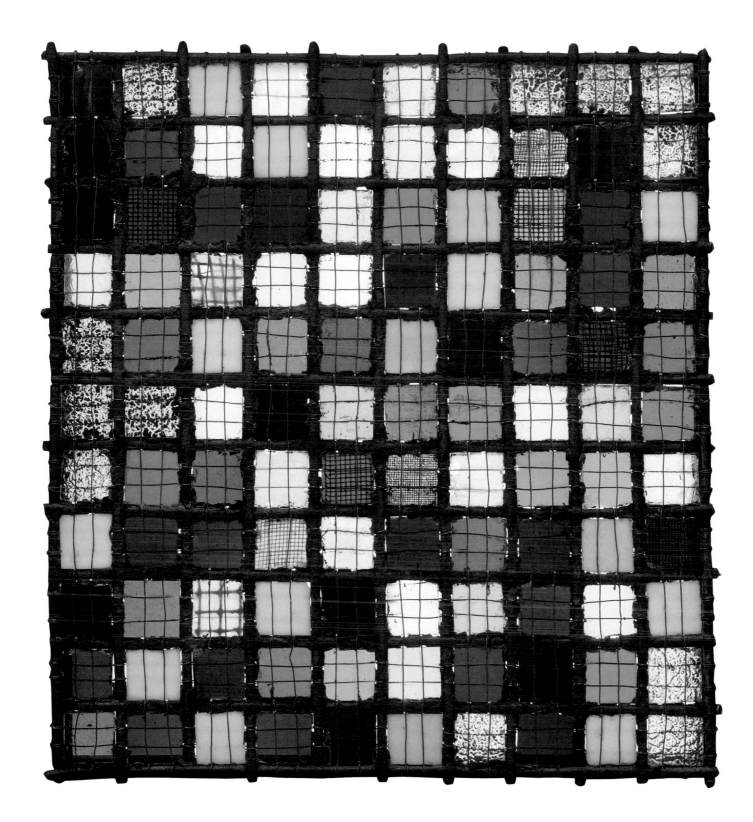

83
Josef Albers
Gitterbild (Lattice picture, also known
as Grid mounted). c. 1921
Glass, iron, and copper wire
13 1/8 x 11 7/8" (33.4 x 30.2 cm)
The Josef and Anni Albers Foundation,
Bethany, Conn.

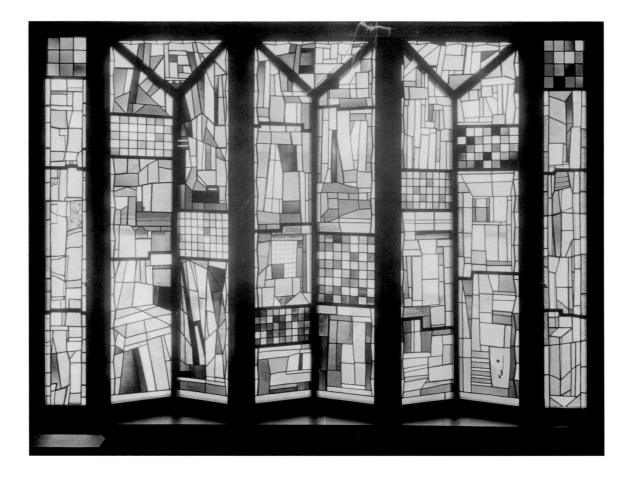

The stylistic progression of Albers's glass works parallels the arc of institutional frameworks that they served as elements in and for architecture. At around the same time that he made *Gitterbild*, as a student in the Bauhaus's small and short-lived glass workshop (for which he would be named technical master in late 1922, when Klee became the workshop's form master), Albers contributed glass windows, some with sections reminiscent of the present work, to two Berlin house commissions (most notably the Sommerfeld House) designed by Gropius and Adolf Meyer with assistance and contributions from Bauhaus colleagues and students (cat. 84). This secular but private context can be seen as a plausible intermediate stage between the sacred public environment of a Catholic church in 1917 and the lay public environments on which Albers worked in 1926–27: the workers' entrance hall of the massive production building of the Ullstein publishing company in Berlin, and the staircase of the Grassi museum of decorative arts in Leipzig, for both of which he designed large-scale, multipanel, abstract windows. These projects were well suited to the Bauhaus's later understanding of itself as a cultural and educational institution engaging with business and industry.

Given that Albers was the artist with the longest association with the Bauhaus — as student and teacher he was there from 1920 to 1933 — it is not surprising that a narrative of the school's development should be reflected in the work of this central figure. It is perhaps surprising, however, that this progression from expressionism to constructivism (loosely defined) should involve an undernoticed but essential detour through a brief but intense engagement with aspects of what we know as Dada. Immediately before making *Gitterbild*, Albers produced a handful of small glass pictures using shards of colored glass that he gathered from trash dumps around Weimar (cat. 93). Surely less a response to the lack of money and good materials and more an engagement with the aesthetics of the used and used-up quotidian object (bottles, commercial glass, costume jewelry), Albers's strategy is reminiscent of Kurt Schwitters's contemporary Merz project. Indeed, aspects of the glass assemblages further echo works by Schwitters in their use of printed paper fragments, their play of circular relief elements off contrasting, flatter rectilinear forms, and their vaguely cosmic allusions (fig. 2).[2] In these works — all apparently dating from 1921, Albers's first full year at the Bauhaus — one can construct a development

84
Josef Albers
Stained-glass window for the staircase of Walter Gropius and Adolf Meyer's Sommerfeld house, Berlin-Steglitz. 1920–21 (destroyed)
Photograph: photographer unknown. 1923.
Gelatin silver print. 6 11/16 x 9" (17 x 22.8 cm).
Bauhaus-Archiv Berlin

Fig.1
Josef Albers
Rosa mystica ora pr[o] nobis. 1917–18 (destroyed)
Stained-glass window for St. Michael's church, Bottrop, Germany
Executed by Puhl & Wagner-Gottfried Heinersdorf, Berlin
Photograph: photographer unknown, n.d.
Gelatin silver print. 7 1/4 x 5 1/16" (18.5 x 12.9 cm).
The Josef and Anni Albers Foundation, Bethany, Conn.

Fig.2
Kurt Schwitters
Konstruktion für edle Frauen (Construction for noble ladies). 1919
Cardboard, wood, metal, and paint
40 1/4 x 33" (102.0 x 83.8 cm)
Los Angeles County Museum of Art. Purchased with funds provided by Mr. and Mrs. Norton Simon, the Junior Arts Council, Mr. and Mrs. Frederick R. Weisman, Mr. and Mrs. Taft Schreiber, Hans de Schulthess, Mr. and Mrs. Edwin Janss, and Mr. and Mrs. Gifford Phillips

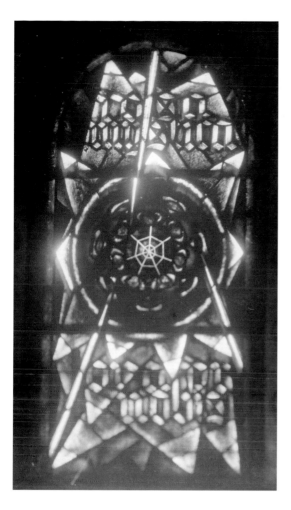

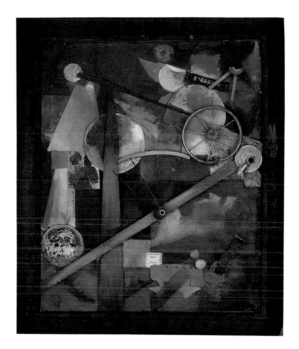

away from figurative and narrative underpinnings (in works that once carried the titles *Mensch* [Man] and *Legende* [Legend]) through decorative agglomeration (*Fensterbild* [Window picture]) toward a more conceptual reflection on composition and construction (*Scherbe ins Gitterbild* [Glass fragments in grid picture; cat. 93]).

The consistent deployment of found fragments of broken and discarded rubbish in these works throws into stark relief the key shift represented by *Gitterbild*, which Albers made using new, unused pieces of glass, manufacturer's samples that he is known to have requested from large firms in Berlin.[3] Although also in a sense found objects, these small squares (cut down to size by Albers) are not simply at the opposite end of the use chain from the discards, they actually stand outside it, for they are samples, intended not to be consumed but to promote consumption. They are models of prototypical colored glass, not intended for use in the world. At once ideal exemplars and an inventory of manufactured, industrial color, these tesserae fit perfectly with the iron grid, which too is both the ideal format of modernist imagining and a crude, found metal armature.

The body of work in glass that Albers produced at the Bauhaus has been overshadowed by his widely influential pedagogy as one of the instructors of the school's famous preliminary course. Yet Albers was picking up the German avant-garde understanding of glass as a quintessentially utopian and spiritual material, a tradition exemplified by Bruno Taut's Glass House for the Deutscher Werkbund exhibition in Cologne in 1914 (p. 141, fig. 1). In doing so Albers found a way to revitalize an Expressionist legacy, creating in *Gitterbild* a paradigm of

color and structural relationships that might propose a model of the artist/designer as working not just with the materials of everyday life but with the ideal as well as the real, in order to stimulate change in the individual and in society.

1. For her generous assistance I warmly thank Brenda Danilowitz, of The Josef and Anni Albers Foundation, Bethany, Conn., whose essential publications provide the basis for the factual information in this essay. See especially her "Catalogue" in *Josef Albers: Glass, Color, Light*, exh. cat. (New York: The Solomon R. Guggenheim Foundation, 1994), pp. 27–127 (together with her "Appendix of Destroyed and Lost Works" and "Appendix of Works in Glass for Architectural Projects" in the same volume); her essay in Bauhaus-Archiv Berlin, Stiftung Bauhaus Dessau, and Klassik Stiftung Weimar, eds., *Modell Bauhaus* (Ostfildern: Hatje-Cantz, forthcoming in 2009), and "From Symbolism to Modernism: The Evolution of Josef Albers's Architectural Glass Works" in *Josef Albers. Vitraux, dessins, gravures, typographie, meubles* (Paris: Editions Hazan, and Le Cateau-Cambrésis: Musée départemental Matisse, 2008), pp. 169–81, 226. Oliver Barker kindly spent several hours introducing me to the resources of the Albers Foundation. While acknowledging open questions about the orientation (front/back as well as rotational) and dating of *Gitterbild*, I have followed the established convention.
2. László Moholy-Nagy, who underwent a parallel development from expressive subjectivism to constructivist objectivity, was similarly engaged with putting together found objects around 1921, in his case cast-off metal pieces. See my "An icon between radical and conventional. László Moholy-Nagy's Nickel Sculpture," in Bauhaus-Archiv Berlin, Stiftung Bauhaus Dessau, and Klassik Stiftung Weimar, eds., *Modell Bauhaus*, and cat. 148 in the present volume.
3. See Danilowitz, "From Symbolism to Modernism," p. 172.

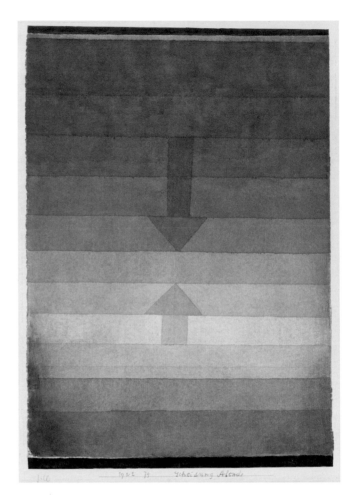

85
Paul Klee
Architektur der Ebene
(Architecture of the plane). 1923
Watercolor and pencil on paper, bordered
above and below with watercolor and ink,
on cardboard
11 x 7 1/8" (28 x 18.1 cm), irreg.
Staatliche Museen zu Berlin, Nationalgalerie,
Muse m Berggruen

86
Paul Klee
Scheidung Abends
(Separation in the evening). 1922
Watercolor and pencil on paper, bordered
above and below with watercolor and ink,
on cardboard
13 3/16 x 9 1/8" (33.5 x 23.2 cm)
Zentrum Paul Klee, Bern. Livia Klee Donation

87
Paul Klee
Gegensätze Abends
(Contrasts in the evening). 1924
Oil transfer drawing on paper with
watercolor, ink, and pencil on board,
with watercolor and ink borders
9 1/16 x 14 3/8" (23 x 36.5 cm)
Private collection

88
Paul Klee
Maibild (May picture). 1925
Oil on cardboard nailed to wood
with original strip frame
16 3/8 x 19 1/2" (41.6 x 49.5 cm)
The Metropolitan Museum of Art, New York.
The Berggruen Klee Collection

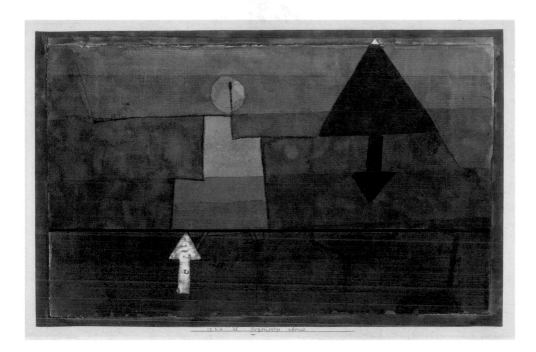

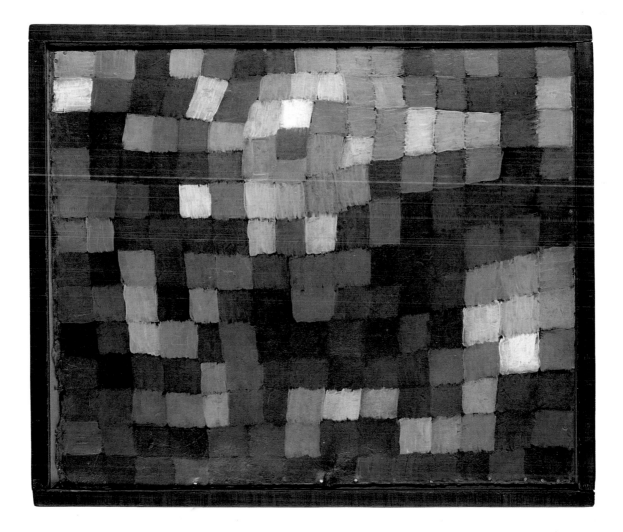

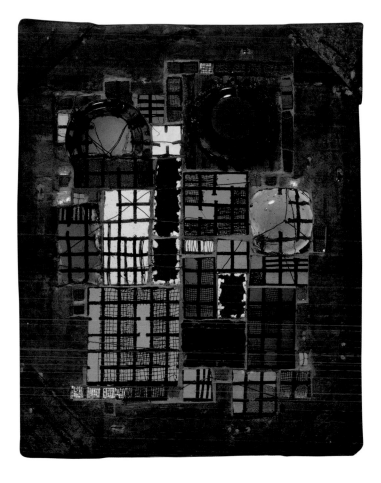

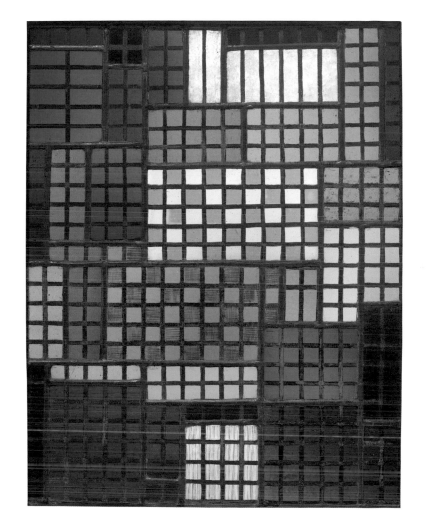

89–92
Gertrud Arndt
Exercises for color theory course
taught by Paul Klee. 1923–24
Watercolor and india ink over pencil
Each: 13 x 8 11/$_{16}$" (33 x 22 cm)
Bauhaus-Archiv Berlin, on long-term
loan from the Arndt family

93
Josef Albers
Scherbe ins Gitterbild
(Glass fragments in grid picture). c.1921
Glass, wire, and metal, in metal frame
15 3/$_8$ x 13 1/$_8$" (39 x 33.3 cm)
The Josef and Anni Albers Foundation,
Bethany, Conn.

94
Josef Albers
Park. 1924
Glass, wire, metal, and paint, in wood frame
19 1/$_2$ x 14 15/$_{16}$" (49.5 x 38 cm)
The Josef and Anni Albers Foundation,
Bethany, Conn.

MARCEL BREUER AND GUNTA STÖLZL
"AFRICAN" CHAIR. 1921
CHRISTOPHER WILK

An example of Bauhaus student work, the "African" chair is the earliest surviving piece of Bauhaus furniture, one of a handful of early objects remaining from the school and one that uniquely brings its first years to life. And yet it is shrouded in mystery: shortly after its making, in 1921, the chair disappeared, resurfacing only in 2004.[1] There are virtually no contemporary records relating to its making, its possible symbolic meaning, or the nature of the collaboration between the makers of its frame and its upholstery; nor, apparently, was it the subject of contemporary commentary. The chair was never exhibited in any Bauhaus exhibition during the school's existence (or, indeed, before 2004), and it was illustrated only once in a Bauhaus publication, in a tiny black-and-white image, part of a mocked-up filmstrip (cat. 96). In an unpublished photo album compiled at the Bauhaus in 1923–24 the same image was enigmatically captioned "*Romantischer Lehnstuhl — Marcel Breuer*" (Romantic armchair — Marcel Breuer).[2] It was not published as the "African" chair until 1949, although at that point it was Breuer who so named it.[3]

The design of this five-legged chair, and the constructional and decorative techniques of its making, were clearly intended to stand apart from those of contemporary European furniture. The chair is thronelike or ceremonial, a quality reinforced by its head-on presentation in the original photograph.[4] The frame and seat are made of thick, solid pieces of wood, and most of the surfaces have been crudely cut with an adze, a chisellike wood-cutting tool worked like an axe and traditionally used to shape surfaces. The patterning with the repeating marks of the adze are an unusual, highly visible, and very self-conscious reminder of the chair's method of making and a feature not easily seen in photographs. (While the roughness is undoubtedly intentional, Breuer does not seem to have been a skilled woodworker). Additional decoration is provided by stripes of color, applied as paint and stain, which contrast with the color of the natural wood, in addition to the richly patterned and colored textiles.

Gunta Stölzl's upholstery, consisting of a seat cushion with a tapestry-woven top and a large, similarly woven panel across the back, is an integral part of the chair and shares a design vocabulary with the frame. Although accomplished, the coarse texture and irregular abstract design depart from the usual aesthetic conventions of contemporary European weaving. (Abstraction, of course, was a key tenet of Bauhaus teaching.) Stölzl described the weaving technique as "gobelin," a term for traditional tapestry-making, but in the case of the back she wove directly onto the warp threads, which were laced through three upright posts of the chair back, rather than on a loom, and without any repetition of the pattern.[5] Most if not all of the chair frame must have been complete by the time the weaving began, presenting a considerable physical challenge to the weaver given the chair's size and weight and the fact that the middle back upright does not sit on the same plane as the outer two. The hemp warp threads, some undyed, some red, were left exposed against the wooden frame to striking effect. Not only do both woodwork and textile eschew the use of anything but the simplest methods of hand production, they also aim to highlight the preindustrial nature of the design and especially what contemporaries would have called its "primitive" character.

In his monograph on Breuer of 1949, Peter Blake claimed that the chair's design derived from "Hungarian peasant furniture," and this may in part account for its form and for its primitivism.[6] Although the example he illustrated seemed unrelated to the design (perhaps because photographs of more relevant chairs were hard to find), the Hungarian-born Breuer must have acknowledged or even suggested this source. Folk arts were widely taught in Hungarian schools and books on them were published during Breuer's youth. Contemporary architects and designers actively researched the subject, producing designs (sometimes roughly carved) that reflected colorful peasant furniture or wood carving and introducing a decidedly primitivist vocabulary into their work.[7] In addition, during the decade before Breuer made his chair, leading Hungarian architects made numerous examples of monumental, thronelike chairs, which he may well have known (fig. 1).[8] Blake also claimed that the chair's upholstery was "strikingly reminiscent of the patterns of Magyar peasant weaving," but Stölzl wrote in the 1960s that she was unfamiliar with Magyar weavings in 1921.[9]

The chair's totemic quality may relate not only to handcrafted Hungarian furniture and wood carving but also to the contemporary interest in non-European "primitive" material cultures. For more than a decade before the chair was made, German Expressionist artists of the Brücke school had painted and carved works of art, and designed interiors and furniture, inspired by art and decorations from Africa, Asia, and Oceania, some of which they studied firsthand in German museums.[10] Bauhaus students and teachers had close links to avant-garde and specifically Expressionist circles in Germany, and they knew the primitivizing French Cubist art of the period. Though Breuer called this his "African" chair and Stölzl later called it the "Negro" chair, it seems unlikely that it recalls any specific African model: African chairs with backs are rare, and examples with high backs that were not themselves based on European models are virtually unknown.[11] The European, vernacular tradition of Viking

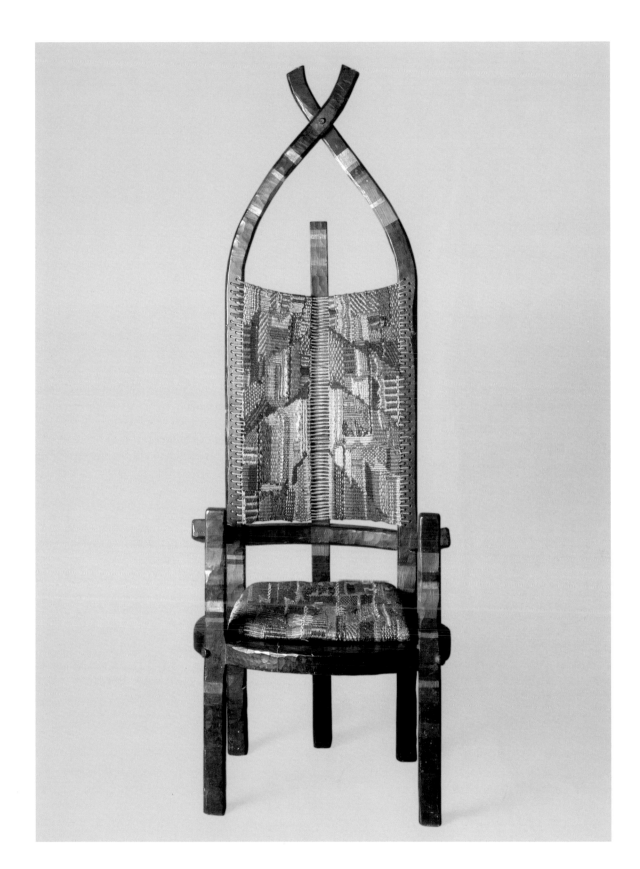

95
Marcel Breuer with textile by
Gunta Stölzl
"African" or "Romantic" chair. 1921
Oak and cherrywood painted with water-soluble
color, and brocade of gold, hemp, wool, cotton, silk,
and other fabric threads, interwoven by various
techniques with twined hemp ground
70 5/8 x 25 9/16 x 26 7/16" (179.4 x 65 x 67.1 cm)
Bauhaus-Archiv Berlin. Acquired with the support
of the Ernst von Siemens Kunststiftung

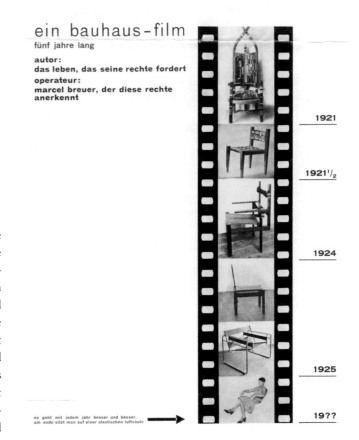

ein bauhaus-film

fünf jahre lang

autor:
das leben, das seine rechte fordert
operateur:
marcel breuer, der diese rechte
anerkennt

1921

1921¹/₂

1924

1925

es geht mit jedem jahr besser und besser.
am ende sitzt man auf einer elastischen luftsäule

19??

or Saxon longhouses, specifically their roof apexes, may have provided the model for the crossed uprights at the top of the chair. In any case, whether or not Breuer and Stölzl were working from specific sources — in Hungarian folk crafts, German Expressionism, or older European traditions, from firsthand knowledge or from a publication — the chair clearly reflects the contemporary artistic interest in the primal vitality (not least in the Nietzschean sense) and "authenticity" of hand-crafted Western and non-Western ethnographic art and design. Artists looked to the visual qualities of such work, but also to its spirit and what they would have perceived as its antibourgeois character. It was surely these generic qualities that Breuer and Stölzl sought to reflect in this chair, and that the names "Romantic" and "African" signified.

Of particular importance to the chair's design may have been the Bauhaus teacher Johannes Itten, who taught both Breuer and Stölzl. A painter and educator, Itten was the charismatic and influential Bauhaus teacher who established its preliminary course, which, in an early form, Breuer and Stölzl would have attended.[12] He was also form master (effectively, artistic director) of six Bauhaus workshops, including woodworking and weaving, and designed examples of both furniture and textiles. He was known for his dedication and expertise as a teacher, for his emphasis on the spiritual dimensions of art practice, and for his incorporation of breathing and physical exercises into his classes, and his presence and influence were such that he must have played a role in the gestation of the chair. It is difficult to imagine, for example, that his strong interest in color theory was not a factor in its unusual striped decoration, potentially an important symbolic aspect of the design.[13] In addition, there is a parallel between Itten's encouraging his students to use old master paintings as the source of "essential" feeling in their work and the similarly inspirational role that peasant or African forms may have played in Breuer's and Stölzl's conception.

Itten taught both designers from the time of their arrival at the Bauhaus, at the ages of eighteen (Stölzl) and nine-

teen (Breuer). Although Stölzl had experience as a weaver and had spent two years at the school by the time the chair was made, Breuer had probably been at the Bauhaus for less than a year, and had little art education other than a brief and unsuccessful stint at art school in Vienna. In a diary entry shortly before the making of the chair, Stölzl acknowledged Itten's role in her development; Breuer later described Itten as a "kind of magician" who had "a very powerful" influence on the early Bauhaus, though Breuer was not personally sympathetic to him.[14]

Itten was not alone among the Bauhaus community in his interest in the spiritual power of art and design, as well as in older forms of art or design. Walter Gropius was closely involved in Expressionist architectural circles in Berlin, and his Bauhaus manifesto, with its call for a brotherhood of craftsmen who would build the "crystal symbol of a new faith," reflected the spirituality and hope of the postwar years. In 1922, however, Itten resigned, effectively forced out of the Bauhaus by Gropius, who the year before had begun to shift the school's orientation decisively away from the self-consciously handmade to design intended for production, from what might be called a more spiritual and expressive attitude to the rationalist, constructivist aesthetic that came to dominate the Bauhaus from 1923 onward. A seemingly crude, primitivizing, highly decorated chair such as this one did not accord with the image of the Bauhaus that Gropius wished to present, as a crucible where art and technology formed "a new unity." Breuer's subsequent furniture, including examples with upholstery by Stölzl (cat. 98), followed the school's new direction more closely.

The "filmstrip" that established the chair's place in Bauhaus historiography was published in 1926 (cat. 96). Presumably designed and captioned by Breuer, it cast the chair in the role of starting point for a story of technological progress from

96
Marcel Breuer
ein bauhaus-film. fünf jahre lang
(a bauhaus film. five years long)
As reproduced in *Bauhaus* 1, no. 1
(December 4, 1926)
Bauhaus-Archiv Berlin

Fig.1
Ede Toroczkai-Wigand
Perosz Tószék (Seat of justice)
As reproduced in Toroczkai-Wigand,
Hajdonába/régös-régön… (In olden times,
long, long ago). Budapest: Táltos, 1917
The Museum of Modern Art Library
New York

the handcrafted unique object to mass-producible ones, and finally to an imagined future in which technology would dispense with the need for chairs, allowing a person to sit, as the caption states, on a "resilient column of air." The images also suggest another implied progress, an aesthetic development from the archetypal, thronelike form of the "African" chair to rectilinear geometric constructions and finally to the realm of abstraction. The 1921 chair thus entered Bauhaus history only in 1926, five years after its design, and did so as a foil for later work rather than as a design valued in its own right. Under Gropius's guidance it was effectively written out of chronicles of the Bauhaus, including not only the MoMA exhibition of 1938 but also most later publications and exhibitions.[15]

1. Christian Wolsdorff, writing after contact with the former owner of the chair, suggests that it was probably sold by 1922 to a family living in Ilmenau, near Weimar, with whom it remained until 2004. See Wolsdorff, "Der Afrikanische Stuhl," Museums Journal (Berlin), no. 3 (2004):40.

2. Bauhaus presentation album, vol. II, p. 1, Bauhaus-Universität, Weimar. Published as Klaus-Jürgen Winkler, Bauhaus Alben 1 (Weimar: Verlag der Bauhaus-Universität, 2006), p. 77. Wolsdorff speculates that the name refers to a relationship between Marcel Breuer and Gunta Stölzl; "Der Afrikanische Stuhl," p. 41, n. 1. The term "romantic," however, was clearly used at the Bauhaus by 1923 to identify work at odds with the school's orientation: see, for example, Walter Gropius's draft circular of 1922 addressed to Bauhaus masters in which he used the words "romantic island" and "wild romanticism" to criticize a tendency at the school to reject a more industrial, less art-for-art's-sake orientation. The document is translated in Hans Maria Wingler, The Bauhaus: Weimar, Dessau, Berlin, Chicago (Cambridge, Mass: The MIT Press, 1969), pp. 51–52.

3. Peter Blake, Marcel Breuer (New York: The Museum of Modern Art, 1949), p. 16. "Breuer calls this his African chair," Blake wrote, perhaps implying that the name was long-standing if informal. In the 1920s and '30s it was rare to give a chair a name or title. This was a marketing phenomenon of the post–World War II period, when Blake's book was published.

4. The chair's overall proportions recall European ceremonial or commemorative chairs, including masonic chairs and those shown in nineteenth-century international expositions. Wolsdorff suggests that the chair could have been "a ceremonial chair for the lead Master of the Bauhaus"; "Der Afrikanische Stuhl," p. 40. There is no evidence, however, that such a chair was used in this role.

5. Stölzl described the upholstery and claimed authorship of the textile in an attachment to a letter to Wingler, January 7, 1964, following the publication of his monumental monograph, Das Bauhaus 1919–1933. Weimar Dessau Berlin (Bramsche: Gebr. Rasch, 1962), in which he had credited only Breuer for the chair. See "Einige Bemerkungen zum Bauhausbuch von Ihnen," in the file "Stölzl, Gunta (1897–1983) 1964–1973 2," Bauhaus-Archiv Berlin.

6. Blake, Marcel Breuer, p. 16. Dörte Nicolaisen, in "Hoe Afrikaans is de 'Afrikaanse Stoel'? Enkele opmerkingen over exotisme in het vroege Bauhaus," Desipientia, zin & waan 13, no. 1 (April 2006):15, claimed that no Hungarian comparisons could be found.

7. Breuer came from a cultured Hungarian family with an interest in the arts; see my Marcel Breuer: Furniture and Interiors (New York: The Museum of Modern Art, 1981), p. 15. I am grateful to Juliet Kinchin for sharing her knowledge of early-twentieth-century Hungarian design, which informs my discussion of this topic. See her essay "Hungary: Shaping a National Consciousness," in Wendy Kaplan, ed., The Arts & Crafts Movement in Europe and America (Los Angeles: Los Angeles County Museum of Art, and New York: Thames & Hudson, 2004), pp. 142–77, which usefully summarizes practices and sources.

8. See, for example, the chair designed by Ede Toroczkai-Wigand, reproduced in his Hajdonába régös-régön (Budapest: Táltos, 1917), n.p., which appeared in a stained-glass window in the palace of culture, Marosvásárhely (now Romania); and the throne by Emil Töry and Móric Pogány for the cupola hall at the Turin exhibition of 1911, illustrated in Panorama: Architecture and Applied Arts in Hungary 1896–1916 (Kyoto: National Museum of Modern Art, 1995), pp. 170, 172. The same hall was decorated with primitivizing architectural ceramic and glass detail made by the Zsolnay firm in the town of Pécs, Breuer's birthplace.

9. Blake, Marcel Breuer, p. 16. Stölzl, attachment to the letter to Wingler, January 7, 1964.

10. On this large topic see Jill Lloyd, German Expressionism: Primitivism and Modernity (New Haven and London: Yale University Press, 1991). For Kirchner's furniture see Wolfgang Henze, Die Plastik Ernst Ludwig Kirchners (Wichtrach/Bern: Henze & Ketterer, 2002), figs. 186–7, 198, 200, and 214. See also Christian Weikop, "The Arts and Crafts Education of the Brücke: Expressions of Craft and Creativity," in Journal of Modern Craft no. 1 (2008), especially pp. 89–94.

11. Blake, Marcel Breuer, p. 16, n. 3. Stölzl used the term "the Negro chair" in her article "In der Textilwerkstatt des Bauhauses 1919 bis 1931," Das Werk 55, no. 11 (November 1968):746, but she may simply have been following Breuer's usage.

12. See Willy Rotzler, ed., Johannes Itten. Werke und Schriften (Zurich: Orell Füssli, 1972), especially Itten's "Autobiographisches Fragment," p. 32; and Rainer K. Wick, Teaching at the Bauhaus (Ostfildern-Ruit: Hatje Cantz, 2000), chapter 5.

13. In "Der Afrikanische Stuhl," pp. 40–41, Wolsdorff hypothesizes that the colors and geometric shapes of the chair's parts (circular seat, square cushion), and its five legs, may refer, in several possible interpretations, to an alleged love affair between Breuer and Stölzl. The article provides no sources for this reading, nor do such theories at all explain the chair's significant primitivism.

14. Stölzl, diary for September 1919–autumn 1920, p. 35, quoted in Magdalena Droste, ed., Gunta Stölzl Weberei am Bauhaus und aus eigener Werkstatt (Berlin: Bauhaus-Archiv, 1987), p. 10. See also Sigrid Wortmann Weltge, Bauhaus Textiles (London: Thames & Hudson, 1993), chapter 5, on Itten and the weaving workshop. The Breuer quotations come from a 1974 interview, in French, conducted by Les Archives du XXième Siècle, Archives of American Art, Series 4, Reel 5718, frame 547, at http://www.aaa.si.edu/collectionsonline/breumarc/series4.htm, which I consulted on December 15, 2008.

15. See Herbert Bayer, Walter Gropius, and Ise Gropius, eds., Bauhaus 1919–1928 (New York: The Museum of Modern Art, 1938), p. 40, where the chair does not appear among illustrations of the earliest work from the "Carpentry Workshop." Its first substantive publication in the historical literature appears in Wingler, The Bauhaus, p. 280.

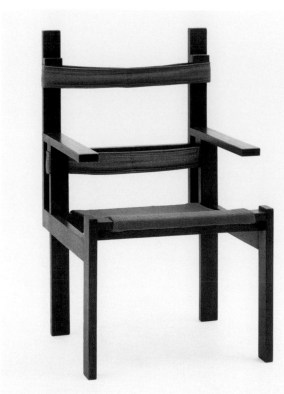

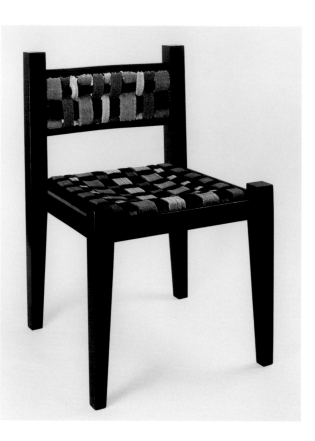

97
Marcel Breuer
Armchair (later titled TI 1a). Designed 1922,
this example produced c.1924
Oak and hand-woven wool
37¼ x 22 x 22½" (94.6 x 55.9 x 57.2 cm)
The Museum of Modern Art, New York.
Phyllis B. Lambert Fund

98
Marcel Breuer with textile by
Gunta Stölzl
Chair. 1921
Birch and black lacquer, with woven
colored webbing
29¾ x 19⁵⁄₁₆ x 19⁵⁄₁₆" (75.5 x 49 x 49 cm)
Klassik Stiftung Weimar, Bauhaus Museum

99
Walter Gropius
Newspaper shelf. Designed 1923,
this example produced for the Oeser
apartment, Berlin, 1928
Mahogany veneer on plywood, wood glue,
coniferous wood, and plate glass top
33¹¹⁄₁₆ x 69 x 26 ¾" (85.5 x 160 x 68 cm)
Bauhaus-Archiv Berlin

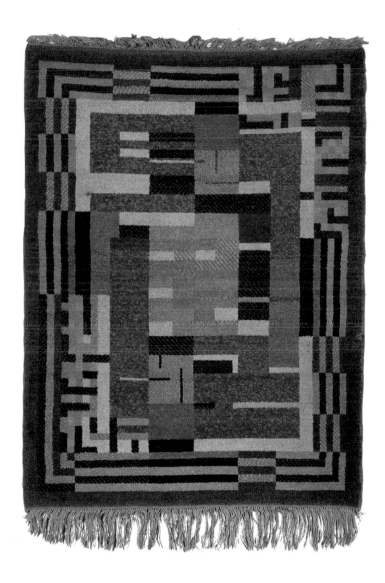

100
Bengt von Rosen
Writing desk. 1923–24
Cherrywood
51 x 32 $^5/_{16}$ x 17 $^5/_{16}$" (129.5 x 82 x 44 cm)
Klassik Stiftung Weimar, Bauhaus-Museum

101
Benita Koch-Otte
Carpet. c. 1923
Wool and jute
6' 8 $^{11}/_{16}$" x 59 $^{13}/_{16}$" (205 x 152 cm)
Klassik Stiftung Weimar, Bauhaus-Museum

102
Paul Klee
Mystisch-Keramisch (I. D. Art eines Stilllebens)
(Mystical ceramic [in the manner of a still life]).
1925
Oil on black ground on thin board,
with original strip frame
13 x 18¾" (33 x 47.6 cm)
Private collection. Courtesy Neue Galerie
New York

103
Otto Lindig
Jug. 1922
High-fired glazed earthenware,
free-thrown and assembled
Height: 19 ¹¹⁄₁₆" (50 cm)
Klassik Stiftung Weimar, Bauhaus-Museum

104
Otto Lindig
Jug. 1922
High-fired glazed earthenware,
free-thrown and assembled
Height: 18 ¹⁄₈" (46 cm)
Klassik Stiftung Weimar, Bauhaus-Museum

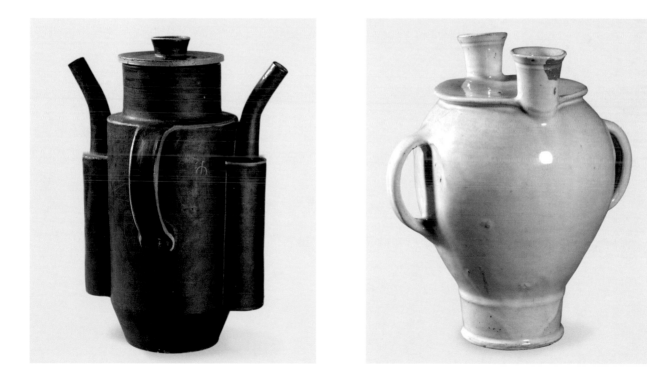

105
Gerhard Marcks
Tile for the stove in the house of the
Bauhaus ceramics instructor in Dornburg,
with a portrait of Otto Lindig. c. 1921
High-fired glazed earthenware
7 5/16 x 7 5/16 x 1 1/4" (18.6 x 18.6 x 3.2 cm)
Klassik Stiftung Weimar, Bauhaus-Museum

106
Theodor Bogler with slip decoration by
Gerhard Marcks
Double pitcher. 1922
High-fired glazed earthenware,
free thrown and assembled with painted
slip decoration
Height: 12 1/2" (31.8 cm)
Klassik Stiftung Weimar, Bauhaus-Museum

107
Theodor Bogler
Double pitcher. 1922
High-fired glazed earthenware,
free-thrown and assembled
Height: 9 1/16" (23 cm)
Klassik Stiftung Weimar, Bauhaus-Museum

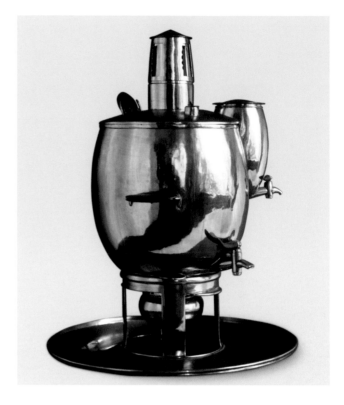

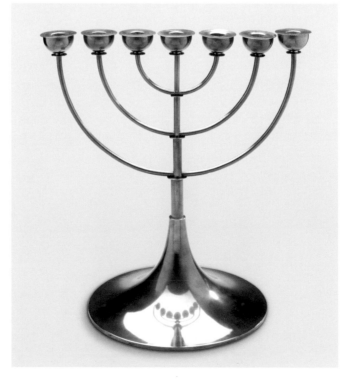

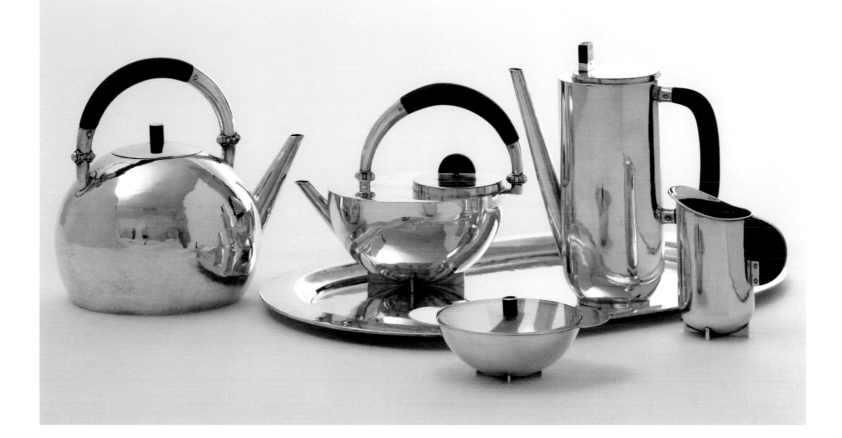

108
Christian Dell
Wine pitcher. 1922
Nickel silver and ebony
Height: 7 15/16" (20.1 cm)
Bauhaus-Archiv Berlin

109
Carl Jakob Jucker
Samovar (MT 1). 1922
Brass, partially silver plated,
wooden handles, and silver tea filter
Height: 19 5/16" (49 cm), tray diam.:
14 3/16" (36 cm).
Bauhaus-Archiv Berlin

110
Gyula Pap
Seven-branch candelabra with
movable arms. 1922
Brass
16 1/2 x 16 7/8" (41.9 x 42.9 cm)
The Jewish Museum, New York. Purchase:
Hubert J. Brandt Gift in honor of his wife,
Frances Brandt; Judaica Acquisitions Fund;
Mrs. J. J. Wyle, by exchange; Peter Cats
Foundation, Helen and Jack Cytryn,
and Isaac Pollak Gifts

111
Marianne Brandt
Coffee and tea set (MT50, MT51, MT52,
MT53, MT54, MT55a). 1924
Silver and ebony, lid of sugar bowl
made of glass
Tray: 13 x 20 1/4" (33 x 51.5 cm)
Bauhaus-Archiv Berlin. Purchased
with funds from the Stiftung Deutsche
Klassenlotterie Berlin

Theodor Bogler is perhaps best-known for a remarkable series of slip-cast teapots from 1923 that embody the Bauhaus's dual concept of its workshops as both educational facilities and laboratories for industrial design. As one of the first ceramics students to qualify, after two years' study, as a journeyman (the first step toward becoming a "master" of his chosen medium), Bogler had been enlisted by Walter Gropius to push the ceramics workshop toward mass production and help shift its "Romantic," craft-based ethos toward the making of effective industrial prototypes. Among the results was a "kit" of molded teapot parts, with separate handles, spouts, and lids that could be attached in different positions to produce alternative versions of the standard form. The sculpture workshop assisted with the creation of plaster models and then molds for casting the teapot components, and production commenced at the end of that year at the Bauhaus ceramic workshop in Dornburg, some twenty miles from Weimar. For some versions of the pot the metal and textile workshops supplied metal handles with cane or cord coverings. But although Bogler's teapots were realized as multiples, the quality of the prototypes was uneven, and the Bauhaus workshop facilities so basic, that this early sally into industrial production was in some senses a heroic failure. The ceramics industry was in crisis and despite initial interest from potential manufacturers and distributors at trade fairs in Leipzig, Frankfurt, and Danzig in 1924, the pot was never licensed for large-scale manufacture.

In many respects Bogler's teapots exemplify both the achievements and the contradictions of the early Bauhaus in Weimar. They brought a traditional craft form into alignment with the modern world of mass-produced objects, and were indicative of a modernist belief in the applicability of basic geometric shapes to industrial production. Meanwhile they preserved the essential organic qualities of the clay material. Yet while the various elements could be molded in multiples, their assemblage required considerable handcraft, especially with regard to the attaching of the handles and spouts, which militated against cost-effective production. By way of these limitations, in both form and technology they remain a characteristic example of early Bauhaus teaching. They are also clearly a product of the unique environment in which they were produced, and a testament to the charged emotional and intellectual world inhabited by the early masters and their students.

The creative energy that Bogler distilled in the teapot series was fed not only from his interaction with others in the ceramics workshop but from the skill set, temperament, and life experiences that he brought to his Bauhaus training. During World War I, he had seen active service as a teenage officer on the Russian and western fronts in 1915–18, and had been no stranger to material deprivation, physical labor, discipline, and the idea of collaborative work toward a higher ideal or end. His soldier's experience had been revelatory for him, showing him both the transformative and the destructive potential of industrial technology: involved in electrification and road-building projects in Russia, he had glimpsed what German equipment and know-how could achieve on a colossal scale when properly directed, but also the devastating power it unleashed in the context of trench warfare. Unable to maintain his loyalty to Germany's quasi-religious codes of military honor, Bogler emerged from the war looking for a new profession and purpose. After a false start with architectural studies in Munich, he soon became excited about the liberating yet grounded form of professional training that the Bauhaus appeared to offer.

Bogler wanted nothing to do with "high" art, and on completing the preliminary course he was drawn to the ancient craft of ceramics, with its intrinsic functionality and literally earthy sense of the real. Ubiquitous and accessible, the medium spoke to a familiar sense of social interconnectedness, continuity, and national identity that appealed to both "right" and "left" ends of the political spectrum. Interwar debates about folk culture, not just in Germany but internationally, emphasized the energy, vitality, and essential modernity of vernacular design forms and principles and their continued relevance to commercial and cultural development. To establish its ceramics workshop the Bauhaus collaborated with a traditional Thuringian pottery, run by the Krehan family, in Dornburg, a picturesque village perched above the River Saal. In October 1920 Bogler joined six other apprentices there, one of them Otto Lindig, his future brother-in-law. Technical training took place in the preexisting workshop, led by Max Krehan, while artistic direction came from Gerhard Marcks, among the first masters to be appointed by Gropius. A second workshop, also containing accommodation for Marcks and the students, was created in the former stables of the town's three grand-ducal castles. Remote from the main Bauhaus premises in Weimar, the area had been a favored haunt of the poet Goethe and was saturated with the sentiment and associations of German Romanticism.

The intense period of experimentation of which the 1923 teapots were part marked a productive highpoint in the

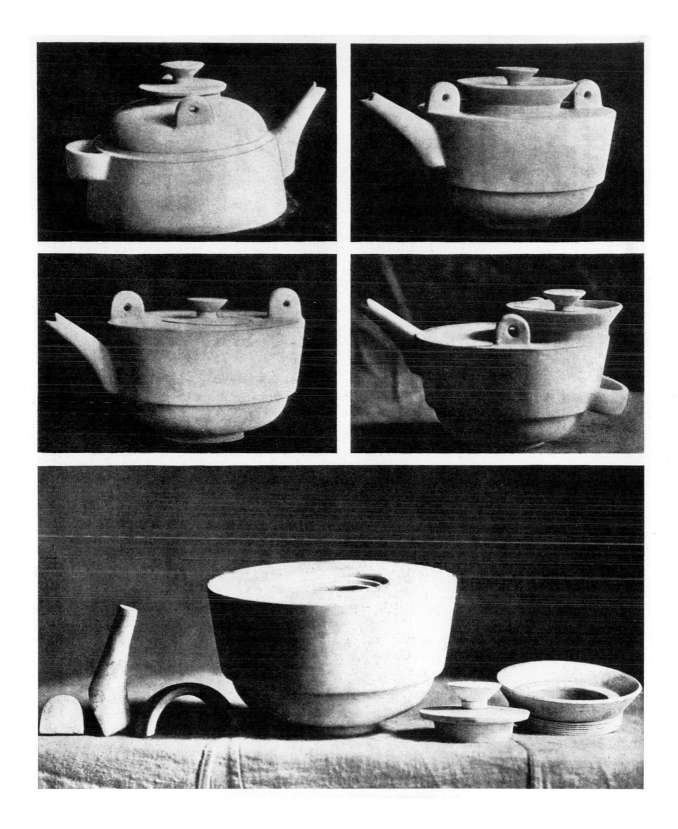

112
Theodor Bogler
Plaster models of elements for ceramic casting,
to be combined to create varied teapots
As reproduced in *Staatliches Bauhaus
in Weimar 1919–1923*. Weimar and
Munich: Bauhausverlag, 1923
The Museum of Modern Art Library,
New York

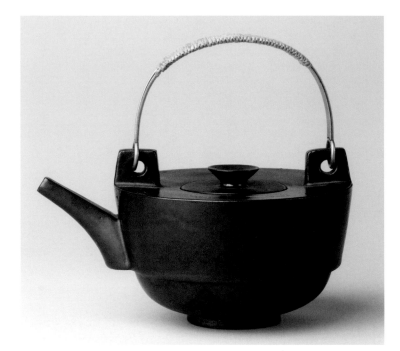

ceramics workshop's short five-year existence. Accommodation and workshop facilities were primitive, but these minimalist conditions — the students grew their own food, dug clay from local beds, chopped wood for the kilns — endowed the products of the workshop with a moral aura. To Bogler the students "felt like a new generation of settlers. Art, craft, nature, technology, music, art, light, water and earth seemed to us like the natural unity of life.... I turned my entire energy to the project, becoming like a revolutionary."[1] In a political sense this meant radical conservatism: "after my military experience I wanted to get as far away as possible from Communism or Bolshevism."[2] Like many other tendencies, the energies feeding the Bauhaus could go in either political direction (crudely, "left" or "right"), and the fact that the Bauhaus seemed to end up on the "democratic" or "progressive" side of things has little to do with an inherent politics of artistic modernism. Bogler shows that the Bauhaus had important links to conservative, even *völkisch* tendencies, and that such links were part of the tremendous ferment, indeed confusion, of those at the center of artistic modernism in the early years of the Weimar Republic.

The Bauhaus's commitment to modernism entailed a rethinking of objects as mundane and everyday as a teapot. Immersed in Plato, Goethe, Nietzsche, and Meister Eckhardt, Bogler joined a quest, both spiritual and pragmatic, for a way to address universal needs, to tap into a Platonic realm of idealized forms — and this while the resulting design was to be accessible to a mass audience. In material form the teapot series gave expression to both the passionate idealism of the "Dornburgers" and an empirical knowledge derived from working daily with clay. On one level Bogler's creative play with geometric, modular forms reads as an exercise in analytical and synthetic thinking, a logical materialization of the rational and reductive design philosophy of the preliminary course and of Gropius's principle of "Art and Technology: A New Unity." This impression is most pronounced in vintage photographs of the preliminary plaster models for the teapots, which are drained of color and texture;

the cool, objective style of the photography and the plaster facture accentuate the sense of perfectible forms. Yet in the ceramic versions this exactness is countermanded by a certain robust and unpolished curtness of execution. The materiality of the clay bodies and irregularly pitted glazes (from matte black-brown to pale white-buff, from translucent to viscous) references an essentially Romantic exploration of inanimate matter through the art of the individual potter.

The complementary perspectives and skills of Marcks and Krehan worked well in the workshop's first years, but as the first batch of students became increasingly assured and independent, the hierarchical relations between masters and students began to change. Bogler's organizational skills and ambition had come to the attention of the school's administration in Weimar, and in October of 1922 he was chosen to assist with the preparations for the first major Bauhaus exhibition. Emerging from the rural isolation of Dornburg, Bogler began to explore collaborations with industrial and commercial partners. During a secondment in March 1923 to the Velten-Vordamm stoneware factory, in Velten, near Berlin, he learned to create plaster molds for slip-casting and developed the prototype storage pots that would be exhibited in the kitchen of the Haus am Horn, the experimental house built for the 1923 exhibition. Apparently at Gropius's suggestion, he also began to develop the molded-teapot system in relation to the "art and technics" mandate for the exhibition.

Delegated to market these and other Dornburg prototypes, Bogler presented them at trade fairs in Frankfurt and Leipzig. The commercial interest they generated, coming at a time when the Bauhaus's financial situation was becoming critical, resulted in increased pressure to improve productivity at Dornburg. The workshop in the stables was now dedicated to serial production, with Lindig and Bogler in charge, but Marcks clearly felt this shift came at the expense of teaching. Although nominally still in control, he found it increasingly difficult to manage Bogler, "a hungry lion" whose evident vocation was to

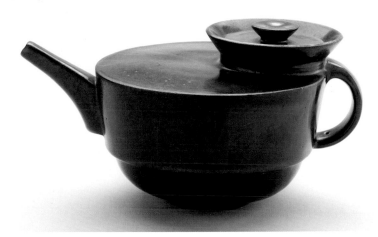

run a large factory.[3] The clash of personalities and political differences led to an irretrievable fallout between Bogler and Marguerite Friedlaender (later Wildenhain), the most talented of the small number of female ceramists in Dornburg, who was passionate in her defense of the masters Krehan and Marcks.[4] By December 1924 the Dornburg adventure was over. Bogler left the Bauhaus to become director of the form and model workshop at the Velten-Vordamm factory. After spending a couple of years trying to implement his ideas in this larger industrial concern, and to come to terms with his wife's suicide, in 1927, he entered the Maria Laach monastery, a center of right-wing Catholicism up to and during World War II. Bogler's religiosity and political affiliations with the radical right put the Bauhaus in an unexpected light.

The ceramics workshop closed in 1925, when the Bauhaus decamped to Dessau, but as the first of the school's ten workshops to engage actively with industry, it was important to the institution's reputation in the Weimar phase. Designs like Bogler's, Lindig's, and Friedlaender's, which resulted so directly from their immersive engagement with ancient craft skills, also served to affirm the organic, vernacular aspect of the roots of much modernist design. Yet the richness and significance of ceramics education within the Bauhaus have been consistently marginalized: both the traditional nature of the medium and the craft emphasis itself sit awkwardly with the dominant view of the Bauhaus focused on Dessau, a view synonymous with a machine aesthetic and the paradigm of architecture, and chiming with the corporate modern legacy of Mies van der Rohe in the United States. For Bogler, though, there was no

problem or conflict between hand methods and those of mass production — he saw himself as a creative artisan *and* an industrial designer. In this sense his teapots should not be seen as part of an inevitable trajectory toward industrial production that left behind the hide-bound crafts (a schema outlined so persuasively by Nikolaus Pevsner in *Pioneers of the Modern Movement* [1936] that the book has done a great deal to shape popular perceptions of the Bauhaus). Bogler did not cultivate a machine aesthetic as an end in itself; for him the idea that the school was about "the Artist's vision of how to live in a machine age was a misrepresentation, a narrowing of the founding principles of the Bauhaus."[5] This was one point on which he and Friedlaender were in agreement. "All in all I have always thought that the picture that the world has got from the Bauhaus was very wrong," she wrote in 1980: "Yes it was the Bauhaus from Dessau, but not from Weimar."[6]

1. Theodor Bogler, *Ein Mönch erzählt* (Honnef: Peters, 1959; rev. ed. of *Soldat und Mönch. Ein Bekenntnisbuch* [Cologne: J. P. Bachen, 1936]), p. 60. Author's trans.

2. Ibid. Bogler was appalled by his encounter with Russian Bolshevik revolutionaries toward the end of his three-year stint on the Russian front.

3. "Seinem künftigen Lebensweg, der zweifellos in die Fabrik geht" (His future life falls in the factory). Gerhard Marcks, letter to Walter Gropius, September 23, 1923. "Seine Lösung heisst: Fabrikbesitzer" (His motto: factory owner). Marcks, letter to Gropius, October 27, 1924. Quoted in Klaus Weber, ed., *Keramik und Bauhaus. Geschichte und Wirkungen der keramischen Werkstatt des Bauhauses* (Berlin: Bauhaus Archiv, 1989), p. 63. Author's trans.

4. See Marcks, letter to Gropius, October 27, 1924. Discussed in ibid., p. 63. See also Dean and Geraldine Schwarz, eds., *Marguerite Wildenhain and the Bauhaus* (Decorah: South Bear Press, 2007). I am grateful to the Schwarzes for their insights into the American legacy of Bauhaus ceramics.

5. Bogler, *Ein Mönch erzählt*, p. 58. Author's trans.

6. Marguerite Friedlaender, letter to Professor William Huff, Department of Architecture, State University of New York, Buffalo, October 14, 1980. Quoted in Schwarz, eds., *Marguerite Wildenhain*, p. 128.

113
Theodor Bogler
Teapot. 1923
Metallic-glazed earthenware, cast and assembled, and raffia-wrapped metal handle
7 5/8 x 8 1/8" (19.4 x 20.6 cm)
The Museum of Modern Art, New York.
Estée and Joseph Lauder Design Fund

114
Theodor Bogler
Teapot. 1923
Metallic-glazed earthenware, cast and assembled
Height: 4 5/8" (11.7 cm), length (spout to handle): 9 1/2" (24 cm), diam.: 6 1/4" (16 cm)
Neue Galerie, New York

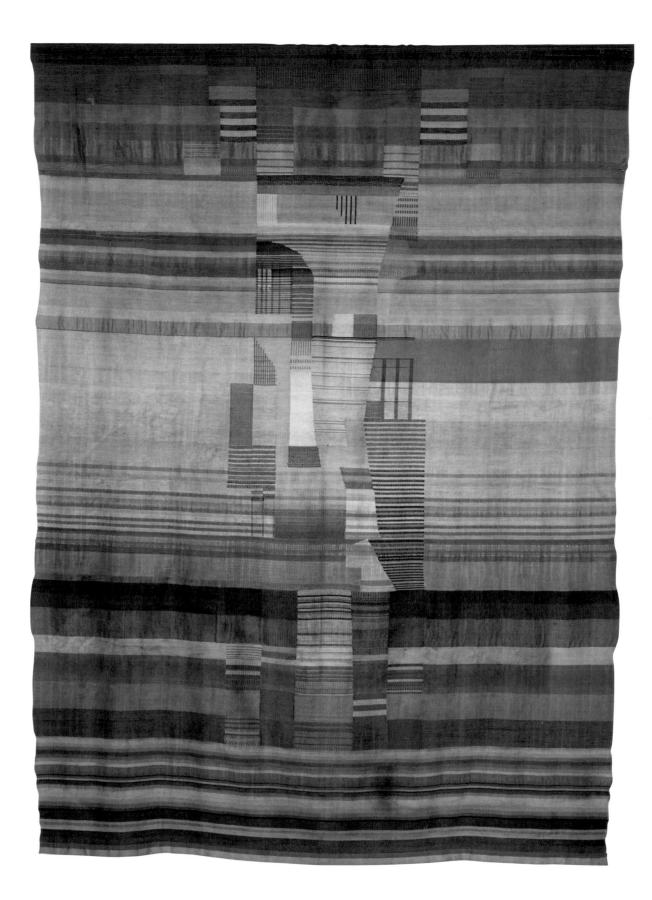

115
Gunta Stölzl
Wall hanging. 1922–23
Cotton, wool, and linen
8' 4 ¹³/₁₆" x 6' 2" (256 x 188 cm)
Harvard Art Museum, Busch-Reisinger
Museum. Association Fund

116
Paul Klee
Der Angler (The angler). 1921
Oil transfer drawing with watercolor
and ink on paper on board
19 ⁷/₈ x 12 ¹/₈" (50.5 x 31.8 cm)
The Museum of Modern Art, New York.
John S. Newberry Collection

117
Paul Klee
Die Zwitscher-Maschine
(The twittering machine). 1922
Oil transfer drawing with watercolor
and ink on paper on board with gouache
and ink borders and pencil
25 ¹/₄ x 19" (64.1 x 48.3 cm)
The Museum of Modern Art, New York.
Purchase

118
Paul Klee
Das Vokaltuch der Kammersängerin Rosa Silber
(Vocal fabric of the singer Rosa Silber). 1922
Watercolor and ink on plastered fabric,
mounted on board with watercolor
and ink borders
24 ¹/₂ x 20 ¹/₂" (62.3 x 52.1 cm)
The Museum of Modern Art, New York.
Gift of Mr. and Mrs. Stanley Resor

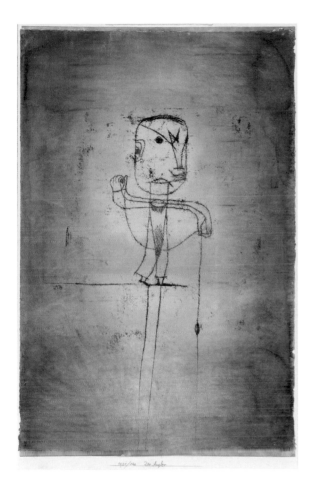

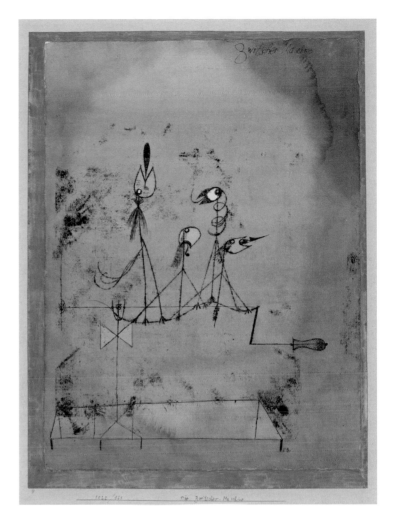

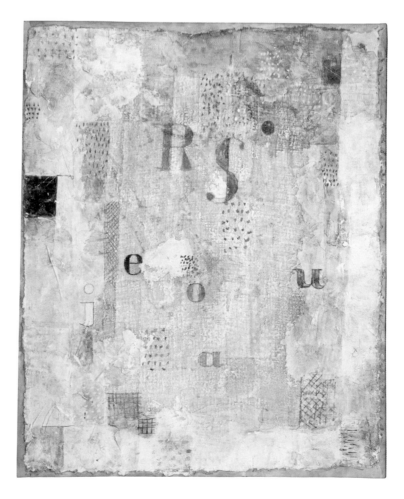

UNKNOWN WEAVER, POSSIBLY ELSE MÖGELIN
WALL HANGING. 1923
T'AI SMITH

For the Bauhaus exhibition of 1923, the weaving workshop displayed this wall hanging among its initial experiments with the woven medium.[1] Amid a grid of irregularly aligned rectangles, one finds the abstracted profile of a bird. Askew against the textured grid, the creature's form seems to yield what we might call a glitch within the woven ground; its biomorphic curves throw the logic of the grid slightly out of joint, but it is nevertheless an artifact of the loom's binary structure — the perpendicular network of warp and weft threads. So the bird both merges with its environment and emerges as pictorial motif.

Like so many pieces from the weaving workshop, this textile bears the stylistic imprint of the Bauhaus form master Paul Klee. The use of an animal and a reverberating, uneven field of colored rectangles indeed seems to draw from the painter's repertoire of motifs and use of decorative forms. But unlike Klee's ink-and-watercolor animals — *Die Zwitscher-Maschine* (The twittering machine, 1922; cat. 117), for example — the symbolic and semiorganic form of the bird cannot escape the weave's latticework. As the Klee-like motif is "translated" from his fluid medium into weaving, it becomes algorithmic, visibly created by a step-by-step and repetitive procedure. In Bauhaus pictorial wall hangings, any potential "freedom" allowed by the unstructured field of an Expressionist painting is necessarily harnessed to the vertical and horizontal. So the bird does not float or begin to bleed into the ground — as it does in this watercolor by Klee — so much as it is bound, caught, within the framework of the weave.

This is not to say that Klee's painterly products were amorphous, or that the weavers' work of this moment was necessarily so mechanical. Indeed the weaving students learned much from Klee's attempts to balance fluid intuition and architectonic patterning — like his *Aus dem Hohen Lied (II. Fassung)* (From the Song of Songs [II version], 1921; cat. 50), which experiments with setting gridded limits around nonuniform, calligraphic letters. The weavers' direct exposure to Klee's presence and teachings began with his arrival in 1921, when they were first exposed to his lessons on color and composition, and continued still more immediately when he taught theoretical courses designed for them from 1927 to 1929. In his approach and imagery they discovered a landscape of possibilities.[2] When discussing the tactile nature of fabric, weaver Otti Berger, for instance, would cite Klee's wisdom on the importance of "intuition."[3] As Jenny Anger notes, though, the notebook drawings that they

119
**Unknown weaver,
possibly Else Mögelin**
Wall hanging. c. 1923
Linen, rayon, and wool
55 ⅞" x 9' 4 ³⁄₁₆" (142 x 285 cm)
Klassik Stiftung Weimar, Bauhaus-Museum

transcribed from the instruction of his course are also perfect approximations of the woven web.[4] Here grids of algebraic computations lay out the possibilities of various chromatic juxtapositions, in theory but also for the weaving practice. On one notebook page by weaver Gertrud Arndt (cat. 120), colors are substituted with numbers or letters on the gray-tonal field and then permuted through mirroring across vertical and horizontal axes. So Klee's imagery and approach found their way into the matrices of the weavers' work. And yet, it should also be noted, the directionality of influence was not a one-way street. In his *Architektur der Ebene* (Architecture of the plane; cat. 85) and *Wall Hanging*, both from 1923, Klee works to translate the woven lattice into washes of ink and watercolor lines. Drawing and painting are thus rendered as though under the tension of warp and weft.[5] Klee often used textile metaphors in his lectures on the principles of patterning, and in his notes (reproduced in the *Pädagogischer Nachlass* [Pedagogical estate], 1923), directional arrows are juxtaposed and combined with sketches of weaves and braids.[6]

In more ways than one, the question of translation might be the conditional tremor of modernist activity. After all,

Bauhaus figures like Johannes Itten, but also Klee, translated visual motifs from a variety of ancient and non-European sources, most notably from Near Eastern, Egyptian, and Indian imagery. The "cult of India" that pervaded the Bauhaus community, especially in the late teens and early 1920s, found its way into Klee's art, despite his apparent reluctance to embrace theosophy or Rudolf Steiner's anthroposophy.[7] In *Der wilde Mann* (The wild man) of 1922, for instance, Klee abstracts the imagery of the Hindu god Narasimha until the symbolic significance of a disemboweled king is reduced to a simple formula: in place of hands and feet, Klee paints arrows signifying the directionality of spilt blood.[8] The systematic arrows of Klee's pictorial architectonics encode the space and imagery of an ancient Indian myth with modern, geometric forms. Similarly, the fluid yet jagged line of Klee's watercolor bird-machines depicts their abstracted beaks and bodies as though floating in the realm of dreams, but also renders these creatures as mechanical glitches, or twitterings, within an otherwise liquid field. Thus unleashed from other cultures, motifs like fish, birds, and architectural patterns beget in Klee's work new systems of meaning in which they open onto a space of theosophical-mechanical hybrids.

In the workshop's tapestry, the formal paradoxes of Klee's imagery are hinged to the loom's mechanical apparatus. Yet the weave also returns the bird motif to its own medium's history — serving to remind further that grids and repetition are not just the consequences of modern European techniques. One has only to think of the weavers' interest, as described by Virginia Gardner Troy, in the works they found in the Berlin Museum für Völkerkunde or in books on ancient Peruvian textiles, which instructed them in the complex weaving structures of the pre-Columbian past.[9] The example, for instance, of a Kelim textile from the Chancay culture of coastal Peru (fig. 1), where birds receive an angular definition in keeping with the woven matrix and with the framing geometric pattern above and below, would have provided the weavers with a model for understanding the checkerboard forms and structural possibilities specific to weaving.

The workshop's tapestry is a significant artifact of this transitional moment at the Bauhaus: its overt craft at once points to a pre-1923 moment marked by the "return-to-nature" *Wandervogel* movement then popular in Germany and opens it up to an industrial world — one in which the regular mathematics of mechanical grids, such as those found in skyscrapers, determine the limits of form. The woven wall hanging also records, as seen in the example of Klee's formal presence in the workshop, the contact of different media at the Bauhaus and the ways they also, at times, began to merge.[10]

1. Michael Siebenbrodt names a student, Else Mögelin, as the tapestry's creator. See Siebenbrodt, *Bauhaus Weimar: Designs for the Future* (Ostfildern-Ruit: Hatje Cantz, 2000), p. 109.

2. See Jenny Anger, *Paul Klee and the Decorative in Modern Art* (Cambridge: at the University Press, 2004), pp. 179–80, and Magdalena Droste, "Wechselwirkungen — Paul Klee und das Bauhaus," in Droste and Wolfgang Kersten, eds., *Paul Klee als Zeichner, 1921–1933* (Berlin: Bauhaus-Archiv, 1995).

3. "Hier könnte man mit dem Maler Klee sagen: Intuition ist immer noch eine gute Sache!" Otti Berger, "Stoffe im Raum," *ReD* (Prague) 3, no. 5 (1930):143.

4. See Anger, *Paul Klee and the Decorative in Modern Art*, pp. 179–80.

5. On the particular influence of the weaving workshop on Klee's painting seen in *Wall Hanging*, and for a reproduction of the work, see K. Porter Aichele, *Klee's Pictorial Writing* (Cambridge: at the University Press, 2002), pp. 155–57. She argues: "*Wall Hanging* marks a transitional point in the shift from a predominance of pictures in which the X retains its independent identity as a sign of architectural, linguistic, and pictorial structure to paintings of the mid-twenties in which the X-sign is absorbed into an overall, increasingly dense surface pattern" (p. 157).

6. Virginia Gardner Troy also discusses Klee's exchange with the weaving workshop and reproduces a page from his *Pädagogischer Nachlass*, dated October 23, 1923, to demonstrate it. Troy, *Anni Albers and Ancient American Textiles* (London and Burlington, Vt: Ashgate, 2002), pp. 86–87.

7. See, for instance, Peg DeLamater, "Some Indian Sources in the Art of Paul Klee," *Art Bulletin* 66, no. 4 (December 1984):657–82, and Roger Lipsey, *The Spiritual in Twentieth-Century Art* (Mineola, N.Y.: Dover Publications, 2004), p. 202.

8. For a discussion and reproduction of *Der wilde Mann* see DeLamater, "Some Indian Sources in the Art of Paul Klee," pp. 658–660.

9. See Troy, *Anni Albers and Ancient American Textiles*, pp. 39–71. Specifically, Troy cites the interest of the Bauhaus weavers in a book by Walter Lehmann, *Kunstgeschichte des Alten Peru* (Berlin: E. Wasmuth, 1924).

10. For a detailed discussion of the entangled relationship between weaving and other media at the Bauhaus, see my "Weaving Work at the Bauhaus: The Gender and Engendering of a Medium," Ph.D. diss, University of Rochester, 2006.

120
Gertrud Arndt
Notes from color theory course taught by Paul Klee. c.1923–24
11 13/16 x 7 11/16" (30 x 19.5 cm)
Ink on graph paper
Bauhaus-Archiv Berlin

Fig.1
Unknown weaver, Chancay, Peru
Kelim textile with fringe (detail). n.d.
Location unknown. Formerly in the Eduard Gaffron Collection, Schlachtensee
As reproduced in Walter Lehmann.
Kunstgeschichte des Alten Peru. Berlin: E. Wasmuth, 1924
Robert W. Woodruff Library, Emory University, Atlanta

121
Paul Klee
Hand puppets created for the artist's son,
Felix Klee. 1916–25
Plaster (or chalk mixture) and papier-mâché
heads, hand-sewn fabric, and found objects
Height: 11" to 22 ¹³⁄₁₆" (28 to 58 cm)
Zentrum Paul Klee, Bern. Livia Klee Donation

122
Paul Klee
Schauspieler-Maske (Actor's mask). 1924
Oil on canvas mounted on board
14 ½ x 13 ³⁄₈" (36.7 x 33.8 cm)
The Museum of Modern Art, New York.
The Sidney and Harriet Janis Collection

123
Paul Klee
Puppentheater (Puppet theater). 1923
Watercolor on two sheets of paper
primed with chalk and glue, bordered in
watercolor and pen, edged at the bottom
with watercolor and pen, mounted
abutting on card
20 ⅛ x 14 ¹³⁄₁₆" (52 x 37.6 cm)
Zentrum Paul Klee, Bern

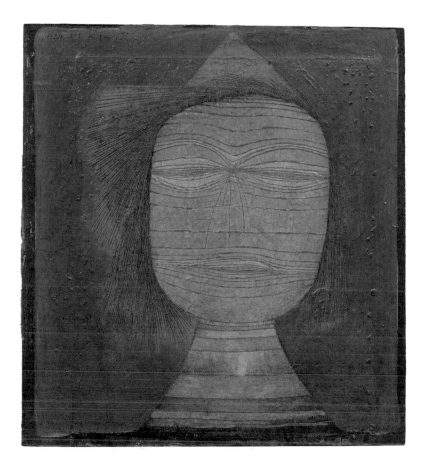

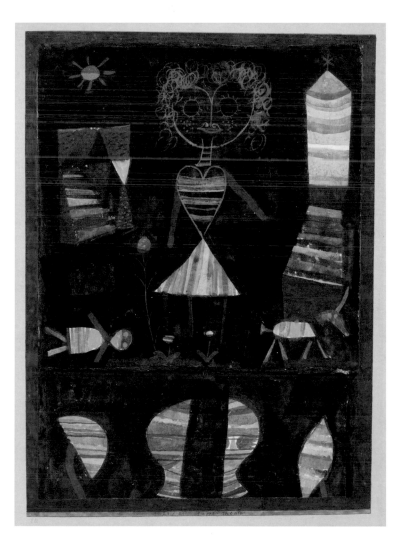

Vasily Kandinsky was among the Bauhaus's most long-standing teachers, but discussion of his role at the school, and of the role that the school in turn played in his own art, has often focused on the theoretical approach to form and color that he was originally hired to teach, in the spring of 1922. Within months of his arrival, however, Kandinsky took over the direction of the wall-painting workshop and painted the most ambitious large-scale work of his career — a work, too, that confidently displayed the still-new geometric style that would define his art from then on. This was the untitled wall painting commissioned by and for the fall 1922 Juryfreie Kunstschau, an annual exhibition held at the Landes-ausstellungsgebäude, Berlin. Designed for the octagonal entrance hall of a modern art museum that would ultimately remain unbuilt for lack of funds,[1] the work consisted of colored and white shapes grouped in various configurations — checkerboards, circles pierced by triangles, wavy lines, polygons, and more — and applied to eight black surfaces framed at their bottoms by a white band a hand's-breadth wide. Kandinsky made maquettes for the work, which his Bauhaus students then copied onto expanses of unstretched dark canvas that were glued onto wood panels directly applied to, and scaled to fill, their supporting walls at the Juryfreie Kunstschau.[2] More than thirteen feet high, the space, judging from installation photographs and the ground plan of the building, comprised four main walls measuring up to twenty-six feet wide, and connected by four narrow surfaces less than six feet wide.[3]

If the work remains little discussed, this is surely in part because little is known about the details and circumstances of the commission and because only Kandinsky's gouache-on-cardboard maquettes for it survive (cats. 124–28). A more significant set of reasons is that our understanding remains insufficient, first, of Kandinsky's role as a wall-painter and of his relationship to the applied arts, and second, of the wall-painting workshop at the Bauhaus and the status of art at the school following its functionalist turn in the early 1920s. Yet the Juryfreie commission reveals design and ornament as instrumental in focusing Kandinsky's ambitions for an abstraction that would not only be experienced as otherworldly or, to use the artist's word, "spiritual" but could also be conceptually understood as such. This same work also marks Kandinsky's most forceful effort to stake out a place for painting in design education. In other words, the Juryfreie wall painting illuminates both the role of design in Kandinsky's art and the role of art in Bauhaus design.

The work was the product of Kandinsky's complex, at times vexed relationship to the applied arts, which, while inspir-ing the formal vocabulary of the abstraction he pioneered in the early 1910s (pattern clusters, line and plane pairings, flat colors), also shaped his desire for an immersive aesthetic experience that would allow for both the utmost impact on the viewer and the utmost seclusion from this world. Early on in his career, starting around 1896 and into the early twentieth century, he had moved in Munich's Jugendstil circles, designing vases, dresses, furniture, and the like, and joining those artists' explorations of the idea of a unification of fine and decorative art.[4] Kandinsky described the impact that being surrounded by design had on his art when he recounted visits to Russian farmhouses in which "the table, the benches, the great stove . . . , the cupboards, and every other object were covered with brightly colored, elaborate ornaments," teaching him "to move within the picture, to live in the picture," and to formulate a goal of "letting the viewer 'stroll' within the picture, forcing him to become absorbed in the picture, forgetful of himself."[5]

Around 1913, however, as Kandinsky's painterly veiling of objects turned into pure abstraction, he grew wary of certain aspects of the applied arts, particularly their detrimental effect on the spiritual and communicative potential of his work. "Now I could see clearly that objects harmed my pictures. A terri-fying abyss of all kinds of questions, a wealth of responsibili-ties stretched before me. And most important of all: What is to replace the missing object? The danger of ornament revealed itself clearly to me; the dead semblance of stylized forms I found merely repugnant."[6] Ornamental motifs and qualities in paint-ing, as Kandinsky's critics argued at the time, risked feeling "dead" because they turned meaningless once dissociated from cultural context. Moreover, they risked returning viewers to the material world with a vengeance because they asserted a pic-ture's materiality, its flat picture plane and status as an object.[7] Kandinsky had admired the use of ornament as an expressive means and language in Persian miniatures, but it seems that, for the time being, he remained unable to produce an equivalent for his own time and culture.[8]

Kandinsky gradually resolved this conflict between his art and design. He initially translated the immersive experience he had come to value in the applied arts into a traditional can-vas format, creating exclusively pictorial spaces in which colors "lie as if upon one and the same plane, while their inner weights are different This difference between the inner planes gave my pictures a depth that more than compensated for the ear-lier, perspective depth."[9] In four paintings of 1914, however, explicitly commissioned as "wall decoration" for the oval entrance

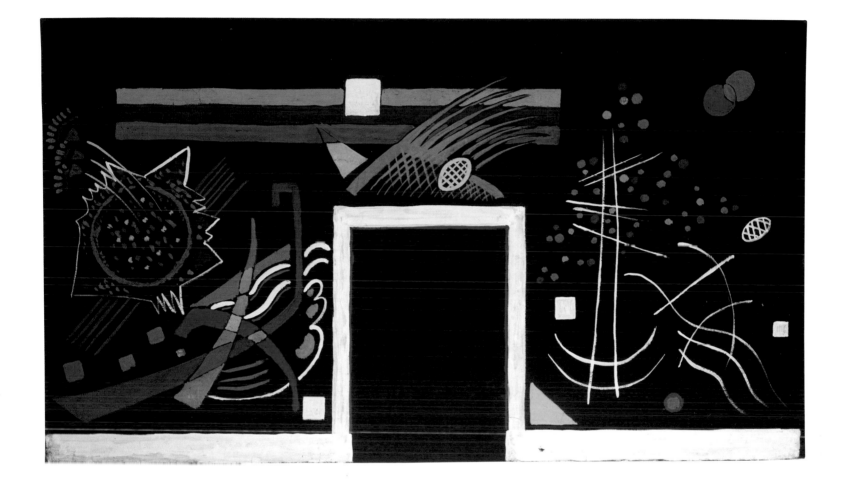

124—28
Vasily Kandinsky
Designs for wall paintings for the Juryfreie
Kunstschau (Jury-free art exhibition), Berlin. 1922
Above: wall A; p. 124, top to bottom: walls B and C; p. 125,
top: wall D; bottom: four corner pieces
Gouache and white chalk on black or brown paper
Each: c. 13 11/16 x 23 5/8" (34.7 x 60 cm)
Centre Pompidou, Paris. Musée national d'art moderne/
Centre de création industrielle

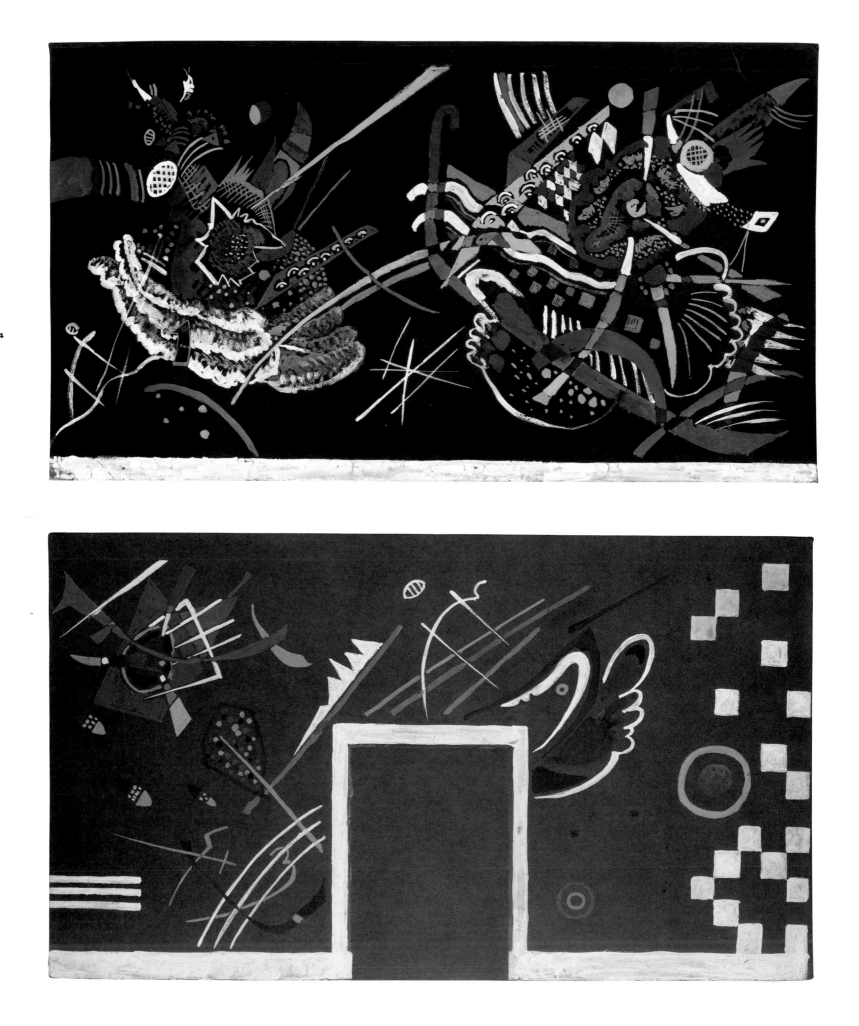

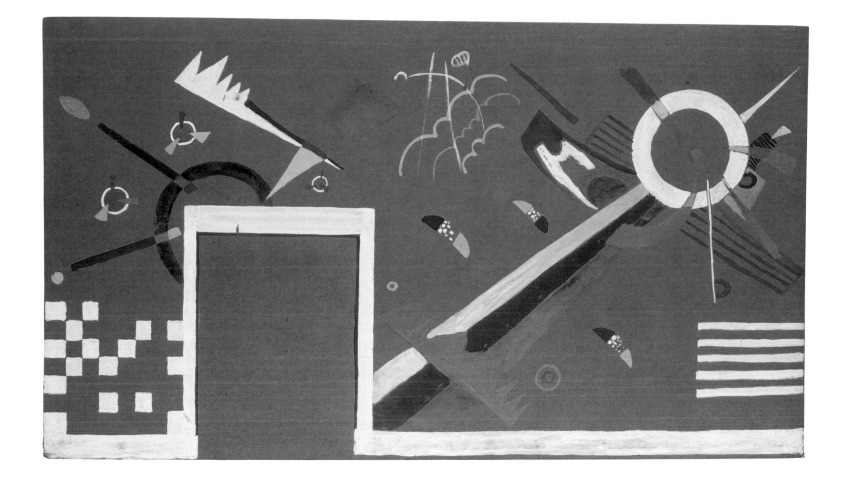

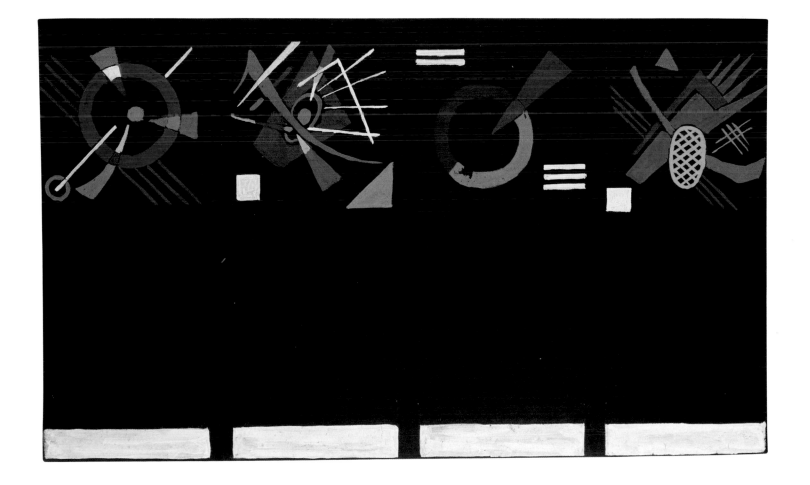

hall of the New York apartment of Edwin Campbell, Kandinsky for the first time complemented that illusionist immersion with an actual, bodily one.[10] Perhaps the double armature of a three-inch gold frame and white molding surrounding each of these canvases alleviated the artist's worries about "mere" decoration; perhaps the spatial distance from the final destination freed him to imagine the artistic potential of spatial design. The oval space and circular hanging of the Campbell panels were a central precedent for the Juryfreie wall painting, helping Kandinsky to understand that certain design elements, rather than stressing the banal material world, could facilitate its substitution with a more conscious, transcendent one.

During a prolonged stay in Russia prompted by World War I, Kandinsky likewise tackled the supposed meaninglessness of ornament, which had threatened his early abstraction, by systematizing his formal vocabulary. In part to address Constructivist colleagues' skepticism about his psychological motivations and his conception of art as autonomous, the apolitical Kandinsky not only pondered further the value of design in his art but also developed a more legible vocabulary of geometric forms and colors. As he would soon outline in *Punkt und Linie zu Fläche* (Point and line to plane) of 1926, his theoretical contribution to the *Bauhausbücher* book series, Kandinsky from here on approached the pictorial rendering of the "spiritual" in an increasingly illustrative, diagrammatic fashion.[11]

The renewed place of design in Kandinsky's art and thinking found expression in his appointment to the Bauhaus, and in his teaching practice there, but above all in the Juryfreie wall painting, which adapted to his otherworldly abstraction the two modes of reception that he had grappled with in relation to the applied arts — a bodily experience and a conceptual language. The painting inaugurated Kandinsky's new style, even traced its evolution from a more spontaneous treatment, in what stylistically appears to be the first panel (although it is inscribed "B" on the verso), to a more systematic one, in the panels inscribed "A," "C," and "D," where Kandinsky increasingly suggested a "spiritual" realm with decipherable pictorial means. It is no accident

that so many of these devices — stripes and patterns, reversals and repetitions — echo decorative traditions, or that a critic dismissively referred to Kandinsky's "patterning of a black wallpaper," a "chinoiserie in which a natural decorative talent happily returns home."[12] For his part no longer plagued by such concerns, Kandinsky now confidently worked with a contemporary version of coded ornament. A process of dematerialization is manifest not only in the dark ground but also in diagonal axes tapering from bottom left to upper right, in incomplete and thus seemingly dissolving checkerboards, and in clusters of differently sized circles. The repetition of some motifs in slightly altered configurations and sizes creates a sense of equlibrium and harmony, as when the two small white squares separated by the door in wall A are sublated by a larger square above, or when a trio of yellow, blue, and red stripes, placed statically parallel to the ground in the same wall, is met by its more dynamically and independently positioned twin on wall D. And a sense of lightness and emancipation is produced by the countering of forms anchored below with related ones floating above, as when the white stripe along the lower segment of the architectural perimeter is quasi-shattered by hovering white forms above, or when the yellow triangle tied into a bottom corner in wall A floats freely in different versions elsewhere.

Kandinsky balanced this approach to abstraction as a language with a more experiential one. Consistent with his previous abstraction, the black grounds — popping open above their bordering white bases and letting colored shapes float as if in outer space — open up illusionistic spaces behind the picture plane. Yet Kandinsky now immersed his viewers in an immaterial world of art not only optically but also literally. In contrast with the related *Proun Room*, which El Lissitzky made for the Grosse Berliner Kunstausstellung in the summer of 1923 and which sought to heighten visitors' consciousness of their surrounding, Kandinsky paradoxically mobilized the very boundaries of the material world to keep it at bay.[13] His painting mapped onto the architecture physically but also in effect, for particular layouts of forms enhanced the bodily experience of surroundedness suggested by the beveled corners. The white band at floor level accentuated the octagonal ground plan and tied the walls into a formal continuum, an effect further enhanced by the strategic repetition of formal motifs across adjacent or nearby walls. Often this is subtle: the red lines underlying the starlike shape on the left of wall A return, now in white, underlying the righthand formal cluster of wall B; the semicircular red stripe jutting out from the bottom left corner of wall A is mirrored approximately

129
Vasily Kandinsky
Wall paintings for the Juryfreie
Kunstschau (Jury-free art exhibition), Berlin.
Installation view. 1922
Photograph: C. J. von Dühre and E. Henschel.
1922. Gelatin silver print. 7 1/16 x 9 7/16"
(18 x 24 cm). Centre Pompidou, Paris.
Bibliothéque Kandinsky

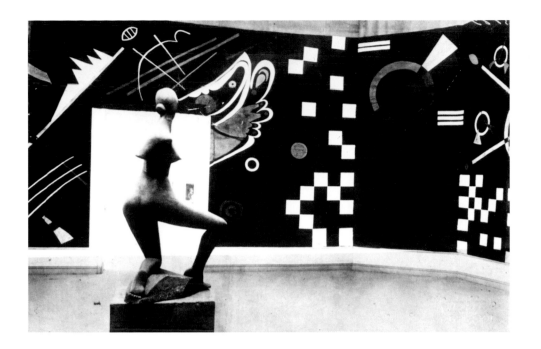

in the right half of wall B. All this is not to say that Kandinsky's painting succumbed to its architectural framework, his art to design, but that the former made possible the experience of the latter as immaterial and otherworldly.

In this respect the Juryfreie work went to the core of Kandinsky's ambitions for the wall-painting workshop and for the medium of painting at the Bauhaus. While heading the workshop between 1922 and 1925, Kandinsky pushed its practice, heretofore expressionist and subdued in palette, toward a synthesis of painting and architecture, color and form, in which, as he stated in his goals for the workshop, color would mold a given space.[14] Yet Kandinsky's formulations betray his hope that ultimately painting could move architecture and design beyond their functional constraints. As he wrote in conjunction with the Juryfreie wall painting, "In addition to synthetic collaboration, I expect from each art a further powerful, entirely new inner development, a deep penetration, liberated from all external purposes, into the human spirit."[15] In this sense the work above all made a case for the possibility of sublating, which is to say preserving and remaking, art and painting amid the Bauhaus's impending turn to functionality in the name of social idealism. Art and painting could help design to look beyond the here and now. And so Kandinsky stayed at the Bauhaus to its very end on German ground. Along the way, in 1927, he notably managed to institute a "free painting" seminar. Four years later, and even more fittingly, he participated in the *Deutsche Bauausstellung* (the annual German trade exhibition for architecture) not only as artist, with his *Improvisation 21* of 1911 on view in one of Ludwig Mies van der Rohe's apartments in the section *Die Wohnung unserer Zeit* (The dwelling in our time), but also as "architect" — which is how the exhibition's catalogue listed him for the Music Room that he contributed to the same section, organized by Mies (cats. 367–69; p. 335, fig. 6).[16]

1. See Jelena Hahl-Koch, *Kandinsky*, trans. Karin Brown (London: Thames & Hudson, 1993), p. 270.

2. See Jean A. Vidal, "Notes techniques sur la réalisation du Salon Kandinsky," in *Le Salon de réception conçu en 1922 par Kandinsky*, exh. brochure (Paris: Musée National d'Art Moderne, 1977). The brochure accompanied the reconstruction of the work for the 1977

opening of the Centre Georges Pompidou. Photographs in the Vasily Kandinsky archive at the Musée National d'Art Moderne and in the Irene Bayer collection at the Getty Research Institute, Los Angeles, show students working on the fabric stretched out on the floor. Some of these photographs are reproduced in *Kandinsky: Russische Zeit und Bauhausjahre 1915 1933*, exh. cat. (Berlin: Bauhaus-Archiv, 1984), pp. 188–89, 192. A photograph of the so-called "wall A" shows the fabric bulging and throwing folds, further evidence of its application directly on the wall. This image was first reproduced as "Peinture murale, 1922," in Will Grohmann, *Wassily Kandinsky* (Paris: Editions Cahiers d'Art, 1930), p. 19.

3. For a plan of the building see the unrelated exhibition catalogue *Grosse Berliner Kunstausstellung 1922* (Berlin: Elsner, 1922), p. 8.

4. See Peg Weiss, "Kandinsky in Munich: Encounters and Transformations," in *Kandinsky in Munich: 1896–1914*, exh. cat. (New York: Solomon R. Guggenheim Museum, 1982), pp. 28–82. Around 1909, for example, and in collaboration with his partner Gabriele Münter, Kandinsky had worked on the interior and furniture designs of their country house in Murnau.

5. Kandinsky, *Kandinsky: Complete Writings on Art*, ed. Kenneth C. Lindsay and Peter Vergo (New York: Da Capo, 1994), pp. 368–69.

6. Ibid., p. 370.

7. Ibid., p. 397.

8. Ibid., p. 73 ff.

9. Ibid., p. 397.

10. Arthur Jerome Eddy, letter to Kandinsky, May 21, 1914, copy in the collection files of the Department of Painting and Sculpture, MoMA. Eddy, a Chicago-based critic, had commissioned the work on Campbell's behalf. Owing to difficulties relating to World War I, the paintings were not installed until the fall of 1916. For a reproduction of a reconstruction of the scheme, see John Elderfield et. al., *Modern Starts: People, Places, Things* (New York: Museum of Modern Art, 1999), p. 185.

11. Kandinsky, *Punkt und Linie zu Fläche* (Munich: Albert Langen, 1926). Trans. in *Kandinsky, Complete Writings on Art*, pp. 524–699. Although the text was published in 1926, Kandinsky began outlines for it in 1914; see ibid., p. 524.

12. Willi Wolfradt, "Ausstellungen: Berlin, Juryfreie Kunstschau," *Das Kunstblatt* 6, no. 12 (December 1922):543.

13. On the *Proun Room* see, for example, Éva Forgács, "Definitive Space: The Many Utopias of El Lissitzky's Proun Room," in *Situating El Lissitzky: Vitebsk, Berlin, Moscow*, ed. Nancy Perloff and Brian Reed (Los Angeles: Getty Research Institute, 2003), pp. 47–75.

14. Kandinsky, "The Work of the Wall-Painting Workshop of the Staatliches Bauhaus," 1924, first published in Hans Maria Wingler, *The Bauhaus: Weimar, Dessau, Berlin, Chicago* (Cambridge, Mass.: The MIT Press, 1969), p. 80. On the history of the wall-painting workshop see Renate Scheper, ed., *Colorful! The Wallpainting Workshop at the Bauhaus* (Berlin: Bauhaus-Archiv, 2005).

15. Kandinsky, letter to Will Grohmann, October 5, 1924, quoted in Grohmann, *Wassily Kandinsky: Life and Work*, trans. Norbert Guterman (New York: Harry N. Abrams, 1958), p. 174.

16. See *Deutsche Bauausstellung Berlin 1931, Amtlicher Katalog und Führer*, exh. cat. (Berlin: Bauwelt, 1931), p. 160. On the Music Room and Kandinsky's work see *Wassily Kandinsky: Le Salon de musique de 1931 es ses trois maquettes originales*, exh. cat. (Strasbourg: Musées de Strasbourg, 2006), esp. p. 54. Philip Johnson, for one, in turn made the claim for Mies's handling of architecture "as an art." Johnson, "In Berlin," *New York Times*, August 9, 1931.

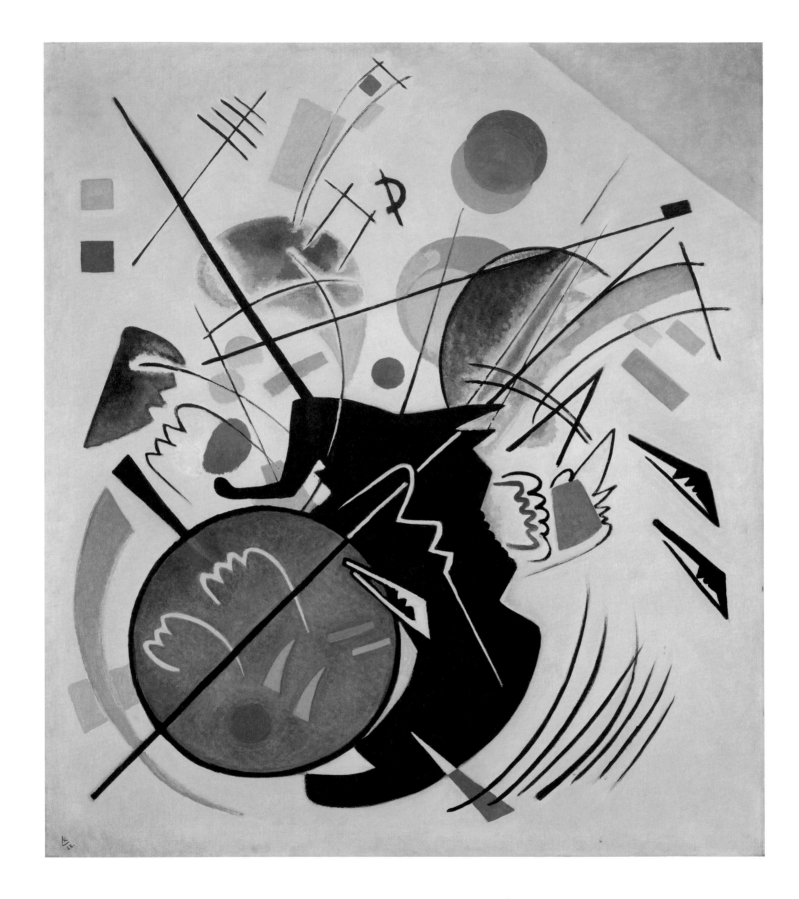

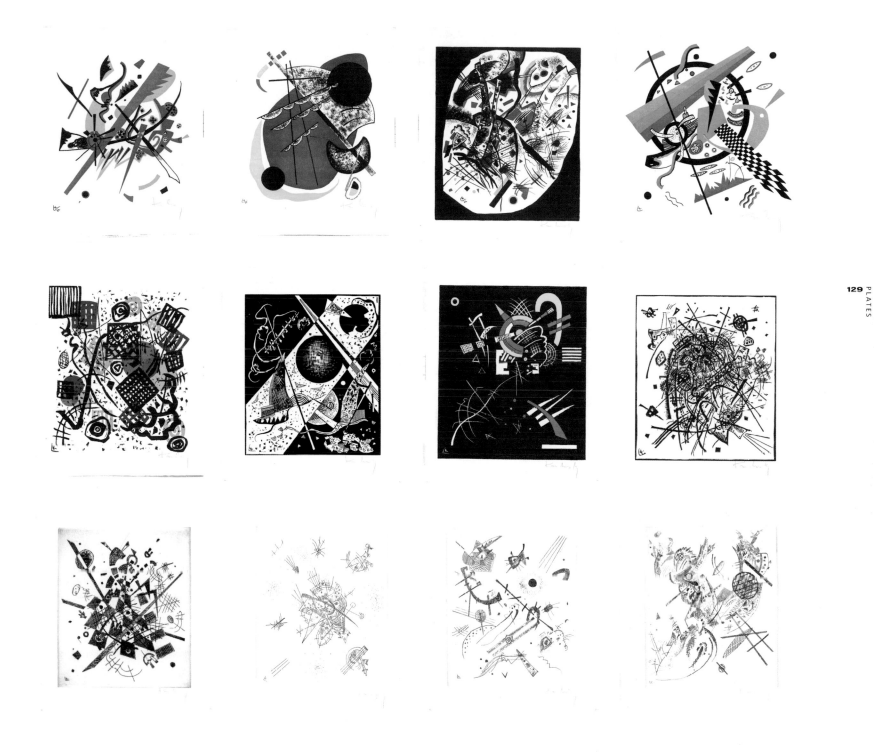

130
Vasily Kandinsky
Schwarze Form (Black form). 1923
Oil on canvas
43 5/16 x 38 3/16" (110 x 97 cm)
Private collection. Courtesy Neue Galerie
New York

131–42
Vasily Kandinsky
Kleine Welten (Small worlds). 1922
Portfolio of 6 lithographs (including two transferred
from woodcuts), 4 drypoints, and 2 woodcuts
Sheets: from 11 13/16 x 10 9/16" (30 x 26.8 cm)
to 14 7/16 x 12 3/8" (36.7 x 31.4 cm)
The Museum of Modern Art, New York.
Purchase (sheets I, II, V, VIII, X, XII)
The Museum of Modern Art, New York. Gift of
Abby Aldrich Rockefeller (sheets III, IV, VI, VII, IX, XI)

LÁSZLÓ MOHOLY-NAGY
CONSTRUCTIONS IN ENAMEL. 1923
BRIGID DOHERTY

"In this age of industrial production and technical exactness," László Moholy-Nagy wrote in 1924, nearly a year after joining the Bauhaus faculty as master of the preliminary course and the metal workshop, "we also strive to produce works of art with total precision. Among the new works that I am exhibiting this February at the Sturm gallery is a series of enamel pictures that were manufactured by machine. To be sure, this manner of manufacturing pictures only comes into play for works created with a will to precise and impersonal technique. One can have works of this sort manufactured on demand on the basis of the Ostwald color charts and a scaled grid. One can therefore even order them by telephone."[1]

The heading under which Moholy discussed these paintings in an essay of twenty years later was "objective standards." Of the "objective standards" that he set out to instantiate in his paintings of the early 1920s, he explained that his "intention was not to demonstrate only individual inventions, but rather the standards of a new vision employing 'neutral' geometric forms." Those "neutral" forms were designed to manifest "the substance of relations" within and among pictorial compositions, and specifically among works in a series with standardized points of convergence and divergence. Crucial to Moholy's attempts to demonstrate "objective standards" in painting were his efforts to maximize the "smooth, impersonal handling of pigment, renouncing all texture variations" — a goal based on the idea that uniformity and smoothness of facture or "surface treatment" would best support the study of "subtle differences in the color relations" among identical compositions of varying sizes in a series.[2] According to Moholy, the study of color relations in abstract painting would in turn help to refine the sensory and cognitive capacities of viewers by confronting them with "new relationships between known and as yet unknown optical…phenomena."[3]

In pursuit of these "new relationships" within and among paintings, both as objects of study and as possible occasions for the instantiation of "objective standards," Moholy turned to the productive and reproductive technologies of a Weimar porcelain-enamel sign factory. Now commonly known as "Telephone Pictures," the group of works that emerged from his collaboration with the factory, whose usual commissions would have encompassed signs for advertising, mass-transit stations, and streets, includes two paintings in the collection of The Museum of Modern Art, *EM 2* and *EM 3*, which, along with *EM 1*, constitute a series of pictures identical in composition and variable in size according to a standardized scale. The abbreviation "EM" refers to the material of which the works'

bonded four-color surfaces were made, *Emaille*, German for "enamel," while the numbers indicate the place of the work in the series, with "1" designating the largest of the three pictures and "3" the smallest. Reviews of Moholy's February 1924 exhibition at the Sturm gallery, Berlin, in which the factory-made paintings in porcelain enamel on steel were first shown (cat. 146), paid particular attention to those works, with one critic deriding them and by extension the entire exhibition as "Constructivism remade as applied art"[4] — a quip intended, no doubt, as a dig at

143
László Moholy-Nagy
Konstruktion in Emaille 3 (Construction
in enamel 3; also known as *EM 3*). 1923
Porcelain enamel on steel
9 ½ x 6" (24 x 15 cm)
The Museum of Modern Art, New York.
Gift of Philip Johnson in memory of
Sibyl Moholy-Nagy

144
László Moholy-Nagy
Konstruktion in Emaille 2 (Construction
in enamel 2; also known as *EM 2*). 1923
Porcelain enamel on steel
18 ¾ x 11 ⅞" (47.5 x 30.1 cm)
The Museum of Modern Art, New York.
Gift of Philip Johnson in memory of
Sibyl Moholy-Nagy

145
László Moholy-Nagy
Konstruktion in Emaille 1 (Construction
in enamel 1; also known as *EM 1*). 1923
Porcelain enamel on steel
37 x 23 ⅝" (94 x 60 cm)
Viktor and Marianne Langen Collection

the larger enterprise of the Bauhaus, where Moholy had taken on a central role the previous spring. The material composition of the sign-factory paintings remained a focal point in their reception for decades, as signaled by the titles used to identify them: a 1937 exhibition in London, for example, included a 1922 work called *Enamel Picture*, and a 1960 exhibition in Zurich appended the name *Enamel Abstract* to the painting now known as *EM 3*, which at that time was in the collection of Philip Johnson.[5]

In contrast to Moholy's essay of February 1924, "*Emaille im Februar 1924*," his 1944 autobiographical text "Abstract of an Artist" asserts that he actually used a telephone in the production of the enamel paintings:

> In 1922 I ordered by telephone from a sign
> factory five paintings in porcelain enamel.
> I had the factory's color chart before me and
> I sketched my paintings on graph paper.
> At the other end of the telephone the fac-
> tory supervisor had the same kind of paper,
> divided into squares. He took down the dic-
> tated shapes in the correct position. (It was
> like playing chess by correspondence.)[6]

The German term for chess played by correspondence is *Fernschach*; in analogy with the German word Moholy probably had in mind, then, we might describe his collaboration with the sign factory as an experiment in *Fernmalerei*, or "telepainting," a phrase that echoes concerns of his essay "*Produktion Reproduktion*," which announces his interest in new (or relatively new) technological media for the recording and transmission of sounds and images, including the gramophone and the Telehor, a precursor of the television invented by the Berlin-based Hungarian Denés von Mihály.

The enamel pictures were made in 1923 and first exhibited publicly in 1924: "*Produktion Reproduktion*" originated a year earlier, in 1922, when it appeared in the avant-garde journal *De Stijl*, and was revised in 1924, as part of the text of Moholy's book *Malerei Photographie Film* (Painting photography film), which would be published in 1925. In the *Malerei Photographie Film* version of the essay, Moholy cites his own recent work in photography as an attempt to extend "those apparatuses (means) that have up to now been put to use only for purposes of reproduction toward productive ends," and he proposes a related experiment to be conducted with gramophone recording plates — listeners, he suggests, might scratch into the wax

plates typically used "to reproduce existing acoustic phenomena" in order to produce instead "new, as yet nonexistent sounds and sound relationships."[7] In this connection, what Moholy describes in "*Emaille im Februar 1924*" as the potential of the enamel paintings to be ordered by telephone from the factory should be seen as a central aim of a project whose "basic premise," like that of the gramophone scenario, "is experimental in the laboratory sense"[8] — another attempt to extend "those apparatuses (means) that have up to now been put to use only for purposes of reproduction toward productive ends."

In the case of the enamel paintings, the productive moment involving the telephone would be the moment in which not only the artist but also a prospective consumer of works in a series might place a call to order one or more of them from the sign factory, thus activating, from a distance, the factory's machinery, not as a reproductive apparatus but, in Moholy's terms, as a productive one. Moholy displays no interest in the technology of the telephone specifically as a medium for transmitting the human voice via a carbon transmitter, electrical wiring, and an electromagnetic receiver. Instead he invokes a network of potential relationships among apparatuses that would create the conditions of possibility for producing paintings by means of the transmission of nonvisual information across distances — "telepainting" as something like the counterpart in the realm of the easel picture to contemporary experiments in early television technology such as Mihály's Telehor system.

To speak of "telepainting" rather than of Telephone Pictures is thus to insist that it makes no difference to our understanding of the significance of these paintings, and of the process of their manufacture, whether the telephone was a potential or an actual part of their extended technological apparatus of production, which also encompassed color charts devised a few years earlier by Wilhelm Ostwald and a spatial-coordinate system (a scaled or projective grid that Moholy in 1944 simply called "graph paper") to map the sheet metal supports for the pictures' bonded porcelain-enamel surfaces.[9] What was consequential for this series of paintings designed to be made in a factory, distant from the artist's studio and indeed without his presence, was that their manufacture involved the transmission not of images bearing a resemblance to them but of nonmimetic information encoded according to the coordinate systems of numbered color charts and scaled grids. The role of the telephone in Moholy's 1924 account was to underscore the fact that the composition of the paintings, based on "mathematically harmonious shapes," could be presented objectively

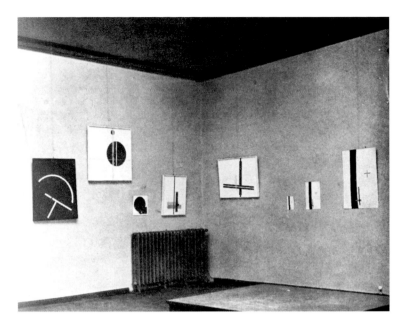

as quantitative data and transmitted through nonvisual media — indeed, that information encoded in this way could adequately have been conveyed by telephone.[10] Moholy may or may not have "sketched" his compositions on graph paper, and in the course of the production process a factory foreman may or may not have done so as well; but in any case the information on which the factory's machines depended to produce the compositions of the enamel pictures was not transmitted — and for production purposes could not have been transmitted — in the form of an image made by the human hand.

The making of paintings to be located in "the realm of objective validity" required not only technologies of mechanical objectivity — from color charts and scaled grids to industrial machinery — but also what Moholy called "ascetic restraint": the repudiation of the kind of "hypertrophic ego" that he saw "personified" in the facture of abstract paintings that emphasized the "personal touch" of the artist's hand. Moholy's embrace of mechanical techniques followed logically from his wish to exceed the capacities, and eliminate the traces, of the hand. "An airbrush and a spray-gun, for example, can produce a smooth and impersonal surface treatment which is beyond the skill of the hand. I was not afraid to employ such tools to achieve machinelike perfection."[11]

Moholy was interested not only in exploiting the resources of industry to establish standards of mechanical objectivity for pictures but also in the possibility of something approaching "structural objectivity" in painting. A Moholian notion of "telepainting" would envision art as potentially "communicable to all" insofar as it could be reconceived according to objective standards by means of which, at its limit, as Lorraine Daston and Peter Galison write, "only structures — not images, not intuitions, not mental representations of any kind — could be conveyed to all minds across time and space."[12] Moholy's 1924 assertion that one could (potentially) order his enamel paintings by telephone, and his 1944 claim that he (actually) dictated the composition of those pictures to the foreman of a factory over the phone, both intend first and foremost to point to the mechanical objectivity of the numbered color chart and the scaled grid as media for the nonmimetic

transmission of a pictorial composition, and of the porcelain-enamel sign factory as a nonartistic site for the making of a painting. In that sense it should not be understood to matter whether Moholy ever spoke into the phone during his experiment in "telepainting." What is meant to matter is what our eyes see, and do not see, when they perceive *EM 1*, *EM 2*, and *EM 3* hanging on the wall next to each other.

1. László Moholy-Nagy, "Emaille im Februar 1924," *Der Sturm* 15, *Monatsbericht* (February 1924):1.
2. Moholy-Nagy, "Abstract of an Artist," 1944, In *The New Vision and Abstract of an Artist* (New York: Wittenborn, 1947), pp. 76–80.
3. Moholy-Nagy, "Production Reproduction," 1922, in *Malerei Photografie Film*, 1925, Eng. trans. *Painting Photography Film*, trans. Janet Seligman (Cambridge, Mass.: The MIT Press, 1969), p. 30. The translation is based on the 1927 revised edition, *Malerei Fotografie Film*.
4. Anonymous review, *Das Kunstblatt* 8, no. 3 (March 1924):96. The review refers to Adolf Behne's February 1924 essay "Snob und Anti-Snob" (*Die Weltbühne* 20, no. 8 [February 21, 1924]:234–36), in which Behne praises Moholy's enamel paintings as an instance of the technological production of works of art in which "there is no longer an original" and situates his invocation of the telephone in relation to a text by Tristan Tzara, Walter Serner, and Hans Arp, published pseudonymously in the *Dada Almanac* in 1920: "The good painter," they assert, "is recognizable, for example, by the fact that he orders his pictures from a cabinet maker according to specifications transmitted by telephone." Alexander Partens, "Dada Kunst," in *Dada Almanach*, ed. Richard Huelsenbeck (Berlin: Erich Reiss Verlag, 1920), p. 89.
5. See Sigfried Giedion, *L. Moholy-Nagy*, exh. cat. (London: London Gallery, 1937), n.p, and *Konkrete Kunst*, exh. cat. (Zurich: Helmhaus Zurich, 1960), p. 19.
6. Moholy-Nagy, "Abstract of an Artist," p. 79.
7. Moholy-Nagy, "Production Reproduction," in *Painting Photography Film*, pp. 30–31. Translation modified by the author.
8. Moholy-Nagy, "Production-Reproduction," in *Photography in the Modern Era: European Documents and Critical Writings, 1913–1940*, ed. Christopher Phillips (New York: The Metropolitan Museum of Art and Aperture, 1989), p. 80.
9. See Philip Ball and Mario Ruben, "Color Theory in Science and Art: Ostwald and the Bauhaus," *Angewandte Chemie International Edition* 43 (2004):4842-46.
10. Moholy-Nagy, "Abstract of an Artist," p. 79.
11. Ibid.
12. Lorraine Daston and Peter Galison, *Objectivity* (New York: Zone Books, 2007), p. 254.

146
László Moholy-Nagy
Enamel pictures installed at the artist's exhibition at the Galerie Der Sturm, Berlin, February 1924
As reproduced in Moholy-Nagy. *Experiment in Totality*. New York: Harper & Brothers, 1950
The Museum of Modern Art Library, New York

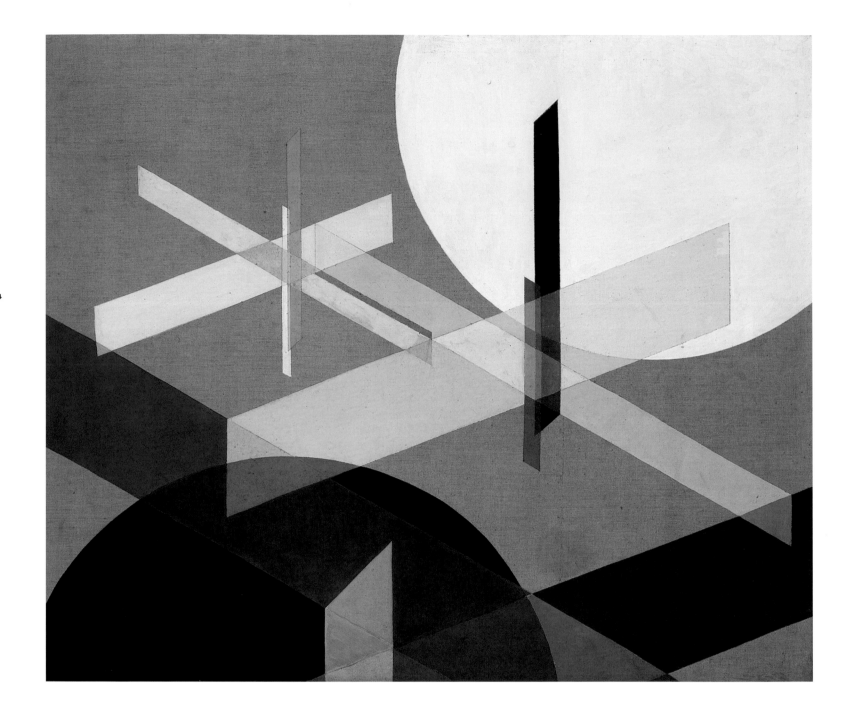

147
László Moholy-Nagy
Z VIII. 1924
Tempera on unprimed canvas
44 7/8 x 51 15/16" (114 x 132 cm)
Staatliche Museen zu Berlin, Neue
Nationalgalerie, Berlin

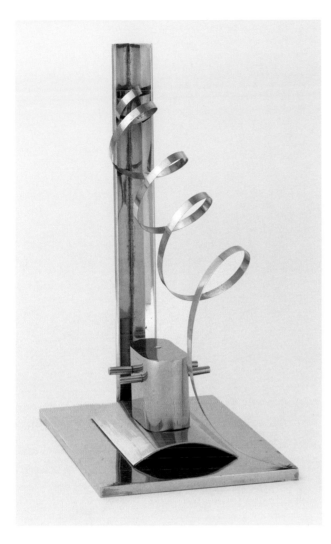

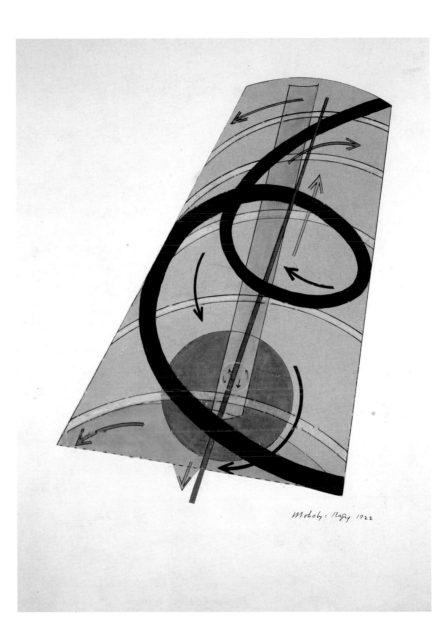

148
László Moholy-Nagy
Nickelplastik (Nickel sculpture). 1921
Nickel-plated iron, welded
14 1/8 x 6 7/8 x 9 3/8" (35.9 x 17.5 x 23.8 cm)
The Museum of Modern Art, New York.
Gift of Mrs. Sibyl Moholy-Nagy

149
László Moholy-Nagy
Kinetisches Konstruktives System
(Kinetic-constructive system). Schematic
diagram of a movable light machine
for a theater. 1922
Cut-and-pasted paper with ink
and watercolor on paper
24 x 18 7/8" (61 x 48 cm)
Bauhaus-Archiv Berlin

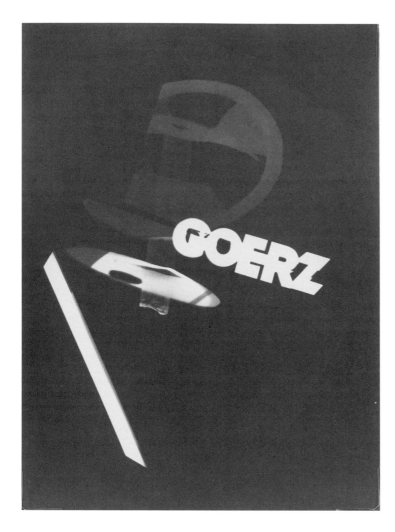

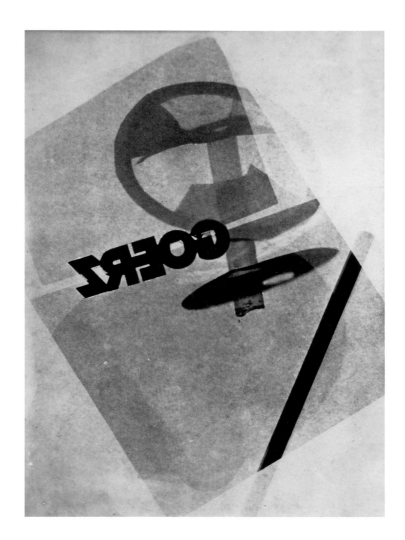

150
László Moholy-Nagy
Werbefotogramm (advertising photogram)
for the Goerz photochemical company. 1925
Gelatin silver print (photogram)
8 1/8 x 6 1/4" (20.6 x 15.9 cm)
Joy of Giving Something, Inc.

151
László Moholy-Nagy
Werbefotogramm (advertising photogram)
for the Goerz photochemical company. 1925
Negative gelatin silver print (photogram)
8 1/2 x 6 1/4" (21.6 x 15.9 cm)
Joy of Giving Something, Inc.

152
László Moholy-Nagy
K VII. 1922
Oil on canvas
45 3/8 x 53 1/2" (115.3 x 135.9 cm)
Tate, London. Purchase

153
László Moholy-Nagy
A XI. 1923
Oil on canvas
52 1/8 x 45 1/4" (132.5 x 115 cm)
Neue Galerie New York

WILHELM WAGENFELD AND CARL JAKOB JUCKER
TABLE LAMP. 1923–24

FREDERIC J. SCHWARTZ

It is one of the earliest and most enduring symbols of the Bauhaus — and as such, it is an ambivalent one. Eighty-five years after its invention, its perfect geometry makes it instantly recognizable as a product of the school, an object of fascination, desire, and delight. Yet the dark secret of this bright light soon spread: "Retailers and manufacturers laughed at our efforts," wrote Wilhelm Wagenfeld years later. "These designs which looked as though they could be made inexpensively by machine techniques were, in fact, extremely costly craft designs." His conclusion was devastating: "a crippled, bloodless picture in glass and metal."[1]

A symbol, then, of failure? Not necessarily. The lamp may well fall short of the standards set by Walter Gropius after the Bauhaus moved to Dessau: an object, he wrote in his "Principles of Bauhaus Production" of 1926, must be designed "by systematic practical and theoretical research into formal, technical and economic fields"; must represent "economical utilization of space, material, time and money"; and must be "suitable for mass production."[2] But though the rhetoric of precision and economy might seem to be the same in Gropius's text and the Bauhaus lamp, they emerge, in fact, from very different moments in the school's history.

Designed in 1923–24, the lamp, in its various versions, was a late product of the Weimar Bauhaus, of the moment of change from an individualistic craft aesthetic — a rejection of the demands of modern production — to one that found a new raison d'être in what Molly Nesbit has called the "language of industry": the seemingly universal, objective, precise, and timeless laws of geometry.[3] It was not an easy or straightforward realignment. For though the rapprochement with industry and the rhetoric that would later be termed "functionalist" seems simple and even obvious, that position was never really espoused until after Gropius had left the school, in 1928. And if the move from an Expressionist or craft aesthetic to one that was called "Constructivist" or "Elementarist" seems sudden and complete from the visual evidence of Bauhaus production, the change in Bauhaus theory took longer. The stylistic shift and the discursive shift were not simultaneous; they took place at different rates. And in this space between visual form and the written word, we see the complex negotiation of a new paradigm of design production. We find clues there to what Wagenfeld and Carl Jucker hoped to achieve in the Bauhaus lamp, clues by which we might better judge it.

So let us roll back the clock to 1923. The new project of "Art and Technology: A New Unity" seems simple enough, but

Gropius grasped at words to describe it in more detail: "The dominant spirit of our epoch is already recognizable although its form is not yet clearly defined. The old dualistic world-concept which envisaged the ego in opposition to the universe is rapidly losing ground. In its place is rising the idea of a universal unity in which all opposing forces exist in a state of absolute balance. This dawning recognition of the essential oneness of all things and their appearances endows creative effort with a fundamental inner meaning."[4] This is the theosophical rhetoric of de Stijl, the words and concepts that gave an urgent meaning to the visual idiom of the ruled line and the Euclidean form. And we can see quite precisely how such ideas were interpreted in the work of László Moholy-Nagy, who had recently emerged as a key figure in the "International Constructivism" that served as a conduit of ideas and forms from Soviet Russia and the Netherlands to Germany and who replaced Johannes Itten in the key pedagogical role of teacher of the preliminary course precisely in 1923. Moholy's painting of the time represents an exploration of these forms that were transcendental in their elimination of traces of the individual, that showed this absolute balance, the inner meaning of forms not drawn into the battle of individual against the universe. *A XX* (1924; cat. 286) explores the different possibilities of form and light in space; under these conditions, they emerge with exhilarating clarity. Opacity turns black into white; translucence turns black into gray. Rotation makes a rectangle into a trapezoid; transparency reveals the perpendicularity of the planes without the cliché of the right angle. Only the hidden tangent at the center of the composition blocks our vision while holding it focused, even longing.

We see the same purity, logic, and economy in the lamp. It is a systematic analysis of circular form. In two dimensions, at the base, it is simply round (something more obvious in the version with a metal bottom and stem). Pulled into the third dimension as a shaft, it becomes a cylinder. Rotated around the diameter, it is the sphere of the shade. And any section of the sphere — here necessitated by the need to change bulbs — remains a circle. Light is subject to the same logic. The transparent glass of the base and shaft in the version we most often see transmits the light; the milky glass of the shade diffuses it; the chrome steel in the center reflects it back. And consider the light itself. In the years before the lamp took form, Expressionist light had a very different poetics. For Bruno Taut, in his Glass House of 1914 (fig. 1), "colored glass destroys hatred."[5] In the crystalline rays of Lyonel Feininger's woodcut for the Bauhaus Manifesto

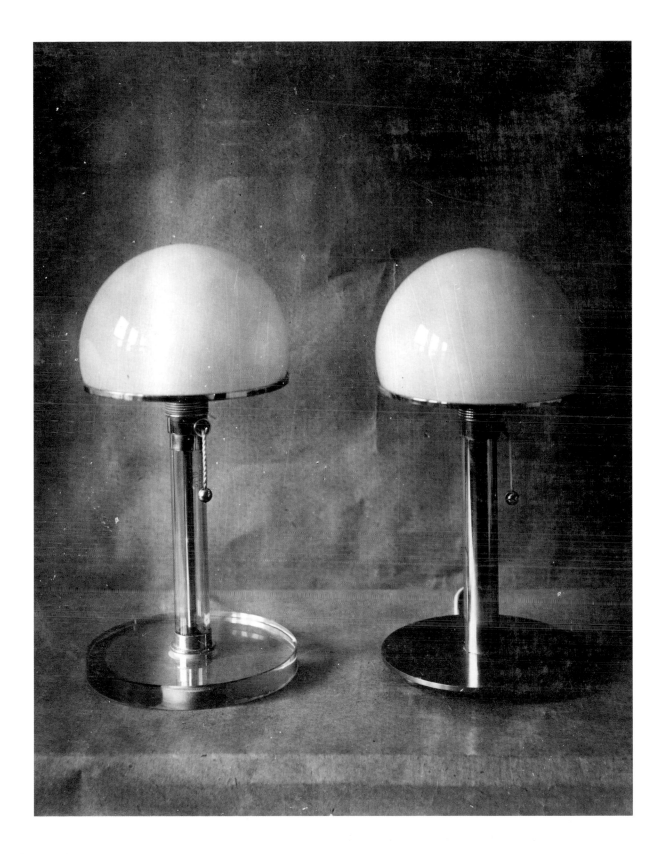

154
Wilhelm Wagenfeld and
Carl Jakob Jucker
Table lamp. Metal- (MT 8/ME 2) and glass-base
(MT 9/ME 1) versions. 1923–24
Photograph: Lucia Moholy. 1924. Gelatin
silver print adhered in the Bauhaus album
Metallwerkstatt. 5 13/16 x 4 9/16" (14.7 x 11.6 cm).
Bauhaus-Universität Weimar, Archiv der
Moderne

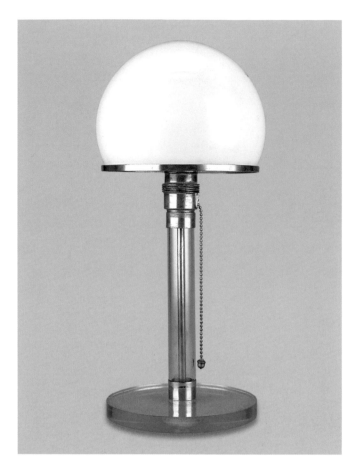 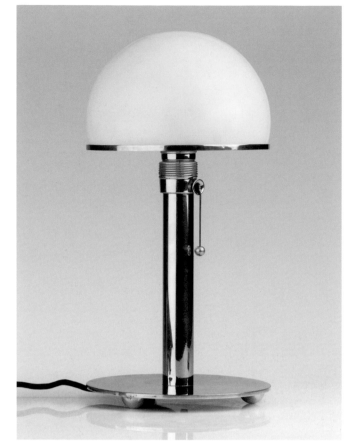

(cat. 38), light is an epiphany. The white light of Wagenfeld and Jucker, however, is even, objective, diffuse, everywhere the same. It won't destroy hatred, but will show it clearly; it won't pierce consciousness with any sort of revelation, but will simply expose the world to the power of the mind.

This was the job, the function, the work, of the lamp. If it evolved further and took a different form in people's homes, no matter: the development of what was called the "type" was a process, and if this experiment in circles and light dropped out of the equation of daily illumination, it nonetheless survived in spirit in all lamps that would follow.

In 1922, an artist in Moholy's own circle called this kind of light, this kind of geometry, "socialism of vision."[6] It is an appealing thought: all minds have access to the logic of the circle and the line; light lays bare the world for everyone. Constructivist principles of elementary form have no secrets but can be the common property of all men and all minds. But the call for "socialism of vision" in the first half of the 1920s was itself a political act, and one considerably less transparent than such words and forms might seem. For "socialism" of various kinds had already been, for more than a half decade, the center of bloody battles. A "socialist" republic had been declared in the Soviet Union; and while this revolution remained a beacon of hope for some in Central Europe and points farther west, it was haunted by the matter of civil war and the specter of compromise and dictatorship. Sympathy for an active, political form of socialism had in fact turned Moholy, who had welcomed the short-lived and brutally repressed Hungarian Soviet Republic of Béla Kun, into an exile.[7] And in Germany itself, it was the forces

of continuity and opposition to the Soviet model that had declared themselves "socialist" — through the Social Democratic party, which had proclaimed a republic with the collapse of the monarchy, in November 1918, and then had made common cause with a conservative bureaucratic, military, and industrial elite to oppose a more frightening form of politics that claimed the same name for itself. This was a compromise, but one imposed by military means as pockets of both left- and right-wing revolt plagued the country through at least 1923. It had disintegrated definitively by 1933.

So by 1923 or 1924, "socialism of vision" already represented an evasion of active politics. Impractical but nonetheless compelling, a vision of the future that still had to be carefully crafted by hand, the Bauhaus lamp serves as a symbol for a moment when politics retreated into visual form. How to judge this is another question. To some, such a retreat might have seemed cynical, a way to claim the mantle of radical politics without putting oneself on the line. To others, form might have seemed the only place in which a utopia could be preserved, suspended in a timeless ether until history and politics could catch up with such a purity of vision, until the light of "socialism" would cast no dark shadows.

This is the situation in which such a lamp could provide its paradoxical illumination. With the halting recovery of capitalist production and the increasing polarization of German politics, however, the overlapping worlds of artistic logic and everyday life were pulled apart. As sculpture, the lamp might still have some claim to validity; but that was not what the Bauhaus was about after 1923, if it ever was. And as an object of

the world, one judged by the criteria of instrumental reason, it failed to live up to the demands of the capitalist rationality of production, or of a project to furnish the dwellings of a mass subject. And so the lamp was wrenched from the world it was meant to create — one of the utopian suspension of politics in a space of pure light and freedom — into one that was much more conflicted. Only in this imperfect world, which we still inhabit, could the lamp be split into "torn halves" of a unity, as Theodor W. Adorno said of autonomous art and mass culture, "to which however they do not add up."[8] In this case, Wagenfeld and Jucker's work was sundered into a mere work of art on the one hand and a mere lamp on the other, into an object of useless beauty and a flawed object of everyday life.

1. Wilhelm Wagenfeld, quoted in Gillian Naylor, *The Bauhaus Reassessed: Sources and Design Theory* (New York: E. P. Dutton, 1985), p. 112.

2. Walter Gropius, "Bauhaus Dessau — Principles of Bauhaus Production" (1926), in Hans Maria Wingler, *The Bauhaus: Weimar, Dessau, Berlin, Chicago* (Cambridge, Mass.: The MIT Press, 1969), pp. 109–10.

3. Molly Nesbit, "The Language of Industry," in Thierry de Duve, ed., *The Definitively Unfinished Marcel Duchamp* (Cambridge, Mass.: The MIT Press, 1991).

4. Gropius, "The Theory and Organization of the Bauhaus," in Herbert Bayer, Walter Gropius and Ise Gropius, eds., *Bauhaus 1919–1928*, exh. cat. (New York: The Museum of Modern Art, 1938), p. 20.

5. "Das bunte Glas/Zerstört den Hass" was one of the rhyming couplets by Paul Scheerbart inscribed on the frieze beneath Bruno Taut's dome. See Scheerbart, "Sprüche für das Glashaus," in Bruno Taut et al., *Frühlicht, 1920–1922: Eine Folge für die Verwirklichung des neuen Baugedankens*, ed. Ulrich Conrads (Berlin: Ullstein, 1963), p. 19.

6. "Constructivism and the Proletariat," in Richard Kostelanetz, ed., *Moholy-Nagy* (New York: Praeger, 1970), p. 186. On the authorship of this article see Victor Margolin, *The Struggle for Utopia: Rodchenko, Lissitzky, Moholy-Nagy, 1917–1946* (Chicago: at the University Press, 1997), p. 66, n. 70.

7. On Moholy-Nagy and the Hungarian revolution see Krisztina Passuth, *Moholy-Nagy* (London: Thames & Hudson, 1985), pp. 15–16.

8. Theodor W. Adorno, letter to Walter Benjamin, March 18, 1936, in *Aesthetics and Politics: The Key Texts of the Classic Debate within German Marxism* (London: New Left Books, 1977), p. 123.

155
Wilhelm Wagenfeld and
Carl Jakob Jucker
Table lamp (MT 9/ME 1). 1923–24
Nickel-plated brass and opalescent glass,
with plate-glass base
Height: 14 5/8" (37 cm)
Private collection. Courtesy Neue Galerie
New York

156
Wilhelm Wagenfeld
Table lamp (MT 8/ME 2). 1924
Nickel-plated brass and opalescent glass,
with nickel-plated iron base
Height: 14 3/8" (36.5 cm), diam.: 7" (17.8 cm)
Private collection, courtesy Galerie Ulrich
Fiedler, Berlin

Fig. 1
Bruno Taut
Glass House (pavilion of the Luxfer-
Prismen-Syndikat), Werkbund exhibition,
Cologne. 1914
Photograph: Photographer unknown. 1914.
Gelatin silver print
Foto Marburg

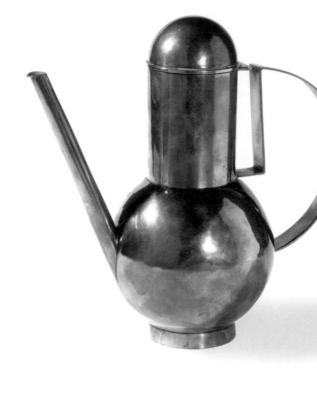

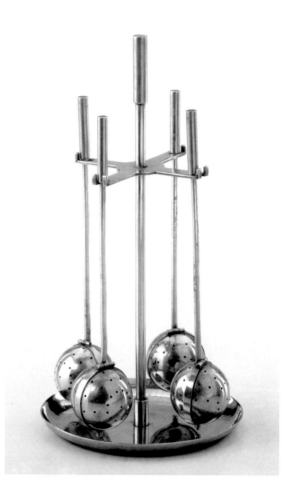

157
Wolf Rössger and **Friedrich Marby**
Liquor pitcher (MT 33?). 1924
Brass, tombac, and nickel silver
with silver-plated interior
Height: 7 1/2" (19 cm)
Klassik Stiftung Weimar, Bauhaus-Museum

158
Wilhelm Wagenfeld
Tea caddies, large (MT 38) and small (MT 39).
1924
Nickel silver
Height, MT 38: 8 7/16" (21.4 cm), MT 39:
5 7/8" (14.9 cm)
Klassik Stiftung Weimar, Bauhaus-Museum

159
Otto Rittweger and **Wolfgang Tümpel**
Stand (MT 21) by Rittweger with four tea
infusers (MT 11) by Tümpel. 1924
Nickel silver
Height of stand: 7 5/16" (18.5 cm); height
of tea infusers: 5 7/8" (15 cm)
Bauhaus-Archiv Berlin

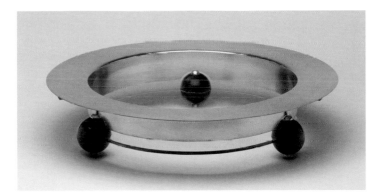

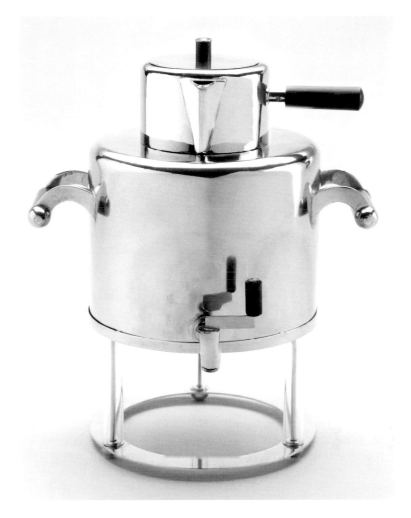

160
Josef Albers
Tea glass with saucer and stirrer. 1925
Heat-resistant glass, chrome-plated steel,
ebony, and porcelain
Cup: 2 x 5½ x 3½" (5.1 x 14 x 8.9 cm),
saucer: 4⅛" (10.5 cm) diam., stirrer: 4¼ x ⁷⁄₁₆"
(10.8 x 1.1 cm)
The Museum of Modern Art, New York.
Gift of the designer

161
Josef Albers
Fruit bowl. 1923–24
Silver-plated metal, glass, and painted wood
Height: 3⅝" (9.2 cm), diam.: 16¾" (42.5 cm)
The Museum of Modern Art, New York.
Gift of Walter Gropius

162
Marianne Brandt
Samovar. 1925
Nickel-plated copper alloy
Height: 12¾" (32.3 cm), width: 10½"
(26.6 cm), diam.: 7¼" (18.3)
Collection Renée Price. Courtesy
Neue Galerie New York

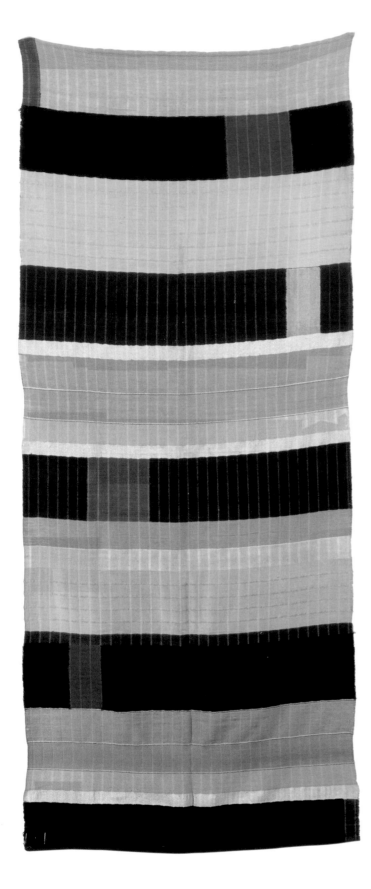

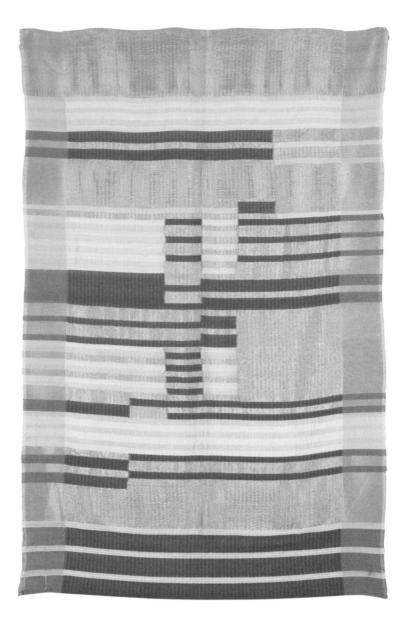

163
Anni Albers
Wall hanging. 1925
Wool and silk
7' 8 7/8" x 37 3/4" (236 x 96 cm)
Die Neue Sammlung—The International
Design Museum Munich

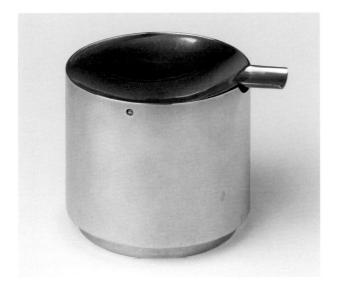

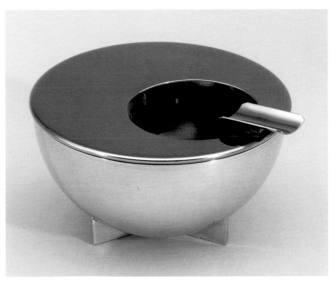

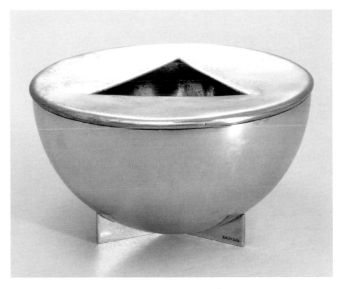

164
Anni Albers
Wall hanging. 1925
Silk, cotton, and acetate
57 1/8 x 36 1/4" (145 x 92 cm)
Die Neue Sammlung—The International
Design Museum Munich

165
Marianne Brandt
Ashtray. 1924
Brass and nickel-plated metal
Height: 2 3/4 (7 cm), diam.: 3 1/8" (7.9 cm)
The Museum of Modern Art, New York.
Gift of John McAndrew

166
Marianne Brandt
Ashtray. 1924
Brass and nickel-plated brass
Height: 2 5/8" (6.7 cm), diam.: 3 1/8" (7.9 cm)
The Museum of Modern Art, New York.
Gift of John McAndrew

167
Marianne Brandt
Ashtray (MT 36). 1924
Brass and nickel-plated brass
Height: 2 3/8" (6 cm), diam.: 4 3/8" (11.1 cm)
Private collection. Courtesy Neue Galerie
New York

JOSEPH HARTWIG
CHESS SETS. 1922–24
BENJAMIN H. D. BUCHLOH

We associate Bauhaus design first of all with utilitarian production — with housing, and with objects of use and consumption. In its ambition of radical democratic aestheticization, its promise to revolutionize the experience of the everyday through not only the universal legibility of technological forms of design but also the collective availability made possible by industrial mass production, the Bauhaus aimed to remake the everyday according to the laws of function and efficiency. Thus it might surprise us that Josef Hartwig, the master craftsman of the Bauhaus wood workshop beginning in 1921, would turn to one of the world's oldest games, one whose presence across history reminds us that the desire for the ludic persists even in the most advanced industrial cultures of modernity.

In fact chess had retained, or perhaps regained, an extraordinary attraction in the first half of the twentieth century. It cannot be accidental, after all, that sets or sites for the public or private performance of chess were designed by artists as diverse and opposite in almost all aspects of their aesthetic and ideological identities as Man Ray, Max Ernst, Alexander Calder, and Marcel Duchamp, on the one hand, and Hartwig and Aleksandr Rodchenko on the other. Chess gives the subject access to cognitive, logical, strategic, and calculating practices to be rehearsed outside the orders of labor and production, outside the spheres of total instrumentalization. The subject thus exercises these capacities from a position of disinterest, defining itself within a ludic aesthetic of the everyday. In this way chess constructs a counter-sphere in which the ruling conditions of universal rivalry and competition, the economic laws of strategic and tactical deception, are manifestly inverted to be deployed in the service of play and pleasure. As late as 1952 Duchamp stated, "I am still a victim of chess. It has all the beauty of art — and much more. It cannot be commercialized. Chess is much purer than art in its social position."[1]

Hartwig was by all accounts a modest master craftsman, yet his designs for a chess set, from 1922 to 1924, are a twentieth-century redesign as meaningful and beautiful as Duchamp's or Rodchenko's. Working under the impact of a newly emerging techno-scientific abstraction, particularly the Suprematism of Kazimir Malevich, Hartwig mediated his utopian aspirations by mobilizing the fundamentals of geometric and stereometric design. Not only did geometric and stereometric abstraction promise forms of universal access and legibility, in Hartwig's chessmen it also proclaimed the subject's universal right to

ludic and productive leisure, like Rodchenko's designs for chessboards, tables, and seats in his Worker's Club for the Paris Exhibition in 1925.

The Russian and Soviet avant-garde had had its first major public display in Germany at the *Erste Russische Kunstausstellung*, at the Galerie van Diemen, Berlin, in 1922. Here Hartwig and his peers from the Bauhaus would have been able to encounter firsthand Russian painting and sculpture that were intended to transform all aspects of representation and of the design of the everyday.[2] The modernist call to "make it new" had been replaced by the directive to make life geometric and stereometric, reflecting a widespread agenda of denaturing myth- and class-based forms of subjectivity — of dismantling figurative representation as the site where the seemingly incontestable hierarchy of classes and right to private property in the means of production, had been naturalized and mythified. This agenda implied a radical assault on the conventions of painting and drawing, which now were subjected to the new techniques of measurement and manufacture and to the deployment of design tools (the compass and rulers, for example, by Rodchenko). If this abolition of the seemingly natural hierarchies embedded in figurative representation was a central project of the techno-scientific forms of avant-garde abstraction, how could the avant-garde resist redesigning a game whose "figures" had played out feudal, military, and clerical hierarchies for centuries with seemingly ontological plausibility?

True to the Bauhaus credo, the forms of Hartwig's stereometrization of these figures follow their functions — the sphere on top of the queen's cubic body, for example, signaling her supreme mobility, the rotated cube on the king's similar body his limited power of single diagonal and axial movement, and the cross form of the bishop the diagonality of that figure's moves. Yet in many ways the chessmen also deconstructed the "natural" orders of representation. First, Hartwig's "disfiguration" withdrew the militaristic, bellicose dimensions of chess, its distant echoes of jousting medieval knights, the innate subtext that games have no function but to train us for war. Yet while Hartwig

168
Josef Hartwig
Chess set (model I). 1922
32 pieces, wood and felt
Smallest: 1 1/16 x 7/8 x 7/8" (2.7 x 2.3 x 2.3 cm),
largest: 2 7/16 x 1 1/16 x 1 1/16" (6.2 x 2.7 x 2.7 cm)
Harvard Art Museum, Busch-Reisinger
Museum. Gift of Julia Feininger

169
Josef Hartwig
Chess set (model XVI). 1924
32 pieces, pearwood, natural and
stained black
Smallest: 7/8 x 7/8 x 7/8" (2.2 x 2.2 x 2.2 cm),
largest: 1 7/8 x 1 1/8 x 1 1/8" (4.8 x 2.9 x 2.9 cm)
The Museum of Modern Art, New York.
Gift of Alfred H. Barr, Jr.

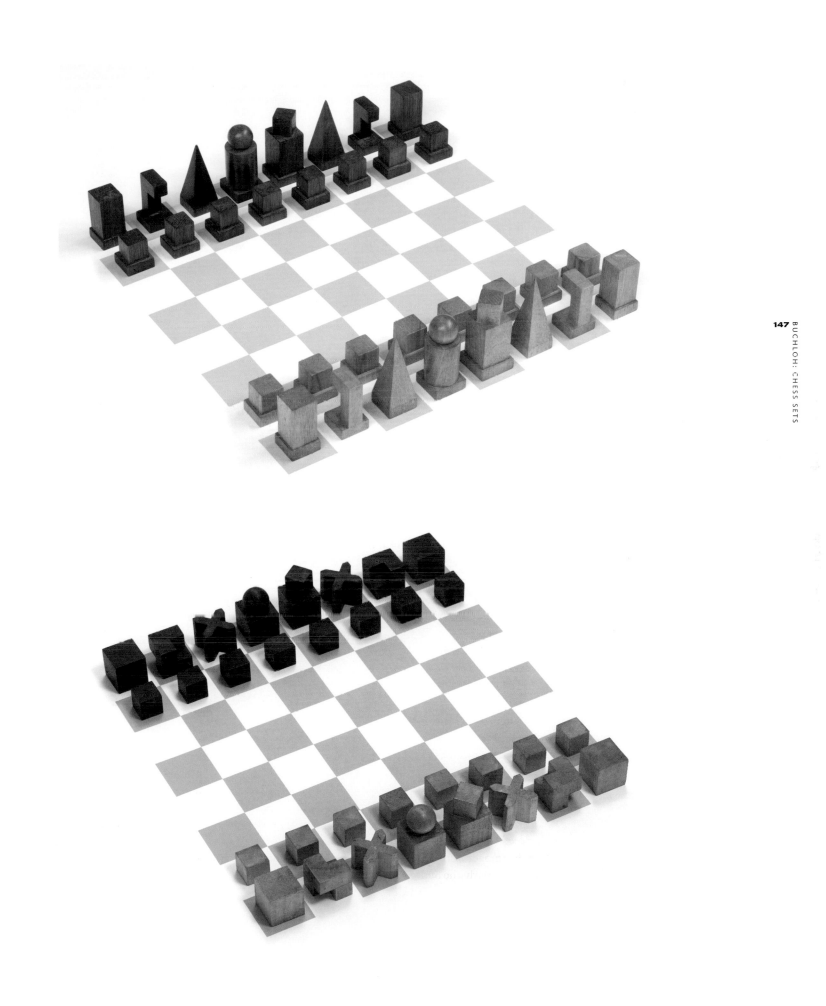

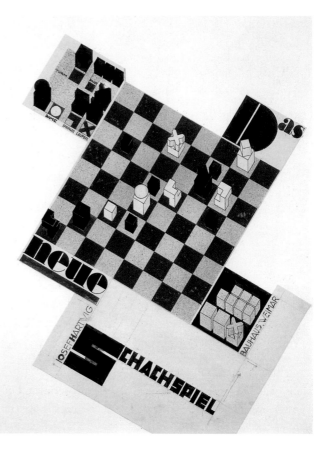

dismantled the anthropomorphism of traditional chessmen, his king, queen, and bishop partly retain the traditional figure's division between head, body, and base — a division that Ernst's and to some extent Man Ray's conical and biomorphic chessmen would ostentatiously reject by fusing all bodily and perceptual functions in a unified, acephalic part object.[3]

This residual anthropomorphism gives Hartwig's "ruling" figures a hybrid status typical of the anthropomorphic figuration of the 1920s, which, when it appears at all, seems in transition to the robotic, the prosthetic, the mechanomorphic, and the marionette. And while these ruling figures collapse body and base into each other in a manner almost comparable to Constantin Brancusi's elimination of that sculptural distinction, the pawns (along with the axonometric architectural castles and the newly designed bishops) are the only figures to be defined as unified, singular objects, pure cubes — the most elementary and egalitarian of the stereometric set. Perhaps the most compelling confrontation of stereometric and diagrammatic abstraction occurs in the cruciform design of the bishop. Here, to signal the piece's diagonal mobility, Hartwig not only cites Malevich's use of the cross shape as the sign for the pictorial equivalence and simultaneity of horizontality, verticality, and diagonality, he further recognizes that Malevich's pictorial and plastic forms had been shifted from plasticity to semiology when El Lissitzky deployed the cross shape as a pure semiological marker in his book *Dlia golosa* (For the voice), a book of Vladimir Mayakovsky's poems published in Berlin in 1923, its title activating the readers of the poems to speak them aloud. Here Lissitzky fractures the cross shape into individual rectangular units whose semiological function (rather than dynamic abstract plasticity) is underlined by their combination with the printed indexical hand sign of commercial advertising, about to become a classic of the newly emerging duality between plasticity and semiology since Duchamp's *Tu m'* in 1918.[4]

Hartwig's chess set, then, embodies a utopian quest for the new subject to be self-determining in ludic and linguistic culture. As if that quest had to be suspended between the mech-

anomorphic and the diagrammatic, all of the chessmen cross far enough over into purely stereometric abstraction for their differences to be perceived as merely functional signs within the spatial diagram of the board. This makes the game and its figures appear as no more than a system of permutational constellations, functioning according to an emerging logic of structural, linguistic, and semiotic differentials — which is of course the game's exact definition. It is not at all accidental that Ferdinand de Saussure used the chess game as an example of the kinds of artificially ascribed differentials that are the site and source of the production of linguistic meaning.[5] Still more astonishing, perhaps, for its comparison with art practices is Duchamp's statement "The chess pieces are the block alphabet which shapes thoughts; and these thoughts, although making a visual design on the chess-board, express their beauty abstractly, like a poem. . . . I have come to the personal conclusion that while all artists are not chess players, all chess players are artists."[6]

It is hard to prove that Hartwig's decision to base his figures on a square plan (in opposition to their traditional circular base), tautologically replicated in the chessboard's grid of squares, consciously echoed the equally tautological schema of Malevich's *Black Square* of 1913. But the diagrammatic grid of squares certainly serves as a map for the quadratic figures, in a self-reflexivity conveying the sense of a social and spatial order that no figure can transcend — undoubtedly an affirmation of the reality principle at the heart of a game that simulates infinite ludic freedom. Seen in place on their checkered black-and-white ground, Hartwig's chessmen appear as the ultimate logic of a deductive composition: their entwinement and confinement demarcate the transition from self-reflexive pictorial

170
Joost Schmidt
Design for an advertisement, *Neue Schachspiel* (The new chess game). 1923
Ink and pencil on paper
13³⁄₄ x 16³⁄₁₆" (48 x 41.1 cm)
Collection Merrill C. Berman

171
Josef Hartwig
Chess set (model XVI) with cardboard packaging designed by Joost Schmidt. 1924
32 pieces, pearwood, natural and stained black; card box with lithographic label
Smallest: ⁷⁄₈ x ⁷⁄₈ x ⁷⁄₈" (2.2 x 2.2 x 2.2 cm), largest: 1⁷⁄₈ x 1¹⁄₈ x 1¹⁄₈" (4.8 x 2.9 x 2.9 cm), box: 2¹⁄₈ x 4⁷⁄₈ x 4⁷⁄₈" (5.4 x 12.4 x 12.4 cm)
Centre Pompidou, Paris. Musée national d'art moderne/Centre de création industrielle

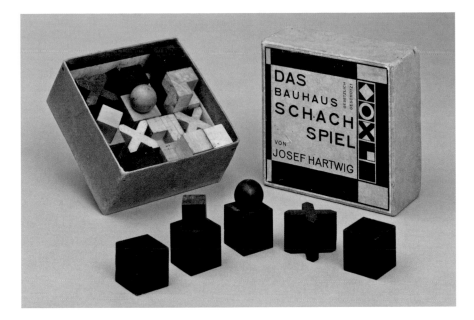

form and sculptural objecthood to the reality of social relations and institutions, and do so with the same clarity with which Rodchenko designed that transition in the chromatic distinctions of his reversible chessboard and in the definition of his chess-player's chair as an operator's seat.[7] In both cases, however — and this makes both Hartwig's and Rodchenko's chess designs still more enigmatic and exceptional — the road from Malevich's supreme moment of free pictorial self reflexivity has not led to pure necessity and the lowest common denominators of utilitarian production (which, in 1923, the artists of both Soviet Productivism and the Bauhaus rightfully perceived as the only radical avant-garde project deserving of the name). Instead it has led into the formerly imaginary, now concretely emerging integration of the freedom of play within the confines of proletarian experience.

That message is even given in the design of the box for the chessmen (cat. 171), which traditionally would have been presented in a wooden case, a hierarchically ordered felt-lined shrine. Hartwig's unassuming cardboard box alleviates those weights by conceiving of the set as a cubic and compact collective of interlocking stereometric figures. The cover, halfway between a Constructivist poster (it almost exactly copies Lissitzky's diagrammatic versions of Malevich's *Black Square* and *Black Circle* on the cover of *Objet Veshch' Gegenstand* no. 3, published with Ilya Ehrenburg in Berlin in 1922)[8] and a *sachlich* design for some simple object of a pauper's daily consumption, announces the functions, purpose, and practical portability of the game in the most common typography of modernity.[9]

That chess could not maintain its promise of situating an emancipated working class in a new place of cognitively activated leisure would become evident in a design of Duchamp's from 1943, when utopian aspirations had given way to an increasingly menacing future of flight, emigration, and exile. If chess could be sustained now at all, then it was at best as a game on the run. Duchamp's traveler's chess set, its figures reduced to flat plastic chips, mere signals, gives us a lucid account of the increasingly precarious condition of the ludic in public life.

1. Marcel Duchamp, in "A Family Affair," *Time* 59, no. 10 (March 10, 1952):82.

2. Publications on Soviet art had of course been available earlier in Berlin, notably Konstantin Umansky's essay "Neue Kunstrichtungen in Russland: Der Tatlinismus oder die Maschinenkunst in Russland," *Der Ararat*, January 1920, and his book *Neue Kunst in Russland 1914–1919*, published in Munich the following April. Both Umansky's term "Maschinenkunst" and his proclamation of the death of art appeared as placards held up by George Grosz and John Heartfield in the Dada Fair, Berlin, in 1920, testifying to the wide reception of his writings among the city's artists.

3. In the evolution of Hartwig's set between 1922 and 1924, it is the bishop that changes most dramatically. In 1922 the bishop is a slender pyramid on a base. By 1923, it appears as a diagonal cross with pointed, arrowlike tips, signaling diagonal direction, yet it is still positioned on a base, like the other figures. By 1924, the bishop has lost its base, so that its crossed planes acquire even more of a directional dynamic.

4. El Lissitzky and Vladimir Mayakovsky, *Dlia golosa* (Berlin and Moscow: Gozisdat, 1923). Lissitzky visited Weimar in 1922, participating in the Dada and Constructivist International conference there.

5. "Of all comparisons that might be imagined, the most fruitful is the one that might be drawn between the functioning of language and a game of chess. In both instances we are confronted with a system of values and their observable modifications. A game of chess is like an artificial realization of what language offers in a natural form." Ferdinand de Saussure, *Course in General Linguistics*, 1916 (New York: McGraw Hill, 1966), p. 88.

6. Duchamp, "Address, Aug. 30, 1952, New York State Chess Association," in Anne d'Harnoncourt and Kynaston McShine, eds., *Marcel Duchamp* (New York: The Museum of Modern Art, 1973), p. 131.

7. Aleksandr Rodchenko's chess table and chairs for a Workers' Club, exhibited in Paris in 1925, have a peculiar dimension of reductivist constraint. Dictated by spatial economy, the design also eliminated distraction; the chairs are fused as a single "work station," and the board rotates so that the players can change colors without changing places. See Peter Noever, ed., *Rodchenko — Stepanova: The Future is Our Only Goal* (Munich: Prestel, 1991), p. 182.

8. Lissitzky designed both the cover and the front page of the first issue of *Objet Veshch' Gegenstand*. For a reproduction of the cover see *El Lissitzky: Maler Architekt Typograf Fotograf* (Halle: Staatliche Galerie Moritzburg, 1982), pp. 44–45.

9. The box, as well as the cards advertising the set's release and presumably the type itself, were the work of Joost Schmidt, a key Bauhaus typographic designer. For reproductions of his designs and typefaces see Gerd Fleischmann, ed., *Bauhaus: Drucksachen, Typografie, Reklame* (Düsseldorf: Edition Marzona, 1984), p. 90. I am grateful to Leah Dickerman for bringing to my attention the marketing of Hartwig's chess set to the chess clubs that proliferated in Germany in the 1920s, reinforcing my understanding of both Hartwig's chess set and the sociopolitical aspirations with which chess was then invested.

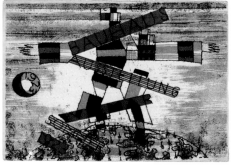

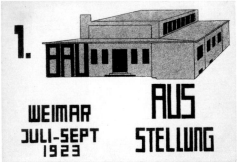

172–91
Bauhaus students and faculty.
Left to right, top: Kurt Schmidt, Oskar Schlemmer, Dörte Helm, Rudolf Baschant,
Schmidt, Paul Klee. Center: Gerhard Marcks, Baschant, Vasily Kandinsky, Herbert Bayer,
Lyonel Feininger, Farkas Molnár, Georg Teltscher, Feininger. Bottom: Ludwig
Hirschfeld-Mack, Hirschfeld-Mack, Paul Häberer, Klee, Bayer, László Moholy-Nagy
Twenty postcards for the 1923 Bauhaus exhibition. 1923
Color lithographs on cardboard
Each: c. 5 1/8 x 3 15/16" (15 x 10 cm), orientation varies
Bauhaus-Archiv Berlin

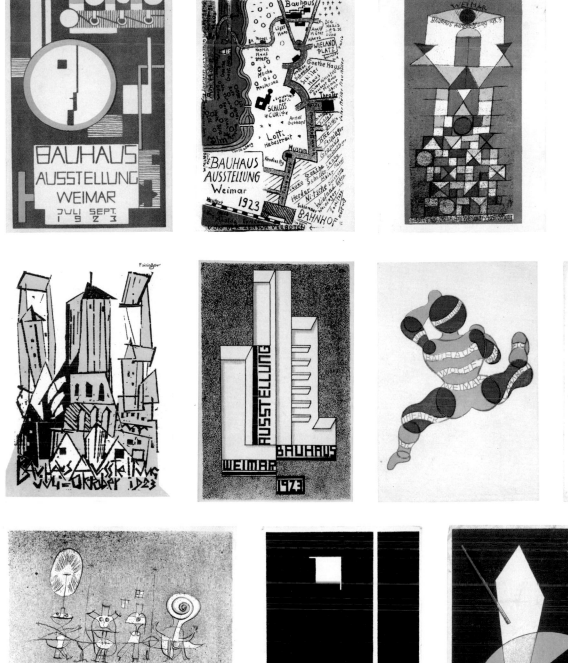

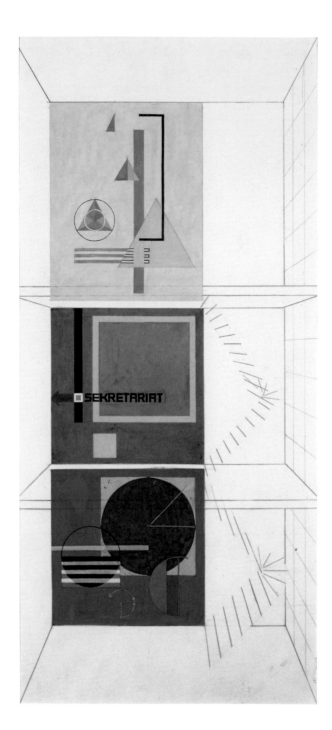

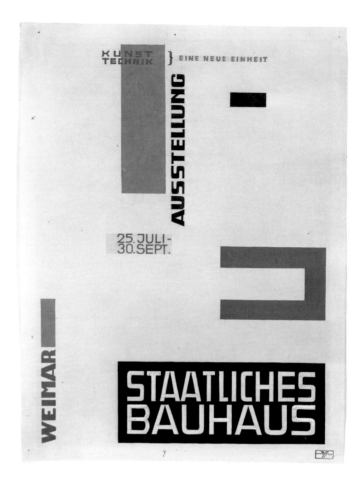

192
Herbert Bayer
Wall-painting design for the stairwell of the
Weimar Bauhaus building on the occasion
of the 1923 Bauhaus exhibition. 1923
Gouache, pencil, and cut paper on paper
22 1/8 x 10 3/8" (58.1 x 26.4 cm)
Collection Merrill C. Berman

193
Herbert Bayer
Design for a poster for the 1923 Bauhaus
exhibition. 1923
Gouache and black ink with pencil on paper
17 3/16 x 12 9/16" (43.6 x 31.9 cm)
Harvard Art Museum, Busch-Reisinger
Museum. Gift of the artist

194
Joost Schmidt
Poster for the 1923 Bauhaus exhibition.
1922–23
Lithograph on paper
27 x 19" (68.6 x 48.3 cm)
Collection Merrill C. Berman

195
Fritz Schleifer
Poster for the 1923 Bauhaus exhibition. 1923
Lithograph on paper
39 3/8 x 28 3/4" (100 x 73 cm)
Collection Merrill C. Berman

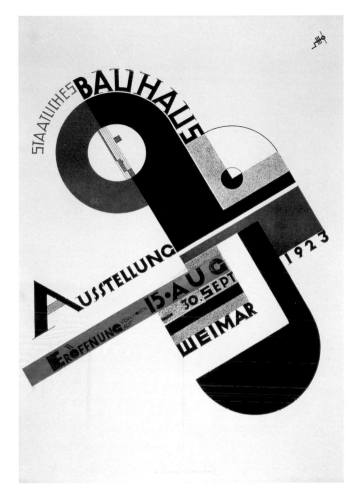

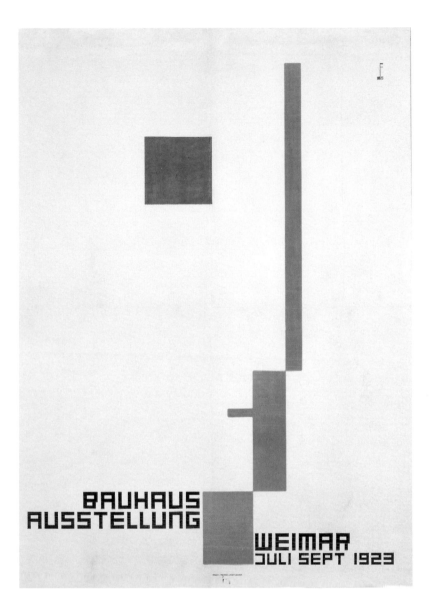

196
Herbert Bayer
Cover of the book *Staatliches Bauhaus in Weimar 1919–1923* (State Bauhaus in Weimar 1919–1923), published on the occasion of the Bauhaus exhibition, Weimar, 1923. Weimar and Munich: Bauhausverlag
Letterpress
9 7/8 x 10 1/16" (25.1 x 25.5 cm)
The Museum of Modern Art, New York. Architecture and Design Study Collection

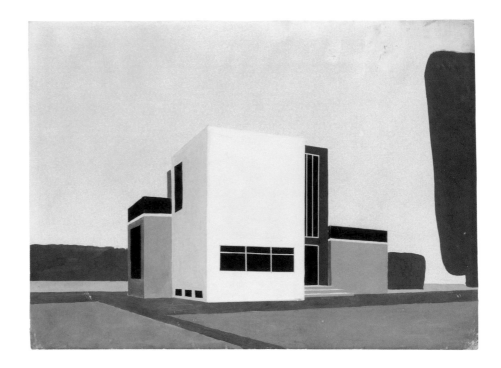

197 (top)
Farkas Molnár
Project for a single-family house.
Inscribed 1922
Gouache over pencil on paper
9 7/16 x 13" (24 x 33 cm)
Bauhaus-Archiv Berlin

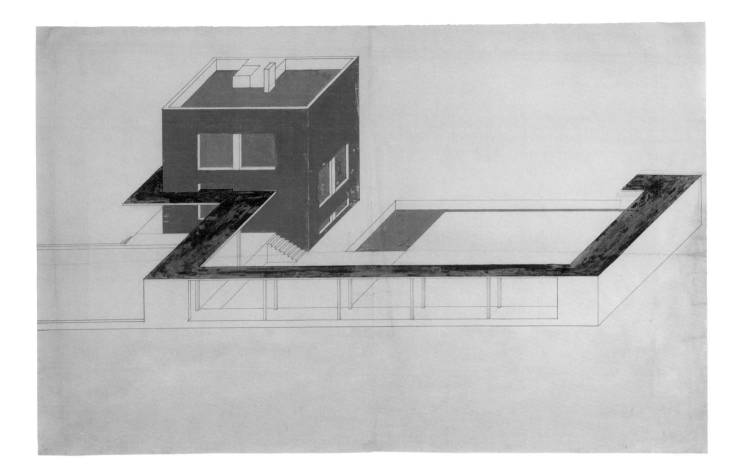

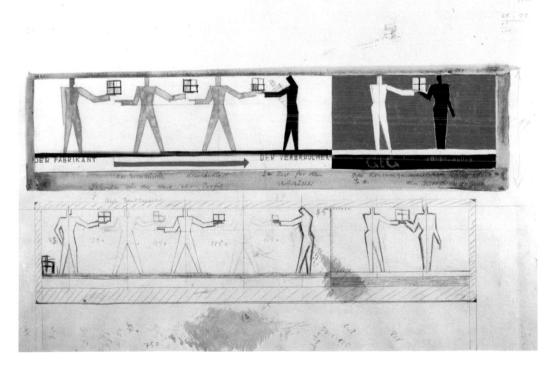

198 (opposite, below)
Farkas Molnár
Project for a single-family house, *Der rote Würfel* (The red cube). Preliminary sketches, plans, and sections. 1923
Pencil on paper
20 1/16 x 11 5/8" (51 x 29.5 cm), irreg.
Deutsches Architekturmuseum, Frankfurt

199 (top)
Farkas Molnár
Project for a single-family house, *Der rote Würfel* (The red cube). Presentation drawing.
1923
Ink and gouache on board
23 1/4 x 36" (59 x 91.5 cm)
Deutsches Architekturmuseum, Frankfurt

200 (bottom)
Farkas Molnár
Project for a single-family house, *Der rote Würfel* (The red cube). Design for a mural: *Der Fabrikant / Der Verbraucher* (The fabricator / the consumer). 1923
Gouache, pencil, and ink on drawing paper
12 13/16 x 19 3/4" (32.6 x 50.2 cm)
Deutsches Architekturmuseum, Frankfurt

ALMA BUSCHER
"SHIP" BUILDING TOY. 1923
CHRISTINE MEHRING

Walter Benjamin once expressed the desire to access "the most extreme concreteness of an epoch as it appears now and again in children's games, [or] in a building."[1] Eighty years later we routinely see buildings, particularly Bauhaus buildings, as expressions of their time, or at least as wrestling with the problems of their time, while children's games remain relegated to history's wastebin. The building blocks that Alma Buscher designed at the Bauhaus, however, featured centrally at a pivotal moment in the school's history. Shortly after enrolling at the Bauhaus, in 1922, and perhaps because she had recently switched from the weaving to the wood workshop, Buscher was put in charge of designing the children's room in the Haus am Horn, the house to be built as part of the school's exhibition the following year. It was as a part of this project that she created the *Bauspiel "Schiff"* ("Ship" building toy), a set of different-shaped and -sized building blocks in the primary colors along with white and green, to be used, as instructions suggest, to build a ship, a slope, a gate, or what have you. Is the "concreteness of an epoch" a matter too concrete for this abstract assembly, a load too heavy for this tiny boat?[2]

Buscher's basic shapes and colors bear the imprint of the Bauhaus's signature preliminary courses but, more interestingly, the *Bauspiel* also perpetuated the principles of the school in those years. Students of Johannes Itten's preliminary course, including Buscher, designed toys because their teacher believed in the pedagogical value of entwining play and work (that is, creative work).[3] In fact many Bauhaus teachers designed toys: Paul Klee created puppetry for his son Felix (cat. 121), Oskar Schlemmer a jointed doll for his daughter Karin, and Ludwig Hirschfeld-Mack spinning tops, for use in both children's play and art students' exploration of color.[4] This widespread practice made sense, for both play (as central to toys) and creativity (as central to modern design and arts education) were based on experimentation, on trying things out. Buscher notably advocated toys that were "not something finished — as offered by those luxury stores. — The child develops, in fact it pursues — it searches."[5] Experimental play and work with essential shapes and colors were thought to lead, in children as in budding designers and artists, to creative communication and construction. The *Bauspiel* was intended to inspire children to create complex structures from basic elements, their meaning and function determined by context — depending on placement, a yellow stick turns anchor or oar, lever or mast. This maps onto Benjamin's notion of play as a means of schooling our mimetic ability, resulting in our human capability for language: "The child wants to pull something and becomes horse, wants to play with sand and becomes baker, wants to hide and becomes cop or robber."[6] For Buscher, that form of play with the simple and familiar was also a means of mastering an increasingly complex, unfamiliar world, a world that included "water as a support — the air mechanically animated — clinking air — actually all the wonders of mechanics."[7]

The *Bauspiel* also stakes out an intricate position at a turning point in Bauhaus history. As is well known, the early 1920s witnessed frictions over the school's direction between Itten, who believed in the autonomy of artistic expression, and Walter Gropius, who advocated a socially useful absorption of art into design. At a moment when Itten would soon leave the school, Buscher's blocks juggled these positions: abstract shapes suitable to formal explorations of relations and proportions dominate the set, while three elements with rounded edges hint at suitability for hull and sails. Extending the artistic dimension of the *Bauspiel*, one might add that philosophy historically has often linked play to art; Kantian aesthetic pleasure, for one, results from a free play of our cognitive powers. Buscher echoes the association of play and art when she insists that the *Bauspiel* "does not want to be anything" and characterizes her toys as "free plays" created "almost without thinking, out of the sheer pleasure in creation as such, in the colored form."[8] A Nuremberg museum's exhibition of toys in 1926 fittingly featured the *Bauspiel* in a section of "artists' toys."[9]

The following year Buscher notably placed her *Bauspiel* in explicit opposition to "Froebel and Pestalozzi games . . . created from purely pedagogical motivations."[10] Yet it is deeply indebted to just those sorts of games and was distributed by the Pestalozzi-Froebel-Verlag from 1926 to 1933. This is, in fact, where the *Bauspiel's* utilitarian dimension coexists with its ambitions of autonomy. As the nineteenth-century German educator Friedrich Froebel, the inventor of the Kindergarten, had notably argued, wooden blocks teach children about the world — about constructions, relations, measurements, and divisions. By the early twentieth century, Froebel's and other theories of reform pedagogy, such as those of the Swiss educator Johann Heinrich Pestalozzi (a crucial influence on Froebel), were entering broad segments of German society; notably, they also shaped the conceptualization of the Bauhaus preliminary course by Itten, who had trained as a school teacher.[11] Buscher's creations easily found a place in an exhibition in Jena in 1924, held on the occasion of the Froebel Days celebrating the educator. The educational use value of the *Bauspiel* is most explicit in that it introduced

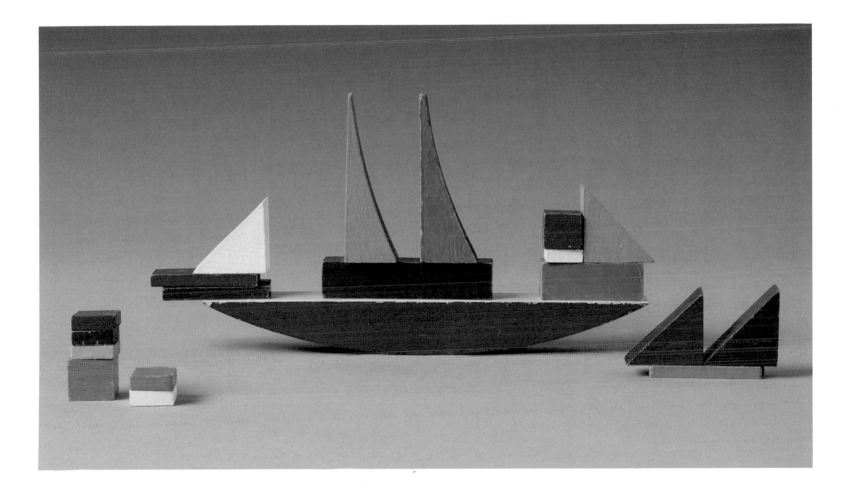

201
Alma Buscher
Bauspiel "Schiff" ("Ship" building toy). 1923
21 pieces, painted wood
Length of largest piece: 10 1/16" (25.5 cm)
Die Neue Sammlung—The International
Design Museum Munich

children to the modern modular construction, and did so with an efficiency appropriate to the functionalist tendencies of the Bauhaus. As stressed in the attendant watercolor (cat. 203), the blocks are cut from two pieces of wood, whose shapes are restored when they are returned to their box.

The first "home" of the *Bauspiel* thus proves important: exhibited in the Haus am Horn — conceived as a model, and modular, solution to the housing crisis plaguing the Weimar Republic — the blocks demonstrated quite literally what might result from children's play with simple, partly modular shapes. In fact not only had building blocks been formative for Gropius, whose office oversaw construction of the Haus am Horn, but they served him as model and metaphor for industrialized housing ideas.[12] The *Bauspiel* was part of Buscher's children's-room ensemble in the exhibition house, where it probably stood in her *Kinderspielschrank* (toy closet), later illustrated in a sales catalogue laid out by Herbert Bayer (cat. 202). Buscher's toy closet also worked with the idea of modular and flexible blocks. Designed for a corner, it featured tall white shelving, a white door with an aperture allowing a role as a puppet theater, and colored boxes usable both for toys and as toys — for storage and as oversized building blocks. The whole was easily removable once a child had outgrown it.[13] Like Russian dolls, the *Bauspiel* in the

Kinderspielschrank in the Haus am
basic, adjustable housing solutio

In that sense, then, Bu
the "concreteness of the epoch
aspirations for the Weimar Rep
metaphor of a ship setting sail fo
argues that "children should
can be who they want to be, in
Benjamin's belief in the revolu
and their play, expressed in the
and unexpected, for change, for
affinities he thought reined i
encouraged by the proletarian
for Benjamin, coupled construc
remaking anew. Reviewing an e
cluded, "Once stashed away, bro
doll turns into a competent pro
play commune."[15] Buscher, unli
dents and teachers who dabble
dialectic. Her *Wurfpuppen* (Th
ible dolls intended quite litera
again, and so forth; her *Bützels*
metric elements, to be carefu

202
Herbert Bayer
Page from *Katalog der Muster* (Catalogue of designs), sales catalogue of Bauhaus objects, layout by Bayer, showing children's toy closet (TI 24) designed by Alma Buscher in 1923. Dessau: Bauhaus, 1925
Letterpress
11¾" × 8¼" (30 × 21 cm)
The Museum of Modern Art, New York. Jan Tschichold Collection, Gift of Philip Johnson

203
Alma Buscher
Design for ship building toy, small version.
1923
Watercolor over pencil on paper
16⁹⁄₁₆ × 8⁹⁄₁₆" (42 × 16 cm)
Klassik Stiftung Weimar, Graphische Sammlungen. Gift of Lore und Joost Siedhoff

204
Alma Buscher
Design for construction of paper crane.
c. 1927
Gouache over pencil on cardboard
Folded: 8¹¹⁄₁₆ × 7⅞" (22 × 20 cm)
Collection Lore und Joost Siedhoff

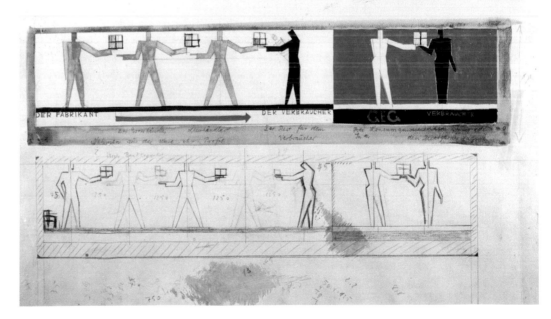

198 (opposite, below)
Farkas Molnár
Project for a single-family house, *Der rote Würfel* (The red cube). Preliminary sketches, plans, and sections. 1923
Pencil on paper
20 1/16 x 11 5/8" (51 x 29.5 cm), irreg.
Deutsches Architekturmuseum, Frankfurt

199 (top)
Farkas Molnár
Project for a single-family house, *Der rote Würfel* (The red cube). Presentation drawing. 1923
Ink and gouache on board
23 1/4 x 36" (59 x 91.5 cm)
Deutsches Architekturmuseum, Frankfurt

200 (bottom)
Farkas Molnár
Project for a single-family house, *Der rote Würfel* (The red cube). Design for a mural: *Der Fabrikant / Der Verbraucher* (The fabricator / the consumer). 1923
Gouache, pencil, and ink on drawing paper
12 13/16 x 19 3/4" (32.6 x 50.2 cm)
Deutsches Architekturmuseum, Frankfurt

Walter Benjamin once expressed the desire to access "the most extreme concreteness of an epoch as it appears now and again in children's games, [or] in a building."[1] Eighty years later we routinely see buildings, particularly Bauhaus buildings, as expressions of their time, or at least as wrestling with the problems of their time, while children's games remain relegated to history's wastebin. The building blocks that Alma Buscher designed at the Bauhaus, however, featured centrally at a pivotal moment in the school's history. Shortly after enrolling at the Bauhaus, in 1922, and perhaps because she had recently switched from the weaving to the wood workshop, Buscher was put in charge of designing the children's room in the Haus am Horn, the house to be built as part of the school's exhibition the following year. It was as a part of this project that she created the *Bauspiel "Schiff"* ("Ship" building toy), a set of different-shaped and -sized building blocks in the primary colors along with white and green, to be used, as instructions suggest, to build a ship, a slope, a gate, or what have you. Is the "concreteness of an epoch" a matter too concrete for this abstract assembly, a load too heavy for this tiny boat?[2]

Buscher's basic shapes and colors bear the imprint of the Bauhaus's signature preliminary courses but, more interestingly, the *Bauspiel* also perpetuated the principles of the school in those years. Students of Johannes Itten's preliminary course, including Buscher, designed toys because their teacher believed in the pedagogical value of entwining play and work (that is, creative work).[3] In fact many Bauhaus teachers designed toys: Paul Klee created puppetry for his son Felix (cat. 121), Oskar Schlemmer a jointed doll for his daughter Karin, and Ludwig Hirschfeld-Mack spinning tops, for use in both children's play and art students' exploration of color.[4] This widespread practice made sense, for both play (as central to toys) and creativity (as central to modern design and arts education) were based on experimentation, on trying things out. Buscher notably advocated toys that were "not something finished — as offered by those luxury stores. — The child develops, in fact it pursues — it searches."[5] Experimental play and work with essential shapes and colors were thought to lead, in children as in budding designers and artists, to creative communication and construction. The *Bauspiel* was intended to inspire children to create complex structures from basic elements, their meaning and function determined by context — depending on placement, a yellow stick turns anchor or oar, lever or mast. This maps onto Benjamin's notion of play as a means of schooling our mimetic ability, resulting in our human capability for language: "The child wants to pull something and becomes horse, wants to play with sand and becomes baker, wants to hide and becomes cop or robber."[6] For Buscher, that form of play with the simple and familiar was also a means of mastering an increasingly complex, unfamiliar world, a world that included "water as a support — the air mechanically animated — clinking air — actually all the wonders of mechanics."[7]

The *Bauspiel* also stakes out an intricate position at a turning point in Bauhaus history. As is well known, the early 1920s witnessed frictions over the school's direction between Itten, who believed in the autonomy of artistic expression, and Walter Gropius, who advocated a socially useful absorption of art into design. At a moment when Itten would soon leave the school, Buscher's blocks juggled these positions: abstract shapes suitable to formal explorations of relations and proportions dominate the set, while three elements with rounded edges hint at suitability for hull and sails. Extending the artistic dimension of the *Bauspiel*, one might add that philosophy historically has often linked play to art; Kantian aesthetic pleasure, for one, results from a free play of our cognitive powers. Buscher echoes the association of play and art when she insists that the *Bauspiel* "does not want to be anything" and characterizes her toys as "free plays" created "almost without thinking, out of the sheer pleasure in creation as such, in the colored form."[8] A Nuremberg museum's exhibition of toys in 1926 fittingly featured the *Bauspiel* in a section of "artists' toys."[9]

The following year Buscher notably placed her *Bauspiel* in explicit opposition to "Froebel and Pestalozzi games . . . created from purely pedagogical motivations."[10] Yet it is deeply indebted to just those sorts of games and was distributed by the Pestalozzi-Froebel-Verlag from 1926 to 1933. This is, in fact, where the *Bauspiel's* utilitarian dimension coexists with its ambitions of autonomy. As the nineteenth-century German educator Friedrich Froebel, the inventor of the Kindergarten, had notably argued, wooden blocks teach children about the world — about constructions, relations, measurements, and divisions. By the early twentieth century, Froebel's and other theories of reform pedagogy, such as those of the Swiss educator Johann Heinrich Pestalozzi (a crucial influence on Froebel), were entering broad segments of German society; notably, they also shaped the conceptualization of the Bauhaus preliminary course by Itten, who had trained as a school teacher.[11] Buscher's creations easily found a place in an exhibition in Jena in 1924, held on the occasion of the Froebel Days celebrating the educator. The educational use value of the *Bauspiel* is most explicit in that it introduced

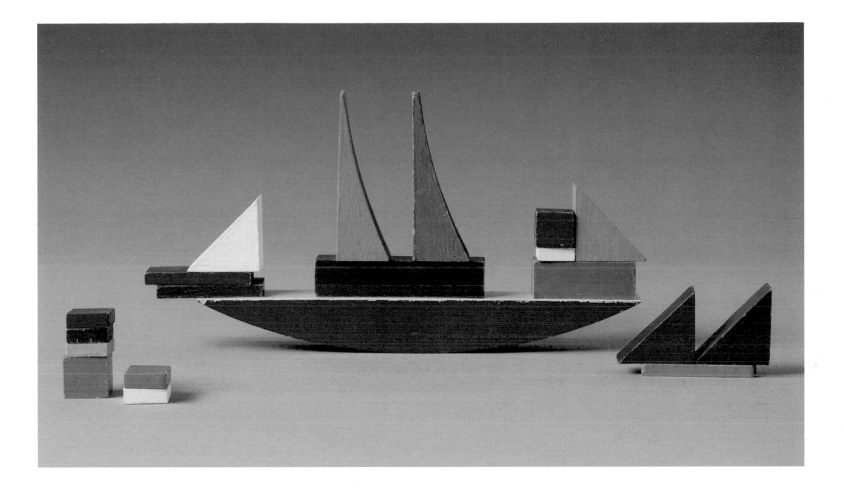

201
Alma Buscher
Bauspiel "Schiff" ("Ship" building toy). 1923
21 pieces, painted wood
Length of largest piece: 10 1/16" (25.5 cm)
Die Neue Sammlung—The International
Design Museum Munich

Tischlerei

TI 24

KINDERSPIELSCHRANK
im Gebrauch

gesch.
Länge 155 cm und 90 cm
Höhe 150 cm
AUSFÜHRUNG
farbig lackiert
mit bunten herausnehmbaren Kästen
für Spielzeug und Bücher
zum Spielen, Sitzen und Fahren
mit Türausschnitt für Puppentheater

children to the modern modular construction, and did so with an efficiency appropriate to the functionalist tendencies of the Bauhaus. As stressed in the attendant watercolor (cat. 203), the blocks are cut from two pieces of wood, whose shapes are restored when they are returned to their box.

The first "home" of the *Bauspiel* thus proves important: exhibited in the Haus am Horn — conceived as a model, and modular, solution to the housing crisis plaguing the Weimar Republic — the blocks demonstrated quite literally what might result from children's play with simple, partly modular shapes. In fact not only had building blocks been formative for Gropius, whose office oversaw construction of the Haus am Horn, but they served him as model and metaphor for industrialized housing ideas.[12] The *Bauspiel* was part of Buscher's children's-room ensemble in the exhibition house, where it probably stood in her *Kinderspielschrank* (toy closet), later illustrated in a sales catalogue laid out by Herbert Bayer (cat. 202). Buscher's toy closet also worked with the idea of modular and flexible blocks. Designed for a corner, it featured tall white shelving, a white door with an aperture allowing a role as a puppet theater, and colored boxes usable both for toys and as toys — for storage and as oversized building blocks. The whole was easily removable once a child had outgrown it.[13] Like Russian dolls, the *Bauspiel* in the

Kinderspielschrank in the Haus am Horn realized and propagated basic, adjustable housing solutions.

In that sense, then, Buscher's tiny toy indeed reveals the "concreteness of the epoch," and the Bauhaus's utopian aspirations for the Weimar Republic, far more than the mere metaphor of a ship setting sail for a better world. When Buscher argues that "children should...have a room in which they can be who they want to be, in which they rule," she echoes Benjamin's belief in the revolutionary potential of children and their play, expressed in their affinities for the improvised and unexpected, for change, for turning things upside down — affinities he thought reined in by bourgeois education but encouraged by the proletarian variant.[14] Revolutionary play, for Benjamin, coupled construction and destruction, constantly remaking anew. Reviewing an exhibition of toys in 1928, he concluded, "Once stashed away, broken, repaired, even the most royal doll turns into a competent proletarian comrade in the children's play commune."[15] Buscher, unlike the many other Bauhaus students and teachers who dabbled in toy design, understood that dialectic. Her *Wurfpuppen* (Throw dolls) of 1924 are lanky, flexible dolls intended quite literally to be tossed, then picked up again, and so forth; her *Bützelspiel* 1923/24 — a set of small geometric elements, to be carefully stacked until they inevitably

202
Herbert Bayer
Page from *Katalog der Muster* (Catalogue of designs), sales catalogue of Bauhaus objects, layout by Bayer, showing children's toy closet (TI 24) designed by Alma Buscher in 1923. Dessau: Bauhaus, 1925
Letterpress
11 3/4" x 8 1/4" (30 x 21 cm)
The Museum of Modern Art, New York. Jan Tschichold Collection, Gift of Philip Johnson

203
Alma Buscher
Design for ship building toy, small version.
1923
Watercolor over pencil on paper
16 9/16 x 6 5/16" (42 x 16 cm)
Klassik Stiftung Weimar, Graphische Sammlungen, Gift of Lore und Joost Siedhoff

204
Alma Buscher
Design for construction of paper crane.
c. 1927
Gouache over pencil on cardboard
Folded: 8 11/16 x 7 7/8" (22 x 20 cm)
Collection Lore und Joost Siedhoff

tumble down again—takes its cue from children's delight in seeing things fall over, expressed in the German exclamation *Bautz!* The *Bauspiel* itself is about constructing and dismantling equally; in fact dismantling becomes constructing and vice versa, for stashing the blocks away into their box is a puzzle that requires concentration and acumen.

All this said, while Benjamin welcomed the fascination with toys evidenced in the collecting and exhibition sensibilities of the museums of the Weimar Republic, he worried about it too, and his worries give the success of Buscher's toys an ominous twist. "Surrounded by a giant world," Benjamin wrote, "children playfully create their own, suitable to them and small; the adult, however, whom the real surrounds relentlessly, threateningly, seizes the world's horrors through its scaled-down image. The trivialization of an unbearable existence played a significant part in the growing interest in children's toys and books after the end of the war."[16] It was bombing in the war to come that ended Buscher's life.

1. Walter Benjamin, letter to Gershom Scholem, Berlin, March 15, 1929, excerpted in Benjamin, *Das Passagen-Werk*, vol. 5 of *Gesammelte Schriften* (Frankfurt: Suhrkamp, 1991), 2:1091. All translations are my own.

2. The *Bauspiel* was distributed by Pestalozzi-Froebel-Verlag, Leipzig, from 1926 to 1933, and has been available from the Swiss toymaker Naef since 1977.

3. See Willy Rotzler, ed. *Johannes Itten: Werke und Schriften* (Zurich: Orell Füssli, 1972), pp. 67, 69, and also 401, n. 108. Alma Buscher echoes Itten's formulations in her essay "Kind, Märchen, Spiel, Spielzeug," *Junge Menschen, Monatshefte*, November 1924, p. 189.

4. See, for example, Andrea Tietze, "Vom Bauklotz bis zum Bützelspiel: Künstlerisches Reformspielzeug des Bauhauses," in Herbert Eichhorn and Isabell Schenk, eds., *KinderBlicke: Kindheit und Moderne von Klee bis Boltanski* (Ostfildern-Ruit: Cantz, 2001), pp. 98–120.

5. Buscher, "Kind, Märchen, Spiel, Spielzeug."

6. Benjamin, "Kulturgeschichte des Spielzeugs," 1928, in *Kritiken und Rezensionen*, vol. 3 of *Gesammelte Schriften*, p. 116. For Benjamin on mimesis and play see his "Lehre vom Ähnlichen," c. 1933, in *Aufsätze, Essays, Vorträge*, vol. 2 of *Gesammelte Schriften*, 1:204–5. It remains unclear whether Benjamin knew Buscher's or other Bauhaus toys, which were not included in the book that Benjamin was reviewing in "Kulturgeschichte des Spielzeugs," probably because they were too contemporary: Karl Gröber, *Kinderspielzeug aus alter Zeit: Eine Geschichte des Spielzeugs* (Berlin: Deutscher Kunstverlag, 1928).

7. Buscher, "Kind, Märchen, Spiel, Spielzeug."

8. Buscher, unpublished ms, quoted in Gunda Luyken, "kunst—ein kinderspiel," in Max Hollein and Luyken, eds., *kunst—ein kinderspiel* (Frankfurt: Schirn Kunsthalle, 2004), p. 37; Buscher, "Freie Spiele—Lehrspiele," *Offset. Buch und Werbekunst* no. 10 (1927):464.

9. *Führer durch die Ausstellung Das Spielzeug*, exh. cat. (Nuremberg: Kunsthalle, 1926), pp. 8, 14–15.

10. Buscher, "Freie Spiele."

11. See Marcel Franciscono, *Walter Gropius and the Creation of the Bauhaus in Weimar: The Ideals and Artistic Theories of its Founding Years* (Urbana: University of Illinois Press, 1971), and Rainer K. Wick, *Teaching at the Bauhaus*, trans. Stephen Mason (Ostfildern-Ruit: Hatje-Cantz, 2000), chapter 5.

12. See Reginald Isaacs, Walter Gropius: *Der Mensch und sein Werk* (Berlin: Mann, 1983), 1:266, and Klaus-Jürgen Winkler, "Das Haus am Horn und das Bauhaus," in Bernd Rudolf, ed., *Haus am Horn: Rekonstruktion einer Utopie* (Weimar: Bauhaus Universität, 2000), pp. 14–15, esp. fig. 5.

13. The room was designed for flexibility and child-suitability. See Georg Muche, "Das Versuchshaus des Bauhauses," in Adolf Meyer, ed., *Ein Versuchshaus des Bauhauses in Weimar* (Munich: Albert Langen, 1925), p. 19, and Winkler, "Ideen für ein Kinderzimmer," in *Alma Siedhoff-Buscher: Eine neue Welt für Kinder*, exh. cat. (Weimar: Stiftung Weimarer Klassik und Sammlungen, 2004), pp. 15–23. (Buscher changed her name to Siedhoff-Buscher on marrying Werner Siedhoff, in 1926.)

14. Buscher, "kindermöbel und kinderkleidung," *Vivos Voco* 5 (April 1926):157; Benjamin, "Programm eines proletarischen Kindertheaters," c. 1928/29, in *Aufsätze, Essays, Vorträge*, vol. 2 of *Gesammelte Schriften*, 2:767–68.

15. Benjamin, "Altes Spielzeug," 1928, in *Kleine Prosa. Baudelaire Übertragungen*, vol. 4 of *Gesammelte Schriften*, 1:515, and "Spielzeug und Spielen," 1928, in *Kritiken und Rezensionen*, vol. 3 of *Gesammelte Schriften*, p. 131.

16. Benjamin, "Altes Spielzeug," p. 514.

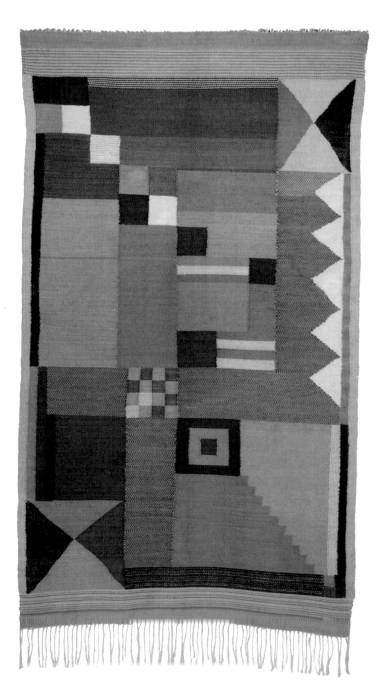

205
Alma Buscher
Design for the children's room in the
Haus am Horn. 1923
Pencil, chalk, watercolor, and gouache
on paper
20¾ x 28" (52.7 x 71.1 cm)
Klassik Stiftung Weimar, Graphische
Sammlungen. Gift of Lore and Joost Siedhoff

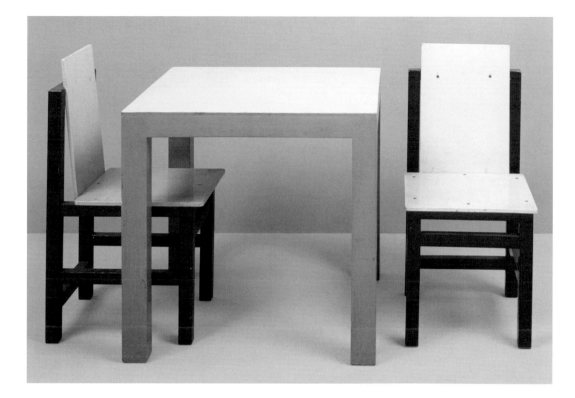

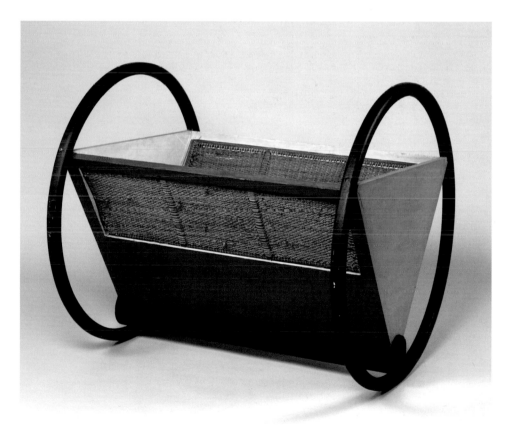

206
Benita Koch-Otte
Carpet for a children's room. 1923
Linen and linen-and-cotton twill weave,
cotton, and viscose
69 $^{11}/_{16}$ x 39 $^{15}/_{16}$" (177 x 101.5 cm)
Klassik Stiftung Weimar, Bauhaus-Museum

207
Marcel Breuer
Children's table and chairs. 1923
Chairs: beech, plywood seats and backs,
table: beech
Chairs: each 22 $^{13}/_{16}$ x 10 $^{7}/_{16}$ x 12 $^{5}/_{8}$"
(58 x 26.5 x 32 cm), table: 19 $^{11}/_{16}$ x 19 $^{1}/_{2}$ x 19 $^{1}/_{2}$"
(50 x 49.5 x 49.5 cm)
Klassik Stiftung Weimar, Bauhaus-Museum

208
Peter Keler
Cradle. 1922
Wood, colored lacquer, and rope work
Circular supports: 36 $^{1}/_{8}$" (91.7 cm) diam.,
width: 38 $^{9}/_{16}$" (98 cm)
Klassik Stiftung Weimar, Bauhaus-Museum

"I always defended myself against the grotesque. I wanted to be at the edge but still avoid making the sublime ridiculous."[1] This was Oskar Schlemmer's response to the Swiss artist Otto Meyer-Amden, the close friend who had suggested that the grotesque was one of Schlemmer's "great talents." It is tempting to think that Schlemmer's whimsical 1923 quasi-human figure carved in walnut, or at least perhaps its title, *Grotesk I* (Grotesque I), was prompted by this dialogue.[2] First exhibited only weeks later at the major Bauhaus exhibition in Weimar in July and August of 1923, the sculpture appears in the exhibition catalogue, just visible on the left side of a photograph of the wood-carving workshop, which Schlemmer directed (cat. 210).[3]

Grotesk I differs sharply from Schlemmer's more geometric and classically proportioned paintings and reliefs. A chimeric, primitivist figure dominated by a swollen, nautilus-shaped head and the sweeping S-curve it forms with the protruding body below, *Grotesk I* is marked anatomically only by its ivory lips and eyes, each topped with a metal button. While indicating the midpoint of the figure's S-curve, the pursed white lips also mask the interpenetration between the upper and lower body sections — the point where the distended belly tapers up into a narrow rod that burrows into the fold of the sculpture's pompadour head. Both the head and the belly sections are attached to a thick vertical spine, which in turn is supported by a metal pole connecting the figure to its rounded, torpedo-shaped foot and base. Unexpectedly, the metal pole allows the figure to swivel, changing the relationship of sculpture and base, and with it the figure's profile.

One of only two freestanding sculptures that Schlemmer made during his Bauhaus years (the other is *Abstract Figure*, from 1921–23; cat. 211), *Grotesk I* was carved by Josef Hartwig, the technical master for both the stone-sculpture and wood-carving workshops, which Schlemmer led as form master from 1921 and 1922 respectively until 1925. At the Bauhaus the very idea of independent, freestanding sculpture was problematic. In his 1919 Bauhaus manifesto, Walter Gropius had rejected autonomous fine art as mere "salon art," lacking in "architectonic spirit," and instead called for the individual arts and crafts to reunite in the service of grand architectural projects.[4] Few commissions for such collaborative projects materialized, however (a significant exception being the all-wood Sommerfeld House designed by Gropius and Adolf Meyer in Berlin in 1921 (cats. 77–82), for which the sculpture student Joost Schmidt made decorative carvings), and by as early as 1922, Gropius had begun to emphasize the need for the workshops to justify themselves by designing

209
Oskar Schlemmer
Grotesk I (Grotesque I). 1923
Walnut and ivory, with metal shaft
22 1/16 x 9 1/4 x 3 15/16" (56 x 23.5 x 10 cm)
Staatliche Museen zu Berlin,
Neue Nationalgalerie, Berlin

and producing marketable objects. Hartwig's initial suggestions for the wood-carving workshop included making "toys…, boxes, chests, and marionette figures."[5] Alma Buscher's wooden *Bauspiel "Schiff"* ("Ship" building toy, 1923; cat. 201) and Hartwig's own Bauhaus chess sets (1922–24; cats. 168, 169) would become the prime examples of such work.

Grotesk I stands at a distance from these Bauhaus efforts to rethink the relationship of art to production and commerce. While always committed to the early Bauhaus program of integrating painting, sculpture, and architecture, Schlemmer was deeply ambivalent about Gropius' growing emphasis on technology and industrial production. In a diary entry of November 1922, he wrote, "I cannot occupy myself with applied art, which only dilutes the concentrated idea… I should not try for something which industry and the engineer do better. What remains is the metaphysical: art."[6]

In part a demonstration piece exploring the formal and material possibilities of wood sculpture, *Grotesk I* emphasizes the interplay of the object's rigidity and sweeping curves, its smooth polished surface and the linear patterning of its hardwood grain. The figure's striking profile, moreover, suggests the similarly curved f-shaped sound hole of a violin or cello, further extending the resonance and self-referentiality of wood as a sculptural material.

The idea of the "grotesque" in Schlemmer's sculpture emerges from the work's incongruous mixture of whimsy and estrangement, the combination of natural and monstrous forms into a quasi-human figure. For Schlemmer, who was both attracted to the grotesque and wary of it, the concept related not only to the art-historical tradition of fantastical ornamentation in ancient Roman and Renaissance frescoes but also to theatrical notions of grotesque dance. He described his *Triadische Ballett* (Triadic Ballet, c. 1924; cats. 216, 217), for example, a complex work of choreography and costume design, as something that "flirts coquettishly with the humorous, without falling into grotesquerie."[7] Above all Schlemmer was interested in literary notions of the grotesque as a dark and subversive category of the comical and was drawn particularly to the unconventional German writer Jean Paul, whom his letters and diaries mention often. In an earlier letter to Meyer-Amden, Schlemmer noted that he had been reading Jean Paul's 1804 *Vorschule der Aesthetik* (School for aesthetics), particularly the section titled "On the Ridiculous."[8] In this work Jean Paul (who, like Schlemmer but 125 years earlier, came to Weimar in the shadow of giants) elaborates an eccentric notion of an "annihilating" humor that is both destructive and liberating, and characterizes the ridiculous as "the arch enemy of the sublime."[9] Even as Schlemmer rejected the identification of his work as grotesque, he was fascinated by such formulations and directly borrowed Jean Paul's language when explaining to Meyer-Amden that while he might approach the grotesque, he wanted to "avoid making the sublime ridiculous."

Schlemmer insisted instead on his work's "sensitive means of purity, conciseness and precision," terms characteristic of the machine aesthetic associated with the Bauhaus.[10] The coexistence of such contrary impulses — purity and the grotesque — is fundamental to Schlemmer's work. *Abstract Figure*, his other freestanding sculpture from these years, is often considered emblematic of a rationalist and classicizing mode of modernism; yet the figure also should be understood as a wounded body with missing limbs, prosthetic replacements,

210
The Bauhaus wood carving workshop
As reproduced in *Staatliches Bauhaus in Weimar 1919–1923.* Weimar and Munich: Bauhausverlag, 1923
The Museum of Modern Art, New York
Architecture and Design Study Collection

211
Oskar Schlemmer
Abstract Figure. 1921–23
As reproduced on the cover of *bauhaus* 3, no. 4 (November 15, 1929)
The Museum of Modern Art Library
New York

and a defensive armor protecting it from further damage.[11] In *Grotesk I* the qualities of "purity, conciseness and precision" may resonate with the reductive simplicity and polished surfaces of Schlemmer's figure; yet they do not account for its distended, swollen, and morphing body, or for the primitivist exoticism of the ivory lips and eyes, elements that evoke the bodily disruptions of the grotesque.

It is precisely in the body's orifices and expansions that the literary theorist Mikhail Bakhtin, in his now classic discussion of Rabelais, located the grotesque, since it is these areas that lead "beyond the body's limited space or into the body's depths."[12] Bakhtin defines the grotesque body as "a body in the act of becoming. It is never finished, never completed."[13] And although for Bakhtin the body's grotesque expansions most often involve the bowels and phallus, his language resonates with Schlemmer's *Grotesk I*, whose belly both swells and narrows as it extends and penetrates into the expanding fold of the figure's head, suggesting a series of ongoing bodily inversions and transformations. The stretching and splitting of *Grotesk I*'s head from its body, moreover, begins to approximate cellular division, a reproductive process that would soon be made literal by the replication of the sculpture in a nearly identical version, *Grotesk II*, created by Schlemmer and Hartwig later the same year.[14]

Whether sublime or ridiculous, *Grotesk I* stands as something of an outlier in Schlemmer's sculptural work. Its deceptive simplicity nonetheless underscores the complex interplay of primitivist fantasy and machine aesthetic that haunts so much of modernist art.

1. Oskar Schlemmer, letter to Otto Meyer-Amden, June 25, 1923, quoted in Karin von Maur, *Oskar Schlemmer* (Munich: Prestel, 1979), 1:357. Translations are my own unless otherwise noted.

2. Von Maur speculates on this question in ibid.

3. *Staatliches Bauhaus in Weimar 1919–1923* (Weimar and Munich: Bauhausverlag, 1923; repr. Munich: Rohwoltsche, 1980), p. 84. The sculpture is also visible in an installation photograph of the 1923 exhibition; see Thomas Föhl et al., *Kunstsammlungen zu Weimar: Bauhaus Museum* (Munich: Deutscher Kunstverlag, 1995), p. 98.

4. See Hans Maria Wingler, *The Bauhaus: Weimar, Dessau, Berlin, Chicago* (Cambridge, Mass.: The MIT Press, 1969), p. 31.

5. Josef Hartwig, in the minutes of a meeting of the Bauhaus craft masters, September 18, 1922. Thüringisches Hauptstaatsarchiv Weimar. Bestand: Bauhaus 12/180.

6. Schlemmer, diary entry, November 1922, in Schlemmer, *The Letters and Diaries of Oskar Schlemmer*, ed. Tut Schlemmer, trans. Krishna Winston (Evanston, Ill.: Northwestern University Press, 1972), p.134. Translation altered.

7. Schlemmer, diary entry, September 1922, in ibid., p. 128.

8. Schlemmer, letter to Meyer-Amden, June 1920, in ibid., p. 82. "Jean Paul" was the adopted pen name of Johann Paul Friedrich Richter. His *Vorschule der Aesthetik* has been translated as *Horn of Oberon. Jean Paul Richter's School for Aesthetics*, intro. and trans. Margaret R. Hale (Detroit: Wayne State University Press, 1973). On Schlemmer and Jean Paul see also Andreas Hüneke, "Nachwort: Sieben Lorbeerkränze für OS samt sieben letzten Worten zu dieser Ausgabe," in Hüneke, ed., *Oskar Schlemmer. Idealist der Form: Briefe Tagebücher Schriften* (Leipzig: Reclam, 1990), p. 349 ff.

9. Jean Paul, *Horn of Oberon*, p. 73 and passim. Translation altered.

10. Schlemmer, letter to Meyer-Amden, June 25, 1923, quoted in von Maur, *Oskar Schlemmer*, 1:357.

11. See Paul Paret, "Picturing Sculpture: Image, Object, Archive" in Jeffrey Saletnik and Robin Schuldenfrei, eds., *Bauhaus Constructs: Fashioning Identity Discourse and Modernism* (London and New York: Routledge, 2009).

12. Mikhail Bakhtin, *Rabelais and His World*, 1965, trans. Hélène Iswolsky (Bloomington: Indiana University Press, 1984), p. 318.

13. Ibid., p. 317.

14. See von Maur, *Oskar Schlemmer*, vol. 2, *Oeuvrekatalog* (Munich: Prestel, 1979), p. 385. An edition of casts in gold-plated silver was made from this version in 1964.

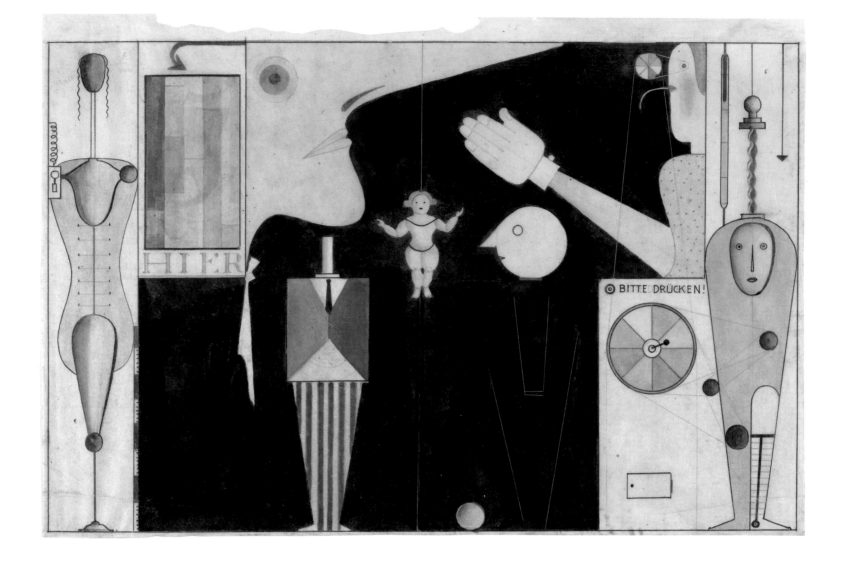

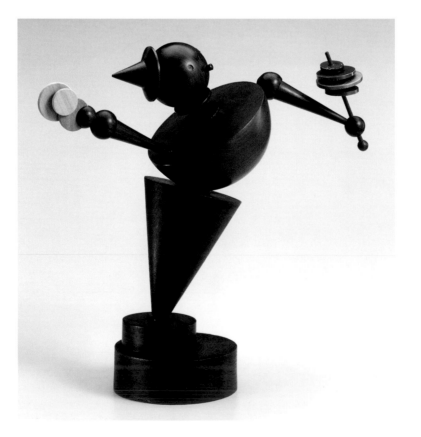

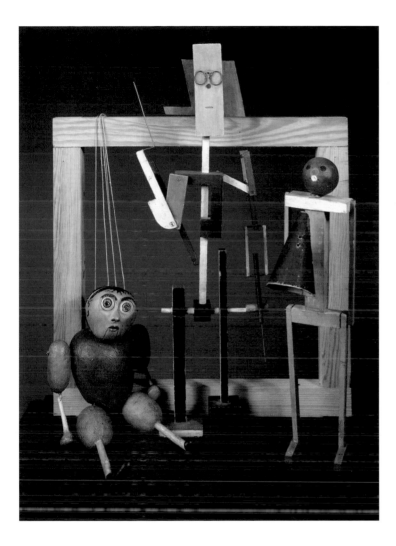

212
Oskar Schlemmer
Drawing related to the set of Schlemmer's
performance *Das figurale Kabinett* (The figural
cabinet, 1922). Executed between 1922 and 1931
Watercolor, pencil, and ink on tracing paper
12 ¹⁄₈ x 17 ³⁄₄" (30.8 x 45.1 cm)
The Museum of Modern Art, New York.
The Joan and Lester Avnet Collection

213
Eberhard Schrammen
Maskottchen (Mascot). c. 1924
Oak and miscellaneous exotic woods,
turned, coated in places with colored
and gold lacquer
Height: 14 ⁹⁄₁₆" (37 cm)
Bauhaus-Archiv Berlin

214, 215
Kurt Schmidt and **Toni Hergt** (fabricator)
Four of eight puppets for the play
Die Abenteuer des kleinen Buckligen
(The adventures of the little hunchback), directed by Oskar Schlemmer at the
Bauhaus theater, Weimar, based on a story from *The Arabian Nights*. Left to right:
Der kleine Bucklige (The little hunchback), *Der Arzt* (The doctor), *Der Ausrufer*
(The town crier), *Der Ölhändler* (The ointment merchant). 1923
Variously wood, metal, cardboard, paper, and iron wire
Height: ranging from 11 ¹³⁄₁₆" (30 cm; *Der kleine Bucklige*) to 20 ³⁄₁₆" (51.2 cm; *Der Arzt*)
Puppentheatersammlung, Staatliche Kunstsammlungen Dresden

OSKAR SCHLEMMER
STUDY FOR THE TRIADIC BALLET. 1924
PAUL PARET

"The yearning for synthesis," Oskar Schlemmer wrote in a draft of the 1922 program of *Das Triadische Ballett* (The triadic ballet), "also reaches out for the theater, because the theater offers the promise of total art."[1] More completely and for longer than any of his Bauhaus colleagues, Schlemmer embraced Walter Gropius's initial call for a synthesis of the arts, and he considered the theater a way of achieving it.[2] Although originally brought to the Bauhaus as a painter and sculptor, Schlemmer, always a restless artist, became head of the Bauhaus stage workshop two years later, in the spring of 1923, and held the position until he left the school, in 1929.

A complex work of choreography and costume design that in its fullest version included three acts, *gelbe*, *rosa*, and *schwarze Reihen* (yellow, rose, and black sequences), with twelve scenes performed as solos, duets, and trios by three dancers in eighteen costumes, *Das Triadische Ballett* occupied Schlemmer off and on for over fifteen years. He began working on the pantomime dances from which it would evolve as early as 1912, and in 1916, in the midst of World War I, he staged several parts in a benefit for his regiment while on home leave. *Das Triadische Ballett* had its full premiere in September 1922, in Stuttgart, followed by performances in the summer of 1923 in Weimar during the Bauhaus exhibition and then in Dresden, with shorter, revised versions in Donaueschingen and Berlin in 1926, and in Paris in 1932.[3]

Schlemmer's many studies, sketches, and presentation drawings for *Das Triadische Ballett* create a rich history of the dance's conception and evolution (cats. 216, 217). His remarkable costumes for *Das Triadische Ballett* and other Bauhaus stage productions, made of padded clothing, metal, and painted papier-mâché, themselves became props for photographic experiments, such as Erich Consemüller's image of costumed figures arrayed on the roof of the Dessau Bauhaus (cat. 218).

Schlemmer's study for *Das Triadische Ballett* of c. 1924 emphasizes his costume designs and, especially, his rationalized conception of the body's movement in space. A work in gouache, ink, and photocollage, the study presents three figures from the dance's third, "mystical-fantastical" series in descending size and shifting scale within an orthogonal but heavily distorted geometric space. The large, foreground figure, which Schlemmer called *Der Abstrakte* (The abstract), is divided into unequal parts of light and dark, and his face is half-covered by an oversized mask or helmet. (For the 1922 premiere and again in 1923, Schlemmer danced this part himself).[4] Wielding a club above his head with one arm, while the other ends in a bell whose clapper protrudes like a sword blade, *Der Abstrakte* extends his oversized

leg forward from one graphed square to the next. The elongated reach of the stylized right leg and the exaggerated foreshortening of the left (a gesture repeated in many of Schlemmer's works) further stretch and distort the image's geometry.

Behind *Der Abstrakte* are two smaller figures: in the middle ground, *Goldkugel* (Gold sphere), an armless dancer constrained within an ovoid torso; and in the upper right corner, farther back in space, *Drahtfigur* (Wire), whose arms reach out above a dense array of wire hoops ringing the waist and repeated around the head. Unlike *Der Abstrakte*, painted in gouache, these figures are presented through photocollage. The photographs show the dancers Albert Burger and Elsa Hötzel, with whom Schlemmer had collaborated closely before a falling-out in 1923 following the performances in Weimar and Dresden.[5]

Das Triadische Ballett, Schlemmer wrote, should "follow the plane geometry of the dance surface and the solid geometry of the moving bodies, producing that sense of spatial dimension which necessarily results from tracing such basic forms as the straight line, the diagonal, the circle, the ellipse, and their combinations."[6] Each of the three figures in the study suggests a different mode of occupying and moving within the graphed space of the stage. While *Der Abstrakte* lunges forward diagonally, the armless *Goldkugel* stands within its grid, and *Drahtfigur* poses on the corner of a square with arms extended as if spring loaded to twirl across the stage.

In that the form of the dancers' costumes significantly determines their motions, Schlemmer's study relates to the Bauhaus chess set designed by the wood-carving workshop master Josef Hartwig (cats. 168, 169). Shunning naturalistic description, Hartwig based his set on the logic and geometry of the game board instead of the conventional iconic resemblance of each piece to its named role (bishop, knight, etc.). An exercise in equivalence between form and function, the shape of each piece corresponds to its allowed moves: a simple cube for the pawns; an X-shaped block for the bishop; and for the queen, a sphere stacked on a cube, indicating her complete range of movement.

216
Oskar Schlemmer
Das Triadische Ballett (The triadic ballet).
c. 1924
Gouache, ink, and cut-and-pasted gelatin silver prints on black paper
22 5/8 x 14 5/8" (57.5 x 37.1 cm)
The Museum of Modern Art, New York.
Gift of Lily Auchincloss

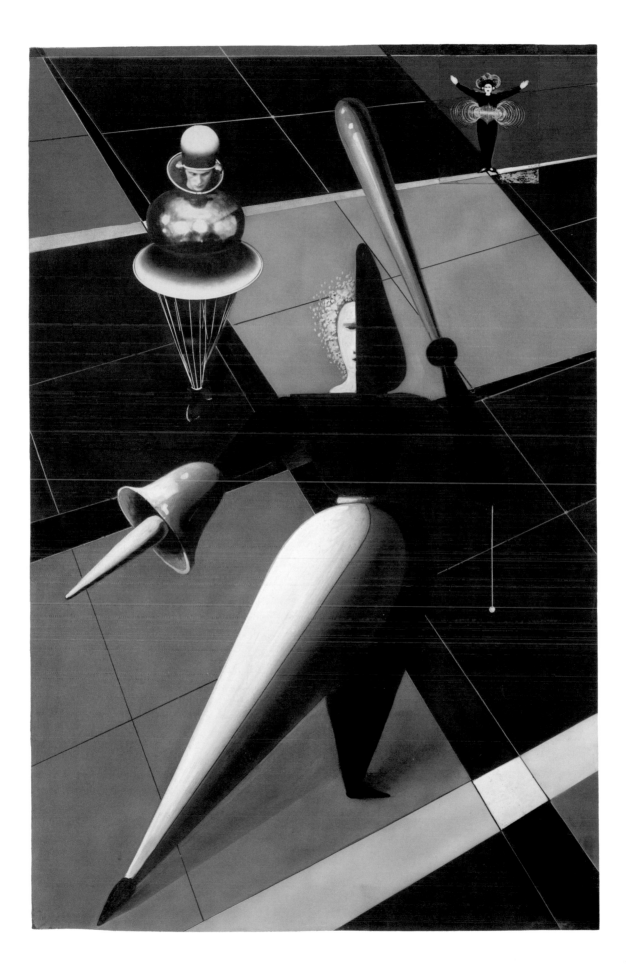

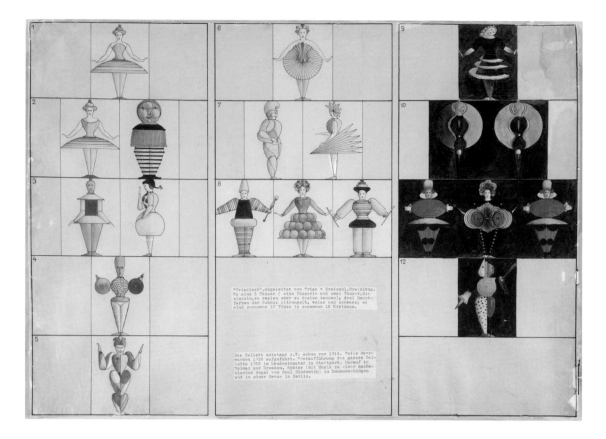

Although operating within a more open and multidimensional system than that of chess, the costumed figures of *Das Triadische Ballett* suggest game pieces moving within the fixed spatial geometry of the stage. This is reinforced in the study by Schlemmer's use of photocollage and pasted paper, which implies the possibility of rearranging and changing the placement of *Goldkugel* and *Drahtfigur*. At one point Schlemmer considered literalizing such board-game procedures in his choreography and fantasized to his friend Otto Meyer-Amden, "Experimental theater again: I want to continue with the geometry of the dance using carpets with various geometrical patterns (chessboard, etc.) on which to dance. Each field will be numbered, and during the dance the numbers will be called out."[7]

Schlemmer conceived of his stage costumes in "spatial-sculptural" terms, describing them as "sculptures, which, worn by the dancers, move in space, decisively influencing bodily sensation."[8] In fact the costumes for *Das Triadische Ballett* are often severely restrictive: the leading leg of *Der Abstrakte* does not bend, *Goldkugel*'s arms are enclosed and cannot be raised, while the extended arms of *Drahtfigur* can never be lowered. In this way *Das Triadische Ballett* transforms the dancers' bodies into the regulated, dehumanized forms of puppets and marionettes. Such objects, both familiar and alien, held great fascination for many early-twentieth-century artists, who like Schlemmer were informed by the tradition of automata and such influential essays

as Heinrich von Kleist's "On the Marionette Theater" of 1810. The dancers in *Das Triadische Ballett*, however, were neither game pieces nor marionettes but human actors. Their limited movements and the restrictive, even oppressive geometries of their costumes reflect Schlemmer's struggle with the relationship of the human body to the machine and of individual subjectivity to the mass culture of modernity.[9]

Particularly striking in *Das Triadische Ballett* is the creative tension between whimsical fantasy and the threat of physical constraint and bodily dismemberment. Schlemmer acknowledged as much when he explained later that "the seemingly violated body achieves new expressive forms of dance the more it fuses with the costume."[10] This violent imaginary is particularly evident in the 1924 study. For all his poise and balance, *Der Abstrakte* wields a club and sword, while behind him *Goldkugel* has no arms. (Another meaning of *Goldkugel* is "Gold bullet.") Even *Drahtfigur*, a costume of glittering effects, might also be viewed as a figure enmeshed in barbed wire. *Das Triadische Ballett* was first performed during the war, and its use of restricted motion, prosthetic devices, and protective encasements evokes not only playful whimsy but also the soldier's experience of cumbersome gear, bodily mutilation, and artificial limbs. In *Das Triadische Ballett*, as is often the case in Schlemmer's work, the geometric language of rationalist modernism belies a powerful specter of vulnerability and bodily damage.

217
Oskar Schlemmer
Costume designs for *Das Triadische Ballett* (The triadic ballet). 1926
Ink, gouache, metallic powder, and pencil, with adhered typewritten elements on paper, mounted on card
13 7/16 x 21 1/8" (38.0 x 53.7 cm)
Harvard Art Museum, Busch-Reisinger Museum. Museum purchase

218
Erich Consemüller
Untitled (The theater class). c. 1927
Gelatin silver print
4 13/16 x 6 7/8" (12.2 x 17.4 cm)
Private collection

219
Oskar Schlemmer
Poster for unrealized performance of *Das Triadische Ballett* (The triadic ballet) at the Leibniz-Akademie, Hannover, February 19 and 26, 1924
Lithograph on paper
32 1/2 x 22 1/8" (82.6 x 56.2 cm)
Collection Merrill C. Berman

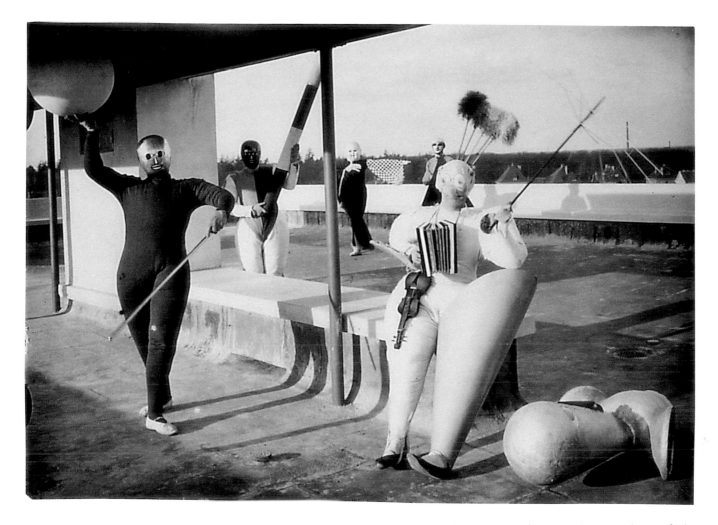

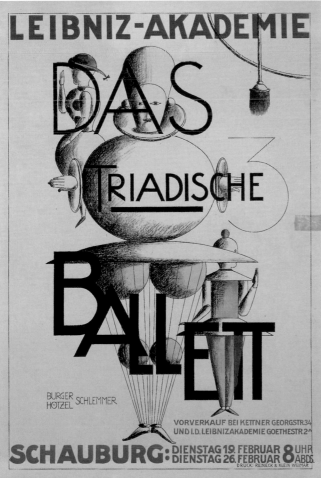

1. Oskar Schlemmer, diary entry, September 1922, in *The Letters and Diaries of Oskar Schlemmer*, ed. Tut Schlemmer, trans. Krishna Winston (Evanston, Ill.: Northwestern University Press, 1972), p. 127. Translation modified by the author. For a reproduction of the program see Dirk Scheper, *Oskar Schlemmer: Die Triadische Ballett und die Bauhausbühne* (Berlin: Akademie der Künste, 1988), pp. 52–53.

2. Schlemmer's idea of theater followed a Wagnerian notion of the Gesamtkunstwerk. Although absent from Walter Gropius's original Bauhaus curriculum, a theater program was initiated in 1921 by the Expressionist-oriented Lothar Schreyer, whom Schlemmer replaced in 1923.

3. For a detailed study see Scheper, *Die Triadische Ballett und die Bauhausbühne*; see also Nancy Troy, "The Art of Reconciliation: Oskar Schlemmer's Work for the Theater," in Arnold Lehman and Brenda Richardson, eds., *Oskar Schlemmer* (Baltimore: Baltimore Museum of Art, 1986), pp. 127–47, and Arnd Wesemann, "The Bauhaus Theater Group," in Jeannine Fiedler and Peter Feierabend, eds., *Bauhaus* (Cologne: Könemann, 2000), pp. 532–48. A planned performance at the Leibniz-Akademie in Hannover, for which a poster was made (cat. 219), did not in the end take place; see Scheper, *Die Triadische Ballett und die Bauhausbühne*, p. 86, and p. 306, n. 195. Schlemmer never settled on the music for *Das Triadische Ballett*. Early performances combined modern and classical compositions; Paul Hindemith composed mechanical-organ music for the work in 1926, but Schlemmer also considered popular songs and marches.

4. A photograph of Schlemmer in this role appears in Scheper, *Die Triadische Ballett und die Bauhausbühne*, p. 43. Schlemmer performed under the pseudonym "Walter Schoppe," a name borrowed from a character in Jean Paul's novels *Siebenkäs* (1796) and *Titan* (1802), who, as Schlemmer describes it, "takes off after his alter ego, which becomes confused and no longer knows which one he really is." Schlemmer, letter to Otto Meyer-Amden, October 25, 1922, in *The Letters and Diaries*, p. 130.

5. See Scheper, *Die Triadische Ballett und die Bauhausbühne*.

6. Schlemmer, diary entry, September 1922, in *The Letters and Diaries*, pp. 127–28.

7. Schlemmer, letter to Meyer-Amden, mid-December 1925, in ibid., p. 186.

8. Schlemmer, "Bühnenelemente," lecture of 1931, quoted in Karin von Maur, *Oskar Schlemmer: Monographie* (Munich: Prestel), p. 134. Author's trans.

9. Schlemmer's program notes for *Das Triadische Ballett* refer to Heinrich von Kleist's essay as well as to E. T. A. Hofmann's *Fantasy Pieces*. See Schlemmer, *The Letters and Diaries*, p. 126. For a nuanced discussion of these issues at the Bauhaus see Juliet Koss, "The Bauhaus Theater of Human Dolls," *The Art Bulletin* 85, no. 4 (December 2003): 724–45.

10. Schlemmer, "Bühnenelemente," p. 134. See also Erich Michaud, "Das 'Triadische Ballett' zwischen Krieg und Technik," in Maria Müller, ed., *Oskar Schlemmer, Tanz, Theater Bühne*, exh. cat. Kunstsammlung Nordrhein-Westfalen (Ostfildern-Ruit: Hatje, 1994), pp. 46–49.

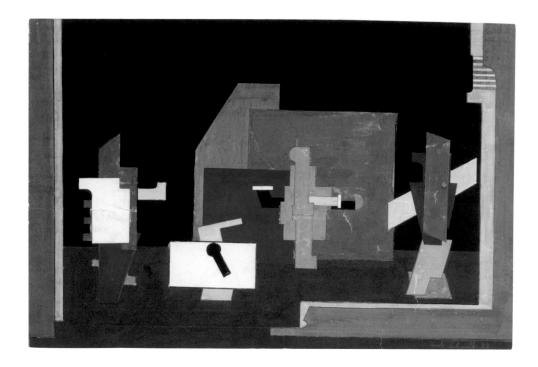

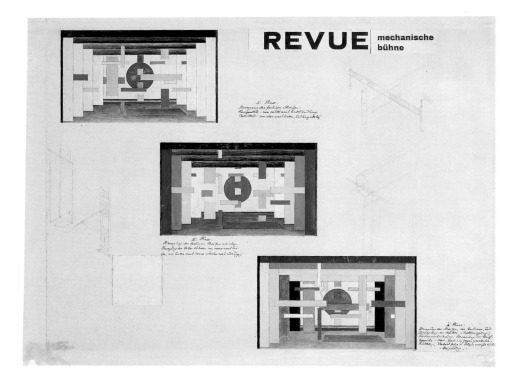

220
Kurt Schmidt
Drawing based on the performance of the
Mechanisches Kabarett (Mechanical cabaret)
by Schmidt, Georg Teltscher, and Friedrich
Wilhelm Bogler. 1924
Gouache on card
13 3/16 x 19 1/8" (33.5 x 48.5 cm)
Klassik Stiftung Weimar, Graphische
Sammlungen

221
Andor Weininger
Revue: Mechanische Bühne, Phase I–III
(Mechanical stage revue, phase I–III). 1926
Pencil, gouache, watercolor, ink, and gold
bronze on cardboard
15 7/8 x 22 1/4" (40.4 x 56.5 cm)
Theaterwissenschaftliche Sammlung,
Universität zu Köln

222
Kurt Schmidt
*Form und Farborgel mit bewegenden
Farbklängen* (Form and color organ with
moving color tones). 1923
Oil and tempera with varnish on wood
40 13/16 x 40 13/16 x 2 15/16" (103.6 x 103.6 x 7.4 cm)
Klassik Stiftung Weimar, Bauhaus-Museum

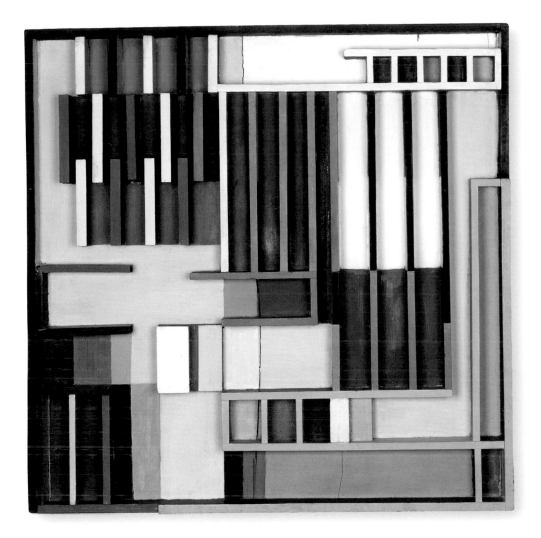

223
Joost Schmidt
Mechanical stage design. 1925–26
Ink and tempera on paper
25 3/16 x 17 5/16" (64 x 44 cm)
Germanisches Nationalmuseum,
Nuremberg. Deutsches Kunstarchiv

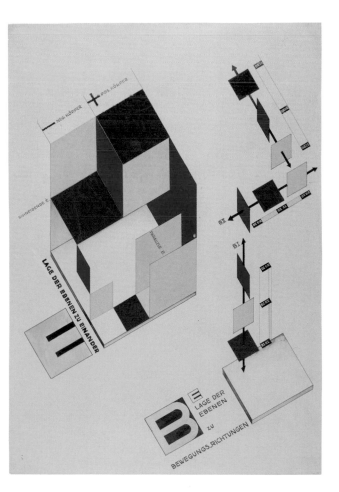

Herbert Bayer arrived in Weimar in the fall of 1921, fresh from architectural apprenticeships in Linz and Darmstadt, where he had been exposed to the Gesamtkunstwerk impulses of Jugendstil design. Drawn to the Bauhaus by the writings of Vasily Kandinsky, Bayer studied under the Russian master in the wall-painting workshop, collaborating on projects for local clients. Also a student of typography and advertising, he was adept at graphics, too, and soon put these various talents to use in his murals and signs for the Bauhaus exhibition of late summer 1923, the first public display of the activities of the school since its founding.[1] Yet his facility with both colored surfaces and commercial design is most evident in his schemes for pavilions, kiosks, and other display structures of 1924–25 — schemes that already show the impact of *Reklame-Architektur*, a new species of building that arose in German metropoles during this period of economic reconstruction, in which advertising becomes an integral part of the facade. By this time, too, László Moholy-Nagy had transformed the Bauhaus with his calls for the "new vision" of the machine age, which also marked Bayer strongly. After a Wanderjahr in Italy in 1923–24, Bayer returned to the Bauhaus, where, in its Dessau incarnation, he taught typography, advertising, and "visual communication" (a Moholy buzz phrase) until his departure in 1928. By this point his schemes for pavilions, kiosks, and the like were already a few years in the past.

What strikes us first about these projects is how boldly they juxtapose verbal and visual elements and representational and abstract modes: emphatic signs for newspapers, cigarettes, and chocolate combine with pure planes in primary colors (plus black, white, and gray). Sometimes Bayer makes these different registers reinforce one another: his cigarette pavilion (cat. 226) shows a smokestack in the shape of a cigarette against a tall red screen above the word "*Cigaretten*" spelled out in capitals on a low yellow facade. At other times he lets his various media fight it out: along with the usual color planes, his "Regina" pavilion (cat. 225) includes a loudspeaker, a flashing electric sign, and a rear-projected film, as well as the name "Regina" somehow written in smoke — a sensorial barrage that seems excessive for the product on sale (toothpaste). Bayer fully intends this mix of control and cacophony — the orderliness of his geometric abstraction is a foil for the liveliness of his words and images — but it also betrays the contrary influences of the three movements that informed the Bauhaus in the early 1920s: de Stijl, Berlin Dada, and Russian Constructivism. Theo van Doesburg, the maestro of

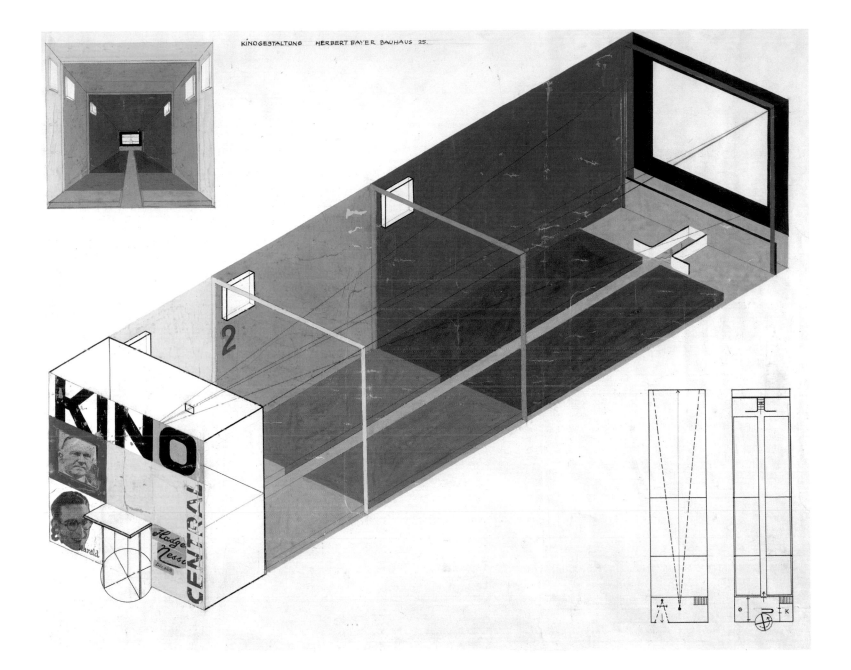

KINOGESTALTUNG HERBERT BAYER BAUHAUS 25.

224
Herbert Bayer
Design for a cinema. 1924–25
Gouache, cut-and-pasted photomechanical
and print elements, ink, and pencil on paper
18 x 24" (54.6 x 61 cm)
Harvard Art Museum, Busch-Reisinger
Museum. Gift of the artist

de Stijl, had orchestrated two meetings between Constructivists and Dadaists, the first in Düsseldorf in May 1922, the second in Weimar in September of that year (cat. 3; El Lissitzky, among others, attended both), and there was an important show of revolutionary Russian art in Berlin that October. It would be hard for a young *Bauhäusler* like Bayer not to be pulled in a few directions at once.

Van Doesburg was in Weimar as early as April 1921, and although he was not invited to teach at the Bauhaus, he did affect its orientation. His influence is strong in the primary colors of the Bayer schemes. According to Yve-Alain Bois, de Stijl pursued a double program of "elementarization," whereby each art was reduced to its fundamental forms, and "integration," whereby these fundamental forms were then used to bind the different arts together in a new ensemble of advanced design.[2] Thus de Stijl often featured the colored plane as the element shared by painting and architecture. Such screens are prominent in the Bayer schemes, which also favor a high perspective — nearly as high as the axonometric projections, with their distinctive combination of elevation and plan, often seen in de Stjil designs. These traits render the Bayer schemes almost diagrammatic; in fact they emerge from graphic design as much as painting or architecture, and call out for a magazine layout perhaps more than for a white wall or a building site. At this time, under the influence of Moholy, Bayer had begun to rationalize typography; his famous "universal type" (cats. 257, 258), which governed the graphic style of the Bauhaus from 1925 on, was both sans serif and without capitals. Under the banner of simplification for the sake of legibility, this type effaced any "calligraphic" trace of the hand and its age-old instruments (pencil, chisel, etc.) — anything, that is, that stood in the way of mechanical reproduction and visual communication.[3] A similar modernization is at work in these stripped-down schemes.

Here the presence of both Berlin Dada and Russian Constructivism also comes into relief. Dada, which flew in the face of such rationalization, is explicit only in the newspaper stand (cat. 228), with its collage of disjunctive journal titles, headlines, and images. (Raoul Hausmann seems the closest reference in this case.) Yet if Dada is residual, Constructivism is emergent: Bayer was probably aware of designs for kiosks and media platforms that Constructivists such as Aleksei Gan, Anton Lavinskii, and, especially, Gustav Klutsis proposed in the early 1920s. These too were intended for publicity (not to

say propaganda) — for journals and books, radio broadcasts and film projections — but they are at once more virtual and more physical than the Bayer schemes, more transparent in their structure (painted planks, rods, and wires held together by tectonic tension) and more active in their operation (most open and close, and some appear mutable and even mobile). In short, the Russian designs are more dynamic, more convinced by the transformational possibilities of their own modernity, more utopian.

With the Bayer schemes clearly in mind, Alexander Dorner, the avant-garde curator of the Hannover Landesmuseum, once suggested that his friend was caught between the formalism of de Stijl and the functionalism of Constructivism: "This inner tension gives Bayer's industrial designs of the 1920's the impact of tremendous will power and an almost puritan conviction. Posters, arrows, loudspeakers, giant cigarettes, smoke, movie screens are forced into the neoplasticist composition. But the composition never really transcends its self-sufficiency; it never merges with the functioning process of industrial and economic life."[4] Dorner is right about the tension here, less so about the trajectory, for the Bayer designs are directed at a world of consumption as much as of production — a world of exhibition, advertisement, and entertainment. Just as they are caught stylistically between de Stijl and Constructivism, so are they suspended politically between the horizons of American capitalism and Soviet communism — the problematic position of modern Germany at large, according to Martin Heidegger and others.

After the failed revolutions that followed the catastrophe of World War I, Germany embraced capitalism: in late 1923 the currency was reformed (earlier in the year, in the midst of rampant inflation, the state bank of Thuringia had commissioned Bayer to design banknotes; cat. 262); in 1924 (the year of most of the Bayer schemes) the Dawes loan plan from the United States began; and with foreign investment and new technology, German industry and business soon recovered. It was in this brief period of relative prosperity before the Great Crash of 1929 that the Bauhaus shifted toward commercial design, and the Bayer schemes are part of this shift: in effect they adapt aspects of de Stijl, Dada, and Constructivism, all socialist or communist in spirit, to sketch a new look for capitalist enterprise.[5] This is not a value judgment but a career trajectory: after leaving the Bauhaus in 1928, Bayer, like Moholy, set up an office in Berlin where he worked on exhibitions and advertisements (he had union clients too), and also as the art director for both German

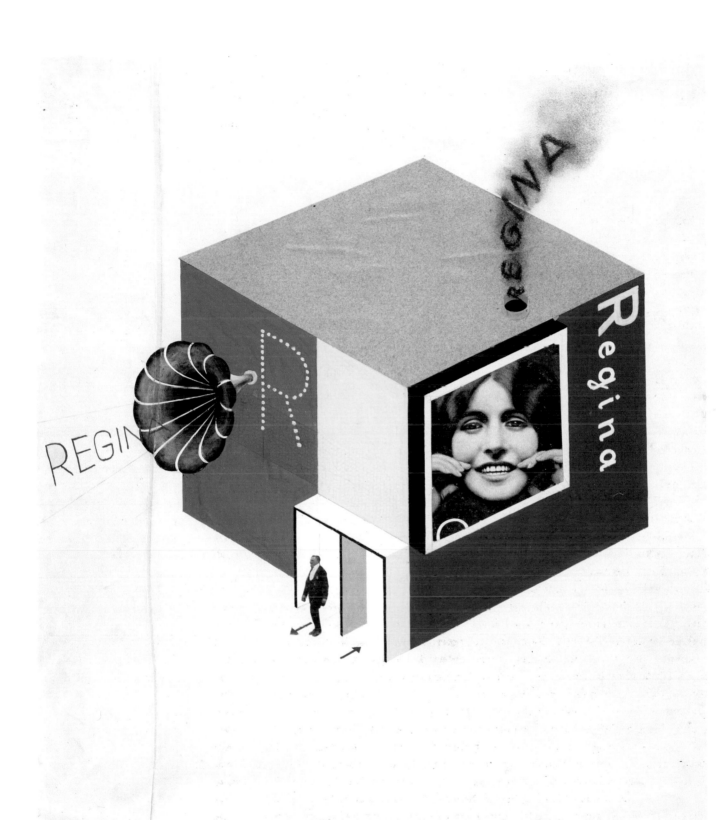

225
Herbert Bayer
Design for a multimedia building. 1924
Gouache, cut-and-pasted photomechanical
elements, charcoal, ink, and pencil on paper
21½ x 18⁷⁄₁₆" (54.6 x 46.8 cm)
Harvard Art Museum, Busch-Reisinger
Museum. Gift of the artist

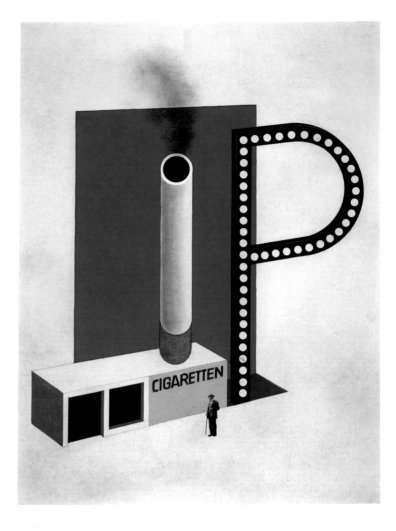

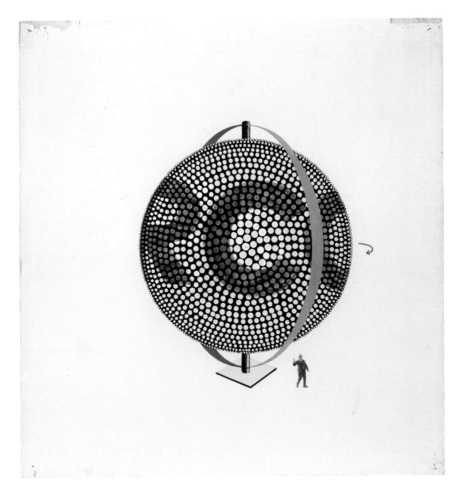

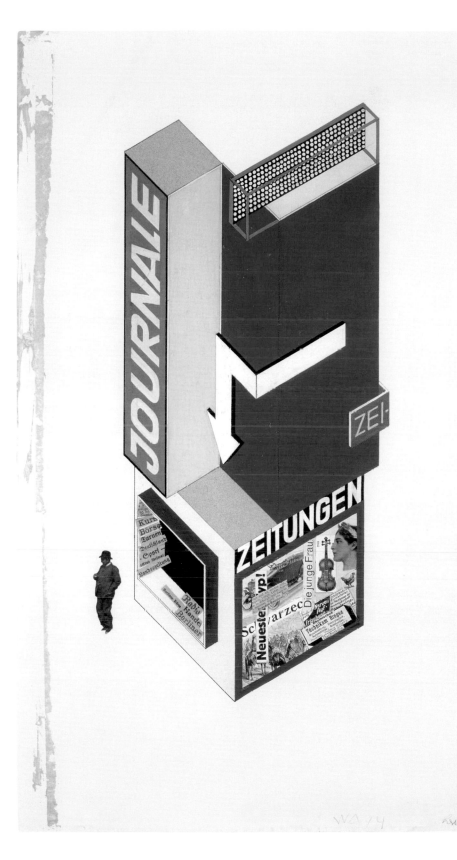

226
Herbert Bayer
Design for a cigarette pavilion. 1924
Ink, tempera, pencil, and cut-and-pasted
photomechanical elements on cardboard
19 7/8 x 14 15/16" (50.5 x 38 cm)
Bauhaus-Archiv Berlin

227
Herbert Bayer
Design for an illuminated advertising
sphere. 1924
Ink, gouache, cut-and-pasted photomechanical
element, and pencil traces on tan card, with
incising and pin holes
20 5/8 x 19 5/16" (52.4 x 49.1 cm)
Harvard Art Museum, Busch-Reisinger
Museum. Gift of the artist

228
Herbert Bayer
Design for a newspaper stand. 1924
Tempera and cut-and-pasted print elements
on paper
25 3/8 x 13 9/16" (64.5 x 34.5 cm)
Bauhaus-Archiv Berlin

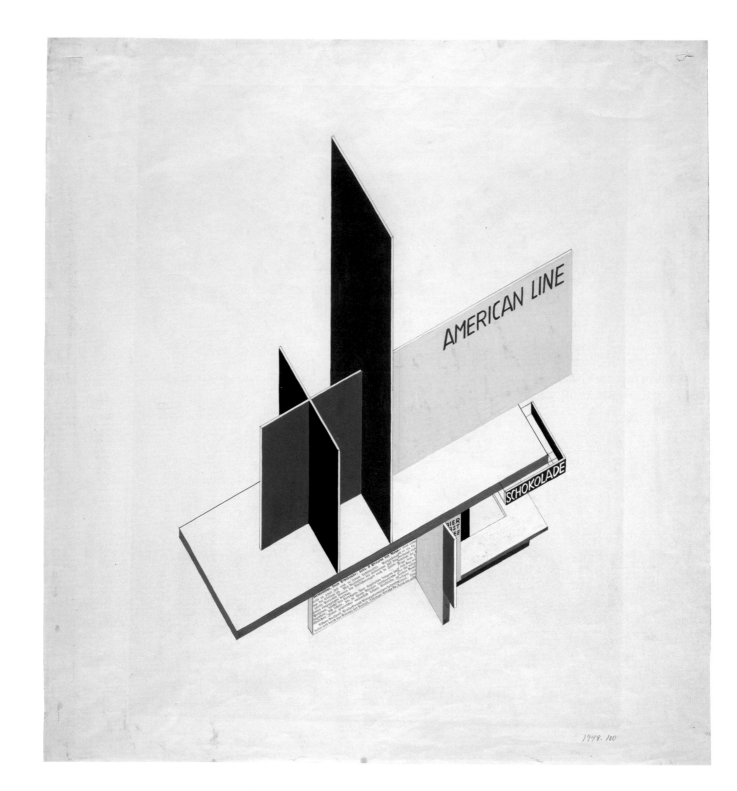

229
Herbert Bayer
Design for kiosk and display boards. 1924
Gouache, ink, pencil, and cut-and-pasted
print elements on paper
20³/₄ x 19¹/₁₆" (57.7 x 48.4 cm)
Harvard Art Museum, Busch-Reisinger
Museum. Gift of the artist

Vogue and the Dorland Studio ad agency. A decade later Bayer continued such work in the United States, where, among other projects, he designed exhibitions for The Museum of Modern Art, including the 1938 Bauhaus show.[6] Eventually he became a consultant for the Container Corporation of America and the chairman of design for Atlantic Richfield (arco).

I suggested above that the Bayer schemes have less to do with architecture than with graphics, but it is more accurate to say that they propose a hybrid of the two. In effect they imagine what architecture will be in a mass-mediated society, how virtual it will become when the old imperative of shelter succumbs to the new priority of publicity, when structure is refashioned as sign. In short, they test-run a *Reklame-Architektur* at the extreme, an architecture that is also an advertisement. Also driven by the increased demand for display windows and movie theaters, *Reklame-Architektur* presented a new kind of address to the urban subject, one that Walter Benjamin, in *One-Way Street*, his great account of Berlin drafted at the same time that the Bayer schemes were produced, called "the dictatorial perpendicular." "Today the most real, mercantile gaze into the heart of things is the advertisement," Benjamin writes. "It tears down the stage upon which contemplation moved, and all but hits us between the eyes with things as a car, growing to gigantic proportions, careens at us out of a film screen."[7] We might think we know where this historical vector leads — to the present popcommercialization of countless urban centers and suburban strips around the world — but in 1924–25 this was hardly clear. Control of public space was contested in Germany until the Nazi seizure of power in 1933, and even in the midst of World War II Europeans could dream of an alternative realm of public appearance delivered over neither to authoritarian rule nor to market forces (as the 1943 proposal of a "New Monumentality" by Sigfried Giedion, Josep Lluis Sert, and Fernand Léger attests).[8]

The enduring interest of the Bayer schemes lies in this historical ambiguity. On the one hand, they point to the rise of a "society of the spectacle," a phenomenon that its principal theorist, the Situationist Guy Debord, in fact dated to the 1920s, with the spread of radio and the invention of sound film and television.[9] On the facade of his cinema, for example (cat. 224), Bayer juxtaposes images of Hollywood star Harold Lloyd and President Calvin Coolidge, in a manner that looks ahead to the Warholian celebrity-continuum of Marilyn Monroe and Mao, and in his design for an "illuminated advertising sphere" (cat. 227)

he conceives the globe as a gigantic eye of spectacular attraction.[10] On the other hand, the Bayer designs are formally and semiotically inventive in ways that exceed any economic mode or political order. The sheer delight in sensorial possibility and technological capacity suggested by the "Regina" pavilion alone, where even smoke is made articulate, is palpable to this day; it diagrams a joyous Gesamtkunstwerk of the first age of "new media."

1. Herbert Bayer's murals in the stair landings followed Vasily Kandinsky's system of blue for circles, red for squares, and yellow for triangles; see cat. 192.

2. See Yve-Alain Bois, "The De Stijl Idea," in *Painting as Model* (Cambridge, Mass.: The MIT Press, 1990). See also Nancy J. Troy, *The De Stijl Environment* (Cambridge, Mass.: The MIT Press, 1983).

3. See Bayer, "toward a new alphabet 'the universal type,'" 1925, in Bayer, *Herbert Bayer: Painter, Designer, Architect* (New York: Reinhold, 1967), p. 26.

4. Alexander Dorner, *The Way beyond "Art": The Work of Herbert Bayer* (New York: Wittenborn, Schulz, 1947), p. 135. Dorner adds in a note: "For instance, Bayer did not investigate the problem of how technically to make the legend in smoke in his 'Regina' pavilion. He was possessed in a purely artistic sense by the novel vision of making sound, moving smoke-characters, light and moving pictures work together as energies." It was Dorner who commissioned El Lissitzky's great *Kabinett der Abstrakten* for the Hannover Landesmuseum in 1927–28.

5. Of the formerly avant-garde technique of photomontage, for example, Bayer would later write that it "is particularly compatible with advertising psychology and the imagery of ideas." Bayer, *Herbert Bayer*, p. 40.

6. See Christopher Phillips, "The Judgment Seat of Photography," *October* 22 (Fall 1982): 41–45.

7. Walter Benjamin, "One-Way Street," written 1923–26, published 1928, in *Walter Benjamin: Selected Writings*, vol. 1, *1913–1926*, ed. Marcus Bullock and Michael W. Jennings (Cambridge, Mass.: Harvard University Press, 1996), pp. 456, 476. For an excellent account of this context, see Janet Ward, *Weimar Surfaces: Urban Visual Culture in 1920s Germany* (Berkeley: University of California Press, 2001). Apropos of both Benjamin and Bayer here, Ward writes, "the instantaneous (vertical) logic of advertising began to emerge even on the new horizontal facades" (p. 139).

8. See Sigfried Giedion, Josep Lluis Sert, and Fernand Léger, "Nine Points on Monumentality," originally planned for a 1943 publication by American Abstract Artists, reprinted in Joan Ockman, ed., *Architecture Culture 1943–1968* (New York: Columbia University Press, 1993), pp. 29–30.

9. See Guy Debord, *Comments on The Society of the Spectacle*, trans. Malcolm Imrie (London: Verso, 1990), and Jonathan Crary, "Spectacle, Attention, Counter-Memory," *October* 50 (Fall 1989). The Bauhaus, Jean Baudrillard once argued, marks "the practical extension of the system of exchange value to the whole domain of signs, forms, and objects." *For a Critique of the Political Economy of the Sign*, trans. Charles Levin (St. Louis: Telos Press, 1981), p. 186.

10. This scheme might be contrasted with Gustav Klutsis's photomontage *Electrification of the Entire Country* (1920), which pictures Vladimir Lenin astride a world united by an electrical grid of communist construction. In the Bayer scheme, by contrast, the human subject is dwarfed by the corporate logo.

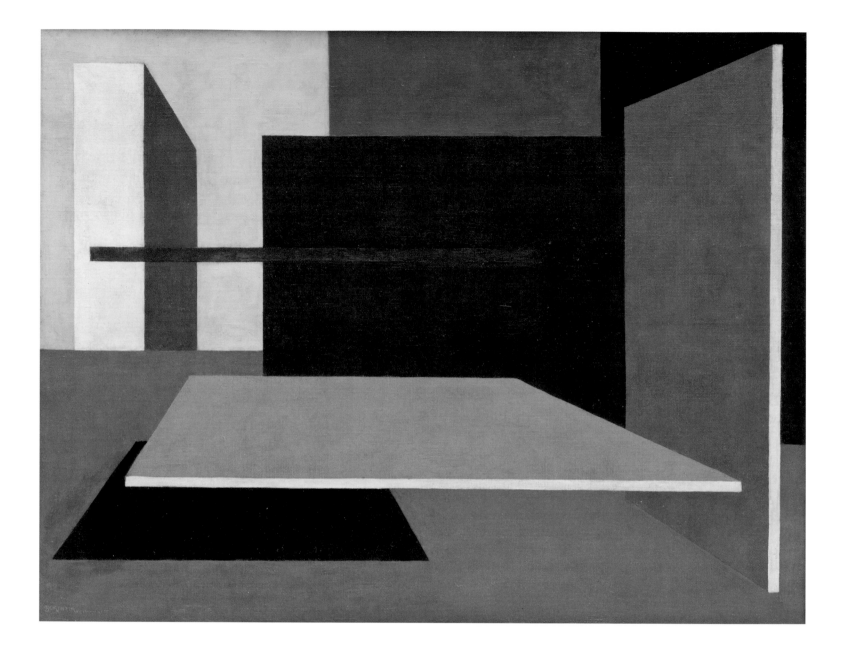

230
Alexander (Sándor) Bortnyik
Untitled. 1923
Oil on canvas
18 ¼ x 23 ⅝" (46.4 x 60 cm)
The Museum of Modern Art, New York.
The Riklis Collection of McCrory
Corporation

231
Peter Keler
Wall-painting scheme for László Moholy-
Nagy's studio, Weimar. c.1925
Gouache on paper
11 ¹³⁄₁₆ x 19 ¾" (30 x 50.1 cm)
Klassik Stiftung Weimar, Graphische
Sammlungen

232
Peter Keler
Wall-painting scheme for László Moholy-
Nagy's studio, Weimar. c.1925
Gouache and silver bronze powder on paper
11 ⅞ x 19 ⅝" (30.2 x 49.8 cm)
Klassik Stiftung Weimar, Graphische
Sammlungen

arbeitsraum weimar 1905, hiersu ein blatt (II.)

blatt (II) verschiebbare rückwand mit vorhang.

COLOR PLANS FOR ARCHITECTURE. 1925–26
MARCO DE MICHELIS

One of the most resilient yet least well-founded myths about the new architecture of the 1920s is that it had to be white. Certainly Mies van der Rohe disliked colored surfaces, or rather he was faithful to the doctrine, traceable back to John Ruskin, that color should derive from material, whether the richly veined marbles of the German Pavilion in Barcelona or the dark red brick of the Esters and Lange houses in Krefeld. In 1929, too, Heinrich Tessenow published an article in which, while admitting the possibility of using the entire spectrum of color, he argued that white, though improved by a glaze of gray or pale yellow, was the most logical choice for architecture and the solution most consistent with the cherished tradition of Biedermeier architecture around 1800.

But Mies and Tessenow were actually exceptions. Since Quatremère de Quincy's studies of polychromy in ancient Greek art a century earlier, and then Gottfried Semper's later, related arguments, color had played a leading role in "modern" architectural debate. In designing the garden city of Falkenberg before World War I, Bruno Taut had used a multicolored palette to replace costlier ornament, and to help to define a distinctive identity for this little housing development within the borders of Berlin; and the Glass House that Taut had built for the Deutscher Werkbund exhibition, Cologne, in 1914 (p. 141, fig. 1) had used every variant of color and surface available in glass, emphasizing the ability of the medium, when other than neutrally transparent, to filter, modify, and tint light. De Stijl doctrine, and the related experiments of Theo van Doesburg and Gerrit Rietveld, called for the use of color — though only the primaries — to decompose and dissolve the masonry box. Even the white walls of Le Corbusier's Villa Stein (Garches, 1927) and Villa Savoye (Poissy, 1928–29), historians have shown, result more from imprecise restoration and, above all, the failure of experiments to find a compact artificial cladding with the qualities of stone than from the pursuit of absolute whiteness. Le Corbusier considered color an "*apporteuse d'espace*" — a producer of space, or a tool for transforming our perception of it, according to the physiological and psychological principles of sensation.[1] Discussing his Villa La Roche (Paris, 1923–25), Le Corbusier wrote of an operation of architectural "camouflage," the paradoxical achievement of a "white" character in the interiors through polychromy: blue for the walls in shadow, red for those in sunlight.[2]

From the Bauhaus's earliest beginnings, nearly all of the school's masters were involved in the search for a "grammar of color." One need only think of Johannes Itten's color sphere

(cat. 66), its application in his design for a "tower of fire,"[3] and its daily use in the teaching of the preliminary course; Vasily Kandinsky's investigations of the relationship between form (*Gestalt*) and color, which had been first discussed at some length in his book *Concerning the Spiritual in Art* of 1911 and which included the famous questionnaire that he distributed at the Bauhaus in 1923, on the mutual influences among geometric shapes and primary colors (cat. 10); and the ideas of Paul Klee and later the young Josef Albers. The lineage of these experiments is well-known, ranging from Isaac Newton, Johann Wolfgang von Goethe, and Philipp Otto Runge to the later theories of Wilhelm Ostwald and Adolf Hölzel, the artist who had been the teacher of both Itten and Oskar Schlemmer. The study of color at the Bauhaus centered around the wall-painting workshop, founded in October 1919 and run first by Itten with Georg Muche, then by Schlemmer and Kandinsky. In 1925, when the Bauhaus moved to Dessau, the former Bauhaus student Hinnerk Scheper took charge of the wall-painting workshop. With some interruptions he would run it until 1933.

The wall-painting workshop undertook many projects, both outside the school, often on commissions linked to Walter Gropius's architectural practice, and within it.[4] Outside the school, the Bauhaus student Dörte Helm developed the blue and earth-tone interior scheme for Gropius and Adolf Meyer's Otte House, Berlin, in 1921–22; and Scheper, then still a student, devised colors consistent with Itten's teachings for the Jena theater renovated by Gropius and Meyer in 1921. Independently of Gropius, Kandinsky made large, abstract murals for the entrance of the *Juryfreie* exhibition in Berlin in 1922 (cats. 124–28). Inside the school, within a few months after it opened, attempts emerged to use wall painting to reconfigure the spaces of its building, an arts academy built by Henry Van de Velde in 1904–11. In June 1919, a competition (without a definitive result) was held for a color scheme for the building's entry hall, and multicolored decorations of "hieroglyphs, arrows, spirals, eyes, parts of steamships, letters" were soon introduced in the canteen and corridors.[5] In the summer of 1920, Itten directed the painting of the

233
Hinnerk Scheper
Orientierungsplan (Orientation plan) for the Bauhaus building, Dessau, designed by Walter Gropius. 1926
Tempera and india ink on paper, mounted on cardboard, with label
33⁷⁄₁₆ x 19⁷⁄₁₆" (□ □ □ □ □ □ □)
Bauhaus-Archiv Berlin. Long-term loan from the Scheper Estate

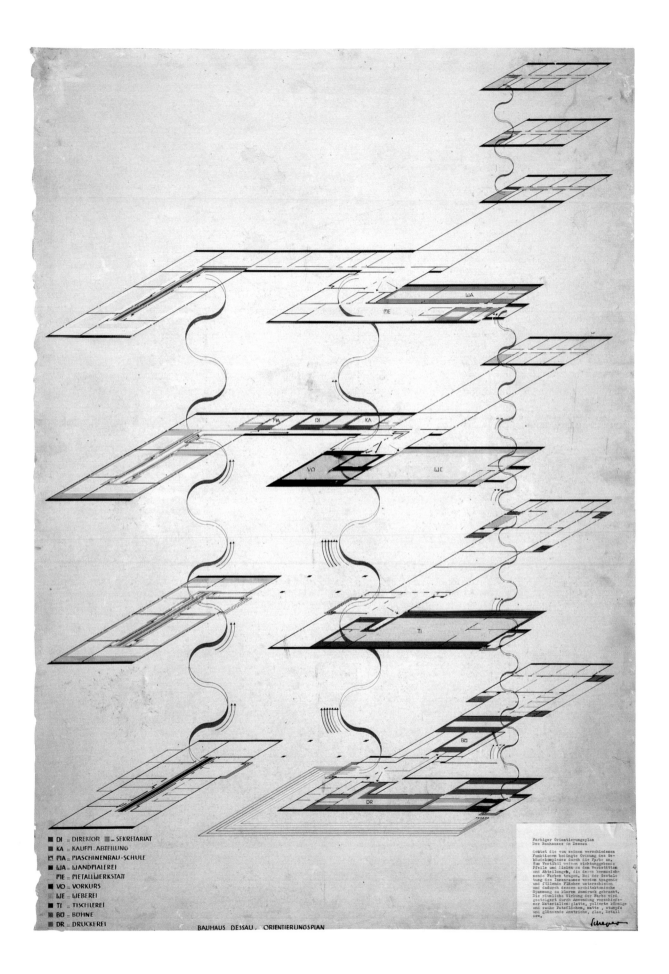

DI = DIREKTOR = SEKRETARIAT
KA = KAUFM. ABTEILUNG
MA = MASCHINENBAU-SCHULE
WA = WANDMALEREI
ME = METALLWERKSTATT
VO = VORKURS
WE = WEBEREI
TI = TISCHLEREI
BÜ = BÜHNE
DR = DRUCKEREI

BAUHAUS DESSAU . ORIENTIERUNGSPLAN

"skylight great gallery" with the chromatic sequence of his color sphere, in concentric circles starting from white at the center and expanding outward to dark blue. Itten also took charge of painting the antechamber to Gropius's office, a project in which Albers too participated.[6]

In 1923, Schlemmer, with a view toward the Bauhaus exhibition later that year, and working with Kurt Schmidt, Josef Hartwig, and Hermann Müller, created murals and plaster reliefs in the entrance to the main building and in the stairwell of the adjacent workshop building, originally designed by Van de Velde as the site for the Kunstgewerbeschule, the school of applied arts. More than color alone, Schlemmer used painting and sculptural modeling here as his tools, aiming for a synthesis that would transform the very notion of architecture. The undogmatic nature of Gropius's school, especially during the Weimar years, is obvious in the variety of works created for the 1923 exhibition by the students Peter Keler, Farkas Molnár, and Herbert Bayer: all had studied privately with Van Doesburg the previous year, and they had clearly absorbed de Stijl color theories. Meanwhile Kandinsky's contemporaneous teachings on relationships between form and color are equally recognizable in, for example, the yellow-triangle/red-square/blue-circle combinations used by Bayer in the signage for the Bauhaus's secondary staircase (cat. 192).

In 1925, the Bauhaus's move to Dessau — and the creation there both of a completely new building for the school and of the Masters' Houses, all designed by Gropius and conceived as the initial core for a *Bauhaus-Siedlung* — represented an extraordinary opportunity for the workshop, now directed by Scheper. Working with his students Keler, Heinrich Koch, Gertrud and Alfred Arndt, Fritz Kuhr, and Vladis Svipas, but also with colleagues on the faculty such as Marcel Breuer and László Moholy-Nagy, Scheper developed a series of projects that seem to mirror Kandinsky's ideas about "the power of color to change space and shapes."[7] Employing a palette that added various pastel gradations and a structured scale of grays to the primary colors, Scheper assigned color the dual task of both characterizing space and orienting its inhabitants. He paid clear attention to perceptual issues, and thus to the power of color in visual experience.

On the exterior of the Bauhaus building itself (cat. 234), Scheper used shades of gray for the fascia of the building's foundation and connecting elements (the cement structure of the bridge, the elongated body of the cafeteria and auditorium, the staircase volume on the windowless end of the workshop building), emphasizing the dimensions and specific characters of the different volumes that made up the school complex. In this way the visual experience of the building was rhythmically measured by the varying composition and overlay of its volumes, following the observer's movement along the continually changing perimeter of Gropius's masterpiece. Inside, meanwhile, paths through the building were painted in colors corresponding to the functional articulation (workshops, administration, and so on) of the spaces and underscoring the school's complex organization (cat. 233).

In the housing, meanwhile, the distinct personalities of the designated residents were decisive. Gropius's own house seems to have been intended as a kind of ideal prototype for domestic living, with all its spatial, distributive, and technical aspects defined by the architect, in collaboration with Breuer. By contrast, in the houses designed for artists such as

Klee, Kandinsky, Schlemmer, Moholy Nagy, Albers, Muche, and Lyonel Feininger, the relationships among domestic space, furnishings, and works of art on display reflected the very different personalities of the users, who often intervened with suggestions, decisions, and solutions. Feininger, for example, wanted to keep his Biedermeier furniture, so different from Breuer's tubular-metal inventions. Albers himself designed prototypes for an armchair and small side tables to exist in dialogue with his paintings on glass on the walls.[8] And Kandinsky's house had golden niches in the living room and black painted walls in the dining room, for which Breuer designed a table and chairs made up of the two geometric figures of the circle and square and the two chromatic extremes of white and black (cats. 240, 241).[9]

The color schemes for these interiors, developed in the teaching workshops, clearly suggest dialogue with the houses' future residents, who had precise ideas about color. In Koch's project for Schlemmer's studio (cat. 239), for example, the progression of tones from yellow toward red and black almost exactly repeats the colors of Itten's color sphere. Keler's proposal for Moholy-Nagy's studio — thin lines and rectangular shapes in vivid tones of red and blue, in contrast with grays and beiges for floor and walls — recalls Moholy's own experiments in painting

(cats. 231, 232). Finally, the alternation of black and blue walls, with a small white niche in the corner, in Kuhr's project for Klee's studio (cat. 238) seems to suggest different backdrops for the practice of painting, and a functional approach to the task that the students were taking on — the task of giving form to a space in which a dialogue among architecture, design, and the visual arts might create the synthesis that Gropius had announced in his manifesto of the spring of 1919.

1. Le Corbusier, in W. Boesiger and O. Stonorov, eds., *Le Corbusier and Pierre Jeanneret. Oeuvre complète 1910–1929* (Zurich: Dr. H. Girsberger, 1930), p. 85. See also Arthur Rüegg, ed., *Le Corbusier — Polychromie architecturale: Farbenklaviaturen von 1931 und 1959/ Color Keyboards from 1931 and 1959/Les Claviers de couleurs de 1931 et de 1959* (Basel: Birkhäuser, 2006).
2. Le Corbusier, in Boesiger and Stonorov, eds., *Le Corbusier and Pierre Jeanneret*, p. 60.
3. See Rolf Bohte and Michael Siebenbrodt, "La Torre del Fuoco di Johannes Itten," in Marco De Michelis and Agnes Kohlmeyer, eds., *Bauhaus 1919–1933. Da Klee a Kandinsky, da Gropius a Mies van der Rohe*, exh. cat. (Milan: Fondazione Mazzotta, 1996), pp. 63–70.
4. See Renate Scheper, ed., *Farbenfroh! Colourful! The Wallpainting Workshop at the Bauhaus*, exh. cat. (Berlin: Bauhaus-Archiv, 2005).
5. *Tägliche Rundschau* 2, December 2, 1920, quoted in ibid., p. 146, n. 12.
6. See Scheper, ed., *Farbenfroh!*, pp. 10–11.
7. Ibid., p. 20.
8. See Gabriele Kolber, *Leben am Bauhaus. Die Meisterhäuser in Dessau* (Munich: Bayerische Vereinsbank, 1993).
9. See Nina Kandinsky, *Kandinsky und ich* (Munich: Kindler, 1976).

234
Hinnerk Scheper
Color scheme for the exterior of the Bauhaus building, Dessau, designed by Walter Gropius. 1926
Tempera over blueprint, cut-and-pasted on gray-green paper
26¾ x 39" (68 x 100 cm)
Bauhaus-Archiv Berlin. Long-term Loan from the Scheper Estate

235
Hinnerk Scheper
Color scheme for the treatment of the walls, director's office in the Bauhaus building, Dessau, designed by Walter Gropius. 1925–26
Tempera, raffia, pencil, and ink on cardboard, mounted on gray cardboard
26¾ x 26¹⁵⁄₁₆" (68 x 68.5 cm)
Private collection, Berlin

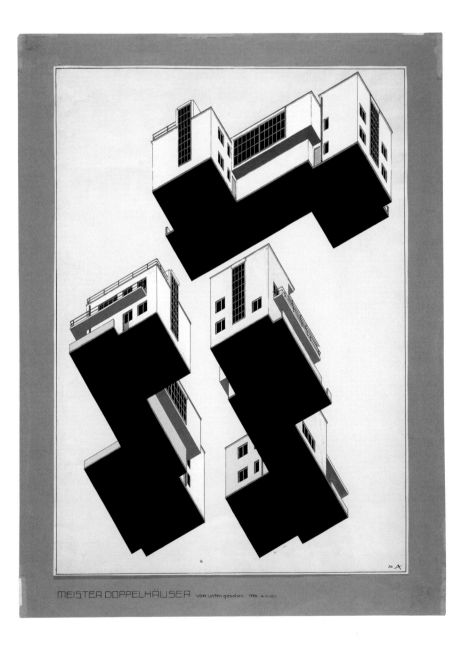

MEISTER DOPPELHÄUSER von unten gesehen · 1926 · Gropius

236 (above)
Walter Gropius
Bauhaus Master Houses, Dessau.
Isometric site plan. 1925–26
Ink and gouache on tracing paper
14 15/16 x 35 11/16" (38 x 90.7 cm)
Harvard Art Museum, Busch-Reisinger
Museum. Gift of Walter Gropius

237 (opposite, below)
Alfred Arndt
Meister Doppelhäuser, von unten gesehen
(Masters' double houses, seen from below).
Color scheme for the exteriors. 1926
Ink and tempera on paper
29 15/16 x 22 1/16" (76 x 56 cm)
Bauhaus-Archiv Berlin

238
Fritz Kuhr
Wall-painting scheme for the studio of
Paul Klee's Master House, Dessau, designed
by Walter Gropius. 1926
Tempera, silver bronze, and pencil on paper
9 7/16 x 13 3/8" (24 x 34 cm)
Bauhaus-Archiv Berlin

239
Heinrich Koch
Wall-painting schemes for the studio
and living room of Oskar Schlemmer's
Master House, Dessau, designed by
Walter Gropius. 1926
Tempera over pencil sketch on drawing
board, mounted on cardboard with
machine-typed label
26 7/8 x 39 7/16" (68.3 x 100.1 cm)
Bauhaus-Archiv Berlin

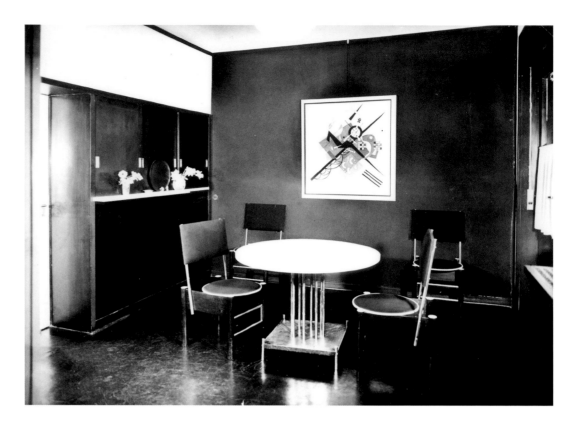

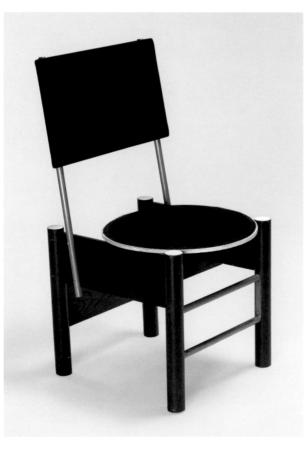

240
Marcel Breuer
Chair for Vasily and Nina Kandinsky's
Master House, Dessau, designed by
Walter Gropius. 1926
Wood, seat covered with textile.
37 3/8 x 19 11/16 x 21 5/8" (95 x 50 x 55 cm)
Centre Pompidou, Paris. Musée national
d'art moderne/Centre de création
industrielle. Kandinsky Bequest

241
Dining room of Vasily Kandinsky's Master
House, Dessau, designed by Walter Gropius.
Table and chairs by Breuer. Kandinsky's
On White II (cat. 242) on wall. 1926
Photograph Lucia Moholy. Gelatin
silver print. 6 11/16 x 9 1/16" (17 x 23 cm).
Centre Pompidou, Paris. Bibliothèque
Kandinsky

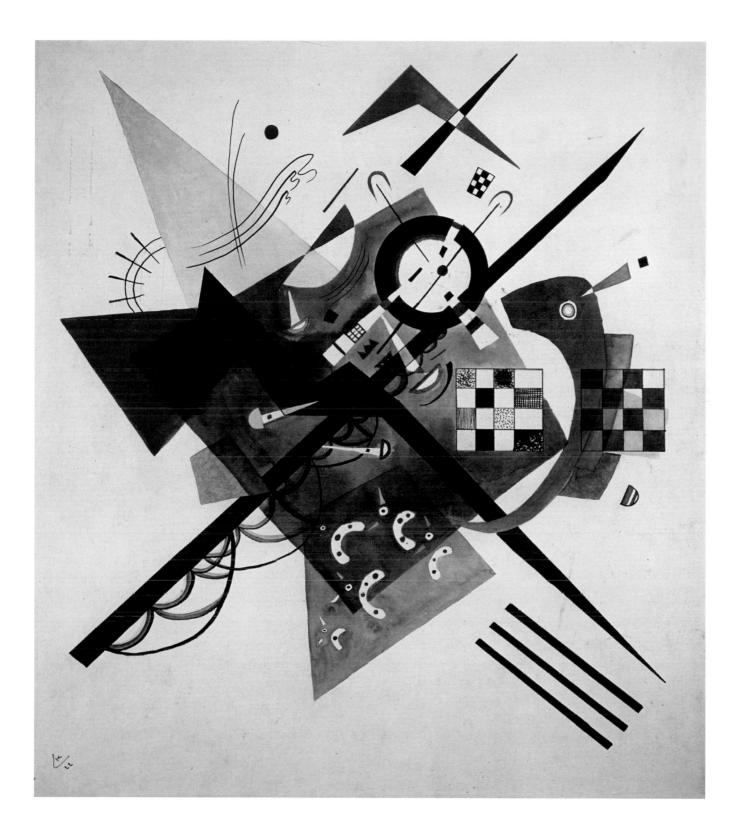

242
Vasily Kandinsky
Auf Weiss II (On white II). 1923
Oil on canvas
41 5/16 x 38 9/16" (105 x 98 cm)
Centre Pompidou, Paris. Musée national
d'art moderne/Centre de création
industrielle. Gift of Nina Kandinsky

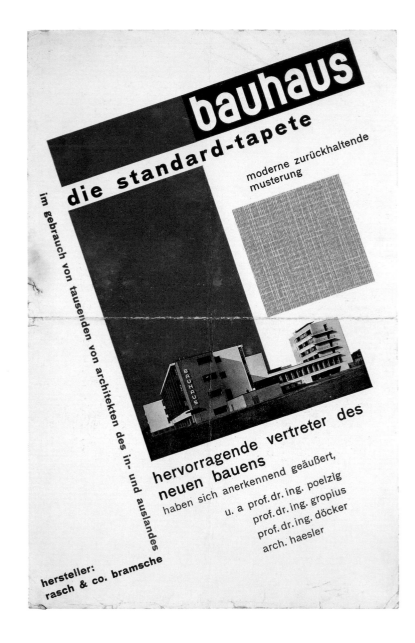

243
Herbert Bayer
Invitation to the inauguration of the Bauhaus
building, Dessau, designed by Walter Gropius,
on December 4–5, 1926. 1926
Letterpress on paper
5 13/16 x 13 3/4" (14.8 x 34.9 cm), folded three
times vertically to standard postcard size
Collection Merrill C. Berman

244
Herbert Bayer
Poster for Bauhaus "*standard-tapete*"
(Standard wallpaper) manufactured
by Gebr. Rasch & Co., Bramsche. c.1927
Lithograph and adhered wallpaper sample
on paper
19 ¾ x 12 ¾" (50.2 x 32.4 cm)
Collection Merrill C. Berman

245
Herbert Bayer
Letterhead for the director of the Bauhaus.
1927
Letterpress on paper
11 ¹¹/₁₆ x 8 ¼" (29.7 x 20.9 cm)
The Museum of Modern Art, New York. Jan
Tschichold Collection, Gift of Philip Johnson

246
László Moholy-Nagy
Studio wing of the Bauhaus building, Dessau,
designed by Walter Gropius. 1927
Negative gelatin silver print
9 ¹¹/₁₆ x 7 ¹/₁₆" (24.6 x 17.9 cm)
Galerie Berinson, Berlin

247
Herbert Bayer
Cover of *Bauhaus Dessau Hochschule
für Gestaltung. Prospekt* (Bauhaus Dessau
college of design. Prospectus). Dessau:
Bauhaus, c.1927
Letterpress and offset on paper
8 ³/₁₆ x 5 ¾" (20.8 x 14.6 cm)
Collection Merrill C. Berman

248 (top)
Iwao Yamawaki
Untitled (Bauhaus building, Dessau). 1931
Gelatin silver print
8 11/16 x 6 1/2" (22 x 16.5 cm)
The Museum of Modern Art, New York.
Thomas Walther Collection. Purchase

249 (left)
T. Lux Feininger
Untitled (from the roof of the Bauhaus
building, Dessau). c.1929
Gelatin silver print
14 3/8 x 11 7/16" (36.6 x 29.1 cm)
The Museum of Modern Art, New York.
Gift of Philip Johnson

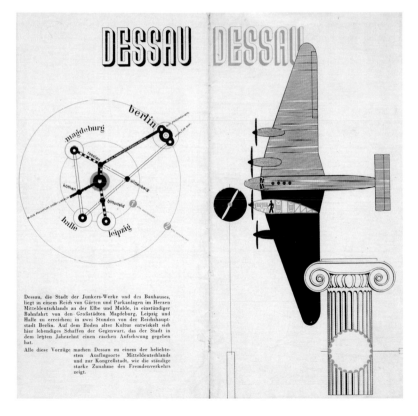

250 (opposite, right)
T. Lux Feininger
Balkons im Sommer (Balconies in summer; Bauhaus building, Dessau). c.1928
Gelatin silver print
9¼ x 7" (23.5 x 17.8 cm)
The Museum of Modern Art, New York. Gift of Philip Johnson

251
Herbert Bayer
Front cover of a brochure for the city of Dessau. 1926
Letterpress on paper
8¼ x 4⅛" (21 x 10.5 cm)
The Museum of Modern Art, New York. Jan Tschichold Collection, Gift of Philip Johnson

252
Joost Schmidt
Back cover of a publicity booklet for the city of Dessau. 1931
Letterpress on paper
9¹/₁₆ x 9¼" (23 x 23.5 cm)
The Museum of Modern Art, New York. Jan Tschichold Collection, Gift of Philip Johnson

253
Joost Schmidt
Outer faces of a foldout brochure for the city of Dessau. 1931
Letterpress on paper
Folded: 9⁷/₁₆ x 4¹¹/₁₆" (24 x 11.9 cm);
unfolded: 18⅞ x 23⁹/₁₆" (48 x 59.8 cm)
Collection Merrill C. Berman

An impulse to record, categorize, and historicize avant-garde artistic production in the 1920s emerged alongside that production itself, and often among its own practitioners. The series of fourteen *Bauhausbücher* (Bauhaus books), published between 1925 and 1930, was not the first effort to take stock of the day's major movements — Lajos Kassák's and László Moholy-Nagy's *Buch neuer Künstler* (Book of new artists, 1922), for example, had already appeared, and Hans Arp's and El Lissitzky's *Die Kunstismen* (Isms of art, 1925) was roughly contemporary — but it was among the first to treat this project in a series of dedicated volumes: a kind of serialized encyclopedia of contemporary artistic production within which the Bauhaus itself played a major role.[1]

Published in both paper- and clothbound versions, the first eight *Bauhausbücher* appeared simultaneously in 1925, followed by two in 1926 and then one a year until 1930.[2] The books share a uniform format, measuring 9 by 7 inches (23 by 18 cm). For every book but one, the cover of the paperback and the jacket of the clothbound version are identical and are printed in black plus one color; the exception is the sixth book, Theo van Doesburg's *Grundbegriffe der neuen gestaltenden Kunst* (Principles of the new art), whose cover and jacket are printed in the three primary colors. Mostly the work of Moholy, the cover designs vary from volume to volume,[3] but each includes the series title — "*Bauhausbücher*" — and the book's number on the front and spine. Beneath their jackets the covers of the clothbound books follow a consistent format designed by Moholy: each is bound in yellow linen and impressed in red ink with the series name and volume number (see nos. 10 and 14 in cat. 254), while the title appears on the spine. The format and external design of the books convey a calculated balance between uniformity, to identify a series, and diversity, reflecting the topics, objects, and theoretical positions represented within each book.

The aims of the series were announced by its coeditors — Walter Gropius and Moholy — in a prospectus of 1924 (cat. 255).[4] According to this statement, the books were to expand the school's pedagogical range, in part by bringing the teachings of its staff to a broader public, in part by effectively expanding that staff through publication of the works of like-minded thinkers. The editors used the vocabulary and model of scientific study, announcing that the books would include "research" (*Forschungen*) and "findings" (*Arbeitsergebnisse*) developed both at the Bauhaus and among other "informed experts" (*bestorientierte Fachleute*). Though varied in approach and result, these probings were nonetheless to be mutually informative — aspects of a single, universal effort to systematically analyze, represent,

and serve the modern world. The prospectus listed thirty-one projected titles, balanced between Bauhaus research and pedagogy, Bauhaus findings and products, and non-Bauhaus contributions.[5] In keeping with this proposal, the fourteen books that actually appeared over the next six years included four texts presenting the theoretical and pedagogical approaches of Bauhaus masters (nos. 2, 8, 9, and 14), four books devoted to the products of the Bauhaus (nos. 3, 4, 7, and 12), and six books by authors or on objects beyond the school (nos. 1, 5, 6, 10, 11, and 13).

It might be argued that the objectives of the books were in effect conveyed by their physical presentation. The internal typography and layout of all but one of them were by Moholy,[6] and exemplified the kind of rationalized research and applied results that were the subject of each volume. Distinguished by a predominant use of sans serif typeface, heavy rules, and bold numerals, the clean, spacious, dynamic appearance of the internal pages stood in contrast to traditional book design (cats. 11, 12). For Moholy, the modern, mechanically printed book was not simply a vehicle of content but a significant form whose identity was to be registered in its design. "Our modern printing products," he wrote, "will, to a large extent, be commensurate with the latest machines; that is, they will have to be based on clarity, conciseness, and precision."[7]

Reduced to its fundamental elements, a mechanically manufactured book comprises typographical figures — letters (retaining no vestiges of penmanship), numbers, and graphic signs (circles, squares, and arrows, for example); rules and margins (positive and negative marks and spaces); and photomechanically reproduced imagery. Moholy embraced these basic elements as his vocabulary, manipulating, inflecting, and drawing attention to them through material- and process-based means. He created emphasis, for example, through the use of bold type, or increased leading between figures; and he divided text blocks or other content sections with rules of varied length, thickness, and orientation, rendering positive the elsewhere often invisible divisions between clusters of figures in the printer's chase. Nowhere is Moholy's self-reflective foregrounding of the materials

254
Bauhausbücher (Bauhaus books). Munich: Albert Langen Verlag, 1925–30
14 bound books, offset and lithography
Each: 9 1/16 x 6 11/16" (23 x 17 cm)
Private collection. Courtesy Neue Galerie New York

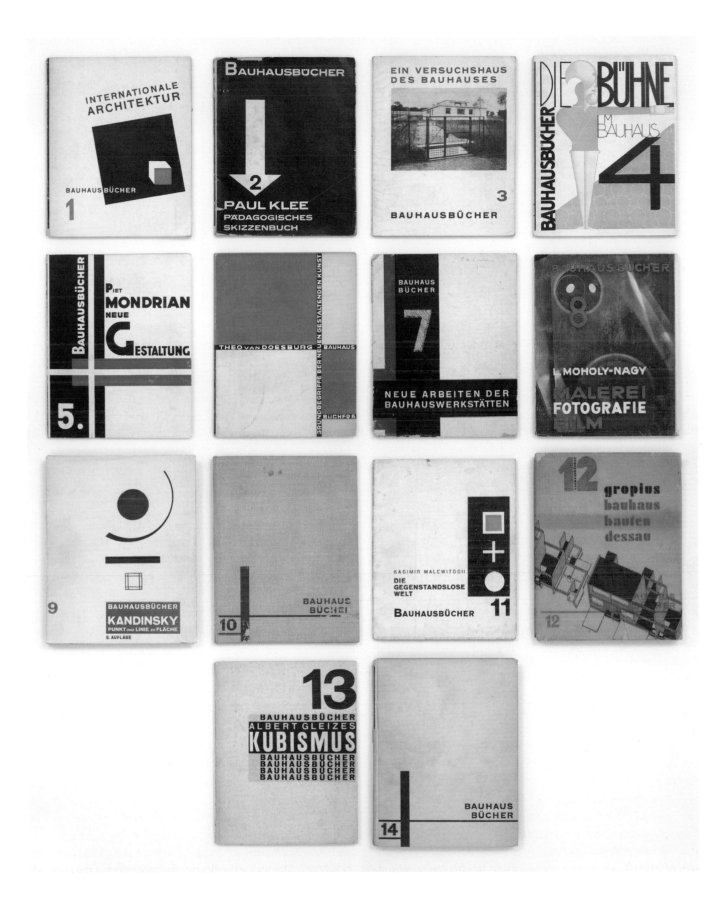

Left to right, top to bottom: *Bauhausbücher* 1: Walter Gropius. *Internationale Architektur* (International architecture). 1925. Jacket: Farkas Molnár. 2: Paul Klee. *Pädagogisches Skizzenbuch* (Pedagogical sketchbook). 1925. Jacket: László Moholy-Nagy. 3: Adolf Meyer. *Ein Versuchshaus des Bauhauses in Weimar: Haus am Horn* (An experimental house by the Bauhaus in Weimar: Haus am Horn). 1925. Jacket: Meyer. 4: Oskar Schlemmer. *Die Bühne im Bauhaus* (The theater of the Bauhaus). 1925. Jacket: Schlemmer. 5: Piet Mondrian. *Neue Gestaltung: Neoplastizismus Nieuwe Beelding* (New design: Neoplasticism new movement). 1925. Jacket: Moholy-Nagy. 6: Theo van Doesburg. *Grundbegriffe der neuen gestaltenden Kunst* (Principles of the new art). 1925. Jacket: Van Doesburg. 7: Gropius (introduction). *Neue Arbeiten der Bauhauswerkstätten* (New work of the Bauhaus workshops). 1925. Jacket: Moholy-Nagy. 8: Moholy-Nagy. *Malerei Fotografie Film* (Painting, photography, film). 1925; shown: second ed., 1927. Jacket: Moholy-Nagy. 9: Vasily Kandinsky. *Punkt und Linie zu Fläche* (Point and line to plane). 1926; shown: second ed., 1928. Jacket: Herbert Bayer. 10: J. J. P. Oud. *Holländische Architektur* (Dutch architecture). 1926. Jacket (not shown): Moholy-Nagy. 11: Kazimir Malevich. *Die gegenstandlose Welt* (The nonobjective world). 1927. Jacket: Moholy-Nagy. 12: Gropius. *Bauhausbauten Dessau* (Bauhaus building Dessau). 1930. Jacket: Moholy-Nagy. 13: Albert Gleizes. *Kubismus* (Cubism). 1928. Jacket: Moholy-Nagy. 14: Moholy-Nagy. *Von Material zu Architektur* (From material to architecture). 1929. Jacket (not shown): Moholy-Nagy

IM **BAUHAUSVERLAG** ERSCHEINEN DEMNÄCHST DIE

BAUHAUSBÜCHER

Von der Erkenntnis ausgehend, daß alle Gestaltungsgebiete des Lebens miteinander eng verknüpft sind, gibt der Bauhaus-Verlag eine Serie von Büchern heraus, welche sich mit den Problemen heutigen Lebens beschäftigen ● Wenn man sich über den Stand neuer Forschungen, neuer Ereignisse eingehend unterrichten will, empfindet man heute oft die Mangelhaftigkeit wortkarger oder oberflächlicher Zeitungsberichte oder illustrierter Zeitungen. So werden die Bauhausbücher künstlerische, wissenschaftliche und technische Fragen behandeln, unter dem Aspekt ihres gegenseitigen Zusammenhanges. Der Bauhaus-Verlag versucht mit dieser Serie den in ihrer Spezialarbeit verankerten heutigen Gestaltern über die Problemstellung, die Arbeitsführung und die Arbeitsergebnisse der benachbarten und verwandten Gebiete Aufschluß zu geben, und ihnen dadurch einen Vergleichsmaßstab für ihre eigenen Kenntnisse und den Fortschritt in anderen Arbeitszweigen zu schaffen. Um eine Aufgabe von diesem Ausmaß bewältigen zu können, hat der Bauhaus-Verlag bestorientierte Fachleute verschiedener Länder, die ihre Spezialarbeit bewußt der Gesamtheit heutiger Lebenserscheinungen einzugliedern bestrebt sind, zur Mitarbeit aufgefordert. Damit erreicht er den doppelten Zweck: den Bauhaus-Kreis mit wertvollen, geistig verwandten Menschen zu erweitern und dadurch der Verwirklichung seiner Ziele, der Synthese aller schöpferischen Arbeiten näherzukommen ● Das Programm der ersten Bände (Schriftleitung: GROPIUS und MOHOLY-NAGY) ist folgendes:

1-2 INTERNATIONALE ARCHITEKTUR von WALTER GROPIUS
3 PÄDAGOGISCHES SKIZZENBUCH von PAUL KLEE
4 DIE BÜHNE IM BAUHAUS
5 NEUE GESTALTUNG von PIET MONDRIAN (Holland)
6 EIN VERSUCHSHAUS DES BAUHAUSES
7 GRUNDBEGRIFFE DER NEUEN GESTALTENDEN KUNST von THEO VAN DOESBURG (Holland)
8 AMERIKA? — EUROPA? von GEORG MUCHE
9 KLEINWOHNUNGEN von DER ARCHITEKTURABTEILUNG DES BAUHAUSES
10 MERZ-BUCH von KURT SCHWITTERS
11 BILDERMAGAZIN DER ZEIT I von OSKAR SCHLEMMER
12 SCHÖPFERISCHE MUSIKERZIEHUNG von H. JAKOBY (Hellerau)
13 FILM UND PHOTOGRAPHIE von L. MOHOLY-NAGY
14 DIE ARBEIT DER STIJL-GRUPPE von THEO VAN DOESBURG
15 KONSTRUKTIVE BIOLOGIE von MARTIN SCHÄFER
16 DIE HOLLÄNDISCHE ARCHITEKTUR von J. J. P. OUD (Holland)
17 FUTURISMUS von F. T. MARINETTI und E. PRAMPOLINI (Italien)
18 DIE ARBEIT DER MA-GRUPPE von L. KASSÁK und E. KÁLLAI (Ungarn)
19 PLASTIK DER GESTALTUNG von A. BEHNE und M. BURCHARTZ

20 PUNKT, LINIE, FLÄCHE von WASSILY KANDINSKY
21 RUSSLAND von ADOLF BEHNE
22 REKLAME UND TYPOGRAPHIE von EL LISSITZKY (Rußland)
23 NEUE ARCHITEKTURDARSTELLUNG von WALTER GROPIUS
24 BILDNERISCHE MECHANIK von PAUL KLEE
25 WERKARBEIT DER GESTALTUNGEN von L. MOHOLY-NAGY
26 ARCHITEKTUR, MALEREI, PLASTIK von den WERKSTÄTTEN DES BAUHAUSES
27 DIE NEUEN MATERIALIEN von ADOLF MEYER
28 ARCHITEKTUR von LE CORBUSIER-SAUGNIER (Frankreich)
29 BILDERMAGAZIN DER ZEIT II von JOOST SCHMIDT
30 NEUE ARBEITEN DER BAUHAUSWERKSTÄTTEN
31 VIOLETT (BÜHNENSTÜCK MIT EINLEITUNG UND SZENERIE) von WASSILY KANDINSKY

Jeder Band enthält ca. **16** Seiten Text und **32** bis **48** ganzseitige Abbildungen oder **48** bis **60** Seiten Text ● Format **18×23** cm ● Preis der einzelnen Bände in festem Pappband Mk. **4.**—, Doppelband Mk. **7.**—

IM **BAUHAUSVERLAG** IST ERSCHIENEN:

„STAATLICHES BAUHAUS WEIMAR"

Das Buch des Staatlichen Bauhauses zu Weimar ist in erster Linie Dokument dieser Anstalt; es reicht aber, dem Charakter der Anstalt entsprechend, weit über eine örtliche oder spezifische Angelegenheit hinaus ins allgemeine, gegenwärtige und zukünftige Gebiet künstlerischen Schaffens und künstlerischer Erziehung ● So wie das Staatliche Bauhaus das erste wirkliche Zusammenfassen der im letzten Jahrzehnt gewonnenen Einsichten in künstlerischen Entwicklungsfragen bedeutet, so nimmt das Buch spiegelnd Teil an diesen Fragen, und bedeutet jedem, der sich über den Stand dieser Dinge unterrichten will, hierzu ein willkommenes Mittel. Darüber hinaus bleibt es ein geschichtliches Dokument. Denn das Bauhaus ist, obwohl zunächst einzigartig, keine insulare Erscheinung, sondern ein kräftiger Trieb, der sich voll entfaltet und auch völlig sich ausbreiten wird. Das bedeutet für das Buch ein Stück künstlerischer

Bestellungen und Vorbestellungen unter Benützung dieser Karte erbeten

BAUHAUSVERLAG G.M.B.H.
MÜNCHEN
WORMSERSTR. 1

and techniques of mechanical printing given more explicit visual form than on the cover of his eight-page brochure advertising the series, from 1928,[8] in which the word "*BAUHAUSBÜCHER*" is spelled out in metal letterpress type and its reflection is simulated photomechanically (cat. 256).

The impact of the *Bauhausbücher* was far-reaching. While the arguments put forth in some volumes — such as Moholy-Nagy's *Malerei, Photographie, Film* (no. 8) and *Von Material zu Architektur* (no. 14) — would prove deeply influential, and the architecture and objects illustrated in others would become iconic through frequent reproduction, the impact of the series as a whole may ultimately have had as much to do with its form as with its content. Published by the Albert Langen Verlag in Munich, an established firm with professional distribution channels,[9] the *Bauhausbücher* were commercially printed in editions of some 2,000 to 3,000.[10] Thin books on machine-made paper with few color reproductions, these were decidedly nonprecious, mass-produced volumes. Like magazines or newspapers, the actual books-as-objects (particularly the lower-priced soft-cover editions)[11] were ultimately exchangeable, even almost disposable — the idea that it would always be possible to obtain another copy seems built into the form, and if the print run was exhausted (as it was by 1928 for nine of the fourteen volumes), the books could be reprinted (as were five of those nine).[12] As machine-made products whose graphic design thematized their mode of manufacture, the books embodied and promoted an economy without originals — an economy that favored infinite reproducibility over unique production. They were in themselves object lessons: there were no *original* Bauhaus books, just as there was no original Jucker/Wagenfeld glass lamp or Hartwig chess set — the books exemplified the Bauhaus *in production*.[13]

Reaching a widespread international readership, the *Bauhausbücher* effectively promoted the school and its production-oriented position of the mid-1920s. They illustrated selected products of the pre-Moholy period, but clearly positioned these objects as prototypes within an economy of mass production.[14] The craft-oriented experimentation of the earlier Weimar period was largely eclipsed. Similarly, the last two Bauhaus books to appear — no. 12, Gropius's *Bauhausbauten Dessau* (Bauhaus building Dessau, 1930), and no. 14 Moholy's *Von Material zu Architektur* (From material to architecture, 1929), both published after the coeditors' joint departure in 1928 — failed to represent the development of the school under its next director, Hannes Meyer. The school's identity as conveyed in these influential books is that of Gropius's Bauhaus after the arrival of Moholy, i.e. from 1923 to 1928; it is the image of the Bauhaus that has remained most prominent in the popular imagination.

1. Thin, moderately priced, popularizing books on art and architecture had precedents in established German series such as *Die Blauen Bücher* (Königstein im Taunus and Leipzig: Karl Robert Langewiesche Verlag, from 1902) and *Velhagen & Klasings Volksbücher* (Bielefeld and Leipzig: Verlag von Velhagen & Klasing, from 1920). A contemporary series appearing in a similar format, but focusing exclusively on architecture, was *Neue Werkkunst* (Berlin, Leipzig, and Vienna: Friedrich Ernst Hübsch Verlag, 1925–32).

2. An editorial note appearing in nos. 3, 4, 7, and 8 informs the reader that "This book was prepared in Summer 1924. Technical difficulties postponed its appearance. The committee of the former State Bauhaus terminated its activities in Weimar and continues under the name 'The Bauhaus in Dessau (Anhalt).'" Second editions of nos. 1, 2, and 8 appeared in 1927; a second edition of no. 9 appeared in 1928; and a second edition of no. 10 appeared in 1929.

3. László Moholy-Nagy designed all of the covers except nos. 1 (Farkas Molnár), 3 (probably Adolf Meyer), 4 (probably Oskar Schlemmer), 5 (Theo van Doesburg), and 9 (Herbert Bayer).

4. Plans for a series of Bauhaus publications apparently began as early as 1923. See Moholy, letter to Aleksandr Rodchenko, December 18, 1923, referring to a "series of brochures" and listing thirty potential topics. Trans. in Krisztina Passuth, *Moholy-Nagy* (Thames & Hudson, 1985), pp. 393–94. Like the major Bauhaus exhibition of 1923, this publication

effort was partly driven by pressure from the Thuringian goverment to demonstrate the school's performance record. See Walter Gropius, letter to Director Schlitte of the Ohlenroth'schen Buchdruckerei, December 3, 1924, quoted in the well-illustrated and informative discussion of these books in Ute Brüning, ed., *Das A und das O des Bauhauses*, exh. cat. (Berlin and Leipzig: Bauhaus-Archiv and Edition Leipzig, 1995), p. 115, n. 2. See also Alain Findeli, "László Moholy-Nagy und das Projekt der Bauhausbücher" in the same volume, pp. 22–26.

5. The 1924 prospectus included all but four of the books that eventually appeared, plus twenty-one titles that did not. Between another prospectus printed in late 1925 (see Hans Maria Wingler, *The Bauhaus: Weimar, Dessau, Berlin, Chicago* [Cambridge, Mass.: The MIT Press, 1969], pp. 130–31), an advertisement in the journal *Offset. Buch und Werbekunst*, no. 7, in 1926 (between pp. 410 and 411), and the lists of forthcoming titles appearing in the books of 1925 and 1926, sixteen additional titles were announced. Together, the thirty-seven unrealized books reflect a similar balance between work at the Bauhaus, including contributions by Josef Albers, Georg Muche, and Joost Schmidt, and books by an international array of outside authors, including George Antheil, Le Corbusier, Raoul Hausmann, Jane Heap, El Lissitzky, Ludwig Mies van der Rohe, Kurt Schwitters, and Mart Stam.

6. Herbert Bayer was responsible for the internal layout of no. 9.

7. Moholy, "Zeitgemässe Typografie. Ziele, Praxis, Kritik," in *Offset*, pp. 375–85. Trans. Wolfgang Jabs and Basil Gilbert as "Modern Typography. Aims, Practice, Criticism" in Wingler, *The Bauhaus*, pp. 80–81.

8. Two versions of this brochure appeared: one in 1928, with the number "14" on the cover and other features inside printed in red; and another in 1929, with minor layout changes and the formerly red areas printed in blue.

9. Founded in 1894, the Albert Langen Verlag published the periodicals *Simplicissimus* (beginning in 1896) and *März: Halbmonatschrift für deutsche Kultur* (beginning in 1907) as well as books by authors including Karl Kraus, Heinrich Mann, and Frank Wedekind.

The *Bauhausbücher* series was initially to have been published by the Bauhausverlag, an independent company based in Weimar and Munich, established to raise funds for the school and to help it reach a broader public. In 1923 and 1924, the Bauhausverlag published print portfolios, the book *Staatliches Bauhaus Weimar 1919–1923*, and various other materials, but in late 1924/early 1925 it declared bankruptcy, necessitating an urgent search for a new publisher.

10. The first eight books were produced concurrently by two different printers: Dietsch & Brückner, Weimar, and Ohlenroth'sche, Erfurt. The later volumes and reprints were printed by Hesse & Becker, Leipzig. The print runs are not included in the first editions, but can be ascertained in some cases from numbers provided in the second editions.

11. The prices of the clothbound books ranged from seven to eighteen marks; the paper-bound editions were always two marks cheaper.

12. See the inside back cover of the eight-page brochure of 1928, whose cover is reproduced as cat. 256.

13. By contrast, the Bauhaus publications that preceded the *Bauhausbücher*, such as the *Neue Europäische Graphik* (1921–24; cat. 48) and *Kleine Welten* (1922; cats. 131–42) portfolios, were produced by the Bauhaus's own printing workshop in limited editions of no more than a few hundred. A shift toward modern commercial printing techniques was already evident in the first book Moholy designed (with cover design by Bayer) for the Bauhaus, *Staatliches Bauhaus Weimar 1919–1923* (Weimar and Munich: Bauhausverlag, 1923; cat. 196), which appeared in an edition of 2,000 (an additionally planned 300 English-language and 300 Russian-language copies announced did not appear) and was executed by the same commercial printer, Dietsch & Brückner, that realized some of the early *Bauhausbücher*.

14. Marcel Breuer's Armchair (later titled TI 1a) of 1922 (cat. 97), for example, was reproduced in *Neue Arbeiten der Bauhauswerkstätten* (New work of the Bauhaus workshops), *Bauhausbücher* no. 7, 1925, p. 29. Gropius's introduction to this book described the Bauhaus workshops as "laboratories" (*Laboratorien*) producing "experimental works for industrial production" (*Versuchsarbeit für die industrielle Produktion*).

255
László Moholy-Nagy
Interior spread of *Bauhausbücher* prospectus.
1924
Letterpress
9 1/8 x 14 3/16" (23.2 x 36 cm) open
Collection Merrill C. Berman

256
László Moholy-Nagy
Cover of *Bauhausbücher* (Bauhaus books)
sales catalogue. 1928
Letterpress on paper
5 15/16 x 8 5/16" (15.1 x 21.1 cm)
The Museum of Modern Art, New York. Jan
Tschichold Collection, Gift of Philip Johnson

Nearly every piece of commercial printing — from a film poster to a candy wrapper — employs written language. Typically, individual styles of lettering melt into the background, embracing transparency and convention over rhetoric and polemic. Not so Herbert Bayer's designs for a universal alphabet, which confronted the contradiction between modern printing processes and their reliance on old traditions and hand-drawn gestures.

Bayer was an Austrian artist and designer who came to Weimar to become a Bauhaus student in 1921, after designing packages in an architect's office in Darmstadt. Like Josef Albers and five other students, he took a teaching position in the school when it moved to Dessau, in 1925. In Weimar, the Bauhaus printing workshop had produced editions of artists' prints for sale (Vasily Kandinsky's *Kleine Welten* [Small worlds, 1922] for example; cats. 131–42), a widespread practice among art schools. In 1923, when László Moholy-Nagy arrived at the Bauhaus and began to implement a publishing program to promote the school's broader interests, the workshop began to take on some of the functions that would have been associated with commercial print shops. Indeed, under Bayer's direction in Dessau from 1925 to 1928, it became a full-fledged design studio creating exhibition posters, letterheads, product catalogues, and other publicity materials for the Bauhaus and outside clients. Many pieces were printed on site.[1]

Bayer's designs for a universal alphabet rebelled against centuries of typographic tradition and German custom. The letterforms in a classical typeface have subtly varied strokes, curves, and angles that take their cues from Renaissance calligraphy or eighteenth-century penmanship. The norm in German printing was Fraktur, a range of types based on medieval script that yielded dense, heavy pages of text. In the 1920s, progressive German designers sought to supplant Fraktur with the roman forms that were standard throughout Europe and the United States.[2] Also coming into favor were bold sans serif typefaces known as "grotesques," built from strokes that vary only minimally in thickness and make scant reference to the calligraphic hand. In Dessau, a basic set of sans serif types was the lifeblood of the Bauhaus printing workshop's modest letterpress facilities.[3]

Taking such anonymous industrial type styles as a starting point, Bayer went farther by building his simple characters from a small vocabulary of curves and right angles, using a triangle and compass in place of the French curves employed by traditional type designers. By working with a small number of interchangeable elements, he sought to automate the design process, taking as his model the production of industrial goods. Banishing diagonals wherever possible, he constructed characters such as "k" and "x" with circular segments in place of the expected angles.

Bayer experimented with numerous variations of his universal alphabet. The proportions of the narrower alphabet (1925; cat. 257) are more in line with conventional typefaces, while the wider forms in the second design (cat. 258), which was published in a Bauhaus leaflet in 1927, seek a more regularized geometry based on the circle.[4] The characters in a traditional typeface vary greatly in width — the letter "i," for example, tends to be narrow while the "m" and "w" are wide. Bayer minimized such differences in order to create a more uniform alphabet. Although he permitted the "i," "j," and "l" to occupy narrow slices of space, he forced the "m" and "w" to meet a standard dimension, resulting in dense, compressed forms that interrupt the even tonality of the character set.

The most radical aspect of Bayer's alphabets, however, lay not in their geometric system but in their obliteration of capital letters. Bayer argued that the uppercase/lowercase distinction had no phonetic purpose and thus violated the functional premise of the Latin alphabet: to translate sound into graphic marks. Speech reveals no difference between uppercase and lowercase, so why should written text do so? Furthermore, German orthography capitalizes all nouns — not just proper ones — causing an even greater proliferation of this useless anomaly on the printed page. Bayer argued that a single-case writing system would streamline everything from a child's mastery of penmanship to the manufacture of typewriters and typefaces.[5] Across his career, he repeatedly argued for single-case text, not only in applications of his universal alphabet but in many texts printed with letterpress types. Several letterheads he designed for the Bauhaus actually deliver arguments for single-case text along their bottom edges, such as "we write everything small in order to save time" (cat. 245).

257
Herbert Bayer
Design for "universal" lettering. 1925
Ink on paper
11 3/4 x 23 5/8" (29.8 x 60 cm)
Harvard Art Museum, Busch-Reisinger
Museum. Gift of the artist

258
Herbert Bayer
Design for "universal" lettering. 1927
Ink and gouache on paper
14 3/4 x 23 3/4" (37.5 x 60.4 cm)
Harvard Art Museum, Busch-Reisinger
Museum. Gift of the artist

Bayer was not alone in his preoccupation with geometric lettering and orthographic reform. In 1917 and 1919, Vilmos Huszár and Theo van Doesburg imposed the de Stijl philosophy on the alphabet by constructing letters entirely from perpendicular elements. At the Bauhaus in 1926, Albers built letters out of repeated geometric components, automating the design process while also providing a glass stencil for accurately reconstructing the letters (cat. 259). Albers's stencil system — constituting not just a set of forms but a tool for reproducing them — is a more rigorous demonstration of modular lettering than Bayer's universal alphabet. Various designers, including Bayer and Jan Tschichold, a chief promoter of the "New Typography," created single-case alphabets inspired by the writings of Walter Porstmann, whose 1920 book *Sprache und Schrift* was part of the movement to introduce standards into all areas of industry.[6]

Bayer's universal alphabet was never manufactured as a metal font for letterpress printing.[7] In order to use the letters in a book or poster, a designer would have to draw them anew or paste photographs of them by hand into a montage for photomechanical reproduction. Hand-rendered letters similar in spirit to Bayer's universal alphabet appear in many Bauhaus posters and publications (cats. 384–86). Among the most spec-

tacular examples are works by Joost Schmidt, who took over the printing workshop from Bayer in 1928. His design for a 1931 catalogue titled *Der Bauhaus Tapete gehört die Zukunft* (The future belongs to Bauhaus wallpaper; cats. 413, 414) features expertly rendered, beautifully proportioned lowercase letters whose curved line emulates the warped space of the accompanying photograph. This merging of text and photography embodied Moholy-Nagy's theory of "typophoto," which proclaimed that the integration of words and images via halftone reproduction would yield a new "hygiene of the optical."[8]

While any graphic designer of the period would have required skills in hand lettering, only a few embarked on the more challenging task of creating a complete, industrially produced typeface.[9] One who did so was Paul Renner, who began work on Futura in Munich in 1924. Although early versions of his alphabet included experimental characters with extreme geometric forms, the final typeface — released in 1927, after three years of ongoing development — is more conservative. The

259
Josef Albers
Kombinations-Schrift (Combinatory letters)
Glass lettering elements. Designed 1926.
Made for Albers by Mettalglas A.G.,
Offenburg/Baden, c. 1928
Milk glass, mounted later on painted wood
24 1/8 x 23 1/8" (61.3 x 60.6 cm)
The Museum of Modern Art, New York.
Gift of the designer

260
Josef Albers
Working design for *Kombinations-Schrift*
(Combinatory letters) lettering. 1926
Pencil, red pencil, and ink on ruled
graph paper
8 3/8 x 11 3/4" (21.3 x 29.8 cm)
The Josef and Anni Albers Foundation,
Bethany, Conn.

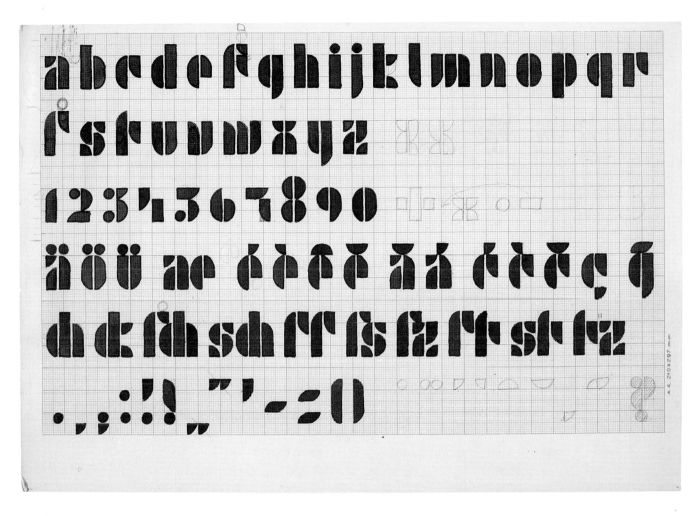

circular "O" of Futura links it to the cruder, more programmatic experiments of the Bauhaus.[10]

Bayer's universal alphabet became a symbol of "Bauhaus typography," even though it was not strictly speaking a typeface. Fixed in memory through a few endlessly repeated reproductions, the universal alphabet was a philosophical idea that reverberated throughout the promotional activities of the Bauhaus and beyond.[11] In 1975, the American commercial designer Ed Benguiat created an exuberant, voluptuous typeface called Bauhaus — in upper as well as lowercase — that popularized the notion of a Bauhaus style while ignoring Bayer's stern intentions.[12] In the mid-1990s, the digital type foundry P22, based in Buffalo, New York, released accurate versions of the universal alphabet and other Bauhaus lettering designs as fully operable digital fonts. Bayer's letters are awkward, inconsistent, and not very useful, yet they gave form to prevalent avant-garde thinking about function, modularity, industrial standards, and machine production. Bayer released his idea into the wilderness of typographic discourse, and there it lived.

1. On Herbert Bayer's career see Gwen Chanzit, *Herbert Bayer: Collection and Archive at the Denver Art Museum* (Denver: Denver Museum of Art, 1988), and Chanzit, *From Bauhaus to Aspen: Herbert Bayer and Modernist Design in America* (Boulder: Johnson Books, 1987). See also Frank Whitford, *Bauhaus* (London: Thames & Hudson, 1984), pp. 166–78. On the printing workshops see Magdalena Droste, *Bauhaus 1919–1933*, trans. Karen Williams (Berlin: Bauhaus-Archiv, and London: Taschen, 2002), pp. 98–100, 148–51, 180–84, 218–23.

2. See Peter Bain and Paul Shaw, eds., *Blackletter: Type and National Identity* (New York: Princeton Architectural Press, 1998).

3. See Droste, *Bauhaus 1919–1933*, p. 148.

4. In Bayer, Walter Gropius, and Ise Gropius, eds., *Bauhaus: 1919–1928* (Boston: Charles T. Branford Company, 1938, 1952, 1959), p. 149, Bayer featured two type designs that he dated to 1925 and 1928 ("improved"). He also reproduced an additional, undated study. Later, in Bayer, *Herbert Bayer: Visual Communication, Architecture, Painting* (New York: Reinhold, 1967), p. 26, he published the improved version only and dated it 1925. See also Ute Brüning, ed., *Das A und O des Bauhauses* (Berlin: Bauhaus Archiv and Edition Leipzig, 1995), pp. 186–87.

5. Bayer, "Towards a Universal Type," 1935, *PM* 6, no. 2 (December/January 1939–40). Reprinted in Michael Bierut, Jessica Helfand, Steven Heller, and Rick Poynor, eds., *Looking Closer Three* (New York: Allworth Press, 1999), pp. 60–62, where it is incorrectly cited as *PM* 4.

6. On typographic and orthographic reform, see Christopher Burke, *Paul Renner: The Art of Typography* (New York: Princeton Architectural Press, 1998), pp. 115–19, and Herbert Spencer, *The Visible Word* (London: Lund Humphries, 1969).

7. See Richard Southall, "A Survey of Type Design Techniques before 1978," *Typography Papers* 2 (1997):31–59.

8. László Moholy-Nagy, *Malerei Photographie Film*, 1925, published in English as *Painting, Photography, Film*, trans. Janet Seligmann (Cambridge, Mass.: The MIT Press, 1969), p. 38.

9. See Southall, "A Survey of Type Design Techniques before 1978."

10. See Burke, *Paul Renner*, pp. 86–115.

11. The universal alphabet appears in nearly every survey of graphic design.

12. On the cultural legacy of Bayer's universal alphabet see Mike Mills, "Herbert Bayer's Universal Type and Its Historical Contexts," in Ellen Lupton and J. Abbott Miller, eds., *the abc's of ▲■●: the bauhaus and design theory* (New York: Princeton Architectural Press, 1991), pp. 38–45.

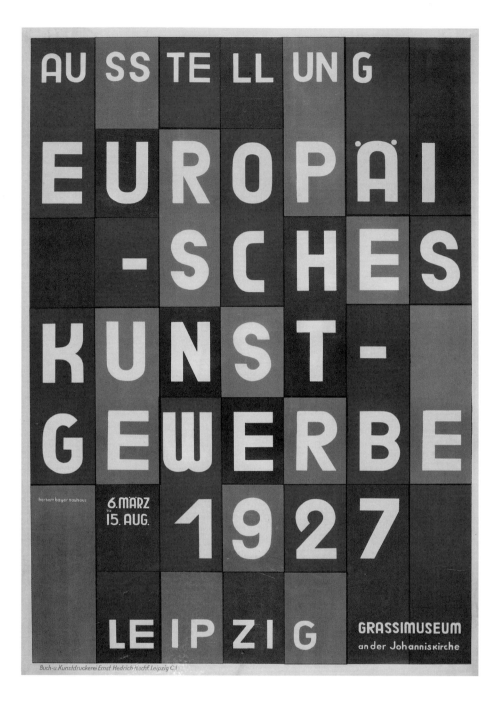

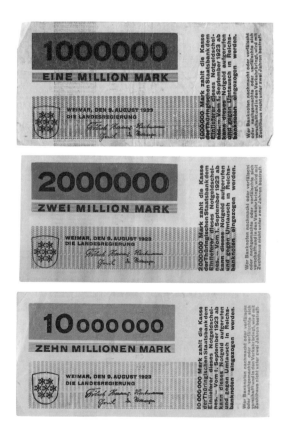

261
Herbert Bayer
Poster for *Ausstellung Europäisches
Kunstgewerbe* (Exhibition of European
decorative arts), Grassimuseum, Leipzig
(March 6–August 15, 1927). 1927
Lithograph on paper
34 1/2 x 22 15/16" (87.6 x 58.2 cm)
Collection Merrill C. Berman

262
Herbert Bayer
Banknotes issued by the state bank
of Thuringia. 1923
Letterpress on paper
Each: 2 11/16 x 5 1/2" (6.8 x 14 cm)
The Museum of Modern Art, New York.
Gift of Manfred Ludewig

263
Herbert Bayer
Poster for *Kandinsky Jubiläums-Ausstellung*
zum 60. Geburtstag (Exhibition celebrating
Kandinsky's sixtieth birthday). 1926
Letterpress and gravure on paper
19 x 25" (48.2 x 63.5 cm)
The Museum of Modern Art, New York.
Gift of Mr. and Mrs. Alfred H. Barr, Jr.

264
Herbert Bayer
Poster for *Architektur Lichtbilder Vortrag*
(Slide lecture on architecture) by the
architect Hans Poelzig. 1926
Lithograph on paper
18 7⁄8 x 25 1⁄2" (47.9 x 64.8 cm)
Collection Merrill C. Berman

265
Herbert Bayer
Richtfest Bauhaus Neubau Einladung
(Invitation to the topping-out ceremony
for the new Bauhaus building [Dessau]),
on March 21, 1926. 1926
Lithograph on paper
6 x 8 3⁄8" (15.2 x 21.3 cm)
Collection Merrill C. Berman

GUNTA STÖLZL
5 CHOIRS. 1928
T'AI SMITH

Measuring over seven feet long by 4½ feet in width, Gunta Stölzl's *5 Chöre* (5 choirs) of 1928 is impressive in scale and in the humming complexity of its polychromatic digital field. The wall hanging's pattern of interrelated shapes is precisely mirrored across its vertical center, such that each horizontal sequence of geometric figures is replicated in reverse on the other half. The central panel of this abstract field seems, moreover, to yield what textile historian Sigrid Wortmann Weltge has called a "visual pun": "It floats like a separate, superimposed hanging, held in place by four black bars."[1] This pattern and its self-contained picture are, indeed, strikingly self-reflexive about the work and its medium, at once mirroring the particular *process* of production on a Jacquard loom and also its status as an *object*. Here, the image of a wall hanging hovers like a ghost of itself within itself — or as an apparition of the Weimar Bauhaus's so-called Expressionist moment within the functionalist Dessau period.

The precision of the seemingly countless circles, triangles, and squares clearly indexes the Jacquard technique by which the piece was woven — a mechanical process that, like its distant nephew the computer program, potentially yields unlimited reproductions of a design. For with the Jacquard apparatus, an item called a punch card (which functions as a code for the design; fig. 1) precisely repeats each horizontal line of a drawing. As the cards are pressed against metal rods, the sequence of negative and positive spaces (holes and no-holes) instructs wire hooks and then cords to lift and release warp threads on the loom. Where the rod passes through a hole, the corresponding warp does not move; but if a rod presses against the card, it lifts the connected warp and allows the weft to pass through. In comparison with a manual weaving process — in which a foot presses a treadle and a hand slides weft between warp threads — the Jacquard mechanism and its punch card can reproduce textiles with swift precision. In *5 Chöre*, the punch cards were used economically such that the connected rods controlled not one warp thread but several, so that the right side is a perfect mirror of the pattern on the left.[2]

266
Gunta Stölzl
5 Chöre (5 choirs). 1928
Jacquard weave in cotton, wool, rayon,
and silk
7' 6³/₁₆" x 56 ⁵/₁₆" (229 x 143 cm)
Die Museen für Kunst und Kulturgeschichte
der Hansestadt Lübeck

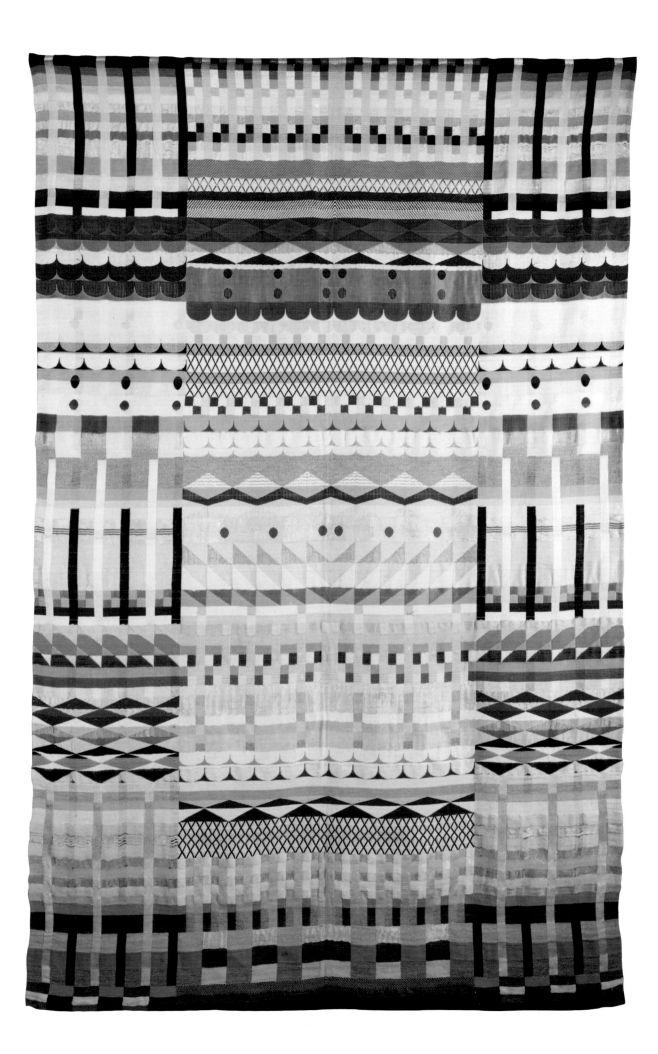

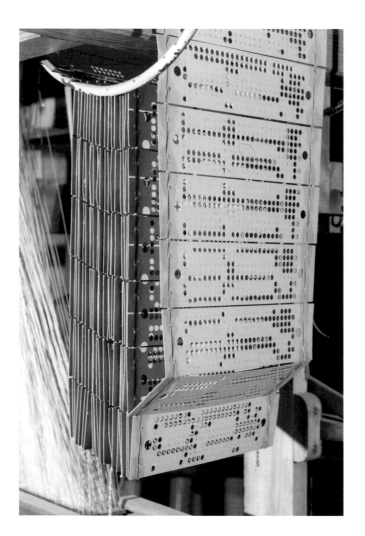

The history of the Jacquard loom in the Bauhaus weaving workshop is instructive for understanding *5 Chöre*'s specificity — that is, how it differs from but also alludes to wall hangings produced in the earlier, Weimar period. In 1925, at the time of the school's move to Dessau, the workshop's form master, Georg Muche, bought six Jacquard looms. Stölzl, then the workshop master, was chagrined, partly because she saw the purchase as a drastic waste of money but also because she felt that these machines were not in keeping with the goals of the weavers, whose energies had so far been expended on hand-looms. Although laborious to operate, the handloom, Stölzl believed, gave the students the opportunity to work out and understand more fully the means and construction of weaving. Beginning from ground zero, so the logic went, the weavers could investigate and experiment within the parameters of their medium. If they were to develop innovative, technologically sophisticated prototypes, they had to be well versed in the various effects produced by the meeting of woven structures and modern materials, like rayon or *Eisengarn*.[3]

Nevertheless, perhaps out of frustration over the perceived waste, perhaps out of curiosity, Stölzl committed herself to poring over the literature and learning the complex technical functions of the Jacquard mammoths that Muche had procured. Within a couple of years she began to make sketches for Jacquard textiles (cats. 267, 268), and with the help of the workshop's new technical assistant, Kurt Wanke, Master Stölzl had, after several attempts, come to understand the basic strengths and limitations of the apparatus and the best way to employ it.[4]

In *5 Chöre*, the work that exemplifies this achievement, her design employed a mirrored motif, thereby using the loom's cords and punch cards economically.

The Jacquard's capacity for mechanical reproduction excited Stölzl, who saw the potential "to influence the public at large in every sphere,"[5] but her Jacquard designs found no customers and no copies were produced. So what she ended up with was not a prototype but a unique piece — something like the early "pictures made of wool" that she herself had derided in an article written two years earlier. In that 1926 text for *Offset. Buch und Werbekunst* she had argued that the creation of tapestries was a thing of the past, for the Bauhaus in Dessau had since put its energy toward experimenting with materials and woven structures and making functional samples of everyday textiles — like curtains or upholstery — for mass production.[6]

Indeed the pictorial composition, but also the chromatic intensity, of *5 Chöre* may exemplify the contradictions and hanging ghosts of this particular Bauhaus moment, just before Hannes Meyer took over as director and shifted the focus to developing mass-produced goods for the working class. Here an emphasis on technical precision and economy of means converges with an interest in the relation of color and musicality. Whether or not Stölzl consciously crafted the apparition of a second "picture made of wool" within the spatial field of this Dessau-produced item, the Jacquard textile nevertheless evokes both Vasily Kandinsky's interest in using technology to develop art forms exploring synesthetic connections — whereby specific shapes have equivalents in colors and sounds — and Gertrud

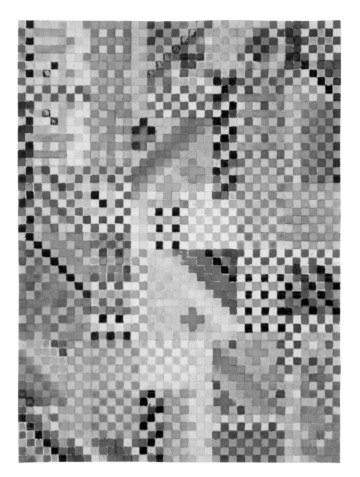

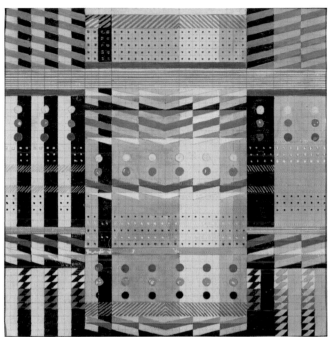

Grunow's earlier principle of "Harmonization,"[7] "the belief," according to Magdalena Droste, "that a universal equilibrium of colour, music, perception, and form is anchored in each person."[8]

Even in Stölzl's title, which could translate at once as "5 choirs" and "5 chords," we see the complex of sources and philosophical inspirations. The name refers to the harmonic field of color that vibrates throughout the piece like a melodic composition or chromatic musical scale,[9] but also to the work's five-patterned system and the composite of harnesses and cords that commands the movement of warp threads on the Jacquard loom. Bauhaus historian Ingrid Radewalt explains that the German word *Chöre* refers to an adjustment of the Jacquard loom, and cites a revealing quotation that Stölzl copied in her handwritten notes: "The harness is divided into choirs. The name 'choir' describes a repeat of the cord system in the choir bed [*Chorbett*]."[10] Within Stölzl's title, then, one finds a double reference to the work's own medium (Jacquard weaving) and to music. The resonance of colors and forms in *5 Chöre* demonstrates the persistence of multisensory explorations throughout the curriculum.

1. Sigrid Wortmann Weltge, *Bauhaus Textiles: Women Artists and the Weaving Workshop* (London: Thames and Hudson, 1993), p. 104.

2. For their help in explaining the complexity of Jacquard mechanisms, I thank fiber artists and weavers Susie Brandt, Warren Seelig, and in particular Bhakti Ziek.

3. *Eisengarn*, which translates literally as "iron yarn," was used for the fabric of Marcel Breuer's early tubular-steel chairs.

4. According to Ingrid Radewalt, Gunta Stölzl's initial Jacquard designs proved faulty in that they required a far too complex threading of the loom. See Radewalt, "Jacquards," in Stölzl, *Meisterin am Bauhaus: Textilien, Textilentwürfe und freie Arbeiten, 1915–1983*, exh. cat. (Ostfildern: Hatje Cantz, and Dessau: Stiftung Bauhaus, 1997), pp. 208–9.

5. Radewalt quotes a letter that Stölzl wrote in 1977 to the Museen für Kunst und Kulturgeschichte der Hansestadt, Lübeck, which had acquired *5 Chöre* in 1929. See ibid., p. 209, n. 3. I thank Yael Aloni for this translation.

6. Stölzl, "Weaving at the Bauhaus," 1926, reprinted in Hans Maria Wingler, *The Bauhaus: Weimar, Dessau, Berlin, Chicago* (Cambridge, Mass.: The MIT Press, 1969), p. 116.

7. Vasily Kandinsky first elaborated on this idea in his 1911 essay *Über das Geistige in der Kunst* (Munich: R. Piper, 1912), published in English as *Concerning the Spiritual in Art*, trans. M. T. H. Sadler (New York: Dover, 1977).

8. Magdalena Droste, *Bauhaus 1919–1933*, trans. Karen Williams (London: Taschen, 2002), p. 33. Gertrud Grünow, who taught at the Bauhaus beginning in 1919 at the request of Johannes Itten, instructed the students in this idea through physical and perceptual exercises.

9. *Chor* may also be translated as "course," in the sense of the course of strings on an instrument such as the lute.

10. See Radewalt, "Jacquards," p. 209, n. 2. The original source of the quotation is Hermann Oelsner, *Die Deutsche Webschule* (Altona, 1902), p. 661. I thank Yael Aloni for this translation.

Fig.1
W. Archer
Jacquard hand loom. Bolton, Lancashire.
c.1910
Museum of Science and Industry,
Manchester, England

267
Gunta Stölzl
Design for a carpet. 1927
Watercolor on graph paper
10 9/16 x 7 7/8" (26.8 x 20 cm)
The Board of Trustees of the Victoria
and Albert Museum, London

268
Gunta Stölzl
Design for a wall hanging. 1928–29
Watercolor and whitener over pencil
on graph paper
10 3/4 x 10 3/8" (27.3 x 26.3 cm)
The Board of Trustees of the Victoria
and Albert Museum, London

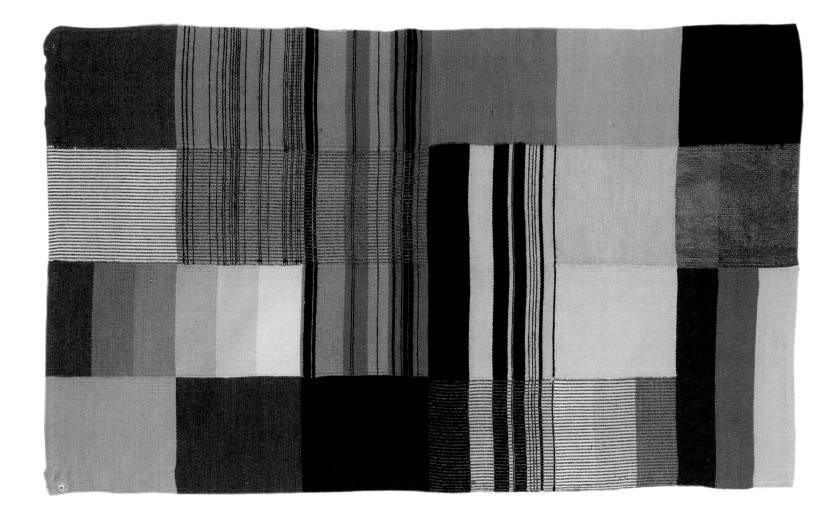

269
Artist unknown
Wall hanging. Late 1920s
Hand-woven wool, cotton, and cellophane
threads, with brass loops hand-stitched
to top edge
27 ½ x 42 ½" (69.8 x 107.9 cm)
Private collection. Courtesy Neue Galerie
New York

270
Lena Meyer-Bergner
Exercise for color theory course taught
by Paul Klee. August 28, 1927
Watercolor and ink over pencil on board
9 ⁵⁄₁₆ x 12 ⁷⁄₈" (23.3 x 32.7 cm)
Bauhaus-Archiv Berlin

271
Joost Schmidt
Cover of the journal *Offset. Buch und
Werbekunst* (Offset: book and advertising
art) no. 7. Special issue on the Bauhaus, 1926
Offset on cardboard
12 ⅛ x 9 ³⁄₁₆" (30.8 x 23.3 cm)
Collection Merrill C. Berman

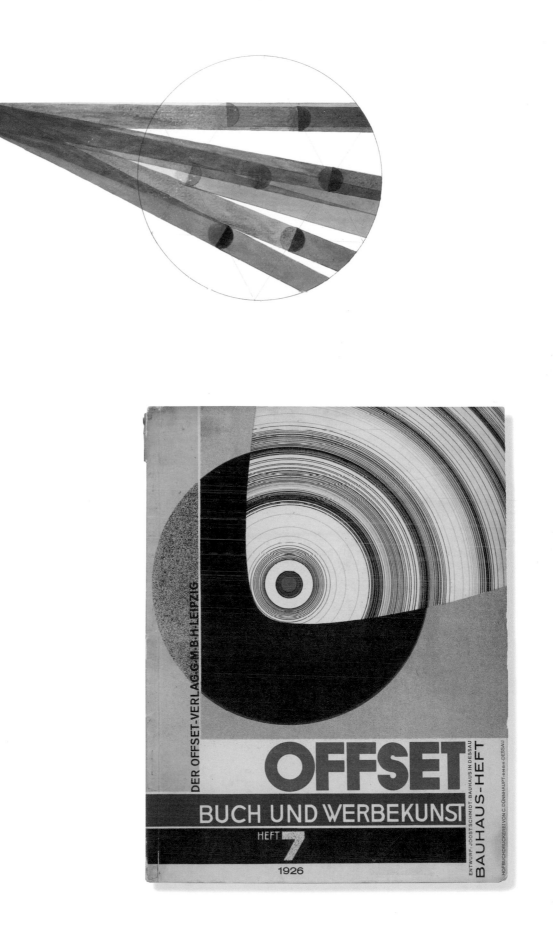

272
Marcel Breuer
Glass-fronted cabinet (TI 66c). 1926
Wood-core plywood with elm veneer, glass,
and nickel-plated metal parts; backs of
interior sections: painted plywood; sliding
doors: glass or plywood, black lacquer
6' 5 9/16" x 65 15/16" x 20 1/16" (197 x 167.5 x 51 cm)
Designsammlung Ludewig, Berlin

273
Josef Albers
Writing desk. Designed for Anna Möllenhoff,
for the Möllenhoff family's Berlin apartment.
c. 1927
Ash veneer, black lacquer, and painted glass
30 x 35 3/8 x 23" (76.2 x 89.8 x 58.9 cm);
30 x 52 1/4 x 23" (76.2 x 127.6 x 58.9 cm) with
leaf extended
Collection Luther M. English

274
Josef Albers
Armchair. Designed 1926, this example
produced 1928
Solid mahogany and mahogany veneer
on beech, solid maple, upholstery on beech
frame, and nickel-plated slotted screws
with round heads
29 1/2 x 24 1/4 x 26 5/8" (75 x 61.6 x 67.6 cm)
Bauhaus-Archiv Berlin

275
Josef Albers
Set of stacking tables. c. 1927
Ash veneer, black lacquer, and painted glass
Ranging from 15 5/8 x 16 1/2 x 15 3/4"
(39.1 x 41.9 x 40 cm) to 24 3/8 x 23 5/8 x 15 7/8"
(62.6 x 60.1 x 40.3 cm)
The Josef and Anni Albers Foundation,
Bethany, Conn.

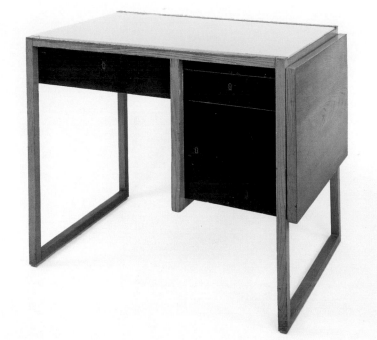

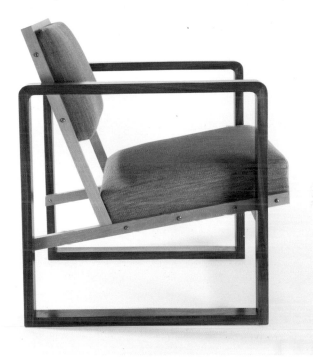

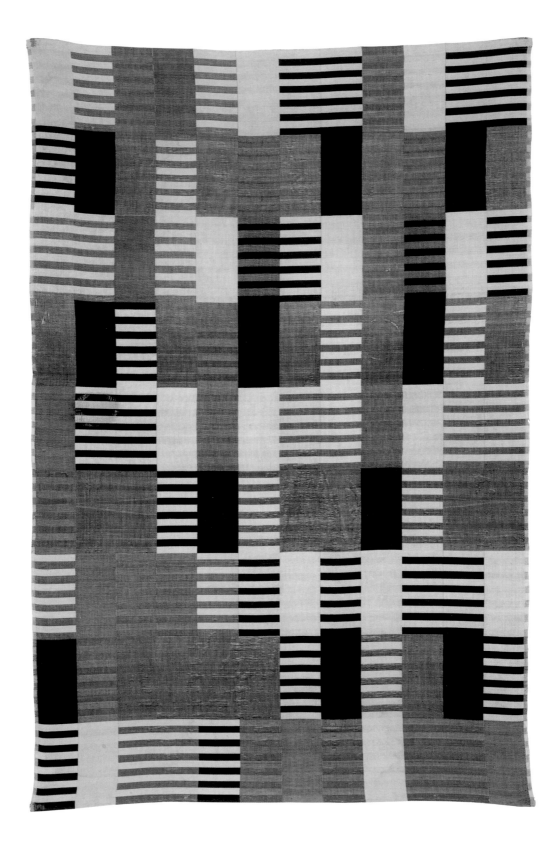

276
Anni Albers
Wall hanging. 1926
Silk (three-ply weave)
70 3/8 x 46 3/8" (178.8 x 117.8 cm)
Harvard Art Museum, Busch-Reisinger
Museum. Association Fund

277
Josef Albers
Overlapping. c. 1927
Opaque black glass flashed on
milk glass, sandblasted
23 x 11" (58.4 x 27.9 cm)
Harvard Art Museum, Busch-Reisinger
Museum. Kuno Francke Memorial
and Association Funds

278
Josef Albers
Goldrosa. c. 1926
Red glass flashed on milk glass,
sandblasted, with black paint
17 9/16 x 12 3/8" (44.6 x 31.4 cm)
The Josef and Anni Albers Foundation,
Bethany, Conn.

279
Josef Albers
Upward. c. 1926
Blue glass flashed on milk glass,
sandblasted, with black paint
17 9/16 x 12 3/8" (44.6 x 31.4 cm)
The Josef and Anni Albers Foundation,
Bethany, Conn.

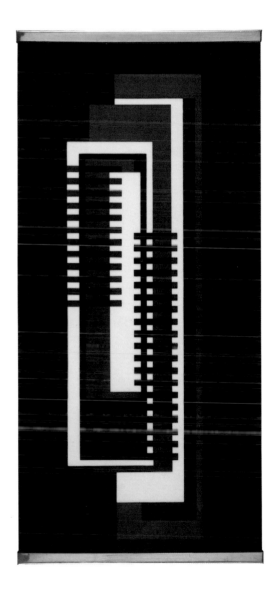

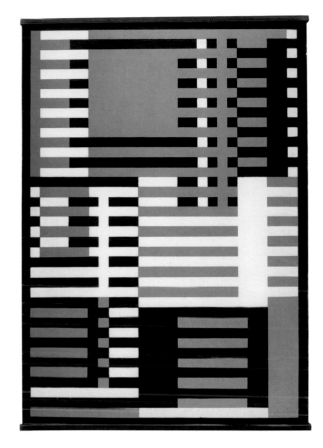

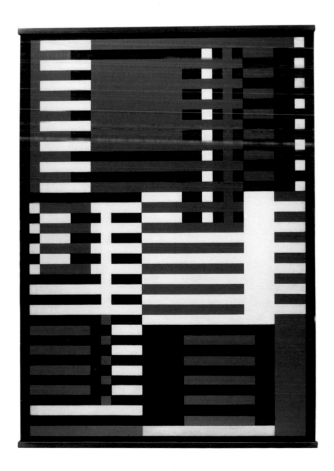

LÁSZLÓ MOHOLY-NAGY
PHOTOGRAMS
MICHAEL W. JENNINGS

When László Moholy-Nagy joined the Bauhaus faculty — in the fall of 1923, as master of the metal workshop and, soon thereafter, director of the preliminary course — he had already been experimenting with cameraless photography for over a year. Although cameraless photography is as old as photography itself—William Henry Fox Talbot produced cameraless images that he called "photogenic drawings" as early as 1834 — the years immediately following World War I were a time of intensive avant-garde experimentation with the form. The German artist Christian Schad made a series of "Schadographs" in 1919, while the American photographer Man Ray, working in Paris, produced the first "Rayograms" in 1921. Moholy's first photograms from 1922,[1] which he made by placing readily identifiable objects directly onto printing-out paper in direct sunlight, reveal an interest not just in what he at this time called "spatial rhythm [and] equilibrium of form"[2] but especially in the problems of spatial relationships among pictorial elements in a nonperspectival field. These images emerged, first of all, out of the artistic ferment that was Berlin in the early 1920s: they are kin not just to the paintings in the style of international Constructivism that Moholy was producing at the time but especially, in their incorporation of objects of daily use such as bathroom fixtures and bobby pins, chicken wire and kitchen utensils, to the "Merz" collages and Dada photomontages made by his friends Kurt Schwitters and Raoul Hausmann.

More important than any direct artistic influence, though, was the relationship between the development of the photogram and Moholy's own theories of art and society.[3] In 1922, the year of his first photograms, Moholy published two remarkable essays: "Constructivism and the Proletariat" and "Production Reproduction." In "Production Reproduction" he discusses the historicization of sense perception, and argues that human sensory and cognitive capacities are inadequate to an understanding of the modern, technologized world. If the human "constituent faculties" are to be developed "to the limit of their potential," art will have to play a central role, "for art attempts to create new relationships between familiar and as yet unfamiliar data, optical, acoustic, or whatever, and forces us to take it all in through our sensory equipment." The essay's principal contribution to our understanding of the new, technologized media lies in its distinction between what Moholy calls "reproduction" and "production." Reproduction is the mimetic replication of an external reality: this "reiteration of relationships that already exist" can have little effect on the development of

new perceptual capacities, since it merely reproduces relationships already accessible to the senses. "Production," however, involves forms of art that actively create new relationships — and force human perception to adapt to them. What Moholy envisions here is a perceptual and cognitive reform of a kind that would permit not just a more adequate understanding of our world but would constitute, he hints, the precondition for social change. In "Constructivism and the Proletariat" he is much more explicit regarding that change: he sees an irreversibly and inextricably intertwined relationship between technology, the worker at the machine, and socialism. Human well-being is, in this view, caused by "a socialism of the mind" that is in turn the creation of an art that "crystallizes the emotions of an age." If we are to imagine a new world, we must be able to perceive the present world for what it is and to imagine a new set of relationships among its elements. The photogram, with its direct fixing of the "moments of the play of light," is ideally suited to create such new relationships — and thus potentially to change the world.[4]

At the Bauhaus, Moholy for the first time had access to a professional darkroom, and his photograms almost immediately began to reflect the application of more sophisticated technologies. He began to replace printing-out paper, which begins to develop as soon as it is exposed to a light source, with developing-out paper, which, because it allows for the recording of a latent image that emerges only during the development process, made possible not just longer exposure times but multiple exposures and complex combinations of light sources. At the Bauhaus the quotidian objects recognizable in the earlier works also gave way to objects free of reference to the everyday world: specially fabricated grids, screens, tubes, sheets, and spirals. Moholy seldom allowed his new forms to touch the photosensitive paper at more than one point; he arranged for some to hover over the paper, others to move in carefully controlled patterns during the exposure. Perhaps most important, he often used multiple light sources or diffused the light, passing it through liquids such as water, oils, or acids before letting it fall on the objects.

For Moholy, the wholly abstract photograms that resulted were experiments within the broad field staked out by his theories, and the mode of that experimentation was an exploration of the materials, elemental processes, and formal properties of the medium of photography itself. Moholy's photograms are in this sense the best evidence for the principles he sought to impart in the preliminary course; and they reflect many of the fundamental convictions of the Bauhaus more

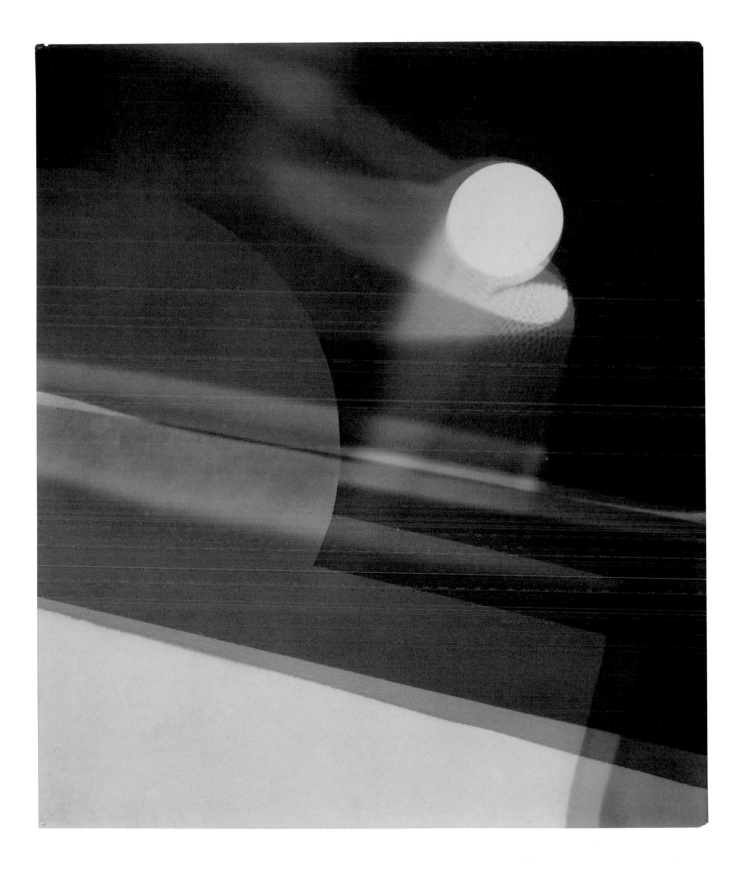

280
László Moholy-Nagy
Untitled. 1924
Gelatin silver print (photogram)
5 1/16 x 4 3/8" (12.9 x 11.1 cm)
Centre Pompidou, Paris. Musée national d'art
moderne/Centre de création industrielle

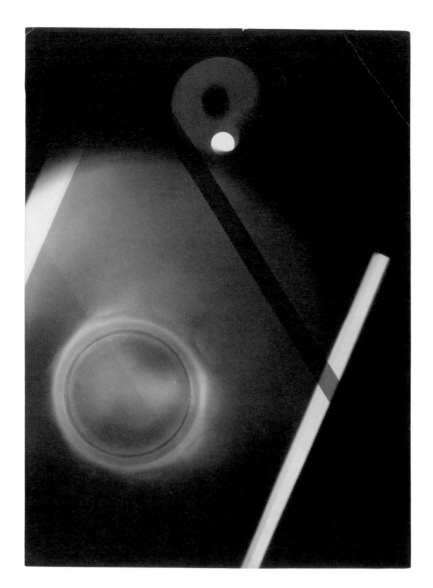

generally. The extent to which each of Moholy's photographs and photograms is provisional and heuristic cannot be overemphasized; each image was an experimental gesture within the larger project of sensory and cognitive reform — never a "work of art."[5] By manipulating the photogram's reflection and absorption of light by varying the surfaces it recorded, he could make it evoke "an immediate optical experience, based on our psychobiological visual organization."[6] The immediacy of this "optical experience" would depend not on the viewer's recognition of objects in the image — Moholy aimed explicitly to eliminate all "imitative elements, even the recollection of them" — but on the relationships arising between these forms.[7] The individual elements themselves were thus far less important than the image's structuring liminalities: the relative "intensities of light, the transposition of black and white, the transition from light to dark and back again."[8] Without direct ties to the preexistent order of the world, which inevitably determines the camera-made photograph, the photogram could become a site of genuine "production"—the creation of new visual relationships. A corollary of this understanding is the resistance of the photogram to interpretation in the ordinary sense: without anchors in the world, the image refuses thematic as well as allegorical interpretation.

All of Moholy's strategies depend on a particular understanding of light, an understanding that intertwined scientific curiosity with an almost religious veneration. To Moholy, light posed a riddle for modern consciousness; of all the incapacities he detected in the contemporary human sensory and cognitive apparatus, he gave pride of place to an insensitivity to light. If the photogram could bring light to our consciousness in a way appropriate to our organic makeup, its function could be almost redemptive. Although the common reaction to a photogram might emphasize the manner in which illumined forms emerge from blackness, Moholy himself emphasized the form's capacity to record the *immediacy* of light, light's direct action on the emulsion — for Moholy, camera photography could represent only a light that was indirect and refracted.

Moholy's slogan "*fotografie ist lichtgestaltung*" plays on an important ambiguity: photography is the production of forms through light, but it is also the shaping of light through the deployment of forms.[9] The illumination of the photosensitive paper thus produces paradoxical effects: objects are revealed by light, yet in that light they are "sublimated, glowing, almost dematerialized."[10] This sense that light emerges in the photogram for the first time in a form available to modern human consciousness is central to any understanding of Moholy's

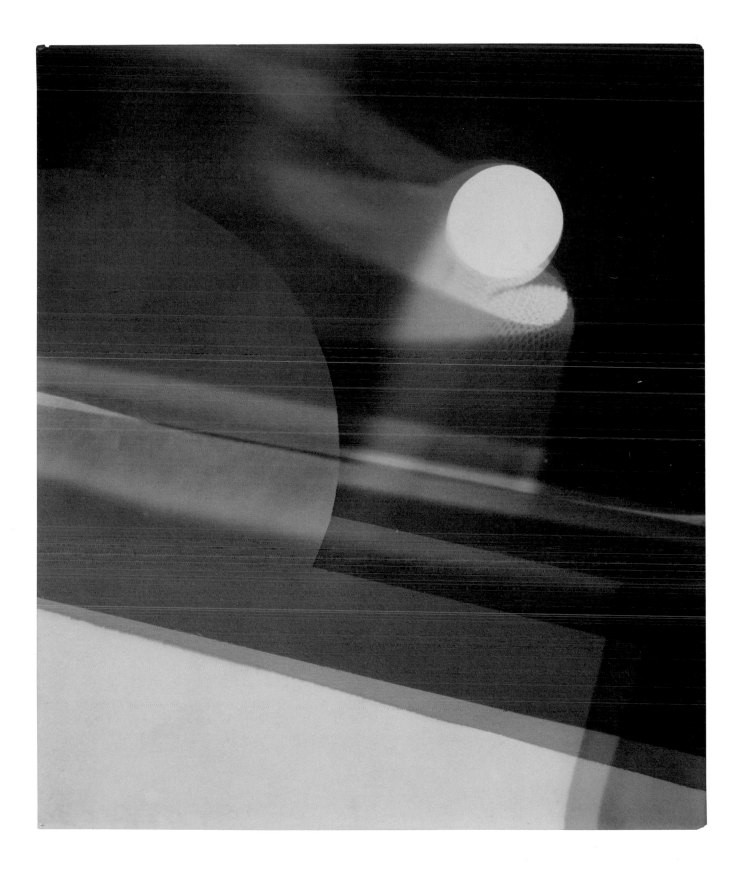

280
László Moholy-Nagy
Untitled. 1924
Gelatin silver print (photogram)
5 1/16 x 4 3/8" (12.9 x 11.1 cm)
Centre Pompidou, Paris. Musée national d'art
moderne/Centre de création industrielle

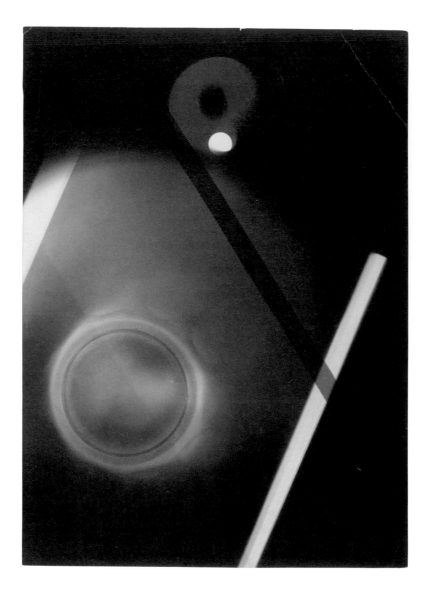

generally. The extent to which each of Moholy's photographs and photograms is provisional and heuristic cannot be overemphasized; each image was an experimental gesture within the larger project of sensory and cognitive reform — never a "work of art."[5] By manipulating the photogram's reflection and absorption of light by varying the surfaces it recorded, he could make it evoke "an immediate optical experience, based on our psychobiological visual organization."[6] The immediacy of this "optical experience" would depend not on the viewer's recognition of objects in the image — Moholy aimed explicitly to eliminate all "imitative elements, even the recollection of them" — but on the relationships arising between these forms.[7] The individual elements themselves were thus far less important than the image's structuring liminalities: the relative "intensities of light, the transposition of black and white, the transition from light to dark and back again."[8] Without direct ties to the preexistent order of the world, which inevitably determines the camera-made photograph, the photogram could become a site of genuine "production"—the creation of new visual relationships. A corollary of this understanding is the resistance of the photogram to interpretation in the ordinary sense: without anchors in the world, the image refuses thematic as well as allegorical interpretation.

All of Moholy's strategies depend on a particular understanding of light, an understanding that intertwined scientific curiosity with an almost religious veneration. To Moholy, light posed a riddle for modern consciousness; of all the incapacities he detected in the contemporary human sensory and cognitive apparatus, he gave pride of place to an insensitivity to light. If the photogram could bring light to our consciousness in a way appropriate to our organic makeup, its function could be almost redemptive. Although the common reaction to a photogram might emphasize the manner in which illumined forms emerge from blackness, Moholy himself emphasized the form's capacity to record the *immediacy* of light, light's direct action on the emulsion — for Moholy, camera photography could represent only a light that was indirect and refracted.

Moholy's slogan "*fotografie ist lichtgestaltung*" plays on an important ambiguity: photography is the production of forms through light, but it is also the shaping of light through the deployment of forms.[9] The illumination of the photosensitive paper thus produces paradoxical effects: objects are revealed by light, yet in that light they are "sublimated, glowing, almost dematerialized."[10] This sense that light emerges in the photogram for the first time in a form available to modern human consciousness is central to any understanding of Moholy's

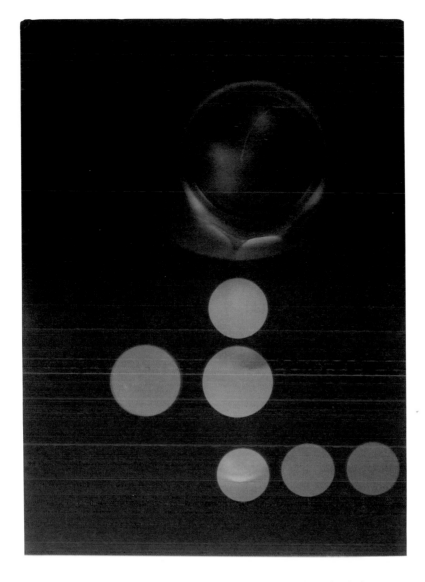

photograms. For all their apparent materialism, these images seek to open direct access to the ideal form of something that had been repressed, hidden from view in modern society: light itself. If the photograms do in fact "produce" new relationships, they do so not between representations of material elements but between massings of light within an "enlightened" space.

1. Although László Moholy-Nagy's's designation of the cameraless photographic image as a "photogram" has become the generally accepted term, in the late nineteenth century the word was applied indiscriminately to camera-based and cameraless photography alike. The term had become established in the German technical and scientific community by 1900. See Andreas Haus, *Moholy-Nagy. Fotos und Fotogramme* (Munich: Schirmer/ Mosel, 1978), p. 18.

2. Moholy-Nagy, "Constructivism and the Proletariat," *MA*, May 1922, reprinted in Sibyl Moholy-Nagy, *Moholy-Nagy: Experiment in Totality* (Cambridge, Mass.: The MIT Press, 1969), p. 19.

3. Moholy was explicit about the relationship of his photograms to his theories: "I arrived at this form of production by means of a theoretical text." Moholy, "Fotoplastische Reklame," 1926, reprinted in Floris M. Neusüss and Renate Heyne, eds., *Das Fotogramm*

in der Kunst des 20. Jahrhunderts (Cologne: DuMont Buchverlag, 1990), p. 122. All translations from this essay are my own.

4. Moholy-Nagy, "Produktion Reproduktion," *De Stijl*, July 1922. Eng. trans. in Christopher Phillips, ed., *Photography in the Modern Era* (New York: The Metropolitan Museum of Art, 1989), pp. 79–80, and "Constructivism and the Proletariat," p. 19.

5. Despite the prices that Moholy's photographs now fetch on the art market, the fact remains that he never cared enough about the finished product to learn how to develop and print his own photographs. His most important photographic work from the 1920s was developed and printed by his wife, Lucia; after their divorce, a series of technicians in Germany and America took over this role.

6. Moholy, quoted in Sibyl Moholy-Nagy, *Experiment in Totality* (Cambridge, Mass.: The MIT Press, 1969), pp. 27–28.

7. Moholy, "Fotoplastische Reklame," p. 123.

8. Ibid., p. 122.

9. This is the title of an essay originally published in *bauhaus* 2, no. 1 (February 15, 1928). The German term *Gestaltung* stands in a complex connotative field, meaning "design," "shape," and "form" and implying the action that yields all these things: "to design," "to give shape," "to form." In the context of the avant-garde movements of the early 1920s, *Gestaltung* is perhaps best translated as "form-production," so as to emphasize the objective, "engineered" aspects of the term over the notion of "creating."

10. Moholy, "Fotoplastische Reklame," p. 122. Neusüss has argued that for Man Ray, the object is transformed with the help of light, while for Moholy, light is transformed with the help of the object. See Neusüss, "László Moholy-Nagy — Fotogramme," in Neusüss and Heyne, eds., *Das Fotogramm*, p. 131.

281
László Moholy-Nagy
Untitled. c. 1923–25
Gelatin silver printing-out-paper print (photogram)
7 1/16 x 5 1/16" (17.9 x 12.9 cm)
Centre Pompidou, Paris. Musée national d'art moderne/Centre de création industrielle

282
László Moholy-Nagy
Untitled. c. 1922–25
Gelatin silver printing-out-paper print (photogram)
7 1/16 x 5 1/16" (17.9 x 12.9 cm)
Centre Pompidou, Paris. Musée national d'art moderne/Centre de création industrielle

283
László Moholy-Nagy
Untitled. 1926
Gelatin silver print (photogram)
9 7/16 x 7 1/16" (23.9 x 17.9 cm)
The Metropolitan Museum of Art, New York.
Ford Motor Company Collection, Gift of
Ford Motor Company and John C. Waddell

284
László Moholy-Nagy
Untitled. c.1926
Gelatin silver print (photogram)
9 7/16 x 7 1/16" (24 x 18 cm)
Centre Pompidou, Paris. Musée national d'art
moderne/Centre de création industrielle

285
László Moholy-Nagy
Untitled. 1923
Gelatin silver print (photogram)
7 1/8 x 9 7/16" (18.1 x 24 cm)
Centre Pompidou, Paris. Musée national d'art
moderne/Centre de création industrielle

286
László Moholy-Nagy
A XX. 1924
Oil on canvas
53 3/8 x 45 1/4" (135.5 x 115 cm)
Centre Pompidou, Paris. Musée national d'art
moderne/Centre de création industrielle

287
László Moholy-Nagy
A 18. 1927
Oil on canvas
37 3/8 x 29 3/4" (95 x 75.5 cm)
Harvard Art Museum, Busch-Reisinger
Museum. Museum purchase

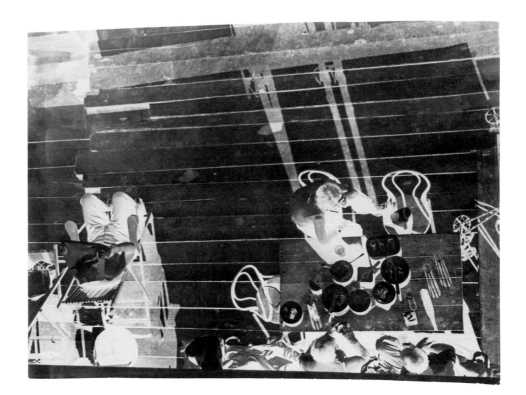

288
Herbert Bayer
Untitled (Sundeck). 1928
Negative gelatin silver print
8 x 11 3/8" (20.3 x 28.9 cm)
The Museum of Modern Art, New York.
David H. McAlpin Fund

289
László Moholy-Nagy
Untitled (On the Wannsee). 1927
Negative gelatin silver print
11 15/16 x 9 3/16" (30.3 x 23.4 cm)
Galerie Berinson, Berlin

290
László Moholy-Nagy
Untitled (Lucia Moholy). c. 1926
Negative gelatin silver print
9 5/16 x 6 13/16" (23.6 x 17.3 cm)
The Museum of Modern Art, New York.
Given anonymously

291
László Moholy-Nagy
Untitled (Lucia Moholy). c. 1926
Gelatin silver print
14 9/16 x 10 5/8" (37 x 27 cm)
The Museum of Modern Art, New York.
Given anonymously

292
László Moholy-Nagy
Untitled (From the Berlin radio tower). 1928
Gelatin silver print
11 1/8 x 8 3/8" (28.2 x 21.3 cm)
The Museum of Modern Art, New York.
Anonymous gift

293
Herbert Bayer
Eiserne Wendeltreppe (Iron winding stair.
Pont transbordeur, Marseille). 1928
Gelatin silver print
13 7/8 x 9 5/8" (35.3 x 24.4 cm)
The Museum of Modern Art, New York.
Thomas Walther Collection. Gift of
Thomas Walther

294
László Moholy-Nagy
Untitled (Decorating work, Switzerland).
1925
Gelatin silver print
19 15/16 x 15 13/16" (50.6 x 40.2 cm)
The Metropolitan Museum of Art, New York.
Gilman Collection, Purchase, Robert
Rosenkranz Gift

295
László Moholy-Nagy
Untitled (Ascona; Schlemmer girls
on balcony). 1926
Gelatin silver print
15 11/16 x 11 3/4" (39.8 x 29.9 cm)
Galerie Berinson, Berlin

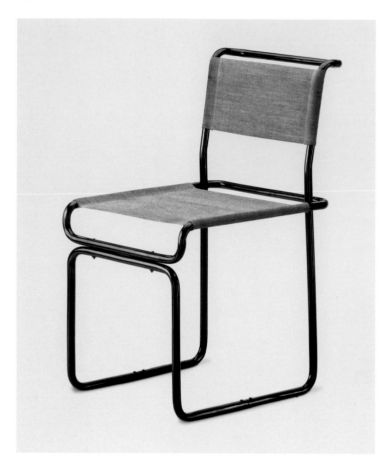

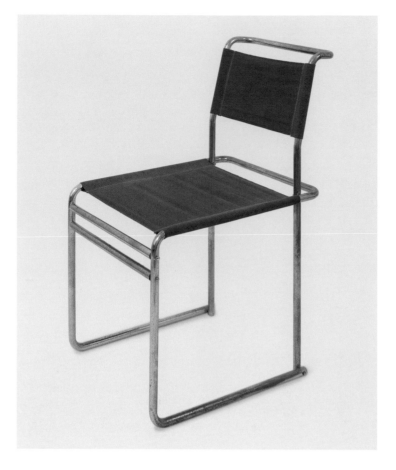

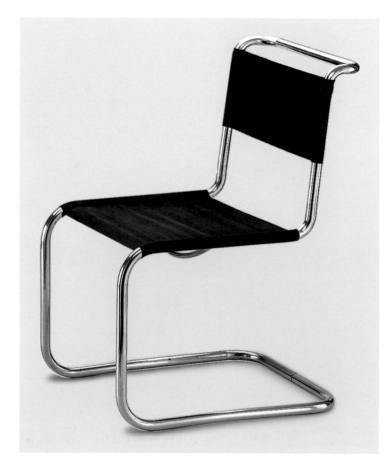

296 (above left)
Marcel Breuer
Chair. 1926
Tubular steel with black-brown finish,
with fabric seating and backrest
33 7/16 x 18 7/8 x 23 13/16" (84.9 x 48 x 60.5 cm)
Bauhaus-Archiv Berlin

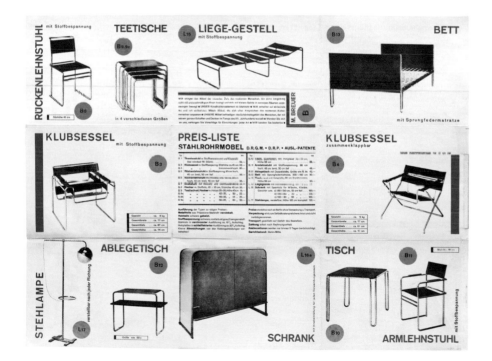

297 (opposite, above right)
Marcel Breuer
Chair (B5). c.1926
Manufactured by Standard Möbel
Nickel-plated tubular steel with red fabric
32 ³/₄ x 17 ³/₄ x 24 ¹/₄" (83.2 x 45.1 x 61.6 cm)
Private collection. Courtesy Neue Galerie
New York

298 (opposite, below)
Marcel Breuer
Chair (B33). 1927–28
Manufactured by Thonet
Chrome-plated tubular steel with steel-
thread seat and back
32 ¹⁵/₁₆ x 19 ⁵/₁₆ x 25 ³/₈" (83.7 x 49 x 64.5 cm)
Designsammlung Ludewig, Berlin

299
Marcel Breuer
Nesting tables (B9). 1925–26
Manufactured by Standard Möbel
Nickel-plated tubular steel and lacquered
wood-core plywood
Ranging from 17 ¹³/₁₆ x 17 ¹³/₁₆ x 15 ³/₈"
(45.2 x 45.2 x 39 cm) to 23 ¹¹/₁₆ x 26 ³/₁₆ x 15 ³/₈"
(60.2 x 66.5 x 39 cm)
Designsammlung Ludewig, Berlin

300
Hajnal Lengyel-Pataky
Das neue Möbel (The new furniture),
folding sales leaflet for furniture offered
by Standard Möbel. 1928
Lithograph on paper
18 ¹/₂ x 24 ⁵/₈" (47 x 62.5 cm)
The Museum of Modern Art, New York.
Gift of Herbert Bayer

MARCEL BREUER
CLUB CHAIR
FREDERIC J. SCHWARTZ

They were, perhaps, the perfect chairs. They were to demonstrate a new way of dwelling: Marcel Breuer's designs were light, easy to move, and neither displaced space nor blocked views. Their surfaces of chromed steel and newly developed textiles were easy to clean; no wooden carpentry poked, no dusty upholstery smothered the sitter's body. Cheap, mass producible, and easy to hand, they were meant to make no demands, to take no room, to be subservient to the user's actions, and to allow the free unfolding of modern life.

But that is a rather static view of these objects, which often evade one's grasp. The chairs were always shadowed by a logic of disappearance that represents not their failure but the unfolding of their full potential. If they were perfect, they were so at one moment only. Even if stripped down to the absolute minimum required for their purpose, they represented only a step — the penultimate step — in the history of sitting. Soon, as we see in Breuer's famous "film strip" of 1926 (cat. 96), people would sit without chairs, buoyed by a surface of elastic air.

The tubular steel chair was not timeless but expressed the history of the type. Its forms did not break with tradition but were instantly recognizable as side chair or club chair; they bore the marks of their past, their evolution, distilling thousands of years of design into a few spare lines. Perhaps this final iteration of the image "chair," feather light, was still necessary to the subject of the time, unable to conceive of certain actions without familiar objects to supplement them, objects that so often, in the past, exceeded their remit and began to determine the actions they were meant to serve. In the dialectic of dwelling, the object was to dissolve in the service of living; the chair was to disappear in the liberation of sitting.

Such a dialectic is unthinkable outside the context of other artistic models of radical freedom explored at the time. Like a Suprematist painting by Kazimir Malevich, the so-called "Wassily Chair" (1925; cat. 302) seems to show the intersection of two geometric forms in space, forms devoid of mass, moving without thrust or momentum, borne, as Malevich sought to achieve in his own kind of non-objective representation, by "pure feeling."[1]

301
Marcel Breuer
Club chair. Designed 1925, this example handmade in 1926
Tubular steel, originally nickel plated (later chromed), and *Eisengarn* (metallized yarn) fabric
27 3/4 x 31 7/8 x 27 3/8" (70.5 x 81 x 69.5 cm)
Stiftung Bauhaus Dessau

302
Marcel Breuer
Club chair (B3). Designed 1925, revised 1928, this example produced 1928 or 1929
Probably manufactured by Standard Möbel
Tubular steel, originally nickel plated (later chromed) and canvas
28 1/4 x 30 3/4 x 28" (71.8 x 78.1 x 71.1 cm)
The Museum of Modern Art, New York. Gift of Herbert Bayer

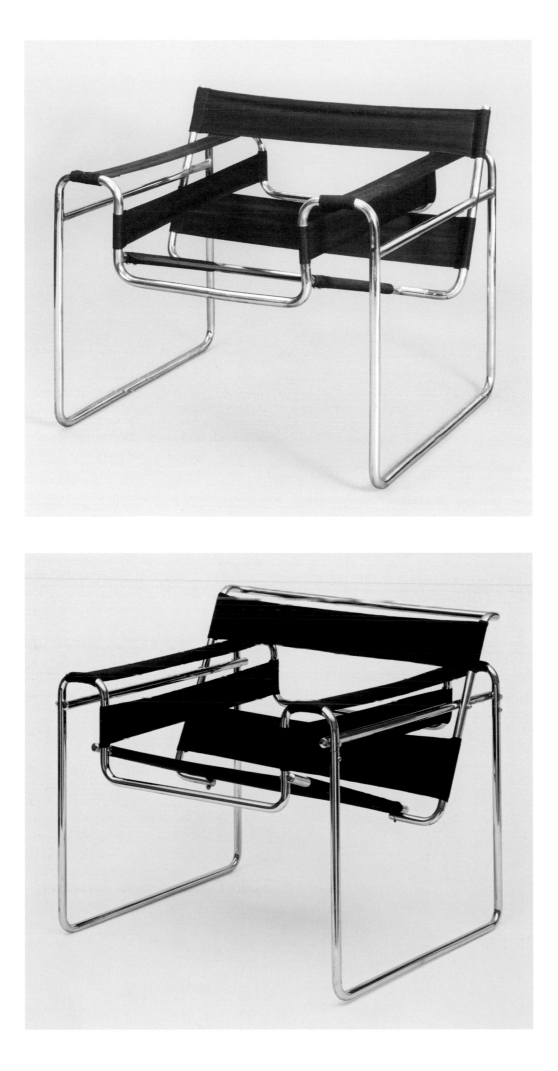

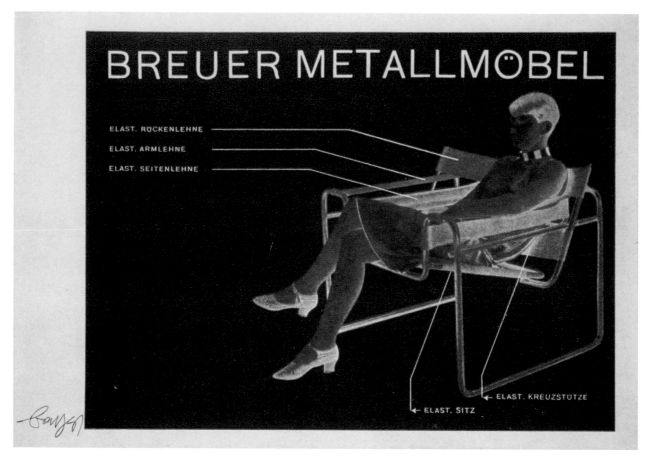

The way the taut cloth of the chair forms a three-dimensional grid in which the planes are interwoven without the friction of intersection: this implies their infinite extension into space not as matter but as force, which is, of course, a lesson from de Stijl, as translated into three dimensions by the furniture of Gerrit Rietveld (fig. 1) and the architectural fantasies of Theo van Doesburg. But most of all the suspension of body in space recalls the non-Euclidean world of El Lissitzky's Prouns (cat. 4), renderings that combine the self-evidence of the ruled line with the spatial ambiguities of once arcane forms of descriptive geometry. Without the indication of scale, Lissitzky's works could represent anything from matchboxes to buildings, from books to cities, even universes — or furniture. As one turns those images around, planes that once seemed to be floor turn into ceiling, forms that seemed to project into space suddenly recede. In these images with no coherent perspective but nonetheless a compelling sense of depth, a world that no longer imposes Newtonian physics looks possible, a world in which one can be in more than one place simultaneously, a world that responds to the position of the viewer instead of fixing her within stable coordinates. The world as Proun is a fantasy often encountered at the Bauhaus. We see it, for example, in T. Lux Feininger's photograph of an unnamed *Bauhäusler* suspended in a series of open slabs, fearlessly climbing over the railing into a space not yet ours (cat. 250). Such vagaries of the ruled line help us to understand Breuer's excitement about tubular steel as making possible furniture "as if drawn in space";[2] and he certainly relished the way the reflections on the chromed surfaces narrow the cylinders of steel into thin strokes of an imaginary pen. In the development from the prototype of the

club chair (cat. 301) and the model sold by Standard Möbel to the version manufactured by Thonet, we can follow Breuer's exploration of the interplay of straight line and spatial void. The upper edge of the seatback in the earlier models ends with the plane of the cloth, while in the later model the steel tubes emerge above the cloth and meet, turning the frame into a continuous line sketched in three dimensions.

The chairs are paradigmatic of the kind of objects explored at the Bauhaus between 1922 and 1928: through a process of repeated abstraction they could begin an endless journey through various media, generating more objects, denying the priority of an original. They suggest an abstraction not of loss but of plenitude. Herbert Bayer's cover for a Breuer catalogue of 1927 (cat. 303) takes Erich Consemüller's picture of a New Woman in the Wassily Chair but presents it as a negative. It is no longer a photograph of an object but the plate for its infinite multiplication; instead of the product, we see the process of reproduction. The rendering of the chair remains plausible but the inhabitant is turned into a shadow, now as insubstantial as the object in which she sits, seemingly visible only as an x-ray. In the Thonet catalogue three years later (cat. 304), the chairs turn, before one's eyes, into photograms. As Moholy created images without a camera by exposing photosensitive paper with objects on them, here the chairs are accompanied by the shadows they cast on the surface behind them. They become visible from above and below, from front and back; they generate new images of themselves. For Moholy, photography was not reproductive but productive; here we see how objects could be subjected to that logic. Moholy was never satisfied with the

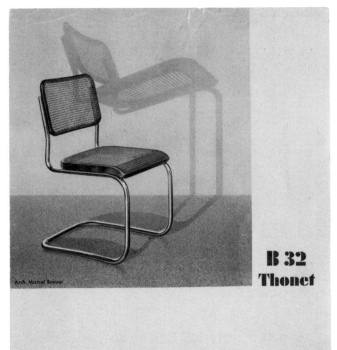

object in itself — anything he made could be photographed, turned into a negative, a positive, drawn through another part of the image-making process. Every object was the motor for infinite reproduction and transformation. The chairs were no different: they became the nucleus of a process of division, of fission, the start of a utopian process of weightless, infinite circulation.

 The chairs, however, became subject to another process of abstraction, one that returned them to earth. They became subject to the abstraction of the commodity, which works by stripping objects of qualities and replacing them with exchange value. Within a market economy that value is universal: everything has its price. The chair relinquished its promises of freedom when Breuer claimed the invention as his own property, denying the Bauhaus its claim to ownership of designs developed there, and as Mart Stam and his financial backers fought over the legal rights to exploit the idea. Stam had made a similar cantilevered chair, but one without the spring of Breuer's, which was made from a single piece of steel: the same form, different technique. When not in the market, the chair spent most of its time in court — not invisible, but as an exhibit, an object of positive contention, not imminent dissolution. Art? Technology? The courts had ways of defining everything as property. If it was art, the first to invent the form, the sketched-out cube with one side flipped up for the backrest, would own the rights to buy, sell, and manufacture the object. If it was a technical invention, the one to figure out how to spring the cantilever would win.

The courts tended toward the former view.[3] As the courts decided the property rights, it became clear that the ultimate space in which the chairs were suspended was the space of the market. The radical freedom of the avant-garde had little to do with the freedom of trade; nothing would dissolve beyond the point at which it would be bought or sold. The legal battles, the attempts to own the ideas, continue to this day; and we continue to sit on our chairs as we always have.

1. Kazimir Malevich, "Suprematismus," in Malevich, *Die gegenstandlose Welt*, Bauhaus-bücher 11 (Munich: Albert Langen, 1927), published in English as *The Non-Objective World*, trans. Howard Dearstyne (Chicago: Paul Theobald, 1959), p. 67. At the Bauhaus and in its early manufacturing history, first by Standard Möbel (1926–28) and then by Thonet (into the 1930s), the chair was simply called the B3. In 1962, when the Bologna firm of Gavina launched a reedition, Marcel Breuer suggested the name "Wassily" in honor of Vasily Kandinsky ("Wassily" and "Vasily" being alternate transliterations from the Russian). The chair became widely known by that name. Gavina was later acquired by Knoll, which continues to produce the "Wassily Chair." See Alexander von Vegesack and Mathias Remmele, eds., *Marcel Breuer: Design and Architecture*, exh. cat. (Weil am Rhein: Vitra Design Museum, 2003), pp. 152, 156.
2. Breuer, "metallmöbel und moderne räumlichkeit," *Das neue Frankfurt* 2, no. 1 (1928):11.
3. On the legal battles over the cantilevered chair, see Frederic J. Schwartz, "Utopia for Sale: The Bauhaus and Weimar Germany's Consumer Culture," in Kathleen James-Chakraborty, ed., *Bauhaus Culture: From Weimar to the Cold War* (Minneapolis: University of Minnesota Press, 2006), p. 126 ff.

303
Herbert Bayer
Cover of *Breuer Metallmöbel* (Breuer metal furniture), loose-leaf sales catalogue for furniture offered by the Standard Möbel company, showing Breuer's B3 club chair of 1925. c.1927
Halftone and letterpress on paper
5 13/16 x 8 1/4" (14.8 x 21 cm)
The Board of Trustees of the Victoria and Albert Museum, London

Fig.1
Gerrit Rietveld made with the assistance of **G. van der Groenekan**
Armchair. Designed 1918, this example produced c.1919
Purpleheart wood, stained
35 x 26 x 26" (88.9 x 66 x 66 cm)
Victoria and Albert Museum, London

304
Unknown
Page from *Stahlrohrmöbel* (Tubular steel furniture), loose-leaf sales catalogue for furniture offered by the Thonet company, showing Marcel Breuer's B32 chair of 1928.
1930–31
Lithograph, gravure and letterpress
8 3/8 x 6 1/8" (21.3 x 15.6 cm)
The Museum of Modern Art, New York.
Architecture and Design Study Collection

305
Marianne Brandt
Ceiling light (ME 94). 1926
Frosted glass, the bottom part flashed
with opal glass, and pressed aluminum
Height: 33 ⁷⁄₁₆" (85 cm), diam.: 9 ¹⁄₁₆" (23 cm)
Stiftung Bauhaus Dessau

306
Marianne Brandt
Ceiling light. 1926
Brushed aluminum sheeting
Diam.: 15 ¹⁵⁄₁₆" (40.5 cm)
Bauhaus-Archiv Berlin

307
Marianne Brandt
Ceiling light (ME 104a). 1926
Opal glass and nickel-plated brass
Height: 34 ¼" (87 cm), diam.: 9 ¹³⁄₁₆" (25 cm)
Bauhaus-Archiv Berlin

308
Marianne Brandt and **Hans Przyrembel**
Ceiling light (ME 105a). 1926
Nickel-plated sheet brass, with granulated-lead-filled weight
Diam.: 11 7/16" (29 cm)
Bauhaus-Archiv Berlin

309
Alfred Schäfter
Ceiling light. 1931–32
Matte-finished aluminum
Height: 31 1/2" (80 cm), diam.: 18 1/8" (46 cm)
Stiftung Bauhaus Dessau

310
Walter Gropius
Törten housing estate, Dessau. 1926–28
Isometric construction scheme. 1926–28
Ink, gouache, and cut-and-pasted element,
on photomechanical print on paper,
mounted on board
26 7/8 x 32 1/16" (68.3 x 81.4 cm)
Harvard Art Museum, Busch-Reisinger
Museum. Gift of Walter Gropius

311
Walter Gropius
Törten housing estate, Dessau. 1926–28
Row houses, isometric. 1926–28
Ink, spatter paint, and gouache, on paperboard
34 15/16 x 43 1/4" (88.8 x 109.5 cm)
Harvard Art Museum, Busch-Reisinger
Museum. Gift of Walter Gropius

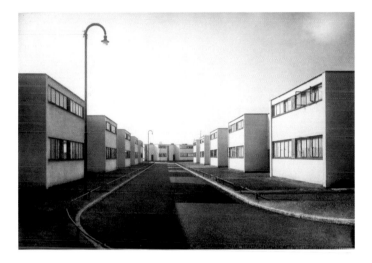

312
Walter Gropius
Törten housing estate, Dessau. 1926–28
Building type A, elevation. 1926–28
Gouache and ink on paper
8 7/16 x 24" (21.5 x 60.9 cm)
Harvard Art Museum, Busch-Reisinger
Museum. Gift of Walter Gropius

313
Walter Gropius
Törten housing estate, Dessau. 1926–28
Street of houses built in the second phase,
with design improvements. Designed 1927,
built 1928
Photograph: Musche. 1928. Gelatin silver
print. 4 13/16 x 6 3/4" (12.2 x 17.2 cm).
Bauhaus-Archiv Berlin

314
Walter Gropius
Törten housing estate, Dessau. 1926–28
Model interior for living room with
standardized workshop-assembled furniture
made from differently colored, stained, and
polished wood
Photograph: Erich Consemüller. c. 1928.
Gelatin silver print. 6 5/8 x 9" (16.8 x 22.8 cm).
Bauhaus-Archiv Berlin

The outstanding portrait photographs made by Lucia Moholy at the Dessau Bauhaus seem at once perfectly in step with later aesthetic trends in the Weimar Republic and a remarkable exception in her own work. Like much of what counts today as the best Bauhaus photography, they formed an extracurricular assignment: perhaps two dozen poses of friends and colleagues, concentrated on the sitters' heads or hands. The school had deputized Moholy to document its architecture and design products for Bauhaus and external publications (cats. 154, 316), an assignment she undertook fortified by practical training in copy photography and print reproduction and by years in editorial service for various publishers.[1] That line of work — reproduction, not production, in the terms of a well-known essay by László Moholy-Nagy, in which Lucia played a formative part[2] — continued for decades in her post-Bauhaus life; in England in 1942, for example, she founded a microfilm service. This career trajectory seems to fulfill the self-analysis in an adolescent diary entry of 1915, apparently her first written reflection on photography: "I am not creative, not productive myself, but probably have a very fine receptivity and capacity for registration [*Aufnahmefähigkeit*]."[3]

The portraits, which so visibly "produce" their subjects, would stand apart from this larger career. They achieved visibility not in "reproduction" — most remained unpublished until late in Moholy's life — but on display in the great photo exhibitions of the late 1920s, such as *Fotografie der Gegenwart* (Contemporary photography; Essen, 1929) and the much-traveled *Film und Foto*, or *Fifo* (Film and foto, 1929–30).[4] It is possible that the portraits connected to her architectural pictures, since she claimed decades later to have "photographed people like houses."[5] Such an equivalence might apply to the diffident, half-length portrait of Julia Feininger that László Moholy-Nagy included in the second edition of his *Malerei Fotografie Film*, published in 1927. He upheld this picture as an "objective portrait," in opposition to the "impressionistic" subjectivity of pictorialist portraiture — although the most salient contrast offered by that particular image is with Moholy-Nagy's own blazingly dynamic views of Bauhaus friends and lovers, such as Oskar Schlemmer and Ellen Frank (p. 2). The unhesitant portrait of painter and Bauhaus professor Georg Muche seems on the contrary far from objective or "architectural"; it is, or wants to be, a picture of the mind.

Herbert Molderings has clarified the chronology for such boldly framed portraits in his study of the photojournalist and Bauhaus graduate Umbo (Otto Umbehr), who was apparently

237 WITKOVSKY: PHOTOGRAPH OF GEORG MUCHE

315
Lucia Moholy
Untitled (Georg Muche). 1927,
possibly printed after 1928
Gelatin silver print
8 7/8 x 6 7/8" (22.6 x 17.5 cm)
The Metropolitan Museum of Art, New York.
Ford Motor Company Collection, Gift of
Ford Motor Company and John C. Waddell

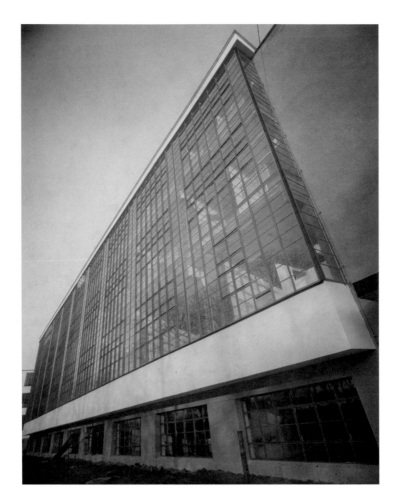

the first in Germany to take portraits — of the artist Paul Citroën, for example, and several female friends — in extreme close-up, beginning at the end of 1926. His pictures, likely inspired by expressionist cinema, featured actresses as well, such as Ruth (Rut) Landshoff (cat. 317), who had had a supporting role in F. W. Murnau's *Nosferatu* (1922). New to photography in Umbo's portraits was a clear, even palpable sense of erotic longing, holding the promise of physical intimacy in nearly unbearable tension with the assurance of unrequited desire. The restraint shown in Alfred Stieglitz's, Paul Strand's, or Edward Weston's portraits of their partners — conveyed through clarity and evenness of tone — is replaced in Umbo's close-ups with the tonal and emotional disequilibrium of cinematic melodrama.

Molderings contends that Moholy, who cropped her 1927 view of Feininger far more tightly for publication in 1930, would not have thought to make works such as Untitled (Georg Muche) before Umbo's interventions (although some of Moholy's portraits continue to be dated to 1926).[6] In 1928 and 1929, meanwhile, extreme close-ups became a staple of Bauhaus photography, as evidenced by László Moholy-Nagy's portrait of Ellen Frank of 1928–29, for example, or the fall 1929 prospectus

junge menschen kommt ans bauhaus! (young people, come to the bauhaus!; p. 4), which includes a number of portraits, nearly all of them tightly cropped (cat. 343).[7]

Cropping alone is not the issue, of course, nor is an evaluation of Moholy's portraits dependent on matters of precedence. Her photographs, while emanating a psychological charge, display none of the despondent eroticism manifested by Umbo, just as her coolly composed studies of hands are a world apart from Stieglitz's views of the impossibly refined fingers of Georgia O'Keeffe. Nor is Moholy after a poster aesthetic, as with Max Burchartz's group of greatly enlarged head shots, including the iconic *Lotte (Auge)* (Lotte [eye], 1928), or Helmar Lerski's worker studies in *Köpfe des Alltags* (Everyday faces, 1931). While her images have impeccable clarity, they cannot be reduced to graphic signs, and they bear neither the cold flatness of prints by Burchartz and other advertising designers nor the exaggerated warmth of Lerski or many other studio photographers linked absolutely to the cinema. Moholy's portraits are not shocking, or haunting, and in fact do not reproduce easily.

The reasons for this divergence are to be found, one may speculate, in Moholy's references, which lie in the nine-

316
Lucia Moholy
Untitled (Bauhaus workshop building from below). 1926
Gelatin silver print
13 7/8 x 10 11/16" (35.2 x 27.2 cm)
The Museum of Modern Art, New York.
Thomas Walther Collection. Gift of
Thomas Walther

317
Umbo (Otto Umbehr)
Ruth. Die Hand (Ruth. The hand). 1927
Gelatin silver print
6 13/16 x 4 3/4" (17.3 x 12 cm)
The Museum of Modern Art, New York.
Thomas Walther Collection. Purchase

Fig.1
Nadar (Félix Tournachon)
Untitled (Charles Baudelaire).
Before March 1855
Salted paper print from glass negative
11 x 6 1/2" (28 x 16.5 cm)
Musée d'Orsay, Paris

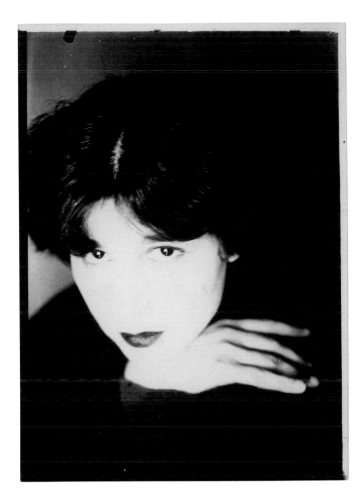

teenth century. These few tremendous photographs are, one may speculate, part of a pedagogical gambit to connect their maker's time with an earlier period in the history of photography. Their psychological tenor is pre-Freudian, untroubled by base drives or traumas. There is the suggestion of a caress offered to men and women alike, certainly in keeping with the blurred gender portrayals important to late-Weimar photography. Yet the highly attentive, emotionally reserved characters created in these images seem of a piece with novels by Gustave Flaubert or perhaps Thomas Hardy, not the flamboyant, distracted androgynes and mercurial femmes fatales of the flapper era.

As a photographic point of comparison, Nadar's portraits of the 1850s seem especially close. The softly modeled contours of *Untitled (Georg Muche)*, its capture of an intent, slightly affected mien floating into clarity above a fuzzily rendered body, recall views by Nadar of sculptor Emmanuel Frémiet or, in a classic image, poet Charles Baudelaire (fig. 1). Faces, the marker of an individuated or oppositional intellect, emerge in all instances from an unmemorable background of bourgeois conformity. In place of conventional symbols of rank or status, there is the revolutionary symbolism of the camera image, which in itself expresses the convergence of mechanical and intellectual vision toward a new — yet already historically grounded — means of communication.

I would submit that Moholy's portrait of Muche is a conscious "registration" if not of Nadar specifically, then of the mid-nineteenth-century portraiture idealized by aesthetically minded advocates of photography in central Europe around 1930. Actualizing their ideal served a pedagogical ambition: to con-

nect with a legacy of achievement in photography, and to argue for its qualities as a "medium" (a word brought newly into vogue during these years). Art historian Franz Roh, who also sat for Moholy (cat. 320), experimented with photographs whose rounded edges and positive-negative reversals likewise recall prints of the mid-1800s, which Roh also collected. (Moholy — or perhaps the sitter — rounded one corner, nineteenth-century fashion, on a small print of this portrait in the collection of The Metropolitan Museum of Art, New York.) Moholy herself was foremost an instructor; she had studied art history at university, and directly after she made these portraits she began to lead photography classes and to write manuals on photographic technique. In 1939, after moving to England, she published *One Hundred Years of Photography*, a modest contribution to the central-European literature on photography as a technical-aesthetic field of historical inquiry.[8] Her apparently exceptional portraits, then, may in fact be part of a broad pedagogical program that Moholy pursued before, during, and after her Bauhaus years.

1. According to Rolf Sachsse, Lucia Moholy's biographer, she served as editor of the daily *Wiesbadener Zeitung* for nearly all of 1915, then worked for Hyperion Verlag in 1917–18. Beginning in 1920, Moholy kept herself and her husband, László Moholy-Nagy, solvent with work as an associate reader at Rowohlt Verlag. See Sachsse, *Lucia Moholy* (Düsseldorf: Marzona, 1985).
2. "Produktion Reproduktion," a pathbreaking text first published in *De Stijl* 5, no. 7 (1922), has long been credited to Lucia and László Moholy-Nagy, although it was signed by László alone.
3. Lucia Moholy, diary entry, 1915, quoted in Sachsse, *Lucia Moholy*, p. 7.
4. Lucia Moholy's photographs were also shown in *Neue Wege der Photographie* (Jena, 1928), and other exhibitions, but details are largely unclear. At least one work in the Jena exhibition was a portrait of three children of *Bauhäusler*, probably made on commission from the school.
5. Lucia Moholy, "Fragen der Interpretation," quoted in Eckhard Neumann, *Bauhaus und Bauhäusler* (Stuttgart: Hallwag, 1971), pp. 169–78.
6. Herbert Molderings, *Umbo (Otto Umbehr) 1902-1980* (Düsseldorf: Richter, 1995), pp. 65–66. Molderings notes that Umbo's portraits were first published in June 1927, in the leisure weekly *Die grüne Post*. Original prints in this vein were shown in Berlin in February 1928, and then at *Neue Wege der Photographie* in Jena the following month. (It should be added that Moholy's portraits, known mostly in exhibition formats, would logically have been printed for such exhibitions as well, in 1928 or 1929 but not earlier.)
7. Ibid., p. 66.
8. See Martin Gasser, "Histories of Photography 1839–1939," *History of Photography* 16, no. 1 (Spring 1992):50–60. See also my essay "Circa 1930: Art History and the New Photography," *Etudes Photographiques* 23 (June 2009).

315
Lucia Moholy
Untitled (Georg Muche). 1927,
possibly printed after 1928
Gelatin silver print
8 ⁷⁄₈ x 6 ⁷⁄₈" (22.6 x 17.5 cm)
The Metropolitan Museum of Art, New York.
Ford Motor Company Collection, Gift of
Ford Motor Company and John C. Waddell

the first in Germany to take portraits — of the artist Paul Citroën, for example, and several female friends — in extreme close-up, beginning at the end of 1926. His pictures, likely inspired by expressionist cinema, featured actresses as well, such as Ruth (Rut) Landshoff (cat. 317), who had had a supporting role in F. W. Murnau's *Nosferatu* (1922). New to photography in Umbo's portraits was a clear, even palpable sense of erotic longing, holding the promise of physical intimacy in nearly unbearable tension with the assurance of unrequited desire. The restraint shown in Alfred Stieglitz's, Paul Strand's, or Edward Weston's portraits of their partners — conveyed through clarity and evenness of tone — is replaced in Umbo's close-ups with the tonal and emotional disequilibrium of cinematic melodrama.

Molderings contends that Moholy, who cropped her 1927 view of Feininger far more tightly for publication in 1930, would not have thought to make works such as Untitled (Georg Muche) before Umbo's interventions (although some of Moholy's portraits continue to be dated to 1926).[6] In 1928 and 1929, meanwhile, extreme close-ups became a staple of Bauhaus photography, as evidenced by László Moholy-Nagy's portrait of Ellen Frank of 1928–29, for example, or the fall 1929 prospectus

junge menschen kommt ans bauhaus! (young people, come to the bauhaus!; p. 4), which includes a number of portraits, nearly all of them tightly cropped (cat. 343).[7]

Cropping alone is not the issue, of course, nor is an evaluation of Moholy's portraits dependent on matters of precedence. Her photographs, while emanating a psychological charge, display none of the despondent eroticism manifested by Umbo, just as her coolly composed studies of hands are a world apart from Stieglitz's views of the impossibly refined fingers of Georgia O'Keeffe. Nor is Moholy after a poster aesthetic, as with Max Burchartz's group of greatly enlarged head shots, including the iconic *Lotte (Auge)* (Lotte [eye], 1928), or Helmar Lerski's worker studies in *Köpfe des Alltags* (Everyday faces, 1931). While her images have impeccable clarity, they cannot be reduced to graphic signs, and they bear neither the cold flatness of prints by Burchartz and other advertising designers nor the exaggerated warmth of Lerski or many other studio photographers linked absolutely to the cinema. Moholy's portraits are not shocking, or haunting, and in fact do not reproduce easily.

The reasons for this divergence are to be found, one may speculate, in Moholy's references, which lie in the nine-

316
Lucia Moholy
Untitled (Bauhaus workshop building from below). 1926
Gelatin silver print
13 7/8 × 10 11/16" (35.2 × 27.2 cm)
The Museum of Modern Art, New York.
Thomas Walther Collection. Gift of
Thomas Walther

317
Umbo (Otto Umbehr)
Ruth. Die Hand (Ruth. The hand). 1927
Gelatin silver print
6 13/16 × 4 3/4" (17.3 × 12 cm)
The Museum of Modern Art, New York.
Thomas Walther Collection. Purchase

Fig.1
Nadar (Félix Tournachon)
Untitled (Charles Baudelaire).
Before March 1855
Salted paper print from glass negative
11 × 6 1/2" (28 × 16.5 cm)
Musée d'Orsay, Paris

WITKOVSKY: PHOTOGRAPH OF GEORG MUCHE

teenth century. These few tremendous photographs are, one may speculate, part of a pedagogical gambit to connect their maker's time with an earlier period in the history of photography. Their psychological tenor is pre-Freudian, untroubled by base drives or traumas. There is the suggestion of a caress offered to men and women alike, certainly in keeping with the blurred gender portrayals important to late Weimar photography. Yet the highly attentive, emotionally reserved characters created in these images seem of a piece with novels by Gustave Flaubert or perhaps Thomas Hardy, not the flamboyant, distracted androgynes and mercurial femmes fatales of the flapper era.

As a photographic point of comparison, Nadar's portraits of the 1850s seem especially close. The softly modeled contours of Untitled (Georg Muche), its capture of an intent, slightly affected mien floating into clarity above a fuzzily rendered body, recall views by Nadar of sculptor Emmanuel Frémiet or, in a classic image, poet Charles Baudelaire (fig. 1). Faces, the marker of an individuated or oppositional intellect, emerge in all instances from an unmemorable background of bourgeois conformity. In place of conventional symbols of rank or status, there is the revolutionary symbolism of the camera image, which in itself expresses the convergence of mechanical and intellectual vision toward a new — yet already historically grounded — means of communication.

I would submit that Moholy's portrait of Muche is a conscious "registration" if not of Nadar specifically, then of the mid-nineteenth-century portraiture idealized by aesthetically minded advocates of photography in central Europe around 1930. Actualizing their ideal served a pedagogical ambition: to con-

nect with a legacy of achievement in photography, and to argue for its qualities as a "medium" (a word brought newly into vogue during these years). Art historian Franz Roh, who also sat for Moholy (cat. 320), experimented with photographs whose rounded edges and positive-negative reversals likewise recall prints of the mid-1800s, which Roh also collected. (Moholy — or perhaps the sitter — rounded one corner, nineteenth-century fashion, on a small print of this portrait in the collection of The Metropolitan Museum of Art, New York.) Moholy herself was foremost an instructor; she had studied art history at university, and directly after she made these portraits she began to lead photography classes and to write manuals on photographic technique. In 1939, after moving to England, she published *One Hundred Years of Photography*, a modest contribution to the central-European literature on photography as a technical-aesthetic field of historical inquiry.[8] Her apparently exceptional portraits, then, may in fact be part of a broad pedagogical program that Moholy pursued before, during, and after her Bauhaus years.

1. According to Rolf Sachsse, Lucia Moholy's biographer, she served as editor of the daily *Wiesbadener Zeitung* for nearly all of 1915, then worked for Hyperion Verlag in 1917–18. Beginning in 1920, Moholy kept herself and her husband, László Moholy-Nagy, solvent with work as an associate reader at Rowohlt Verlag. See Sachsse, *Lucia Moholy* (Düsseldorf: Marzona, 1985).

2. "Produktion Reproduktion," a pathbreaking text first published in *De Stijl* 5, no. 7 (1922), has long been credited to Lucia and László Moholy-Nagy, although it was signed by László alone.

3. Lucia Moholy, diary entry, 1915, quoted in Sachsse, *Lucia Moholy*, p. 7.

4. Lucia Moholy's photographs were also shown in *Neue Wege der Photographie* (Jena, 1928), and other exhibitions, but details are largely unclear. At least one work in the Jena exhibition was a portrait of three children of *Bauhäusler*, probably made on commission from the school.

5. Lucia Moholy, "Fragen der Interpretation," quoted in Eckhard Neumann, *Bauhaus und Bauhäusler* (Stuttgart: Hallwag, 1971), pp. 169–78.

6. Herbert Molderings, *Umbo (Otto Umbehr) 1902-1980* (Düsseldorf: Richter, 1995), pp. 65–66. Molderings notes that Umbo's portraits were first published in June 1927, in the leisure weekly *Die grüne Post*. Original prints in this vein were shown in Berlin in February 1928, and then at *Neue Wege der Photographie* in Jena the following month. (It should be added that Moholy's portraits, known mostly in exhibition formats, would logically have been printed for such exhibitions as well, in 1928 or 1929 but not earlier.)

7. Ibid., p. 66.

8. See Martin Gasser, "Histories of Photography 1839–1939," *History of Photography* 16, no. 1 (Spring 1992):50–60. See also my essay "Circa 1930: Art History and the New Photography," *Etudes Photographiques* 23 (June 2009).

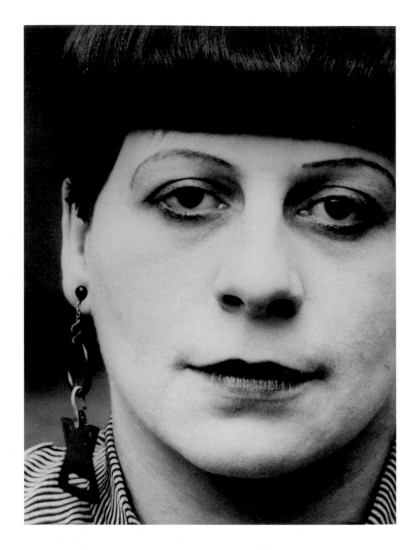

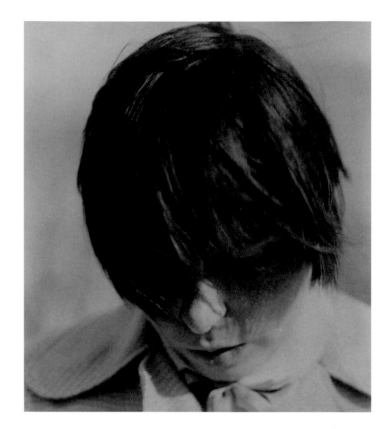

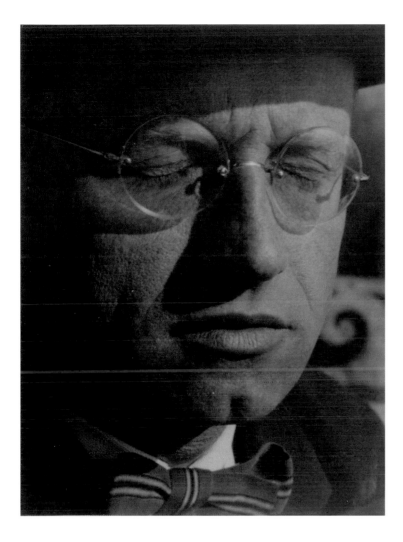

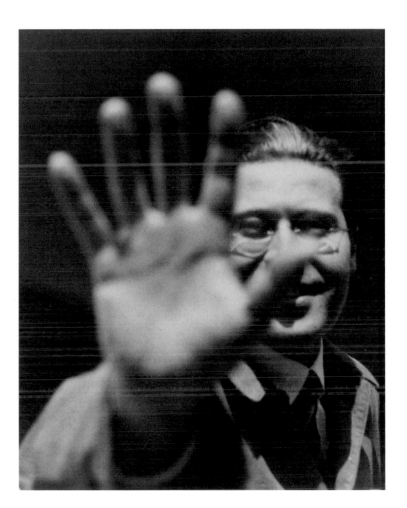

318
Lucia Moholy
Untitled (Florence Henri). 1927
Gelatin silver print, probably printed after 1928
14 5/8 x 11" (37.1 x 28 cm)
The Museum of Modern Art, New York.
Thomas Walther Collection. Gift of
Thomas Walther

319
Lucia Moholy
Untitled (Edith Tschichold). 1925–26
Gelatin silver print, probably printed after 1928
10 3/4 x 9 5/8" (27.4 x 24.5 cm)
The Museum of Modern Art, New York.
Horace W. Goldsmith Fund through
Robert B. Menschel

320
Lucia Moholy
Untitled (Franz Roh). 1926
Gelatin silver print, probably printed after 1928
14 11/16 x 10 15/16" (37.3 x 27.8 cm)
The Metropolitan Museum of Art, New York.
Warner Communications, Inc., Purchase Fund

321
Lucia Moholy
Untitled (László Moholy-Nagy). 1925–26
Gelatin silver print, probably printed after 1928
10 1/16 x 7 7/8" (25.6 x 20 cm)
The Metropolitan Museum of Art, New York.
Ford Motor Company Collection, Gift of
Ford Motor Company and John C. Waddell

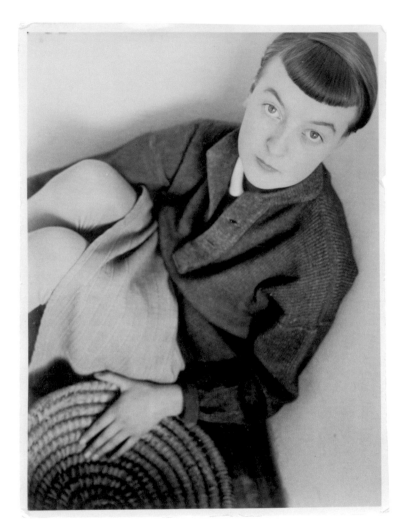

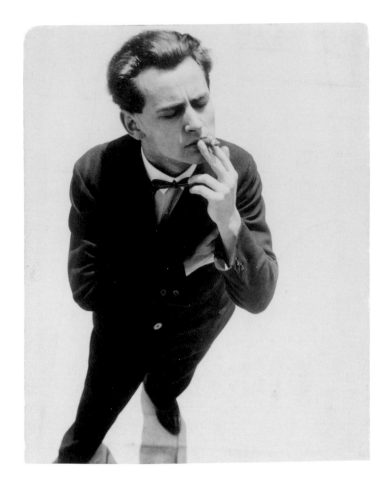

322
Photographer unknown
Untitled (Lis Beyer). February 20, 1929
Gelatin silver print
4 9/16 x 3 7/16" (11.6 x 8.7 cm)
Bauhaus-Archiv Berlin

323
T. Lux Feininger
Untitled (Clemens Röseler). c. 1928
Gelatin silver print
4 7/16 x 3 1/2" (11.3 x 8.9 cm)
The Metropolitan Museum of Art, New York.
Ford Motor Company Collection. Gift of
Ford Motor Company and John C. Waddell

324
Josef Albers
*Marli Heimann, III.IV 31, Alle während 1
Stunde* (Marli Heimann, April 3, 1931,
all during an hour). 1931
Twelve gelatin silver prints mounted on board
Overall: 11 11/16 x 16 7/16" (29.7 x 41.8 cm)
The Museum of Modern Art, New York.
Gift of The Josef Albers Foundation, Inc.

325
Josef Albers
Klee, Dessau XI 29 (Paul Klee, Dessau
November 1929). 1929
Three gelatin silver prints mounted on board
Overall: 6 3/4 x 16 7/16" (17.1 x 41.8 cm)
The Museum of Modern Art, New York.
Gift of The Josef Albers Foundation, Inc.

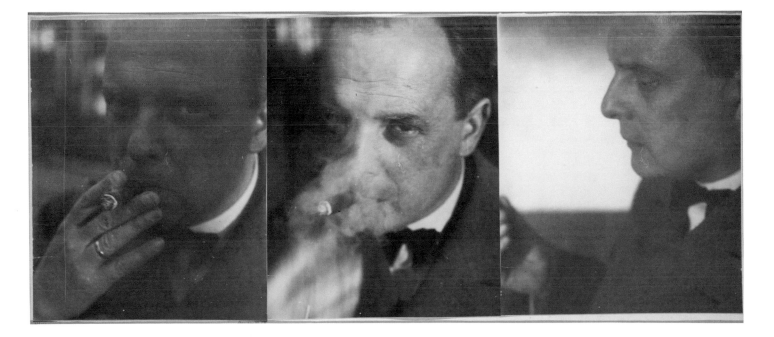

326
Vasily Kandinsky
Massiver Bau (Massive building). 1932
Gouache on brown paper, mounted
on cardboard
13 x 19 3/16" (33 x 48.7 cm)
Kunstmuseum Basel, Kupferstichkabinett

327
Vasily Kandinsky
Rotes Quadrat (Red square). 1928
Watercolor on paper
12 11/16 x 19" (32.2 x 48.3 cm)
Long Beach Museum of Art. The Milton
Wichner Collection

328
Paul Klee
Horizont, Gipfelpunkt und Atmosphaere
(Horizon, zenith, and atmosphere). 1925
Watercolor (sprayed) on paper mounted
on cardboard
14 15/16 x 19 9/16" (37.9 x 26.9 cm)
Solomon R. Guggenheim Museum,
New York

329
Paul Klee
Briefbild Z. 5. Dezember 1927
(Letter picture Z. December 5, 1927). 1926
Watercolor (sprayed) and ink on paper,
on board
9 5/16 x 12" (23.7 x 30.5 cm)
Centre Pompidou, Paris. Musée national d'art
moderne/Centre de création industrielle

330
László Moholy-Nagy
Zwischen Himmel und Erde (Between
heaven and earth). 1923–27
Cut-and-pasted gelatin silver prints,
a photogram, and photomechanical
reproductions with pencil on paper
25 9/16 x 19 11/16" (65 x 50 cm)
Galerie Berinson, Berlin

331
László Moholy-Nagy
Rutschbahn (Slide). 1923
Cut-and-pasted photomechanical
reproductions, ink, and pencil on paper
25 1/2 x 19 1/2" (64.7 x 49.5 cm)
The Museum of Modern Art, New York.
Gift of Mrs. Sibyl Moholy-Nagy

332
László Moholy-Nagy
Eifersucht (Jealousy). 1927
Cut-and-pasted photographs and
photomechanical reproductions with
drawn elements on paper
25 ⅛ x 22 ⅟₁₆" (63.8 x 56.1 cm)
George Eastman House, Rochester, N.Y.

333
László Moholy-Nagy
Massenpsychose (Mass psychosis). 1927
Cut-and-pasted photographs and photo-
mechanical reproductions with pencil,
ink, and gouache on paper
25 ¼ x 19 ⅜" (64.2 x 49.2 cm)
George Eastman House, Rochester, N.Y.

MARIANNE BRANDT
OUR UNNERVING CITY. 1926
MATTHEW S. WITKOVSKY

Unsere irritierende Grossstadt (Our unnerving city) is among the most intricate of the approximately four dozen photomontages made by Bauhaus metalworker Marianne Brandt, almost all between 1926 and 1931. While the majority of her compositions follow her mentor, László Moholy-Nagy, in the sparing deployment of single images over large expanses of neutral background, this composition nearly covers the surface with an accretion of overlapping scenes and characters. The result is a grand, quasi-cinematic narrative that exemplifies the "metropolitan melodrama," itself an exemplary genre in the film and literature of Weimar Germany and interwar central Europe.

Brandt demonstrates terrific compositional skills in her photomontages. Her leanest and her fullest creations alike show a keen sense for scale, rhythm, and the play of perspective. In *Unsere irritierende Grossstadt*, she invites our attention through suggestions of a plausible perspective: the two views of buildings at bottom right are angled inward, the bridge and the massive courtyard at center face straight out, and an extension of that bridge has been excerpted to create a dramatic, single line that shoots inward from the left. Out of this vortex thrusts the arrowlike facade of Chilehaus, a recently completed, signal addition to the Hamburg skyline.[1] To reach that jutting form we have only to follow the cyclist at center right, who pedals us into the heart of the work, and implicitly over the foot and car traffic toward the architecture beyond.

In other words, Brandt knows how to draw in viewers. Single figures — the Josephine Baker–like dancer at left, the portly worker at bottom, the cyclist in the middle of the picture, and the vaulting gymnast at top — are matched in scale and thus anchor the panorama symmetrically at its cardinal points. Sprawled behind them are great tropes of urban industrialization in the interwar era: skyscrapers or abstract building blocks, streets packed with crowds, large machinery on the move. This imagery coexists, indeed forms an indissociable unity with, scenes of exotic leisure (desert dunes, hatted tourists passing among the natives, the daredevil ascent of a glacier), which most city-dwellers could apprehend only in magazines or onscreen. The views Brandt chooses, indeed, could only be pictured in the illustrated press or the cinema; they offer an otherwise unattainable proximity to sights and events of terrific grandeur. The cycling race at bottom, observed in a news photo apparently taken on the racetrack, and the film still at top of a man carrying off a fainting woman, merely underscore the

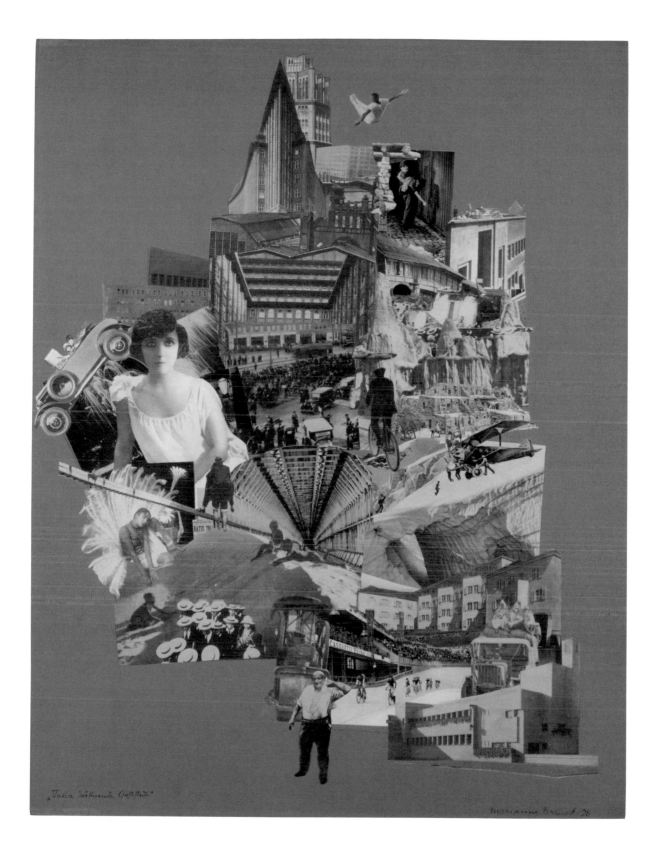

334
Marianne Brandt
Unsere irritierende Grossstadt
(Our unnerving city). 1926
Cut-and-pasted newspaper clippings
on gray cardboard
25 x 19 ⅛" (63.5 x 48.6 cm)
Private collection, Chicago

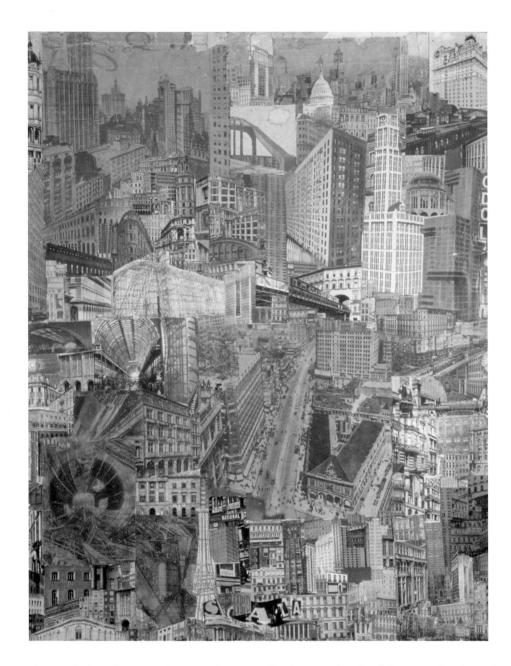

sensation one has in this work that all metropolitan incident is staged for the camera. There is no distinction here between experience and its representation as spectacle, or what today is called a reality show.

As protagonist in this urban thriller, Brandt has chosen a young lady, or more likely a female mannequin, another figure of great currency in the narratives of Weimar Germany. This is the New Woman, a creature born of and for the news media, who personified the unreality of those times. Newly independent yet in many ways more enslaved than ever, the New Woman tussled in story after story with her self-identification as a puppet or two-dimensional image.[2] Our mute heroine offers no sustained comment on this predicament, nor does the creator of this montage; their achievement is to personalize the swirl of events around them, and in so doing to enlist our sympathy in this worried yet ultimately affirmative drama of modern urban existence.

Brandt scholar Elizabeth Otto has noted the precedent for *Unsere irritierende Grosstadt* in the work of onetime

Bauhaus student Paul Citroën, who showed one of his series of montages on the theme of the metropolis at the first Bauhaus exhibition in 1923.[3] Perhaps the most monumental image from that series, Citroën's *Grossstadt* (Metropolis; cat. 335) of 1923, was reproduced in German daily newspapers as well as in progressive art publications at home and abroad, and had reached the status of icon by the time Brandt made her work, three years later.[4] Brandt — who, unlike Citroën, kept her work in photomontage utterly private — repeats his device of a breathing space at the center of a packed wall of imagery. She departs decisively from Citroën, however, in her insistence upon narrativity, and in her formidable orchestration of scale and perspective in the service of that goal. Where Citroën provides a setting alone, and makes that setting (the city) into a visual subject, Brandt insists on human protagonists whose stories allegorize the city around them.

For these reasons Brandt's work comes closer in spirit to Polish photomontages of a slightly later date, such as *Miasto młyn życia* (City, the mill of life), made by avant-garde filmmaker

and popular photomontagist Kazimierz Podsadecki for the cover of the Cracow leisure weekly *Na szerokim świecie* in June 1929 (fig. 1).[5] Podsadecki, like Brandt, sends athletes leaping to the summits of buildings while small aircraft girdle the skyline. Such elements of optimism are more than offset, however, by scenes of anarchic brutality, including strangulation and a cowardly shooting. Podsadecki, working after the release of Fritz Lang's *Metropolis* in 1927, comes closer than Brandt to that film's dystopic futurism, mixing in for added effect references to the emergent genre of gangster movies. One further element in common, however, between *Unsere irritierende Grosstadt* and *Miasto młyn życia* is the central presence of a young woman to address the audience. Brandt's choice for that role, recurrent in her photomontages, looks composed and perhaps reflective, whereas Podsadecki proffers the voyeuristic sight of an unwitting victim. Despite this great difference, the two female agents allegorize a common reader response: paralytic fascination with the spectacle of a world in which creation and destruction form mutually sustaining, all-consuming cancers.

1. See Elizabeth Otto, *Tempo, Tempo: The Photomontages of Marianne Brandt* (Berlin: Bauhaus-Archiv and jovis, 2005), p. 156, n. 2.

2. As a shorthand guide to the voluminous literature on this subject I offer the fourth chapter of my book *Foto: Modernity in Central Europe, 1918–1945* (Washington, D.C.: National Gallery of Art, 2007).

3. Otto, *Tempo, Tempo*, p. 43. The montage Paul Citroën showed in 1923 is reproduced in *Staatliches Bauhaus in Weimar 1919–1923* (Weimar and Munich: Bauhausverlag, 1923), p. 215, and, in an installation view, in Bernd Finkeldey et al., *Konstruktivistische Internationale Schöpferische Arbeitsgemeinschaft 1922–1927. Utopien für eine europäische Kultur* (Stuttgart: Gerd Hatje, 1992), p. 184.

4. See Herbert Molderings, "Paul Citroën and Photography: The Beginnings in Berlin," in Flip Bool et al., *Paul Citroen 1896–1983* (Amsterdam: Focus Publishing, 1996), pp. 6–10.

5. See Stanislaw Czekalski, "Kazimierz Podsadecki and Janusz Maria Brzeski: Photomontage between the Avant-Garde and Mass Culture," *History of Photography* 29, no. 3 (Autumn 2005):256–73.

335
Paul Citroën
Grossstadt (Metropolis). 1923
Cut-and-pasted photomechanical
reproductions on paper
29 15/16 x 23" (76.1 x 58.4 cm)
Prentenkabinet Universiteit Leiden

Fig.1
Kazimierz Podsadecki
Miasto młyn życia (City, the mill of life). 1929
Photolithograph of photomontage
17 1/8 x 11 7/16" (43.5 x 29 cm)
Museum Szutki w Łodzi, Lodz

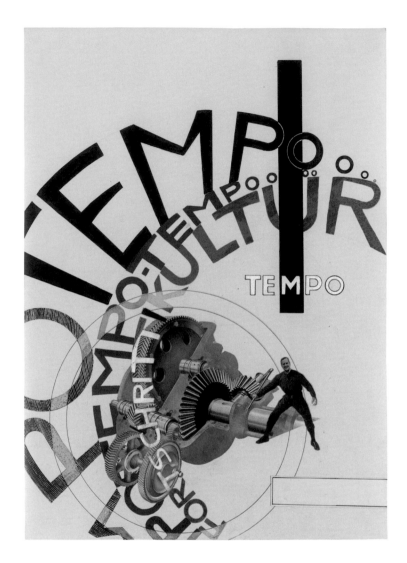

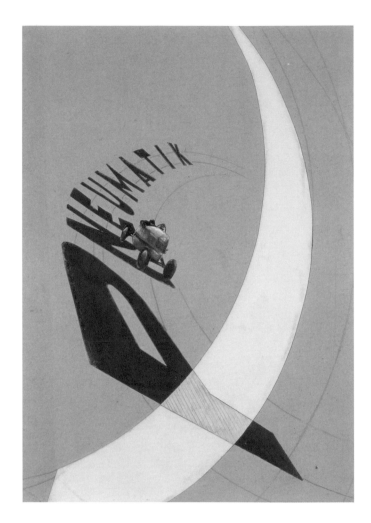

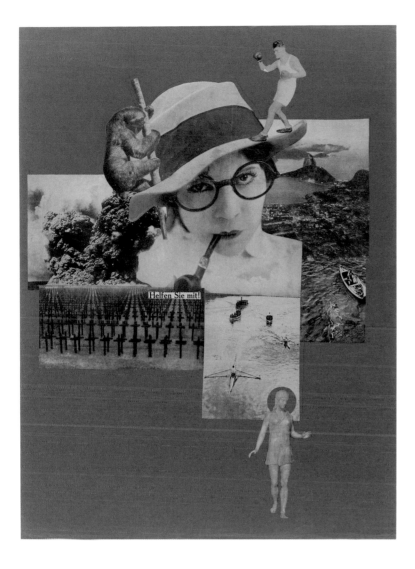

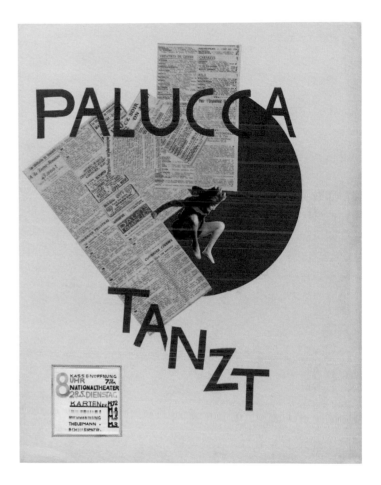

336
Marianne Brandt
Tempo-Tempo, Fortschritt, Kultur
(Tempo-Tempo, progress, culture). 1927
Cut-and-pasted newspaper clippings with ink
20 1/2 x 15 11/16" (52 x 39.8 cm)
Kupferstich-Kabinett, Staatliche
Kunstsammlungen Dresden

337
László Moholy-Nagy
Pneumatik (Pneumatic). 1926
Gouache, pencil, and cut-and-pasted
photomechanical element on paper
12 5/8 x 9 1/16" (32 x 23 cm)
Louisiana Museum of Modern Art,
Humblebaek, Denmark. Donation:
The Joseph and Celia Ascher Collection,
New York

338
Marianne Brandt
Helfen Sie mit! (Die Frauenbewegte)
(Come help! [The liberated woman]). 1926
Cut-and-pasted newspaper clippings with
pencil on gray cardboard
26 7/8 x 19 13/16" (68.3 x 50.3 cm)
Kupferstich-Kabinett, Staaatliche
Kunstsammlungen Dresden

339
Marianne Brandt
Palucca Tanzt (Palucca dances). 1929
Cut-and-pasted newspaper clippings with ink
25 1/16 x 19 11/16" (63.7 x 50 cm)
Kupferstich-Kabinett, Staatliche
Kunstsammlungen Dresden

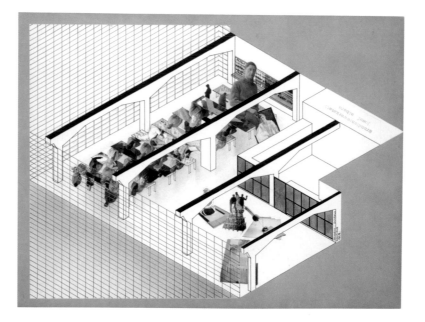

340 (top)
Hermann Trinkaus
Grundlehrewerkstatt Josef Albers (Preliminary-
course workshop of Josef Albers). From *9 Jahre
Bauhaus: Eine Chronik* (9 years Bauhaus:
a chronicle), a set of works made for Walter
Gropius on his departure from the school. 1928
Photographs and newspaper clippings, ink,
watercolor, printed ink on paper, mounted
on yellow card
16 7/16 x 21 5/8" (41.7 x 55 cm)
Bauhaus-Archiv Berlin

341 (opposite, center)
Gunta Stölzl
Selbstportrait (Self-portrait). From *9 Jahre Bauhaus: Eine Chronik* (9 Years Bauhaus: a chronicle), a set of works made for Walter Gropius on his departure from the school. 1928
Cut-and-pasted photographs, plastic and glossy foil, sequins, rayon, and colored tissue paper on paper, mounted on red cardboard
16 7/16 x 21 7/8" (41.7 x 55.5 cm)
Bauhaus-Archiv Berlin

342 (opposite, below)
Edmund Collein
Erweiterung des Prellerhauses (Extension to the Prellerhaus). From *9 Jahre Bauhaus: Eine Chronik* (9 years Bauhaus: a chronicle), a set of works made for Walter Gropius on his departure from the school. 1928
Cut-and-pasted photographs and photo-mechanical reproductions, with handwritten stickers on paper
16 5/16 x 21 5/8" (41.5 x 55 cm)
Bauhaus-Archiv Berlin

343
T. Lux Feininger
Untitled (Group of Bauhaus students). From left: Georg Hartmann, Naf(tali) Rubinstein, Miriam Manuckiam, Günter Menzel. c.1929
Gelatin silver print
4 5/8 x 3 1/2" (11.8 x 8.9 cm)
Bauhaus-Archiv Berlin

344
T. Lux Feininger
Untitled (Sport at the Bauhaus). c.1927
Gelatin silver print
9 5/16 x 7 1/16" (23.7 x 17.9 cm)
Bauhaus-Archiv Berlin

The campuslike building of the Bundesschule des ADGB (Federal school of the Allgemeiner Deutscher Gewerkschaftsbund, or German trade union federation) is as rational and raw as a factory yet also welcoming and uplifting, convivial in its social arrangements, and integrated into the landscape. After it was completed, in 1930, 120 members of the ADGB would assemble here for one or two months at a time to study management, economics, insurance, labor law, and industrial hygiene. In the recuperative natural setting of a pinewood glade in the state forest of Bernau, near Berlin, they acquired knowledge and developed relationships that were to help them advance the workers' movement in transforming the capitalist system of production toward greater social equity.

The school was designed by Hannes Meyer with his partner, Hans Wittwer, and a group of Bauhaus students in early 1928. Meyer had arrived at the Bauhaus in April 1927 to initiate the school's first full architecture program. By August, arrangements had been made for Wittwer to join the school, where he and Meyer then collaborated on the competition for the Bundesschule. Their partnership had only been formed the previous year but had already gained recognition for competition entries for the Peterschule in Basel (1926) and the League of Nations in Geneva (1927; cat. 30). Having structured the new curriculum into separate courses on building theory and building practice, Meyer sought real commissions like this one to draw the two together.[1] Other commissions included small houses and an apartment building that extended Walter Gropius's Törten housing estate in Dessau. Meyer and Wittwer's project for the ADGB won over proposals by Erich Mendelsohn, Max Taut, and several others[2] for its careful development of the program for the "school behind the school": Meyer had written that buildings should be the "direct transcription of the functional diagram,"[3] and approached the assignment by first conceiving a pattern of communal life for the new institution and then giving it a "rich and vigorous architectural expression."[4]

In this sprawling complex of linked buildings the daily lives of the trade unionists were housed in rooms and arrangements of spaces specifically designed for their functions, interlocking like the parts of a machine or the cells of a living organism. Seeking to balance individual and community while also reconciling technology and nature, Meyer and Wittwer integrated each part into a harmonious, smoothly operating whole. The auditorium, dining hall, and offices were grouped into a square entry block, through which everyone had to pass and where everyone assembled. While the residences for teachers and their families marched along the roadway, those for students stepped down the gently sloping site in a series of three-story buildings. The 120 trade unionists were divided into twelve "cells" of ten members each, who were intended to eat, study, and exercise together. Each cell occupied the five double rooms on each floor of the residential blocks, of which there were four, arranged end on end like dominos yet staggered and linked by a diagonal hallway. Much more than a corridor, this hall was a social space with views to the landscape and stairs that spatially linked the cells (cat. 348). Its expansive floor-to-ceiling windows, within red casements, provided generous light and views as well as counterpoint to the buildings' yellow brick walls and exposed concrete structure. At its end, a cantilevered stairway rose alongside a two-story building that housed the library, class- and seminar rooms, and the gymnasium, which opened to the playing fields outside (cat. 345).

Meyer had long been interested in cooperative models of living and work and had been active in the Swiss cooperative movement, which pursued a path between capitalism and communism. In 1919–20 he had designed the Freidorf cooperative housing estate in Basel, which integrated social facilities within a strongly geometric site plan. The modularity and symmetry of the plan were inspired by a study of Palladian proportions and were intended to link spatial, psychological, and social harmony in an immediately perceptible way.[5] With his Co-op Vitrine of 1924–25 (fig. 1), a display of cooperatively manufactured products, Meyer embarked on a new mode of practice that sought to transform industrial capitalism from within by redeploying its tools — standard objects, serial production, and advertising — in the service of a collectivist society.[6] The projects for the Peterschule and League of Nations extended this approach into architecture by adopting rationalized spatial planning, industrialized construction, and the technical expression of structure.

345
Hannes Meyer and **Hans Wittwer**
Bundesschule des Allgemeinen Deutschen Gewerkschaftsbundes (Federal school of the German trade union federation), Bernau. 1928–30
School wing. East view
Photograph: Walter Peterhans. c. 1930.
Gelatin silver print. 11⁹⁄₁₆ x 15¾" (30 x 40 cm).
Deutsches Architekturmuseum, Frankfurt

346
Hannes Meyer and **Hans Wittwer**
Bundesschule des Allgemeinen Deutschen Gewerkschaftsbundes (Federal school of the German trade union federation), Bernau. 1928–30
Main entrance with offices, loading platform, and garage. Side view. 1930
Photograph: Walter Peterhans. c. 1930.
Gelatin silver print. 11¹³⁄₁₆ x 15¾" (30 x 40 cm). Bauhaus-Archiv Berlin

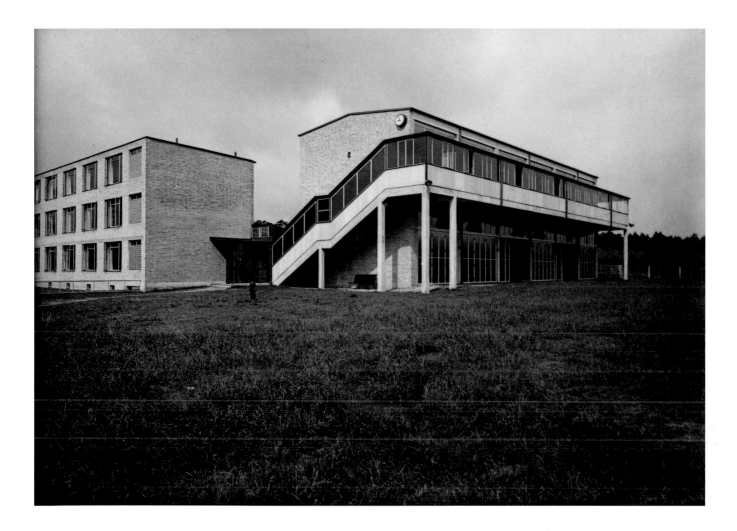

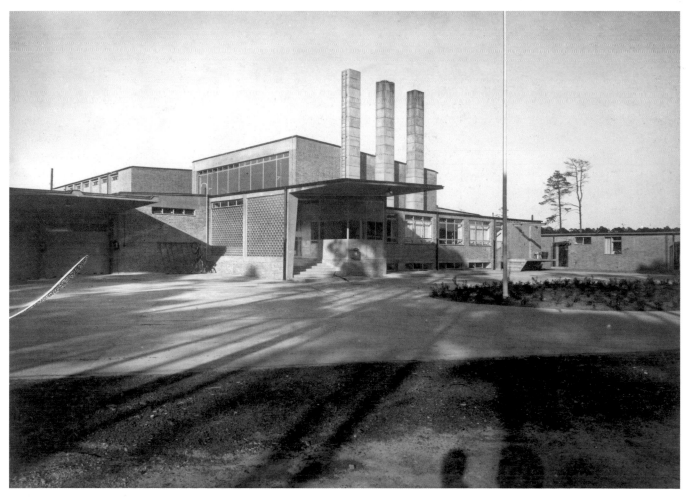

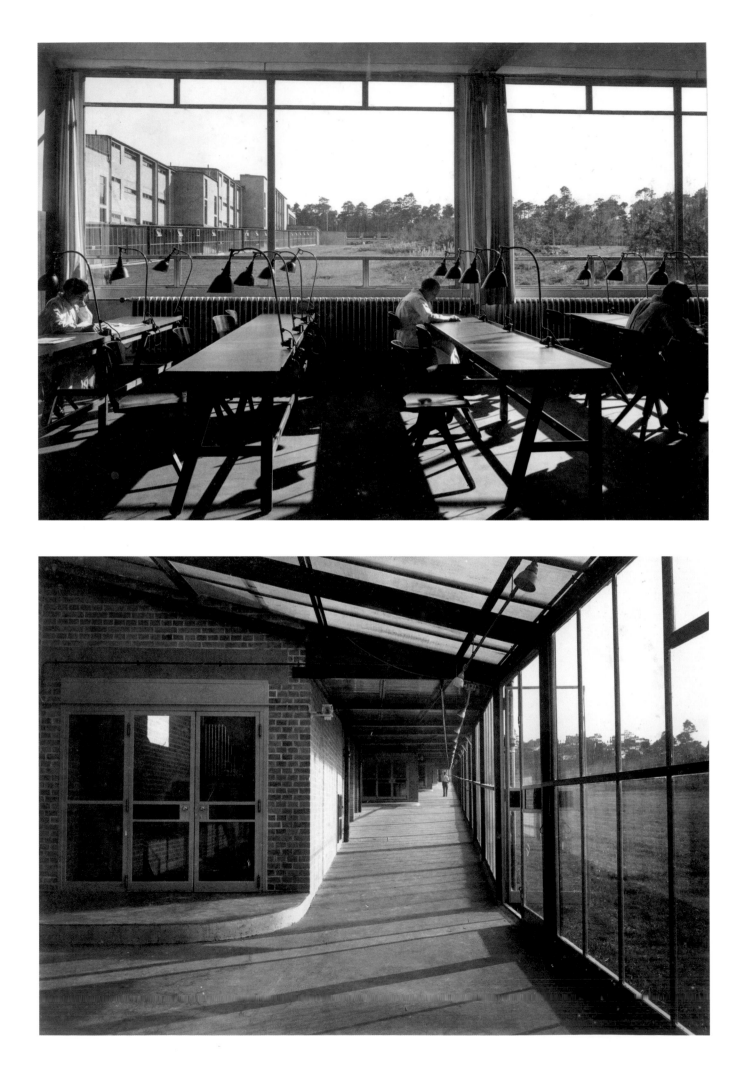

Meyer won the ADGB competition shortly after becoming director of the Bauhaus, in March 1928. He pursued the commission with the students but without Wittwer, who would leave the school in February 1929.[7] Meyer was employing cooperative principles when he assigned the students to "vertical work-brigades," which combined seniors and juniors and brought experts together with novices for the planning and execution of the building.[8] He sought to replace the traditional architect with a creative team of specialists in town planning, building materials, heating, ventilation, statics, and lighting — all subjects of study in the theory curriculum.[9] The drawings for the project overflowed with analytical diagrams, exposure to sun calculations, and furniture arrangements that were to lead directly into functional form. Meyer also shifted the architect's coordinating role from working with trades on the construction site to preparing drawings that integrated technical specifications in advance.[10]

Like other leftist constructivists in his circle — Hans Schmidt, Mart Stam, El Lissitzky, Arthur Korn — and before them the Workers' Group of Constructivists in Moscow, Meyer railed against artistic composition and aesthetics as arbitrary, functionless, and formulaic.[11] He distinguished between art that was dead — yesterday, Bohemia, "atmosphere, color values, burr, mellow tones, and random brushstrokes," art for art's sake — and a new kind of creative work, integral to the new times and its communal consciousness. "Art," he explained in 1926, had "an undisputed right to exist, provided the speculative spirit of mankind has need of it after the graphic-colored, plastic-constructive, musical-kinetic overthrow of its philosophy of life."[12] In the sphere of architecture, Meyer declared building to be social and biological, nothing more than "organization: social, technical, economic, psychological organization." Like "all things in the world," it was the "product of the formula: (function times economy)."[13] Yet the Bundesschule went well beyond the technocratic determinism that this implied by incorporating subtleties of form, material, and technical means — even in color, rhythm, and the size of bricks — to enhance the use and comfort of what would otherwise be a utilitarian environment. The critic Adolf Behne suggested that the building's elemental simplicity, precision, and clarity served to maximize the pleasure of living and learning.[14] So too did the abundance of light, the variety of the views, the well-proportioned rooms, the muscular structure of the gymnasium, the glass-block ceiling of the dining hall, and the electrical equipment of the auditorium. Changes in color from scarlet to vermillion and pink helped visitors to find their way in the residential wings, while illuminated signs, similar to railway signals, shone green, yellow, blue, and red. From the entry drop-off to the biomorphic swimming pool that elegantly restructured one end of the small lake, the spaces of the complex were carefully configured to yield

347
Hannes Meyer and **Hans Wittwer**
Bundesschule des Allgemeinen Deutschen
Gewerkschaftsbundes (Federal school of
the German trade union federation), Bernau.
1928–30
Reading room
Photograph: Walter Peterhans. c.1930.
Gelatin silver print. 11 13/16 x 15 3/4"
(30 x 40 cm). Bauhaus-Archiv Berlin

348
Hannes Meyer and **Hans Wittwer**
Bundesschule des Allgemeinen Deutschen
Gewerkschaftsbundes (Federal school of
the German trade union federation), Bernau.
1928–30
Glass walkway linking the four student-
residence buildings. View toward southwest
Photograph: Walter Peterhans. c.1930.
Gelatin silver print. 11 13/16 x 15 3/4"
(30 x 40 cm). Bauhaus-Archiv Berlin

Fig.1
Hannes Meyer
Co-op Vitrine, designed for the *Internationale
Ausstellung des Genossenschaftswesens und
der sozialen Wohlfahrtspflege*, an exhibition
of Swiss cooperative products in Gent
and Basel. 1925
Photograph: possibly Th. Hoffmann. 1925.
Gelatin silver print. 3 x 4 1/8" (7.6 x 10.4 cm).
Galerie Kicken Berlin

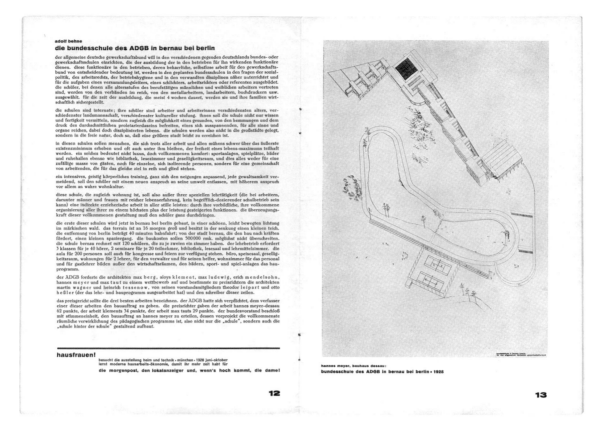

experiences of well-being that constituted what Meyer called "psychological organization."

Meyer's polemical statements are easily taken out of context and misread as one-sided, but belonged to a world view that was in fact holistic. He sought to educate the "total" and "harmonic" human being through integration and the balance of opposites. In reinforcing the "scientific pole" of Bauhaus teaching, Meyer also sought to expand its "artistic pole," in order to nourish the design workshops from both directions. He gave greater scope to the school's artists by expanding the preliminary course, asking Paul Klee and Vasily Kandinsky to teach more hours, and making the curriculum for all four preliminary courses more firmly specified.[15] He continued the courses in free painting — which Klee and Kandinsky had succeeded in introducing in 1927, free of the obligation to serve design training — and asked Oskar Schlemmer to begin a new seminar on "Man." He described the program of guest lectures as similarly balanced between the "scientific" offerings of Karel Teige, Otto Neurath, Konrad von Meyenburg, Rudolf Carnap, and Hans Prinzhorn and the "life relief" of Hermann Finsterlin, Hans Richter, Dziga Vertov, and Piet Zwaart.

Meyer's biologistic conception of human society, technology, and culture was adopted from popular science writers such as Raoul H. Francé, who argued that engineering and art alike should employ the biotechnic principles and construction methods of nature, as revealed by science. Meyer embraced not only the physical sciences and engineering but also the human sciences of psychology and sociology, through which art was being redefined and broadened. The psychology of art was integral to the new scientific foundation for architecture and design, and Meyer's own building practice incorporated considerations commonly taken to be aesthetic. Only with the recent restoration of the ADGB complex by Winfried Brenne and Franz Jaschke have vistiors been able to appreciate once more how much its qualities exceed the purely utilitarian.[16]

In describing buildings as the "plastic translation … of social-pedagogical functions,"[17] Meyer pointed to their value in retraining people for the new collectivist society. Before his dismissal as director of the Bauhaus, in 1930, he had planned to introduce courses in sociology and Gestalt psychology for this purpose. Visual training for psychic well-being went hand in hand with social reorganization and the organic way of living that was to be made possible through advances in industry and science. The principles underlying biological processes — functionality, efficiency, economy of means, optimization, harmony — provided the basis for Francé's doctrine of life, which in turn informed Meyer's comprehensive approach to "design for living" that would be healthy, objective, and egalitarian.[18] In applying science and technology to the cause of social change, Meyer effectively extended and radicalized the tradition of creative pedagogy using elemental means inaugurated in the nineteenth century by the reformer Johann Heinrich Pestalozzi (a pioneer of the Swiss cooperative movement in which Meyer participated), then developed by Friedrich Froebel (designer of educational toys), and later institutionalized in the preliminary course of the Bauhaus. In so doing, Meyer sought to bring mind, body, and society into a new harmonious alignment with nature under the historical conditions of modern industrial society.

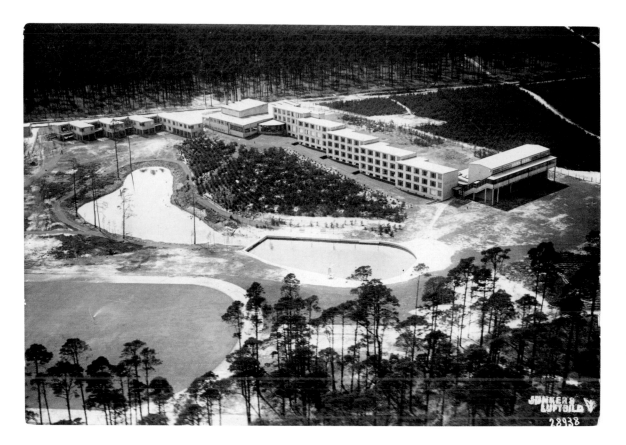

1. See Hannes Meyer, letter to Adolf Behne, December 24, 1927, reproduced in Bauhaus-Archiv and Deutsches Architekturmuseum, *Hannes Meyer 1889–1954 Architekt Urbanist Lehrer* (Berlin: Ernst & Sohn, 1989), p. 216.

2. Six architects were invited to compete: Max Berg, Alois Klement, Wilhelm Ludewig, Erich Mendelsohn, Meyer, and Max Taut. They were given six weeks to meet a deadline of April 4, 1928. The jury consisted of Heinrich Tessenow, Martin Wagner, and Behne, together with Theodor Leipart and Otto Hessler, representatives of the ADGB. See Behne, "Bundesschule in Bernau bei Berlin. Architekt Hannes Meyer," in Preussisches Finanzministerium, ed., *Sonderdruck aus dem Zentralblatt der Bauverwaltung* 51, no. 14 (1931):212–22, reproduced in Bauhaus-Archiv and Deutsches Architekturmuseum, *Hannes Meyer 1889–1954*, p. 189–190.

3. Meyer, "Die Bundesschule des ADGB in Bernau bei Berlin," repr. and trans. in Claude Schnaidt, *Hannes Meyer. Bauten, Projekte und Schriften. Buildings, Projects and Writings*, trans. D. Q. Stephenson (New York: Architectural Book Publishing Co., 1965), p. 40. Translation altered by author.

4. Ibid., p. 49.

5. Meyer, "Wie ich arbeite," *Architektura CCCP* 6 (Moscow, 1933); partial trans. in Schnaidt, *Hannes Meyer*, pp. 19–21. For a discussion of these ideas as the basis of Meyer's radicalization of perception see K. Michael Hays, *Modernism and the Posthumanist Subject: The Architecture of Hannes Meyer and Ludwig Hilberseimer* (Cambridge, Mass.: The MIT Press, 1992), pp. 85–88, 23–53.

6. The Co-op Vitrine was commissioned for the Internationale Ausstellung des Genossenschaftswesens und der sozialen Wohlfahrtspflege, an exhibition of Swiss cooperative products in Gent and Basel in 1924 and 1925, directed by Bernhard Jäggi. See K Hays, *Modernism and the Posthumanist Subject*, pp. 121–47, and Maria Gough, *The Artist as Producer: Russian Constructivism in Revolution* (Berkeley: University of California Press, 2005).

7. The ADGB competition marked the end of Meyer's partnership with Wittwer. After Meyer's departure for the USSR, in 1930, however, the client turned to Wittwer in 1931 to help solve some technical problems with the building.

8. See Magdelena Droste, *Bauhaus 1919–1933* (Cologne: Taschen, 1990), p. 190.

9. Meyer, "Vorträge in Wien und Basel, 1929," in Meyer, *Bauen und Gesellschaft. Schriften, Briefe, Projekte*, ed. Lena Meyer-Bergner (Dresden: Verlag der Kunst, 1980), p. 60.

10. The benefits were noted in the improved technical performance of the building that Meyer and his students designed for Walter Gropius's Törten housing estate in Dessau. See Wallis Miller, "Architecture, Building, and the Bauhaus," in Kathleen James-Chakraborty, ed., *Bauhaus Culture: From Weimar to the Cold War* (Minneapolis: University of Minnesota Press, 2006), p. 84.

11. Meyer was active in the constructivist circles that published the journals *Veshch'* and *ABC*, which reiterated the calls for pure construction and direct intervention in the system of production made by the Moscow Constructivists in 1920–21, but also in Germany before World War I by members of the Deutscher Werkbund and after it under the banner of the *"Neues Bauen."*

12. Meyer, "Die neue Welt," *Das Werk*, no. 7 (1926), reprinted and trans. in Schnaidt, *Hannes Meyer*, p. 93.

13. Meyer, "bauen," in *bauhaus zeitschrift* 2, no. 4 (1928):12–13, reprinted and trans. in ibid., pp. 94–97.

14. Behne, quoted in Bauhaus-Archiv and Deutsches Architekturmuseum, *Hannes Meyer*, p. 189.

15. See Droste, *Bauhaus 1919–1933*, pp. 170–71.

16. The restoration was undertaken between 1998 and 2008 by the Berlin-based firm of Brenne Gesellschaft von Architekten, and was funded by the Province of Brandenburg and the Handwerkskammer Berlin.

17. Meyer, "Die Bundesschule des ADGB in Bernau bei Berlin," in Meyer, *Bauen und Gesellschaft*, p. 64.

18. See "The Course of Training in the Architecture Department," *junge menschen kommt ans bauhaus!*, advertising pamphlet published by the Bauhaus in Dessau (1929), trans. in Hans Maria Wingler, *The Bauhaus: Weimar, Dessau, Berlin, Chicago* (Cambridge, Mass.: The MIT Press, 1969), p. 151.

349
Hannes Meyer and **Hans Wittwer**
Bundesschule des Allgemeinen Deutschen Gewerkschaftsbundes (Federal school of the German trade union federation), Bernau.
1928–30
Description and site plan
As reproduced in *bauhaus: zeitschrift für gestaltung* 2, no. 2/3 (1928)
Bauhaus-Archiv Berlin

350
Hannes Meyer and **Hans Wittwer**
Bundesschule des Allgemeinen Deutschen Gewerkschaftsbundes (Federal school of the German trade union federation), Bernau.
1928–30
Postcard showing aerial view from southwest
Photograph: Junkers Luftbildzentrale.
c. 1930. Gelatin silver print. 4¾ x 6¾"
(12 x 17.3 cm). Bauhaus-Archiv Berlin

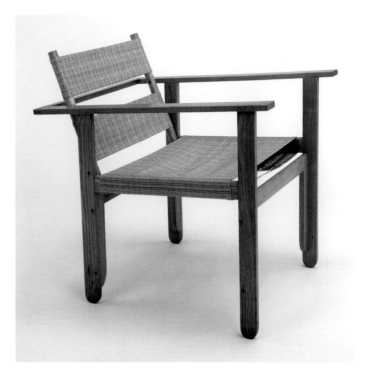

351
Designer unknown
Folding chair (TI 240). Designed 1929,
this example produced in the early 1930s
by Karl Bökenheide
Beech, partially glued and stained, with
steel-sheeted hinge, metal screws, and linen
37 3/8 x 24 x 34 5/8" (95 x 61 x 88 cm)
Stiftung Bauhaus Dessau

352
Wera Meyer-Waldeck
Chair. c.1929, type created for Hannes
Meyer's traveling exhibit *Die Volkswohnung*
(The people's apartment), 1929
29 1/8 x 22 7/16 x 28 9/16" (74 x 57 x 72.5 cm)
Bauhaus-Archiv Berlin

353
Wera Meyer-Waldeck and **Josef Pohl**
Desk. c.1929, type displayed in Hannes
Meyer's traveling exhibit *Die Volkswohnung*
(The people's apartment), 1929, and used in
his ADGB building
Wood and linoleum
29 1/8 x 37 1/8 x 25 1/16" (74 x 94.3 x 63.7 cm)
Stiftung Bauhaus Dessau

354
Josef Pohl
Wardrobe on wheels for bachelors. 1930
Plywood with tropical wood veneers,
beech strip frame, edges reinforced with
solid tropical wood, nickel-plated fittings,
and porcelain furniture casters
59 5/8 x 24 1/8 x 28 7/8" (151.5 x 61.3 x 73.3 cm)
Bauhaus-Archiv Berlin

355
Gustav Hassenpflug
Folding table. 1928
Top: Birch veneer on plywood, stained to
imitate cherry, with matte-finish shellac;
legs: solid alder with finish stained to match
top; steel and nickel-plated brass hardware
Height: 27 9/16" (70 cm). Tabletop, unfolded:
35 7/16" (90 cm) diam., folded: 3 9/16" (9 cm) wide
Bauhaus-Archiv Berlin

356
Unidentified student
Exercise for preliminary course
taught by Josef Albers. c. 1929
Photograph: Erich Consemüller.
Gelatin silver print. 4 11/16 x 6 7/16" (11.9 x 16.3 cm).
The Josef and Anni Albers Foundation,
Bethany, Conn.

357
Werner Zimmermann and **Paul Reindl**
Exercises for preliminary course
taught by Josef Albers. c. 1929
Photograph: Erich Consemüller.
Gelatin silver print. 4 1/2 x 6" (11.5 x 15.3 cm).
The Josef and Anni Albers Foundation,
Bethany, Conn.

358 (top left)
Artist unknown
Exercise for preliminary course
taught by Josef Albers. n.d.
Industrially painted wire screen
13 9/16 x 6 13/16" (34.5 x 17.3 cm)
The Josef and Anni Albers Foundation,
Bethany, Conn.

359 (top right)
Artist unknown
Exercise for preliminary course
taught by Josef Albers. n.d.
Industrially painted wire screen
6 7/8 x 7 5/8" (17.5 x 19.3 cm)
The Josef and Anni Albers Foundation,
Bethany, Conn.

360 (bottom left)
Wils Ebert
Exercise for preliminary course
taught by Josef Albers. 1929
Steel wire, bent and welded
Height: 7 1/2" (19 cm), diam.: 7 1/2" (19 cm)
Stiftung Bauhaus Dessau

361 (bottom right)
Monica Bella Ullman (later Broner)
Exercise for preliminary course
taught by Josef Albers. 1929–30
Cut-and-pasted patterned wallpaper,
glued on cardboard
12 3/16 x 9" (31 x 22.9 cm)
Bauhaus-Archiv Berlin

EXERCISES FOR COLOR THEORY COURSES
HAL FOSTER

As the Bauhaus sought to define the fundaments of composition and construction, the study of color was basic to its project. Central to the preliminary-course classes taught by Paul Klee and Vasily Kandinsky (who came to the Bauhaus in 1920 and 1922 respectively), color analysis was elaborated by Kandinsky in an advanced seminar, and Klee addressed it in *Pedagogical Sketchbook* (1925), as did Kandinsky in *Point and Line to Plane* (1926). The previous preliminary-course master, Johannes Itten, had already established color study as a Bauhaus staple, and Klee and Kandinsky continued his focus on primary and secondary colors, with exercises involving chromatic contrasts, combinations, and scales in various formats (including circles, checkerboards, banded triangles, and vertical and stepped rows of rectangles). Of special interest to all three masters were the effects of complementary colors, especially the famous law of simultaneous contrasts (whereby we see the complementary of a primary even when it is not present).

Not much of this investigation was original — like Itten, Klee and Kandinsky drew on color theory stretching back through Adolf Hölzel, Wilhelm Ostwald, Robert Delaunay, and the Neo-Impressionists to Eugène Delacroix, Michel-Eugène Chevreul, Philipp Otto Runge, and Johann Wolfgang von Goethe — but they did stamp this tradition distinctively.[1] For example, whereas Georges Seurat saw color as affective, Klee and Kandinsky presented it as all but animate: colors possessed not only different temperatures, from the warmth of yellow to the coolness of blue, but also different personalities, often described as active, passive, or neutral (lines were thought to be similarly "voiced"). In large part this ascription of agency stemmed from the belief that modernist painting, in its march toward abstraction, had a will, even a life, of its own; yet Klee and Kandinsky did not regard color as purely a matter of painting or even of vision.[2] Concerned above all with compositional harmony, they often used musical analogies (Klee was a virtuoso violinist). Kandinsky also claimed a sensitivity to synaesthesia — when he saw a color, he heard a sound — and he sometimes gave his students exercises in which musical compositions were to be analyzed through different color-shapes (cat. 370).

On his arrival at the Bauhaus Kandinsky was well established as a theorist and a pedagogue (he had published his celebrated text *Concerning the Spiritual in Art* in late 1911, and had set up the academic program for Inkhuk, the Moscow institute of art and culture, in 1920), and his approach bordered

on the dogmatic. In particular he sought to regulate the subjective effects of color and line in an objective system based in the first instance on oppositions of yellow and blue and of verticals and horizontals. This would become the basis of his theory of composition; it was also the source of a telling episode involving a questionnaire that Kandinsky circulated at the Bauhaus in 1922–23 (cat. 10), asking all *Bauhäusler* to fill in a blank triangle, square, and circle with the color that each form seemed to elicit. The majority of the respondents agreed with his own answer — yellow for the triangle, red for the square, and blue for the circle — but whether this was due to an "internal necessity" of these color-shapes (a Kandinsky mantra) or his own art of persuasion is unclear.

These color-shapes inform several works associated with Kandinsky in this exhibition, and none more so than the exquisite 1929–30 study in tempera and pencil on paper by Eugen Batz (cat. 362). On a vertical black ground Batz presents the three intersecting color-shapes twice, once as solid forms in the upper right and once in outline in the lower left. In the solid cluster the primaries overlap to create the secondaries: the yellow triangle produces an orange shape with the red square and a green shape with the blue circle, while the red square creates a violet shape with the blue circle. (Batz also uses the web of the paper nicely to distinguish the different zones tactilely.) The outline cluster then provides a key to these overlaps: the yellow triangle appears to be above the blue circle, and the blue circle above the red square. (Kandinsky felt that red holds the picture plane more effectively than expansive yellow and recessive blue.) Even as the study stands as a work in its own right — it achieves a dynamic balance not only among the intersecting color-shapes but also between the opposed clusters — it also functions as a demonstration of color theory.

Yet in doing so the Batz study points to tensions within this theory. Even as Kandinsky explored natural laws of color and perception, he often resorted to culturally determined conventions of meaning (for example, he deemed yellow earthy and blue heavenly). Moreover, even as Kandinsky insisted on the

362
Eugen Batz
Exercise for color-theory course taught by Vasily Kandinsky. 1929
Tempera over pencil on black paper
15 7/16 x 12 15/16" (39.2 x 32.9 cm)
Bauhaus-Archiv Berlin

363
Eugen Batz
Exercise for color-theory course taught by Vasily Kandinsky. 1929–30
Tempera over pencil on black paper
16 5/8 x 12 15/16" (42.3 x 32.9 cm)
Bauhaus-Archiv Berlin

objectivity of his investigation (*Point and Line to Plane* is peppered with qualifiers like "organic," "scientific," and "elemental"), he could not altogether suspend its subjective dimension.[3] Indeed, despite his aspiration to the systematic, Kandinsky was haunted by the arbitrary, and one might argue that his painting is too — hence again his reliance on vague formulas of determination like "internal necessity." And then there is the question of a language of color, indeed of vision, that, paradoxically for a language, purports to be self-evident, natural, and immediate (color "works upon the soul," Kandinsky writes in *Concerning the Spiritual in Art*).[4] Perhaps in the end the study of color at the Bauhaus should be understood as a site where tensions between objective principles and subjective experiences, natural laws and arbitrary conventions, were worked over, if not resolved.

Klee was less systematic in his analysis of color; "intuition joined to research" was the credo of his teaching, and among the examples by his students in the exhibition, the beautiful 1923–24 studies by Gertrud Arndt best convey this spirit of experiment (cats. 89–92). Arndt presents four variations on the same theme, two intersecting triangles within two overlapping circles on a vertical white ground (cat. 92). In each case the forms are colored and shaded differently, slightly disturbing our expectations. The virtually colorless bottom pair is a study in contrasts: on the left the forms are light where they don't touch, so that the darkest shape is the central lozenge where they all converge; this principle is reversed on the right, where the central lozenge is thus the lightest shape. Weirdly, the dark lozenge, which should recede from us, seems to approach, while the light lozenge, which should advance toward us, looks like a distant aperture. The top pair also brings little perceptual surprises. On the left

the yellow elements, the upper circle and the lower triangle, recede more than advance, while the blue elements, the upper triangle and the lower circle, stand out as the dominant figures. Meanwhile on the right the yellow triangles are patterned with red triangles, and it is this figure that emerges most distinctly. In all four studies the basic form hardly appears similar, let alone identical; here experimentation with color and contrast offers fresh insights rather than prescribed results.

In the Arndt studies color trumps line, and so it does, eventually, in *Pedagogical Sketchbook*. In keeping with academic tradition, Klee gives line or design pride of place, but only at first, for toward the end of his short text he implies that color is the more dynamic element (he uses arrows to diagram how different colors suggest different movements in a given composition). A kind of telos thus emerges in which color leads to "a harmonization of elements toward an independent, calm-dynamic and dynamic-calm, entity."[5] Klee concludes, "We have arrived at the spectral color circle where all the arrows are superfluous. Because the question is no longer 'to move there' but to be 'everywhere' and consequently also 'There!'"[6] This sense of perfect presence is evoked in a fine color wheel of 1922–23, in gouache and collage, by Ludwig Hirschfeld-Mack (cat. 366). Here the colors rotate clockwise from red and violet, through blue and green, to yellow and orange, and each color lightens in twelve steps from the black of the circumference to the white of the center. This wheel does indeed appear to move everywhere — around, in and out, through — even as it also projects the instantaneity of an image seen all at once — "There!"

Yet also evident here, in the opposition between the explicit facticity of the collage and the implicit transparency of

color as light, is a tension, felt throughout the Bauhaus, between a commitment to materiality and a desire for immateriality. For some *Bauhäusler*, of course, this was less a thorny contradiction than a necessary passage from the one state to the other. László Moholy-Nagy, for example, came to the Bauhaus (soon after Hirschfeld-Mack made his collage) in order to argue for a Hegelian march from painting, through photography and film, to virtual light-displays — that is, for a telos of modernist art that would pass "from material" (the materiality of the traditional arts) "to architecture" (the disembodied architecture of light).[7] Perhaps this transformation to the "new vision" is foreshadowed in the Hirschfeld-Mack study; certainly Hirschfeld-Mack moved on to experiment with his own "reflected-light compositions," which he described in 1924 as follows: "Yellow, red, green, blue, in glowing intensity, move about on the dark background of a transparent linen screen — up, down, sideways — in varying tempi. They appear now as angular forms — triangles, squares, polygons — and again in curved forms — circles, arcs and wave-like patterns. They join, and overlappings and color-blendings result."[8] Inspired by his first encounter with film — that is, with "light in motion, arranged in a rhythm based on time sequences" — Hirschfeld-Mack presented these reflected-light compositions as "a new means of expression for pictorial representation" beyond painting.[9] Such was the great ambition that stirred in his little color study.

1. A couple of connections might be underscored here: Paul Klee was much influenced by Robert Delaunay (whose 1912 essay "Light" he translated), and Vasily Kandinsky drew heavily on Paul Signac's *From Eugène Delacroix to Neo-Impressionism* (1899). For a helpful text in English see Claude V. Poling, *Kandinsky's Teaching at the Bauhaus* (New York: Rizzoli, 1986).

2. For Kandinsky this was no great contradiction. In *Concerning the Spiritual in Art*, of 1911, he writes, "And so at different points along the road are the different arts, saying what they are best able to say, and in the language which is peculiarly their own. Despite, or perhaps thanks to, the differences between them, there has never been a time when the arts approached each other more nearly than they do today, in this later phase of spiritual transformation." Trans. M. T. H. Sadler (New York: Dover, 1977), p. 19.

3. Bauhaus color theory is sometimes an exercise in the pathetic fallacy, or the fetishistic projection of affect or agency onto color. On this score, with the most rigorous modernists, green in particular can't win: while Piet Mondrian banished it because of its associations with the natural world, Kandinsky saw it as a class enemy, writing, "In the hierarchies of colours green is the 'bourgeoisie' — self-satisfied, immovable, narrow." Ibid., p. 38.

4. Ibid., p. 24. This question of a language of vision — at once natural and conventional, essential and arbitrary — might be the modernist conundrum par excellence. For an excellent discussion of the issue with regard to the Bauhaus see Ellen Lupton, "Visual Dictionary," in Lupton and J. Abbott Miller, eds., *the abc's of ▲■● : the bauhaus and design theory* (New York: Princeton Architectural Press, 1991). The question of whether the three Kandinsky color-shapes are native or learned is posed, indirectly but piquantly, by the cradle designed out of these forms by Peter Keler in 1922 (cat. 208).

5. Klee, *Pedagogical Sketchbook*, trans. Sibyl Moholy-Nagy (New York: Prager, 1953), p. 59.

6. Ibid., p. 61. In a sense this is Klee's version of the Pascalian image of God as a circle whose center is everywhere and circumference nowhere.

7. László Moholy-Nagy published *Von Material zu Architektur* (From material to architecture) in 1928. Based on his Bauhaus lectures, it was revised and published in English as *The New Vision* in 1930.

8. Ludwig Hirschfeld-Mack, Berliner Börsenkurier, August 24, 1924, as quoted in Herbert Bayer, Walter Gropius, and Ise Gropius, eds., *Bauhaus: 1919–1928* (New York: The Museum of Modern Art, 1938), p. 64.

9. Hirschfeld-Mack, "Reflected-Light Compositions," 1925, in Hans Maria Wingler, *The Bauhaus: Weimar, Dessau, Berlin, Chicago* (Cambridge, Mass.: The MIT Press, 1969), pp. 82–83.

364, 365
Reingard Voigt
Exercises for color theory course
taught by Paul Klee. 1929–30
Watercolor on paper, mounted on board,
364 with india ink, 365 with printed labels
8 1/16 x 13 1/16" (20.4 x 33.2 cm)
Bauhaus-Archiv Berlin

366
Ludwig Hirschfeld-Mack
Study in color intensity: twelve-part
color circle with 120 colors. 1922–23
Gouache and cut-and-pasted paper on
art paper
20 3/16 x 25 3/8" (51.3 x 64.5 cm)
Bauhaus-Archiv Berlin

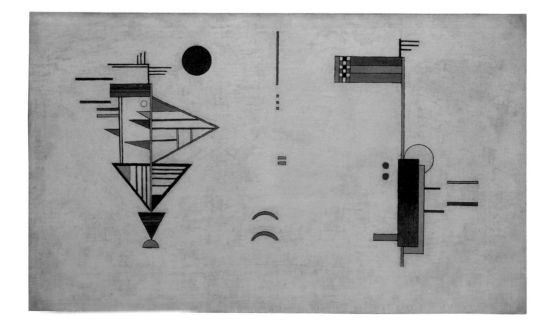

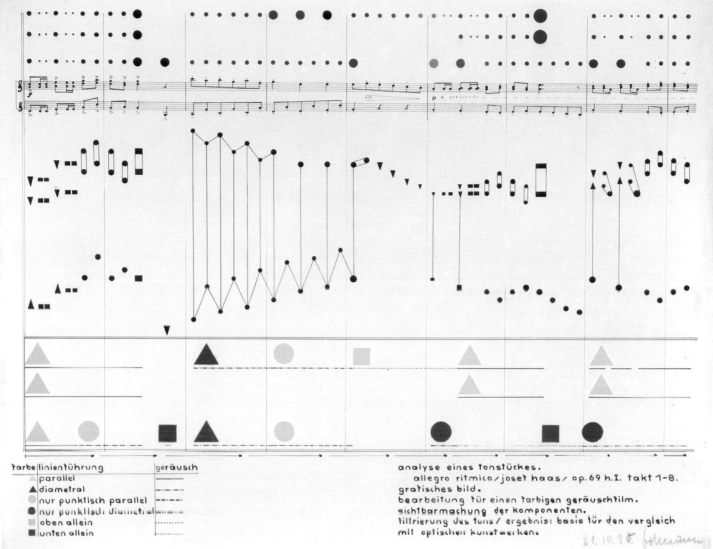

367
Vasily Kandinsky
Design for a ceramic-tiled music room
at the *Deutsche Bauausstellung* (German
building exhibition), Berlin. 1931
Left wall
Oil on board
17 ¹⁵/₁₆ x 29 ½" (45.5 x 75 cm)
Musée d'art moderne et contemporain
de Strasbourg. Gift of Société L'Oréal

368
Vasily Kandinsky
Design for a ceramic-tiled music room
at the *Deutsche Bauausstellung* (German
building exhibition), Berlin. 1931
Center wall
Oil on board
17 ¹¹/₁₆ x 39 ³/₈" (45 x 100 cm)
Musée d'art moderne et contemporain
de Strasbourg. Gift of Société L'Oréal

369
Vasily Kandinsky
Design for a ceramic-tiled music room
at the *Deutsche Bauausstellung* (German
building exhibition), Berlin. 1931
Right wall
Oil on board
17 ¹⁵/₁₆ x 29 ½" (45.5 x 75 cm)
Musée d'art moderne et contemporain
de Strasbourg. Gift of Société L'Oréal

370
Heinrich-Siegfried Bormann
Visual analysis of a piece of music, from
a color-theory class with Vasily Kandinsky.
October 21, 1930
Ink and gouache over pencil on paper
18 ⅞ x 24 ³/₁₆" (48 x 61.5 cm)
Bauhaus-Archiv Berlin

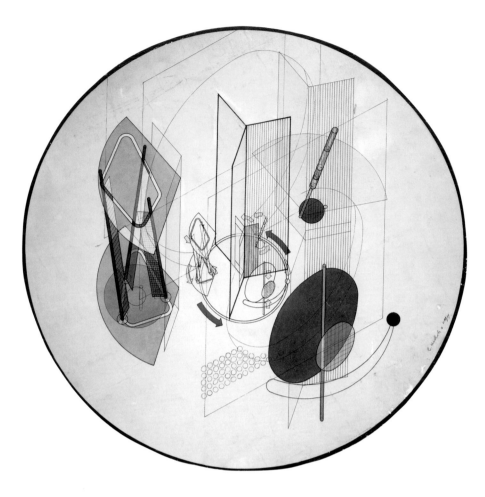

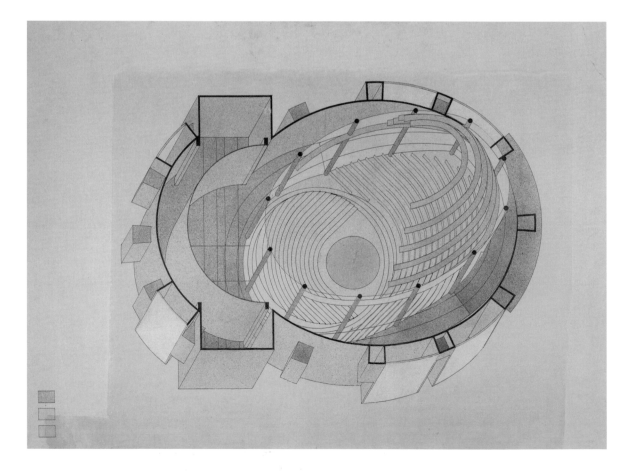

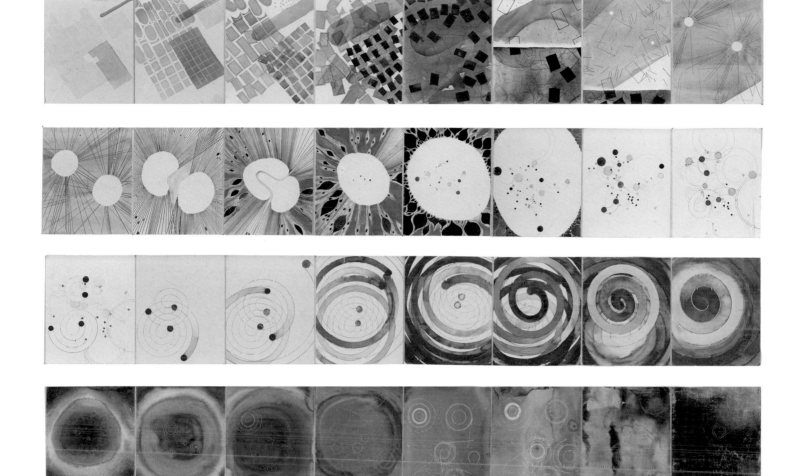

371
László Moholy-Nagy
Zeichnerische Darstellung des Lichtrequisits
(Graphic representation of the light prop). 1930
Watercolor, ink, and pencil on cut-out
circular paper
Diam.: 20 ½" (52 cm)
Bauhaus-Archiv Berlin

372
Walter Gropius. Drawing by
Stefan Sebök
Total-Theater (Total theater), Berlin.
Designed for Erwin Piscator. Isometric
sectional view. 1927
Ink, gouache, and spatter paint
on composition board
32 ⅝ x 42 ¹¹⁄₁₆" (82.8 x 108.4 cm)
Harvard Art Museum, Busch-Reisinger
Museum. Gift of Walter Gropius

373
Kurt Kranz
Untitled picture series (Project for
an abstract color film). 1930
32 drawings in watercolor, gouache,
and ink on paper, mounted on canvas
Each drawing: 7 ¹⁄₁₆ x 5 ¹¹⁄₁₆" (17.9 x 14.5 cm);
overall dimension of canvas: 7 ¹⁄₁₆ x 15' 8 ⅜"
(17.9 x 478.5 cm)
Kunsthalle Bielefeld

LÁSZLÓ MOHOLY-NAGY
LIGHT PROP FOR AN ELECTRIC STAGE. 1930
ALEX POTTS

László Moholy-Nagy's *Lichtrequisit einer elektrischen Bühne* (Light prop for an electric stage) was not finished until 1930, well after he left the Bauhaus, in 1928. The immediate motivation for its completion may in part have come from the work he was doing at the time as a stage designer based in Berlin. The work's conception, however, is very much a product of the pedagogical and experimental activity with which he had been involved while teaching at the Bauhaus. His interests there were radically intermedia, moving across photography, film, theater, and stage design as well as more conventional object-making and painting. Direct, three-dimensional experimentation with light and space effects had been particularly important for him, not just envisioning such effects in drawings and paintings.

The *Lichtrequisit*, too, was first shown in a context that represented something of a return to Moholy's Bauhaus days: it formed part of the Werkbund installation devised under the directorship of Walter Gropius for the *Exposition de la Société des Artistes Décorateurs* in Paris in 1930. The installation, conceived as a model communal apartment, included areas designed by Herbert Bayer and Marcel Breuer as well as Gropius. Moholy's *Lichtrequisit*, as the main feature in a small room that included three figures from Oskar Schlemmer's *Triadische Ballett* (Triadic ballet), complemented the designs for new domestic spaces, furniture, and lighting with a theatrical spectacle enlivened by movement and special light effects.[1]

Lichtrequisit einer elektrischen Bühne subsequently acquired the designations "Light-Display Machine" and "Light-Space Modulator," testifying to a fundamental and productive uncertainty over its identity.[2] Initially, in fact, it was presented in two different forms, as the centerpiece of the elaborately lit installation at the Paris exhibition (cat. 376) and as the generator of a complex sequence of light effects in Moholy-Nagy's short film *Lichtspiel: Schwarz Weiss Grau* (Lightplay: black white gray; cat. 375). Even as the object displayed in a museum that it later became (now mostly seen in replica), it can be viewed in different ways: as a kinetic sculpture but equally well as a model for a fairly elaborate mechanism, or even as a proposal for a mobile architecture.

The rotating base is divided by the tall, empty rectangular frames into three equal sectors, into each of which is set a separately moving part. These parts are placed so close together that they are quite hard to distinguish — one a precarious, spindly, skeletal, towerlike structure surmounted by a horizontal, partly rounded metal plate, one a large, fixed, vertically oriented perforated disk in front of which a small disk moves and a ball slides to and fro inside an open metal runner, and

one a plastic screwlike object that circles around and dips up and down, poking through a moving plastic plate. Like much modern sculpture, *Lichtrequisit* was not handmade by the artist. Even the design was only partly his. The technical diagrams were worked out by a draftsman/engineer working in Walter Gropius's office, and the apparatus was realized from these drawings in the theater studio of the Berlin electrical corporation AEG.[3] This approach to fabrication had precedents in work Moholy produced while at the Bauhaus, such as his Constructions in Enamel (cats. 143–45).

More remarkable than the formal structure — the work looks almost arbitrarily complicated — is the shifting interplay between the parts as they carry out different cyclical movements. Because the surfaces are reflective, shiny metal or translucent plastic, they create intriguing light and shade effects. These were dramatized when Moholy-Nagy showed the machine to visitors to his Berlin workshop in a closed room, illuminated "as it turned slowly" by "invisible lights" that "flared up and turned off, producing gigantic shadows on the walls and ceiling."[4] This aspect of the work was also foregrounded in its installation at the 1930 exhibition in Paris. There it was enclosed in a large box with a circular opening in one side through which the viewer could see the constantly changing spectacle created by 120 different-colored light bulbs shining on the mechanism (the lights were hidden from view and programmed to flash on and off in a prearranged sequence). Reflections from the mechanism projected further play of light and shadow onto the back wall of the box.[5]

This mobile was a "prop" of a rather special kind. Seen through the circular frame, its constantly moving forms filled the viewer's entire visual field. "Light prop" became indistinguishable from "electric stage." The theater one saw was no longer a conventional stage on which actors and props made their appearances. Instead, the forms and projected patterns constituted a self-contained piece of "abstract" theater, realizing a new "theater of totality," the "concentrated activation of sound, light (color), space, form and motion," in which "man as coactor" was no longer necessary, that Moholy-Nagy envisaged in his essay in a 1922 Bauhaus publication on theater.[6]

The film *Lichtspiel: Schwarz Weiss Grau* enhanced the work's "light-display machine" element through its double exposures and its interplay of positive and negative images.[7] Moholy filmed the mobile from very close and from a variety of oblique angles. At the outset, it is seen framed by circular openings, which echo both the opening in the viewing box at

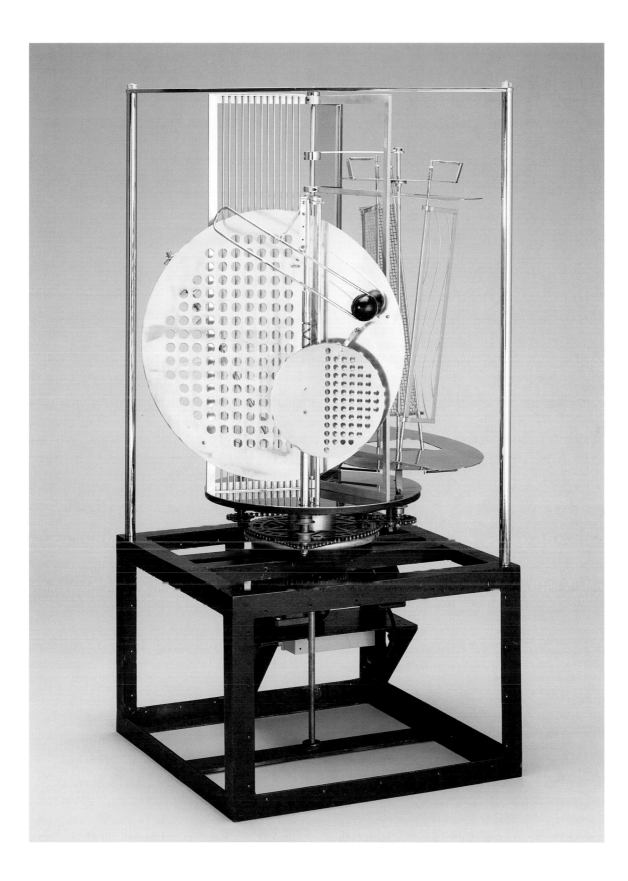

374
László Moholy-Nagy
Lichtrequisit einer Elektrischen Bühne
(Light prop for an electric stage). 1930
Aluminum, steel, nickel-plated brass,
other metals, plastic, wood, and
electric motor
59 ½ x 27 ½ x 27 ½" (151.1 x 69.9 x 69.9 cm)
Harvard Art Museum, Busch-Reisinger
Museum. Gift of Sibyl Moholy-Nagy

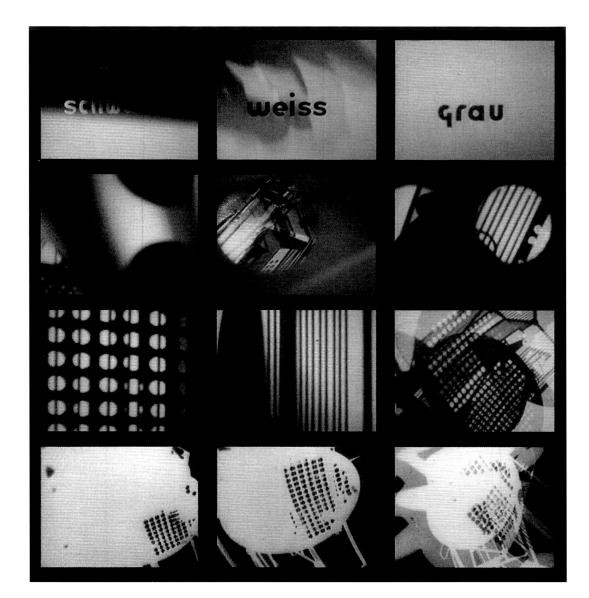

the Paris exhibition and the circular perforations in the large metal disk that is a prominent feature of the mechanism itself. The play of moving parts seems suspended in space. Their visual metamorphosis stages a dissolution of sculptural mass like that Moholy later conjured up in his book *Vision in Motion*: "sculpture…has tactile existence but may be changed to visual grasp: from static to kinetic; from mass to space-time relationship."[8] This shift was a common preoccupation of the earlier twentieth-century European avant-garde. Constantin Brancusi's photo from c. 1927 of his highly polished, streamlined *Bird in Space* dissolves the earthbound shape in a brilliant burst of light, though in contrast to Moholy-Nagy's film, the anchoring base is still visible.[9]

The filmic dimension to the artist's conception of the work is very much privileged in the account recorded by the artist's future wife, Sibyl Moholy-Nagy, recollecting her expe-

riences when she first saw the apparatus displayed in Moholy's workshop, in 1931. She was working at the time for a Berlin motion picture syndicate that Moholy was trying unsuccessfully to interest in his experimental films. When Moholy invited her to view the apparatus in action soon after she had seen the film, her comment that the effect was "almost as beautiful as the film" apparently met with Moholy-Nagy's warm approval.[10] Later on, though, Moholy-Nagy expressed disappointment that while viewers of the film responded to its transformation of the machine into "photographic 'light' value," they failed to appreciate the "technical wit or the future promise" of the mechanism.[11] This suggests a further conception of the object, appropriate to his educational mission, as the model for a radically new three-dimensional design exploiting the full formal and expressive possibilities of working directly with "light (color), space, form and motion."

375
László Moholy-Nagy
Stills from the film *Lichtspiel: Schwarz Weiss Grau* (Lightplay: black white gray). 1930
5 min 30 sec, 16 mm, black and white, silent
Tate, London. Courtesy Hattula Moholy-Nagy

376
László Moholy-Nagy
Lichtrequisit einer Elektrischen Bühne (Light prop for an electric stage). 1930
At the Deutscher Werkbund exhibition, Paris, 1930
As reproduced in *Die Form* 5, no. 11/12 (1930)
The Museum of Modern Art Library, New York

Fig.1
Vladimir Tatlin
Monument to the Third International (model).
Photographed in the former Akademiia khudozhestv (Academy of arts), Petrograd. 1920
Wood and metal
Height: 15'3 1/16" (465 cm), diam.: 11'5/16" (336 cm)
Photograph: photographer unknown. 1920.
Gelatin silver print. Moderna Museet, Stockholm

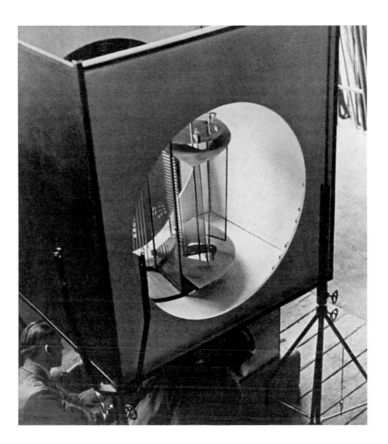

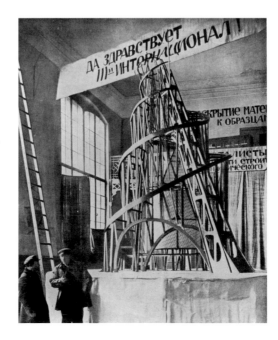

Envisioned in this way not as an art object in its own right but as a model for a radically new, dynamic, multimedia construction, *Lichtrequisit* has certain affinities with the model for *Monument to the Third International* that Vladimir Tatlin exhibited in Russia in 1920 (fig. 1), even if the latter was conceived in political circumstances very different from the commercial ones of the Paris show where the *Lichtrequisit* made its first appearance. Like the work by Tatlin, Moholy Nagy's *Lichtrequisit* looks forward to a future in which modern technology would overcome the massiveness and fixity of traditional structures. At the same time, there is a tension between the projected vision of a radically new world of open, mobile forms and the somewhat old-fashioned materiality and inertia of the apparatus itself, which are at odds with the more seamless look of techno-perfection that Moholy cultivated in his paintings. Witnessing the *Lichtrequisit* in action, one becomes aware of clanking sounds and slightly jerky movements, and even viewing the film, the strong sense one has of moving parts underlying and offering resistance to the fluid play of light and shade is integral to the effect. Apparently a customs official once mistook the light machine for a "mixing machine."[12] The interest it holds as the source of an ultra-modern "light play" derives in part from these lingering affinities with everyday mechanical apparatuses of the modern world.

1. See *Werkbund-Ausstellung Paris 1930: Leben im Hochhaus/Werkbund Exhibition Paris 1930: Living in a High-rise* (Berlin: Bauhaus-Archiv, 2007).

2. László Moholy-Nagy himself seems to have kept to the designation *"Lichtrequisit"* or "Light prop." See his "Abstract of an Artist," in *The New Vision* (New York: Wittenborn, Schultz, 1949), p. 80, and *Vision in Motion* (Chicago: Paul Theobald, 1947), pp. 288–89, although the captions to illustrations of the work in *Vision in Motion* (p. 238) use the term "The light display machine." He himself began using the title "Space Modulator" for paintings produced in the 1940s. Moholy's widow, Sibyl Moholy-Nagy, called the work "Light Space Modulator," and may have been responsible for the currency of this designation after it was given to the Busch-Reisinger Museum, Harvard, in 1956. See her *Moholy-Nagy: Experiment in Totality* (New York: Harper and Brothers, 1950), p. 64.

3. Hannah Weitemeier, *Licht-Visionen: Ein Experiment von Moholy-Nagy* (Berlin: Bauhaus-Archiv, 1972), p. 47. This book offers the fullest published account of *Lichtrequisit*.

4. Sibyl Moholy-Nagy, *Moholy-Nagy: Experiment in Totality*, pp. 64–66. The passage is quoted in Richard Kostelanetz, ed., *Moholy-Nagy: An Anthology* (New York and Washington, D.C.: Praeger, 1970), pp. 147–48.

5. For the description of the apparatus published by Moholy-Nagy in 1930 see Joseph Harris Caton, *The Utopian Vision of Moholy-Nagy* (Ann Arbor: UMI Research Press, 1984), p. 65.

6. László Moholy-Nagy, "Theater, Circus, Variety," in Walter Gropius, Moholy-Nagy, and Oskar Schlemmer, *Die Bühne im Bauhaus*, Bauhausbücher no. 4, Eng. trans. as Gropius, ed., *The Theater of the Bauhaus* (Middletown, Conn.: Wesleyan University Press, 1960), p. 60.

7. The film can be found in a number of public collections, including MoMA's.

8. László Moholy-Nagy, *Vision in Motion*, p. 241.

9. Repr. in, e.g., Pierre Schneider, *Un Moment donné. Brancusi et la photographie* (Paris: Hazan, 2007), pp. 106–7.

10. Sibyl Moholy-Nagy, *Moholy-Nagy: Experiment in Totality*, p. 66.

11. László Moholy-Nagy, *The New Vision*, p. 83.

12. Sibyl Moholy-Nagy, *Moholy-Nagy: Experiment in Totality*, p. 67.

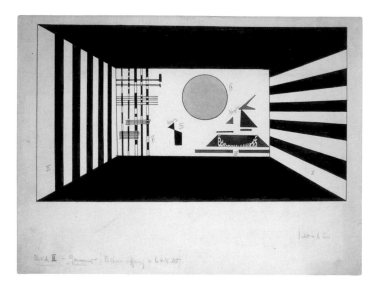

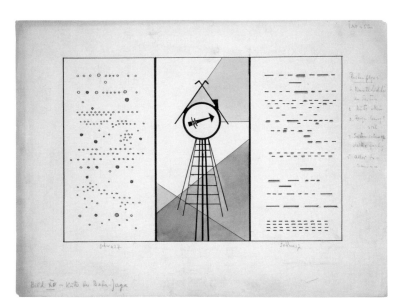

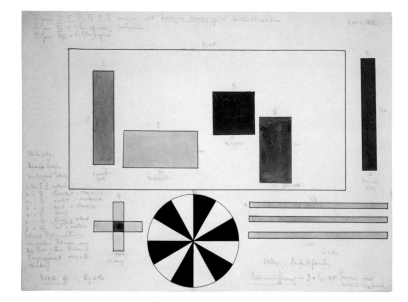

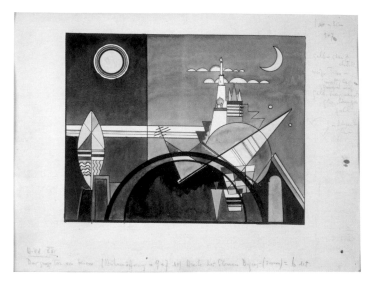

377 (top left)
Vasily Kandinsky
II. *Gnomus* (Gnome). c.1928
The second of sixteen movements
for Modest Mussorgsky's *Pictures at an
Exhibition*, for performance at the
Friedrichtheater, Dessau, April 11, 1929
8 1/8 x 14 3/16" (20.6 x 36.1 cm)
India ink, watercolor, and gouache on paper
Centre Pompidou, Paris. Musée national d'art
moderne/Centre de création industrielle

378 (bottom left)
Vasily Kandinsky
VII. *Bydlo* (Cattle). c.1928
The seventh of sixteen movements
for Modest Mussorgsky's *Pictures at an
Exhibition*, for performance at the
Friedrichtheater, Dessau, April 11, 1929
11 13/16 x 15 3/4" (30 x 40 cm)
India ink, watercolor, and gouache on paper
Centre Pompidou, Paris. Musée national d'art
moderne/Centre de création industrielle

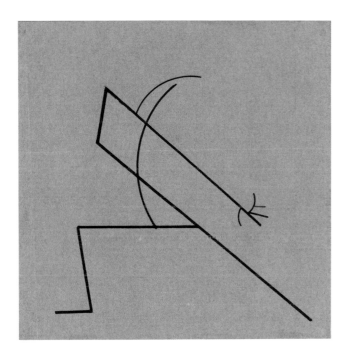

379 (opposite, top right)
Vasily Kandinsky
XV. *Hütte der Baba-Jaga*
(The hut of Baba Yaga). c.1928
The fifteenth of sixteen movements
for Modest Mussorgsky's *Pictures at an
Exhibition*, for performance at the
Friedrichtheater, Dessau, April 11, 1929
11¹³/₁₆ x 15¾" (30 x 40 cm)
India ink, watercolor, and gouache on paper
Centre Pompidou, Paris. Musée national d'art
moderne/Centre de création industrielle

380 (opposite, bottom right)
Vasily Kandinsky
XVI. *Das Grosse Tor von Kiew*
(The great gate of Kiev). c.1928
The sixteenth of sixteen movements
for Modest Mussorgsky's *Pictures at an
Exhibition*, for performance at the
Friedrichtheater, Dessau, April 11, 1929
8⅜ x 10¹¹/₁₆" (21.3 x 27.1 cm)
India ink, watercolor, and gouache on paper
Centre Pompidou, Paris. Musée national d'art
moderne/Centre de création industrielle

381
Vasily Kandinsky
*Zwei grosse parallellaufende Linien auf einen
geraden Winkel gestützt* (Two large parallel
lines supported by an angle). Analytical
drawing after photograph of the dancer
Gret Palucca by Charlotte Rudolph. 1925
Ink on tracing paper
6½ x 6⅜" (16.5 x 16.2 cm)
Staatliche Kunstsammlungen Dresden,
Kupferstich-Kabinett

382
Vasily Kandinsky
Drei Gebogene, die sich in einem Punkt treffen
(Three curves meeting at a single point).
Analytical drawing after photograph
of the dancer Gret Palucca by Charlotte
Rudolph. 1925
Ink on tracing paper
7⅝ x 6⅛" (19.3 x 15.5 cm)
Staatliche Kunstsammlungen Dresden,
Kupferstich-Kabinett

383
Franz Ehrlich, after sketches by
Joost Schmidt
Poster for Bauhaus exhibition, Gewerbemuseum
Basel (April 21–May 20, 1929). 1929
Lithograph on paper
50 x 35½" (127 x 90.2 cm)
Collection Merrill C. Berman

384
Erich Mrozek
Design for a poster for *Internationale
Hygiene Ausstellung* (International hygiene
exhibition), Dresden. 1930
Gouache on paper
16½ x 23⅜" (41.9 x 59.4 cm)
Collection Merrill C. Berman

385
Friedrich Reimann
Exercise for type and advertising course
taught by Joost Schmidt, using the brand
name "Kandem" in sans serif and slab
serif typefaces. 1931
Ink on paper
16 9/16 x 23¼" (42 x 59 cm)
Bauhaus-Archiv Berlin

386
Erich Comeriner
Design for poster for Muuu Effektenbörse
(stock exchange). 1927–28
Cut-and-pasted printed papers with
gouache on paper
22⅞ x 16 7/16" (58.1 x 41.8 cm)
Collection Merrill C. Berman

HYGIENE

internationale ausstellung

dresden 1930

kandem sind

kandem sind

Kandemlampen

sind in allen
ausführungen am lager

schrift schmidt

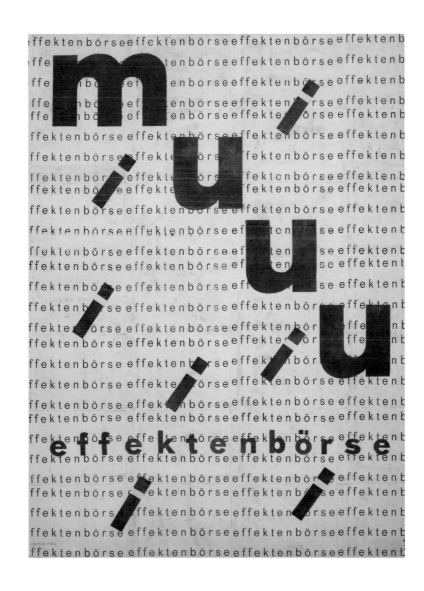

387 (opposite, above)
Hajo Rose (Hans-Joachim Rose)
Design for a fabric print pattern made
from typewriter type. 1932
Typewriting on paper
11 5/8 x 8 1/4" (29.5 x 20,9 cm)
Bauhaus-Archiv Berlin

388 (opposite, below)
Joost Schmidt
Cover of the pamphlet *Bauhaus vorhangstoffe
tapeten* (Bauhaus curtain fabrics, wallpaper).
Dessau: Bauhaus, 1930–31
Lithograph
5 7/8 x 8 1/4" (14.9 x 21 cm)
Collection Merrill C. Berman

389
Hajo Rose (Hans-Joachim Rose)
Design for a fabric print pattern made from
typewriter type. 1932
Typewriting on paper. Additional
designs on verso
11 1/16 x 5 1/16" (28.1 x 12.9 cm)
Bauhaus-Archiv Berlin

390
Hajo Rose (Hans-Joachim Rose)
Fabric with printed typewriting pattern. 1932
Cotton and rayon
26 3/16 x 44 1/8" (66.5 x 112 cm)
Bauhaus-Archiv Berlin

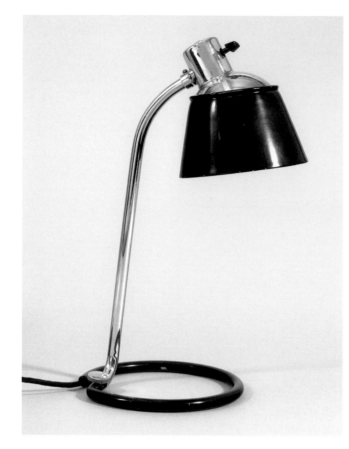

391
Heinrich-Siegfried Bormann
Desk lamp. 1932
Manufactured by Körting & Mathiesen
(Kandem no. 934)
Nickel-plated-aluminum shade, tubular
nickel-plated-brass arm and base,
all external parts black lacquer
Height: 18⅛" (46 cm), diam.: 6⁵⁄₁₆" (16 cm)
Bauhaus-Archiv Berlin

392
Marianne Brandt and
Hin Bredendieck
Desk lamp. 1928
Manufactured by Körting & Mathiesen
(Kandem no. 756)
Sheet-steel shade, steel arm and parts,
cast-iron base, all external parts reddish
bronzed, inside of shade coated with
aluminum paint
Height: 18½" (47 cm)
Bauhaus-Archiv Berlin

393
Herbert Schürmann
Design for a logo for the Kandem brand
of the firm Körting & Mathiesen. 1932
Ink on paper
Composition: 7¼" (18.4 cm) diam.
Collection Merrill C. Berman

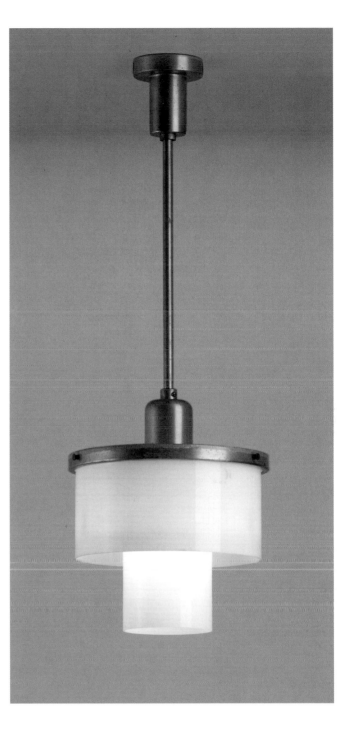

394
Marianne Brandt and
Hin Bredendieck
Bedside table lamp (basic version). 1928–29
Manufactured by Körting & Mathiesen
(Kandem no. 702)
Sheet-steel shade, tubular steel arm and
parts, cast-iron base, all external parts ivory
lacquer, inside of shade coated with matte
aluminum lacquer
Height: 9 13/16" (25 cm), diam.: 4 1/8" (10.5 cm)
Justus A. Binroth, Berlin

395
Marianne Brandt and **Helmut Schulze**
Double cylinder hanging lamp. 1929
Manufactured by Körting & Mathiesen
(Kandem no. 666)
Nickel-plated brass and opaque glass
Height: 30 5/16" (77 cm)
Bauhaus-Archiv Berlin

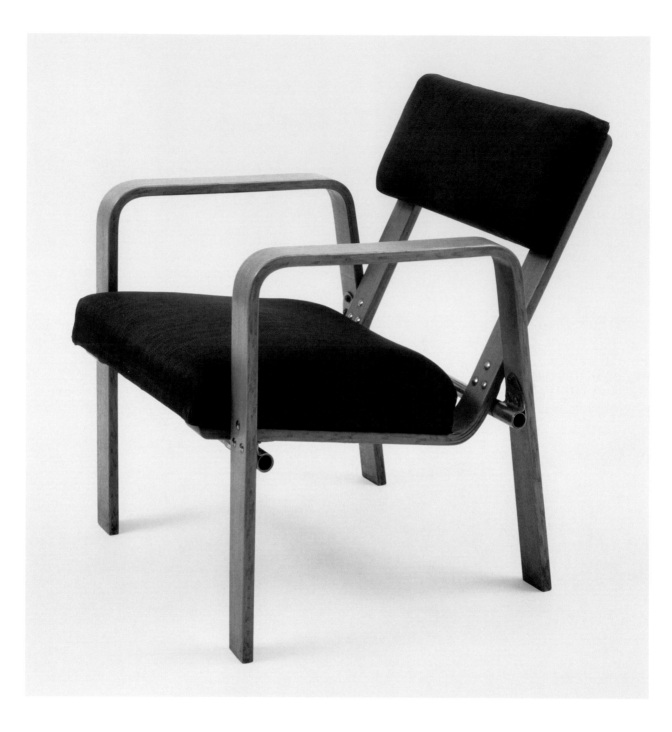

396
Josef Albers
Armchair (TI 244). 1929
Laminated beech and tubular steel,
with canvas upholstery
28 1/2 x 23 1/8 x 28 1/2" (72.4 x 58.7 x 72.4 cm)
The Museum of Modern Art, New York.
Gift of the designer

397
Hin Bredendieck and **Hermann Gautel**
Work stool. 1930
Chrome-plated tubular steel and five-layer,
steam-curved lacquered beech plywood
23 11/16 x 15 3/8 x 19 13/16" (60.1 x 39 x 50.3 cm)
Bauhaus-Archiv Berlin

398
Friedrich Karl Engemann
Armchair. 1929
Tubular steel and plywood
31 1/2 x 22 1/16 x 22 13/16" (80 x 56 x 58 cm)
Stiftung Bauhaus Dessau

399
Hubert Hoffmann
Stool designed for easy disassembly. 1933
Plywood with aluminum braces, upholstery
15 3/4 x 19 11/16 x 17 11/16" (40 x 50 x 45 cm)
Bauhaus-Archiv Berlin

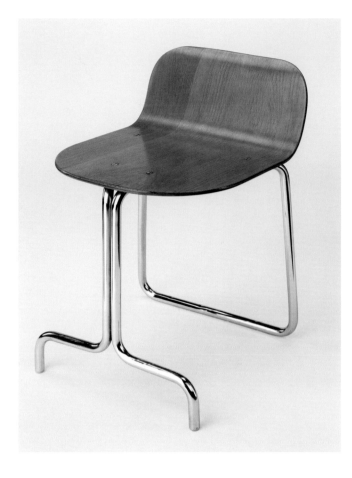

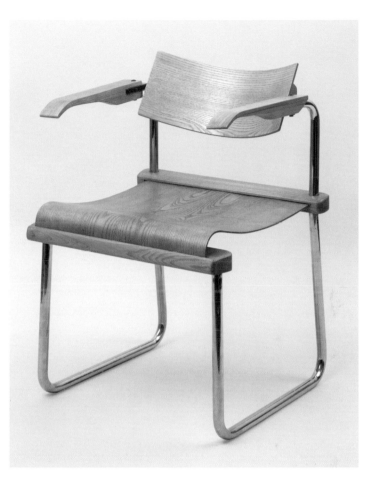

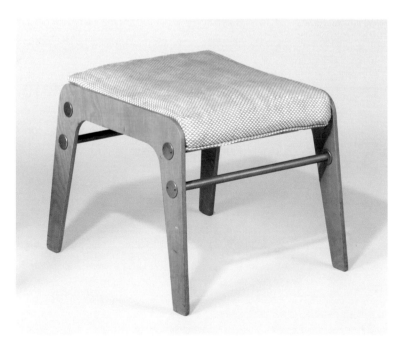

400
Walter A. Peterhans
Toter Hase (Dead hare). c.1929
Gelatin silver print
11 5/16 x 12 7/16" (28.8 x 31.6 cm)
Bauhaus-Archiv Berlin

401
Walter A. Peterhans
Wochenende (Weekend). Before May 1929
Gelatin silver print
10 1/16 x 13" (25.5 x 33 cm)
Galerie Berinson, Berlin

402
Theo H. Ballmer
Eigenschaften der Emulsion (Properties
of the emulsion). Exercises for photography
class taught by Walter Peterhans. c.1929
Photographs and typewritten strips,
mounted on card
11 3/4 x 16 1/2" (29.8 x 41.9 cm)
The J. Paul Getty Museum, Los Angeles

403
Theo H. Ballmer
Untitled (Light bulb). c.1929
Gelatin silver print
11 5/16 x 8 5/8" (28.7 x 21.9 cm)
The J. Paul Getty Museum, Los Angeles

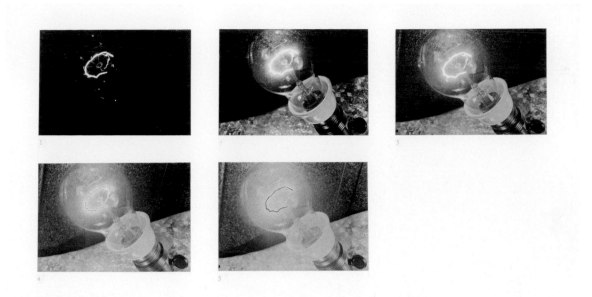

Eigenschaften der Emulsion Aufgabe 1

Beziehungen zwischen Exposition und Dichte des Silberniederschlages

1) stark unterexponiert 2) unterexponiert 3) normal exponiert
4) überexponiert (Solarisation) 5) stark überexponiert (starke Solarisation)

404
Erich Comeriner
Untitled (Spiral with chair). c.1929
Cut-and-pasted photographs and
photomechanical reproductions on paper
16¹⁵/₁₆ × 24" (43 × 61 cm)
Erich Comeriner Archiv. Galerie David,
Bielefeld

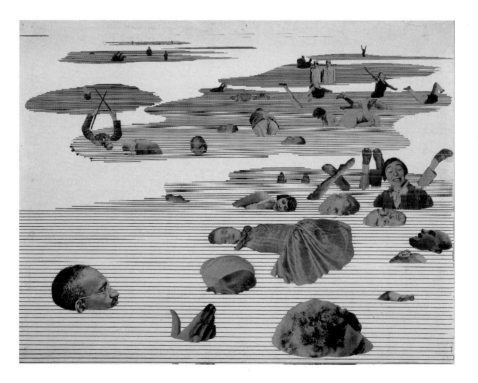

405
Kurt Kranz
Zahlen Zeichen Reihe (Number signs row).
1930–31, vintage prints mounted on card
by the artist in 1970
10 gelatin silver prints, mounted on board
Each: 5 3/8 x 7 11/16" (13.6 x 19.5), overall:
27 9/16 x 15 15/16" (70 x 40.5 cm)
Bauhaus-Archiv Berlin

406
Kurt Kranz
Spielt euer Spiel (Play your game). 1931
Cut-and-pasted photomechanical
reproductions with pencil and ink on paper
19 5/8 x 25 1/2" (49.8 x 64.7 cm)
The Museum of Modern Art, New York.
Horace W. Goldsmith Fund through
Robert B. Menschel, The Family of Man Fund,
David H. McAlpin Fund and Purchase

407
Kurt Kranz
Versinkende (The sinking ones). 1931
Cut-and-pasted gelatin silver prints and
photomechanical reproductions on paper
19 11/16 x 24 13/16" (50 x 63 cm)
Galerie Berinson, Berlin

WALLPAPER DESIGN
JULIET KINCHIN

At first sight these discreetly patterned wallpaper samples appear eminently inoffensive. Wallpaper, the "stuff" that surrounds us, has long been accorded a lowly status as an ancillary, almost parasitic product that assumes a presence only when conjoined to a wall. As a formless entity, unbounded by clear outlines of size or shape, it tends to recede into the background of our consciousness, resistant to both possession as a collectible and display as an iconic artifact in museums and exhibitions. Yet the inherently subservient character of wallpaper belies its aesthetic power, its economic significance as an industrial product, and the heated nature of the debates it continues to engender.

Bauhaus wallpapers exemplify this paradox. Beginning under the directorships of Hannes Meyer (1928–30) and then Mies van der Rohe (1930–33), the school forged partnerships with businesses to manufacture student designs on a wide scale, and in association with Gebrüder Rasch of Bramsche, wallpaper became the Bauhaus's most lucrative product — even after the institution was closed, in 1933. More than other consumer goods, wallpaper's affordability across a broad public spectrum, and its widespread availability in domestic and institutional markets, gave it the potential to homogenize the German interior and blur distinctions of social class. Arguably it was wallpaper that most effectively inserted the name and concept of the Bauhaus into the popular imagination, yet few are now aware of this industrial-design and commercial success story.[1]

That the production of wallpaper has been persistently marginalized, even omitted altogether, in standard accounts of the Bauhaus is indicative of the medium's problematic status in the modern interior and in modernism more generally. From a purely functionalist perspective, decorative wallpaper was surplus to need. As the Swedish designer Josef Frank remarked of the Weissenhofsiedlung, the modernist housing development built in Stuttgart in 1927, "Modern people have white walls."[2] But if color and texture *were* to be introduced to those walls, then architects and designers wanted to be in control. "What to do with our walls?" was a question that had preoccupied design reformers since the mid- to late-nineteenth century, when the introduction of cheap roller printing had suddenly placed a huge array of cheaply colored and garishly patterned papers within reach of the ordinary homeowner. The material itself was discussed as a potential health hazard; there was speculation about the use of vermin-harboring paper stock, rotting animal glues, and arsenical colors. In an effort to counter a popular taste for floral and representational patterns, British design reformers

from A. W. N. Pugin and Henry Cole to Charles Lock Eastlake and C. F. A. Voysey consistently advocated abstract, nonillusionistic designs of flattened or abstract patterns that respected the two-dimensionality of the wall's surface. The fine grids, wavy patterns, and cross-hatching of the first Bauhaus wallpapers, produced in 1929, represent a culmination of these earlier design-reform tendencies. In some cases the patterning of grids and flecks is based on the texture of the paper (cat. 410).

The related design-reform tenets of "truth to materials" and "truth to construction," which directly fed international modernism, placed an overwhelming emphasis on design as content and structure as opposed to surface decoration. By association the critical language of these debates, which persisted throughout the late-nineteenth and into the twentieth century, gendered wallpaper as feminine: in covering cracks and blemishes, disguising the "true" nature of the wall, it was often presented, like furniture veneers or like women's cosmetics, as insincere, superficial, a way of "dressing up" rooms to appear what they were not.[3] Overly decorated walls were seen as attention-seeking and by implication "immodest" compared to quiet, plain ones. Like the female consumer, wallpaper appeared to be in the thrall of fickle fashion, more prey to seasonal change than other components of the interior. In conscious reference to the culturally embedded legacy of such debates, the marketers of the Bauhaus wallpapers emphasized the "structure" of the school's rational, sober designs, and the "timeless" quality that distinguished them from the restless changeability of most patterns, which were changed annually.

Wayward consumer preferences did not always follow the dictates of the professionals, however, particularly in interior decoration. While the spatial configurations of homes were generally predetermined by architects and builders, wallpaper remained one area in which people could exercise choice and individual taste. In the interwar years a sense of consumer agency was further encouraged by the growing acceptability of home improvement as both a leisure activity and an economic necessity. Despite the waning popularity of densely patterned interiors

408
Hubert Hoffmann
Jetzt. Einst. Bauhaus Tapeten
(Now. Then. Bauhaus wallpaper). 1929–30
Cut-and-pasted paper with gouache
and ink on paper
11³/₁₆ x 8¼" (28.4 x 21 cm)
Collection Merrill C. Berman

(rooms were generally smaller and more multipurpose), wallpaper remained the standard form of decoration for the majority of homes.

In Germany a modernist reconsideration of wallpaper got under way in the mid-1920s, when the colossal housing schemes that Ernst May began to build in Frankfurt in 1925 showed that it could enhance the structural and aesthetic program of the new architecture (*Neues Bauen*). At around the same time, after a period of stagnation following World War I due to material shortages and inflation, the German wallpaper industry seemed poised to recover its position as a major producer and exporter. In 1927, keen to explore new markets and the possibility of architectural commissions, the wallpaper-factory director Emil Rasch made an approach to the Bauhaus through his sister, who had studied alongside Hinnerk Scheper in the Weimar wall-painting workshop. Despite some initial reservations, the school's director, Hannes Meyer, and Scheper, now the master of the wall-painting workshop, were receptive to the idea and a contract was signed in March 1929. Wallpapers fitted Meyer's concern to produce a limited range of universally valid, popular products to meet "people-oriented demand." The Bauhaus had nothing to lose in that Rasch was prepared to take on all the financial risk, and control of designs and colors were to stay with the school. Any prospect of royalties, however small, was attractive given the institution's precarious finances. The agreement also gave the Bauhaus first option on designing the marketing, posters, and other advertising for the wallpapers in order to ensure compatibility with their larger "brand."

Following a school-wide competition, designs by Bauhaus students were developed under Scheper's direction in the wall-painting workshop. The first collection, issued in September 1929 for the 1930 season, comprised 145 different wallpapers based on fourteen patterns, each available in five to fifteen color variations. Further collections came out annually until 1933, with some of the more popular patterns, occasionally in modified colorways, being carried over from year to year. The designs were not dissimilar from others already on the market, but reflected Scheper's teaching on color as a means of underlining the inherent architectural qualities of a space ("The most important function of color in a room is its psychological effect on the human being. Color can lift or depress the spirits, make the room larger or smaller, have a fresh and invigorating or dull and tiring effect")[4] and his insistence on the command of techniques of shading color, such as spraying, scumbling and screening, so as to avoid masking a lively wall surface with a uniform paper skin that would obscure color gradations. These textured, lightly patterned, often monochromatic wallpapers enveloped the interior in subtly colored effects that were hardly recognizable as patterns and were economical to hang as there was no need to match repeats. Their small, subdued patterns were ideally suited to decorating the relatively small spaces of modern housing estates. They were affordable, and their washable finish was hygienic.

In the first year, the Rasch company manufactured 4½ million rolls. After a slow start, sales grew steadily, with a 300% increase by the end of the 1930 season. Rasch's aggressive

409
Designer unknown
Roll of wallpaper. 1931
Manufactured by Gebr. Rasch & Co., Bramsche
Printed paper
Width: 20 1/16" (51 cm)
Stiftung Bauhaus Dessau

410
Heinrich Bormann
Designs for wallpaper. 1931
One sheet from a set of five,
each with six designs
Chalk pastel, rubbed over textured paper
Each design: 3 x 2 3/16" (7.6 x 5.5 cm),
sheet: 8 1/4 x 11 13/16" (21 x 30 cm)
Stiftung Bauhaus Dessau

Fig.1
Tapetenfabrik Rasch & Co., Bramsche
Frontispiece from an advertising catalogue for
Bauhaus wallpapers, along with additional patterns
from the Weimar and May companies. 1937–38
Letterpress and wallpaper on paper
11 5/8 x 8 1/4 x 1/2" (29.5 x 21 x 1.3 cm)
The Museum of Modern Art, New York.
Architecture & Design Purchase Fund

and innovative marketing tactics were crucial to the success of the brand and its longevity. "The term Bauhaus wallpaper has indeed worked magic in the battle with wall paint, in the struggle against modern architects' basically hostile attitude to wallpapering," commented the *Deutsche Tapeten-Zeitung* in 1932.[5] There was no denying the message of the dynamic advertisement designed by Friedrich Vordemberge-Gildewart: "Rasch stands for more turnover." By 1933, sales had leveled off, with the factory operating at full capacity. For a while Rasch maintained a personal agreement with Mies van der Rohe, providing a commission that helped to sustain the school's curtailed teaching program in Berlin after the Nazis had closed it in Dessau. In 1933, when the Berlin school was threatened with closure, he paid a one-off sum of 6,000 reichsmarks to acquire all rights to the designs, the revenues from them, and the Bauhaus name as it applied to wallpaper. With further skillful maneuvering, Rasch also managed to make his wallpaper the only product allowed to keep the name "Bauhaus" throughout the years of the Third Reich. This little-publicized fact complicates our view of the Bauhaus legacy, showing how the Bauhaus name was perpetuated in the Third Reich despite postwar myths of its complete suppression by the Nazis. Inevitably the social idealism with which the venture had begun was compromised. The cover of a 1938 Rasch catalogue (fig. 1) juxtaposes the different styles of the Bauhaus, May and Weimar collections indicating that the Bauhaus brand of modernism became simply one consumer choice among many. Yet this same image also testifies to the versatility and viability of Bauhaus design principles in the marketplace, and to the enduring success of Bauhaus wallpapers as a popular, affordable, and irrefutably industrial product.

1. Recent scholarly interest in this area has been stimulated by the revisionist perspectives presented in an excellent dual-language study, Burckhard Kieselbach, Werner Möller, and Sabine Thümmler, eds., *Bauhaustapete: Reklame und Erfolg einer Marke/Advertising and Success of a Brand Name* (Cologne: DuMont, 1995).

2. Josef Frank, quoted in Justus Bier, "Zur Frage der Tapetenmusterung," *Deutsche Tapeten-Zeitung*, 1931, p. 189, quoted and trans. in Kieselbach, Möller, and Thümmler, eds., *Bauhaustapete*, p. 18. Trans. Claudia Spinner and López-Ebri.

3. The characters of Mr. and Mrs. Veneering in Charles Dickens's novel *Our Mutual Friend* (1862) exemplified these associations. For fuller discussion of the gendering of wallpaper see Beverley Gordon, "Woman's Domestic Body: The Conceptual Conflation of Women and Interiors in the Industrial Age," *Winterthur Portfolio* 31 (1996):281–301; Jan Jennings, "Controlling Passion: The Turn-of-the-Century Wallpaper Dilemma," in ibid., pp. 243–63; and Juliet Kinchin, "Interiors: nineteenth-century essays on the 'masculine' and 'feminine' room," in Pat Kirkham, ed., *The Gendered Object* (Manchester: at the University Press, 1996), pp. 12–29.

4. Hinnerk and Lou Scheper, "Arkhitektura i tsvet," in *Maliarnoe delo* (Moscow) nos. 1–2 (1930):12–15.

5. *Deutsche Tapeten-Zeitung*, 1932, p. 286, quoted and trans. in Kieselbach, Möller, and Thümmler, eds., *Bauhaustapete*, p. 18. Trans. Claudia Spinner and López-Ebri.

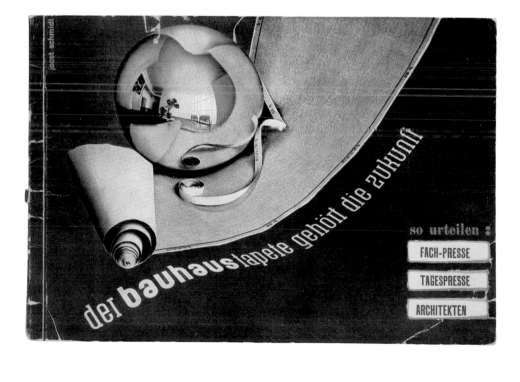

411
Florence Henri
Composition No. 76. 1928
Gelatin silver print
10 1/2 x 14 5/8" (26.7 x 37.1 cm)
The Museum of Modern Art, New York.
John Parkinson III Fund

412
Florence Henri
Untitled (Self-portrait). 1928
Gelatin silver print
6 1/8 x 4 13/16" (15.5 x 12.2 cm)
Metropolitan Museum of Art, New York.
Ford Motor Company Collection.
Gift of Ford Motor Company and
John C. Waddell

413
Joost Schmidt
Two designs for the cover of the pamphlet
Der Bauhaus Tapete gehört die Zukunft
(The future belongs to Bauhaus wallpaper). 1931
Gelatin silver prints with gouache,
mounted on paper
11 5/8 x 8 1/4" (29.5 x 20.9 cm)
Bauhaus-Archiv Berlin

414
Joost Schmidt
Cover of the pamphlet *Der Bauhaus
Tapete gehört die Zukunft* (The future
belongs to Bauhaus wallpaper). 1931
Letterpress on paper (with cut-outs)
5 13/16 x 8 1/4" (14.8 x 21 cm)
Bauhaus-Archiv Berlin

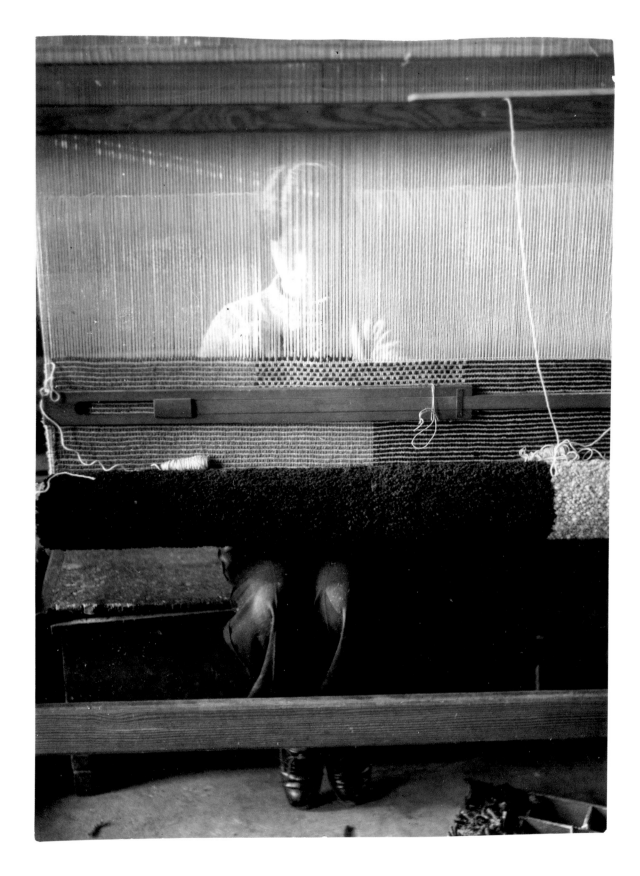

415
Hajo Rose (Hans-Joachim Rose)
Untitled (Michiko Yamawaki at the loom).
1930–32
Gelatin silver print
6 ¼ x 4 ⁷⁄₁₆" (15.9 x 11.3 cm)
Bauhaus-Archiv Berlin

416 (top left)
Gunta Stölzl
Samples of reversible coat fabrics. 1923–28
Left to right: wool, silk, and cotton; wool
and cotton; wool and cotton
Left to right: 8 x 5⅛" (20.3 x 13 cm), 8 x 6"
(20.3 x 15.2 cm), 8⅛ x 8⅛" (20.6 x 20.6 cm)
The Museum of Modern Art, New York.
Phyllis B. Lambert Fund

417 (top right)
Gunta Stölzl
Samples of upholstery fabrics. 1928
Clockwise from lower left: wool, cotton,
and rayon; wool, cotton, and metal thread;
wool and cotton
Clockwise from lower left: 5 x 5½"
(12.7 x 14 cm), 6 x 5⅞" (15.2 x 14.9 cm),
6⅜ x 6" (16.2 x 15.2 cm)
The Museum of Modern Art, New York.
Phyllis B. Lambert Fund

418 (bottom left)
Anni Albers
Samples of furnishing fabrics. 1929
Left to right: linen and cotton; linen, cotton,
and rayon; cotton and linen; linen and cotton
Left to right: 4¼ x 7½" (10.8 x 19 cm),
4½ x 7½" (11.4 x 19.1 cm), 4½ x 7½"
(11.4 x 19 cm), 4½ x 7½" (11.4 x 19 cm)
The Museum of Modern Art, New York.
Gift of the designer

419 (bottom right)
Anni Albers
Samples of upholstery fabrics. 1929
Top to bottom: cotton; cotton and rayon;
cotton; linen, cotton, and rayon
Top to bottom: 7⅛ x 4¼" (18.1 x 10.8 cm),
7½ x 4¼" (19.1 x 10.8 cm), 5¼ x 7⅞"
(13.3 x 20 cm), 4⅝ x 7⅞" (11.8 x 20 cm)
The Museum of Modern Art, New York.
Gift of the designer

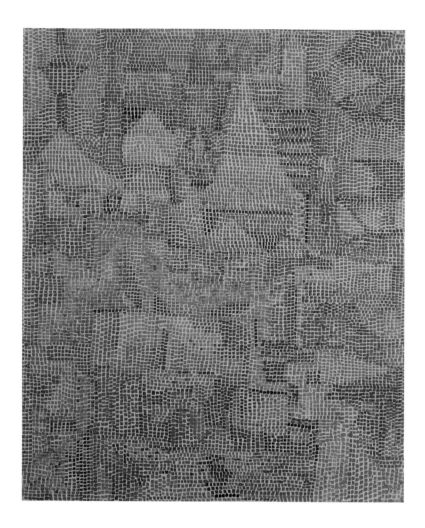

420
Paul Klee
Schlossgarten (Castle garden). 1931
Oil on canvas
26½ x 21⅝" (67.2 x 54.9 cm)
The Museum of Modern Art, New York.
Sidney and Harriet Janis Collection Fund

421
Paul Klee
Landschafts-Wagen Nr. 14
(Landscape wagon no. 14). 1930
Watercolor and ink on silk, mounted on card
Mount: 19⁷⁄₁₆ x 25³⁄₁₆" (49.3 x 64 cm)
Harvard Art Museum, Busch-Reisinger
Museum. Museum purchase

422
Otti Berger
Curtain. c. 1930
Linen, cotton, rayon, and other yarns,
in rib and twill weave
7' 2⅝" x 55⅞" (220 x 142 cm)
Bauhaus-Archiv Berlin

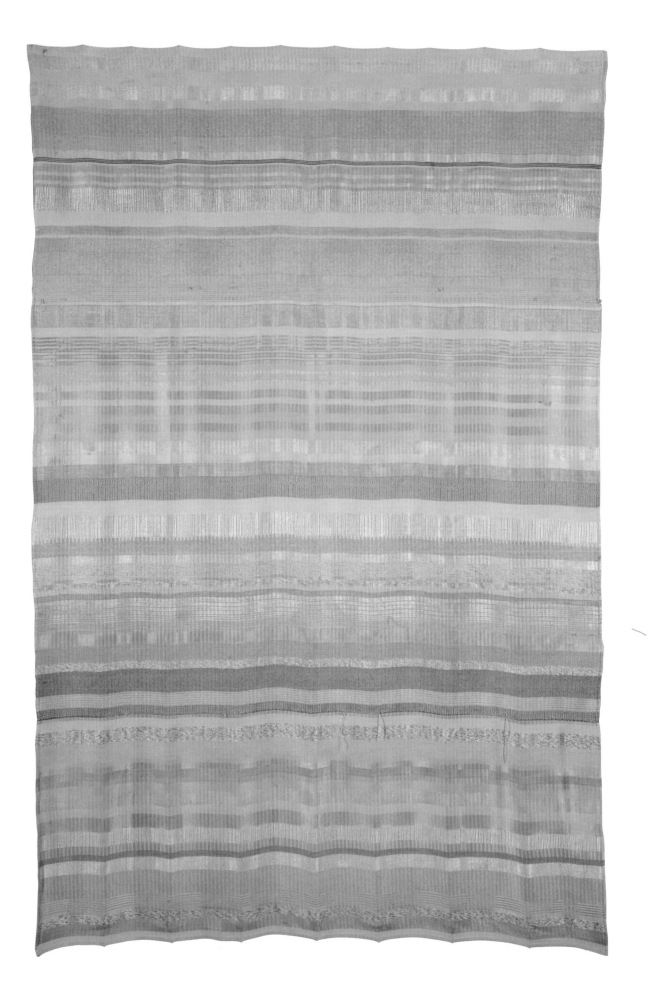

PAUL KLEE
FIRE IN THE EVENING. 1929
ALEX POTTS

Feuer Abends (Fire in the evening) and *Hauptweg und Nebenwege* (Highway and byroads; cat. 444) — both dating from 1929, toward the end of Klee's ten-year stint teaching at the Bauhaus — throw into relief something central to the artist's involvement with Bauhaus pedagogy: the potentially conflicted relationship between a commitment to systematic procedure and a fascination with the wayward, comic, and disruptively intuitive. The latter emerges explicitly from time to time in his theoretical reflections on art, doing so even in his *Pädogogisches Skizzenbuch* (Pedagogical sketchbook), published in 1925 as the second in the *Bauhausbücher* series (cat. 254). With its clean design by László Moholy-Nagy, the book has the appearance of a systematically organized primer for teaching the generative principles of pictorial form but begins by invoking "an active line on a walk, moving freely, without goal. A walk for a walk's sake."[1]

The basic layout of *Feuer Abends*, one of Klee's more purely abstract paintings, may at first seem quite systematic.[2] A series of regular horizontal bands is interrupted by vertical cuts where a band changes color and either splits into equal parts or combines with an equivalent neighbor. There is a general drift toward smaller subdivisions on the left-hand side of the work. Hue and tone, not unexpectedly, are handled more intuitively, but have a systematic aspect: color is skewed toward the cool end of the spectrum through the elimination of yellow, and there is a greater concentration of deeper, darker colors in the more densely subdivided left half of the painting. Closer examination, though, reveals gratuitous variations in the horizontal banding. The initial impression that bands change width in multiples of two, exemplifying what Klee called a "divisional" structure of repeated, exactly equivalent units, proves illusory.[3] Many bands that look as if they should be equivalent are in fact noticeably different in width, irregularities disguised when one first surveys the painting by variations of tone and hue.

A more striking unsettling of stable pictorial order is produced by the contest between the work's vertical and horizontal structuring. In places, several bands coalesce into vertical blocks, creating motifs that cut across the horizontal layering but are inherently unstable. No fixed figure-ground relation emerges. It is as if the painting offered an illusion of order and stability, but then induced sequences of discontinuous formal effects played out in time. In pictures as in life, Klee insisted, "The space in which we move belongs to time.... Only the dead point is timeless."[4] Instability is created, not just by the shifting

definitions of shape, but also by the transformation of the pictorial field that occurs as abstract forms momentarily coalesce into the panorama teasingly invoked by the title *Feuer Abends* and the one small burst of bright red-orange.

Feuer Abends: is this not the stuff of pictorial kitsch — a gentle fire burning at the close of day amid a shadowy prospect of natural greenery and dark blue sky? How beautiful! Well, fire can be threatening, too. One might recall that in the Bauhaus at the time, political fires were not just simmering but on occasion flaring up, with growing Communist Party activism in the student body. Walter Gropius had resigned as director the previous year, and Klee was dealing with a work environment marked by a new functionalist, antiaesthetic ethos that he was increasingly finding antithetical to his commitments as an artist. The political instability and uncertainty were intensified by the dramatic rise of the political right: the local press had been mounting hostile attacks on the Bauhaus, and toward the end of the year the Nazis achieved their first major breakthrough in elections in neighboring Thuringia. At this juncture, Klee, far from feeling safely ensconced at the Bauhaus, was negotiating to leave for a post at the more traditional Düsseldorf academy.

This said, the poetic, almost fairy tale resonances of the picture remain unavoidable, as do the suggestions of a commitment to "pure" pictorial abstraction. At the same time, it is impossible to hold on to a perception of the work as unequivocally uplifting and beautiful — whether as a poetic vision of evening calm or a polyphony of form, tone, and color. Implicit in the playing with form, and in the toying with a clichéd image of "fire in the evening," is an ironic attitude and a detachment very evident in Klee's private commentary on his own situation and on the world around him.[5] Even in his public declarations of artistic faith, as in his *Schöpferische Konfessionen* (Creative credo) of 1920, a bemused irony manifests itself both in understated, subtly playful turns of phrase and in the substance of what is said. Klee took care to qualify the declaration that artistic "symbols console the mind...showing that there is something more than the earthly and its possible intensifications" by observing how such "ethical gravity coexists with impish tittering at doctors and priests."[6]

Much of Klee's art deploys a visual language bordering on caricature and is explicitly witty and ironic, as in the painting *Analyse verschiedener Perversitäten* (Analysis of diverse

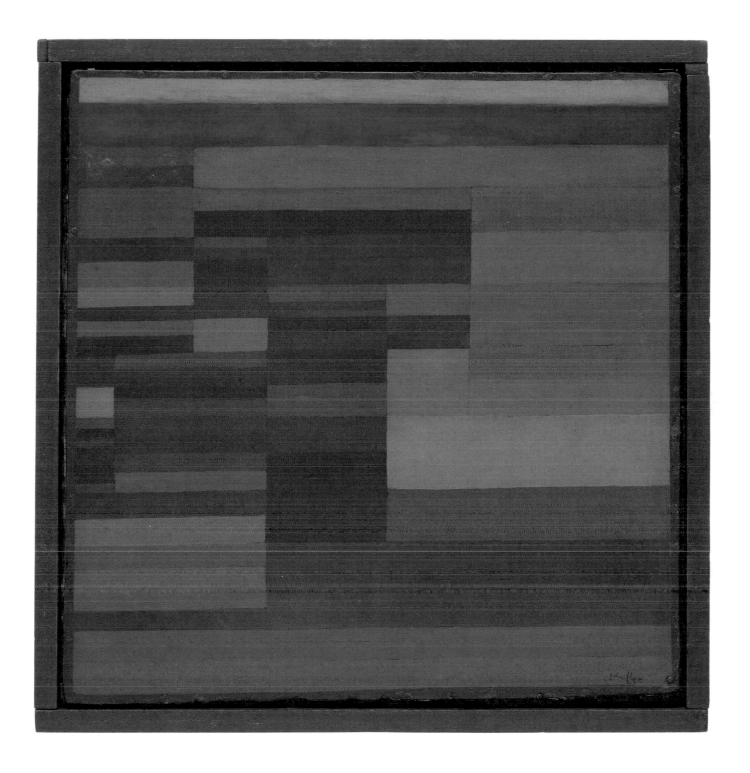

423
Paul Klee
Feuer Abends (Fire in the evening). 1929
Oil on cardboard
13 3/8 x 13 1/4" (33.8 x 33.3 cm)
The Museum of Modern Art, New York.
Mr. and Mrs. Joachim Jean Aberbach Fund

perversities, 1922; cat. 424), dating from the beginning of his time as a Bauhaus teacher. Drawing plays a key role in such works, a drawing that combines formal inventiveness and sketching with wayward doodling. The drawing in *Hauptweg und Nebenwege*, a painting that shares *Feuer Abends*'s formal logic of stratification, produces subtly witty effects more explicit than the latter's veiled ironic undertones. There is an unruliness to the irregular network of lines marking out the borders of the lightly painted blocks of color. A straight, broad highway leads up and into the distance amid a profusion of irregular byways, many leading nowhere, splitting off from and coupling with one another. Allegories on the path of life come to mind. It has been suggested that Klee, now that he was about to leave the Bauhaus to devote himself more fully to his art, could have fashioned here an image of the true way triumphing over a

confusion of half-finished, distracting and anarchic byways.[7] Besides being at odds with Klee's detached way of commenting on turning points in his life, such an interpretation ignores the fact that irregularity is the very life of the picture. The profusion of forms delineating the byroads makes the ground buckle and move, and this, together with the enlivening of the thin skein of oil paint produced by scratches in the thickened ground, gives the work density and substance, making it an imagined world rather than a mere pictorial schema.

The painting is in a way a meditation on the complexities of the ethos Klee sought to realize in his art and in his teaching at the Bauhaus. The sense he had of a larger project was clearly sustained by a belief that the radical formal experimentation in which he and his contemporaries were engaging was leading toward a new understanding of art (and life), and represented a true path, as it were. At the same time, the highway was nothing without the byways; in Klee's view, the pursuit of an ideal was "relative," not "absolute" — an open process in which "irregularity" played a guiding role.[8]

The vernacular commonplaceness of the title *Hauptweg* and Nebenwege gently mocks the work's symbolic connotations,

424
Paul Klee
Analÿse verschiedener Perversitäten
(Analysis of Diverse Perversities), 1922
Ink and watercolor on paper laid down
on cardboard
18 1/2 x 12 3/8" (47 x 31.4 cm)
Centre Pompidou, Paris. Musée national d'art
moderne/Centre de création industrielle.
Gift of Heinz Berggruen

425
Paul Klee
Page from Paul Klee, *Pädagogisches
Skizzenbuch* (Pedagogical sketchbook).
Bauhausbücher no. 2. Munich: Albert
Langen Verlag, 1925
Bauhaus-Archiv Berlin

1.⑫

⑫ **Übungsaufgaben**

(auf Grund der Dreigliederung): Erstes Organ aktiv (Hirn),
Zweites Organ medial (Muskel),
Drittes Organ passiv (Knochen).

a) **Wasserrad und Hammer** (Fig. 25):

Fig. 25

I Das Wassergefäll (aktiv).　II Das Räderwerk (medial).　III Der Hammer (passiv).

Wasserkästen des großen Rades.　Speichen des kleinen Rades.

Treibriemen.

20

just as the matter-of-fact, lively, ludicrous confusion of byways does the true path in the picture itself, and rather as the suggestions of pictorial cliché and the somewhat wayward pattern-making deflect the poetics of *Feuer Abends*. Klee operates in a low or vernacular mode as much as he does in a high one. The engagingly informal quality of some of the diagrams in his *Pädagogisches Skizzenbuch* (e.g., cat. 425) is as integral to his thinking as the abstract general principles they illustrate. Implicit in this approach is a certain larger understanding of things in the modern world that Klee's most perceptive early critic, Carl Einstein, perhaps came closest to identifying. He claimed that Klee's art demonstrated how "myth and world can hardly be united with one another today; they make fun of one another in an ironic struggle, because we are not capable of finding their unity."[9] Klee put this less acerbically when he concluded his fullest public statement of an artistic credo in a lecture he gave in 1924 with a comment on the "dream, the vague possibility," he saw embodied in the Bauhaus project: "We have found the parts, but not the whole. We still lack the ultimate strength, for there is no culture to sustain us".[10] How clear-headed that proved to be.

1. Paul Klee, *Pädagogisches Skizzenbuch*, 1925, published in English as *Pedagogical Sketchbook*, trans. Sibyl Moholy-Nagy (London: Faber and Faber, 1953), section I.1. Klee's essay "Exakte Versuche im Bereich der Kunst" (Exact experiments in the realm of art, 1928) is gently ironic about the more rigorously functionalist program associated with Hannes Meyer, first as the new head of architecture and then as director of the Bauhaus: "From the standpoint of dogma, genius is often a heretic. It has no law other than itself. The school had best keep quiet about genius.... For if this secret were to emerge from latency, it might ask illogical and foolish questions." Klee, *Notebooks*, vol. 1, *The Thinking Eye*, trans. Ralph Manheim (London: Lund Humphries, 1961), p. 70. For all their difference of approach, Meyer and Klee maintained a reasonably cordial relationship; Meyer edited the journal *Bauhaus*, in which the essay was published.

2. On Klee's career at the Bauhaus see Wulf Herzogenrath, Anne Buschhoff, and Andreas Vowincke, eds., *Paul Klee — Lehrer am Bauhaus* (Bremen: Hauschild, 2003).

3. Klee, *Pedagogical Sketchbook*, section I.6. The term used in the original German edition of 1925 is "*dividuel*."

4. Klee, *The Thinking Eye*, p. 78. On Klee's prioritizing of movement over form see Oskar Bätschmann, "Grammatik der Bewegung. Paul Klees Lehre am Bauhaus," in Oskar Bätschmann and Josef Helfenstein, eds., *Paul Klee Kunst und Karriere* (Bern: Stämpfli, 2000), pp. 107–24.

5. This is brought out particularly well in O. K. Werckmeister, *The Making of Paul Klee's Career 1914–1920* (Chicago and London: Chicago University Press, 1984).

6. Klee, *The Thinking Eye*, p. 80.

7. See Frank Zöllner, "Paul Klee, Hauptweg und Nebenwege," *Wallraf-Richartz-Jahrbuch* 16 (2000):263–90.

8. Klee, *The Thinking Eye*, p. 80.

9. Carl Einstein, *Die Kunst des 20. Jahrhunderts* (Berlin: Propyläen, 1928), p. 157.

10. Klee, *The Thinking Eye*, p. 95.

426
Waldemar Hüsing
Primary school with eight classrooms.
Project for architecture course taught
by Ludwig Mies van der Rohe. Perspective
drawing. 1932
India ink and wash, with printed label
on paper
10⅝ x 15⅞" (42.2 x 39.4 cm)
Bauhaus-Archiv Berlin

427
Howard Dearstyne
Court-house. Project for architecture
course taught by Ludwig Mies van der Rohe.
Plan. 1931
Pencil on paper
11 x 7¹¹/₁₆" (28 x 19.5)
Library of Congress, Washington, D.C.

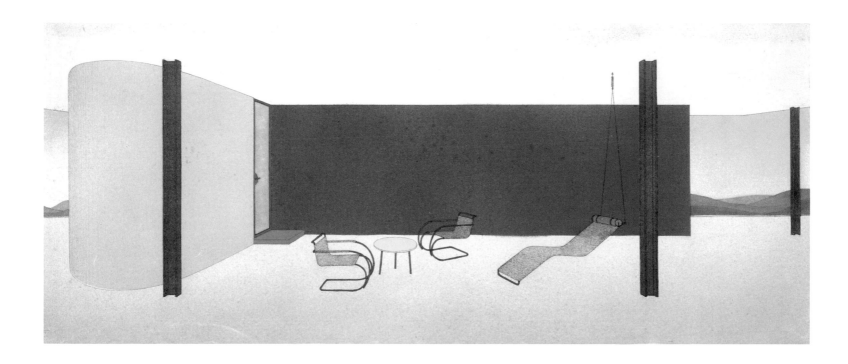

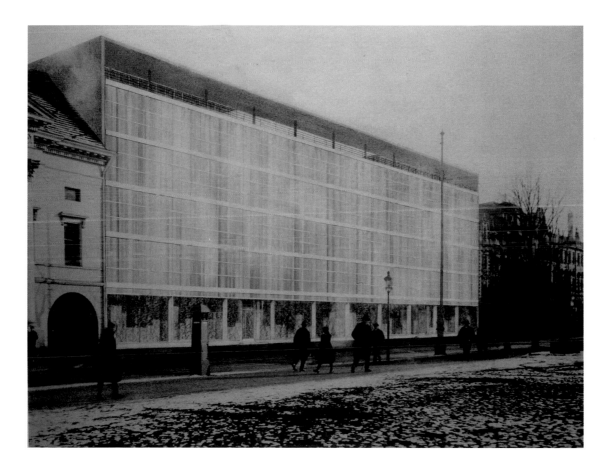

428
Eduard Ludwig
Single-story house on the river Havel.
Project for architecture course taught
by Ludwig Mies van der Rohe. Interior
perspective of living room. 1932
Pencil and tempera on cardboard
16 ⅝ x 23 ¹¹/₁₆" (42.3 x 60.2 cm)
Bauhaus-Archiv Berlin

429
Eduard Ludwig
Renovation of the Borchardt department
store, Dessau. Project for architecture
course taught by Ludwig Mies van der Rohe.
View of the exterior. c. 1931
Photograph with drawn and painted
additions, mounted on plywood
31 ½ x 42 ½" (80 x 108 cm)
Stiftung Bauhaus Dessau

430

Ludwig Mies van der Rohe and
Lilly Reich

Furniture designs, as reproduced in the
price list of the Bamberg Metallwerkstätten
firm. Berlin-Neukölln. 1931
Offset lineblock on paper
11 ¾ x 16 ⁹/₁₆" (29.8 x 42 cm)
Bauhaus-Archiv Berlin

431

Lilly Reich

Design for a chair without arms. c. 1931
Charcoal on tracing paper
41 ¼ x 32" (104.8 x 81.3 cm)
The Museum of Modern Art, New York.
Lilly Reich Collection, Mies van der Rohe
Archive, gift of the architect

432

Lilly Reich

Chair seat curve. c. 1931
Charcoal on tracing paper
41 ½ x 29" (105.4 x 73.7 cm)
The Museum of Modern Art, New York.
Lilly Reich Collection, Mies van der Rohe
Archive, gift of the architect

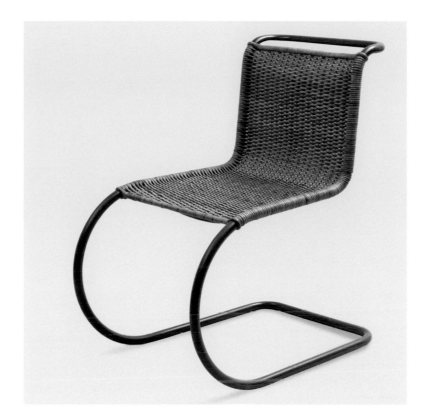

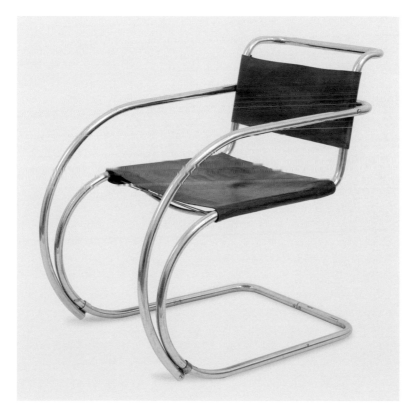

433
Ludwig Mies van der Rohe with
Lilly Reich
Side chair (MR 10). c.1931
Manufactured by Bamberg Metallwerkstätten,
Berlin, Neukölln
Tubular steel painted red with cane seat
31¼ x 19 x 27½" (79.4 x 48.2 x 69.8 cm)
Private collection. Courtesy Neue Galerie
New York

434
Ludwig Mies van der Rohe
Armchair. 1927–30
Chromium-plated tubular steel and leather
31¼ x 21⅞ x 34¼" (79.4 x 55.6 x 87 cm)
Private collection. Courtesy Neue Galerie
New York

PIUS PAHL
HOUSE C. 1932–33
DETLEF MERTINS

Pius Pahl's House C (1932–33) is one of many Bauhaus student projects that explored a building type known in German as *Flachbau mit Wohnhof*, literally "low building with living court" or more typically "court-house." House C is a single-story building with a flat roof and several garden courts bounded by walls as high as the house, forming a rectangular precinct of enclosed and open spaces. The indoor space is L-shaped, with separate wings for living and sleeping. An open-air court extends from the east directly into the entrance foyer without any change in level. Floor-to-ceiling glass walls join the living room to the garden visually and spatially, while a conservatory provides an indoor counterpart to the garden like that in the Tugendhat House (1929–30), which Ludwig Mies van der Rohe, Pahl's teacher, had recently completed in Brno, in the modern-day Czech Republic. Like many of Mies's previous houses, Pahl's project provides an expansive terrace for outdoor living and dining. The bedroom wing is organized along a glazed hallway generous enough for children's play. The house is large, but its lack of provision for live-in servants suggests a design intended for a merely prosperous family rather than an affluent one.

Pahl had arrived at the Bauhaus in 1930, having already acquired practical training in carpentry and interior design.[1] He designed House C during his final two semesters in the architecture program, which were taught by Mies after he became director of the school that same year. Shifting the program toward a more normative training, Mies compressed much of the curriculum developed previously under Hannes Meyer in order to teach the final year of the three-year course himself, focusing on the design of private houses, which had been the mainstay of his practice for over twenty years. The first four semesters were dedicated to technical and scientific studies taught largely by outside engineers and scientists. Courses included the study of building law, materials, projective geometry, statics, heating and ventilation, physics, chemistry, mathematics, psychotechnics, and psychology. In the second year, Ludwig Hilberseimer taught housing and systematic town planning guided by principles of economy, efficient infra-

structure, uniform orientation to the sun, mixtures of low and tall buildings, and variations on modern building types. In working with Mies, students used the skills acquired in building technique and functional design as a platform for more abstract, ideal design tasks involving disciplined judgment of proportions, material combinations, and spatial relations. Mies also taught sketching as essential to the search for form.

For Mies, working on country houses had provided a crucial vehicle for developing his conception of space as a freely flowing continuum. Assigning a series of houses as students' projects served to extend this research into an elemental architectonic system capable of uniting house and garden in the service of a new way of living, as much outdoors as inside. Mies's emphasis on private bourgeois houses disturbed those committed to public housing and social reform, but he contended that an architect who could design a house well could do almost anything. He also distinguished himself among modernists for arguing that beauty should remain central to the art of building even as it embraced industrialization and the demands of mass society. For Mies, the forces of technology and rationalization needed to be mastered for human ends — to "build them into a new order . . . that permits free play for the unfolding of life."[2] What was decisive, he declared, "is only how we assert ourselves toward these givens. It is here that the spiritual-cultural problems begin."[3]

In summarizing the discussions at the school, Pahl echoed Mies's concern with the changing forms of society, the cultural effects of mechanization, the threat to individuality in an industrial society, and the need to assimilate these conditions intellectually.[4] In uniting house and garden, architecture and nature, under the sign of modern abstraction, Mies sought to purify and elevate technology's domination of nature by designing rarefied spaces for human intellectual and spiritual life — islands of tranquillity and light in an increasingly dark world. He later employed these ideas in the Hubbe House Project, intended for Magdeburg (1934–35), and the Ulrich Lange House Project, for Krefeld (1935), where, however, he

435
Pius Pahl
House C. Court-house project for architecture course taught by Ludwig Mies van der Rohe. Perspective view of entrance. 1932–33
Ink on paper
27 1/2 x 39 3/8" (69.8 x 100 cm)
Bauhaus-Archiv Berlin

436
Pius Pahl
House C. Court-house project for architecture course taught by Ludwig Mies van der Rohe. Perspective view from garden court. 1932–33
Ink on paper
27 7/16 x 39 3/16" (69.7 x 99.5 cm)
Bauhaus-Archiv Berlin

437
Pius Pahl
House C. Court-house project for architecture course taught by Ludwig Mies van der Rohe. Perspective view of entrance hall. 1932–33
Ink on paper
27 9/16 x 39 3/16" (70 x 99.5 cm)
Bauhaus-Archiv Berlin

HAUS C PIUS PAHL

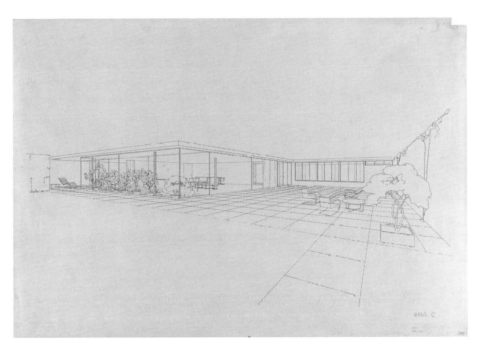

HAUS C

HAUS C PIUS PAHL

HAUS B

broke the continuity of the perimeter to allow favored views of the landscape and a poignant contrast between idealized and untouched nature.

The number of students studying architecture at the Bauhaus during these years was small, typically fewer than a dozen, and Mies's instruction was informal. He assigned a graduated sequence of projects, from small to large, simple to complex, beginning with the one-bedroom House A, then progressing to the two-story detached House B and finally to the single-family House C.[5] Pahl's designs for House A and B (cat. 438) suggest that all three were treated as variations on the same type, differing in size but maintaining the same general division and form and even the ratio of open plan to contained rooms. Through repetition and combination, students also explored the potential of this house type to create a new kind of urban fabric, a modern version of a city of atria, like ancient Pompeii. After Mies emigrated to Chicago, in 1938, he continued to work with students on the court-house idea. George Danforth, for instance, remembered Mies showing photographs of Pahl's drawings, from which he copied the plan into his student sketchbook.[6]

Pahl's various projects integrated building, furnishings, and landscape with economy and simplicity. Like Mies,

he incorporated curtains to shield his glass walls, and groupings of furniture (designed by Mies with Lilly Reich) to define activity areas within his flowing open spaces. His delicate drawings reveal dexterity in handling a formal repertoire that went beyond Mies's own distilled language, emulating alternatively Le Corbusier's plasticity (a Beach House of 1932–33 has piloti, strip windows, and roof terrace) or Hilberseimer's rationalism.[7]

Mies encouraged students to explore their ideas through as many as a hundred sketches, which they would review together at length, fine-tuning the ability to judge "what good architecture is," as the American Bauhaus student Howard Dearstyne put it. In a letter home in 1931, Dearstyne continued, "One of the uncomfortable (perhaps) sides of associating with an architect of the first rank is that he ruins your taste for about all but one-half of one percent of all the architecture that's being done the world over."[8] Studies by Wilhelm Jakob Hess reveal how Mies would sketch over his students' drawings during these discussions, guiding them to develop what he himself was working to envisage (cat. 439). The final design would be drawn up after weeks or even months of study and sessions that often concluded with Mies simply suggesting "Try it again."[9]

After the Bauhaus was closed, in 1933, its graduates and former faculty had difficulty finding employment and some left the country.[10] In 1933–34 Pahl took a yearlong study tour through Switzerland, Italy, and Tunisia. He then found employment, first in Zurich and then back in Germany, including a short period as municipal architect in Saarbrücken in 1936–37. After the Nazis defined cultural policy to favor classicism and

438
Pius Pahl

House B. Court-house project for architecture course taught by Ludwig Mies van der Rohe. Perspective view of dining room and study. 1931
Ink on paper with printed label
17 11/16 x 27 3/8" (45 x 69.5 cm)
Bauhaus-Archiv Berlin

439
Wilhelm Jakob Hess

Single-story structure. Project for architecture course taught by Ludwig Mies van der Rohe (with corrections by Mies). Interior perspectives. 1932
Pencil on tracing paper
17 3/8 x 22 3/8" (44.1 x 56.9 cm)
Bauhaus-Archiv Berlin

traditional vernaculars, a role nevertheless remained for modernism in the design of industrial buildings. In 1938, the year Mies emigrated to America, Pahl became a regional department head for the Reichswerke Hermann Göring, which had been founded in 1937 as a state holding company to mobilize economic resources for Hitler's war effort and achieve economic control of occupied areas. It had also absorbed Hermann Rimpl's Baubüro, which counted numerous *Bauhäusler* among its 700 architects.[11] Pahl designed several industrial complexes for the Reichswerke, then, in 1941, became a partner in a private office in Ludwigshafen.

After World War II, Pahl opened his own practice in Germany before moving to South Africa in 1952. There he helped introduce modernism and won recognition especially for his houses, some of which were court-houses adapted to local sites, climates, and construction vernaculars.[12]

The author wishes to thank Dr. Lydia de Waal, Ilse Wolff, and Peter Jan Pahl for information about Pius Pahl's career in South Africa, as well as Klaus Weber at the Bauhaus-Archiv Berlin and Dara Kiese at The Museum of Modern Art.
1. On Pahl's life and career see John Kench, "Pius Pahl: A Balance of Freedom and Discipline," *Architecture South Africa*, March/April 1988. See also Norbert Korrek, *Pius E. Pahl: Architekt: Ein Schüler von Mies van der Rohe und Ludwig Hilberseimer*, exh. cat. (Weimar: Hochschule für Architektur und Bauwesen Weimar Universität, 1995). Born in 1909 in Oggersheim/Pfalz, Pahl died in 2003 in Stellenbosch, South Africa.
2. Ludwig Mies van der Rohe, "The Preconditions of Architectural Work," 1928, in Fritz Neumeyer, *The Artless Word: Mies van der Rohe on the Building Art* (Cambridge, Mass.: The MIT Press, 1991), p. 301.
3. Mies van der Rohe, "The New Time," 1930, in ibid., p. 309. Translation altered by the author.
4. Pahl, "Experiences of an Architecture Student," in Eckhard Neumann, ed., *Bauhaus and Bauhaus People*, trans. Eva Richter and Alba Lorman (New York: Van Nostrand Reinhold, 1970), pp. 227–31.

5. See Howard Dearstyne, "Mies van der Rohe's Teaching at the Bauhaus in Dessau," in ibid., p. 215. See also Magdalena Droste, *Bauhaus 1919–1933* (Cologne: Taschen, 1990), p. 212, and Droste and Jeannine Fiedler, eds., *Experiment Bauhaus*, exh. cat. (Berlin: Bauhaus-Archiv, 1988), p. 346.
6. See Droste and Fiedler, eds., *Experiment Bauhaus*, p. 346. George Danforth studied at the Armor Institute of Technology (later the Illinois Institute of Technology), where Mies became director of the architecture school in 1938.
7. For the Beach House see Rolf Achilles, Kevin Harrington, and Charlotte Myhrum, eds., *Mies van der Rohe: Architect as Educator*, exh. cat. (Chicago: Illinois Institute of Technology and University of Chicago Press, 1986), p. 86.
8. Dearstyne, "Mies van der Rohe's Teaching," p. 213.
9. See Sandra Honey, "Mies van der Rohe: Architect and Teacher in Germany," in Achilles, Harrington, and Myhrum, eds., *Mies van der Rohe: Architect as Educator*, pp. 47–48.
10. Wilhelm Wagenfeld and Herbert Bayer were among the notable Bauhaus designers who initially remained in Germany. Bayer produced graphic design for the Nazis before emigrating to the United States in 1938.
11. See Winfried Nerdinger, "Bauhaus-Architekten im 'Dritten Reich,'" in *Bauhaus-Moderne im Nationalsozialismus. Zwischen Anbiederung und Verfolgung*, ed. Nerdinger in collaboration with the Bauhaus-Archiv (Munich: Prestel, 1993), pp. 153–178. See also Nerdinger, "Bauhaus Architecture in the Third Reich," in Kathleen James-Chakraborty, ed., *Bauhaus Culture: From Weimar to the Cold War* (Minneapolis, London: University of Minnesota Press, 2006), pp. 139–152. For more on the Reichswerke Hermann Göring see R. J. Overy, *War and the Economy of the Third Reich* (Oxford: at the University Press, 1994). Documents of Pahl's life, employment and projects during this period are part of the Pius E. Pahl Collection at the Bauhaus-Archiv Berlin.
12. The Trumpelmann House in Krigeville was published in "Two Houses, Stellenbosch, Cape," *Architect and Builder* (January 1958): 38–43; an unnamed court-house was published in "Courtyard House, Parow North," *Architect and Builder* (January 1965): 14–21; and another unnamed court-house appeared in "House, Stellenbosch, Cape," *Architect and Builder* (August 1969): 12–17. Pahl won numerous awards, most notably the Gold Medal of the South African Institute of Architects (2001). His student work appeared in the exhibition *Pius E. Pahl: Architekt: Ein Schüler von Mies van der Rohe und Ludwig Hilberseimer*, curated by Korrek at the Hochschule für Architektur und Bauwesen Weimar Universität in 1995. A full retrospective at the Sasol Art Museum of the University of Stellenbosch in 2002 presented him as not only an architect but also a carpenter, designer, glazier, and artist in the Bauhaus tradition.

440
Josef Albers
Skyscrapers B (also known as *Skyscrapers II*).
c.1929
Sandblasted flashed glass
14 1/4 x 14 1/4" (36.2 x 36.2 cm)
Hirshhorn Museum and Sculpture Garden,
Smithsonian Institution, Washington, D.C.
Gift of the Joseph H. Hirshhorn Foundation

441
Josef Albers
Skyscrapers A (also known as *Skyscrapers I*).
c.1929
Sandblasted opaque flashed glass
13 3/4 x 13 3/4" (34.9 x 34.9 cm)
Private collection

442
Josef Albers
Skyscrapers on Transparent Yellow. c.1929
Sandblasted flashed glass with black paint
13 7/8 x 13 7/8" (35.2 x 35.2 cm)
The Josef and Anni Albers Foundation,
Bethany, Conn.

443
Pius Pahl
Fixed units in an extendable neighborhood
of terraced houses. Project for architecture
course taught by Ludwig Hilberseimer
examining the theme of "*Das wachsende
Haus*" (The extendable house). Perspective
view, floor plans, and site plans. 1931–32
India ink on drawing paper
56 x 23 3/8" (42.3 x 59.4 cm)
Bauhaus-Archiv Berlin

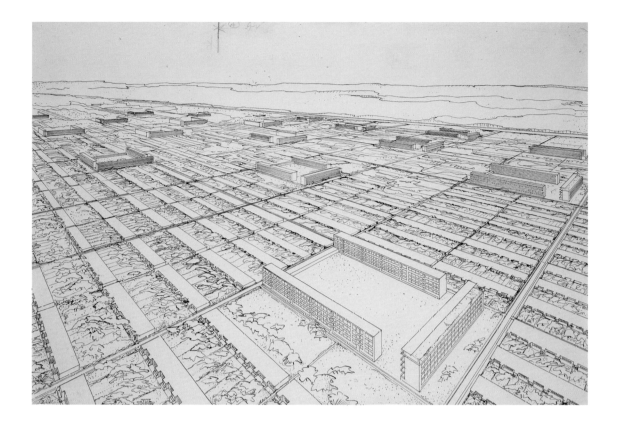

444
Paul Klee
Hauptweg und Nebenwege
(Highway and byroads). 1929
Oil on canvas
32 ¹⁵/₁₆ x 26 ⁹/₁₆" (83.7 x 67.5 cm)
Museum Ludwig, Cologne

445
Ludwig Hilberseimer
Project for a mixed-height housing
development of row houses and apartment
buildings. Aerial perspective. c.1930
Ink on paper
Approx. 13 x 19 ½" (33 x 49.5 cm)
The Art Institute of Chicago. Gift of
George E. Danforth

446
Hajo Rose (Hans-Joachim Rose)
Untitled. 1931
Gelatin silver print
9 ⁵/₁₆ x 7" (23.7 x 17.8 cm)
The Museum of Modern Art, New York.
Thomas Walther Collection. Gift of
Thomas Walther

OSKAR SCHLEMMER
BAUHAUS STAIRWAY. 1932
ANDREAS HUYSSEN

Bauhaustreppe (Bauhaus stairway) highlights Oskar Schlemmer's continuing stake in figuration. In this it differs from many other avant-garde experiments in the visual arts of its time; it was while Bauhaus painters such as Vasily Kandinsky and Paul Klee were embracing abstraction and flat surfaces that Schlemmer was using painting to create a new kind of abstract human form in space, a form that he called "*Kunstfigur.*" His commitment to figuration in space was nurtured by his work as director of the Bauhaus theater workshop from 1923 to 1929, where he created one of the major theatrical experiments of the Weimar Republic, his famous mechanical ballet. As film and photography moved to the center of Bauhaus projects under the influence of László Moholy-Nagy, Schlemmer, even while he participated in several of the school's new-media efforts, defended the power of painting to explore imagined architectural environments in relation to ideas about the "new man" of modern times.

Schlemmer painted *Bauhaustreppe* in 1932, in reaction to the decree closing down the Dessau Bauhaus issued by the regional Nazi party in August of that year. (The school would survive into 1933 by moving to Berlin.) He himself had already left the institution, in 1929, to become a professor at the Staatliche Akademie in Breslau. The date and circumstance of the painting's origin — Schlemmer worked on it intensely in the weeks immediately following the order that forced the school from Walter Gropius's famous Dessau building — mark it as a melancholy memorial to the Bauhaus's utopian ambition of bringing forth new forms of spatial design and artistic production that in turn would inspire a new, more communal way of life. The closed, protected pictorial space of *Bauhaustreppe* harks back to the better days of the Dessau school, evoking civility, thought, and peaceful purpose at a time of increasing political chaos and economic collapse in the last year of the Weimar Republic. The Nazis had barely come to power when they closed down an exhibition of Schlemmer's in Stuttgart that prominently featured *Bauhaustreppe.* A few years later they would destroy some of his works as Bolshevist art, and would include others in the infamous exhibition *Entartete Kunst* — "Degenerate art" — of 1937.

447
Oskar Schlemmer
Bauhaustreppe (Bauhaus stairway). 1932
Oil on canvas
63 7/8 x 45" (162.3 x 114.3 cm)
The Museum of Modern Art, New York.
Gift of Philip Johnson

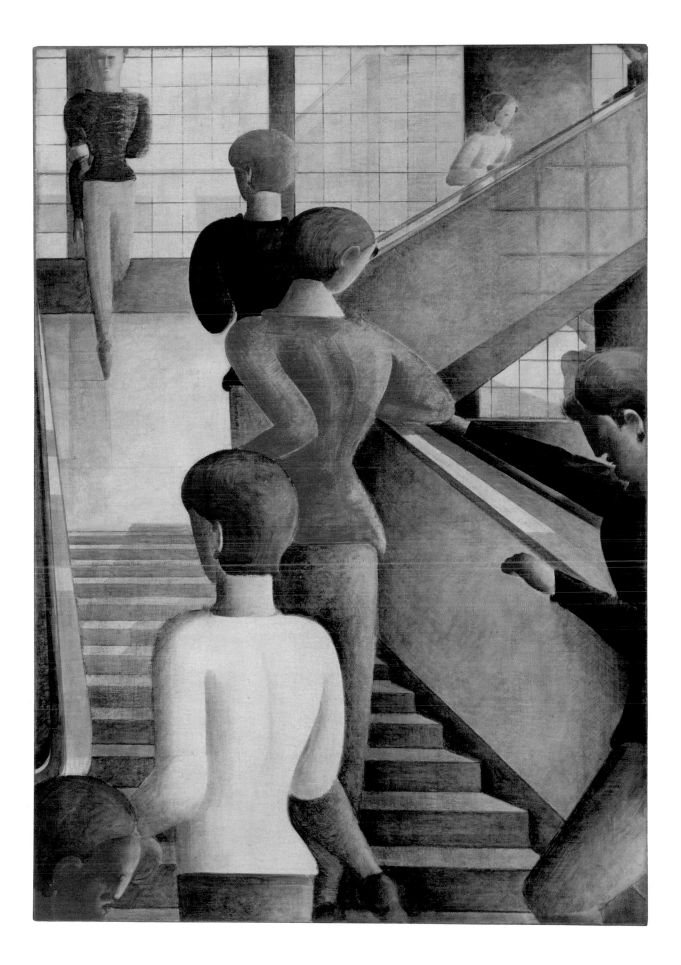

HUYSSEN: BAUHAUS STAIRWAY

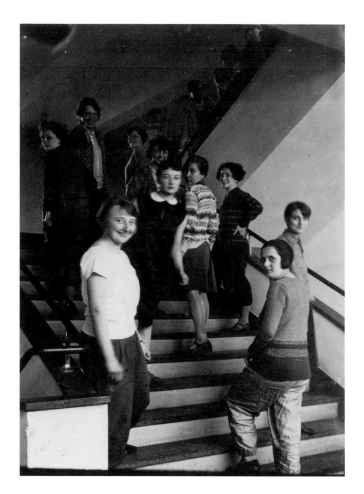

By then, *Bauhaustreppe*, thanks to the intervention of Alfred H. Barr, Jr., and Philip Johnson, on behalf of The Museum of Modern Art, had had the way prepared for its escape to New York.

Bauhaustreppe centers on three mannequin-like figures climbing the stairs in the Dessau Bauhaus. We see them from behind, with only one side of each face partly exposed. Schlemmer deeply appreciated German Romantic painting, especially that of Caspar David Friedrich, who often used this rear-view perspective on his figures, inviting the viewer into the pictorial space. Two more-partial figures appear in profile in the lower-left corner and to the right; poised at the bottom of the stairs, they look down as if for firm grounding in their ascent toward the muted light that streams in through the window grid above. Their gender cannot be determined, while the three central figures are clearly marked as women by their dress and tailored waists. The one unambiguously male figure is the dancer on the upper landing, who stands on point facing the viewer, a reference to Schlemmer's dance and ballet projects on the Bauhaus stage.

The stairs turn at the landing, proceeding upward at a 90-degree angle to their first flight. Clearly, in rendering this functional space in the Dessau building, Schlemmer did not intend *Neue Sachlichkeit* verism; the actual staircase made 180-degree turns, as we see in, for example, a photograph of the school's weavers staged by Schlemmer himself in the late 1920s (cat. 448). And where the window wall of Gropius's building respected ideals of transparency, and of making the interpenetration (*Durchdringung*) of architectural volumes manifest (fig. 1), the window grid that Schlemmer shows bathing the rectangular landing in a luminous yellow light is somewhat opaque — as if Schlemmer wanted to protect the inner space of the school, sheltering it from outside interference.

Other distortions include the perspectively exaggerated inward angle of the staircase's lower balustrade and the accompanying foreshortening of the steps. The landing itself seems to have been flipped 90 degrees, forming a flat, near-vertical surface on which the dancer hovers as if frozen on point. The bluish shadow on the landing floor, cast by the mullion behind the dancer, accentuates this flattening of perspectival space. Equally puzzling in spatial terms is the appearance of the window grid on the stair's otherwise solid upper balustrade. Is this a reflection of another set of glass windows on an opposite wall? Or does it describe the continuity between the window grid beyond the landing and that on a lower floor, visible in the triangle formed by the framework of the stairs? Another figure in profile, half-hidden but large, appears behind that lower set of windows. Such moments of gentle spatial disorientation capture our eye and give the painting its serene coherence and airiness.

There is a further paradox. Both the dancer and the ascending figures seem arrested in motion, an impression accentuated by the woman in red, whose elbow rests on the banister as if she had paused to look sideways and down to a lower floor. At the same time, though, the painting suggests slow upward ascent, an effect subtly supported by the perspectively extended arm of the rightmost figure, whose hand seems to reach forward to touch the woman's elbow. Indeed all of the five figures on the first flight of stairs overlap visually, forming a group on its way together up to class or some other Bauhaus event, while the dancer stands guard over their progress.

Given that Schlemmer, through the use of masks and geometric costume designs, introduced to the theater a sense of the mechanization of the human figure, it is perhaps understandable that the doll-like figures of his paintings are often considered part of the aggressively cold stream of modernist

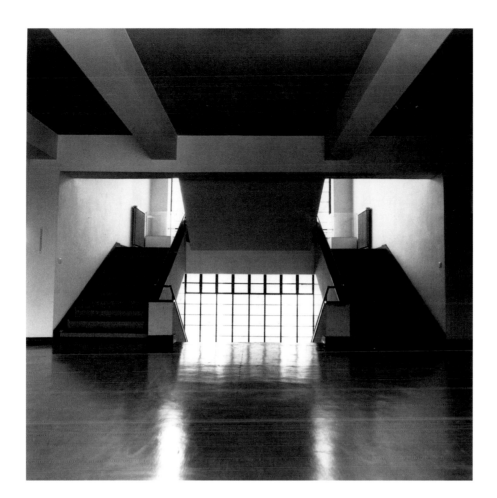

and specifically Weimar culture that ran from Dada to the Neue Sachlichkcit — its merging of art and technology, its antihumanism, its cynicism. His figures are seen as lifeless, soulless robots, negative expressions of collectivization and mass society. Such a view, however, does an injustice to an artist who, as his diaries and letters show, was deeply committed to the tradition of German humanism of the Goethe age, to classical ideas of measure, proportion, and style, and to the figure of the human transcending political chaos.

Like Gropius in his Bauhaus manifesto of 1919 (cats. 38, 39), Schlemmer wanted to transcend the opposition between the mechanical and the organic. His stylized human figures are always whole and intact, rather than grotesquely prosthetic, as in George Grosz or Otto Dix. He may forgo any individualizing physiognomy, but his groups of figures never suggest the alienation and loss seen in the faceless mannequins of Giorgio de Chirico; they are always spatially connected, literally in touch, as if in communication and sharing joint purpose. In the context of post-1918 Germany, after both a lost international war and something like civil war in many major cities, I read the absence of physiognomy as a fundamentally humanist, egalitarian gesture. Schlemmer's programmatic avoidance of facial differentiation distinguishes him clearly from the kind of physiognomic speculation gone wild seen in the writing of Ludwig Klages or Oswald Spengler, and from both Grosz's and Dix's aggressive satirical portraits of the pillars of bourgeois society, on the left, and Nazi physiognomic theories of racial selection, on the right. It was physiognomy, after all, that was the organizing principle of *Entartete Kunst*, which juxtaposed modernist portrait painting with photographs of patients in mental wards.

When Schlemmer painted *Bauhaustreppe*, his project was under siege, as was the Weimar avant-garde in general. He structured the painting in such a way that it seems to be asking its viewers to step inside it, joining the school's students there, as the artist in Marguerite Yourcenar's story "How Wang-Fo Was Saved" enters his painting to escape the threat of execution. Schlemmer's life was never in immediate danger in Nazi Germany, but much of his work was destroyed and he was increasingly isolated and deprived of opportunities to work and exhibit. To this day his oeuvre has remained underappreciated and misinterpreted. At The Museum of Modern Art, *Bauhaustreppe* has long occupied the landing of a staircase leading upward to the galleries where visitors can engage with the artistic achievements of modernism. Emerging from a period of catastrophic political failure, Schlemmer's vision of the human is a unique index of Weimar culture as something other than the popular understanding of it as all glitter and doom.

448
T. Lux Feininger
Untitled (Women weavers on the stairway of the Bauhaus, Dessau). 1927–28
Gelatin silver print
4 1/2 x 3 1/4" (11.4 x 8.3 cm)
Private collection. Courtesy Neue Galerie New York

Fig.1
Walter Gropius
Stairway in the Bauhaus building, Dessau. 1926
Photograph: Michael Siebenbrodt. c. 1976.
Gelatin silver print. Bauhaus-Universität Weimar, Archiv der Moderne

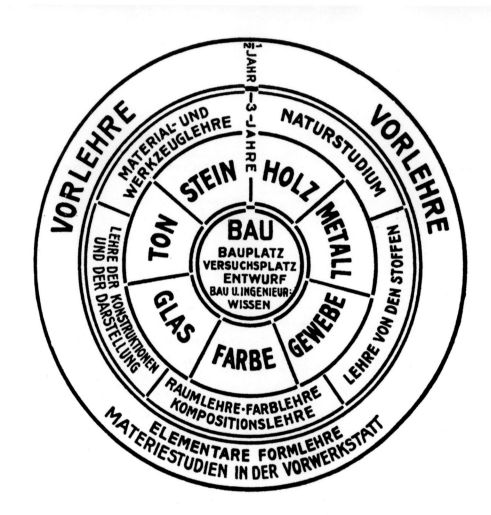

Walter Gropius. Diagram of the Bauhaus curriculum, published in the *Satzungen Staatliches Bauhaus in Weimar* (Statutes of the state Bauhaus in Weimar). July 1922. Letterpress on paper. Sheet: 7 7/8 x 11 5/8" (20 x 29.5 cm). Bauhaus-Archiv Berlin

14 YEARS BAUHAUS: A CHRONICLE
ADRIAN SUDHALTER
WITH RESEARCH CONTRIBUTIONS BY DARA KIESE

This chronicle — the name pays homage to the portfolio *9 Jahre Bauhaus: Eine Chronik* (9 years Bauhaus: a chronicle), prepared for Walter Gropius by masters and students when he left the school, in 1928 — presents the fourteen years of the school's existence according to its academic schedule: winter (October–March) and summer (April–June) semesters and a three-month summer recess (July–September). For sources see p. 337.

OCTOBER 1918 – MARCH 1919

November 9, 1918. Abdication of Kaiser Wilhelm II. The Social Democrat party declares a republic, with Friedrich Ebert as its provisional chancellor.
November 11. Signing of the armistice ending World War I.
January 5–12, 1919. A general strike and the Spartacus uprising in Berlin are brutally suppressed by minister of defense Gustav Noske, supported by the mercenary *Freikorps* (volunteer army).
January 15. Karl Liebknecht and Rosa Luxemburg are murdered by the *Freikorps*.
February 9. First meeting of the national assembly in Weimar, a city remote from the violent social unrest in Berlin.
February 11. Ebert is elected president of the new republic.

In November 1918, after serving as a cavalry officer on the Western Front for almost all of the four years of World War I, Walter Gropius, a thirty-five-year-old architect whose reputation as a proponent of modern building dates from before the war, returns to Berlin. Architectural commissions are scarce, contributing to a rare atmosphere in which artists and architects collaborate closely, forming groups, exhibiting together, and producing journals aimed at social transformation. Gropius is a participant in the newly founded Novembergruppe (November group) and the Arbeitsrat für Kunst (Worker's council for art), artists' groups committed to social revolution. Early in 1919, an invitation to head the Weimar Kunstgewerbeschule (School of applied arts), first extended to Gropius in 1915 when its director, the Belgian architect and cofounder of the Deutscher Werkbund Henry van de Velde, was encouraged to resign as a non-German, is reactivated. Gropius is now asked to lead not only the Kunstgewerbeschule, which has been closed since 1915, but also the adjacent Hochschule für bildende Kunst (Academy of art), which has remained open during the war. He accepts the offer. On March 20, 1919, at his request, the provisional local state government approves renaming the combined schools the Staatliches Bauhaus in Weimar (State Bauhaus in Weimar).

Gropius/Weimar

SUMMER SEMESTER 1919
Students: 84 ♀ + 79 ♂
(+ 2 identified in the enrollment records only by initials)

June 28. Signing of the Treaty of Versailles, which calls for a reduction of the German army, forbids German-Austrian cooperation, and imposes heavy war reparations on Germany.
August 11. Weimar constitution signed.

Gropius takes up his duties on April 1, 1919. Toward the end of the month, he prints the pamphlet *Programm des Staatlichen Bauhauses in Weimar* (Program of the state Bauhaus in Weimar; cats. 38, 39), in a large run, on inexpensive colored paper, with an Expressionist woodcut of a cathedral by Lyonel Feininger on the cover and a text by Gropius within. A call to students unlike any before it, the program adopts the look and feel of contemporary avant-garde journals and broadsheets, communicating Gropius's intention to extend the ethos of Berlin's utopian avant-garde to the new institution.

Although the school is renamed by the beginning of this semester and students continuing from the Hochschule are enrolled in it, Gropius's new program and faculty are not fully in place. The Bauhaus's first true semester will begin in the winter of 1919–20, when incoming students arrive expressly to study at the newly established school.

WINTER SEMESTER 1919–20
Students: 119 ♀ + 126 ♂

February 24, 1920. At the first mass meeting of the German Worker's Party (renamed the National Socialist Worker's Party in August 1920), in Munich, Adolf Hitler announces the party's program.
March 15. An attempted right-wing coup, led by Wolfgang Kapp, collapses under pressure from a general strike.

Probably in response to the distribution of Gropius's *Programm*, student enrollment at the Bauhaus this semester is the highest it will ever be, with a total of 245. **Hinnerk Scheper**, **Joost Schmidt**, and **Gunta Stölzl** are among the incoming students.

The Bauhaus buildings, formerly the Hochschule (fig. 1) and the Kunstgewerbeschule, have been built by van de Velde in 1904–11 as part of a plan for a single Grossherzoglich-Sächsische Kunstschule (Grand-ducal Saxon school of art) and sit across from one another, forming an open town square. Offices, studios, and the

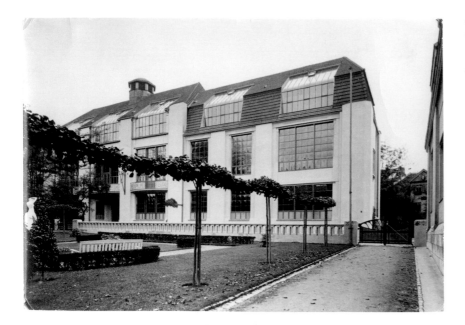

1. Henry van de Velde. Hochschule für bildende Kunst (Academy of art), Weimar. Designed 1904, built 1904–11. Home of the Bauhaus between 1919 and 1925. Photograph: Louis Held. c. 1906. Gelatin silver print. 6¹/₈ x 8³/₄" (15.5 x 22.2 cm). Bauhaus-Archiv Berlin

office of Gropius's private practice are in the Hochschule, workshops in the Kunstgewerbeschule. Behind the Kunstgewerbeschule is the Prellerhaus (named after a former inhabitant, the painter Louis Preller), which is adapted for student accommodations.

According to Gropius's *Programm*, the Bauhaus's goal is to instruct students in a combination of craft (workshop training), fine art (drawing and painting), and science (analytical methods). The school offers three courses of instruction, for *Lehrlinge* (apprentices; trainees bound to a master), *Gesellen* (journeymen; craftsmen certified to work in a trade, but not to set up their own workshop), and *Jungmeister* (junior masters; craftsmen ready to run their own businesses and to train apprentices). Workshop instruction (in the school's own facilities or in private workshops under contract with the Bauhaus) comprises six areas: sculpture (stone, wood, ceramics, plaster), metalwork, cabinetry, painting/decorating (wall, glass, panel), printmaking, and weaving.

Lyonel Feininger, **Gerhard Marcks**, and **Johannes Itten**, Gropius's first teaching appointments, begin work this semester, joining the existing faculty of the Hochschule. They are called "masters" rather than "professors," retaining the guildlike terminology of the Kunstgewerbeschule. These and Gropius's other appointments of the Weimar period are already well-known artists, coming largely from the circle around Herwarth Walden's magazine and gallery Der Sturm (The storm), Berlin, a center for German Expressionism and international avant-garde art. Gropius also draws from the Deutscher Werkbund, an organization founded in 1907 to pair manufacturers and retailers with architects and designers so as to raise the standards of mass-produced commodities and industrial design.

Feininger, a forty-eight-year-old American-born artist, exhibited with Vasily Kandinsky and Paul Klee in the landmark *Erster Deutscher Herbstsalon* (First German autumn salon) at Der Sturm in the fall of 1913, and had his first one-man show at the gallery in 1917. He will oversee the printmaking workshop. Marcks, a thirty-year-old sculptor, made terra-cotta reliefs for the vestibule of Gropius's factory buildings at the 1914 Cologne Werkbund exhibition. He oversees the ceramics workshop. The thirty-one-year-old Itten studied with Adolf Hölzel, a pioneer of abstract pedagogical methods. Itten's first one-man show was at Der Sturm in 1916, the same year he founded his own art school in Vienna. Itten introduces a *Vorunterricht* (preliminary course; also referred to in this period as *Vorlehre*, and later as *Grundlehre* or *Vorkurs*), drawing on the teaching methods he has developed in Vienna, in which students are encouraged to abandon conventional artistic training and to experience color, form, and texture in themselves, acquiring a fundamental sensitivity to form and materials that can be applied to subsequent artistic production. Itten is also responsible for all of the remaining workshops.

SUMMER SEMESTER 1920
Students: 72 ♀ + 89 ♂

Georg Muche, a twenty-five-year-old abstract painter who has often exhibited at Der Sturm and has taught at the school affiliated with it, joins the staff this semester and takes over the stone and weaving workshops from Itten.

Among the incoming students is **Josef Albers**. At the age of thirty-two, Albers, a former public schoolteacher whose profession exempted him from military service during the war, is one of a number of students who are older than some of the masters; this collapsing of generational divisions, in part resulting from the social upset of the war, contributes to the school's nontraditional character.

Another enrollee is the eighteen-year-old Hungarian **Marcel Breuer**, formerly an architecture student in Vienna. World War I and the subsequent dissolution of the Austro-Hungarian Empire have led to political crisis in Hungary: a five-month liberal republic has given way to Béla Kun's 132-day Bolshevik dictatorship, followed by a counterrevolutionary "White Terror" (1919–21) that has sent many left-leaning artists and intellectuals into exile. In the Bauhaus's early years its Hungarian community includes Fred Forbát (who has prompted Breuer to join), László Moholy-Nagy, Farkas Molnár, and Gyula Pap.

Following the *Programm*'s promise of "plays, lectures, poetry, music, costume parties" to nurture community and encourage "friendly relations between masters and students," the semester begins with a series of "Bauhaus evenings" featuring members of the avant-garde, including Der Sturm poet and playwright (and Walden's ex-wife) Else Lasker-Schüler (April 14) and the Expressionist architect Bruno Taut (May 5). With these evenings the vibrant cultural life of Berlin is transported to Weimar.

WINTER SEMESTER 1920–21
Students: 72 ♀ + 94 ♂

On December 18, 1920, in Berlin-Steglitz, a ceremony is held marking the completion of the structural framework of the Sommerfeld House (cat. 22), commissioned from Gropius and his architectural partner, Adolf Meyer, by the timber merchant Adolf Sommerfeld, an early supporter of the Bauhaus. Fulfilling the statement in the *Programm* that "the aim of all visual arts is the complete building," Gropius will call on the Bauhaus workshops to provide furniture, stained-glass windows, and textiles for the house, which will be completed the following year (cats. 77, 79–82, 84).

The ceramics workshop, which has been leasing facilities from a Weimar pottery firm, the Hoftöpferei Schmidt, moves to the Töpferei Krehan, a traditional Thuringian pottery workshop run by the brothers Max and Karl Krehan in the stables of a castle in Dornburg, some twenty miles from Weimar.

Walter Klemm, Max Thedy, and other members of the remaining faculty of the Hochschule succeed in reviving that school, which will take over the right wing of the former Hochschule building in the summer-1921 semester. The Bauhaus and the Hochschule will share the building until the Bauhaus moves to Dessau, in April 1925.

SUMMER SEMESTER 1921
Students: 53 ♀ + 86 ♂

July 29. Hitler becomes the first chairman of the National Socialist party.

The *Satzungen des Staatlichen Bauhauses in Weimar* (Statutes of the state Bauhaus in Weimar), issued in January 1921 to supersede the *Programm* of 1919, go into effect this semester and will remain largely unaltered until 1925. Workshop study is now overseen by a team of a *Meister der Formlehre* (later *Formmeister* or form master; one of Gropius's prominent appointees who provides formal and theoretical training) and a *Meister des Handwerks* (later *Technischer Meister* or *Werkmeister*; a workshop master, a craftsman with technical mastery). Among the most significant changes is obligatory participation in Itten's preliminary course, which also serves as a semester-long students' probationary period: only on successful completion of the preliminary course can students select a workshop and form master of their choice. The school now adds bookbinding to the existing workshops. Like the ceramics students, the bookbinding students lack their own facilities; instead, the school leases the workshop of Otto Dorfner, nearby at Erfurter Strasse 8.

The form master responsible for the bookbinding workshop is **Paul Klee**, who also from this semester forward teaches a course on composition as part of the preliminary instruction. Already forty when he joins the faculty, Klee knows several members of the staff through his participation in the influential Expressionist group Der Blaue Reiter (The blue rider) and through Der Sturm, but he lacks teaching experience.

Also new to the staff this semester is the thirty-one-year-old **Oskar Schlemmer**, like Itten a former student of Hölzel's and like Marcks a participant in the 1914 Werkbund exhibition in Cologne, where he executed murals. Despite his interest in the stage (he had left the Stuttgart Akademie der Bildenden Künste in April 1920 to devote himself fully to his *Triadische Ballett* [Triadic ballet, 1912–22; cats. 216–19]), at the Bauhaus Schlemmer takes over from Itten as form master of the stone-sculpture workshop.

In April 1921, Theo van Doesburg, a member of the Dutch de Stijl group, moves to Weimar, where he will remain for over a year. He offers private classes in the studio of Bauhaus student Karl Peter Röhl, which are attended largely by Bauhaus students. Apparently Van Doesburg hopes to obtain a teaching position at the Bauhaus and to influence the school's direction.

WINTER SEMESTER 1921–22
Students: 47 ♀ + 100 ♂ (11)

Mid-November 1921. The value of the German mark begins to fall in response to the weight of war reparations. In 1922 and 1923, inflation will turn to hyperinflation.

Lothar Schreyer, founder of the Der Sturm theater in 1918, joins the staff, taking over from Klee as form master of the bookbinding workshop and charged with creating a stage workshop. There is no official accreditation yet for stage work, but its significance will be outlined in a section of the updated *Satzungen* of July 1922.

In October, in an effort to raise funds beyond those provided by the state of Thuringia, the Bauhaus *Meisterrat* (Council of masters) resolves to publish a series of print portfolios titled *Neue Europäische Graphik* (New European graphics; cat. 49). The first portfolio, which appears at the beginning of 1922, contains works by Feininger, Itten, Klee, Marcks, Muche, Schlemmer, and Schreyer. It is a rare instance in which these artists, who publicly maintain their independent reputations rather than presenting themselves as any kind of artists' group, publish together, under the heading "Masters of the State Bauhaus in Weimar." Four more portfolios are planned, featuring work

by artists beyond the Bauhaus, from France (failed to appear), Germany, Italy, and Russia. In a further attempt to raise funds, an auction of works by the masters is held at the Sturm gallery on December 15.

Herbert Bayer, a twenty-one-year-old Austrian, enrolls as a student this semester.

SUMMER SEMESTER 1922
Students: 52 ♀ + 95 ♂

June 24. Walter Rathenau, Germany's foreign minister, is assassinated shortly after successfully negotiating a reconciliation treaty with Soviet Russia.

At the age of fifty-six, **Vasily Kandinsky** is the oldest artist to join the Bauhaus staff. A pioneer of abstract painting, he is already well-known through his exhibitions, and through writings including the almanac of Der Blaue Reiter and *Über das Geistige in der Kunst* (On the spiritual in art, both 1911). On arriving at the Bauhaus, Kandinsky begins teaching form and color as part of the school's preliminary course and is responsible for the wall-painting workshop. In this latter capacity he immediately begins working with students (Bayer among them) to prepare a set of architecturally scaled mural paintings to be displayed at the annual Juryfreie Kunstschau (Jury-free art exhibition) in Berlin in late fall (cats. 124–29).

On May 1, the Bauhaus makes its first public contribution to the city of Weimar: a concrete monument — a faceted, semiabstract lightning bolt — in the Weimar cemetery, commissioned by local trade unions and designed by Gropius (the competition winner). The *Märzgefallenen-Denkmal* (Monument to the March dead; cats. 56, 57) commemorates nine local workers whom the military shot dead as they took part in the nationwide general strike that thwarted the attempted coup by right-wing politician Wolfgang Kapp on March 15, 1920, a martyrdom that had moved the Bauhaus community.

An exhibition of Gropius's and Meyer's architecture, with contributions by Forbát, Molnár, and others, opens in the Bauhaus building on June 23.

The intentions of the newly founded Bauhausverlag (Bauhaus press) are put forth in the July 1922 *Satzungen*: "to propagate and publicize the ideals and work of the Bauhaus and related enterprises by means of pamphlets and prints." It will not be until May 1923, when the Munich publisher Franz May provides half the requisite capital, that the Bauhausverlag actually begins operation in Munich under his directorship.

SUMMER RECESS 1922

Van Doesburg organizes an International Congress of Constructivists and Dadaists at the Hotel Fürstenhof, Weimar, on September 25. It is attended by artists including Hans Arp, El Lissitzky, Hans Richter, Kurt Schwitters, and future Bauhaus master László Moholy-Nagy. Weimar is a carefully chosen location: Van Doesburg has been trying to influence the direction of the Bauhaus, and at least two of the school's students — Röhl and Werner Graeff — participate in the event. As the congress is conceived largely for publicity (it is reported on in Van Doesburg's magazine *Mécano* and many posed photographs are taken; cat. 3), its timing during the summer recess, when much of the Bauhaus community is away, is of little consequence — its significance lies in its power to represent shared alliances and objectives, which will ultimately prove influential at the school.

WINTER SEMESTER 1922–23
Students: 50 ♀ + 76 ♂

On February 17, 1923, Schreyer presents a dress rehearsal of *Mondspiel* (Moon play; cat. 65) in which two students, Eva Weidemann and Hans Haffenrichter, perform behind large, geometrically painted body masks. The costume of The Moon, a large horizontal eye, appears onstage, and that of Mary, a rigid figure over six feet tall (cat. 65), hangs above it. The unseen actors inhabit these forms, speaking fragmented, phonetic (yet still clearly German) lines. In presenting these nonnaturalistic elements of movement and sound, the performance is true to the objectives of the stage workshop, but masters and students condemn its heavy-handed mysticism, and Schreyer's proposal to present it in conjunction with the major Bauhaus exhibition upcoming in the summer is rejected. Schreyer resigns.

Ever worried about the continuation of local-government financing for the Bauhaus, Gropius resolves that the school must raise funds by creating marketable products and through collaborations with industry. Itten opposes this change of direction and also resigns.

SUMMER SEMESTER 1923
Students: 34 ♀ + 70 ♂

With the departure of Itten and Schreyer and the arrival of **László Moholy-Nagy**, the Bauhaus undergoes a major shift. By the time the twenty-eight-year-old Moholy arrives at the Bauhaus

with his wife, Lucia (née Schulz), he already stands out in the Sturm circle as a proponent of abstract, geometric, "constructive" art appropriate for a new, rational postwar society. A founder of the Hungarian journal *Ma* (Today) in 1919, Moholy is also a synthesizer of ideas circulating within the international avant-garde, a trait that suits him well at the Bauhaus. Together with Albers — the first Bauhaus student to become a teacher there — Moholy takes over the preliminary course, turning it into a more strictly material-based training. He also takes over the metal-work workshop.

Carrying out a resolution of June 1922, students and teachers work to prepare the summer exhibition (planned to coincide with a Werkbund conference in Weimar), which will display the school's products, justify its existence to the state of Thuringia, and raise money though sales. The school hires its first business manager, Emil Lange. Schlemmer, in charge of the stage workshop since Schreyer's departure, begins working with students on a performance of *Das Triadische Ballett*, which has premiered on September 30, 1922, at the Stuttgart Landes-theater. The ballet will be the centerpiece of the events accom-panying the exhibition.

SUMMER RECESS 1923

On August 15, Gropius presents the slide lecture *Kunst und Technik: Eine neue Einheit* (Art and technology: a new unity), proclaiming the school's new direction and inaugurating the exhibition, which opens the same day. Internal and external signage by Bayer, Josef Malten, and others transform Van de Velde's buildings. The stair-cases of the former Hochschule bear abstract reliefs by Joost Schmidt; the stairwell and vestibule of the former Kunstgewerbe-schule are decorated with murals and reliefs by Schlemmer. Student works, products of both the preliminary course and the workshops, are shown in the Hochschule, which also hosts the *Ausstellung Internationaler Architekten* (Exhibition of international architects; also called *Internationale Architekturausstellung*), an exhibition organized by Gropius comprising models, photographs, and drawings of contemporary architecture, including his own (cat. 27). On the second floor, the newly refurbished director's office is open to the public (cat. 20). This integrated interior, overseen by Albers, has been refurbished by the wall-painting workshop and is outfitted with Bauhaus objects from the cabi-netry, weaving, and metal workshops. The Kunstgewerbeschule

exhibits further products of the workshops, and painting and sculpture by both masters and students of the Bauhaus is on view in the city's Landesmuseum.

Coinciding with the opening of the exhibition is the *Bauhauswoche* (Bauhaus week), a program of lectures and perfor-mances (August 15–19). These include Schlemmer's *Triadische Ballett*, performed at Weimar's Deutsches Nationaltheater on August 16 by Schlemmer and the dancers Albert Burger and Elsa Hötzel, and a *Mechanisches kabarett* (Mechanical cabaret; cat. 220) on August 17 by the students Kurt Schmidt and Georg Teltscher performed at Jena's Stadttheater, recently remodeled by Gropius's office together with members of the Bauhaus community.

Earlier in the summer, on July 23, the experimental Haus am Horn has opened to the public (fig. 2). Designed by Muche, planned and executed by Meyer, this single-family house is con-ceived as a prototype for a larger development and is built in four months. Like the director's office in the Hochschule, it is fur-nished with objects designed and made at the Bauhaus and is intended to unite the visual arts with architecture.

On the occasion of the exhibition, the Bauhausverlag publishes the book *Staatliches Bauhaus in Weimar 1919–1923* (State Bauhaus in Weimar 1919–1923), with a cover designed by Bayer (cat. 196) and interior typography by Moholy. The book docu-ments the school's purpose, structure, and products and for the first time enumerates the roster of workshops and their personnel, which had been in flux since the school's founding: cabinetry (*Formmeister*: Gropius / *Technischer Meister*: Reinhold Weidensee), wood sculpture (Schlemmer / Josef Hartwig), stone sculpture (Schlemmer/Hartwig), wall painting (Kandinsky/Heinrich Beberniss), glass painting (Klee/Albers; fig. 3), metal (Moholy/Christian Dell), ceramics (Marcks/Max Krehan), weaving (Muche/Helene Börner), printing (Feininger/Karl Zaubitzer), and stage (the book lists both Schreyer and Schlemmer, although the former has already left the school). It is the Bauhaus's first serious attempt to write its own history; Gropius's introductory essay will appear as a freestanding flyer in 1924. The Bauhausverlag also publishes two portfolios: *Meistermappe des Staatlichen Bauhauses* and Marcks's *Das Wielandslied der Edda* (cats. 43–45).

The exhibition, which closes on September 30, is a media success and accomplishes the desired outcome of secur-ing state funding for at least another year. The ailing economy, which has contributed to the state's threat to discontinue the Bauhaus's funding, is part of a nationwide crisis. Bayer designs

3. Glass painting workshop in Henry van der Velde's former Kunstgewerbeschule (School of applied arts). As reproduced in *Staatliches Bauhaus in Weimar 1919–1923*. Weimar and Munich: Bauhausverlag, 1923. The Museum of Modern Art Library, New York

emergency currency for the bank of Thuringia (cat. 262), from a one-million-mark note (issued August 10) up to a five-hundred-million-mark note (issued October 13).

WINTER SEMESTER 1923–24
Students: 35 ♀ + 71 ♂

October 19, 1923. The Berlin stock market closes due to hyperinflation.
November 8. The *Reichswehr* (national army) marches into Weimar, dissolving the Social Democrat/Communist coalition government that Thuringia has formed in October.
November 8. Hitler, Hermann Göring, and others attempt a putsch in Munich. The putsch fails and Hitler is sent to jail, where he will write *Mein Kampf*.
November 15. A provisional currency, the Rentenmark, backed by real estate and industry, is introduced to stabilize the economy.
February 10, 1924. Three conservative parties gain a majority in elections of the Thuringian parliament.

On October 16, 1923, at the city registry in Weimar, Gropius (who has divorced Alma Schindler Mahler the previous year) marries Ilse (known as Ise) Frank. Klee and Kandinsky are witnesses.

Deeply impressed by the 1923 Bauhaus exhibition, Marianne Brandt, who at thirty-one has already earned a degree in painting, begins a new course of study at the Bauhaus. Brandt is one of a new generation of students, including Carl Jucker and Wilhelm Wagenfeld, whose work in the metal shop profoundly registers Moholy's influence.

SUMMER SEMESTER 1924
Students: 27 ♀ + 60 ♂

SUMMER RECESS 1924

August. The Rentenmark is replaced by the Reichsmark.
September 1. The Dawes Plan is enacted, reducing reparations and providing Germany with American loans, which have a stabilizing effect on the economy.

In September, the now-conservative Thuringian government threatens to terminate the masters' contracts at the beginning of the Summer 1925 semester, since the school is unprofitable.

WINTER SEMESTER 1924–25
Students: 34 ♀ + 68 ♂

Facing financial and administrative crisis, Gropius attempts to devise sources of funding other than the state. In October he establishes the *Kreis der Freunde des Bauhauses* (Circle of friends of the Bauhaus), with the aim of raising "moral and practical" support for the school through memberships. Drawing on his connections, the group's board is a who's who of cultural figures of the period: Peter Behrens, H. P. Berlage, Marc Chagall, Albert Einstein, Gerhard Hauptmann, Josef Hoffmann, Oskar Kokoschka, Hans Poelzig, Arnold Schönberg, Franz Werfel, and others. In October Gropius establishes the Bauhaus GmbH (Bauhaus corporation) and manages to secure significant investments through shares and loans from private industry. Despite these efforts, in December the Thuringian state government offers inadequate funds and a mere six-month contract, impeding the development of the Bauhaus GmbH and forcing Gropius to announce the school's closing to newspapers throughout the country.

By January 1925, Gropius is discussing moving the school to various German cities including Dessau, Frankfurt am Main, Krefeld, Magdeburg, and Mannheim. In Dessau, in the state of Anhalt, Ludwig Grote, *Landeskonservator* (curator for the state), recognizes the school's significance and its potential benefit to Dessau, a city seeking to establish a cultural dimension that it so far lacks. He brings it to the attention of the mayor, Fritz Hesse, a constant advocate for the school in the coming years, who arranges to invite the Bauhaus to Dessau by incorporating it, at first, into the Städtische Kunstgewerbe- und Handwerkerschule (Applied arts and trade school). He additionally promises it a new building. On February 11, Feininger writes to his wife, "They [Dessau] want us immediately and in toto — and Gropi, the good man, not here, and nowhere to be reached. This we didn't dream of when we sent him out on his four-week vacation with our blessings." Moving more quickly than expected, the negotiations are largely handled by Kandinsky and Muche in Gropius's absence.

Upon the school's departure from Weimar, many of the products of its workshops become the property of the state of Thuringia. Others are purchased by Gropius and the other masters. In the case of four major wall hangings, it is decided that

the originals will remain in Weimar and copies, woven in mirror image by Helene Börner, will be taken to Dessau.

During the last days of the semester in Weimar, on March 28 and 29, 1925, the Bauhaus holds the *Letzter Tanz* (Last dance), a farewell party at the nearby Ilmschlösschen castle. The invitation, designed by Bayer, strikes a playfully morbid tone — "To our communal passing, a last celebratory party"—and includes a mock condolence card, signed "ministry," from the "deeply mourning friends and family in Weimar." The Bauhauskapelle (Bauhaus band), founded in 1924 by the students Hans Hoffmann, Heinrich Koch, Rudolf Paris, and Andor Weininger, performs.

Gropius/Dessau

SUMMER SEMESTER 1925
Students: 20 ♀ + 42 ♂

April 26. Following Ebert's early death, Paul von Hindenburg is elected second president of the Weimar Republic. Feininger reports from Weimar that the city is jubilant about this "'savior' of the Vaterland...who is to lead the country into war again."

In April, the Bauhaus moves to Dessau, a city of some 70,000 inhabitants (as compared to Weimar's population of 30,000) that is home to a number of important industries, including the Junkers airplane factory.

With few exceptions, the Bauhaus community remains intact. Of the masters, only Marcks resigns, accepting an offer to teach at the Burg Giebichenstein, a like-minded school of applied arts in Halle. Schlemmer's arrival is delayed by discussions of his contract, but he will come to Dessau for the winter 1925–26 semester. In addition, a handful of former students including Wagenfeld, Erich Dieckmann, and Otto Lindig remain in Weimar to teach at a new school occupying Van de Velde's buildings. Under the direction of Otto Bartning, this school will retain the name "Bauhaus" until April 1, 1926.

Five former students — Albers, Bayer, Breuer, Scheper, and Joost Schmidt — are promoted to the faculty. Having trained at the Bauhaus in both form and technical expertise, this next generation of so-called "young masters" (the term is not used in official school publications) is prepared to fulfill Gropius's long-held aim of combining form master and technical master in a single person. Feininger, at his own request, is relieved of teaching obligations in Dessau, but continues to be a part of the Bauhaus staff and community.

Josef Albers and Annelise (Anni) Fleischmann, a student since the summer semester of 1922, marry in Dresden on May 9. In a letter to a friend, Josef Albers refers to Anni's Jewish heritage when he writes that they will not yet return to his hometown of Bottrop, because "the mixed marriage is still too fresh for presenting myself there." By contrast, apparently, the Bauhaus provides a tolerant social oasis of sorts.

Because of the move to Dessau, the semester starts late — on May 13 — and accommodations are makeshift. Classes are held in the building of the Städtische Kunstgewerbe- und Handwerkerschule, workshops in the storerooms of a mail order firm; the masters' studios are in the spaces of the Städtischen Kunsthalle (Municipal art museum). By late July, Gropius's designs for a new school building and Masters' Houses have been approved and construction is underway.

WINTER SEMESTER 1925–26
Students: 25 ♀ + 43 ♂

In the planning since Moholy's arrival in the summer of 1923 but postponed for many reasons, including the move to Dessau and the financial status of the Bauhausverlag (which declared bankruptcy in late 1924/early 1925), the first eight volumes of the *Bauhausbücher* — the Bauhaus book series — appear in October 1925 (cat. 254). A total of fourteen books will be published by 1930. Edited by Gropius and Moholy and designed by Moholy, these reasonably priced volumes have a consistent graphic identity. Some written by Bauhaus masters, others by significant figures beyond the school, on topics ranging from Bauhaus products and teaching practice to broader artistic trends, these books provide the most widespread public platform for the dissemination of the Bauhaus's name, identity, and ideas to date.

In November, with an eye to designing a consistent typographic identity for the school's printed materials, Bayer sets the *Katalog der Muster* (Catalogue of designs; cat. 202) and the *Lehrplan* (Curriculum) entirely in sans serif type. The *Katalog der Muster* includes prototypes marketed by the Bauhaus GmbH (incorporated in Dessau on October 7), identified by a product number prefaced by an abbreviation indicating the workshop: "ME" (*Metall*") for metal products (since Bartning's school in Weimar retains the rights to produce some of these objects, their former designations as "MT" are abandoned) and "TI" (*Tischlerei*") for furniture. The *Katalog* marks an important shift, from the Bauhaus as designer and producer to the Bauhaus as designer of prototypes for external manufacture.

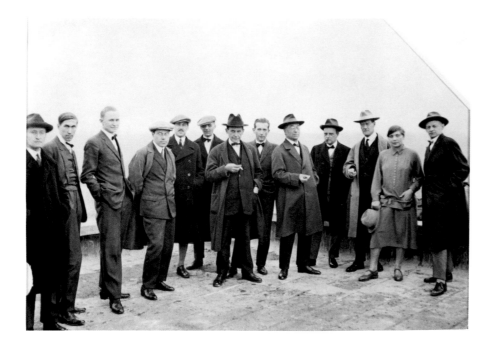

4. Bauhaus masters on the roof of Walter Gropius's Bauhaus building, Dessau, at the building's opening, December 5, 1926. From left: Josef Albers, Hinnerk Scheper, Georg Muche, László Moholy-Nagy, Herbert Bayer, Joost Schmidt, Gropius, Marcel Breuer, Vasily Kandinsky, Paul Klee, Lyonel Feininger, Gunta Stölzl, Oskar Schlemmer. Photograph: photographer unknown. Original negative: 3 1/16 x 4 3/4" (9 x 12 cm). Print: 1998. Bauhaus-Archiv Berlin

The *Lehrplan*, the first significant update to the curriculum since the *Satzungen* of January 1921, lists the teaching staff—Gropius, Kandinsky, Klee, Moholy, Muche, Schlemmer, Albers, Bayer, Breuer, Scheper, and Joost Schmidt—and only five workshops (as opposed to the ten listed in *Staatliches Bauhaus in Weimar 1919–1923* in 1923) for which one could obtain journeyman status: cabinetry, metal, wall painting, textiles, and printing. Wood sculpture, stone sculpture, glass painting, and ceramics are no longer offered; stage undergoes a hiatus but will be reinstated.

Lodgings remain temporary, as Gropius's new buildings are still under construction. Ceremonies marking the completion of the structural frameworks for the Masters' Houses and main building are held respectively on November 21, 1925, and March 21, 1926. The latter is marked by the *Weisse Fest* (White party), held on March 20, 1926, in the local community and youth center. The invitation, designed by Bayer, calls for costumes "2/3 white, 1/3 color (polka-dotted, checkered, striped)," a scheme reflected in the invitation design and perhaps reflecting the painting scheme of the Bauhaus building itself, the project of Bayer and the student Alfred Arndt.

SUMMER SEMESTER 1926
Students: 21 ♀ + 60 ♂

Members of the weaving workshop have challenged Muche as form master, leading him to abandon that role on June 15. He will remain on the Bauhaus faculty, however, for another year.

SUMMER RECESS 1926

Gropius's Masters' Houses (cats. 236, 237), located within walking distance of the school in a pine-wooded plot, are ready for occupancy in July. There are four, a single house for the director (Gropius; later the home of Hannes Meyer, then of Ludwig Mies van der Rohe; cat. 34) and three double houses with studios for the masters: Moholy (later Albers) and Feininger; Muche (later Meyer, then Schoper) and Schlemmer (later Arndt); Kandinsky and Klee. Select students live in the twenty-eight-unit Prellerhaus (named after the former student residence in Weimar), the five-story, balconied, residential wing of the new Bauhaus building:

kitchen and dining room on the first floor, female students on the second floor, male students on the third to fifth floors.

WINTER SEMESTER 1926–27
Students: 28 ♀ + 73 ♂

In October, the state of Anhalt grants the Bauhaus the status of *Hochschule*, making it the equivalent of a college or technical trade school. The official name is now Bauhaus Dessau Hochschule für Gestaltung, and from this semester forward the "masters" become "professors." According to the newly printed *Bauhaus Dessau: Satzung, Lehrordnung* (Bauhaus Dessau: statutes, teaching regulations), which will remain in effect until October 8, 1930, study is now divided into three tiers: the preliminary course (now called *Grundlehre*; normally two semesters), which is obligatory for all students and functions as a probationary period; form and workshop instruction (normally six semesters); and study in architecture or "practical research." To qualify for this third level, students must have attained journeyman qualification or the equivalent.

Stölzl, who had succeeded Börner as technical master of the textile workshop upon the school's move to Dessau, is promoted to the level of "young master," her contract effective January 20, 1927. The only woman to achieve this position at the school, she crosses out student status on her Bauhaus identification card, writing in the word "*Meister*" (master) in its masculine form (the feminine would be "*Meisterin*").

On the weekend of December 4–5, opening ceremonies are held for the new Bauhaus building (fig. 4). It is the Bauhaus's most significant publicity event to date, attended by over a thousand guests, including political figures, architects, artists, and scholars. After opening remarks by Gropius, Hesse, and others, guests are invited to tour the building and its workshops, as well as Gropius's nearby Törten housing development. Bauhaus objects are exhibited and are available for order. The new building includes a theater, for the first time allowing performances on the school's premises; set between the auditorium and the canteen, the stage is separated from them by moveable walls, which, when removed, create a large uninterrupted space and allow performances to be viewed from two sides. Schlemmer inaugurates the theater with

a series of dances based on theatrical elements: dance of forms, dance of gestures, dance of backdrops. On Sunday, December 5, a "film demonstration" is shown — a series of short documentaries, created by the Humboldt GmbH and grouped under the title *Wie wohnen wir gesund und wirtschaftlich?* (How do we live in a healthy and economic way?), that include a segment on Gropius's Master House in which his wife, Ise, her sister, the actress Ellen Frank (p. 2), and others demonstrate features of the building.

To coincide with these ceremonies, the first issue of the journal *bauhaus* (later subtitled *zeitschrift für bau und gestaltung* [Magazine for building and design]), edited by Gropius and Moholy and designed by Moholy, appears on December 4. (It will be published quarterly until November 1929, and thereafter irregularly through the last issue, of December 1931). It is printed in lowercase letters; a sidebar declares uppercase letters unnecessary and extraneous, asking why, if we use only one alphabet to speak, we should need two to write? The premier issue again demonstrates Gropius's self-conscious interest in historicizing the Bauhaus: along with photographs and plans of the new Dessau buildings and short essays by masters, it contains a *bauhaus-chronik 1925/1926* (Bauhaus chronicle 1925/1926), detailing the move to Dessau and the school's current presence throughout Germany in commissions, exhibitions, museum collections, performances, job placements, and publications.

The rapid colonization of Dessau with Bauhaus structures — unlike Weimar, where the only remaining public traces of Gropius's Bauhaus are the *Märzgefallenen-Denkmal* and the Haus am Horn — continues in March 1927 with the erection of Muche's and the student Richard Paulick's experimental Steel House, built of prefabricated parts.

In a diary entry dated March 24, Ise Gropius reports on Breuer's decision to market his tubular-steel chairs independently of the Bauhaus. Together with the Hungarian architect Kalman Lengyel, Breuer founds Standard Möbel GmbH, whose first catalogue, *Breuer Metallmöbel* (Breuer metal furniture; cat. 303), will appear around June 1927 and includes eight models identified by "B" (for "Breuer") numbers. Standard Möbel has financial difficulties from the start, prompting Breuer to manufacture and market his designs through Thonet beginning in 1928.

SUMMER SEMESTER 1927
Students: 43 ♀ + 110 ♂

On April 29, Gret Palucca, a celebrated student of the avant-garde dancer Mary Wigman, performs on the Bauhaus stage. Dessau's closer proximity to Berlin, together with its new facil-ities, are reinvigorating the dialogue between the Bauhaus and the larger avant-garde community.

For the first time, architecture becomes an official part of the Bauhaus curriculum. Bauhaus students have long had opportunities to work on Gropius's private projects and to study architecture through other means, but not until April 1927 and the appointment of **Hannes Meyer**, a thirty-eight-year-old Swiss architect who has made an impression on Gropius and other faculty members during the ceremonies opening the Bauhaus building in December 1926, does the school establish an official department of architecture, marking an important shift in its focus and in the type of students it attracts. The position had first been offered to Mart Stam, who declined.

The thirty-four-page *Bauhaus Dessau Hochschule für Gestaltung: Prospekt* (Bauhaus Dessau college of design: prospectus; cat. 247) outlines a curriculum now reduced to four areas — architecture, advertising, stage, and "free painting and sculpture" — over a minimum of five semesters. It also lists the faculty: Feininger, Gropius, Kandinsky, Klee, Meyer, Moholy, Schlemmer, Albers, Bayer, Breuer, Scheper, Joost Schmidt, and Stölzl.

On her return to Dessau in April from a nine-month stay in Paris, Brandt becomes a *Mitarbeiter* (associate), a paid position in the metal shop. Among other duties she is charged with negotiating contracts with outside firms, the most important being the lighting firms Körting & Mathiesen (whose products are marketed under the name "Kandem"), Leipzig, and Schwintzer & Gräff, Berlin. Both contracts will be signed in 1928.

This is Muche's last semester at the Bauhaus before leaving to teach at Itten's private art school in Berlin.

SUMMER RECESS 1927

July 23. The Werkbund exhibition *Die Wohnung* (The dwelling) opens in Stuttgart. It includes the Weissenhof Siedlung, a housing development built by leading modern architects including Gropius, Ludwig Hilberseimer, and Mies.
August 19. The first National Socialist party rally, in Nuremberg, includes the spectacle of 30,000 marching brownshirts.

On July 10, the third issue of *bauhaus* appears, edited by Schlemmer and dedicated to the stage. It coincides with the *Deutsche Theater-Ausstellung* (German theater exhibition) in Magdeburg (May 14–end of September), to which the Bauhaus contributes. With a designated theater in the Dessau building and an official course of study at the school, stage finally achieves a prominent place at the Bauhaus, a nexus of the arts on a par with architecture.

5. Umbo (Otto Umbehr). Josef Albers and students of the preliminary course in a critique at the Bauhaus in Dessau. c.1928–29. Gelatin silver print. $4^{7}/8 \times 6^{7}/8$" (12.3 x 17.4 cm). The Josef and Anni Albers Foundation, Bethany, Conn.

The representation of performances in publications and exhibitions becomes a subgenre of stage production itself: from diagrammatic scripts to photographs and photomontages, these representations exceed the documentary function, manifesting a preoccupation with analytical, mechanized form equal to that characterizing the performances (e.g., cats. 212, 216, 218, 220, 221).

WINTER SEMESTER 1927–28
Students: 41 ♀ + 125 ♂

November 26, 1927. In local elections, Hesse's German Democratic Party loses half its seats on the Dessau city council (going from four to two), and other left-wing coalition parties lose seats to the right.

Alfred H. Barr, Jr., a graduate student at Harvard University and an associate professor at Wellesley College, who will become founding director of The Museum of Modern Art, New York, in 1929, travels with his Harvard classmate Jere Abbott to Europe to collect materials for a course on contemporary art. They visit the Bauhaus in early December, staying for some three days and meeting Feininger, Gropius, Klee, Moholy, Schlemmer, and others.

On February 4, 1928, Gropius announces that he is leaving the Bauhaus for private practice. The Bauhaus, he says, is "strengthened" to the point where he can "leave the future leadership of it, without detriment," to others. To be his successor, Gropius proposes Hannes Meyer to the magistracy of the city of Dessau. As the founder of the institution, through the unceasing trials of its over-eight-year history, Gropius has applied diplomacy, adaptability, and, in Ise Gropius's words, "undogmatic leadership" to ensure the school's survival as both an institution and a rare and extraordinary community. It is difficult for many to separate the institution from the man, and to imagine its ongoing existence without him. Meyer tries to quell this anxiety by emphasizing the autonomous life of the school, which at this point, he promises, will go forward despite changes in personnel.

At a farewell party held for Gropius on March 25, students and teachers present him with the portfolio *9 Jahre Bauhaus: Eine Chronik* (9 years Bauhaus: a chronicle; cats. 340–42), which presents various aspects of the school — workshops, professors, students — in humorous collages. Gropius's own likeness appears on an elaborately ornamented "diploma," presented by Bayer on behalf of students of advertising and the printing workshop, which mocks a graphic tradition that the Bauhaus has abolished.

In May, as part of a reciprocal arrangement whereby students of the Vkhutemas school in Moscow had visited the Bauhaus in the summer of 1927, Stölzl and the two students Peer Bücking and Arieh Sharon visit Moscow.

This semester Klee begins lecturing on form in the weaving workshop.

Meyer/Dessau

SUMMER SEMESTER 1928
Students: 47 ♀ + 128 ♂

Hannes Meyer's official responsibilities as director begin on April 1.

In the most significant staff turnover in the history of the institution to date, three members of the staff — Bayer, Breuer, and Moholy — depart with Gropius. Their responsibilities, respectively for typography, cabinetry, and metalwork, are assumed respectively by Joost Schmidt, Josef Albers (fig. 5), and Brandt (who is not promoted to the teaching staff but nevertheless serves as acting head of the metalwork shop).

On April 4, Meyer and his architectural partner Hans Wittwer, together with Bauhaus students, enter a competition for the Bundesschule des Allgemeinen Deutschen Gewerkschaftsbundes (Federal school of the German trade union federation), or ADGB, in Bernau, near Berlin. They win the commission, fulfilling Meyer's aim of bringing to the Bauhaus a project involving real, practical contributions from all departments. The project will prove Meyer's main focal point and achievement during his directorship.

On April 4 and 11, Modest Mussorgsky's *Pictures at an Exhibition* is performed at Dessau's Friedrich-Theater with costumes and sets designed by Kandinsky (cats. 377–80). Paul Klee's son, Felix, assists on the production.

SUMMER RECESS 1928

On July 1, the first issue of *bauhaus* appears under the editorship of Meyer and the Hungarian art critic Ernst Kállai, on staff at the Bauhaus as press officer. The cover shows a grid of portraits of the Bauhaus teaching staff, and the issue opens with an affirmation that despite the changes in personnel, "*das bauhaus lebt!*" (The Bauhaus lives!). Alongside contributions by teachers, attention focuses on the students. The issue includes their responses to a questionnaire about their experience at the Bauhaus — Otti Berger, Max Bill, Erich Comeriner, Lux Feininger, and Hubert Hoffmann are among the respondents — accompanied by playful snapshots of them at work and play. The issue is egalitarian and transparent in tone (it includes budgetary statistics) and seems to represent a conscious effort to nurture the Bauhaus community. It also functions as a quarterly annual report, an enticement for prospective students, and a roundup of noteworthy items outside the school.

WINTER SEMESTER 1928–29
Students: 46 ♀ + 130 ♂

Among those invited to lecture at the Bauhaus this semester are Lissitzky, who discusses the Bauhaus and Vkhutemas (October 1, 1928), and Naum Gabo, who speaks about his own work (November 2).

As part of Meyer's effort to preserve the character of the Bauhaus community, a new emphasis is placed on parties, cornerstones of the life of the institution from the beginning. While Meyer is director, the school's parties are directed by Schlemmer and reach an unmatched level of inventiveness and popularity. If not the high point, certainly the most photogenic of these highly orchestrated, performative events is the *Metallisches Fest* (Metal party), on February 9, 1929. The pure qualities of metal lend themselves to costumes and decorations that magically transform the Bauhaus through shimmering, reflective surfaces. According to Schlemmer, "The Bauhaus was also attractive from the outside, radiant in the winter night: the windows with metal paper stuck inside them, the light bulbs —white and colored according to the room — the views through the great glass block — for a whole night these transformed the building of the 'Hochschule für Gestaltung,' that place of work."

On March 1, the Bauhaus signs a contract with the wallpaper manufacturer Emil Rasch, the brother of Marie Rasch, a student at the Bauhaus during the Weimar years. The wall-painting workshop oversees a competition for designs, open to all students, from which a selection will be made by Albers, Hilberseimer (who will join the architecture department the following month), Scheper, and Joost Schmidt.

SUMMER SEMESTER 1929
Students: 51 ♀ + 122 ♂

Among the new appointments this semester is **Walter Peterhans**, a thirty-one-year-old photographer whose father is the director of the lens manufacturer Zeiss Ikon A.-G. Peterhans is hired to head a new photography department as a supplementary specialization within the advertising department.

Appearing in 1929, the first prospectus to be published under Meyer — *junge menschen kommt ans bauhaus!* (young people come to the bauhaus!; p. 4) — uses apparently informal snapshot photography to promote a compelling public image of a young and vivacious artistic community (cats. 343, 344). The statutes appearing in this prospectus are reprinted unchanged from the *Satzung, Lehrordnung* of October 1926, and the choice of specialized study continues in the four areas offered by Gropius: architecture, advertising (now with options of photography and printing), stage, and free painting and sculpture. A journeyman certificate is still a prerequisite for the study of architecture, which is now defined as a nine-semester course and is clearly a school priority. Bauhaus diplomas are now to be granted. Among the new teaching staff listed, no fewer than four —Anton Brenner, **Ludwig Hilberseimer**, Alcar Rudelt, and Mart Stam — belong to this department. Hilberseimer is a thirty-four-year-old architect and radical theorist of cities who, like Gropius, was active in avant-garde circles directly after the war.

On April 20, the most significant exhibition of Bauhaus production since the 1923 show opens in Basel: the work of the masters —Albers, Feininger, Kandinsky, Klee, and Schlemmer — appears at the Kunsthalle, that of the preliminary courses, workshops, building departments, and free-painting classes at the Gewerbemuseum. Organized by Meyer to coincide with the ten-year anniversary of the school's founding, this is not a retrospective account but a kind of status report. At the Gewerbemuseum, where objects such as textile samples, lamps, hardware, and even foldable furniture are displayed on temporary display boards, the installation looks more like a trade show or educational display than a museum exhibition (cat. 36). The separation of objects between the two venues registers a rift that has grown between fine and applied art at the Bauhaus. Parts of the Gewerbemuseum exhibition will travel in Switzerland and Germany through August 1930.

SUMMER RECESS 1929

The Museum für Kunst und Kulturgeschichte Lübeck has purchased a major Jacquard weaving by Stölzl (by May 1929; possibly in September 1928, at the Leipzig trade fair; cat. 266). This acquisition is reported in *bauhaus* on July 15.

In July, Brandt leaves her position as acting head of the metal workshop to join Gropius's office in Berlin.

Die Volkswohnung (The people's apartment), an exhibition of furniture, lamps, and fabric from the Bauhaus workshops, is shown at the Grassi Museum, Leipzig, in September (cat. 37). The exhibition is advertised with the slogans "demonstration of principles for furnishing small apartments," "all wasted space avoided," and "reducing the housewife's workload is a guiding principle for technical innovation." Such functionalist, implicitly antiformalist rhetoric unmistakably distinguishes Meyer's Bauhaus from Gropius's: in place of utopianism and a vision for the future, it insists upon realism and social relevance.

WINTER SEMESTER 1929–30
Students: 58 ♀ + 143 ♂

October 24, 1929. The crash of the New York stock market leads to the withdrawal of American loans to Germany, which have been the basis of relative economic stability since 1924.

Following Brandt's departure during the summer recess, at the start of this semester Meyer consolidates the metal, cabinetry, and wall-painting workshops under the former student Alfred Arndt, as a single workshop titled *Ausbau* (interior finishings).

On October 1, 1929, a farewell party is held for Schlemmer, who, after nine years of teaching at the Bauhaus, during which, in recent years, he has created an active program of touring performances beyond Dessau, is leaving for a teaching position at the Staatliche Akademie für Kunst und Kunstgewerbe (State academy for art and applied arts), Breslau (now Wrocław, Poland). On September 8 he writes to a friend, "Hannes Meyer and a group of students reject the Bauhaus Theater productions as irrelevant, formalistic, too personal. Kandinsky supported and defended me, as did Klee — and both said: the people at the Bauhaus will only later realize what they have lost." None of this controversy is publicly acknowledged and a large part of the November 15 *bauhaus* magazine (the last issue under Meyer; cat. 211) is devoted to Schlemmer's accomplishments.

In January 1930, the firm of Gebr. Rasch & Co. GmbH, in Bramsche, offers the first sample book of fourteen Bauhaus-designed wallpapers under the brandname *Bauhaus-Tapeten*. Considering paint an active element in architectural design but wallpaper just a decorative masking, the earlier Bauhaus has resisted wallpaper, which, however, now provides the school with its single most lucrative product.

SUMMER SEMESTER 1930
Students: 51 ♀ + 137 ♂

May 14–July 13. Organized by the Werkbund, the German section of the *Exposition de la société des artistes décorateurs*, Paris, presents a review of the Gropius-era Bauhaus.

Meyer's ADGB building is inaugurated on May 4 (cats. 345–50). His most notable achievement as Bauhaus director, it involves input from many members of the Bauhaus community. Anni Albers, for one, develops a fabric for the auditorium, using cellophane on one side for its light-reflecting qualities and chenille on the other to absorb sound. This fabric earns her her Bauhaus diploma. A culmination of Meyer's theoretical and practical positions, the ADGB is both comparable to and perhaps implicitly critical of Gropius's Dessau Bauhaus building, and might be considered a socially conscious corrective to the founding director's abstract formalism.

SUMMER RECESS 1930

By July, just as Meyer's extension to Gropius's Törten housing development, realized with the Bauhaus architecture department, becomes ready for occupancy, public accusations mount against Meyer for his Communist sympathies and affiliations. On August 1, 1930, he is summarily dismissed by the government of the state of Anhalt. "The cultural reactionaries," he writes on August 16, "had long prepared for the kill to take place during the Bauhaus vacation." On August 5, on the recommendation of Gropius, the forty-four-year-old Berlin-based architect **Ludwig Mies van der Rohe** signs a contract to become director of the Bauhaus.

Mies/Dessau

WINTER SEMESTER 1930–31
Students: 11 ♀ + 122 ♂

October 1930. Thuringia's National Socialist government appoints Paul Schultze-Naumburg, an advocate of traditional German, *völkisch*

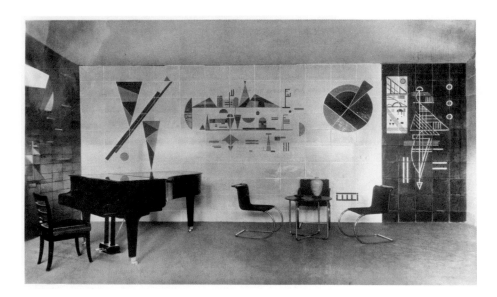

6. Vasily Kandinsky. Music Room at the *Deutsche Bauausstellung* (German building exhibition), Berlin, May 9–August 2, 1931. Photograph: photographer unknown. Copy print from a newspaper photograph. Bauhaus-Archiv Berlin

architecture, to direct the school in the Bauhaus's former Weimar building. Schultze-Naumburg immediately orders the destruction of Schlemmer's wall designs, remaining there from the 1923 exhibition.

As the new director of an institution under siege, Mies acts immediately to dispel an image of unruliness that puts the school at risk in the current political climate. Among his first acts is to convert the Prellerhaus from student residences to studios and workrooms (second, third, and fourth floors) and guestrooms for teachers and visitors (fifth floor). Students must find other accommodations and the Bauhaus community is dispersed. In a letter of October 22, Gustav Hassenpflug writes to Otti Berger that with the conversion of the Prellerhaus "the liveliest idea of the Bauhaus disappears."

New statutes are issued on October 8. The Bauhaus now offers a clearly defined six-semester (three-year) course, divided into general instruction (an updated preliminary course, now referred to as *Allgemeine Ausbildung* or general instruction, including mathematics, science, and lectures on psychology, art history, and other topics; students with adequate prior training may omit this step with the director's approval) leading to specialized instruction in one of five areas: building and interior finishing (*Bau* and *Ausbau*), advertising, photography, weaving, and fine art. These will remain unchanged until the closing of the Bauhaus, in 1933.

In January 1931, after a year's hiatus, *bauhaus* reappears, now edited by Hilberseimer. It runs to only four pages, devoted to architecture, Josef Albers's combinatory lettering, and a list of Bauhaus products in commercial production: lighting (Körting & Mathiesen), wallpaper (Gebr. Rasch & Co.), opaque glass (Gewerkschaft Kunzendorfer Werke), and fabric (Polytex-Gesellschaft m.b.h.).

Having unofficially informed Meyer of his intention to leave in May 1930, Klee now teaches his last semester at the Bauhaus (his contract is terminated on April 1, 1931). Estranged from the school's current direction and uncomfortable with his relegation to the status of "free painter," he has only stayed because of his attachment to the Bauhaus community and a self-confessed lack of courage to leave. Klee's departure will be commemorated in the December 1931 issue of *bauhaus*, edited by Kandinsky, who will write a personal essay on their ten years as colleagues at the school.

SUMMER SEMESTER 1931
Students: 47 ♀ + 130 ♂

After a trying and drawn-out sequence of events, Stölzl leaves the school on July 7 (Anni Albers fills in for her until the end of the semester), ending a twelve-year affiliation. The previous semester, the students Grete Reichardt, Ilse Voigt, and Herbert von Arend have filed charges against Stölzl, accusing her of "incorrect" behavior in her private life. They presumably refer to her marriage to Sharon, who is Jewish, on August 27, 1929, when she is already pregnant. Mies has dismissed the charges in November 1930, but in March 1931, Voigt's father has made an official complaint to the city government of Dessau, leaving Stölzl no choice but to resign. Only two years earlier, writing to her brother about Sharon, Stölzl has noted that "things are a little easier at the Bauhaus than in the respectable parlor of an apartment building"; clearly, however, as a protected enclave the Bauhaus is becoming more permeable to conservative forces. The issue of *bauhaus* for July 1931 is devoted to her. "On October 1 of this year Gunta Sharon-Stölzl leaves the Bauhaus. . . . That one can speak of Bauhaus fabric, is her accomplishment." With the Stölzl and Klee commemorative issues, *bauhaus* ceases publication.

Mies organizes *Die Wohnung unserer Zeit* (The dwelling in our time), a section of the *Deutsche Bauausstellung* (German building exhibition) in Berlin (May 9–August 2; cats. 18, 33). The exhibition includes full-scale houses, designed by Mies, Lilly Reich, and others, and rooms designed by members and former members of the Bauhaus community including Albers, Breuer, Gropius, and Kandinsky. Kandinsky's contribution, a ceramic-tiled music room (fig. 6; cats. 367–69), is his second architecturally scaled project of the Bauhaus period.

SUMMER RECESS 1931

The State Museum for New Western Art, Moscow, presents an exhibition of Bauhaus work under Meyer (July 2–September).

WINTER SEMESTER 1931–32
Students: 53 ♀ + 144 ♂

On January 5, 1932, Mies's colleague **Lilly Reich**, an accomplished forty-six-year-old designer and architect, joins the staff. She

7. Student Ernst Louis Beck at the entrance of the Bauhaus building in Berlin-Steglitz, c. 1933. Photograph: photographer unknown. Original negative 3 1/8 x 2 3/8" (8 x 6 cm). This print 1985. Bauhaus-Archiv Berlin

8 (opposite). The Bauhaus building in Dessau after the school's departure. c. 1932–33. Photograph: photographer unknown (possibly Josef Tokayer). Gelatin silver print. 5 1/8 x 7 1/16" (13 x 18 cm). Bauhaus-Archiv Berlin

shares responsibility for *Ausbau* instruction with Arndt and heads the weaving department. She also manages much of the daily administration of the Bauhaus for Mies.

In February, in the tradition of the competition for wallpaper patterns, students are invited to submit designs for printed curtain fabrics to be developed by M. van Delden & Co., Gronau. Among the most innovative results to go into production is an abstract design created by Hajo (Hans-Joachim) Rose on a typewriter (cats. 387, 389, 390).

On March 19, students refuse to leave a meeting held in the canteen — their favored gathering place — and Dessau police are called in to clear the premises. As a result, the student ringleaders, Cornelius van der Linden and Heinz Schwerin, are expelled. Mies is probably concerned less by the students' political convictions than by the ramifications of their conduct within the local community and its consequences for the school's future in the current political climate.

SUMMER SEMESTER 1932
Students: 38 ♀ + 139 ♂

May. A National Socialist/German Nationalist coalition wins regional elections for the Anhalt government.

Aware of the increasing threat to the school's financial support as the right gains a majority in Anhalt, Mies carefully manages the image of the Bauhaus, discouraging boisterous student activity and emphasizing the school's productivity through, for example, regular exhibitions in the building (a practice initiated by Meyer). These include an exhibition of abstract (and as such nonpolitical) *Glasbilder* (glass pictures) by Albers, on view from May 1 to 18 (cat. 440 was among the works included).

SUMMER RECESS 1932

The series of exhibitions held in the school's main building concludes with the regular semester-end show, which opens on

July 6. Forewarned by the unwavering Bauhaus supporter Hesse, still Dessau's mayor, that a delegation of state officials will visit the exhibition to determine whether the school will continue to receive funding, Mies carefully selects the objects to be included. On July 8, he leads a group including Hesse, Minister President of Anhalt Alfred Freyberg, and — for his expertise in matters architectural — Schultze-Naumburg, the outspoken enemy of modern architecture who now heads the school in the Bauhaus's former building in Weimar, through the exhibition. On August 19, Hesse leads another group of National Socialist city council members and press through the exhibition. Nine years earlier, Gropius's summer exhibition of 1923 has been instrumental in convincing the Thuringian government to continue to fund the school. Now, at a moment of financial crisis and extremist politics, the strategy fails to convince the Anhalt government to do likewise. On August 22, the city legislature decides to discontinue classes and discharge the Bauhaus teaching staff, effective October 1.

In September, Mies talks with officials from Leipzig and Magdeburg about the possibility of continuing the school as a state-funded institution in one of those cities. He and Hesse simultaneously work together on an agreement (made official on October 5) that will grant him the right to maintain the school under the name "Bauhaus" and to take legal ownership of the trademark "Bauhaus Dessau." It is estimated that profits from Bauhaus products, in particular the Gebr. Rasch wallpapers, will be sufficient to pay the salaries of the most of the staff, allowing Mies to make the school a financially independent institution. On September 24, Mies announces to the students that the Bauhaus will continue as an independent institution in Berlin. The address is to be announced; classes will begin on October 18.

Owing to the reduced budget, the contracts of Arndt, Joost Schmidt, and Lyonel Feininger are terminated.

Mies/Berlin

WINTER SEMESTER 1932–33
Students: 25 ♀ + 90 ♂

January 30, 1933. Hitler is named chancellor of Germany.
April 1. Boycott of Jewish businesses begins throughout the country.

On October 10, 1932, the Bauhaus signs a three-year lease to rent the former Berlin telephone-company buildings at Birkbuschstrasse 55/56, on the corner of Siemensstrasse in Berlin-Steglitz (fig. 7). A new curriculum, printed in October 1932, lists

the teaching staff: Albers, Friedrich Engemann, Hilberseimer, Kandinsky, Mies, Peterhans, Reich, Rudelt, and Scheper.

The first months of the semester are apparently spent cleaning and painting the new building. Classes finally start in January, as do preparations for a party to be held on Saturday, February 18, intended to raise funds: admission is ten Reichsmarks, and a raffle — three Reichsmarks per ticket — is held for works by current staff (Kandinsky), former staff (Feininger, Klee, Schlemmer), and other prominent modern artists (Willi Baumeister, Erich Heckel, Karl Hofer, Georg Kolbe, Wilhelm Lehmbruck, Ewald Ma007é, Emil Nolde, Pablo Picasso, Karl Schmidt-Rottluff, and Renée Sintenis). The party draws some 700 guests and is a great success. The student Annemarie Wilke writes a letter describing the rooms on the ground floor as "making an unbelievably elegant impression," which she contrasts with the thematic rooms of popular appeal on the second floor designed by Albers, Kandinsky, and Peterhans. A room designed by Mies to display the artworks to be raffled is elegantly draped in cloth; raw silk at the windows and cotton on the walls and ceiling. The letter conveys, above all, a vivid impression of the vibrant, self-identified Bauhaus community as still intact.

SUMMER SEMESTER 1933
Students: 5 ♀ + 14 ♂

On April 11, at the start of the summer semester, Berlin police and National Socialist militia seal off the Berlin Bauhaus on orders of the Dessau public prosecutor's office, in order to search it for evidence incriminating Hesse, who is charged with "irregularities in office" but is more broadly targeted as an adversary of the new regime. The next day, Mies meets with the culturally influential Nazi ideologue Alfred Rosenberg, hoping to win his support for reopening the school. In Mies's later recollection, Rosenberg asks him the simple yet incisive question, "Why didn't you change the name, for heaven's sake?" The problem, Rosenberg's question implies, lies in the name "Bauhaus" itself — it has become a powerful signifier for radical left-wing culture — rather than in Mies's program, and might easily have been solved through a simple semantic substitution. Beyond its role as a cultural and political signifier, however, "Bauhaus" is also a brand name, which literally pays for the continued existence of the school.

The school remains closed for three months, during which Mies tries unsuccessfully to meet with the head of the Gestapo. On July 20, 1933, the faculty unanimously votes to dissolve the Bauhaus due to economic difficulties arising from its protracted closure. A letter relaying this decision to the Gestapo crosses in the mail with a letter dated July 21, *from* the Gestapo, saying that the school may reopen under certain conditions, including the dismissal of Hilberseimer and Kandinsky. On August 10, Mies announces the closure of the Bauhaus to the students, noting, "We would have agreed to these conditions, but the economic situation does not allow for a continuation of the institution."

Sources

This chronicle has benefited from an ongoing dialogue with Dara Kiese, who has been extremely generous with her knowledge of the Bauhaus and with her prior research. The information presented here relies mainly on primary sources, many of them published in accessible anthologies. The most significant collection of such material remains Hans Maria Wingler's *The Bauhaus: Weimar, Dessau, Berlin, Chicago*, first published in German in 1962 and in English by The MIT Press in 1969, followed by several later editions. Peter Hahn's *Bauhaus Berlin* (Berlin: Kunstverlag Weingarten, 1985) comprehensively documents the school's Berlin period. Among the Bauhaus's own publications, Gropius's *Staatliches Bauhaus Weimar 1919–1923* (Weimar and Munich: Bauhausverlag, 1923) and the magazine *bauhaus*, published in Dessau from 1926 to 1931, provide important, consciously self-historicizing accounts. Published anthologies of the correspondence and journals of Lyonel Feininger, Paul Klee, Oskar Schlemmer, Gunta Stölzl, and others are invaluable resources, as are the unpublished diaries of Ise Gropius (Bauhaus-Archiv Berlin). I am indebted to Michael Siebenbrodt, Wolfgang Thöner, and Christian Wolsdorff for responding to specific questions, to Frederic J. Schwartz for his thoughtful comments, and to Klaus Weber, who, in generously sharing his expertise throughout the course of this project, has been an educator and collaborator in the tradition of the Bauhaus itself.

The student-enrollment statistics provided here derive from Folke Dietzsch, *Die Studierenden am Bauhaus. Eine analytische Betrachtung zur Struktur der Studentenschaft, zur Ausbildung und zum Leben der Studierenden am Bauhaus sowie zu ihrem späteren Wirken*, Ph.D. thesis, Hochschule für Architektur und Bauwesen, Weimar, 1990. For events beyond the Bauhaus I have relied on various published chronologies of the Weimar Republic.

BAUHAUS 1919–1933: WORKSHOPS FOR MODERNITY

Individual works of art appearing herein may be protected by copyright in the United States of America, or elsewhere, and may not be reproduced in any form without the permission of the rights holders. The copyright credit lines listed below are in some instances provided at the request of the rights holders. In reproducing the images contained in this publication, the Museum obtained the permission of the rights holders whenever possible. Should the Museum have been unable to locate the rights holder, notwithstanding good-faith efforts, it requests that any contact information concerning such rights holders be forwarded so that they may be contacted for future editions.

©2009 The Josef and Anni Albers Foundation/Artists Rights Society (ARS), New York: p. 95, fig. 1; cats. 49, 83, 84, 93, 94, 160, 161, 163, 164, 259, 260, 273–79, 324, 325, 340, 396, 401, 419, 440–42. Courtesy The Josef and Anni Albers Foundation, Bethany, Conn.: p. 95, fig. 1; cats. 260, 273, 356–59, 441; p. 332. Art Resource, N.Y. Photo Tim Nighswander: cats. 83, 93, 94, 275, 278, 279, 442. Courtesy The Art Institute of Chicago, © The Art Institute of Chicago: cat. 445. ©2009 Artists Rights Society (ARS), New York/ADAGP, Paris: cats. 10, 72, 124–29, 130–42, 242, 326, 327, 335, 367–69, 377–82; p. 335. ©2009 Artists Rights Society (ARS), New York/c/o Pictoright Amsterdam: p. 231, fig. 1. ©2009 Artists Rights Society (ARS), New York/Pro Litteris, Zurich: cats. 61, 66, 67. ©2009 Artists Rights Society (ARS), New York/VG Bild-Kunst, Bonn: front cover, spine, back cover, endpapers, p. 2; cats. 4, 6, 12, 13, 17, 19, 20, 22, 28–30, 33–35, 38–42, 49–51, 56, 57, 77, 79–82, 87; p. 95, fig. 2; cats. 85, 86, 88–92, 95, 98, 99, 102, 111, 115–18, 120–23, 143, 144–56, 158, 162, 165–69, 170, 171, 192–94, 196, 201–5, 223–29, 236, 237, 241, 243–47, 251–53, 255–58, 261–68, 271, 281–95, 303, 305–8, 310–21, 328–34, 336–39, 341, 362, 363, 371, 372, 374–76, 387–90, 392, 394, 395, 413–17, 420, 421, 423–25, 430, 433, 434, 444, 446; pp. 322, 330. © Estate Theo Ballmer: cats. 402, 403. © Bauhaus-Archiv Berlin: cats. 1, 23, 360. Courtesy Bauhaus-Archiv Berlin: endpapers, p. 4; cats. 2, 3, 5, 6, 10, 13, 17, 22, 28, 29, 31, 32, 34, 36, 37, 49, 63, 64, 66, 67, 72, 77–81, 84, 89, 92, 96, 109, 120, 172–91, 237, 235, 270, 296, 313, 314, 322, 343, 344, 346–50, 352, 361–63, 370, 385, 387, 389, 391, 395, 400, 405, 413–15, 422, 425, 438; pp. 322, 324, 327, 335, 337. © Agency for Photographs of Contemporary History, Berlin (ABZ): p. 327. Photo Fotostudio Bartsch: cats. 69, 99, 355, 397, 399. Photo Markus Hawlik: back cover, cats. 48, 59, 62, 73, 90, 91, 149, 176, 180, 197, 235, 237–39, 340–42, 364–66, 426, 430, 435–37, 443, pp. 336, 337. Photo Hermann Kiessling: cats. 226, 228, 233, 371, 428. Photo Hartwig Klappert: cat. 95.

Photo Fred Kraus: cats. 108, 111, 274. Photo Bernd Kuhnert: cats. 306, 307. Photo Gunter Lepkowski: cats. 52, 65, 159, 213, 234, 308, 354, 392. Photo Jochen Littkemann: cat. 390. Photo Atelier Schneider: cats. 14, 16, 47, 60, 439. Bauhaus-Archiv Berlin/Ernst von Siemens Kunststiftung. Photo Hartwig Klappert: cat. 95. Courtesy Bauhaus-Archiv Berlin/Centre Pompidou, Musée national d'art moderne: p. 330. Courtesy Bauhaus-Universität Weimar, Archiv der Moderne: cat. 154, p. 321. Courtesy the Herbert Bayer Collection and Archive, Denver Art Museum: cat. 35. Courtesy Galerie Berinson, Berlin: p. 2; cats. 246, 289, 295, 330, 401, 407. Courtesy Collection Merrill C. Berman. Photo Jim Frank: cats. 170, 192, 194, 195, 219, 243, 245, 247, 253, 255, 261, 264, 265, 383, 384, 386, 388, 393, 408. Photo Jeffrey Sturges: front cover, cat. 271. Courtesy Bildarchiv Preussischer Kulturbesitz/Art Resource, N.Y. Photo Jens Ziehe: cats. 85, 147, 209, 214, 215. Courtesy Justus A. Binroth. Photo Christoph Sandig: cat. 394. Courtesy BLDAM, Bildarchiv, Zossen, Brandenburg: cat. 27. © Estate Theodor Bogler: cats. 106, 107, 112–14. © Estate Marcel Breuer: cats. 25, 31, 95–98, 207, 240, 272, 296–99, 301, 302. Bridgeman-Giraudon/Art Resource, N.Y. University of Leiden: cat. 335. CNAC/MNAM/Dist. Réunion des Musées Nationaux/Art Resource, N.Y.: cats. 280, 281, 329, 377–79. Photo Jacques Faujour: cats. 171, 282, 285. Photo Jacqueline Hyde: cats. 124, 126–28. Photo Erich Lessing: cat. 242. Photo Georges Meguerditchian: cat. 125. Photo Philippe Migeat: cats. 284, 424. Photo Jean-Claude Planchet: cat. 380. Photo Bertrand Prévost: cat. 240. Photo Peter Willi: cat. 286. Courtesy Centre Pompidou, Mnam-Cci, Bibliothèque Kandinsky: cats. 129, 241. © Estate Edmund Collein: cat. 342. © Estate Erich Comeriner/Galerie David, Bielefeld: cats. 386, 404. Courtesy estate Erich Comeriner/Galerie David, Bielefeld: cat. 404. © Estate Erich Consemüller: cats. 7, 218, 314, 356, 357. Courtesy estate Erich Consemüller: cats. 7, 218. Courtesy Designsammlung Ludewig, Berlin: cats. 272, 298, 299. Deutsches Architekturmuseum, Frankfurt: cats. 198–200, 345. © Estate Johannes Driesch: cat. 54 . © Estate Franz Ehrlich: cat. 383. © Estate T. Lux Feininger: cats. 249, 250, 323, 343, 344, 448. Courtesy Galerie Ulrich Fiedler, Berlin: cats. 70, 156. © Galleria Martini & Ronchetti, Genoa: cats. 411, 412. Courtesy George Eastman House, International Museum of Photography and Film, Rochester, N.Y.: cats. 332, 333. Courtesy Germanisches Nationalmuseum, Nuremberg. Deutsches Kunstarchiv: cat. 223. Courtesy The J. Paul Getty Museum,

Los Angeles: cats. 8, 402, 403. Courtesy Research Library, The Getty Research Institute, Los Angeles: cat. 24. © Estate Werner Graeff: cat. 73. Courtesy the Solomon R. Guggenheim Museum, New York: cats. 50, 328. © The President and Fellows of Harvard College. Photo Junius Beebe: cat. 374. Photo Imaging Department: cats. 168, 193, 224, 225, 236, 257, 258, 312. Photo Katya Kallsen: cats. 38, 39, 217, 229, 276, 287, 311, 372, 421. Photo Allan Macintyre: cats. 41, 227, 277. Photo Michael A. Nedzweski: cat. 115. Photo Rick Stafford: cat. 310. © Estate Ludwig Hirschfeld-Mack: cats. 11, 186, 187, 366. Courtesy Hirshhorn Museum and Sculpture Garden, Smithsonian Institution, Washington, D.C.: cat. 440. © Estate Waldemar Hüsing: cat. 426. The Jewish Museum, N.Y./Art Resource, N.Y.: cat. 110. Courtesy Joy of Giving Something, Inc. Photo Jeffrey Sturges: cats. 150, 151. © Estate Carl Jucker: cats. 26, 109, 154, 155. Courtesy Galerie Kicken, Berlin: p. 259. Courtesy Klassik Stiftung Weimar: pp. 62–63, cats. 23, 43–45, 53–56, 58, 68, 71, 74–76, 98, 100, 101, 103–7, 119, 157, 158, 203–8, 220, 222, 231, 232. © Estate Benita Koch-Otte: cats. 101, 206. © Estate Kurt Kranz: cats. 373, 405, 406, 407. © Estate Fritz Kuhr: cat. 238. Courtesy Kunsthalle Bielefeld: cat. 373. Courtesy Kunsthaus Zurich: cat. 61. Courtesy Kunstmuseum Basel. Photo Martin P. Bühler: cat. 326. Courtesy the Viktor and Marianne Langen Collection. Photo Sasa Fuis Photography, Cologne: cat. 145. Courtesy the Library of Congress, Washington, D.C.: cat. 427. © Estate Otto Lindig: cats. 55, 103, 104. © Long Beach Museum of Art: cat. 327. Courtesy Louisiana Museum of Modern Art, Humblebaek: cat. 337. © Estate Rudolf Lutz: cats. 68, 69. Courtesy Musées de la Ville de Strasbourg. Photo M. Bertola: cats. 367–69. ©2009 Museum Associates/LACMA: p. 95, fig. 2. Foto Marburg/Art Resource, N.Y.: p. 141. Courtesy Gerhard-Marcks-Haus, Bremen: cat. 46. © Gerhard-Marcks-Haus, Bremen: cats. 43–46, 53, 55, 105, 106, 178. Copy photograph © The Metropolitan Museum of Art: cats. 88, 283, 294, 315, 320, 321, 323, 412. Courtesy Moderna Museet, Stockholm: p. 277, fig. 1. Courtesy MOSI (Museum of Science & Industry, Manchester): p. 208. © Estate Erich Mrozek: cat. 384. © Die Museen für Kunst und Kulturgeschichte der Hansestadt Lübeck: cat. 266. The Museum of Modern Art, New York. Department of Imaging Services: cats. 4, 33, 97, 113, 131–43, 148, 160, 161, 165, 166, 211, 244, 251, 256, 290–93, 302, 317, 325, 396, 411, 447. Photos Robert Gerhardt: spine, cats. 25, 40, 116, 117, 216, 423, 431, 432. Thomas Griesel: cats. 20, 21, 26, 30;

p. 103; cat. 112; p. 119; cats. 122, 169, 196, 202, 210, 252, 259, 262, 300, 304, 406; p. 295, fig. 1; cats. 416, 417–19. Paige Knight: cats. 318, 319, 324. Jonathan Muzikar: frontispiece (p. 1), cats. 1, 212, 248–50, 288, 316, 446. Mali Olatunji: cats. 19, 118, 263. Rosa Smith: cats. 9, 11, 12, 18, 57, 146, 376. Soichi Sunami: p. 13. John Wronn: cats. 144, 230, 331, 420; p. 328. Courtesy private collection, photo John Wronn: cat. 433. © Museum Szutki w Łodzi, Lodz: p. 251. Courtesy the Board of Trustees, National Gallery of Art, Washington, D.C.: cat. 42. Courtesy Neue Galerie New York/Art Resource, N.Y.: cat. 153. Courtesy Neue Galerie New York. Photo Hulya Kolabas: cats. 114, 162. © Estate Pius Pahl: cats. 435, 436, 437, 438, 443. © Estate Gyula Pap: cat. 110. © Estate Walter Peterhans: 37, 345, 346, 347, 348. Courtesy private collection: cats. 155, 167, 269. Photo Jeffrey Sturges: cats. 87, 102, 130, 254, 297, 434, 448. Courtesy private collection, Chicago. Photo Michael Tropea: cat. 334. © Estate Lilly Reich: cats. 18, 430–33. Réunion des Musées Nationaux/Art Resource, N.Y. Photo P. Schmidt: p. 239, fig. 1. Courtesy Rheinisches Bildarchiv Köln: cat. 444. © Estate Franz Scala: cat. 59. © Scheper estate, Berlin: cats. 233–35. © Estate Fritz Schleifer: cat. 195. ©2009 Estate Oskar Schlemmer, Munich: cats. 173, 209, 211, 212, 216, 217, 219, 447. © Estate Kurt Schmidt: 172, 176, 214, 215, 220, 222. © Estate Eberhard Schrammen: cat. 213. © Estate Lothar Schreyer: cats. 60, 62, 63, 64, 65. © Estate Herbert Schürmann: cat. 393. Courtesy Kupferstich-Kabinett, Staatliche Kunstsammlungen Dresden: cats. 338, 339, 381, 382. Photo Herbert Boswank: cat. 336. Die Neue Sammlung—The International Design Museum Munich. Photo Archiv Die Neue Sammlung: cats. 163, 164, 201. © Stiftung Bauhaus Dessau. Photo Kelly Kellerhoff, Berlin: cat. 15. Courtesy Stiftung Bauhaus Dessau: cats. 309, 351, 429. Photo Sebastian Kaps, Dessau: cat. 410. Photo Kelly Kellerhoff, Berlin: cats. 15, 301, 305, 353, 360, 398, 409. Photo Peter Kühn, Dessau: 82. ©2008 Tate, London: cat. 152. ©2009 Tate, London/© Hattula Moholy-Nagy: cat. 375. Courtesy Theaterwissenschaftliche Sammlung, Universität zu Köln: cat. 221. © Phyllis Umbehr/Galerie Kicken, Berlin: p. 332, fig. 5. © V&A Images: p. 231, fig.1; cats. 267, 268, 303. © Estate Andor Weininger: cat. 221. © Estate Marguerite Wildenhain: cat. 52. © Estate Anny Wottitz: cats. 47, 48. Courtesy Zentrum Paul Klee, Bern: cats. 51, 86, 121, 123.

North Castle Public Lib (Armonk)

3 1001 15142495 0

DEC 15 2009

ARM

TRUSTEES OF THE MUSEUM OF MODERN ART

David Rockefeller*
Honorary Chairman

Ronald S. Lauder
Honorary Chairman

Robert B. Menschel*
Chairman Emeritus

Agnes Gund
President Emerita

Donald B. Marron
President Emeritus

Jerry I. Speyer
Chairman

Marie-Josée Kravis
President

Sid R. Bass
Leon D. Black
Kathleen Fuld
Mimi Haas
Richard E. Salomon
Vice Chairmen

Glenn D. Lowry
Director

Richard E. Salomon
Treasurer

James Gara
Assistant Treasurer

Patty Lipshutz
Secretary

Wallis Annenberg
Celeste Bartos*
Sid R. Bass
Leon D. Black
Eli Broad
Clarissa Alcock Bronfman
Donald L. Bryant, Jr.
Thomas S. Carroll*
Patricia Phelps de Cisneros
Mrs. Jan Cowles**
Douglas S. Cramer*
Paula Crown
Lewis B. Cullman**
Joel Ehrenkranz
H.R.H. Duke Franz of Bavaria**
Kathleen Fuld
Gianluigi Gabetti*
Howard Gardner
Maurice R. Greenberg**
Vartan Gregorian
Agnes Gund
Mimi Haas
Alexandra A. Herzan
Marlene Hess
Barbara Jakobson
Werner H. Kramarsky*
Jill Kraus
Marie-Josée Kravis
June Noble Larkin*
Ronald S. Lauder
Thomas H. Lee
Michael Lynne
Donald B. Marron
Wynton Marsalis**
Robert B. Menschel*
Harvey S. Shipley Miller
Philip S. Niarchos
James G. Niven
Peter Norton
Maja Oeri
Richard E. Oldenburg**
Michael S. Ovitz
Richard D. Parsons

Peter G. Peterson*
Mrs. Milton Petrie**
Gifford Phillips*
Emily Rauh Pulitzer
David Rockefeller*
David Rockefeller, Jr.
Sharon Percy Rockefeller
Lord Rogers of Riverside**
Richard E. Salomon
Ted Sann**
Anna Marie Shapiro
Gilbert Silverman**
Anna Deavere Smith
Jerry I. Speyer
Joanne M. Stern*
Mrs. Donald B. Straus*
Yoshio Taniguchi**
David Teiger**
Eugene V. Thaw**
Jeanne C. Thayer*
Joan Tisch*
Edgar Wachenheim III
Thomas W. Weisel
Gary Winnick

Ex Officio:

Glenn D. Lowry
Director

Agnes Gund
Chairman of the Board of P.S.1

Michael R. Bloomberg
Mayor of the City of New York

William C. Thompson, Jr.
Comptroller of the City of New York

Christine C. Quinn
*Speaker of the Council of the
City of New York*

Jo Carole Lauder
*President of
The InternationalCouncil*

Franny Heller Zorn
and William S. Susman
*Co-Chairmen of
The Contemporary Arts Council*

*Life Trustee
**Honorary Trustee

Published in conjunction with the exhibition

Bauhaus 1919–1933: Workshops for Modernity

organized by Barry Bergdoll, Philip Johnson Chief Curator of
Architecture and Design, and Leah Dickerman, Curator, Department
of Painting and Sculpture, The Museum of Modern Art, New York,
November 8, 2009–January 25, 2010

HyundaiCard GE Partner

The exhibition is made possible by HyundaiCard Company.

Major support is provided by Mrs. Stephen M. Kellen.

Additional funding is provided by Jerry I. Speyer and Katherine G. Farley
and by Robert B. Menschel.

The accompanying publication is made possible by
The International Council of The Museum of Modern Art.

Produced by the Department of Publications,
The Museum of Modern Art, New York

Edited by David Frankel
Designed by McCall Associates, New York
Production by Marc Sapir
Printed and bound by Oceanic Graphic Printing, Inc., China

This book is typeset in FF Kievit, Hoeffler Text,
Berthold Akzidenz-Grotesk, and FF Din.
The paper is 157 gsm Gold East Matt Artpaper

Published by The Museum of Modern Art,
11 W. 53 Street, New York, New York 10019

© 2009 The Museum of Modern Art, New York

Copyright credits for certain illustrations are cited opposite.
All rights reserved

Distributed in the United States and Canada by D.A.P./Distributed
Art Publishers, Inc., New York. Distributed outside the United States
and Canada by Thames & Hudson Ltd, London

Library of Congress Control Number: 2009932327
ISBN: 978-0-87070-758-2

Cover: Joost Schmidt. Cover of the journal *Offset. Buch und Werbekunst*
no. 7 (detail). 1926. Offset on cardboard, 12 1/8 x 9 3/16" (30.8 x 23.3 cm).
Collection Merrill C. Berman. See cat. 271 (p. 211)

Back cover: Alfred Arndt. *Meister Döppelhäuser, von unten gesehen*
(Masters' double houses, seen from below; detail). 1926. Ink and tempera
on paper, 29 15/16 x 22 1/16" (76 x 56 cm). Bauhaus-Archiv Berlin.
See cat. 237 (p. 188)

Spine: Paul Klee. *Der Angler* (The angler; detail). 1921. Oil transfer drawing
with watercolor and ink on paper on board, 19 7/8 x 12 1/2" (50.5 x 31.8 cm).
The Museum of Modern Art, New York. John S. Newberry Collection.
See cat. 116 (p. 115)

Endpapers, front: Hajo Rose (Hans-Joachim Rose). Design for a
fabric print pattern made from typewriter type (digitally extended).
1932. Typewriting on paper, 11 5/8 x 8 1/4" (29.5 x 20.9 cm).
Bauhaus-Archiv Berlin. See cat. 387 (p. 282)

Endpapers, back: Hajo Rose (Hans-Joachim Rose). Design for a
fabric print pattern made from typewriter type (digitally extended).
1932. Typewriting on paper, 11 1/16 x 5 1/16" (28.1 x 12.9 cm).
Bauhaus-Archiv Berlin. See cat. 389 (p. 283)

Halftitle (p. 1): Charlotte (Lotte) Beese. Untitled. 1928.
Gelatin silver print, diam.: 3 3/8" (8.5 cm). The Museum of Modern Art,
New York. Thomas Walther Collection. Gift of Thomas Walther

Title (p. 2): László Moholy-Nagy. Untitled (Ellen Frank). c. 1929.
Gelatin silver print, 14 15/16 x 11" (38 x 28 cm). Galerie Berinson, Berlin

Contents (p. 4): Hannes Meyer. Back cover of brochure *junge menschen
kommt ans bauhaus!* (young people, come to the bauhaus!). 1929.
Letterpress on paper, 5 13/16 x 8 1/4" (14.8 x 21 cm). Bauhaus-Archiv Berlin

Plates opener (pp. 62–63): Peter Keler. Wall painting scheme
for László Moholy-Nagy's studio, Weimar (detail). c. 1925.
Gouache on paper, 11 13/16 x 19 3/4" (30 x 50.1 cm). Klassik Stiftung Weimar,
Bauhaus-Museum. See cat. 231 (p. 183)

Printed in China